D1034032

Kierkegaard After MacIntyre

Kierkegaard After MacIntyre

Essays on Freedom, Narrative, and Virtue

EDITED BY

John J. Davenport and Anthony Rudd

With Replies by
Alasdair MacIntyre and Philip L. Quinn

DISCARDED

BOWLING GREEN STATE
UNIVERSITY LIBRARIES

OPEN COURT
Chicago and La Salle, Illinois

Cover painting by Wilhelm Bendz, *Interior from Amaliegade with the Artist's Brothers* (ca. 1829); oil on canvas. 32.3 x 49 cm. Used with the permission of The Hirschsprung Collection, Copenhagen.

To order books from Open Court, call toll-free 1-800-815-2280.

Open Court Publishing Company is a division of Carus Publishing Company.

© 2001 by Carus Publishing Company

First printing 2001

All rights reserved. No part of this publication may be reproduced, stored in a retrieval system, or transmitted, in any form or by any means, electronic, mechanical, photocopying, recording, or otherwise, without the prior written permission of the publisher, Open Court Publishing Company, 315 Fifth Street, P.O. Box 300, Peru, Illinois 61354-0300.

Printed and bound in the United States of America.

Library of Congress Cataloging-in-Publication Data

Kierkegaard after MacIntyre : essays on freedom, narrative, and virtue / edited by John J. Davenport and Anthony Rudd ; with replies by Alasdair MacIntyre and Philip L. Quinn.
 p. cm.
 Includes bibliographical references and index.
 ISBN 0-8126-9438-4 (alk. paper) — ISBN 0-8126-9439-2 (pbk. : alk. paper)
 1. Kierkegaard, Søren, 1813–1855—Ethics. 2. MacIntyre, Alasdair C. After virtue. I. Davenport, John J., 1966– II. Rudd, Anthony. III. MacIntyre, Alasdair C. IV. Quinn, Philip L.
 B4378.E8 K54 2001
 170'.92—dc21 2001021223

For Robin and Jeanine

Contents

Acknowledgments

The idea for this book came from conversations we began at a conference on Kierkegaard held at St. Olaf College in Northfield, Minnesota, in July 1997. We agreed that Alasdair MacIntrye's critique of Kierkegaard in *After Virtue* represented an important opportunity to clarify Kierkegaard's views about ethical rationality by way of response. But we also agreed that there were important similarities as well as remaining differences between Kierkegaard's work and MacIntyre's project—and more broadly between "existentialism" and the neo-Aristotelian "virtue ethics," which is currently flourishing within analytical philosophy. And this suggested to us the possibility of a mutually enlightening dialogue between these traditions. We also thought it would be useful to scholars working from either a background in Kierkegaard studies or contemporary ethical theory to have a volume that collected representative Kierkegaardian replies to MacIntyre's original critique of Kierkegaard, along with new essays developing and broadening their original ideas, and replies from opposing perspectives.

We are grateful to all the contributors to this volume—both to those whose work had been previously published for allowing us to reprint their papers here and to those who accepted our requests to write new pieces for this volume. It has been especially pleasing to find our sense of the value of this project shared by other Kierkegaard scholars. We thank the Søren Kierkegaard Society of the United States for featuring early drafts of two new papers for this book in their session at the Eastern Division conference of the American Philosophical Association in Boston (December 27, 1999). The participants in that session, including Professor MacIntyre, helped encourage the work brought to fruition here. Phil Quinn was kind enough to amend his lively response at the Boston session for inclusion in the present volume, and this has enriched our project. And we are also very

ix

grateful to Alasdair MacIntyre for agreeing to write his response to all the papers, thus initiating the dialogue we had hoped to stimulate and greatly adding to the value of the book.

Thanks are also due to the Graduate School of Arts and Letters of Fordham University for supporting editorial work on the manuscript of this book with Ames Fund grants in two successive years, and for providing a course reduction in the fall semester of 2000 to John Davenport to assist his work on this project. We thank our colleagues for encouraging this work, and also our families and relatives for their emotional support throughout the process. We would also like to express sincere thanks to Kerri Mommer at Open Court for her tireless effort to make this a better book, and to Matt Edgar for all his help with the manuscript.

It is also appropriate here to thank the publishers of the first five papers in the present volume for permission to reprint these articles from their journals. Their original publication was as follows:

1. Peter J. Mehl, "Kierkegaard and the Relativist Challenge to Practical Philosophy," *Journal of Religious Ethics* (1986): 247–78; reprinted by kind permission of Blackwell Publishers (Oxford and New York).

2. Jeffrey S. Turner, "To Tell a Good Tale: Kierkegaardian Reflections on Moral Narrative and Moral Truth," *Man and World* 24 (1991): 181–98; reprinted by kind permission of Kluwer Academic Publishers (Dordrecht, Netherlands, and Norwell, Massachusetts).

3. Marilyn G. Piety, "Kierkegaard on Rationality," *Faith and Philosophy* 10, no. 3 (1993): 365–79; reprinted by kind permission of the Society of Christian Philosophers (Grand Rapids, Michigan).

4. John J. Davenport, "The Meaning of Kierkegaard's Choice Between the Aesthetic and the Ethical: A Response to MacIntyre," *Southwest Philosophy Review* 11 (1995): 73–108; reprinted by kind permission of the author and the Southwestern Philosophical Society.

5. Gordon D. Marino, "The Place of Reason in Kierkegaard's Ethics," *Kierkegaardiana* 18 (1996): 49–64; reprinted by kind permission of the author and the Søren Kierkegaard Society of Denmark. Marino's essay is also being reprinted in *Kierkegaard and the Present Age,* ed. Marino (Marquette University Press, 2001).

Anthony Rudd's paper, "Reason in Ethics: Kierkegaard and MacIntyre," was originally published in Italian translation by the Italian journal *Studi Perugini* in 1997. This is the first publication of the paper in English.

Finally, we also thank Alasdair MacIntyre and the University of Notre Dame Press for permission to reprint a short selection from *After Virtue,* 2nd ed., 1984.

General Sigla

Note: Because each author in this collection refers to different editions of Kierkegaard's works and prefers different reference styles, we have not imposed a single set format for referring to Kierkegaard texts. Moreover, since the essays by Turner, Mehl, Piety, and Marino were first published as articles in well-known journals, it seemed appropriate to reproduce the referencing method in the original published versions of these essays. Some of the new essays also make reference to older translations of Kierkegaard's works, which are explained within those articles.

Otherwise references to Kierkegaard's works are by the sigla given here. These sigla largely follow those in the *International Kierkegaard Commentary* series edited by Robert Perkins, which have become near-standard in Kierkegaard scholarship today. With the exception of the *Journals and Papers*, the *Point of View*, and Lowrie's translation of *Either/Or* II, references are to *Kierkegaard's Writings*, the complete translation of Kierkegaard's works under the general editorship of Howard V. and Edna H. Hong. All the Kierkegaard volumes are published by Princeton University Press, Princeton, New Jersey, and except as otherwise indicated, they are translated by Howard V. and Edna H. Hong. We have added separate sigla for some of MacIntyre's recent works.

SIGLA FOR KIERKEGAARD'S WORKS

| CA | *The Concept of Anxiety*, trans. R. Thomte and A.B. Anderson, 1980 |
| CI | *The Concept of Irony*, 1989 |

CUP I *Concluding Unscientific Postscript* (Text) 1992
CUP II *Concluding Unscientific Postscript* (notes and
 commentary) 1992
EO I *Either/Or,* Volume One, 1987
EO II *Either/Or,* Volume Two, 1987
Lowrie, EO II *Either/Or,* Volume Two, trans. Walter Lowrie, 1944.
EUD *Eighteen Upbuilding Discourses,* 1990
FT *Fear and Trembling* (published in one volume with
 Repetition) 1983
JC *Johannes Climacus, or De Omnibus Dubitandum Est*
 (Published in one volume with *Philosophical Fragments*)
 1985
JP *Søren Kierkegaard's Journals and Papers.* Seven volumes,
 edited and translated by Howard V. and Edna H. Hong,
 assisted by G. Malantschuk. Indiana University Press,
 Bloomington and London. (1) 1967, (2) 1970, (3&4)
 1975, (5–7) 1978
PC *Practice in Christianity,* 1991
PF *Philosophical Fragments* (published in one volume with
 Johannes Climacus) 1985
PH "On the Occasion of a Confession: Purity of Heart is to
 Will One Thing," in *Upbuilding Discourses in Various
 Spirits,* 1993.
PV *The Point of View for my Work as an Author,* tr. Walter
 Lowrie, New York: Harper and Row, 1962.
R *Repetition* (published in one volume with *Fear and
 Trembling*) 1983
SLW *Stages on Life's Way,* 1988
SUD *The Sickness Unto Death,* 1980
TA *Two Ages: The Age of Revolution and the Present Age. A
 Literary Review,* 1978
TM *The Moment and Late Writings,* 1998
UDVS *Upbuilding Discourses in Various Spirits,* 1993
WA *Without Authority* 1997
WL *Works of Love,* 1995

SIGLA FOR MACINTYRE'S WORKS

AV *After Virtue: A Study in Moral Theory,* Second Ed.
 (University of Notre Dame Press, 1984)

DRA *Dependent Rational Animals: Why Human Beings Need the Virtues*, The Paul Carus Lecture Series 20 (Open Court Publishing Company, 1999)

WJ *Whose Justice? Which Rationality?* (University of Notre Dame Press, 1988)

Contributors

Karen Carr is Professor and Chair of Religious Studies at Lawrence University in Appleton, Wisconsin. She is the author of *The Banalization of Nihilism: Twentieth-Century Responses to Meaninglessness* (SUNY Press, 1992) and "The Offense of Reason and the Passion of Faith: Kierkegaard and Anti-Rationalism," in *Faith and Philosophy* 13, no.2 (April 1996).

John Davenport is Assistant Professor of Philosophy at Fordham University in New York City. His articles cover topics in existentialism, ethical theory, moral psychology, free will and moral responsibility, political philosophy, and the philosophy of religion.

Richard Johnson has recently completed his doctorate in Theology and Religious Studies at the University of Bristol, UK, with a thesis on MacIntyre, Kierkegaard, and postmetaphysical philosophy. He has also conducted seminars on Kierkegaard and on the difficulties of proclaiming Christianity in a pluralist society.

Bruce Kirmmse is Professor of History at Connecticut College in New London, Connecticut, and Guest Lecturer at the Søren Kierkegaard Research Centre at the University of Copenhagen. He is the author of *Kierkegaard in Golden Age Denmark* (Indiana University Press, 1990); *Encounters with Kierkegaard* (1996); "'Out with It!' The Modern Breakthough, Kierkegaard and Denmark," in *The Cambridge Companion to Kierkegaard* (1998); and many other scholarly articles on Kierkegaard and the history of ideas.

Norman Lillegard is Professor of Philosophy and Religion at the University of Tennessee, Martin, Tennessee. He is the author of "Judge William in the Dock: MacIntyre on Kierkegaard's Ethics," in *International Kierkegaard Commentary: Either/Or Part II* (Mercer University Press, 1995).

Alasdair MacIntyre is now Senior Research Professor of Philosophy and Fellow of the Center for Ethics and Culture at the University of Notre Dame. He recently taught at Duke University, and previously held the McMahon/Hank Chair of Philosophy at the University of Notre Dame. He is the author of *Dependent Rational Animals: Why Human Beings Need the Virtues* [1998 Carus Lectures] (Open Court Publishing Company, 1999); *Three Rival Versions of Moral Inquiry: 1988 Gifford Lectures* (University of Notre Dame Press, 1990); *Whose Justice? Which*

Rationality? (University of Notre Dame Press, 1988); *After Virtue: A Study in Moral Theory* (University of Notre Dame Press, 1981); and many well-known earlier books and articles on moral theory and the history of ethics.

Gordon Marino is Associate Professor of Philosophy and Director of the Søren Kierkegaard Library at St. Olaf College in Northfield, Minnesota. He is the author of *Kierkegaard's Anthropology* (Marquette University Press, 2001); co-editor of the *Cambridge Companion to Kierkegaard* (1995); and author of several other articles.

Peter Mehl is Assistant Dean of the College of Liberal Arts, Director of General Education, and Associate Professor of Philosophy and Religion at the University of Central Arkansas. He is also the author of "Moral Virtue, Mental Health, and Happiness," in *International Kierkegaard Commentary: Either/Or Part II* (Mercer University Press, 1995); "Matters of Meaning: Autonomy, Authenticity and Authority in Kierkegaard," *Philosophy in the Contemporary World* 4 nos.1 and 2 (Spring and Summer, 1997); "William James's Ethics and the New Casuistry," The *International Journal of Applied Philosophy* 2, no. 1: (Summer/Fall 1996).

Edward Mooney is Professor of Philosophy at Sonoma State University in California. Aside from numerous articles on Kierkegaard and religion, he is the author of *Selves in Discord and Resolve: Kierkegaard's moral-religious psychology from Either/Or to Sickness Unto Death* (Routledge Press, 1996); *Knights of Faith and Resignation: Reading Kierkegaard's Fear and Trembling* (SUNY Press, 1991); and editor of *The Inward Morning*, by Henry Bugbee (Georgia University Press, 1999) and *Wilderness and the Heart: Essays on Bugbee's Philosophy of Place, Presence, and Memory* (Georgia University Press, 1999).

Marilyn Piety is Assistant Professor of Philosophy in the Department of Humanities and Communications at Drexel University in Philadelphia, PA. Her Ph.D. thesis focused on Kierkegaard's epistemology, and she has presented several papers on Kierkegaard. Aside from "Kierkegaard on Rationality," she is also the author of "The Problem with the *Fragments:* Kierkegaard on Subjectivity and Truth," *Auslegung* 16, no.1 (1990).

Philip Quinn holds an O'Brien Chair in Philosophy at the University of Notre Dame. He is the co-editor of the *Companion to the Philosophy of Religion* (Blackwell, 1999); author of "Kierkegaard's Christian Ethics" in *The Cambridge Companion to Kierkegaard* (1998); "The Divine Command Ethics in Kierkegaard's *Works of Love*" in *Faith, Freedom, and*

Rationality (Roman and Littlefield, 1996); "Original Sin, Radical Evil, and Moral Identity" in *Faith and Philosophy* 1, no. 2 (April 1984); *Divine Commands and Moral Requirements* (Oxford University Press, 1980); and numerous other articles on divine command ethics and related topics. He recently finished his term as Chairman of the Board of the American Philosophical Association.

Anthony Rudd is Lecturer in Philosophy at the University of Hertfordshire in Watford, England. He is the author of *Kierkegaard and the Limits of the Ethical* (Oxford UK: Clarendon Press, 1993) and several related articles.

Jeffrey S. Turner is Associate Professor and Chair of Philosophy at Bucknell University in Lewisburg, PA. He has published on Kierkegaard, contemporary ethical theory, and Plato.

Introduction

I

The last two decades of the twentieth century have seen a distinct revival of interest in Kierkegaard in the English-speaking world, and this has affected philosophers as well as theologians, social theorists, and literary and cultural critics.[1] And this serious philosophical examination of Kierkegaard has done much to discredit earlier misreading of his works. A certain familiar caricature has presented Kierkegaard as an "irrationalist"; as the advocate of a blind fideism requiring the rejection of all ordinary ethical norms; as the apostle of an empty and purely formal notion of "authenticity" which would regard any belief as self-validating, just as long as it was held with passion and sincerity. This image will no doubt take time to fade away entirely, but enough work has been done to demonstrate its utter inadequacy, and to bring out by contrast the true subtlety and complexity of Kierkegaard's thought. It is now increasingly appreciated that, far from being a simple irrationalist, antinomian fideist, or sub-Sartrean existentialist, Kierkegaard has a particularly sophisticated account of the nature and limitations of rationality in the ethical and religious spheres; of the ethical development of personality and of the virtues; and of human freedom.

Coincidentally or not, within the same period, there has also been a marked shift in the concerns of mainstream Anglo-American moral philosophy. Writers such as Charles Taylor, Bernard Williams, Harry Frankfurt, Martha Nussbaum, and Iris Murdoch[2] have moved discussion away from a narrowly focused preoccupation with the semantic analysis of ethical propositions, and from the rather unhelpfully formulated debate between moral "realists" and "anti-realists." Instead they have concerned themselves with such issues as the nature of human flourishing, the moral

psychology of the virtues, and the conditions under which people are able to find a sense of meaning and purpose in their lives. And this has brought moral philosophy back into close connection both with central issues in philosophical psychology, and also with literary concerns. In short, moral philosophy has, though without generally realizing it, become more Kierkegaardian.

This suggests that it may be useful to bring Kierkegaard into more explicit dialogue with these trends in recent moral philosophy. This volume opens up such a dialogue, focusing in particular on the work of Alasdair MacIntyre. This is for several reasons: Firstly, because MacIntyre is one of the most prominent and influential figures in the developments in English-language ethics mentioned above. Secondly, many of his most important themesCthe critique of emotivism, the importance of teleology and of the unity of life, the understanding of human life in narrative terms—are particularly Kierkegaardian. Thirdly, despite various large changes in his own substantive views, MacIntyre, in contrast to many other contemporary moral philosophers, has always been concerned with religious issues. More particularly, in his work of the last twenty years or so, from *After Virtue* to *Three Rival Versions of Moral Enquiry* and *Dependent Rational Animals*, he has moved from a secular neo-Aristotelianism to a form of Thomism. Although MacIntyre himself has been very reserved in dealing with specifically theological issues in these works, they inevitably raise questions about the relation of ethical to religious considerations—and these were of central concern to Kierkegaard.

Fourthly, MacIntyre himself provided the impetus for the effort in recent Kierkegaard scholarship to answer the charge of irrationalism and to develop a more subtle understanding of Kierkegaard's moral psychology in the process. In his *Encyclopedia of Philosophy* article, and in *After Virtue*, MacIntyre spends several pages discussing Kierkegaard. This direct encounter provides a natural starting point for dialogue between Kierkegaardians and MacIntyre, but it also provides a potential obstacle. For, despite the presence of distinctly Kierkegaardian elements in his own work, MacIntyre does portray Kierkegaard (or at least, the author of *Either/Or*) as ultimately an irrationalist and an advocate of "criterionless choice" as a foundation for ethics. Because MacIntyre makes this case in a particularly lucid fashion—and because of the wide influence of *After Virtue*—this passage has become a standard starting point for those who have attempted to show the inadequacy of irrationalist interpretations of Kierkegaard. MacIntyre's discussion has, then, acquired a certain status as *the* classic statement of an objection to Kierkegaard which is often also encountered in much less sophisticated forms. Hence, a number of attempts to show that Kierkegaard has a positive contribution to make to

our understanding of ethical reasoning have started from a critique of the account MacIntyre provides in *After Virtue.*

Overall, this book has two closely related goals. Part One of this anthology collects together several previously published articles that directly address the questions raised about Kierkegaard in *After Virtue.* Our selection certainly does not include all notable essays on this topic;[3] it offers a representative selection of articles building on previous scholarship in which we discern a convergence towards a new consensus on what Kierkegaard meant by authentic "self-choice" in *Either/Or*, and on the way in which Kierkegaard conceives ethical selfhood generally. In the process of responding to MacIntyre's "irrationalism" objection, these essays attempt to clarify the senses in which Kierkegaard's own conception of freedom is teleological, and his understanding of the development of ethical personality involves a quest for narrative unity, a commitment to practices involving social values, and a self-understanding conditioned by historical reality—all of which are central themes in MacIntyre's own work on virtue ethics.

MacIntyre's historical approach to rationality (framed most recently in terms of his concept of "tradition") and his social conception of the good human life can therefore be seen to relate positively to some of the central themes in Kierkegaard's pseudonymous writings on human selfhood and knowledge, as well as to some themes in his later religious works. In fact, and despite MacIntyre's initial diagnosis of Kierkegaard's existential approach to ethics as a failure, some of Kierkegaard's insights can actually be deployed to support some of MacIntyre's key theses. Indeed they may even provide a basis for a more nuanced conception of such notions as tradition, virtuous character, and the human good, that could help overcome problems which arise in MacIntyre's own treatment of these issues.

Hence, our goal in Part Two is to move this dialogue forward with new essays further exploring these positive connections between Kierkegaardian and MacIntyrian interpretations of ethical selfhood. These essays move beyond the narrower task of responding to MacIntyre's particular critique of Kierkegaard in *After Virtue*, and concentrate on exploring philosophically fruitful relations between MacIntyre's and Kierkegaard's ideas on a wider range of questions.

A central issue raised by both MacIntyre's and Kierkegaard's work is that of dialogue between adherents of different traditions, standpoints, or world views. Can there be rational debate among an aesthete, a humanistic ethicist, and a Christian? Or between an Aristotelian and an Augustinian?[4] Or a Thomist, an Enlightenment rationalist, and a Nietzschean "genealogist"?[5] This theme is explicitly addressed by a number of essays in this volume; but in addition to addressing the problem of debate across traditions, we hope that our collection will itself demonstrate the possibility

of such debate, by bringing what we might crudely characterize as "existentialism" and "virtue theory" into a mutually enlightening conversation. In the remainder of this introduction, we describe how each essay in this volume contributes to that conversation.

II

Peter Mehl agrees with MacIntyre that Kierkegaard was addressing a crisis in the Enlightenment's attempt to find a rational basis for morality. But in his essay, "Kierkegaard and the Relativist Challenge to Practical Philosophy," Mehl provides a very different account from MacIntyre of what Kierkegaard's response to this perceived crisis was. According to Mehl, Kierkegaard attempted to overcome it, not by an appeal to criterionless choice, but by developing a philosophical anthropology which could serve as a basis for reflective moral practice. Taking as basic to Kierkegaard's concerns the question posed by MacIntyre, "What sort of person am I to become?," Mehl notes the Kantian as well as Aristotelian background to Kierkegaard's thought, and argues that his aim was to take human subjectivity seriously without collapsing into a mere ethical *subjectivism*. On this account Kierkegaard does not deny that ethics is concerned with the "universally human," but he is concerned to tie that universality down to a basis of lived experience; hence his commitment to what Mehl calls "radical empiricism"—which could also be described as a phenomenological approach to ethics.

In a new postscript to his article, written for the present volume, Mehl raises some new questions about Kierkegaard's interpretation of the "normatively human" or the final form of human existence. These questions pose a direct challenge to MacIntyre as well: does the social and historical relativity of human life undercut the view that it has an intelligible *telos*? While MacIntyre might be sympathetic to some of Mehl's reservations about Kierkegaard's notion of the autonomous person as "strong evaluator" (in Charles Taylor's terms), it is worth considering whether MacIntyre's new approach to defending the notion of the normatively human (in *Dependent Rational Animals*) could help Kierkegaard against some of Mehl's criticisms.

One of the most interesting recent developments in moral philosophy has been the recognition of the significance of art, and especially literature, for moral thought. *After Virtue* made narrative—the ability to tell coherent stories about ourselves—crucial to our ethical self-understanding. However, Jeffrey Turner, in his essay, "To Tell a Good Tale: Kierkegaardian Reflections on Moral Narrative and Moral Truth," suggests that MacIntyre's narrative ethics and the "tradition"-based understanding

of moral truth that goes with it is particularly vulnerable to the threat of slipping into aestheticism in the Kierkegaardian sense. He agrees with several other writers in this volume in seeing the Judge in *Either/Or* II as arguing for views which are in significant respects close to MacIntyre's; but he cautions us against accepting what the Judge has to say at face value. A crucial aspect of *Either/Or* in Turner's interpretation is the Judge's tendency to aestheticize his own life; to tell pleasing tales about it rather than to live the stories he tells. And Turner goes on to diagnose a rather similar seduction by the aesthetic in MacIntyre's narrative of the decline and fall of the Aristotelian tradition of moral thought—a narrative which a number of other critics have felt too tidy to be entirely plausible.

The fundamental objection that MacIntyre raises to Kierkegaard is that the choice he calls on us to make between the ethical and the aesthetic cannot be a rational one. Marilyn Piety's "Kierkegaard on Rationality" attempts a direct answer to this charge. Piety starts from the problem that, if the justification of a choice must be in terms of a framework of basic beliefs or assumptions, then a choice between such frameworks cannot be rational. She argues that this might be so if rationality were something wholly "objective" and disinterested; but that this is a mythologized conception of reason. Even in the sciences, reason is situated and contextual, and rationality in ethical and religious matters is necessarily bound up with the concern of the individual to make sense of his/her life. Hence Piety, rather like Mehl, argues for a conception of passionate or interested rationality. To adopt a dispassionate stance towards the question, "What sort of person should I be?" would be to wholly miss the point of ethics; it would in fact be thoroughly irrational. For Piety it is, ultimately, the agent's essential interest in his or her own happiness that provides the context in which the paradigm-shift from the aesthetic to the ethical can be understood as a rational one.

John Davenport provides a detailed reading of the Judge's letters in *Either/Or* in his essay, "The Meaning of Kierkegaard's Choice Between the Aesthetic and the Ethical," which has been revised for this volume. Focusing on MacIntyre's claim that Kierkegaard adopted a traditional set of ethical precepts but, incoherently, based their acceptance on arbitrary choice, Davenport argues that this reading misses the Kantian internalism of Kierkegaard's ethical thought. A choice is only ethical if it is made on the basis of ethical motives; one cannot choose from an uncommitted stance that is not itself within one of the spheres of existence. This analysis of the meaning of existential choice is further developed with reference to Frankfurt's account of volitional identification. The choice that moves an agent from the aesthetic life-view into the ethical is not about perceiving the authority of moral principles and ideals, but about identifying with such norms and actively forming one's character in light of them.

Davenport goes on to stress Kierkegaard's affinities with Aristotle as well as Kant, claiming that he offers us a "new synthesis" of positions often thought incompatible. (But the Aristotelianism that Davenport ascribes to Kierkegaard is thus significantly different from MacIntyre's firmly anti-Kantian version of Aristotelianism.)

The essays mentioned above, while often appreciative of MacIntyre's substantive insights, have been uniformly hostile to his account of Kierkegaard in *After Virtue*. (It is nevertheless a tribute to that account that it has provoked so much fruitful disagreement, forcing Kierkegaard scholars to clarify their understanding of such notions as choice, authenticity, and ethical rationality.) Gordon Marino's essay, "The Place of Reason in Kierkegaard's Ethics," while disagreeing with much of MacIntyre's reading of Kierkegaard, is somewhat more sympathetic to the spirit of MacIntyre's critique. Marino criticizes MacIntyre for his account of Kierkegaard's allegedly criterionless choice, but he does think that, although Kierkegaard's Judge offers reasons to the aesthete to adopt an ethical way of life, nevertheless, Kierkegaard himself underestimated the role of reason in the moral life. Furthermore, he accuses him of a refusal to acknowledge the genuine perplexity that people may find themselves in when considering how to act. Hence, although rejecting part of MacIntyre's charge of "irrationalism," Marino thinks that it is not wholly without justification.

III

The new essays in Part Two of this volume expand the discussion to embrace a wider set of of issues beyond the boundaries of the dispute occasioned by MacIntyre's original critique of Kierkegaard. These essays by scholars representing a broad cross-section of different perspectives in Kierkegaard scholarship, approach the connection between Kierkegaard and MacIntyre from several novel angles, shedding light on previously unexplored thematic overlaps and live points of dispute. Anthony Rudd and Richard Johnson both focus on questions raised by MacIntyre's *Three Rival Versions of Moral Enquiry* and his previous books about historical rationality and the conflict between traditions, and show how Kierkegaard's philosophical analysis of knowledge, reason, and value sheds light on these questions. Karen Carr and Bruce Kirmmse are both concerned to place Kierkegaard's challenge to Aristotelian rationalism in the context of the theological tradition to which he undoubtably belonged. Their analyses are especially valuable in that they bring Kierkegaard's specifically Christian late works into the dialogue with MacIntyre. Norman Lillegard, Edward Mooney, and John Davenport focus on aspects of

Kierkegaard's moral psychology that further clarify his critique of aestheticism and link his analysis more directly with MacIntyre's narrative account of the self and its virtues.

Rudd's new essay develops themes from his book, which argued that Kierkegaard, like MacIntyre and Bernard Williams, is looking for a form of what Michael Sandel calls the "encumbered self," whose understanding of its identity is situated in its roles and relations, and ultimately in terms of the transcendent relation to God. Like Charles Taylor's, MacIntyre's critique of modernity focuses on the problem of Hobbesian individualism, i.e., the disengaged self who regards all social relationships and traditions as contingent to herself, or even as something entered into only for instrumental reasons. Along with this goes the skepticism of a radically individualist conception of knowledge hostile to tradition. As a result, moral knowledge has lost its social and epistemic bases. Yet as Rudd now argues, the tradition-bound conception of reason that MacIntyre has developed in response is clearly un-Aristotelian, and is perhaps even 'postmodern,' in its focus on historicity. And this leads to problems about how we conceive tradition in its normative sense, and how we avoid the problem of relativism which MacIntyre associated with the genre of Nietzschian genealogical critique. There is also a deficient sense in which liberalism can and has been regarded as a tradition. But we do not belong to these new genres in the way needed to facilitate moral development, on MacIntyre's analysis.

It is here that Kierkegaard provides another way of framing MacIntyre's problem. After reviewing the charge of irrationalism, Rudd argues that arbitrary choice is the mark of aesthetic nonengagement, and Kierkegaard's "A" is a prototype of the rootless Sartrean or Rortyian ironic self. Judge William's argument that this is despair—a form of life in which stable identity and personal fulfillment is impossible—thus seems very similar to MacIntyre's argument for a life with narrative shape defined by participation in practices and tradition.[6]

Yet MacIntyre does not regard the choice he poses between Aristotle and Nietzsche (which interestingly resembles the choice between ethics and aestheticism) as an appeal to arbitrary choice.

At this point, Rudd introduces the analogy between progress in science and in ethics. MacIntyre's analysis of rational choice between traditions (in the broad sense) can be compared to Lakatos's way of assessing rival scientific paradigms, but there remain problems with this approach as a method of objective evaluation. Moreover, the choice between traditions of moral enquiry with viable claims to coherence is not *identical* to the first-personal choice of how to live. Instead, for Kierkegaard the process that moves us from the aesthetic to the ethical frame of reference can be motivated only via honest "self-scrutiny," an existential encounter with

myself of the Socratic kind, in which I ask what I care about and what gives my life meaning. For the aesthete, this results in taking his despair seriously for the first time.[7] Similarly, movement between theoretical frameworks in science inevitably involves a first-personal element of unformalizable judgment.[8]

Rudd concludes by suggesting that several problems Kierkegaard raises for the ethical life-view parallel familiar concerns about the viability of MacIntyre's project. Even if the sort of moral commitments that Judge William/MacIntyre believe are essential for a meaningful life remain available to us today, they do not explain how or why we must combine the goods involved in different relationships in an orderly way.[9] Nor do they justify the sort of liberal virtues of tolerance, open dialogue, and unconstrained debate which MacIntyre still regards as canons of rational community. These questions indicate Kierkegaard's own reason for thinking that full narrative unity cannot come only from identifying with a particular tradition and its social roles and values, but must be supplemented and transformed by a personal relation with God.

Richard Johnson picks up MacIntyre's own struggle with Nietzsche as an opening in which the relevance of Kierkegaard's contribution again becomes clear. Johnson argues that the superiority of Kierkegaard's Religiousness B both to 'tradition' and 'genealogy' becomes apparent in their conflict: Kierkegaard's existential ontology implies a more powerful diagnosis of their respective limitations than either of them can give of the other. MacIntyre advocates returning to the sort of rational onto-theology that has been the primary target of genealogical postmodernism, and ends up at best in Religiousness A. Against this, Johnson argues that trying to supply ethics with a metaphysical justification undermines its categorical priority.[10]

Inspired by Derrida's reading of Kierkegaardian singularity and Levinas's critique of reciprocal-return relations, Johnson develops a Derridian critique of MacIntyre's "Aristotelian ethic of proportional desert." Such an ethics is still trapped in a kind of 'economy' that cannot contain the singular relations of religious responsibility. Since Nietzsche also radically privileges individual subjectivity, he also escapes MacIntyre's categories. The neo-Aristotelian view can only diagnose Nietzsche's rejection of all claims for objective moral values as a response to the failure of the Enlightenment project, and as a reaction against traditional virtues that remains parasitic on them.[11]

Kierkegaard provides the basis for a more radical critique of Nietzsche. Because his analysis can account for evil in its spiritually most extreme forms, Kierkegaard proves better equipped than MacIntyre to answer "Nietzsche's titanism" in the spirit of its own transgression of the universal. The account of demonic despair in the *Sickness Unto Death* is a damning

anticipatory indictment of Nietzsche. Willing defiantly to be himself without any dependence on the transcendent, Nietzsche attempts the ultimate form of self-completion; but this attempt at absolute self-mastery proves to be utterly self-defeating, for without any factical limits, the self lacks all concreteness, and its absolute freedom is forced to remain in abstraction and emptiness. We might say, in the spirit of Johnson's analysis, that such a Nietzschian self actually does suffer the fate that Sartre (who was really diagnosing Nietzsche's failure to overcome nihilism by sheer self-assertion) predicted of all for-itselves: freed from responsibility to the ethical, it becomes incapable of being bound by any of its own commitments, since it lacks the medium necessary for the volitional inertia involved in authentic freedom. Thus as Johnson says, the kind of arbitrariness MacIntyre found in *Either/Or* is much more accurately predicated of the empty freedom resulting from Nietzschian despair. What Nietzsche tried in bad faith to regard as authentic freedom is in fact a symptom of the sin of demonic despair, in which the finite human self, by trying to become its own God, robs itself of any concrete meaning.

For Johnson, Kierkegaard can provide a better critique of Nietzsche than MacIntyre is able to devise because, unlike Nietzsche and MacIntyre, Kierkegaard sees the essential divide between Christianity and Platonism. Moreover, his Religiousness B depends on recognizing the depth of the rift between Athens and Jerusalem; Nietzsche also perceived this tension, but MacIntyre's narrative minimizes it. In his emphasis on the absolute paradox as requiring faith in some sense to *oppose* natural human reason, Johnson's analysis connects with the main themes developed by Carr and Kirmmse.

Building on her previously published argument that Kierkegaard's anti-rationalist theology is neither "supra-rationalist" (like Aquinas's) nor irrationalist,[12] Karen Carr suggests that Kierkegaard belongs not with the emotivists but rather with a long line of Christian theologians (dating back to the first century) who are suspicious of philosophy and natural theology because of the tendency of these genres to dilute or remove the absoluteness of Christian revelation. Not all Christian thinkers share this suspicion: Aquinas is the most obvious representative of the tradition holding that natural theology illuminates revelation, which complements and completes the deliverances of reason. But opposition to Platonic and Aristotelian rationalism forms a very long tradition within Christianity. The role Kierkegaard gives to Socrates in his pseudonymous works is usefully understood against this background, because, despite Kierkegaard's admiration or even love for him, Kierkegaard uses Socrates as a foil to demarcate what is distinctively Christian in contrast to Socratic "paganism." Socrates cannot recognize "the pervasive power of humanly willed error," or sin, as a result of which "reason and introspection" are not adequate to impart saving knowledge or to produce a good will. Sin has epistemological

implications: because our reason is corrupted, revelation cannot simply be consistent with but beyond the deliverances of human reason; rather they will sometimes clash.

Since Kierkegaard regards revelational authority as beyond rational justification, his view might at first seem like a religious version of emotivism, but as Carr points out, Kierkegaard's view is antirelativist despite being antirationalist: it embraces the notion of an absolute standard, even though it cannot be justified by human reason.[13]

Kierkegaard's motive for distinguishing reason and absolute authority is primarily to emphasize the danger of reason's arrogant self-assertion and pretensions to Archimedian insight (which reflects the corrupted will's desire for independence from God). If such a separation of reason and ethicoreligious authority is described as emotivist, however, then emotivism would have a much longer history (and a different origin) than MacIntyre's account implies.

Bruce Kirmmse, like Carr, emphasizes the Christian perspective behind Kierkegaard's philosophical works, but emphasizes the extent to which this perspective leads Kierkegaard to share some of MacIntyre's concerns about modernity. Placing him more locally within the tradition of Lutheran and Danish Pietism, Kirmmse asks how Kierkegaard the man would have responded to *After Virtue*. Like Carr and Johnson, he thinks MacIntyre has underappreciated the tension between historical Christianity and classical culture, with its omnipresent fatalism, to which Kierkegaard is so attuned. In Kierkegaard's rival history of ideas, Greek philosophy is unable to come further than the idea that life on earth is an evil, a trial to be endured, in which the soul's return to its former heavenly state is the best hope possible. Only Christianity, with its radically new form of hope, offers a soteriology that can answer and overcome this essential poverty in Greek thought. At the same time, Kirmmse is sympathetic with MacIntyre's concerns about the ambiguous status of "the ethical" in Kierkegaard's pseudonymous works. This is because in Kierkegaard's view, humanist ethics (e.g. Kantian formalism) is also incapable of providing any adequate final meaning, or any real answer to the nothingness of fate. Given the gap between ethical ideals and our capacity to realize them,[14] only within Christian categories of grace and redemption is an authentic sense of freedom opened up for human beings. Thus Christianity fundamentally alters the terms of life, rather than merely revising the Aristotelian concept of the human *telos*, as MacIntyre's reading of Aquinas suggested. These perspectives also lead to two quite different accounts of how the modern world has lost its moral compass.

Carr and Kirmmse's arguments effectively reopen not only key theological debates between the Lutheran and Thomist traditions that have a bearing on MacIntyre's historical narrative, but thereby also focus

attention on an issue MacIntyre has broached but never fully addressed[15]: namely, Augustinian Christianity as a moral tradition distinct from Aristotelianism, the enlightenment project of Encyclopedia, and the genealogical/Nietzschian tradition of the twentieth century. But while Kirmmse emphasizes the radicality of Kierkegaard's critique of modernity, relative to which MacIntyre's history of decline is optimistic, he also argues that Kierkegaard's reaction against Danish Hegelianism led him to anti-congregational extremes. MacIntyre's critique of Samuel Johnson's "Christian Stoicism" proves to be a useful corrective to Kierkegaard at this point. Kirmmse is thus sympathetic to MacIntyre's concern that Kierkegaard (like the Marxists) has incorporated more than he realized of the bourgeois liberal individualism that he opposed. The question this leaves for MacIntyre and for Kierkegaardians is: can religious community still play a valuable role in providing the social and historical basis for restoring flourishing civic life and achieving whatever part of the human good is possible in this mortal life?

The next set of essays considers what Kierkegaard can contribute to the most important debates in moral psychology underlying virtue ethics in contemporary Anglo-American philosophy. By focusing on Kierkegaard's signed work, *A Literary Review*, Norman Lillegard shows that there is a clear conceptual difference for Kierkegaard between virtues that can be exemplified in various versions of aesthetic human existence, and virtues that are essentially linked to the ethical mode of life. Lillegard's analysis highlights the important point that since some kinds of aesthetic life involve sustained passions, some level of integrity or narrative integration is possible in the choices that constitute such aesthetic lives. Not all aesthetes try to live like 'A' in *Either/Or* I, who aims for as Sartrean a set of disjointed or atomistic episodes as possible. More 'heroic' aesthetes, like Gyllembourg's figure Claudine, are distinguished by the fact that they do build a life out of choices that consistently reflect their immediate pathos, and thus constitute a genuine "character," at least for a time. But their passion lacks the ethical basis necessary for resilience in the face of life's greatest difficulties; it is also unable to embrace all significant aspects of their life. It is an infinite passion, but is not aimed at an object with the kind of infinite value needed to warrant it (in Tillich's sense, it is subjectively infinite, but not objectively infinite).[16]

The result is a life whose subplots are not unified with its main plot, and a main plot line that disintegrates in crises: it lacks "purity of heart." Lillegard argues that for Kierkegaard, this incomplete synchronic and diachronic unity of lives exhibiting aesthetic virtues remains so limited because the agent does not actively shape her passion through choices guided by a rational self-concept: she lacks a "life-view." Actions flowing from her passion do not exhibit the Aristotelian virtues of practical

rationality, as MacIntyre describes it: as *zetesis* and *epagogue* descending from a rational *arche* or ideal. They are not governed by the concept of her efforts as expressions of a vocation within a particular community, in which she is responsible for her past, and so they are liable to self-deception and *akrasia*. It would be interesting in this context to ask if, in MacIntyre's terms, some of the heroic aesthete's apparent virtues turn out to be only "simulacra" of the virtues.

Lillegard's analysis connects directly with several of the themes in the last two essays by Mooney and Davenport. In a carefully balanced analysis, Edward Mooney draws a series of subtle comparisons between Kierkegaard and MacIntyre, starting with their similar use of polar contrasts as a rhetorical device to map the landscape of existential alternatives offered to us. Both authors draw rich portraits of different life-views, using fictional or historical figures as their paradigms, and criticizing each in turn in order to undermine the "self-images" of their age. Yet out of Kierkegaard's either/or's, like MacIntyre's conflict of traditions, is supposed to come not skeptical *ataraxia*, but a better sense of the direction in which the solutions lie. MacIntyre's notion of criterionless choice does accurately describe the result of the liberal consumerist ideology of empty freedom and 'unencumbered selves' making decisions by brute preference, which has come to dominate our fragmented culture. But Kierkegaard does *not* hold that significant debate or conversation enriching understanding on both sides is impossible across life-spheres.[17]

Like Lillegard, Mooney turns to MacIntyre's own account of practical reasoning to describe the kind of moral dialogue Kierkegaard sets up between exemplars of the existence-stages. Even though there is no impartial position outside both spheres, their comparative advantages and disadvantages can become apparent in the interchange.[18]

In this light, Mooney argues that Kierkegaard had good rhetorical reasons to set up the conflict of *Either/Or* in a plastic way calculated to adapt to each reader's biases, getting different readers existentially involved in one way or another, or tempting a reader inclined to equipollent fence-sitting, who then finds his own detached observer stance challenged. Like an inconclusive Platonic dialogue, the book's form is meant to engage us in thinking passionately for ourselves about our own life, and in the process to discover our moral stance as a reader-interlocutor. In Mooney's view, MacIntyre's narrative may have similar edifying ambitions. Given his understanding of moral inquiry as an attempt to ground moral practice, MacIntyre may not be so far from Kierkegaard's view that moral philosophy can and should be *life-transforming*.

The last part of Mooney's essay extends his own earlier arguments that the right link between the 'what' or content of our moral truths and 'how' we appropriate them subjectively depends on a personal will with a certain

kind of humility, autonomy, and other virtues. Kierkegaard's works are formed to encourage this kind of will in his readers's relationship to the texts. Kierkegaard wishes neither for readers who will uncritically adopt his private views (which remain without authority) nor for the merely speculative attention of Encyclopedia-builders. Mooney's nuanced understanding of the "pious willingness" at the center of Kierkegaard's notion of authentic individuality provides a different way of grasping the connection between faith as an individual relationship and progress in moral understanding.

This analysis also complements the account of existential virtues developed in Davenport's new essay, "Towards an Existential Virtue Ethics." Davenport argues that in his pseudonymous books, along with *Works of Love* and the various *Edifying Discourses*, Kierkegaard should be read as fashioning a new kind of virtue ethics (albeit one with clear roots in the Stoics, St. Augustine, and Duns Scotus). Starting with *Either/Or*, Kierkegaard focuses on a set of existential or proto-virtues involved in earnestness of will, which is the *sine qua non* of the traditional substantive virtues and vices. For the virtues and vices are themselves dispositions of freedom in earnest willing or authentic commitment of the self. Davenport argues that this conception provides what is missing from the account in MacIntyre's *After Virtue*: namely, an explanation of why engaging in practices and committing oneself to a life-narrative unified by a consistent and mutually supporting set of ground projects is necessary for realizing the human *telos*. MacIntyre's account in turn helps clarify why Kierkegaard believes these steps towards our *telos* are impossible except by personally appropriating the sort of ethical standards and ideals of character required by practices and unity of purpose.

But within existential virtue ethics, at least prior to the stage of religious faith, the human *telos* is conceived as the authentic relation-to-self necessary for a subjectively meaningful life. It is not understood as *eudaimonia* in the sense of an all-embracing Aristotelian chief good. While the conditions of becoming authentic and enjoying a life with sustained meaning-for-oneself do ground *the necessity to take ethics seriously*, they do not function as a complete metaphysical ground for the absolute authority of ethical standards and ideals, nor do they require that the agent attain a morally good character in the process.

At this point Davenport, like several other contributors in this volume, emphasizes the central importance of Kierkegaard's account of radical evil in *Sickness Unto Death*. Although moving into the ethical life-view or sphere of existence requires attaining a sensitivity to ethics and its implications for our concrete circumstance (a sensitivity that grows more acute with the practice of making morally worthy choices guided by this sensitivity) the will always remains capable of rebellion. If persistence in evil

leads to ignorance of or insensitivity to ethics, this itself is a result of prior well-informed and (hence) radically evil turns in our inmost volitional direction. If Davenport is right, then Kierkegaard has taught us a vital lesson: an adequate virtue ethics must accurately reflect the full reality of human freedom (which is incompatible with the Platonic model of a will necessarily oriented towards the Good), and yet avoid reducing the will to arbitrariness, or reducing moral ideals to subjective preferences. Kierkegaard, as we understand him more clearly now after the encounter with MacIntyre, has shown us how to steer this course between Greek eudaimonism and Sartrean voluntarism.

IV

As the essays reprinted in Part One of this volume illustrate, a new consensus has emerged among Kierkegaard scholars in the wake of MacIntyre's challenge to Kierkegaard, Sartre, and Nietzsche in *After Virtue*. Virtually all interpreters now agree that Kierkegaard did not intend in *Either/Or* to imply that responsible agents enter into the realm of moral action through arbitrary choice or Sartrean groundless passion. Instead, we find agreement that Kierkegaard understands the movement from various forms of aesthetic life to the ethical life-view as a teleological progress, or as the maturation of spirit required (though not determined) to reach the true form of a human self. For Kierkegaard, this requires achieving a kind of inner relation to oneself in all one's concrete detail as an historical and social being, a relation that can only be completed in an innermost relation to the Absolute as personal God.

But beyond this consensus, the new essays in Part Two of this volume reveal a divergence among commentators interested in both Kierkegaard's and MacIntyre's approaches to ethics. To some, Kierkegaard after MacIntyre stands in even sharper contrast to both classical and enlightenment forms of the overarching humanist ethical tradition(s). To others, Kierkegaard now stands in even clearer proximity to MacIntyre's own hermeneutic account of an ethics of engagement in the sort of community that provides traditional standards of virtue. This raises historical issues about Kierkegaard's relation both to St. Thomas Aquinas and Luther. It also raises interpretive issues about how to reconstruct Kierkegaard's moral psychology in light of ideas not only from MacIntyre, but also other critics of contemporary ethics, such as Bernard Williams, Charles Taylor, Owen Flanagan, and Harry Frankfurt. But the new essays in this book do agree that the multivalent connections and contrasts between Kierkegaard's and MacIntyre's work, especially in their analyses of the human condition in modernity, provide a new vantage from which to

reassess the fundamental conceptual questions we encounter not only as academics trying to make progress in philosophical and theological ethical theory, but also as individuals trying to live worthy lives.

The replies by Philip Quinn and Alasdair MacIntyre in Part Three both positively address these practical questions, while also responding to the earlier essays. In his fascinating and challenging essay, which is a revised version of his comments at the American Philosophical Association meeting in Boston (December 1999), Professor Quinn argues in some sense (like Gaunilo to Anselm) 'On behalf of the aesthete.' In particular, he questions Lillegard's and Davenport's emphasis on MacIntyre's idea of narrative unity as a regulative ideal found in Kierkegaard's understanding of the ethical way of life. In his "deflationary response to the yearning for unity, integration, and wholeness in our lives" (p. 329), Quinn praises diversity, variation, and even discord in the finite goods we pursue as the path towards a rich balance of meaning. Calm Apollonian interpretations of authenticity that emphasize singlemindedness of purpose are too rationalist and always in danger of lapsing into narrow monomania: they need a more romantic, Dionysian corrective. Quinn ends by developing Wayne Booth's idea of the self as a chorus of voices that speak together but not always in harmony. There is surely something to the alternative picture Quinn presents, and we are indebted to him for prompting us to reconsider how we interpret the ideal form of the self.

In the final essay, which replies in some form to all the others, MacIntyre restates his original concern about the choice between the aesthetic and the ethical, acknowledging that it needs to be reformulated to meet criticisms by Mooney and others. He then offers an inspired defense of the new, sharpened version of his arbitrariness charge. Although the transition from the aesthetic to the ethical mode of life can be justified, and although retrospectively Kierkegaardian agents can comprehend and approve that justification, it cannot operate prospectively as the motive for their life-changing choice. One cannot reason oneself out of the aesthetic. This is ultimately because Kierkegaard has a different concept of will than Aquinas and Aristotle: for Kierkegaard, action cannot be explained in terms of deliberate choice or *prohairesis* as a practical syllogism or process of practical reason.

But MacIntyre also suggests that, while discontinuity between the aesthetic and ethical life-views is the dominant theme in *Either/Or*, their connections are also acknowledged in certain places. In this light, he asks whether we might not reinterpret the aesthetic stage as one of covert resistance to the ethical call, which refuses to ask the questions that only an acknowledgment of the ethical can answer (p. 348). This seems to us not very far from the account of aestheticism and its problematic developed by several of Kierkegaard's defenders in the present volume.

We have necessarily left aside here many intriguing aspects of MacIntyre's original contribution, which will repay close study. As with reflection on *After Virtue* during the last two decades, reflection on MacIntyre's insights will be invaluable not only in the effort to restore Kierkegaard to his rightful place in the history of ethics, but also in reconsidering the central questions in moral psychology that divide opposing traditions today. While Quinn and MacIntyre have the last word in our book, we are certain the conversation will continue.[19]

NOTES

1. See, e.g., C.S. Evans, *Kierkegaard's 'Fragments' and 'Postscript': The Religious Philosophy of Johannes Climacus* and his *Passionate Reason*; M. J. Ferraira, *Transforming Vision*; H. Ferguson, *Melancholy and the Critique of Modernity*; A. Hannay, *Kierkegaard*; E. Mooney, *Knights of Faith and Resignation* and *Selves in Discord and Resolve*; G. Pattison, *Kierkegaard: The Aesthetic and the Religious*; A. Rudd, *Kierkegaard and the Limits of the Ethical*; S. Walsh, *Living Poetically; Kierkegaard's Existential Aesthetics*; M. Westphal, *Becoming a Self.*

2. See, e.g. C. Taylor, *Sources of the Self* and *The Ethics of Authenticity*; B. Williams, *Moral Luck* and *Ethics and the Limits of Philosophy*; H. Frankfurt, *The Importance of What We Care About* and *Necessity, Volition, and Love*; M. Nussbaum, *Love's Knowledge*; I. Murdoch, *The Sovereignty of Good* (a pioneering work in this respect) and *Metaphysics as a Guide to Morals.*

3. See in particular the essays by Mooney, Bellinger, Lillegard, and Mehl in the *International Kierkegaard Commentary* volume on *Either/Or Part II*, ed. Robert Perkins (Macon, GA: Mercer University Press, 1995); Anthony Rudd, *Kierkegaard and the Limits of the Ethical* (Oxford: Clarendon Press, 1993), ch. 3; Edward Mooney's *Selves in Discord and Resolve* (New York: Routledge, 1996), especially chs. 2, 3, and 6; and Timothy Jackson's early essay, "Kierkegaard's Metatheology," *Faith and Philosophy* 4, no.1 (January 1987): 71–85.

4. See MacIntyre, *Whose Justice? Which Rationality?*, chs. 10 and 11.

5. See MacIntyre, *Three Rival Versions*, passim.

6. In this respect, we (Rudd and Davenport) are in close agreement. The only difference of emphasis between us seems to be that Rudd portrays MacIntyre and Kierkegaard as giving roughly *parallel* analyses, while Davenport portrays their analyses as *complementary*. Davenport also argues that what Rudd calls the inherent desire for a coherent and meaningful life constitutes the minimal existential *telos* of libertarian freedom in Kierkegaard, but not an Aristotelian *telos* as chief good. He agrees with Rudd, however, that the same kind of teleology to which Kierkegaard appeals is the kind to which MacIntyre's argument in *After Virtue* actually appeals as well.

7. There is a hermeneutic circle here: when the aesthete earnestly faces his

state of mind, he can see that the evidence of his own experience favors the Judge's account; yet even before that, the phenomenological force of this account encourages him into the requisite seriousness. In Heidegger's terms, the aesthete must acquire a new fore-conception in order to interpret the evidence authentically, but he can only come into this new fore-conception by a willingness that grows out of his deficient (but not empty) understanding of the same evidence within his distortive fore-conception. Yet this is just what we should expect. And the same kind of hermeneutic epistemology (which itself is a development of Aristotle's notion of habituation) seems to underlie MacIntyre's account of reason.

8. Compare this with Marilyn Piety's appeal to Polyani's notion of first-personal reasoning in framework-shifts.

9. This concern is similar to one raised by Philip Quinn regarding what kind of narrative unity, if any, we should care about cultivating in our lives. MacIntyre may have gone some ways towards answering this question in *Dependent Rational Animals* by situating individual unity in the kind of community that alone (in his view) can foster the just generosity we all require to flourish as creaturely beings with essential dependencies on others for our development and well-being.

10. Compare this to Hannay on the irreducibility of the ethical in Kierkegaard (as discussed in Davenport's essay "Towards an Existential Virtue Ethics," chapter 12 in the present volume).

11. It is interesting in this regard to note that MacIntyre continues this kind of critique of Nietzsche in his recent book, *Dependent Rational Animals*, where he argues that Nietzsche's notion of liberation compelled him to reject the sort of "commitments and relationships" that make "shared communal deliberation possible," thereby demonstrating to what lengths one must go to avoid implicit commitment to "the virtues of acknowledged dependence" (p. 165). Yet although his extremism is made apparent here, on this account Nietzsche succeeds in remaining a radical alternative to the life-view MacIntyre has defended so eloquently. By escaping in this way, Nietzsche thus again seems to relativize MacIntyre's life-view, to make it only one position among the small list of coherent options, rather than the *only* one that is finally coherent. Nietzsche's ghost thus continues to haunt MacIntyre's project, suggesting that we should more seriously consider Kierkegaard's position, which does have the resources to answer Nietzsche directly, and in his own agonistic fashion.

12. See Karen Carr, "The Offense of Reason and the Passion of Faith: Kierkegaard and Anti-Rationalism," *Faith and Philosophy* 13, no. 2 (April 1996): 236–51.

13. We might add that, at least on one plausible reading of *Without Authority*, Kierkegaard does not think that claims of revelation completely transcend rational scrutiny and critique. Although humility is essential in our relation to revealed truth, this virtue itself is one of the necessary marks of the genuine bearer of revelation.

14. This is the theme of John Hare's book on Kant and Kierkegaard entitled *The Moral Gap* (Oxford: Clarendon Press, 1996).

15. See *Whose Justice? Which Rationality?*, ch. 1, pp. 10–11. MacIntyre has begun to trace the historical origins of Protestant philosophy in his account of Duns Scotus in *Three Rival Versions of Moral Enquiry*, and in informal remarks he

has often made on questions raised by the history of Protestant disputes with Thomism. We hope that the re-encounter with Kierkegaard in this volume will help prompt a fuller discussion of these issues.

16. Compare this to Davenport's distinction between simple utilitarian and nonconsequentialist/heroic aesthetes in his essay, "The Ethical and Religious Significance of Taciturnus's Letter in Kierkegaard's *Stages on Life's Way*," in the *International Kierkegaard Commentary: Stages on Life's Way*, ed. Robert Perkins (Macon, GA: Mercer University Press, 2000).

17. Mooney's account at this point seems close in spirit to Hans-Georg Gadamer's notion of the "fusion of horizons" of intelligibility, a notion to which MacIntyre's hermeneutics of cross-tradition reason-giving and communicative action is clearly indebted. We might also compare Mooney's account of dialogue among positions occupying frames of reference between which there cannot be impartial third parties to the hermeneutics developed in Stephen Watson's *Tradition(s)* (Bloomington: Indiana University Press, 1997), which in turn is deeply indebted to MacIntyre and Gadamer.

18. Alastair Hannay and Anthony Rudd have also suggested that the juxtaposition in *Either/Or* is meant to have direct phenomenological value. Mooney has extended this line of interpretation in a highly illuminating way.

19. Davenport has replied to the new version of MacIntyre's arbitrariness charge in an essay titled "Kierkegaard, Anxiety, and the Will," presented by invitation at the *Kierkegaard Research Seminar* (August 16-18, 2000), hosted by the Søren Kierkegaard Research Center at Copenhagen University, Denmark. This essay will appear in the next *Kierkegaard Studies Yearbook*, vol. 6, ed. Niels Jørgen Cappelørn and Herman Deuser (Walter de Gruyter, 2001).

Excerpt from Chapter 4 of *After Virtue*[1]

ALASDAIR MACINTYRE

A central thesis of this book is that the breakdown of this project [of an independent rational justification of morality] provided the historical background against which the predicaments of our own culture can become intelligible. To justify this thesis it is necessary to recount in some detail the history of that project and its breakdown; and the most illuminating way to recount that history is to recount it backwards, beginning from that point at which for the first time the distinctively modern standpoint appears in something like fully-fledged form. What I earlier picked out as the distinctively modern standpoint was of course that which envisages moral debate in terms of a confrontation between incompatible and incommensurable moral premises and moral commitment as the expression of a criterionless choice between such premises, a type of choice for which no rational justification can be given. This element of arbitrariness in our moral culture was presented as a philosophical discovery—indeed as a discovery of a disconcerting, even shocking, kind—long before it became a commonplace of everyday discourse. Indeed that discovery was presented precisely with the intention of shocking the participants in everyday moral discourse in a book which is at once the outcome and the epitaph of the Enlightenment's systematic attempt to discover a rational justification for morality. The book is Kierkegaard's *Enten-Eller* [*Either/Or*] and, if we do not usually read it in terms of this historical perspective, that is because over-familiarity with its thesis has dulled our sense of its astonishing novelty in the time and place of its writing, the Northern European culture of Copenhagen in 1842.

Enten-Eller has three central features to which we ought to attend. The first is the connection between its mode of presentation and its central thesis. It is a book in which Kierkegaard wears a number of masks and by their very number invents a new literary genre. Kierkegaard was not the first author to divide up the self, to allocate it among a series of masks, each of

which acts out the masquerade of an independent self, and so to create a new literary genre in which the author is present as himself more directly and intimately than in any form of traditional drama and yet by his partitioning of his self denies his own presence. Diderot in *Le Neveu de Rameau* was the first master of this new, peculiarly modern genre. But we can see a partial ancestor of both Diderot and Kierkegaard in that the argument between the sceptical self and the Christian self which Pascal had intended to conduct in the *Pensées,* an argument of which we possess only the dismembered fragments.

Kierkegaard's professed intention in designing the pseudonymous form of *Enten-Eller* was to present the reader with an ultimate choice, himself not able to commend one alternative rather than another because never appearing as himself. 'A' commends the aesthetic way of life; 'B' commends the ethical way of life; Victor Eremita edits and annotates the papers of both. The choice between the ethical and the aesthetic is not the choice between good and evil; it is the choice whether or not to choose in terms of good and evil. At the heart of the aesthetic way of life, as Kierkegaard characterizes it, is the attempt to lose the self in the immediacy of present experience. The paradigm of aesthetic expression is the romantic lover who is immersed in his own passion. By contrast the paradigm of the ethical is marriage, a state of commitment and obligation through time, in which the present is bound by the past and to the future. Each of the two ways of life is informed by different concepts, incompatible attitudes, rival premises.

Suppose that someone confronts the choice between them having as yet embraced neither. He can be offered no *reason* for preferring one to the other. For if a given reason offers support for the ethical way of life—to live in that way will serve the demands of duty *or* to live in that way will be to accept moral perfection as a goal and so give a certain kind of meaning to one's actions—the person who has not yet embraced either the ethical or the aesthetic still has to choose whether or not to treat this reason as having any force. If it already has force for him, he has already chosen the ethical; which *ex hypothesi* he has not. And so it is also with reasons supportive of the aesthetic. The man who has not yet chosen has still to choose whether to treat them as having force. He still has to choose his first principles, and just because they are *first* principles, prior to any others in the chain of reasoning, no more ultimate reasons can be adduced to support them.

Kierkegaard thus presents himself as not endorsing either position. For he is neither 'A' nor 'B'. And if we take him to be presenting the position that there are no rational grounds for choice between either position, that the either/or choice is ultimate, he denies that too, for he is not Victor Eremita any more that he is 'A' or 'B'. Yet at the same time he is everywhere,

and perhaps we detect his presence most of all in the belief that he put into the mouth of 'B' that anyone who faces the choice between the aesthetic and the ethical will in fact choose the ethical; for the energy, the passion, of serious choice will, so to speak, carry the person who chooses into the ethical. (Here, I believe, Kierkegaard asserts—if it is Kierkegaard asserting—what is false; the aesthetic *can* be chosen seriously, although the burden of choosing it can be as passion-ridden as that of choosing the ethical. I think especially of those young men of my father's generation who watched their own earlier ethical principles die along with the deaths of their friends in the trenches in the mass murder of Ypres and the Somme; and who returned determined that nothing was ever going to matter to them again and invented the aesthetic triviality of the nineteen-twenties.)

My account of Kierkegaard's relationship to *Enten-Eller* is of course crucially different from that given by Kierkegaard himself later on, when he came to interpret his own writings retrospectively in terms of a single unchanging vocation; and the best Kierkegaard scholars of our own time such as Louis Mackey and Gregor Malantschuk, have in this respect at least endorsed Kierkegaard's self-portrait. Yet if we take all the evidence that we have of Kierkegaard's attitudes in and up to the end of 1842—and perhaps the text and the pseudonyms of *Enten-Eller* are the best evidence of all— it seems to me that their position is difficult to sustain. A little later in *Philosophiske Smuler* [*Philosophical Fragments*] in 1845 Kierkegaard invokes this crucial new idea of radical and ultimate choice to explain how one becomes a Christian and by that time his characterization of the ethical has changed radically too. That had become already abundantly clear even in 1843 in *Frygt og Baeven* [*Fear and Trembling*]. But in 1842 he still stands in the most ambiguous of relationships to his new idea—simultaneously being its author and disowning its authorship. For this idea is not merely at odds with Hegel's philosophy, which already in *Enten-Eller* is one of Kierkegaard's chief targets. This idea destroys the whole tradition of a rational moral culture—*if* it itself cannot be rationally defeated.

The second feature of *Enten-Eller* to which we must now turn concerns the deep internal inconsistency—partially concealed by the book's form—between its concept of radical choice and its concept of the ethical. The ethical is presented as that realm in which principles have authority over us independently of our attitudes, preferences and feelings. How I feel at any given moment is irrelevant to the question of how I must live. This is why marriage is the paradigm of the ethical. Bertrand Russell has described how one day in 1902 while riding a bicycle he suddenly realized that he was no longer in love with his first wife—and from this realization there followed in time the break-up of that marriage. Kierkegaard would have said, and surely rightly, that any attitude whose absence can be discovered in a sudden flash while riding a bicycle is only an aesthetic

reaction and that such experience has to be irrelevant to the commitment which genuine marriage involves, to the authority of the moral precepts which define marriage. But now whence does the ethical derive this kind of authority?

To answer this question consider what kind of authority any principle has which it is open to us to *choose* to regard as authoritative or not. I may choose for example to observe a regime of asceticism and fasting and I may do this for reasons of health, let us say, or religion. What authority such principles possess derives from the reasons for my choice. Insofar as they are good reasons, the principles have corresponding authority; insofar as they are not, the principles are to that same extent deprived of authority. It would follow that a principle for the choice of which no reasons could be given would be a principle devoid of authority. I might indeed adopt such a principle from whim or caprice or from some arbitrary purpose—I just happen to like acting in that way—but if I then chose to abandon the principle whenever it suited me, I would be entirely free to do so. Such a principle—and it may even be stretching language to call it a principle—would seem clearly to belong to Kierkegaard's aesthetic realm.

But now the doctrine of *Enten-Eller* is plainly to the effect that the principles which depict the ethical way of life are to be adopted *for no reason*, but for a choice that lies beyond reasons, just because it is the choice of what is to count for us as a reason. Yet the ethical is to have authority over us. But how can that which we adopt for no[2] reason have any authority over us? The contradiction in Kierkegaard's doctrine is plain. To this someone might reply that we characteristically appeal to authority when we have no reasons; we may appeal to the authority of the custodians of the Christian revelation, for example, at the very point where reason breaks down. So that the notion of authority and the notion of reason are not, as my argument suggests, intimately connected, but are in fact mutually exclusive. Yet this concept of authority as excluding reason is, as I have already noticed, itself a peculiarly, even if not exclusively, modern concept, fashioned in a culture to which the notion of authority is alien and repugnant, so that appeals to authority appear irrational. But the traditional authority of the ethical, in the culture which Kierkegaard inherited, was not of this arbitrary kind. And it is this traditional concept of authority which must be embodied in the ethical if it is to be as Kierkegaard describes it. (It is not surprising that just as it was Kierkegaard who first discovered the concept of radical choice, so it is in Kierkegaard's writings that the links between reason and authority are broken too.)

I have argued then that there is a deep incoherence in *Enten-Eller*; if the ethical has some basis, it cannot be provided by the notion of radical choice. Before I turn to ask why Kierkegaard should have arrived at this incoherent position, however, let me notice a third feature of *Enten-Eller*.

It is the conservative and traditional character of Kierkegaard's account of the ethical. In our own culture the influence of the notion of radical choice appears in our dilemmas over *which* ethical principles to choose. We are almost intolerably conscious of rival moral alternatives. But Kierkegaard combines the notion of radical choice with an unquestioning conception of *the* ethical. Promise-keeping, truth-telling and benevolence embodied in universalizable moral principles are understood in a very simple way; the ethical man has no great problems of interpretation once he has made his initial choice. To notice this is to notice that Kierkegaard is providing a new practical and philosophical underpinning for an older and inherited way of life. It is perhaps this combination of novelty and tradition which accounts for the incoherence at the heart of Kierkegaard's position. It is certainly, so I shall argue, just this deeply incoherent combination of the novel and the inherited which is the logical outcome of the Enlightenment's project to provide a rational foundation for and justification of morality.

To understand why this is so it is necessary to turn back from Kierkegaard to Kant. Because of Kierkegaard's own ceaseless polemics against Hegel, it is all too easy not to notice Kierkegaard's positive debts to Kant. But it is in fact Kant who in almost every area sets the philosophical scene for Kierkegaard. It is Kant's treatment of the proofs of the existence of God and his view of what constitutes rational religion that provide a crucial part of the background for Kierkegaard's account of Christianity; and it is equally Kant's moral philosophy which is the essential background for Kierkegaard's treatment of the ethical. It is not difficult to recognize in Kierkegaard's account of the aesthetic way of life a literary genius's version of Kant's account of inclination—whatever else Kant may be thought, and it is difficult to exaggerate his achievement, he was as clearly *not* a literary genius as any philosopher in history. Yet it is in Kant's honest and unpretentious German that Kierkegaard's elegant but not always transparent Danish finds its paternity.

NOTES

1. This selection, by kind permission of Professor MacIntyre and the University of Notre Dame Press, is from *After Virtue*, 2nd ed., pp. 39–43.

2. There seems to be a typo in the second American edition of *After Virtue* at this point, for the text here actually reads "for one reason." We have corrected this error here to reflect the British edition (Duckworth).—*Eds.*

PART I

After Virtue and *Either/Or*

1

Kierkegaard and the Relativist Challenge to Practical Philosophy

PETER J. MEHL

Summary

Kierkegaard is considered in light of the contemporary debate over rationality and relativism, especially as it pertains to his understanding of human moral existence. He is interpreted as providing a philosophical anthropology as a basis for affirming responsible personhood. The Kantian and, more briefly, the Hegelian and Aristotelian influence on his views are discussed, and it is argued that Kierkegaard draws on these to formulate a view of the universally human as the potential possessed by each individual which is to be actualized. This view is distinguished from, yet encompasses, the human being as "subjective actuality" which is relative to each individual, and as "empirical actuality," which is peripheral and variable. Finally, his view of essential humanness is interpreted as formulated by employing a "radical empiricism" of the lived-experience of actually searching for a meaningful perspective on human praxis, a "method" that draws on a comprehensive conception of rationality.

Introduction

Alasdair MacIntyre's (1981:39–41) recent interpretation of Søren Kierkegaard's ethical perspective as a last irrational and desperate attempt to support the failing Enlightenment project of justifying morality is a distortion of Kierkegaard's overall position. Kierkegaard does *not* claim that only a radically irrational act of choice can justify an ethical life. While MacIntyre, I believe, is right in his claim that Kierkegaard inherits a crisis in the Enlightenment's attempt to ground morality within the autonomous rationality of consciousness, it is a mistake to portray

3

Kierkegaard as simply accepting this crisis as insurmountable and then presenting a completely irrational and relativistic view in ethical issues. The tendency to interpret Kierkegaard in this manner, however, is widespread among philosophers who either have only scant acquaintance with his writings or read him with preconceived portraits in mind.[1] All too often Kierkegaard is seen through the eyes of Neo-orthodox theology or Sartrean Existentialism. As Mark Taylor (1975:18) points out in his study: "the two major trends of thought to which Kierkegaard gave rise—Neo-orthodoxy and Existentialism—have more often than not inhibited rather than advanced an adequate understanding of Kierkegaard's own ideas." Neither of these modern orientations accurately depicts Kierkegaard's position. The former have focused discussions of his writings on the dramatic "teleological suspension of the ethical" and the "leap of faith," while the latter, as a result of Sartre's influence, have focused on notions of an anxiety of freedom without any direction and a self which develops itself out of nothing.

Following in the footsteps of more recent and more accurate and comprehensive interpretations of Kierkegaard, I will argue that Kierkegaard is primarily concerned with providing a philosophical anthropology as a basis for a coherent and reasonable approach to moral *praxis*, while, at the same time, acknowledging the modern awareness of the historical relativity of human life and understanding. In this effort I will be looking not at his views concerning the limitations of ethical existence, but at his defense of it. And here I will be concerned with his anthropology and its epistemological roots. Kierkegaard, I will argue, is preeminently concerned with formulating a perspective from which the individual as an active moral agent can be comprehensively grasped. His concern is not so much with critical ethical reflection as with the basic constitution of human moral existence, that which undergirds and is the possibility for ethical analysis. Thus he becomes primarily concerned with philosophical anthropology and its relation to moral, and finally, religious *praxis*.

A central question in such a practical philosophy, as MacIntyre (1981:112) puts it, is "what sort of person am I to become?" And, as he further notes, this question is "in a way an inescapable question in that an answer to it is given *in practice* in each human life." Kierkegaard's philosophy seeks to clarify conceptually this existential issue of personal becoming, and thus it first seeks to understand what it means to be a human agent, a person. The difficulty here, as Kierkegaard sees it, is that such an issue inevitably involves more than conceptual clarification; it involves not simply answering such a question, but actually becoming engaged in the answer, taking up the solution into one's life. This means, according to Kierkegaard, that some effort must be made to get the reader to focus on the status of his or her own life, on his or her own self-determining

decisions. And it is this emphasis in Kierkegaard's writings that has caused his philosophy to be read as one of irrational subjectivism.

In addition, there is Kierkegaard's further emphasis on the attempt to take seriously the relativity and limitations of human life and understanding. This emphasis has caused his philosophy to be misconstrued as a relativism that provides the individual with no general philosophical orientation in life-activity. However, Kierkegaard's insistence on the temporality of human existence and understanding does not result in a position that has no claims to objectivity at all. Rather, it takes him back to actual lived experience as a starting point for formulations which, I will argue, revolve around links between a descriptive theory of humanness and a normative theory of value. His psychological or anthropological conceptions have direct bearing on his "practical" concerns. "What is true [of Kant and Hume] is also true of Diderot, of Smith, and of Kierkegaard. All reject any teleological view of human nature, any view of man as having an essence which defines his true end." This claim of MacIntyre's (1981:52) is plainly mistaken in Kierkegaard's case. In his effort to straddle the peculiarly modern distinction between fact and value, Kierkegaard's views center precisely on, as MacIntyre puts it, a "notion of man-as-he-could-be-if-he-realized-his-*telos*." MacIntyre's (1981:40–41) insistence that Kierkegaard employs a traditional concept of the ethical (a concept derived from Kant and the wider Protestant culture) is largely correct, but that he offers not rational defense of it is not. In fact, it is more accurate to say that it is the historical background which MacIntyre sees such moderns as Kant and Kierkegaard rejecting—in MacIntyre's (1981:52) words "the secular rejection of both Protestant and Catholic theology and the scientific and philosophical rejection of Aristotelianism"—that Kierkegaard explicitly draws on as a basis for his teleologically oriented practical anthropology. As Gadamer (1981:47–48) points out in an autobiographical note: "What Kierkegaard had taught us and what we then called 'existential' (*existenziell*), found its prototype in the unity of *ethos* and *logos* that Aristotle had thematized as practical philosophy, and especially as the virtue of practical rationality."

But then, having refuted irrationalist readings of Kierkegaard, the central question becomes: is Kierkegaard successful in his effort to reappropriate such classical and more objectivist themes *and* find a way through relativism? Is he finally a victim or an exorcist of the "Cartesian anxiety" over firm foundations for knowledge and action? This question comes down to how Kierkegaard justifies his position, to what he finally appeals in support of his view of the human agent and why he thinks such an appeal is valid. To answer this question, one first has to *understand* his philosophy, and it is precisely here, as I have mentioned, that all too often he has been misconstrued. Because of his effort not to deny the subjectivity

and relativity of human experience, Kierkegaard has been and continues to be the subject of much philosophical name-calling—subjectivism, relativism, irrationalism are all charges that have been leveled against him. I want to argue that in no simple sense are these labels applicable.

Situating Kierkegaard Philosophically

Kierkegaard's whole philosophical effort could be said to be motivated by what Richard Bernstein (1983:16-20) has labeled "the Cartesian anxiety," the anxious concern to find "a stable and reliable rock upon which we can secure our thought and action." In the *Concluding Unscientific Postscript* Kierkegaard (1941:275) reveals this central focus of his philosophy in a personal note: "The youth is an existing doubter. Hovering in doubt without a foothold for his life, he reaches out for the truth—in order to exist in it." Having inherited the failing Enlightenment project of justifying morality (not to mention religious faith), as well as Hegel's historicism, Kierkegaard turns inward to personal existence as well as toward the history of philosophy and of Christianity to see if some means for charting life might not be found. He is convinced that neither Kant's critical idealism nor Hegel's absolute idealism is beyond the reach of the skeptical powers of disciplined reflection; neither offers that stable rock upon which the ethico-religious concerns of the individual can be given a firm foundation. As James Collins (1983:21) says of Kierkegaard: "This unshakable support was to be found neither in the physical world of the scientists nor in the purely logical constructions of the philosophers." In fact, as regards pursuits of objective knowledge, that is, empirical knowledge, there is good evidence in Kierkegaard's writings of an adherence to a form of critical empiricism. As Robert Perkins (in Crites, 1972:22n.) said in a symposium on Kierkegaard:

> The only authors he refers to with approval in epistemological matters are Hume and Greek skeptics. All objective knowledge for Kierkegaard is empirical, and it is in every sense an approximation. . . . There is no element of the a priori. Objective knowledge is an approximation, but more like Hume's skepticism than Kant's synthetic a priori.

Where then is Kierkegaard to find his sure point of departure? Is it, as many authors on Kierkegaard seem to think, that he simply gives up on the possibility of finding such a point and formulates his whole philosophical perspective by leaps and bounds? Kierkegaard's practical philosophy is not a "faith philosophy," a philosophy simply built on personal belief; it is a philosophy that follows Kant's distinction between the knowing subject

(objectivity) and the moral agent (subjectivity). It is built upon a sort of "radically empirical" examination of human existence, the concrete process of personal existing, and issues in a coherent philosophical anthropology. As Stephen Crites (1972:23) says: "Hegel and Kierkegaard, in their divergent ways, took precisely the Kantian formulation of free, self-active, self-productive praxis as opposed to objective knowledge as such, for the point of departure from which they constructed their most highly developed conceptions." Kierkegaard then follows the German Idealists in centering on the reality of the subjective, but this means for him the personal self-reflexive relationship one has to one's actual becoming, and not Hegel's excessively abstract speculations about absolute Spirit. And to counter Hegel's extremely idealistic views of the becoming of the human person, Kierkegaard draws not only on Kant but on Aristotle as well.

Historically Kierkegaard employs numerous sources; the above three seem crucial. In spite of certain fundamental disagreements with Hegel, he draws heavily on Hegel's phenomenology of spirit to formulate his anthropology. As Crites (1972:66) notes, Kierkegaard's dialectic of selfhood really amounts to "the construction of a new 'phenomenology of spirit' alternative to Hegel's." It is, however, less well known that Kierkegaard draws on Aristotle's philosophy in the construction of his perspective on human being. In fact, one might argue that it was Kierkegaard's contact with Aristotle, via Trendelenburg's revival of Aristotle, that helped Kierkegaard center on the crucial difference between ideal being and actual being—a difference which he thought Hegel wrongly ignored.[2] Nevertheless, Kierkegaard's main source, I think, is Kant's ethical thought, especially his later views found in *Religion Within the Limits of Reason Alone*. Kierkegaard, like Kant, is primarily concerned with issues fundamental to ethics: what does it mean to be a person, and what is the relation among freedom, reason, and personhood? Like Kant, he is concerned with presuppositions applicable to any possible ethical life; he rarely discusses material rules for conduct. It is thus worthwhile to review not only Kant's position, but also briefly the influence of Aristotle and Hegel. I will begin with Kant.

In this later work, *Religion Within the Limits of Reason Alone*, Kant significantly shifts away from the more formalistic and rationalistic position articulated in the *Grounding for the Metaphysics of Morals*, and it is this shift that Kierkegaard vigorously affirms.[3] As is well known, Kant wants to demonstrate that ethics can be grounded in the autonomous rationality of the individual in such a manner that ethics will in no way be heteronomous. In other words, ethics will be dependent on nothing but practical reason. As a result Kant finds himself forced into a position where the free will and the moral will, that will that follows the dictates of practical reason, are one and the same. As he says (1981:23) in the *Grounding*, "the

will is nothing but practical reason. . . . The will is a faculty of choosing only that which reason, independently of inclination, recognizes as being practically necessary, i.e., as good." And further on: "a free will and a will subject to moral laws are one and the same" (1981:49). Numerous problems are then raised: in what sense is one obligated to be moral if the free will is the same as the moral will, for obligation seems to presuppose real choice? Or, how is this position to be reconciled with the plain fact that individuals do not always follow the dictates of practical reason and yet are freely choosing not to?[4]

To attempt to solve these problems Kant resorts to his distinction between the intelligible or noumenal world and the sensual or phenomenal world. The individual belongs then to two worlds: in the noumenal world reason and freedom coincide, and the moral will rules. In the phenomenal world, however, the individual confronts himself as a sensual being with irrational desires, enmeshed in social conditions—as a being shaped by various determinations. The experience of moral obligation occurs when the phenomenal world encounters the noumenal one, when the body, inclination, natural appetite encounters the mind, reason, or moral will. The moral will triumphs, is autonomous, when it controls and represses the concrete self. Although this explains how obligation is possible, it seems to leave the moral will without the necessity Kant desires. In addition, it seems to presuppose some third element through which the encounter between the sensible and the intelligible occurs. As the individual is also a creature of the sensible world, he or she is able to turn away from what practical reason dictates; he or she is able to choose to be determined by the phenomenal self, that is, to be heteronomous. But if one chooses, then one is already free. This possibility, Kant realizes, is necessary if obligation is real. But then in what sense is the categorical imperative categorical?

In *Religion Within the Limits of Reason Alone*, Kant (1960:19) admits that a free will and a moral will are *not* one and the same; the human will, as he puts it, is an "absolute spontaneity;" it is transcendentally free. The self is now conceived as having a will that is radically free, and is then caught between the commands of practical reason, rational self-dertermination: freedom, and the attractions of sensible desire, nonrational determination: bondage. The will that is categorically obligated is not the will of the rational person *qua* rational person, but it is the will of the person as rational *and* responsible, as accountable to the self as rational being. The notion of will now has two meanings: *Wilkür*, the will as the faculty of choice, and *Wille*, the moral will, the dictates of practical reason. It is the mark of the human personality (it is the meaning of personhood) that *Wilkür* has the capacity to adopt *Wille* as its determining ground. "The predisposition to *personality* in man, [is man] taken as a rational and at the

same time *accountable* being" (Kant, 1960:21). And this, Kant (1960:21) stresses, is not the same as the individual as simply a rational being: "[F]rom the fact that a being has reason it by no means follows that this reason, by the mere representing of the fitness of its maxims to be laid down as universal laws, is thereby rendered capable of determining the will (*Wilkür*) unconditionally, so as to be practical of itself; at least not so far as we can see."

What is needed in order that the will behave in accordance with practical reason is this aspect of the self which Kant calls the "predisposition to personality." This "predisposition to personality," it now seems, is as fundamental as "personality itself," as the *Wille*, for only when the *Wilkür* functions in its capacity to adopt *Wille* as its determining ground is there "good character." Only when this occurs do we *actually* have a rational and responsible being, a genuinely free personality. Kant (1960:22–23) now makes the importance of the "predisposition to personality" explicit:

> The predisposition to personality is the capacity for respect for the moral law [*Wille*] as *in itself a sufficient incentive of the Wilkür*. This capacity for simple respect for the moral law within us would thus be moral feeling, which in and through itself does not constitute an end of the natural predisposition [to personality] except so far as it is the motivating force of the *Wilkür*. Since this is possible only when the *Wilkür* incorporates such moral feeling into its maxim, the property of such a *Wilkür* is good character. The latter, like every character of the *Wilkür*, is something which can only be acquired; its possibility, however, demands the presence in our nature of a predisposition on which it is absolutely impossible to graft anything evil. We cannot rightly call the moral law, with the respect which is inseparable from it, a *predisposition* to *personality*; it is personality itself. But the subjective ground for the adoption into our maxims of this respect as a motivating force seems to be an adjunct to our personality, and thus to deserve the name of a predisposition to its furtherance.

This "subjective ground," I submit, is really nothing other than the will as transcendentally free and capable of "standing in relation to" *Wille*. It is *Wilkür* in its capacity to "take account of" whether it has actually adopted *Wille*. And although this capacity belongs to *Wilkür* "by nature," it must be chosen by *Wilkür*. One only really becomes a person if one grasps oneself as transcendentally free *and* as held accountable for one's adopting of *Wille*. To be a person I must choose to continually pattern my action in relation to the prescriptions of practical reason; only in so doing am I actually a rational and responsible being, and only thus a genuinely free being.

While the essence of the personality is the *Wille*, it is not necessarily the actuality of the person. *Wille* is a possibility, an incentive, which *Wilkür*

can reject. The cost of this rejection, however, is the rejection of oneself as a person, for the very meaning of personhood is rational responsibility: freedom. And in this sense Kant seems to be saying that the *Wille* is categorical for the individual. Yet the key point, it now seems, is that the self as transcendentally free can reject itself as actually free; it can disregard its capacity to respect *Wille* and thus lose itself as a person. *Either* one can choose to let oneself be determined; one can give oneself up to heteronomy, the whims or desire, the fates of the situation. *Or* one can choose freedom, that potential for rational and responsible self-determination inherent in one's nature, one's "predisposition to personality." From here the distance to Kierkegaard is not far, for this is the heart of his *Either/Or* as well.

The main difference between this later position of Kant's and his earlier position is this emphasis on the notion of the "predisposition to personality," the subjective ground of the capacity to be moral and the necessity of the individual grasping him- or herself as having such a predisposition. Practical reason is not the whole of the human personality taken as moral agent. The capacity to stand in relation to *Wille*, to maintain it as the concrete guide of the *Wilkür*, is also crucial. Practical reason is a necessary but not a sufficient condition for personhood; what is needed is to grasp oneself as a transcendentally free being that stands in relation to *Wille*, and is thus a rational *and a responsible* being. All of which is to say that ethics is dependent on the *predisposition* to personality, on the individual's natural capacity to recognize and actually adopt *Wille* as a sufficient incentive for *Wilkür*, as the fulfilment of personhood.

It would seem that for Kant there is now a sense in which there is an "ought" at the heart of his description of humanness, at the heart of what the human being "is." There is a basic unity between the noumenal and the phenomenal aspects of the self, something which Kant earlier seemed to deny was possible.[5] And it seems that it is by virtue of the *Wilkür*, which contains a natural predisposition to personhood, and stands as a third party in relation to *Wille* and to desire that the linkage takes place. Although Kant never fully worked out this more triadic view of the human person, a view which sees an ethical imperative within which, for the individual as radically free, is a *telos* that he or she must continually strive to actualize, it is precisely this view that Kierkegaard focuses on.

Kierkegaard's practical philosophical anthropology is centered on the belief that responsible freedom is at the heart of what it means to be a person. To Kierkegaard's mind, it is the destiny of every individual to become spirit, spirit being rational and responsible self-determination. To quote Kierkegaard (1972:267): "Personality manifests itself as the absolute which has its teleology in itself." This theme, of course, is at the heart of German Idealism. As Marx (1972:7), a most diligent student of German

philosophy, pointed out, the troubling thing about Kant is the antagonism between "is" and "ought," but with Hegel the "ought" lies in reality itself: "if previously the gods had dwelt above the earth, they now became its center." But we have seen how even the later Kant was moving more toward the idealistic understanding of human reality as defined by its relation to a potential moral *telos:* human freedom—and thus maybe the later idealists were influenced by this aspect of Kant's philosophy.

In any event, it is necessary to look briefly at the Hegelian influence on Kierkegaard. At the heart of Hegel's idealism is a vision of Being as determined by Rational Spirit, *Geist.* Behind the phenomena of human history there is a phenomenology of Spirit, an active and rational dialectical process of organic development with a definite end. As Richard Bernstein (1971:18) puts it:

> Hegel is claiming that if we take a world historical perspective, we will see that there is an inner *logos* to the seemingly chaotic multiplicity of events. This *logos* has a teleological form. There is a narrative or "story" to be discovered in history—this is the epic of the ways in which *Geist* is realizing itself, moving from freedom and self-determination as an abstract idea to its concrete embodiment in human institutions.

Essentially the same dynamic takes place at the level of each human life: an individual as a vehicle of *Geist* is propelled through various stages toward the actualization of him- or herself as rational self-determination, toward concrete freedom. For Hegel this dialectical path has a certain necessity. While one may experience oneself as freely choosing one's destiny, from the perspective of *Geist* one is fully determined; the individual's potential is his or her necessity. Kierkegaard, I think, agrees that the existential development of the individual has such a dynamic dialectical path as his or her destiny, but this destiny is not a necessity: it is a possibility. This is because the individual as fundamentally free can choose or disregard him- or herself as having a capacity for personhood, as spirit. And yet it seems that Kierkegaard concurs with Hegel (and with Kant), that freedom is one's highest interest, it is the heart of what it means to be spirit, but (and here is the rub) *actually* to become spirit, *actually* to maintain oneself as responsible freedom is exceedingly difficult. While for Hegel this interest of spirit is reached when the individual realizes that he or she is essentially *Geist,* for Kierkegaard such a realization is just the beginning of the arduous task of actually being spirit, for the individual is temporal; the individual *exists.*

There is good evidence that for support in his polemic against Hegel's excessive idealism, Kierkegaard draws on the realism of Aristotle. George

Stack has done an extensive study of this line of influence. Stack points to an influence deriving from both the *Metaphysics* and from the *Nicomachean Ethics*. As regards the first source he cites (1977:77–78) Aristotle's view that

> [though] there is a universal teleology pervading the development of beings, the process of development from potentiality to actuality is non-necessary. To be sure, he does hold that there is a 'natural' tendency for beings to have their potentialities realized or (in the case of men) to realize their potentialities. [But] whatever has potentialities is perishable and, hence, contingent. As Aristotle expresses it in his *Metaphysics*: "everything that is potential may fail to be actualized. Therefore, that which is capable of being may both be and not be."

As regards the second source, Stack cites (1977:92, 100–103) Aristotle's account, in the *Nicomachean Ethics*, of *proairesis* (deliberate choice) as involving both desire and *phronesis* (practical reasoning) purposely directed toward an ethical *telos*, as affording a surer test of character than our actions, and as the foundation for the development of character through repeated *praxis*. If all these points are accurate views on Aristotle, then I would agree that Kierkegaard concurs with him at many points. Like Aristotle in the *Metaphysics*, Kierkegaard employs contingency in his anthropology: like Aristotle in *Nicomachean Ethics*, Kierkegaard employs teleological and aretaic views in his understanding of the dynamics of personhood. Stack's study, to my mind, indicates that there is much evidence to counter claims that Kierkegaard has given up on formulating a philosophically sound view of the universally human as it is oriented in moral *praxis*.

Another point where Kierkegaard was influenced by Hegel should be mentioned. Hegel's emphasis on *Geist* as only coming to light within the concrete drama of human history so the workings of *Geist* take place only through the "material" of the actual world is, in a way, affirmed by Kierkegaard. As Hegel (1953:31) confidently states this view, the drama of human history is based in "need, instinct, passion, private interest, even opinion and subjective representation. These vast congeries of volition, interests, and activities constitute the tools and means of the World Spirit for attaining its purpose, bringing it to consciousness, and realizing it."

For Kierkegaard, as we will see, this amounts to saying that one's concrete and relative existence, one's "given" particularity, is as much an expression of universal humanness as is the call to responsible freedom. For Kierkegaard the temporal, the relative is to be seen as an essential element of the universally human. This aspect, what Kierkegaard refers to as the "aesthetic" side of the human being, is that which one is "immediately,"

or as MacIntyre (1981:50–51) puts it, "man-as-he-happens-to-be" prior to ethical enlightenment.

Kierkegaard's View of Human Moral Existence

To return to Kierkegaard, what exactly is his reasoning concerning this inner transcendent center of responsible choice that constitutes the heart of what it means to be a person? For Kierkegaard, Kant's difference between autonomy and heteronomy is *almost* exactly what he concretely formulates as the difference between the "ethical" life and the "aesthetic" life. I say "almost" because for Kierkegaard the phenomenal self, the "aesthetic" life, is absorbed and transformed by the ethical life—not repressed and denied. Still, the Either/Or that runs throughout Kierkegaard's thought is that of *either* choosing to disregard one's essential self, one's self as the power of responsible freedom, *or*, as Kierkegaard puts it into the mouth of his ethical protagonist Judge William, to *choose thyself.*

To choose oneself means, first and foremost, to choose that predisposition to personality referred to by Kant, and thus to apprehend oneself as having a potential for personhood. In this choice one is not choosing merely another possible incentive, an element of oneself as a particular empirical being with contingent desires and interests, but the power of responsible freedom itself, the ability to sustain a self-conscious relationship to the material content of one's thought. John Cobb, Jr. (1979:106), in an early book, succinctly characterizes what Kierkegaard speaks of as spirit. The individual becomes conscious of him- or herself as having a "subjective center [which has] no given character of its own other than that of being in each new situation concretely responsible for the soul's total response. This transcendent, responsible center is the 'personal I'."

It is this center, this power for personhood, that Kierkegaard takes as his Archimedean point. As he sees it, to have such a center is founded on the power to have a relationship to oneself, to take account of oneself, to know how it actually "stands" with oneself. Such a power is a pervasive condition of human subjectivity. Having such an ability, Kierkegaard seems to believe, implies responsible personhood, for with it I am impelled to answer to myself; I continually find myself able to take account of my intention.[6] To Kierkegaard's mind, one can pursue a life that consciously denies this certainty, but paradoxically one can only do so by virtue of the fact that one has this certainty, thus implicitly reaffirming as well as contradicting it. While everything that I know about the objective world, even myself as an object in that world, may be uncertain, only an empirical possibility, the question of how I stand in relation to what I may know I am able to discern with certainty; my intention I can know. Kierkegaard refers

to this subjectively apprehended relation as one's "ethical reality," or one's "real subjectivity."

This notion of one's ethical reality constitutes a second and third sense of the term "reality," both of which, Kierkegaard seems to claim, are significantly different from reality in the sense of "empirical particulars." Ethical reality refers to both the general potential for maintaining oneself in responsible freedom and, as Kierkegaard often uses this term, it refers to *actually* doing so, which is then relative to each individual. Ethical reality is a potential, a category characterizing humanness for Kierkegaard; yet ethical reality can only become "actual," can only "exist," if an individual chooses this "potential-for" ethical reality. To avoid confusion, I will use the term "subjectively actual," or "real subjectivity," as Kierkegaard often does, to refer to the actual or existential maintaining of ethical reality by an individual.

Kierkegaard does not always speak explicitly of the general potentiality for ethical reality, but it is present as the heart of his project; it is the center of the abstract anthropology upon which are hung the concrete modes of existing often portrayed in his pseudonymous works. The most sustained discussion of this "ethical reality" is in the *Concluding Unscientific Postscript*, and in order to evaluate Kierkegaard's proposals it is necessary briefly to review this. Again, it is from within the subjective perspective, as Kierkegaard understands it, that each individual as a person has this perennial point around which the whole relativity of life is to be unified and centered, and integrity and constancy of character achieved.

Knowledge of this "ethical reality" (in both senses of the phrase) concerns each individual's self-reflexive relationship to him- or herself, and is not an approximation to empirical "objective" reality. As Kierkegaard (1941:280) states this difference: "All knowledge about reality is possibility. The only reality to which an existing individual may have a relation that is more than cognitive, is his own reality, the fact that he exists." Immediately two things must be explained. First, by "more than cognitive," Kierkegaard does not mean noncognitive or nonrational, for by cognitive he has in mind the theoretical grasping of the details of the "objective' world (which is always in terms of possibilities) and by "more than cognitive" he means to include the internal relationship that an individual sustains to himself. Secondly, by "exists" Kierkegaard means an individual's "subjective actuality," the existential sense of "ethical reality," his reality in a more psychological sense. This reality is more than "cognitive," more than simply "objective," since it is the grasping of the *relationship* that constitutes my subjective actuality. As Kierkegaard (1941:178) says, "*When the question of the truth is raised subjectively, reflection is directed subjectively to the nature of the individual's relationship; if only the mode of this relationship is in the truth, the individual is in*

the truth even if he should happen to be thus related to what is not [objectively, empirically] *true."* [7]

The individual that strives for subjective actuality does so by virtue of the fact that he or she maintains a self-reflexive relationship to his or her own self-determining decisions, in other words, by virtue of the fact that one has chosen oneself as a being with a potentiality for rational and responsible freedom, for "ethical reality." As Kierkegaard (1941:302) puts it, showing his indebtedness to Kant: "The real action is not the external act, but an internal decision in which the individual puts an end to the mere possibility and identifies himself with the content of his thought in order to exist in it." The reality, then, that one grasps in this self-reflexive act is one's own reality considered as what one is as a subject. This grasping is a knowledge relationship, yet, according to Kierkegaard, it is not an abstract identity between thought and being, for to grasp what one is subjectively is to perceive the inner relationship one actually maintains toward what claims one's allegiance.

While subjective actuality is analogous to the modern sense of psychological identity, it only includes one's so-called natural self, Kant's sensible self, one's talents, dispositions, etc., indirectly. Actually it is more like one's sense of character: the conscious, responsible, and intentional formation of one's sensible, natural, or phenomenal self into a definite unity and constancy (Kierkegaard, 1972:266–67). One's phenomenal self is an empirical reality, hence perceived as a possibility, but one's subjective reality is the one reality that can be known *as* actuality. "The real subject is not the cognitive subject, since in knowing he moves in the sphere of the possible: the real subject is the ethically existing subject" (Kierkegaard, 1941:281). This, by the way, is what Kierkegaard means when he says that "subjectivity is truth." To summarize: either I self-consciously strive to intend all my life-activities, and am becoming subjectively actual, or I do not, and am thus not subjectively actual: I have ethical reality only as a possibility. In Kierkegaard's (1941:284) words: "This ethical reality is the only reality which does not become a mere possibility through being known, and which can be known only through being thought; for it is the individual's own reality. Before it became a reality it was known by him in the form of a conceived reality, and hence as possibility."

The last sentence of this passage refers to ethical reality in the sense of a generic potential or possibility for any individual. To have an ethical reality, Kierkegaard is claiming, is the possibility of being a person; it is a potential which every individual has as a human being, but one which only becomes an actuality when the individual maintains him- or herself in responsible freedom. For Kierkegaard, as for Kant, there is a sense in which an individual who does not become autonomous is not a person at all—although such an individual is still potentially a person. Thus, there is for

Kierkegaard a difference between "ethical reality" as what the particular individual achieves who actually lives in conscious responsible freedom, who strives for autonomy, and "ethical reality" as a conceived potential which characterizes what it means to be a person, as the heart of what it means to be human.

There are, then, as is becoming clear, three senses of the term "reality," or "existence," in Kierkegaard's thought, and it is necessary to distinguish these if one is adequately to interpret and evaluate his philosophical position. My point, in fact, is that interpreters of Kierkegaard who do not grasp these distinctions are inadvertently led to picture Kierkegaard's views as irrational, relativistic, and subjective (as completely relative to each individual). The subjective in this individualistic sense of the word is a crucial element in the essentially human, but it is not the whole of it.

The first sense of reality I have already mentioned, empirical "objective" reality, the things and events of the world, the particulars of the existing world. Knowledge of these "objects" is not without validity, but it is of the order of the probable, the possible, a symbolic approximation more or less adequate. Objective reality is both an overflow of particulars that is never fully absorbed by the generalities of concepts and beyond the final grasp of a consciousness that is historically conditioned. Knowledge of "objective" reality is limited and largely relative, yet the individual person (as regards natural inclinations, personal interests, social situation, family background, etc.), is also such an object. To this dimension of, as Kierkegaard calls it, "immediacy" which constitutes the existential center of the aesthetic life, I will return. Structuring one's *praxis* upon such a basis is doomed to failure because such an incentive or guide is contingent; a constant basis lies in "ethical reality."

The second and third meanings of the term "reality" I have just reviewed: an individual's "ethical reality" as potential and as actual. But ethical reality as a potential requires closer investigation, for it is this notion that gives Kierkegaard's anthropology the leverage to collapse the fact-value distinction, to weld a normative stance to a descriptive one.

In the *Concluding Unscientific Postscript*, Kierkegaard (1941:274) claims: "Every human being must be assumed in essential possession of what essentially belongs to man. The task of the subjective thinker is to transform himself into an instrument that clearly and definitely expresses in existence whatever is essentially human." That is to say, it is the ethical task of the individual to become essentially human, and, as we have seen, this is because the heart of essential humanness compels the individual actually to become essentially human. And thus one can only escape this normative center, the call to personhood, in the sense that, as John Silber (1960:cxxv) states it, "a prisoner who is shot to death as he goes over the wall of the prison can be said to have escaped." In looking at the influence

of Kant, Hegel, and Aristotle we have already seen how Kierkegaard believes this is the case: human beings are essentially beings that have as their essential function the actualizing of what characterizes them *qua* humans. The individual's highest interest concerns the natural predisposition to personhood. The highest need of the human being is to become a person, and that means becoming a center of responsible freedom. When Kierkegaard says that the central task confronting the existing individual is to exist,[8] he is referring to this need to move from ethical reality as a potential to it as an actuality. In this sense, there is an ethical *telos* at the center of what it means to be a human person.

However, as Bernstein (1971:70) points out, referring to Marx and Hegel and, I believe, to Kierkegaard's anthropology as well: "Such an orientation cuts at the heart of the modern dogma that there is an unbridgeable gap between the descriptive and the prescriptive, between fact and value, or between the 'is' and the 'ought'." How such an orientation is possible takes us to the reasoning behind Kierkegaard's view of the universally human. But first a few more words on Kierkegaard's bridging of reality and ideality and the notion of concrete universality as an ideal for human flourishing.

As Kierkegaard formulates it, the self, to put it briefly, is a synthesis of finitude and infinitude which freedom (spirit) is responsible for actualizing. That is, one becomes essentially human, as Kierkegaard (1941:320) says, "through bringing the existential categories into relationship with one another," by actually striving to achieve the synthesis that one is potentially. By "existential categories" Kierkegaard means (1) finitude, the empirical world, oneself as a natural, limited, and relative being, (2) infinitude, the rational and imaginative power of the mind, the reflective power to generate symbolic meaning, and (3) spirit, self-consciousness, responsible freedom (Kierkegaard, 1954:146, 162). The urge toward this unity is put into play by the self experiencing the call to personhood, its highest interest—what Kierkegaard often calls the "existential pathos of being spirit." This call to personhood, or existential imperative, is the link between the manifold interests of finitude and the formal constraints of practical reason. For Kierkegaard it is the fundamental natural capacity that designates the heart of humanness. As I pointed out earlier in the section on Kant's later thought, this notion of a basic human potential is the key to building a bridge between the "is" and the "ought." With this notion Kierkegaard has a normative standard by which to measure human existence. Kierkegaard's examination of human existence leads to the view that living with an eye toward personal responsibility is the heart of what is essentially human.

As I have indicated, what Kierkegaard means by the essentially human is not exactly what Kant means. There is more to what Kierkegaard means

by the essentially human than Kant's autonomy versus heteronomy. Kierkegaard's view of the essentially human is far richer and more demanding than Kant's, and very much more Hegelian and Christian. As Schrader (1968:691) compares Kierkegaard to Kant: "Whereas Kant's view of the moral sensibility was more or less Platonic and repressive, Kierkegaard's is Hegelian and ringingly affirmative." As noted earlier, what Kierkegaard assimilated from the Romanticism of Idealism was an appreciation for the concreteness of life, for the individual as opposed to the universal. This, I think, along with a basic Christian affirmation of the goodness of existence, allows him to formulate a view of the universally human that includes the facticity of concrete life, a view that includes the life of aesthetic richness, of concrete participation in the world. Such a view, as Schrader (1968:692) argues, maintains a basic unity of the self, avoiding the "identification of the self with one of its presumed higher faculties."

In contrast to Kant, then, Kierkegaard includes in his view of the essentially human not only man as a rational and as an accountable being but as a sensual being, a participant in the phenomenal world. The ethical life is not simply a repression and a disregarding of the concreteness of the aesthetic life; it is a transformation of it, a "dethroning" of it as the existential center of life. To choose oneself is not simply to affirm the moral will, one's potentiality for rational self-determination, but it is to do so concretely, and the concrete is my empirical situation. Thus, as Kierkegaard (1972:255) explains it: "The individual thus becomes conscious of himself as this definite individual, with these talents, these dispositions, these instincts, these passions, influenced by these definite surroundings, as this definite product of this definite environment. But being conscious of himself in this way, he assumes responsibility for all this." As Schrader (1968:699) rightly says, on Kierkegaard's view, "It is fairly easy to see how friendship, marriage, or a career can be the result of a decision for which the individual assumes moral responsibility. . . . [T]hese commitments reflect his inclinations and serve to focus and unify them. As commitments they represent material obligations for which he is responsible."

Schrader further notes, rightly again I think, that if there is any principle of moral obligation beyond the imperative to responsible freedom, it is one that includes the natural or material aspects of volition as well as the rational aspects. Such a principle would be centered in personal responsibility. It would include a striving to maintain the integrity of the "personal I," and to unify all that empirically constitutes the individual's "world" in accord with practical reason. But this demand is not only founded on the constraints of practical reason but on the natural internal predisposition toward, the preeminent human interest in, responsible selfhood. While Kierkegaard, as I mentioned earlier, rarely mentions rules for conduct, these would, I think, primarily be concerned with *praxis* in accord with the

demand of personhood, a demand that, in interpersonal relations, would call for respect for the other as person, as an autonomous center of responsible freedom.

The task of being universally human is to become continually a synthesis of the temporal, empirical contingencies reflectively apprehended and practically ordered (finitude and infinitude synthesized), and spirit, the power to move in self-conscious and responsible freedom. In this endeavor the individual *identifies* with the contingent or relative aspect of his or her world and strives in life to become *transparent* to this world, to make every move in complete rational and responsible self-determination. Thus, the material content of an ethical life is still an individual with desires, talents, social engagements, concrete participation in the world, etc. As Kierkegaard (1967b:78) says in his journal, "the person who really becomes spirit, for which he is intended, at some point takes over his entire being (by choosing himself as it is called in *Either/Or*)." Or, as he says (1941:309) in the *Postscript*, "Ethics concentrates on the individual, and ethically it is the task of every individual to become an entire man." To become entirely human means to become a concrete universal: "He who regards life ethically sees the universal, and he who lives ethically expresses the universal in his life, he makes himself the universal man, not by divesting himself of his concretion, for then he becomes nothing, but by clothing himself with it and permeating it with the universal" (Kierkegaard, 1972:260). It is not too far-fetched to say that Kant's more repressive and controlling ethical imperative becomes for Kierkegaard an imperative of unity and integration, of complete responsibility—a more Christian imperative.

Kierkegaard and the Rationality-Relativism Debate

We now have before us those features of Kierkegaard's practical philosophy essential to answer the question of how Kierkegaard's position fares in the current debate concerning rationality and relativism. This debate is well capsulized by Richard Bernstein in his latest book, *Beyond Objectivism and Relativism*. According to Bernstein (1983:2), there is a new "conversation about human rationality" taking place that questions the modern dichotomy between "objectivism" and "relativism." In Bernstein's (1983:8) words, objectivism is "the basic conviction that there is or must be some permanent, ahistorical matrix or framework to which we can ultimately appeal in determining the nature of rationality, knowledge, truth, reality, goodness, or rightness." Objectivism, then, Bernstein continues, "is closely related to foundationalism," the perennial quest in Western philosophy for the eternally true epistemological point from which to develop the final all-encompassing system. Relativism, on the other hand, is "the basic

conviction that when we turn to the examination of those concepts that philosophers have taken to be the most fundamental . . . we are forced to recognize that in the final analysis all such concepts must be understood as relative to a specific conceptual scheme, theoretical framework, paradigm, form of life, society, or culture" (Bernstein, 1983:8). To Bernstein's mind, the underlying issue that energizes both relativism and objectivism is captured in the metaphor (mentioned earlier) of a "Cartesian anxiety." This is a fear, as he puts it (1983:18), that is characterized by the belief that "*Either* there is some support for our being, a fixed foundation for our knowledge, *or* we cannot escape the forces of darkness that envelop us with madness, with intellectual and moral chaos." The irony is that when the craving for objectivism is seen as based in misleading metaphors of firm foundations and eternal edifices and is given up, it is seen that relativism was its parasite. Relativism, and the skepticism it engenders, loses its power when such objectivist images of knowledge are no longer considered the only viable alternative, when it is seen that even scientific inquiry (especially in the case of theory-choice) is more a form of interpretive and practical rationality than an infallible knowing based on fool-proof methods.

In Bernstein's words, this new conversation concerning rationality is one that goes beyond objectivism and relativism, that exorcizes the Cartesian anxiety, and that sees that our epistemic situation is not one of either having a narrow but permanent standard of rationality or, failing that, having mere arbitrariness. Rather it offers us a middle way where the scope of rationality is wider and rationality is seen as an interpretative endeavor that finally is an exercise in human deliberation and judgment unbounded by definite criteria which can easily decide right views from wrong. It is in this direction that Kierkegaard tends to go.

It is important, however, to see that this does not mean relativism, for there are rational and experiential constraints on a conceptual system. Hilary Putnam (1981:54–55) in his book *Reason, Truth and History* offers a concise characterization of this conception of rationality, a conception often labeled "holism." In his words (1981:54–55): "What makes a statement, or a whole system of statements—a theory or conceptual scheme—rationally acceptable is, in large part, its coherence and fit; coherence of 'theoretical' or less experiential beliefs with one another and with more experiential beliefs, and also coherence of experiential beliefs with theoretical beliefs." Putnam's (1981:143) point is that a wider conception of rational acceptability allows us to see ways to bridge the factual and the evaluational and undercuts our tendency "to be too realistic about physics and too subjectivistic about ethics." Kierkegaard, I think it can be argued, employs a similar view in his effort to conceptualize the dynamics of human moral existence.

Richard Rorty also is a major participant in this conversation, and his unique characterization of it captures something of the position toward which Kierkegaard leans. In his view (1970:365–70) it is a struggle between "systematic philosophy and edifying philosophy." The former wants to "build for eternity," to find the one right method, or "permanent vocabulary," the latter, however, is "reactionary"; it distrusts "the notion that man's essence is to be a knower of essences," is more "historically conscious," and "wants to keep space open for the sense of wonder which poets can sometimes cause. . . ." In Rorty's words (1979:377), the edifying philosophers, among which he includes Kierkegaard, "are thus agreeing with Lessing's choice of the infinite *striving for* truth over 'all of Truth'." And Kierkegaard (1941:97) does explicitly approve of Lessing's words as well. Rorty's edifying philosophers, however, as Bernstein points out (1983:9), tend to look like complete relativists in their effort, through indirect communication, aphorisms, etc., not to fall into the trap of *proving* that objectivism is mistaken while, at the same time, attempting to loosen the grip of Cartesian anxiety. As Rorty puts it, "The problem for the edifying philosopher is that qua philosopher he is in the business of offering arguments, whereas he would like simply to offer another set of terms, *without* saying that these terms are the newfound accurate representations of essences." This is precisely the dilemma that Kierkegaard is in: he looks like a relativist, and in the sense that he rejects the finality of world-historical systems he is, but he has a constructive intent that leads him to argue for what he takes to be pervasive features of human experience.

Kierkegaard's position is anything but a position in which reason plays no part in justifying pursuing the ethical life. In fact, Kierkegaard attempts to develop a teleological view of humanness which is the justification for becoming a rational and responsible center of self-determination, for pursuing the call to personhood. The central thrust of the edifying philosopher is practical and anthropological, and not theoretical and metaphysical. While Rorty is right to see Kierkegaard as an edifying philosopher, Kierkegaard is also, as we have seen, constructive. An edifying philosopher need not be only reactionary and totally antisystematic; he or she can pursue truths in a rational and meaningful manner without claiming that "the system is now completed." The edifying philosopher can be, as I think Kierkegaard often is, adhering to a more comprehensive conception of rationality, a conception that widens the scope of philosophy to include the "radically" empirical or experiential data of human problems and projects. Nevertheless, there is no shortage of misunderstanding regarding Kierkegaard's views.[9]

Robert Solomon's exceptionally askew picture of Kierkegaard's thought is especially interesting on this issue, for he begins by asserting what MacIntyre asserts, viz., that Kierkegaard is claiming that there is no

rational justification for living ethically. But then he points out that Kierkegaard does offer reasons, reasons, however, which are only psychological. Solomon (1972:88) first states Kierkegaard's position this way: "Departing from nearly every philosophy in the Western tradition, Kierkegaard has reason play virtually no role whatever in answering the most pressing question of philosophy, that is, 'What is the good life for man?' One's choice of a way of life . . . has no reasons to support it."

As usual, what has probably tripped up Solomon is Kierkegaard's persistent claim that ethical theories, views of the good human life, and even elaborate rational justifications for these views, are empty unless the individual has the resolve actually to choose to live in relation to what he or she knows. Kierkegaard never says that no reasons can be given for making the choice to engage in an ethical life—his whole anthropological contemplation is a rational and existential justification for making the choice. Still, such forceful reasons can never be a substitute for the individual actually maintaining him- or herself in the effort to be "ethically actual," as Kierkegaard says.

Interestingly enough, Solomon then goes on to point out that though Kierkegaard claims that there is no rational justification for moving from aesthetic existence, he does give psychological reasons. The reason, says Solomon (1972:96–97), "which Kierkegaard gives for moving from one stage to the next are not logical but *psychological*, they are not logically compelling, but they may be compelling for some individual." And, a bit further on, such reasons are "not logically compelling but personal or 'subjective' reasons, and because these consist of feelings and not propositions, one might argue that these 'reasons' are not even relevant to considerations of rationality." Solomon, of course, misunderstands what Kierkegaard is doing, and he seems to have a narrower view of rationality than does Kierkegaard. Kierkegaard's reasons are existential reasons; that is, they are founded in his anthropology, in his picture of the universally human, *the* subjective. Solomon (1972:97) thinks that Kierkegaard, unlike Kant and Hegel, who claim that "they are writing truths holding for 'any rational creature'," is writing for those who just happen to be morally inclined. In fact, it is Kierkegaard's claim, as I have argued, that he is writing truths holding for any rational *and at the same time existing and accountable* creature.

Our question, then, comes down to this: since Kierkegaard's justification of making the choice of the ethical life rests on this anthropology, an anthropology which sees the ethical life as a destiny of every individual, upon what does this anthropology rest? It is the reasoning behind this anthropology, what could be called Kierkegaard's "ontology of human finitude," that now becomes our concern. How Kierkegaard formulates what he calls the "universally human" is of central concern, for only if

there are *rational grounds* for this formulation can *reasons* be provided for pursuing ethical existence. This is a difficult question, for as I have said, Kierkegaard does not often speak directly to this issue of justification—for the crucial issue, as he sees it, is to *exist*, to become a person. And yet everything turns on the anthropology in general, for only if this has some validity does it make sense to insist that the task of human existence is actually to become what he is claiming one potentially is: a concrete center of self-conscious, responsible freedom.

I will argue that Kierkegaard has formulated his anthropology from within the actual process of trying to find a foothold for *praxis*. That is, he employs a dialectic of theory (critical reflection) and *praxis* (existential appropriation) which in its movement alternates between the disclosure of new existential horizons and the critical assimilation of them. In this process *praxis* becomes ever more permeated by reflection and reflection is continually overturned by unforeseen existential conditions. Formulating an existential anthropology, Kierkegaard insists, is impossible outside the actual life process; only from within do the existential categories make sense. As John Elrod (1975:22) says in his recent study of Kierkegaard: "Kierkegaard is anxious to draw a sharp distinction between pure and existential thought. Pure thought is a theoretical and detached kind of thinking which characterizes the spectator of existence. Existential thinking reflectively examines and describes existence while maintaining a relationship with it."[10]

In the *Postscript*, Kierkegaard (1941:315) often stresses that "the subjective thinker seeks to understand that abstract determination of being human in terms of this particular existing human being." He reveals in his journal (1967b:#1046) that such an experiential understanding of the universally human has been a central aim of his philosophical endeavor:

> Even though I achieve nothing else, I nevertheless hope to leave very accurate and experientially based observations concerning the conditions of [human] existence. I am convinced above all that these conditions are always essentially the same. . . . Using my diagram, a young person should be able to see very accurately beforehand, just as on a price list: if you venture this far out, then the conditions are thus and so, this to win this to lose; and if you venture out this far, these are the conditions, etc.

If there is still any doubt that he makes this distinction between subjective actuality (real subjectivity) and that reality he believes is constitutive of human being as such, it should be dispelled by reading this passage:

> There are three existence-spheres: the aesthetic, the ethical and the religious. The metaphysical is abstraction; there is no man who exists metaphysically. The

metaphysical, ontology, *is* but does not *exist*; for when it exists it is in the aesthetic, in the ethical, in the religious, and when it is it is the abstraction of or the *prius* for the aesthetic, the ethical, the religious. (Kierkegaard, 1940:430)

Thus, for Kierkegaard, as I have insisted, there is a distinction within his understanding of humanness between potential being and actual being: all humans have the same potential to exist ethically; each human is the synthesis of the temporal and the spiritual, and in that synthesis lies the essential condition for any possible human moral existence. But an individual does not become "actual" by necessity, but by his or her own free self-activity. Kierkegaard's concrete "existence-spheres" constitute actual points upon an encompassing "ontology" of potential humanness. As Crites (1972:66) says: "it is important to recognize that Kierkegaard's corpus is wrought upon a rather firmly joined dialectical skeleton."

The central point, again, is that of the difference between objective knowing (theoretical scientific thought) and subjective knowing (existential thought), but what exactly is the difference? It might seem at first glance that the difference is that the former is constrained by the limits of conceptual thought as regards its ability to penetrate empirical reality, but the latter is not subject to these limits since the mind knows its own intentions. But while we saw that Kierkegaard believes that the self-reflexive character of the human psyche provides it with a point of transcendence, there is not, Kierkegaard means to say, such a point in the endeavor to frame a portrait of the universally human. That is to say, his Archimedean point, the constancy of the individual as a center of responsible freedom, rests on an analysis of actual, lived experience, and thus is subject to whatever limits the anthropological analysis is subject. As we saw in Kant's later ethical thought, the predisposition to personality, the call to self-conscious and responsible freedom, is *experienced* as a natural capacity of the human being to stand in a rational and accountable relation to life-activity. Thought must grasp such a manifestation as the possibility of personhood; self-consciousness must grasp itself as such and thus as the power for responsible freedom. Kierkegaard (1972:193) speaks of such an experience in this way:

> There comes a moment in a man's life when his immediacy is, as it were, ripened and the spirit demands a higher form in which it will apprehend itself as spirit. Man, so long as he is immediate spirit, coheres with the whole earthly life, [but] now the spirit would collect itself, as it were, out of this dispersion, and become in itself transformed, the personality would be conscious of itself.

The anthropology, or "ontology of human finitude," is created *a posteriori* as the "subjective thinker" increasingly encounters him- or herself

in the endeavor to understand his or her life. The anthropological categories (subject, object, spirit, freedom, possibility, actuality, aesthetic existence, ethical existence, etc.), are discerned by the existential thinker as he or she is immersed in the actual process of historical becoming. Part of such an analysis, as Kierkegaard (1941:224) says in the *Postscript*, involves the effort *"to exhibit the existential relationship between the aesthetic and the ethical within an existing individual."* Such an existential analysis is possible because "the subjective thinker is an existing individual and a thinker at one and the same time; he does not abstract from existence, but lives in it while at the same time thinking" (Kierkegaard, 1941:314).[11]

In this conceptual endeavor I think Kierkegaard means to employ pragmatic reasoning: the reality of spirit, or the capacity for personhood, is supported by the inescapable experience of despair which is the consequence of the denial of spirit. It seems that Kierkegaard thinks it reasonable to include in framing his anthropology the felt experiences which result form the actual pursuit of, or turning away from, certain life-orientations. Most importantly for Kierkegaard, the reality of despair is the cost of turning away from the capacity for personhood, for responsible freedom. As Gene Outka (1982:186) reads Kierkegaard:

> The expression of its [i.e. the capacity for autonomous responsible freedom] ineradicability is found in his analysis of despair, an analysis which applies to all of us. For our refusal to commit ourselves to the highest good proves to involve horrific cost. This capacity persists as an anthropological datum which none of us can ignore or disavow altogether, even when we refuse to make the actual movements.

As Kierkegaard (1972:208) says, "the spirit will not let itself be mocked, it revenges itself upon you, it bonds you within the chains of melancholy." His writings are full of descriptions of negative and positive human conditions (despair, anxiety, joy, victory, suffering, etc.), conditions which he includes as "existential costs" when figuring what sort of person to become. In the context of discovering the consequences of self-activity he often speaks of the edification or "upbuilding" of the human person; there are certain life-orientations that do not build up the personality but thwart it. And such human experiences, it seems that Kierkegaard is saying, constitute reason for deciding for or against certain paths. In general, Kierkegaard's anthropological contemplation is always related to and derived from the actual endeavor of the subject to conceptualize itself in existence, an endeavor that seems to involve a pragmatic dimension.

Paul Tillich (1959:98), in his reflections on existential philosophy, points out the *limits* of the endeavor to conceptualize human existence: "An ontological doctrine of man develops the structure of finitude as man

finds it in himself as the center of his own personal existence. But of course, in traveling this way he cannot escape his finitude. The way to finitude is itself finite and cannot claim finality: such is the limit set upon the Existential thinker." Kierkegaard's portrait of man, then, never has complete finality; his project defies the urge to foundationalism and tries to keep open the wound of limitless self-transcendence bound by historical finitude. But this is not to say, I believe, that his portrait has no validity for, again, it would make little sense for Kierkegaard to claim that the essential human task is to become essentially human if he had no reasonable and conceptually clarified view of what is universally human. Although such a portrait is derived from the historicity of the subjective, it is not without objectivity (rational validity). But what sort of objectivity?

The heart of Kierkegaard's existential analysis appears to me to be a sort of "radical empiricism" of subjectivity, of human agency, and from this he comes to view human existence under a teleological model. But what guides this sort of empiricism as it formulates this view? Allen Wood, in his comparison of Aristotle and Marx, points out that teleological models claim that the ethical *telos* is that which by nature humans strive toward, and thus may seem to commit the fallacy of equating the desired with the desirable. But as Wood (1981:29–30) sees it, such claims may be seen as holding "that the desires [goals] which it is correct to ascribe to an agent are not only (or necessarily) those which the agent may consciously avow, but those which best make its behavior intelligible." This, I think, is precisely the tack that Kierkegaard is taking; he believes that the best way to make human existence intelligible is to view it as subject to a *telos*, as subject to the actualization of a potential which is objectively present as the "natural vocation" of the human being.

It would seem, then, that Kierkegaard is approaching a more "natural law" view of morality, while affirming some aspects of a more "liberal" view. As Iris Murdoch (1966:113) points out in an essay entitled "Metaphysics and Ethics," the "liberal view," as she calls it, follows Hume and claims, "Moral attitudes are habits of sentiment built up in society, and do not need, and cannot have, any greater sanction." Kierkegaard, however, follows a more classical Aristotelian and Hegelian position, a revised Kantian view, and sees morality as centered in a *telos* that the individual discovers within the self as his or her natural destiny, the destiny of concrete humanness. In Kierkegaard's (1941:311) words, "the unification of the different stages of life in simultaneity is the task set for human beings." As Murdock (1966:115) portrays the "natural law" view:

> Here the individual is seen as moving tentatively *vis-à-vis* a reality which transcends him. To discover what is morally good is to discover that reality, and to become good is to integrate himself with it. He is ruled by laws which he can

only partly understand. He is not fully conscious of what he is. His freedom is not an open freedom of choice in a clear situation; it lies rather in an increasing knowledge of his own real being, and in the conduct which naturally springs from such knowledge.

Of course (as mentioned earlier) Kierkegaard does not see ethical existence, the heart of the universally human, naturally (inevitably) following on the increasing knowledge of oneself as subject to such a *telos*, and in this respect he affirms the "liberal" view that the individual plays a crucial role in a conscious and practical effort to attain to personhood. This is what marks Kierkegaard as an existentialist, but he is not so radical as modern existentialists who see humans as radically free, and as holding moral views simply as recommendations based on a contingent matrix of habit and tradition. Kierkegaard follows a version of the "natural law" view; he insists that human beings are encompassed in a web of existential categories, categories which define developmental conditions and practical tasks imposed on them. He argues that the individual becomes more fully conscious of his or her actual condition in the practical venture of self-understanding and self-realization. He "attacks" an aspect of the liberal view in his polemic against nineteenth-century Christendom, where everyone is Christian simply by virtue of living in a society where Christian moral attitudes are held. For Kierkegaard, Christian consciousness, "Religiousness B" (which I did not explicate), as well as "Religiousness A," arise as the final encompassing stages in the struggle to integrate oneself with the potential for personhood. In Christian existence this ideal of human flourishing, the *telos* of existence, is attained most fully.

To take the position that he does means, of course, that Kierkegaard adheres to a more "experiential empiricism" and rejects in his formulations of "essential subjectivity" any narrow sense of empiricism. And yet, as I mentioned initially, he does seem to hold such a narrow view when it comes to knowledge of any "objective" empirical reality. It is fair to say, I think, that Kierkegaard never fully works out the distinctions between empirical knowledge and the sort of experiential knowledge (radically empirical knowledge) of the structure of human reality gleaned from thinking existence, from an endeavor largely composed of introspection but also of detailed observations of concrete personalities. His main concern is to maintain the distinction between empirical knowledge (in the sense of knowledge of objects), knowledge which he sees as secondary to the heart of ethical existing, and knowledge that each individual has of his or her own "subjective actuality," knowledge of "how" one "stands," whether one maintains an actual relation to what one has understood. It is here, of course, that his (1941:182) famous definition of truth properly applies: "An objective uncertainty held fast in an appropriation-process of the most

passionate inwardness is the truth, the highest truth attainable for an *exist-ing* individual." It is in this stance that one becomes a concrete person.

The question, however, is does "existential knowledge" of human exis-tence in general fall under the objectively uncertain, the always approxi-mate yet rationally guided sort of knowing which characterizes any empirical search? My view is that Kierkegaard believes that formulating a philosophical anthropology, while also objectively uncertain (in the sense of never being unconditionally valid), and thus an empirical approxima-tion, has greater promise than purely speculative examinations of a world-historical sort. One point, it seems, is that the fruits of subjective examination are more persuasive than "sense" or "scientific" knowledge, for they are discerned inwardly; they are founded in the dynamics of per-sonal experience, and grow out of the intensely practical issue of personal becoming. But another point that I think Kierkegaard means to make is that conceptions of human existence are concerned with a pervasive pat-tern that is inwardly apprehended, not the details of sense knowledge, and thus their validity is applicable to and measured in the different arena of human subjectivity. Yet, he does admit at certain points that his views are based on observations of individuals as well as literary study, and his "aes-thetic" works constitute a rich portrait of human interests, desires, pas-sions, moods, etc. On the whole, it seems reasonable to say that he means to include his anthropological view under the objectively uncertain in the empirical sense—his views make no claim to special personal knowledge. The only real difference between his existential empiricism and a positivis-tic sense of empiricism—an important difference—is that his empiricism is more comprehensive; it includes the inwardly apprehended dynamics of subjectivity. He would then have to admit (as he sometimes seems to), that his distinction between subjective/existential knowledge, the basis of his anthropological formulations, and "objective"sense knowledge is one of degree rather than kind—in the sense that both are subject to rational assessment. This reading is consistent with my thesis that he is employing a wide conception of rationality, a conception that cuts beneath the dichotomy between objectivism (empirical sense knowledge equals ratio-nal validity) and relativism (existential subjective knowledge equals per-sonal preference). Such a conception allows him to investigate human subjectivity rationally.

In this light, however, I think it would also be fair to say that though Kierkegaard is, in his attempt to formulate a view of humanness based on an experiential abstraction from personal becoming, moving away from an epistemology centered in the "Cartesian anxiety," he does not fully escape its presuppositions. Thus, he overemphasizes the individual's self-reflexivity of intentionality (that point where the distinction between subjective and objective knowing is the sharpest), in an effort to maintain a permanent

point of practical orientation, when what he needs to explicate more fully is his move to a more radically empirical or experiential perspective.[12]

In any event, the sort of standard Kierkegaard seems to follow in employing such a "radical empiricism" is not simply what happens to appeal to his particular personality, but general intelligibility. Following in the footsteps of Kant, Kierkegaard is employing reason in its practical capacity. As Kant (1965:26) says in the *Critique of Pure Reason*, if reason is only applicable to the theoretical, to empirical knowing, it threatens "to make the bounds of sensibility coextenxive with the real, and so to supplant reason in its practical employment." Thus, Kant's claim that the bounds of sensibility are *not* the bounds of the real provides Kierkegaard the key to thinking, in an even wider context than Kant himself does, about practical human concerns, ethical and religious concerns. And what is required to think legitimately in this arena, says Kant, is intelligibility; practical reason must be able to think its objects with consistency—ideas thus thinkable Kant calls "subjectively sufficient."

As Gregor Malanschuk (1971:111–12) depicts it in his excellent study, this is exactly what Kierkegaard does. Kierkegaard "centers his attention on applying consistent thinking to the actuality of the person as subject," and uses "the idea of organic coherence [as] the goal for his dialectical work." There is, to speak with a contemporary voice, a more "holist" conception of rationality being employed by Kierkegaard. He is certainly not an objectivist, believing that he can finally systematize human existence building from a given and immediately certain foundation, nor is he merely a relativist thinking that he *just* speaks of what is true for him—which is not to say that he does not sometimes speak of what is true for him! A crucial point to see is that Kierkegaard employs the notion of coherence at two levels: anthropological and methodological. Just as the individual seeks to become essentially human, and to make him- or herself whole, a task which he or she always has as a temporal being, so too does the existential thinker confront the task of thinking human existence coherently, a task never completed in time. For Kierkegaard the existing individual who tries to think existence is always "on the way" to coherence, just as an ethical being is in striving for unity and constancy of self. Thus, a central thrust in Kierkegaard's philosophy is the overcoming of "Cartesian anxiety" by learning to live without the finality of the system and living with a sense of historical finitude, and thus with a greater sense of personal responsibility for decision. Finally, of course, this emphasis leads Kierkegaard to forms of religious existence, existence in faith, as most conducive to human flourishing.

The notion that there is a "coherence" to Kierkegaard's corpus, a unifying theme, is a fairly recent position for Kierkegaard interpretation. In the past the general consensus was the Kierkegaard wanted to have nothing to

do with the building of abstract structures, that his category is simply the existing individual, and the individual cannot be subject to a general perspective. To claim that there is a coherent picture of human existence in Kierkegaard's works is not, of course, to claim that his works are systematic, or that his statements are logically interrelated to form a rational edifice in which everything has its necessary place. As Mark Taylor says (1975:23), "'Coherence' is intended to indicate a middle ground between those authors who hold that Kierkegaard's works are disunited and those who argue that they are 'systematic'." Of course, the point still remains that for Kierkegaard, regardless of the cognitive force of a vision of human existence, it is incumbent upon the individual to choose to adhere to such a vision. And for the making of such decisions practical intelligence is a necessary but not a sufficient condition—the sufficient condition includes an actual step.

Conclusion

Kierkegaard, then, attempts to formulate a vision of human existence that allows the individual some concrete orientation in the eminently practical question of what sort of person he or she is to become. Such a question is, Kierkegaard believes (with MacIntyre), inescapable, for one is an *existing* being—such a question gets answered in the course of a lifetime. And it is also inescapable in the sense that the concrete apprehension of despair forces the issue of personhood upon one. First and foremost, Kierkegaard provides concrete portrayals of what sorts of persons one can become. In various ideal portraits of possible life styles from aestheticism to Christian religiosity, he outlines the ways individuals confront the call to personhood, the *telos* of human existence. The unifying focus of Kierkegaard's thought is a picture of the universally human as a potential possession of each individual, a possession which makes everyone a center of responsible freedom, and thus makes it incumbent upon everyone to affirm himself or herself as such. In this way Kierkegaard attempts to restore a model of humanness present at least since the time of the Hebrew prophets, running through Christian theological anthropology (many important aspects of which I did not cover), and reaffirmed in aspects of German Idealism and Romanticism.

But it could be said that the unique philosophical challenge Kierkegaard has to meet in formulating his practical philosophy is how to rescue the individual as a center of personal responsibility from being lost as a result of the historicity of human understanding. Lost, that is, in either an idealistic perspective that sees such a situation as a license for speculative excess or an overly pessimistic perspective that sees it as leading to

nihilism regarding ethico-religious concerns. His solution is to formulate, from within a perspective of "radical empiricism," of experiential abstraction, a view of the universally human. Such a view, as Elrod (1975:23) points out, contains "universals, but not in the rationalistic or essentialist sense of the word. They are not *a priori* conditions of thought which are logically necessary; they are universals which are read off from man's concrete, lived experience." Even the notion of spirit, linked to the pervasive capacity of self-reflexivity, is, as I have argued, experientially based. It becomes manifest in an individual, as Kierkegaard says, and must be grasped by thought as a possibility for the individual. Thus, such universals and transcendental points have to be seen as objectively uncertain (as in not being unconditionally valid), but this does not mean that they are without experiential grounding or uninformed by rational thought. In the final analysis, Kierkegaard's "existential thought," while maintaining its validity within such general determinants of rational thought as intelligibility, coherence, consistency, accurate observation, etc., falls victim to the limitations of an understanding encompassed by history. As he says in his journal (1938:465):

> It is perfectly true, as philosophers say, that life must be understood backwards. But they forget the other presupposition, that it must be lived forwards. And if one thinks over that proposition it becomes more and more evident that life can never really be [fully] understood in time simply because at no particular moment can I find the necessary resting place from which to understand it— backwards.

Perhaps the best picture of Kierkegaard's practical philosophy with which to end is his point (1941:182) that thinking and living as an *existing*, as an historical being, entails a certain risk, a certain faith; it means holding fast to "objective uncertainties," as if "out upon the deep, over seventy thousand fathoms of water." I like this image because it supports my reading of Kierkegaard as undercutting the Cartesian anxiety, an anxiety which Descartes (1969:149) expresses as the fear of having "all of a sudden fallen into very deep water" where "I can neither make certain of my feet on the bottom, nor can I swim and so support myself on the surface." Kierkegaard, however is thinking human life, is making the existential movements, is swimming. Further, what I think Kierkegaard is driving at in this image is what is expressed in Otto Neurath's (1959:201) metaphor, which became a motto for Quine's "holistic" philosophical views. In our search for knowledge, "we are like seafarers who must rebuild their ship on the open sea, never able to dismantle it in dry-dock and to reconstruct it there out of the best materials."

NOTES

1. For two especially faulty interpretations of Kierkegaard's views as completely irrationalist see Shestow (1969:34), whose views Perkins (1973:197–217) criticizes in his excellent essay, and Kaufmann (1965:14–18), whose views Crites (1976a:38–39) criticizes in his introduction to Kierkegaard's *Crisis in the Life of an Actress.*

2. On this Aristotelian line of influence see Stack (1977:45–51) and Collins (1983:109–11).

3. In many important respects I am in debt in this section of my paper to Silber's (1960:lxxix–cxlii) excellent analysis of the evolving character of Kant's ethical thought. In addition, Reinhold Niebuhr (1964:118–20) points out some of the changes in Kant's later ethical thought.

4. On Kant's dissatisfaction with his earlier formulations of the categorical imperative, see especially Silber (1960:lxxxi) and Paton (1948:202–6).

5. On this denial see Silber (1960:xcix) and Paton (1948:277).

6. See also Kierkegaard (1972:259) and Elrod (1975:115–25) for a fuller explication of the inwardness of ethical existence.

7. Kierkegaard has added a footnote to this passage in which he indicates that his concern is about "essential truth, or about the truth which is essentially related to existence." This footnote refers back to pages 176–77 (Kierkegaard, 1941), where he stresses that essential knowledge is precisely what we now call existential knowledge, and that it, as we will see, is derived from experience:

> All essential knowledge relates to existence. . . . All knowledge which does not inwardly relate itself to existence, in the reflection of inwardness, is, essentially viewed, accidental knowledge; its degree and scope is essentially indifferent. That essential knowledge is essentially related to existence does not mean . . . that knowledge corresponds to something existent as its object. But it means that knowledge has a relationship to the knower, who is essentially an existing individual. . . .

8. Howard and Edna Hong (Kierkegaard, 1967b:535), in their commentary on Kierkegaard's journals, point to the meaning behind Kierkegaard's use of the word "exist" when speaking of the ethical pursuit of personhood. "The Danish language has two words, *existere* (to exist as a striving person) and *vaere til* (to be there in time and space, *Dasein* in German)."

9. I was pleased, however, to find, after completing this essay, that Robert Perkins (1973:216–7) concludes, as I do, that Kierkegaard's epistemological views are most consistently seen as an "empiricism" with "existential extension," and not an irrationalism. In Perkins' view Kierkegaard has "attempted to widen the data of empiricism."

10. Elrod's (1975:13–28) chapter on the methodological foundations of Kierkegaard's views is an excellent introduction to the issues dealt with in this essay, and I am quick to acknowledge my debt to it.

11. It seems that the young Marx had similar epistemological views, yet he was more interested in the dynamics of social life. But these views are neither idealistic

nor positivistic empiricist. As Marx says, his approach "is not devoid of premises. Its premises are men, not in any fantastic isolation and rigidity, but in their actual, empirically perceptible process of development under definite conditions. As soon as this actual life-process is described, history [a concrete human life for Kierkegaard] ceases to be a collection of dead facts as it is with the empiricists (themselves still abstract), or an imagined activity of imagined subjects, as with the idealist" (Marx, 1972:155).

12. Here, as well as in the case of Kierkegaard's use of pragmatic arguments, comparisons with William James's philosophical views would reveal striking parallels. I anticipate developing this conversation in subsequent work.

REFERENCES

Bernstein, Richard J. 1971. *Praxis and Action: Contemporary Philosophies of Human Activity*. Philadelphia: University of Pennsylvania Press.
———. 1983. *Beyond Objectivism and Relativism: Science, Hermeneutics and Praxis*. Philadelphia: University of Pennsylvania Press.
Cobb, John. B., Jr.1979. *The Structure of Christian Existence*. New York: Seabury Press.
Collins, James. 1983. *The Mind of Kierkegaard*. Princeton: Princeton University Press.
Crites, Stephen. 1972. *In the Twilight of Christendom: Hegel vs. Kierkegaard on Faith and History*. Chambersburg, PA: American Academy of Religion.
Descartes, René. 1969. "Meditations," in *Philosophical Works of Descartes*. Vol. 1. Trans. Elizabeth S. Haldane and G. R. T. Ross. Cambridge: Cambridge University Press.
Elrod, John W. 1975. *Being and Existence in Kierkegaard's Pseudonymous Works*. Princeton: Princeton University Press.
Gadamer, Hans-George. 1981. *Reason in an Age of Science*. Cambridge: The MIT Press.
Hegel, G. W. F. 1953. *Reason in History*. Trans. Robert S. Hartman. New York: The Liberal Arts Press.
Kant, Immanuel. 1960. *Religion Within the Limits of Reason Alone*. Trans. Theodore M. Greene and Hoyt H. Hudson. Essay by John R. Silber. Harper Torchbook edition. New York: Harper and Row.
———. 1965. *Critique of Pure Reason*. Trans. Norman Kemp Smith. New York: Saint Martin's Press.
———. 1981. *Grounding for the Metaphysics of Morals*. Trans. James W. Ellington. Indianapolis: Hackett Publishing.
Kaufmann, Walter. 1965. *Existentialism from Dostoevsky to Sartre*. Cleveland: Meridian Books.
Kierkegaard, Søren. 1938. *The Journals of Søren Kierkegaard*. Trans. Alexander Dru. Oxford: Oxford University Press.
———. 1940. *Stages on Life's Way*. Trans. Walter Lowrie. Princeton: Princeton University Press.
———. 1941. *Concluding Unscientific Postscript*. Trans. David F. Swenson and Walter Lowrie. Princeton: Princeton University Press.

————. 1954. *The Sickness Unto Death*. Trans. Walter Lowrie. Princeton: Princeton University Press.

————. 1967a. *Crisis in the Life of an Actress*. Trans. Stephen Crites. London: Cox & Wyman.

————. 1967b. *Søren Kierkegaard's Journals and Papers*, Vol. 1. Trans. Howard V. and Edna H. Hong. Bloomington: Indiana University Press.

————. 1972. *Either/Or* Vol. 2. Trans. Walter Lowrie. Revisions Howard A. Johnson. Princeton: Princeton University Press.

MacIntyre, Alasdair. 1981. *After Virtue: A Study in Moral Theory*. 1st. ed. Notre Dame: University of Notre Dame Press.

Malantschuk, Gregor. 1971. *Kierkegaard's Thought*. Trans. Howard V. Hong and Edna H. Hong. Princeton: Princeton University Press.

Marx, Karl. 1972. *The Marx-Engels Reader*. 2nd ed. Robert C. Tucker. New York: W. W. Norton.

Murdock, Iris. 1966. "Metaphysics and Ethics." Pp. 99–123 in D. F. Pears (ed.), *The Nature of Metaphysics*. New York: St. Martin's Press.

Neurath, Otto. 1959. "Protocal Sentences." Pp. 199–208 in A. J. Ayer (ed.), *Logical Positivism*. New York: The Free Press.

Niebuhr, Reinhold. 1964. *The Nature and Destiny of Man* Vol. 1. New York: Charles Scribner's Sons.

Outka, Gene. 1982. "Equality and Individuality: Thoughts on Two Themes in Kierkegaard." *Journal of Religious Ethics* 10/2 (Fall): 171–203.

Paton, H. J. 1948. *The Categorical Imperative*. Chicago: University of Chicago Press.

Perkins, Robert L. 1973. "Kierkegaard's Epistemological Preferences." *International Journal for Philosophy of Religion* 4 (Winter): 187–217.

Putnam, Hilary. 1981. *Reason, Truth and History*. Cambridge: Cambridge University Press.

Rorty, Richard. 1979. *Philosophy and the Mirror of Nature*. Princeton: Princeton University Press.

Schrader, George. 1968. "Kant and Kierkegaard on Duty and Inclination." *The Journal of Philosophy* 65 (November): 688–701.

Shestov, Leo. 1969. *Kierkegaard and the Existential Philosophy*. Trans. Elinor Hewitt. Athens: Ohio University Press.

Solomon, Robert C. 1972. *From Rationalism to Existentialism: The Existentialists and Their Nineteeth-Century Backgrounds*. New York: Harper and Row.

Stack, George. 1977. *Kierkegaard's Existential Ethics*. University, AL: University of Alabama Press.

Taylor, Mark C. 1975. *Kierkegaard's Pseudonymous Authorship: A Study of Time and Self*. Princeton: Princeton University Press.

Tillich, Paul. 1959. *Theology of Culture*. New York: Oxford University Press.

Wood, Allen. 1981. *Karl Marx*. London: Routledge and Kegan Paul.

A Postscript to
"Kierkegaard and the Relativist Challenge to Practical Philosophy"

Although I wrote this eassy some fifteen years ago, it still very closely reflects my views. I still think that Kierkegaard is not a fideist, that a central aim of his authorship is to convey a well-founded vision of human life and praxis. I have, however, come to the conclusion that my reading of Kierkegaard's defense of his theological anthropology undermines his confidences more than I had previously realized. While I still firmly believe that Kierkegard was formulating a theological anthroplogy as warrant for a vision of human praxis, I now think that his confidence in his "radically empirical" or existential phenomenological approach to human existence is undercut to a great extent by the social and historical relativity of human life and understanding. And since this is the case, I have come to have less confidence in his vision of the normatively human—a vision that carries him on to his ardent affirmation of traditional Christianity. Most of my criticisms appear in articles I have written since this essay appeared, so I will only briefly review them here.[1]

Kierkegaard is clearly aware that anything like a Hegelian vision of the totality of human life and history is beyond our grasp. Yet Kierkegaard believes that he can cut through the limitations of finite existence to formulate a perpective on humans that provides, in MacIntyre's terms, a view of man-as-he-could-be-if-he-realized-his-*telos*. In many respects Kierkegaard is deeply skeptical of claims to knowledge in any strong sense. Empirical knowledge is always approximate knowledge, knowledge subject to the dialectic of doubt and belief. But Kierkegaard, I judge, has one clear and firm confidence: he believes he can and has grasped the essence of the human condition as one where human beings qua human beings are compelled toward Christian existence. Christian existence is the endpoint of a series of "stages" that all humans are driven to begin, and to traverse, on pain of despair and self-contradiction. Kierkegaard's key claim is that humans have a "predispositon to personhood," where personhood comes to a stance I call the strong moral/spiritual evaluator and actor. But the stance of the morally and spiritually strong agent is one that the self comes to realize is impossible to maintain in concrete existence. We have then an ought at our heart which we cannot adequately realize. This realization compels us into religious modes of existence, and finally Christian existence, an existence that is centered in a faith in God's grace through Christ.

But the point of my early paper was to counteract claims such as MacIntyre's that Kierkegaard has no rational basis for his claims about the proper normative stance for human beings. Kierkegaard has a considered approach to human existence, he has a "method" which leads him to these

claims. And that method is best seen as proto-existential phenomenology, or a radically empirical examination of the conditions of human existence. As Kierkegaard says in his journals, "I hope to leave very accurate and experientially based observations concerning the conditions of [human] existence. I am convinced above all that these conditions are always essentially the same."[2] And indeed Kierkegaard did leave very careful and insightful descriptions of the conditions of human existence, but to a greater extent than he realized these are conditions that reflect the Western Christain cultural context in which he was nurtured. They are not the universal conditions of human existence. (I make this claim not only on the basis of anthropological and historical studies, but because I think that on Kierkegaard's own terms he cannot make good on his anthropological argument for Christian existence.) In short, if I was right about his existential empiricism, then his confidence in the stance of strong moral/spiritual personhood is undercut. All individuals are not compelled to traverse the stages on pain of despair. Other careful analyses of concrete lived experience will reveal that humans traverse other life paths and patterns of praxis, and these may be more or less tenable and practically satisfying.

Some of what Kierkegaard ascribes to the human self can, I believe, be justified, but other aspects are overstated, and derive less from the basic constituents of the self, and more from the stringent Protestant Christian heritage within which he was nurtured. All human consciousness, as MacIntyre knows well, is nurtured in a specific cultural tradition and is subject to specific social conditions. While Kierkegaard seems to realize this, I do not believe he grasped the full and deep implications for formulating his vision of the human self. The implication is that (contra Kierkegaard) there is no noncontroversial vision of the human self upon which we can build *the* ideal moral or normative vision of human life.

I suggested in my paper that Kierkegaard was walking an epistemological tightrope between a negative stance of theoretical "objective" skepticism and a positive stance of existential empiricism—an empiricism that gets a grip on the conditions of human existence and orients us in lifepraxis. Such an empiricism I argued was Kierkegaard's bridge over the rationality-relativism dilemma. The results of this existential empiricism are always subject to revision as the "subjective thinker" apprehends further determinations of the conditions of human existence. Kierkegaard's existential approach also includes a pragmatic dimension. What are the actual consequences to the human psyche of a specific life-orientation and mode of praxis? Does a life-orientation build up and edify, or does it defeat and demoralize? A radically empiricial and pragmatic existentialism is a bridge, but after the crossing one must leave behind strong claims to *the* normatively human. Overall, Kierkegaard's existential analysis approaches a vision of humans as enmeshed in natural, even divine, conditions that impose

certain attitudes and tasks upon them. The crucial question was (and I suppose still is) just how confident Kierkegaard is in his affirmation of this vision of the human as compelled toward strong moral/spiritual personhood, and then toward Christianity as a world view and practical stance that best satisfies our deep religious urge.

Although this is not discussed in my paper, I think that Kierkegaard is very confident that humans are deeply destined for strong personhood and thereby naturally set for a religiosity that transcends empiricial conditions, and finally for a specifically Christian religiosity. The Kierkegaardian moral ideal—the strong evaluator—is an attitude that requires constant critical analysis and articulation of one's set of values, and finally a justification for them that is ultimately secure, that roots out worries about mistaken assumptions, unacceptable implications, self-deceptions, and unconcious motives. To pursue this specific ideal is not an easy task, for it means finally that I confront the question of exactly what will orient my life from this rigorous standpoint. Judged against this perspective everything seems to pale: I search for a life that I can will absolutely; I search for satisfaction of an infinite requirement. As Kierkegaard says, we are to devote ourselves absolutely to an absolute *telos*, to will absolutely this absolute *telos*; in short, we are to "will the infinite." I take this to mean that the strong evaluator is anxious to find a stable rock upon which to secure thought and action.

Following my suggestion in "Kierkegaard and the Relativist Challenge to Practical Philosophy," I have come to believe even more firmly that Kierkegaard is still too deeply in the grip of the Cartesian anxiety. If I stick to Kierkegaard's existential empiricism, I cannot conclude that all humans are strongly subject to the existential trajectory that he explicates. Some may feel subject to it, but all are not so compelled, and many can live good and satisfying lives apart from it. I do think that humans are compelled in a limited sense toward a moral and psychological posture. That is, they must, on pain of unhappiness and frustration, adopt and identify with some set of broadly moral convictions, and must find a medium for self-expression. But if I am right about the Kierkegaardian "method" then I must be more generous to my neighbors' views and existential orientations, remembering that they too may be living in equally plausible and satisfying stances. That does not mean that the Kierkegaardian vision is not a position to strive to more clearly articulate and defend. I for one still find myself deeply involved in and attracted to it; although I must admit that I do have worries about it engendering too much despair and frustration on the one hand, and too much moral and spiritual self-righteousness on the other.

To conclude, I still think that those who see Kierkegaard as announcing an ungrounded particularism, a version of fideism, have simply got him wrong. Overall he is defending a deeply traditional Christianity in a

manner that in his times was radically innovative and provocative. To approach matters from the subjective side, from the side of the moral and spiritual agent, rather than the theoretical observer, is not an irrationalism but an effort to expand the bounds of reason's employment into the existential and psychological—something commonplace in our day. So Kierkegaard expands our vision of humans and their religious life, but he overstates the power and persuasiveness of his vision. His analysis is one provisional and open-ended piece of our efforts to conceptualize ourselves and our moral and religious lives, and we should not think his conclusions are demanded with the urgency he conveys.

NOTES

1. "Despair's Demand: An Appraisal of Kierkegaard's Argument for God," *International Journal of Philosophy of Religion*, 32: 167–82; "Moral Virtue, Mental Health and Happiness: The Moral Psychology of Kierkegaard's Judge William," in *International Kierkegaard Commentary: Either/Or Vol. II*, ed. Robert Perkins, Macon, GA: Mercer University Press, 1995; "Matters of Meaning: Authenticity, Autonomy and Authority in Kierkegaard," *Philosophy in the Contemporary World* 4, nos. 1&2 (Spring & Summer 1997): 27–32.
2. *Søren Kierkegaard's Journals and Papers,* vol. II, tr. Howard V. Hong and Edna H. Hong (Bloomington: Indiana University Press, 1967), #1046.

2

To Tell a Good Tale: Kierkegaardian Reflections on Moral Narrative and Moral Truth[1]

JEFFREY S. TURNER

Summary

In Whose Justice? Which Rationality? *Alasdair MacIntyre lays out a "traditional conception" as a plausible candidate for the conception of moral truth underlying narrative theories of morality. But this view is unable to deal with the threat to our moral narratives found in what Kierkegaard called "the aesthetic sphere." A look at* Either/Or *establishes an ironic similarity between MacIntyre's treatment of Kierkegaard and Judge William's response to the Young Man: in the tone of their arguments, we see how both fall prey to the seductive danger of over-aestheticizing one's own tales. The Judge's polemics subtly undermine themselves from within, as do MacIntyre's. Hence we are left, as Kierkegaard intimated in* Either/Or, *with a tension between the beautiful and the good.*

1

It has become quite fashionable these days to speak of the moral value of literature. Contemporary philosophers like Hilary Putnam[2] and Alasdair MacIntyre[3] have called our attention to the importance of the notions of "narrative" and "story" in our moral self-understanding. Literary critics like Peter Brooks have emphasized this point as well:

> Our lives are ceaselessly intertwined with narrative, with the stories that we tell and hear told, those we dream or imagine or would like to tell, all of which are reworked in that story of our own lives that we narrate to ourselves in an episodic, sometimes semi-conscious, but virtually uninterrupted monologue. We live immersed in narrative, recounting and reassessing the meaning of our

past actions, anticipating the outcome of our future projects, situating ourselves at the intersection of several stories not yet completed.[4]

According to an important strand of contemporary thought, philosophical reflections on the nature of morality will be blind if they are not connected with "the stories that we tell and hear told, those we dream or imagine or would like to tell. . . ." It is no longer plausible, according to this strand of thought, to seek moral principles *in abstraction from* our narrations about ourselves; if we are to find moral principles, they must be found *within* the narrative structure of human life, for the human being is, as MacIntyre has put it, "essentially a story-telling animal" (AV 216).

Nonetheless thinkers embracing this emphasis on the moral importance of narrative and story-telling have only begun to situate their discourses with respect to the problem of truth. Consider, e.g., MacIntyre's "disquieting suggestion" in the beginning of *After Virtue* that our comprehension of morality today is in the same state our comprehension of science would be if there had been a catastrophic destruction of scientific laboratories, instruments, and books many years ago. What view of moral truth has MacIntyre *already presupposed* by making such a suggestion?[5] *Could* we fall away from the truth of morality *in the same sense* in which we would have fallen away from the truth of science in MacIntyre's easily-imaginable possible world? How does the sense of truth involved in "narrative" accounts of morality like MacIntyre's compare with the more familiar sense of scientific truth invoked in his thought experiment?

These questions are particularly pressing for MacIntyre, who needed a conception of moral truth in *After Virtue* for at least two reasons. First of all, such a conception was required in order to sustain that work's historical narrative about morality in the West, since he openly admitted that his history would not be told from the "value-neutral" standpoint of "academic history" but instead would be "philosophical history" in Hegel's sense (AV 3f.). Thus MacIntyre sought a "true historical narrative" (AV 10f.) and clearly this was to be interpreted not as a search for some kind of merely chronological truth: MacIntyre wanted to dismiss some historical accounts in favor of others, he needed to choose among various possible historical accounts of morality—*for evaluative reasons*. Part of his historical tale involved dismissing certain kinds of narratives for "trading in moral fictions," as he put it.[6] And so MacIntyre needed, in order to ground *After Virtue*, to formulate and defend the theory of moral truth required for his history of Western moral thought.

He has attempted to do just this in his more recent work, *Whose Justice? Which Rationality?*[7] But before considering the views about moral truth needed to sustain MacIntyre's historical vision—with which, of course, other "moral narrative" theorists might not agree, insofar as they

might not share that vision—let us consider another reason why MacIntyre needed a conception of moral truth in *After Virtue*. According to MacIntyre a "narrative concept of selfhood" is required in order to grasp the unity of a human life: we need to see ourselves as living, from birth to death, the particular kind of unity found in narratives. And so at another level too he needed some notion of moral truth, for it would have to be crucial to his account—and indeed one would think this must be so for *any* plausible narrative theory of morality—that *not just any* story about a person's life will be morally acceptable.[8] The moral narrative theorist must say, for example, that the tales inveterate hypocrites tell of their lives are in some important sense not true, and so these theorists will need to dismiss some accounts in favor of others, for evaluative reasons. Insofar as they have tied morality to the telling of life-stories, they will therefore need to develop some conception of moral truth.

In *Whose Justice? Which Rationality?* MacIntyre has begun to develop the conception of moral truth presupposed in *After Virtue,* and we can take that conception as a plausible candidate for the view of moral truth that narrative moral theorists in general might develop. The key paragraph of that book in this regard is:

> Those who have reached a certain stage in that development [the development of traditions] are then able to look back and to identify their own previous intellectual inadequacy or the intellectual inadequacy of their predecessors by comparing what they now judge the world, or at least part of it, to be with what it was then judged to be. To claim truth for one's present mind-set and the judgments which are its expression is to claim that this kind of inadequacy, this kind of discrepancy, will never appear in any possible future situation, no matter how searching the enquiry, no matter how much evidence is provided, no matter what developments in rational enquiry may occur. The test for truth in the present, therefore, is always to summon up as many questions and as many objections of the greatest strength possible; what can be justifiably claimed as true is what has sufficiently withstood such dialectical questioning and framing of objections. In what does such sufficiency consist? That too is a question to which answers have to be produced and to which rival and competing answers may well appear. And those answers will compete rationally, just insofar as they are tested dialectically, in order to discover which is the best answer to be proposed so far. (WJ 358)

The central feature of this conception of moral truth[9] is what I will call its "traditional" character, which is evident in at least three ways in the passage just quoted. First, the context in terms of which the problem of truth arises and in which that problem is worked out is itself tradition-bound. It is only within on-going, tradition-bound activity that the question of truth can even arise, and MacIntyre takes some pains at this point in his text to

make clear that it can only arise at a relatively advanced state of development in a tradition: we do not, first of all and most of the time, question whether our judgments are true or false (WJ 355). And answering the question of truth as well takes place not in a pure confrontation between subject and reality, but in the tradition-bound activity of dialectic: "what can be justifiably claimed as true is what has sufficiently withstood such dialectical questioning and framing of objections." The process of establishing what is true is itself part of the activity of *traditions,* not of Cartesian subjects or Hegelian absolute knowers (WJ 360f). Second, one claims truth according to MacIntyre primarily for a "mind-set," not a judgment: judgments are "expressions" of one's mind-set. Thus the primary locus of truth is something more like what one usually takes a tradition to offer (a "mind-set") than anything like a tradition-independent "fact" (and, of course, MacIntyre rejects the latter, at least when interpreted in the manner of Russell, Wittgenstein, and Ramsey: WJ 357f). Third, and perhaps most importantly, there can be no appeal to some *extra-traditional criteria* of truth, according to MacIntyre: the criteria of truth are themselves subject to debate among various traditions. And so the truth about truth, too, is born from the claims of competing traditions about what dialectical sufficiency itself is.

This traditional conception of moral truth underlies MacIntyre's historical narratives in *After Virtue* and *Whose Justice? Which Rationality?*, as well as his claims for the moral importance of narrative in our individual lives. Thus, for example, with regard to the former MacIntyre pointedly *invites criticism* of his historical tale,[10] because he believes that "the test for truth in the present. . . is always to summon up as many questions and as many objections of the greatest strength possible," and with regard to the latter MacIntyre stresses how our own narratives are born in the contexts of the traditions in which we live:

> we are never more (and sometimes less) than the co-authors of our own narratives. Only in fantasy do we live what story we please. In life, as both Aristotle and Engels noted, we are always under certain constraints. We enter upon a stage which we did not design and we find ourselves part of an action that was not of our making. Each of us being a main character in his own drama plays subordinate parts in the dramas of others, and each drama constrains the others. (AV 213)

It might at first sound as if MacIntyre is referring here only to the ways in which *individuals* influence the narratives of *other individuals,* but the references to Aristotle and Engels make clear that for MacIntyre the narratives of our lives are essentially bound up with the *traditions* which "design the stage" on which we find ourselves.[11] Hence his emphasis on

(for example) *practice* as a component of virtue in *After Virtue* and on the moral importance of *normality* in *Whose Justice? Which Rationality?* have underneath them the claim that moral truth is essentially bound up with the tradition-bound character of human being.

The naturalness of something like MacIntyre's "traditional" theory of moral truth for moral narrative theories is undeniable. If we see morality as bound up with the tales we tell of our lives and if we recognize, as I have argued we should, that this involves reviving the idea of moral truth, a plausible candidate for moral truth will be the traditional conception MacIntyre has put forward. For it seems likely that the context of truth for particular moral narratives is always tradition-bound: we ask, *from within some shared tradition,* whether a moral tale is in fact true. And the notion of truth at stake here does seem tied to something like a "mind-set," rather than a judgment or set of judgments: to claim that a moral tale is false is not, *prima facie,* grounded in saying that some one "proposition" or several "propositions" which are part of the tale are false. It means rather that *the whole tale* is somehow misguided. Lastly, it seems plausible to maintain that the criteria of truth for moral tales are themselves the subject of dispute among various traditions and so here too the traditional conception seems on firm ground: what it means to speak of truth with respect to moral narratives itself seems to be something decided by "the best answer to be proposed so far"—the best answer within the *agon* concerning truth whose participants are philosophical traditions.

Nonetheless I shall argue in what follows that the traditional conception is inadequate because it is unable to deal with a serious threat to moral truth: the seductive danger of what Kierkegaard called simply "the aesthetic." The aesthetic constitutes a deeper danger to moral narrative than has yet been seen, either by narrative theorists or by commentators on MacIntyre. This might well be because they have failed to see the importance of the aesthetic as Kierkegaard did, as a pervasive "sphere" or way of life. From that perspective, the seductivity of the aesthetic means that we can never *simply banish* the desire to "tell a good tale" for the sake of "the ethical": we *cannot help* but aim for beautiful tales in thinking and telling about our lives. The aesthetic character of a narrative is thus a necessary condition for moral truth. It is not, however, a sufficient condition: moral truth involves not only aesthetic concerns but also something like "good faith," i.e., something like *living* the stories one *tells.*

In what follows I use MacIntyre's traditional conception of moral truth as a test case, but my basic claim about the seductive danger of the aesthetic will concern narrative moral theories in general. I will begin by giving narrative moral theorists their central claim, that morality is inherently tied to our capacity to tell stories, and so it is to a particular set of stories that I now turn. But although the stories with which I will concern myself

initially are stories about particular characters, the problematic I will uncover will concern moral truth *per se*—both the truth of particular human narratives and of the kinds of large-scale historical tales MacIntyre spun in *After Virtue*.

<div align="center">2</div>

Few modern thinkers have grappled with the issues discussed above as deeply as Søren Kierkegaard. His "pseudonymous works," and to some extent his other more "direct" works as well, are extended reflections on the relations between narrative, morality, and truth. The sheer experimental character of the form of Kierkegaard's work, the kinds of narratives we see in the pseudonymous corpus, are themselves an indication of Kierkegaard's reflections on the structure of narrative: in *Either/Or* we have the story of an odd confrontation between a young "aesthete" and an older "Judge," whereas in *Fear and Trembling* we hear the tale of an author who claims not to understand faith at all while at the same time engaged in writing a book about faith—a book whose dialectical lyricism is present even as its author denies being a philosopher or a poet. The works of "Johannes Climacus" offer us a very different narrative embodiment: a jesting dialectical thinker pushes Christian notions to the limit, merely for the purpose of self-amusement (or so we think if we take his autobiographical statements to be made earnestly, rather than in jest). Kierkegaard's own experiments in narrative structures indicate at the very least an awareness of the important link between narrative and moral truth; at best they might well offer us tales on the way to a conception of moral truth. Kierkegaard's works are themselves part of our own moral history, and MacIntyre's account in *After Virtue* [12] has a place for at least one of them. MacIntyre offers us a rather brief reading of *Either/Or*; though he does not devote much space to it (only five pages), he still gives it a central place in his tale, for he sees *Either/Or* as "a book which is at once the outcome and the epitaph of the Enlightenment's systematic attempt to discover a rational justification for morality" (AV 39). In this founding work of Kierkegaard's pseudonymous project we see the failure of Enlightenment views of morality laid out in stark detail: the rejection of a teleological view of human nature is nonetheless coupled with a smuggling in of a particular view of what the *telos* of human life is. In particular, MacIntyre sees the surface of *Either/Or* as presenting us with a bare choice between "A" (the aesthetic) and "B" (the ethical), while at the same time beneath the surface choosing for us by maintaining that "anyone who faces the choice between the aesthetic and the ethical will in fact choose the ethical"—an assertion MacIntyre himself holds to be false (AV 41).

Rather than discuss the truth-status of this or any other "assertion" in *Either/Or* directly, I will pursue such matters indirectly, for the *tone* of MacIntyre's treatment of Kierkegaard is as intriguing as his systematic claims about *what* Kierkegaard has said. MacIntyre seems intent on teaching Kierkegaard, or perhaps enthusiastic readers of him, a lesson: doesn't Kierkegaard know, he wants to say, that the aesthetic *can* be chosen seriously? In an odd sort of way, he seems to recall Judge William of the second volume of *Either/Or*, whose haste to teach the aesthete "A" perhaps leads the Judge himself astray; this is "odd" because the content of MacIntyre's teaching about the possibility of choosing the aesthetic is *precisely the opposite* of the Judge's.

But in order to flesh this out I must first turn to a more detailed consideration of the relation between A and the Judge in Kierkegaard's *Either/Or*.[13]

Either/Or tells the tale of a confrontation between a young man, "A," an "aesthete," and an older man, "B," a Judge and an advocate of the ethical way of life. Or rather, it begins to tell that tale, for there really is no explicit confrontation between A and B within *Either/Or* itself. What the text offers us is a set of papers written by A, a diary supposedly written by "Johannes the Seducer," two letters written from B to A, and a little sermon supposedly written by a Jutland priest, which B includes as his final words to A; the editor of these papers tells us that "when the book is read, A and B are forgotten; only the points of view confront each other and expect no final decision in the particular personalities" (EO I 14). We certainly receive no "factual" information as to whether B's arguments convinced A, and so we readers must think through the confrontation between the two, we must interweave these stories with those we tell of our own lives. *This* narrative is told in such a way as to invite us to construct a confrontation between A and B, a confrontation that the story itself—frustratingly—withholds from us.

In constructing such a confrontation it might be worthwhile to pay some attention to "particular personalities," even if these do not immediately offer us a final resolution to the problems posed within the text. The editor, Victor Eremita, tells us that "A's papers contain a multiplicity of approaches to an aesthetic view of life . . . B's papers contain an ethical view of life" (EO I 13). A's "aestheticism" resounds throughout volume I, but its most systematic expression is no doubt found in his essay "Rotation of Crops: A Venture in a Theory of Social Prudence" (EO I 281–300). The central theme of the essay is that one ought to lead one's life "arbitrarily":

One sees the middle of a play; one reads the third section of a book. . . . One enjoys something totally accidental; one considers the whole of existence from this standpoint; one lets its reality run aground on this. . . .

> It is very advantageous to let the realities of life be undifferentiated in an arbitrary interest like that. Something accidental is made into the absolute and as such into an object of admiration. . . . The more consistently a person knows how to sustain his arbitrariness, the more amusing the combinations become. The degree of consistency always makes manifest whether a person is an artist or a bungler. . . (EO I 299f.).

The reference to artistry at the close of this passage is no accident, for art as traditionally understood is that which turns the accidental into the absolute. "The poet's function," says Aristotle, "is to describe, not the thing that has happened, but a kind of thing that might happen, i.e., what is possible, as being probable or necessary."[14] When A seeks a studied arbitrariness in his own life, then, he is seeking to turn his life into a work of art.

To do this, however, requires one to view one's life from an "aesthetic distance." The traditional ways we think of engaging ourselves in the world are all bracketed by the principles A develops here: even erotic relationships are to be developed only up to the point where one falls in love—then one should break them off for the sake of the infinity of poetic reflection. That is no doubt a beautiful infinity, but it is an infinity which can only be enjoyed at the cost of holding the world at a safe distance.

A engenders this distance from his own life, though, only to attempt to overcome it by turning his life into a work of art. "One considers the whole of existence from this standpoint; one lets its reality run aground on this . . .": A hopes to *conquer* reality by way of poetic reflection, and to understand the aesthetic project fully we would need to understand the way in which A attempts to conquer the artistic distance from life which he himself has created by *fusing* poetry and life into an indissoluble whole.

The letters of B or "Judge William" which make up volume II clearly aim at teaching A a lesson. The lesson is meant to be the deepest of all possible lessons because the Judge wants to change A's way of life: we have here an attack on the aesthetic project itself, on the aesthetic "sphere." According to B it is categorically imperative that A—who knows quite well that he loses himself in aesthetic reflection (EO II 192)—move on to "a higher form of existence." A must face up to his own despair, and it is B's primary task to get him to do so. Thus whatever "philosophy" is contained in the works of the Judge has an eminently practical purpose: to get his young friend A to change the way he lives his life.

One might well wonder whether A will feel the weight of B's criticism in his (an)aesthetized state—where every reality is poetized, where blows become "blows" which may or may not "land." It would certainly take a good bit of work for A not to feel the force of some of that criticism, though, for it strikes to the heart of A's project:

Just consider, your life is passing; for you, too, the time will eventually come even to you when your life is at an end, when you are no longer shown any further possibilities in life, when recollection alone is left, recollection, but not in the sense in which you love it so much, this mixture of fiction and truth, but the earnest and faithful recollection of your conscience. Beware that it does not unroll a list for you—presumably not of actual crimes but of wasted possibilities, shadow pictures it will be impossible for you to drive away. (EO II 16)

Notice that A is indicted here only for the harm he does to himself. His life, his "tentative efforts at living" (EO II 7), will in the end be wasted because these tentative efforts are not made in the service of anything higher. A's "mixture of fiction and truth" allows him to play with poetic possibilities not in order to *actualize* any of them, but simply to lose himself in them. The judge suggests that A's poetic remembering, which is aesthetically equivalent to a forgetting (EO I 293), will in the end give way to the stirrings of a conscience. This conscience will show A that he has let his life slip away into the ethereal world of mere possibilities.

Whether B's blows land here, or whether A, with a quick backward movement of the head, avoids them, I do not here decide. I speak of these matters only to set the context of B's first letter to A, the so-called "Aesthetic Validity of Marriage." B first begins his sustained attack on "the aesthetic way of life" there, and I shall focus primarily on the first twenty pages or so of that letter, for my concern is not so much with the *substance* of B's criticism as with its *tone*, not with the "what" but the "how."[15]

In the opening paragraph of his letter B claims to be writing to A in "the more admonishing and urgent tone" suitable in a letter but not a treatise (EO II 5). Now this itself should give us pause, for admonition has an odd ethical status: it lives in an odd tension and must draw a fine line. On the one hand, one needs to take care that the object of one's admonitions understands that something serious is under discussion, and that this matter relates directly to him or her. One does not want to run the risk of telling stories or parables which are so enjoyable to listen to, so aesthetically pleasing, that one's listener or reader forgets that the moral of the story is ultimately meant to apply to him or her. The Judge quite clearly understands this much about admonition: after introducing it as a theme he tells the story about the Prophet Nathan's dealings with King David, who "presumed to understand the parable the prophet had told him but was unwilling to understand that it applied to him. Then to make sure, Nathan added: You are the man, O King" (EO II 5).

On the other hand, though, one also needs to take care lest one's admonitions sound *too serious*: direct criticism of another naturally brings about hostility; the one criticized will in all likelihood become "defensive," and here, too, one's real point will be lost.[16] The Judge will only scare A

away, or more likely, anger him, if his attack is too personal and too direct. In admonishing another person one needs to draw a fine line between being overly sympathetic and overly critical. Is the Judge able to draw such fine lines?

It is not at all clear that he is. He sometimes appeals to a purely traditional path in an attempt to keep A in line, as for example when he suggests that his writing on legal paper "can perhaps have its good side if it can contribute to giving my words a certain official quality in your eyes" (EO II 5). If this is meant seriously (in a tone of "urgent admonition") then one can only wonder how well the Judge really knows the aesthete A, or how adept the former is dialectically. For surely someone like A, who has seen through the bad faith of much of what ordinarily passes for a "good life" (cf. EO I 34), will not be kept in line merely by the traditional look of official pieces of paper. A sees the distinction between the traditional and the aesthetic far too clearly for the Judge's little ploy to have any hope of working; one begins to wonder whether the latter's sight in such matters is as clear.

One wonders more deeply about these things when the Judge allows himself "a little polemical prologue" before turning to the task of saving the aesthetic repute of marriage.

> In order, however, that you may yield with all the more confidence to the upbuilding that the reading of this little essay can possibly provide you, I always have at the outset a little polemical prologue to which appropriate consideration will be given to your sarcastic observations. But by doing that I also hope to pay appropriate tribute to the pirate cities and then be able to settle down calmly to my calling, for I am still within my calling, I who, myself a married man, battle on behalf of marriage—*pro aris et focis.* (EO II 8f.)

What exactly is the point of such polemical prologues? The Judge wants them to free up A's mind so that he may be edified by reading the letter, but this is no doubt rather naïve: the Judge himself remarks that setting A's dialectical powers in motion will only lead A astray (EO II 5). Why then does he do this? Why give in to the tendency to argue with A directly, to attack him and his way of life? Why run the risk of crossing that fine line admonition must draw?

The Judge tells himself that he must first take care of A's "sarcastic observations" before he earnestly fights to save the reputation of marriage; he feels he can only fight "calmly" when he has exorcized the demonic sarcasm of A. But he himself is all too easily carried away with his role as exorcist. Though he says to A, "I do not intend to preach to you" (EO II 15), in fact he does: the tone of the beginning of his letter is quite clearly that of a sermon from the pulpit. And he enjoys preaching so much

that he begins to forget his original task. More than once (cf. EO II 17) the Judge gets carried away with his polemics, so that he must *call himself back* to his investigation, to the "real" concern of his letter—all too easily he loses himself in a string of rancorous accusations. One might wonder, though, why he gets so carried away, how it is that he brings himself so far afield. Why does the Judge, representing "the ethical," address the aesthete A in such a direct, and directly critical tone? And once having done so, why does it cause him to all but forget the real point of his letter? What is the source *within the Judge himself* of his little "polemical prologue"?

A closer look at the Judge's attitude towards A is in order here. He does not deny the gifts, the "potential," A exhibits in his aesthetic attitude towards life; in fact the Judge explicitly recognizes these things:

> How often you entertained me—yes, I readily admit it—but how often you also tormented me with your stories of how you had stolen your way into the confidence of one and then another married man in order to see how deeply bogged down he was in the swamp of marital life. You are really very gifted at slipping in with people; that I will not deny, nor that it is very entertaining to hear you relate the consequences of it and to witness your hilarity every time you are able to peddle a really fresh observation. But, to be honest, your psychological interest is not in earnest and is more a hypochondriacal inquisitiveness.
>
> But now to the subject. . . . (EO II 8).

Carried away from his real task, the Judge admits that it entertains him to listen to the criticisms A offers of these poor husbands; and this not only because of the stories themselves but because A has so much fun in the telling. With an appreciation of the talents of the young aesthete, though, comes the thought that his criticism of life in the marital "swamp" just might have some merit: the Judge admits that A is not "shadow-boxing" (EO II 7) in his criticisms of marriage.

And yet—to whom do these criticisms apply? If A is not merely delivering blows to the air, where do his blows land? Who is this poor husband, stuck in the "swamp" of marital life?

One might be tempted to throw the Judge's own words back in his face: "You are the man, O King." This temptation may well come more from the fact that the ethical advocate so clearly desires to exclude this possibility than for any other reason. As is perhaps befitting his social position, the Judge seems perfectly comfortable with his station in life, his occupation, his family life: he is a husband "entitled to use the formal phrase 'with us'" (EO II 154). He never considers that anything could possibly be wrong within these comfortable surroundings; he never considers, for example, that his own marriage might be more problematic than as he

represents it. His attitude towards his marriage is one of *complete confidence,* as one can see from the fact that the Judge intends to describe an *actuality*—his own marriage—not merely some poetic *possibility* (cf. e.g. EO II 119). Hence when he shows that the aesthetic can be preserved in marriage, that the first love is an eternal love, and so on, he purports to transcend the "merely aesthetic" realm of pure possibility: all of these proofs are meant to have existential import in that he is claiming that these things are all true *of his own marriage.* The marital swamp is reserved for *other* husbands,

> those wretched husbands who sit and lament that love vanished from their marriage long ago; those husbands who, as you once said of them, sit like lunatics, each in his marital cubicle, slave away in chains, and fantasize about the sweetness of engagement and the bitterness of marriage; those husbands who, according to your own correct observation, are among those who with a certain malicious glee congratulate anyone who becomes engaged. (EO II 32f)

A's "sarcastic observations" about married men are indeed true of many, many husbands—but not of the Judge, of course. After all, he would never assume that his own marriage is "an instance of the norm" (EO II 9). . . .

Now there are several ways to express despair. One is to shout loudly, to make it clear to all and sundry, that one has lost hope and is in despair —that is the way of "those wretched husbands." They say what they mean and mean what they say: they are in despair. Yet there is another way to express despair, a far subtler way, as Kierkegaard at any rate knew well: that is to shout loudly and make it clear to all and sundry that one has *not* lost hope and that one is *not* in despair. If one is in despair in this way, one might even get carried away with all of this nay-saying and mock those who openly admit to being in despair. The Judge takes such pains to show A that he is *not* in despair about his marriage, that he is filled with "confident joy" (EO II 31) as he writes about his own marriage, in short, that his marriage *is* the normative example—that one really can't help but wonder: Why all these proofs? Why all this rejoicing and shouting, this "confident joy"?

As the Judge himself notes, "he who champions accuses" (EO II 6)— and if this is true of the universal, e.g., the nature of marriage in general, so much the more so of the particular, of (let us say) the Judge's own marriage. If the Judge feels called upon to speak on behalf of marriage and especially his own marriage, that is because he has already accused or indicted it himself: he is in despair about his marriage, however much he might deny it, or even better: *precisely because* of how much he might deny it.

We find confirmation for this reading when the Judge closes his first letter and thus seals his envelope with an invitation to A to come visit him and his wife (EO II 154). What is the meaning of this closing overture, which on B's own account "corresponds" to his opening paragraph (EO II 5)? What is his motivation here—why does he need to finish this attempt at a conversation with an invitation to meet in person?

The Judge already knows that his polemics will, by the end of this one-hundred and fifty page "letter," have driven A away, and thus he invites A to his house not because this invitation has been implied throughout his letter but rather because he seeks to heal a rift the letter itself has opened up. His admonition has been so harsh that he fears A will have been swept away. This invitation itself, though, will never heal the *real* rift that caused the Judge to get carried away with his polemical prologues, and thus eventually to drive A from his door. The real source of all of this is a split within the Judge himself. If the Judge admits that A's criticisms hit home everywhere but *his* home, that is because his own polemics are addressed as much to himself as they are to A: in despair the Judge is trying to deny the truth that he is bored with his own marriage. He knows this and yet he hides it from himself and from A; his project to educate A about the true nature of the aesthetic is done in what Sartre called "bad faith."[17]

The well-intentioned Judge has been carried away with his own story about himself. In his attempt to put the aesthetic in its place (subordinate to the ethical), the aesthetic gets the best of him: he himself "mixes fiction and truth" when telling about his relationship with his wife. He covers over his own boredom by mocking the boredom of other husbands. He hides his own despair about his marriage, and tells A—but more importantly tells himself as well—that *this* marriage preserves the aesthetic, is an eternally first love, and so on (in short, that it is both beautiful *and* good). In doing all of this he does indeed display a relation between the aesthetic and marriage: he *does* "preserve the aesthetic even in everyday life," but not in the way he means to. He preserves the aesthetic in everyday life by offering an overly beautiful account of that life. This is displayed, though, only to those of his readers (existing, as we do, outside of his text) who can see through these beautiful, all-too-beautiful stories about his married life to the real truth of his own display. But this truth is something he cannot yet see, in fact something the structure of his own story prevents him from seeing.

3

Having retold part of Kierkegaard's tale in *Either/Or*, I now return to issues more directly connected with moral narrative and moral truth. What

might we learn from *Either/Or* about the nature of the truth required by narrative theories of morality?

The first lesson, admittedly a negative one, is that what I have called the "traditional conception" of moral truth cannot be wholly sustained, for it cannot withstand the assault "the aesthetic" wages on it. Let us consider briefly the ways in which *Either/Or* plays out this aesthetic attack on the traditional conception of moral truth. Recall that there were three central features of the traditional conception: first that the context of truth was itself tradition-bound; second that it is something like a "mind-set" which serves as the primary bearer of truth rather than some immediate relation to reality like the grasp of a fact; and third that the criteria of truth are themselves a matter of debate among traditions.

Now the aesthetic concerns of A attempt to undermine all three of these features. Most central, perhaps, is the aesthetic attempt to fuse poetry and life, to become a "poet-hero"; this attempt undercuts, in an interesting way, the traditionalist's claim that the primary locus of truth is the "mind-set" rather than the "fact." MacIntyre argued in *After Virtue* that the notion of "fact" has its origins in the attempt to close the gap between *seems* and *is* (AV 79-81); he supplements this in *Whose Justice? Which Rationality?* with a systematic account of why there can be no closing this gap by appeal to the "facts of common sense" or to a standpoint of universality and impartiality (WJ 329–335). But the aesthete closes the gap (or at any rate: tells himself that he does) between *seems* and *is* not by any of these traditional philosophical maneuvers but by the project of living a poetic life. As we have already seen, he wants to turn his own life into a work of art: he strives for an *artistic* closure apparently untouched by the claims of tradition. By turning the arbitrary or accidental into the absolute, he thinks he will escape not only the "mind-set" of those bunglers around him, but the whole problematic of conflict between rival mind-sets; by virtue of his claim to have laid hold of "the absolute" (a claim made, perhaps, only to himself) he believes that he has closed the gap between *seems* and *is* by means of his own *factum,* by means of what his own poetic activity has *done*.

And the fact that the aesthete's poetic deed is not, in his mind at least, in competition with others, leads us to the way the aesthetic project attempts to undermine the other two features of the traditional conception of moral truth. As opposed to traditionalist claims that establishing truth is part of the activity of *traditions,* and thus also that the truth about moral truth is to be found only in the dialectical struggles of competing traditions, the aesthete simply refuses to engage himself in such tradition-bound activity. Rising above such activity, he writes essays for the Συμπαρανεκρώμενοι, the "fellowship of the dead": he does not aspire to communicate with the living but instead with secret societies whose

members are trying as much as possible to go beyond life. Perhaps by the time of the "Rotation of Crops" essay he has given up even *that* audience; at any rate he clearly has no desire to engage in dialectical struggles about the truth of his claims, for he would ultimately find such struggles—boring. The aesthetic silence which enframes A's works shows how MacIntyre's argument against absolutist perspectives fails against the aesthetic perspective, because this silence is *neither Cartesian nor Hegelian*. A appears to realize, as Descartes and Hegel did not, that the claim to possess an absolute discourse requires that one *not* attempt to communicate directly with others; in this way he sees himself as standing outside *all* traditional demands.

The Judge's first letter in the second volume of *Either/Or* attempts to respond to this aesthetic attack by restoring something like the traditional conception. First, and most importantly, the Judge accuses A of "mixing fiction and truth" in his aestheticism: rather than unite poetry and life the young aesthete loses himself in his poetic tales. Thus A must be brought to see that his tales are after all just that—*his* tales. They still require to be shared with others, and so to enter into that traditional world in which tales are recounted and reassessed publicly rather than in the privacy of one's own beautiful fantasy world.[18] To use MacIntyre's terminology, A must be brought to see that he finds himself on a stage he did not design and within an action that he did not make.

But from this it follows that with respect to the *context* and *criteria* of truth, too, the Judge attempts to restore the claims of the traditional account over and above any aesthetic account. Both the form of his discourse (an admonishing letter) and its content (the "well-tested" [EO II 153] advice to follow more traditional paths in life) attempt to bring A back within the traditional fold, back within that context of discussion between individuals *within* the traditions in which (according to him) they always live. And he always includes "a little polemical prologue" at the beginning of his discussions in order to draw the young aesthete into the conversation, in order to engage A in debate about the criteria of truth themselves. He always hopes to give "appropriate consideration . . . to [A's] sarcastic observations" (EO II 8), to give the aesthetic its due when it comes to moral truth.

The Judge, though, himself holds on to a beautiful tale about his own life which he does *not* subject to dialectical scrutiny: that his marriage is the ethical (and aesthetic) norm. Thus an ethical response attempting to put the aesthetic in its place is insufficient, and indeed must remain so. *There is no escaping* "mixing fiction and truth," nor can the traditional contexts give us all we want with respect to moral truth: the advocate of the ethical way of life too writes in a secret context, for he knows his letter has driven his young friend from his door (EO II 154). The Judge himself still

attempts to design his own stage and to make the action of his tale for himself.

What Kierkegaard's *Either/Or* has uncovered for us, therefore, is a very real and present danger about the aesthetic. Stated most baldly, the danger centers on its *seductive* character: one can all too easily fall prey to the seductive power of the aesthetic, as *both* A *and* B do. We can never simply remove the "aesthetic" character of the tales we tell about our lives on behalf of some concern for the "ethical," because none of us—not even Judge William—wants to tell a boring tale about ourselves. The aesthetic is a pervasive feature of our lives, it is a permanent "sphere" of human existence, and thus a minimal condition of the moral truth of the stories we tell ourselves might well be that they can't be boring: the "story-telling animal" cannot help but desire to tell and hear *interesting and beautiful* tales.

From this standpoint we might turn back to MacIntyre's historical narrative in *After Virtue*, and consider again the parallel drawn earlier between MacIntyre and Judge William. Is MacIntyre, like the Judge, seduced by the aesthetic precisely while trying to banish it?

Consider the theme in *After Virtue* and *Whose Justice? Which Rationality?* of The Fall from Aristotelian Grace, a fall which, on MacIntyre's account, can only be overcome by attempting to recapture some revised version of the Aristotelian *polis*. Given the centrality of this theme for MacIntyre (without it as his *telos* his own narrative will of course collapse), we might now ask ourselves whether he too has fallen prey to the desire to tell some kind of interesting, perhaps even beautiful tale—which is nonetheless *not true*. Does his philosophical narrative perhaps depend on an overly romantic account of the Greek *polis*, an account which in its own way turns the real into the ideal? Could it be that Aristotle's *polis* is itself a "moral fiction"?

The central question of the tale of *After Virtue* was, we recall: *Aristotle or Nietzsche?* But if we worry about his treatment of Aristotle, we might have to reconsider his accusation of Nietzsche as well:

> Here again it is clear that Nietzsche had to mythologize the distant past in order to sustain his vision . . . when Nietzsche projects back on to the archaic past his own nineteenth-century individualism, he reveals that what looked like an historical enquiry was actually an inventive literary construction. Nietzsche replaces the fictions of the Enlightenment individualism, of which he is so contemptuous, with a set of individualist fictions of his own. (AV 129)

Accusations of an "inventive literary construction," of "individualist fictions": MacIntyre has put himself in the position of a Judge and from there he criticizes the moralities of the Enlightenment as well as anti-Enlightenment thinkers like Nietzsche. But like the Judge of *Either/Or* he

may well have fallen prey to his own *eris:* in his strife against others he uncovers, tragically, *his own inventive literary construction.* For MacIntyre, too, "had to mythologize the distant past in order to sustain his vision." The reason for MacIntyre's repeated projection of over-aestheticizing onto someone else, and what might "really" be at the roots of MacIntyre's work, *is his own desire* to escape the "collection of strangers" (AV 251) in which he has found himself.

How might we tell whether this is the case? What kind of conception of moral truth, finally, has this paper itself generated? A more positive insight into moral truth might arise out of the critique of the Judge and of MacIntyre presented here. For part of what we might learn from all of this —though I will not pursue the matter in full detail here—is that moral truth is a certain *relation* between *one's life itself* and *the stories one tells* about one's life. We have seen that the Judge wants to show A that his attempt to fuse poetry and life fails, and that it fails because pursuing his aesthetic project leads A to forget about the importance of *living* the stories he *tells.* The same notion—that the Judge does not *live* the beautiful, all-too beautiful stories he *tells* about his marriage—was central to the criticism of the Judge's treatment of A. And MacIntyre, too, worries that we modern-day emotivists and liberals do not *live* the tales we *tell* of ourselves.[19] Thus what may have begun to show itself (albeit primarily negatively) is that moral truth is the right relation between one's life and the stories one tells about it, a "good faith" expressed perhaps by the "harmony" between one's life and one's stories about it.[20]

More could, and no doubt should, be said of this "right relation." In this paper I have argued that reflecting on narrativity and moral truth finally throws us back, as Kierkegaard in *Either/Or* predicted, to a *tension* between "the aesthetic" and "the ethical," between "the beautiful" and "the good." Whether this tension itself turns us toward the (Platonic) claim that the beautiful *is* the good—whether we now want to say that the most aesthetically pleasing tales are like those Kierkegaard took himself to be telling, namely tales of the *seduction towards the truth*—is worth considering. If that were so, we might then say that to tell a good tale is to tell a beautiful tale, and vice versa.

NOTES

1. Earlier versions of this paper were presented at the 1989 Meetings of the Søren Kierkegaard Society and the Eastern Division of the American Society for Aesthetics.

2. Cf. e.g. "Literature, Science, and Reflection," Part Two of *Meaning and the Moral Sciences* (Boston: Routledge & Kegan Paul, 1978).

3. *After Virtue,* 2nd ed. (Notre Dame: University of Notre Dame Press, 1984). Further references to this work will be cited as "AV" followed by page number(s).

4. *Reading for the Plot: Design and Intention in Narrative* (New York: Vintage Books, 1984), p. 3.

5. Raimond Gaita is one of the few commentators on MacIntyre to have recognized the importance of this question: cf. his "Virtues, Human Good, and the Unity of a Life," *Inquiry* 26 (1983): 407–27. MacIntyre responds in "Moral Rationality, Tradition, and Aristotle," pp. 447–66.

6. Cf. especially chapters four and five of *After Virtue.* It is the moral theories of the enlightenment in particular—because they seem to articulate moral principles in abstraction from our narratives about ourselves—that are subject to this attack.

7. *Whose Justice? Which Rationality?* (Notre Dame: University of Notre Dame Press, 1988). Further references to this work will be cited as "WJ" followed by page number(s).

8. MacIntyre implicitly if not explicitly recognizes this: cf. his treatment of Sartre at AV 214–16, where he argues that the intelligibility of a narrative need not exclude its truth. Thus the Sartrean either/or—"Either he will write what is true or he will write an intelligible history, but the one possibility excludes the other" (AV 214)—is according to MacIntyre itself a falsification of the nature of human narratives and human life.

9. MacIntyre intends this to be a conception of truth *per se,* and not just of moral truth: cf. e.g. his "Epistemological Crises, Dramatic Narrative and the Philosophy of Science," first published in *The Monist* 69 (1977), to which he refers at WJ 361. But it is questionable whether this "traditional" conception of truth adequately captures scientific truth, although I will not argue that point here.

10. MacIntyre closes the "Postscript to the Second Edition" of *After Virtue* with the rather typical academic remark that the criticisms of others have contributed to his own work, but this has the perhaps atypical feature of being generated from his own conception of truth: MacIntyre quite clearly *must* welcome and pay close attention to criticism, given his dialectical characterization of the process of reaching truth. The close of *Whose Justice? Which Rationality?* as well as the end of its first chapter need to be taken in a similar spirit, as an *invitation* to others to write their "rival histories." Cf. also "Moral Rationality, Tradition, and Aristotle," pp. 465f.

11. This is perhaps the place to note that the conception of truth MacIntyre works from is in many important respects similar to the one developed by Heidegger in Division One of *Being and Time:* cf. WJ 355–61 with ¶44 of Heidegger's work.

12. Though not, alas, in WJ: Kierkegaard is only mentioned once (WJ 165), and then only in passing.

13. In what follows, all references to this work will be from the recent translation of *Either/Or* by Howard V. and Edna H. Hong (Princeton: Princeton University Press, 1987); for the sake of brevity I will refer to these works using the standard sigla "EO I" for the first volume and "EO II" for the second. To preserve

consistency with the body of my text, I have changed the Hongs' spelling of "esthetic" to "aesthetic" throughout.

14. *Poetics* 1451a38–bl, Ross translation.

15. In this way my own approach is meant to mimic Kierkegaard's in his pseudonymous authorship; cf. *Concluding Unscientific Postscript,* trans. David F. Swenson and Walter F. Lowrie (Princeton: Princeton University Press, 1968), p. 181.

16. Cf. Kierkegaard's own comments about why he did not attack Christianity directly: *The Point of View for My Work as An Author,* trans. Walter Lowrie (New York: Harper & Row, 1962), p. 25.

17. Cf. *Being and Nothingness: An Essay on Phenomenological Ontology,* trans. Hazel Barnes (New York: Washington Square Press, 1956), pp. 86–116.

18. Note that the Judge attempts to do this explicitly with several of the tales he knows the young aesthete tells himself: cf. EO II, pp. 7f. and 13–15.

19. It is crucial to note that the rejection of emotivist culture with which MacIntyre begins *After Virtue* and the critique of liberalism at the close of *Whose Justice? Which Rationality?* are based on a rejection of the *hypocrisy* underlying these modem lifestyles: emotivists make claims of objectivity in spite of themselves and liberals smuggle in a positive conception of the good in spite of their claim to abstain from such conceptions.

20. The extent to which "Johannes Climacus"—Kierkegaard's pseudonym for the author of *Philosophical Fragments* and *Concluding Unscientific Postscript*— offers us an adequate interpretation of this relation via his "claim" that "truth is subjectivity" is a worthy subject for discussion, but I will not take it up here.

3

Kierkegaard on Rationality

MARILYN GAYE PIETY

Summary

This essay is concerned with Kierkegaard's views on the nature of human rationality in the specific context of the relation between competing interpretations of existence. Contemporary dialogue has reached the point where it appears movement between such interpretations can only be understood as rational, if it is seen as a natural or evolutionary development and not as the result of a choice. This essay provides a sketch of a theory of rationality which enables us to make sense of the impression that we do, at least occasionally, choose *between competing interpretations of existence and that we make such choices for what we believe are good, or even compelling reasons.*

The idea has been advanced that human behavior, or more specifically, choice, can only be understood as rational within a particular concept framework. Proponents of this view contend that any possible system of justification must be understood as relative to a particular framework or system of values and hence that it is not possible to make rational choices *between* frameworks. Charles Taylor argues, on the other hand, that movement between frameworks can be rational. He bases this argument, however, on the claim that such movement is a natural or evolutionary development and not the result of a *choice*.[1] The contemporary debate on this issue has reached the point where it appears we must consider *either* that it is not possible to choose rationally between frameworks, *or* that there is rational movement between frameworks, but that this movement is not the result of a choice.

Taylor contends that the transition from one framework to another is effected through what he refers to as "error reducing moves."[2] That is, he

asserts that insofar as a given framework may involve certain incoherences, and insofar as an individual may be motivated to reduce these incoherences, his effort to do this may actually eventuate in the production of, or transition to a *new* framework. He asserts that the situation of Luther with respect to traditional Catholicism could be understood as exemplifying a movement of this sort.

Taylor argues, however, that such a transition from one framework to another is not the result of an appeal to some criterion that is *independent* of the two frameworks in question, but rather that it is the natural result of the desire of the individual for a more coherent scheme for interpreting his existence. Taylor does not see the individual as *choosing* between competing systems of interpretation, but rather as developing new systems through an effort to reduce the incoherences or errors inherent in the old systems.

Thus, while many theorists are disposed to see the movement from one framework to another as fundamentally irrational, Taylor sees it as rational. Taylor is in agreement with the former group, however, in that he is not willing to allow that there are any criteria independent of the two frameworks in question, such that an appeal to these criteria would justify, or show to be rational, the *choice* of one over another.

It would appear that the *impasse* at which the contemporary debate on the nature of human rationality has arrived is the result of the tendency of philosophers, despite their efforts to the contrary, to cling to the old Enlightenment view of disinterested and dispassionate reasoning as the paradigm of that rationality. I shall argue that Kierkegaard provides us with a picture of an *interested* and *impassioned* reason which enables us to see how it is possible for the transition from one framework to another to be *both* rational *and* the result of a choice and that insofar as it does this, it represents a more "reasonable" picture of reason than the one that has been traditionally offered by metaphysics.

I

The view that choice can only be understood as rational relative to a particular conceptual framework is precisely the one that provides the foundation for Alasdair MacIntyre's charge in *After Virtue*[3] that Kierkegaard considers moral commitment to be "the expression of a criterionless choice,"[4] or a choice between "incompatible and incommensurable moral premises, a choice for which no rational justification can be given." MacIntyre refers to this position as Kierkegaard's "discovery" and identifies it as his primary contribution to the history of moral or ethical philosophy; a contribution which MacIntyre claims marks the beginning of the "distinctively modern standpoint" on the nature of moral debate.

MacIntyre is undoubtedly correct in his identification of the distinctively modern standpoint on such debates. He is not correct, however, as will become clear in the pages which follow, in his ascription of this view to Kierkegaard.

Kierkegaard's frameworks may be designated 'aesthetic,' 'ethical,' 'religious' and 'paradoxically religious' or 'Christian.'[5] That is, Kierkegaard's individual views existence from within one or the other of these alternative schemes of interpretation. The aesthetic individual, for example, views existence as defined aesthetically. He interprets the value of the phenomena of his existence—including his own actions—as derivative of, or reducible to, their aesthetic significance. Thus an aesthete values actions not insofar as they exemplify morally uplifting principles, but rather insofar as they are immediately compelling, interesting, or sensuously gratifying.

The difficulty, as MacIntyre so forcefully pointed out, is that different frameworks represent significantly different systems of values, hence what may serve as a criterion for choice within an ethical framework will very likely not enjoy the same status within an aesthetic framework.[6] The moral superiority of an ethical over an aesthetic interpretation of existence cannot serve, for an aesthete, as a criterion for choosing it over his present interpretation, because such "superiority" is not considered by an aesthete to be of any positive value. This situation is, of course, mirrored by that of the ethicist; hence one might conclude from this, as indeed MacIntyre does conclude, that such a choice between frameworks as Kierkegaard has B recommending to A in *Either/Or,* cannot be a rational one.

MacIntyre focuses upon the transition from an aesthetic to an ethical view of existence. It is clear, however, from Kierkegaard's own description of this transition, that MacIntyre has not properly understood Kierkegaard's position. The aesthetic stage of existence is also referred to by Kierkegaard as the stage of immediacy. To be an aesthete, for Kierkegaard, means to have an understanding of existence which interprets it in terms of what appears, in an immediate sense, to be true about it. Such an individual has his consciousness, according to Kierkegaard—and in particular his consciousness of suffering—in the dialectic of fortune and misfortune.[7] Thus Kierkegaard argues that misfortune or suffering is, for this individual, "like a narrow pass on the way; now the immediate individual is in it, but his view of life must essentially always tell him that the difficulty will soon cease to hinder because it is a foreign element. If it does not cease, he despairs, by which his immediacy ceases to function, and the transition to another understanding of existence is rendered possible."[8]

What happens to the aesthete is that, in his despair, it seems to him as if there is a discrepancy between his suffering—insofar as it is persistent—and the interpretation of existence in which suffering is viewed as having merely accidental significance. Thus the aesthete, using the persistence of

his suffering as a criterion for choosing between a view of existence in which suffering is considered merely accidental and a view in which it is seen as essential, may reject the aesthetic interpretation in favor of an ethical one. Such an individual adopts an ethical framework, not because it promises to *alleviate* his suffering, but because it provides an interpretation of his existence which sees suffering as something essential to that existence, and thus provides a more adequate—or one might even say more rational—account of his subjective experience.

It may be that there are other criteria, or other aspects of subjective experience apart from suffering, that could serve as criteria for choosing between competing interpretations of existence on Kierkegaard's view. Suffering is, however, the criterion which Kierkegaard himself chooses to focus upon when examining the nature of the transition from one stage of existence to another in the *Postscript*[9] and it will become apparent, in the pages which follow, that this criterion alone is enough to expose the erroneous nature of MacIntyre's interpretation of Kierkegaard and his subsequent charge that Kierkegaard was an irrationalist.

II

Insofar as one framework or interpretation of existence may be spoken of as more adequate than another—that is, insofar as it may be spoken of as providing a more satisfactory account of the nature of the subjective experience of a particular individual—it is entirely reasonable to consider that it is more rational.[10] What is likely less clear, however, is precisely *how* the individual comes to consider that one interpretation is more adequate than another. In this instance we are concerned specifically with how it is that the individual comes to consider that the persistence of suffering is too great for the aesthetic interpretation of existence to be plausible, for it appears that it would be entirely possible for an individual to persist in suffering while *simultaneously* persisting in the belief that the suffering was indeed accidental and that in the next moment, with a change of fortune, it would stop.

Objectively, there is no incoherence in the idea that an aesthetic individual may experience persistent suffering. The accidental may indeed be persistent. The aesthetic interpretation of existence is not contradicted by the occurrence of what is, within this framework, the improbable persistence of suffering. Such statements of probability or improbability as a given framework expresses "cannot be strictly contradicted by any event [e.g., the persistence of suffering] however improbable this event may appear in its light. The contradiction must be established by a *personal* act of appraisal [my italics]."[11] The question is: Whence arises this "personal

act of appraisal"; or when and how does the individual come to consider the persistence of his suffering to be too great and hence too improbable, within the aesthetic framework, for that interpretation of existence to be correct?

It is at this point that Kierkegaard's views concerning the role of passion in human reason come into play. It is widely recognized by Kierkegaard scholars that, as Heinrich Schmidinger expresses it: *"Subjektives Engagement ist . . . immer mit Leidenschaft and Pathos verbunden."*[12] It has also been observed, however, that Kierkegaard considers passion to be opposed to reflection,[13] hence it is often believed that subjective engagement, according to Kierkegaard, is purely emotional, or devoid of any intellectual component.

This view is the result of a failure to appreciate that the intellectual dimension of human experience is not reducible, for Kierkegaard, to reflection. Reflection is indeed dispassionate or disinterested, according to Kierkegaard.[14] He also speaks of "abstract" or "systematic" thought as disinterested.[15] This would appear, however, to be a rather abbreviated or shorthand way of emphasizing that the object of such thought is not the self, for he states elsewhere that all knowledge "is interested,"[16] whether the object of interest is something outside the knower, as is the case in metaphysics, or whether it is the knower himself, as is the case in ethics and religion.

Kierkegaard often equates passion and interest.[17] It is thus reasonable to assume that, if knowledge is interested, then it is also passionate, or involves passion at some level. But if knowledge involves passion, then it would appear that passion is not essentially opposed to reason, but rather plays an important part in the activity of the knower as such. If this is the case, then the passionate nature of subjective engagement does not preclude the possibility that such engagement could be rational. Hence, the "personal act of appraisal" in question is not a merely arbitrary, capricious, or emotional reaction to a phenomenon or particular set of phenomena; it is the result of a rational assessment of this phenomenon, or these phenomena, where the reason in question is of a passionate or interested sort.

The difficulty is that very few scholars appreciate the way in which passion informs reason, on Kierkegaard's view. In order to throw some light on this issue I shall depart for a moment from the examination of Kierkegaard's texts and turn instead to the consideration of the views of a more contemporary philosopher on this same issue. Michael Polanyi, whose views on probability I quoted above, is concerned in his book *Personal Knowledge* with how it is that apparently objectively meaningless probability statements become subjectively meaningful guides for interpreting reality.[18] Polanyi maintains that there is an area of extremely low

probability—i.e., what we would refer to in everyday speech as an area of high improbability—that we find generally unacceptable. The occurrence of an event that is associated with this level of improbability leads us, he argues, to reject the interpretation of existence within which this event is considered so improbable and to search for a new interpretation where events such as the one in question are considered more probable. Polanyi goes on to point out, however, that any attempt to *formalize* the precise degree of improbability that we find unacceptable and which, when connected to a particular phenomenon within a given theory or interpretation of existence, would lead us to reject that view as false "is likely to go too far unless it acknowledges in advance *that it* [i.e., the formalization] *must remain within a framework of personal* [i.e., impassioned subjective] *judgement.*"[19]

The metaphysical tradition has led us to believe that such impassioned subjective judgment is vastly inferior—if indeed it has any claim to legitimacy at all—to dispassionate objective judgment. In a situation such as the one described above, however, a purely dispassionate or objective perspective would lead to no judgment at all, but rather to a sort of skeptical *epoche*. That is, viewed purely objectively, the occurrence of a highly improbable event says nothing about the truth or falsity of the framework within which it is viewed as improbable; it neither supports it, nor discredits it, so it fails to provide us with a foundation—i.e., an *objective* foundation—for any judgment whatsoever concerning the status of the framework.

It is clear, though, that not only do we often make such judgments, we appear to be *compelled* to make them simply by virtue of the kind of creatures we are. The difficulty is that there appear to be no fixed guidelines in relation to these judgments. But to say that there are no *fixed* guidelines is not to say that there are no guidelines at all. Passion, which has traditionally been considered to be in essential opposition to reason, permeates our understanding—or attempts to understand—our situation at such points and it is this passion, according to Kierkegaard, which serves as a guide to the judgments we make in these situations.

III

The metaphysical tradition has been reluctant to appreciate the way in which passion informs our understanding of ourselves and the phenomena of our experience, hence it is to Polanyi, a chemist turned philosopher— i.e., a metaphysical interloper—that we must turn for the explicitly formulated observation that some of the most meaningful of our assertions in

science are only possible as the result of a collaboration of reason and passion and that these assertions will thus always and necessarily "have a passionate quality attached to them."[20]

Passion is admittedly not an easy concept to elucidate. Some effort at elucidation is necessary, however, because it is precisely passion that, according to Kierkegaard, informs the understanding of an individual in such a way that extra-framework criteria, or reasons for choosing between competing interpretations of existence, may come to exist for him.

A *positive* account of the meaning of 'passion' is difficult, if not impossible, to provide. An impression of this meaning may be provided, however, if the expression is understood to be contrasted with such expressions as 'dispassion' or 'disinterestedness.' Polanyi claims that passion is to be found in our "personal *participation*"[21] with the phenomenon whose probability is in question. Such participation might be understood to exemplify an essentially interested, as opposed to disinterested, relation to this phenomenon. It is just such an *interested* stance which Kierkegaard believes is appropriate with respect to the subjective phenomenon of suffering.[22] That is, Kierkegaard maintains that we have an essential interest in determining or choosing the proper interpretation of existence. Our eternal blessedness, or eternal damnation is, according to Kierkegaard, ultimately dependent upon this choice. But if we do not take such an interested stance in relation to the phenomena of our subjective experience, then it will never be possible for us to choose between various interpretations of existence [23]—and, in particular, to choose the *correct* one—for the criteria for such choices can only exist for the *interested* observer. It is for this reason that Kierkegaard argues in the *Postscript* that Christianity has "nothing whatever to do with the systematic zeal of the personally *indifferent* individual [my italics]," but assumes rather "an infinite personal passionate *interest* [my italics]" on the part of the individual as *"conditio sine qua non."* [24]

Thus it becomes clear that the discernment of a discrepancy between the aesthetic interpretation of existence, which sees suffering as accidental, and the persistence of the suffering which the individual experiences, is the result of an impassioned or subjective judgment on the part of that individual. The greater the degree of passion with which the consciousness of the individual is informed, the less high the degree of the improbability of the suffering need be, in order for the individual to seize upon that improbability as grounds for rejecting the interpretation of existence within which the particular account of suffering is contained.[25]

Picture the aesthete who experiences persistent suffering, but does not despair—i.e., he does not judge that his subjective experience discredits the interpretation of existence which views it as improbable. What distinguishes

such an individual from one who *does* despair? It would appear that the individual who does not despair, fails to do so because he considers the phenomena of his existence—or of his subjective experience—*objectively*, which is to say, *dispassionately;* while the individual who *does* despair, does so precisely because he considers these same phenomena *subjectively* or *passionately*.

It is one thing, however, to observe that a choice between competing interpretations of existence is only possible if one takes a passionate or interested stance relative to the phenomena of one's subjective experience, and another to argue that such a stance justifies rather than merely explains this choice. Passion, for Kierkegaard, is the very essence of human existence. It is well known that Kierkegaard proposes that subjectivity is truth,[26] but it is not so well known that he also proposes that subjectivity is passion.[27] To be dispassionate, or insufficiently passionate, for Kierkegaard, is to be indifferent to existence, and this, in turn, amounts to being insufficiently human. It is for this reason that Kierkegaard considers the choice of an ethical over an aesthetic interpretation of existence to be *justified,* rather than merely *explicable.* That is, a passionate perspective relative to the phenomena of one's subjective experience is the only sort of perspective that is in keeping, on Kierkegaard's view, with the essence of the individual. A dispassionate perspective would not cohere with that essence.

Thus passion emerges as the catalyst of the exchange of one perspective of existence for another. That is, passion breaks down the apparent coherence or descriptive adequacy of a particular interpretation of existence. Unless the consciousness of the individual is informed with a sufficient degree of passion, the persistence of his or her suffering cannot serve as a criterion for rejecting the aesthetic in favor of the ethical interpretation of existence.

It is, of course, possible to be *too* passionate. If the consciousness of the individual is informed with too much passion, the resultant interpretation of existence may cross over into the pathological. Such a phenomenon is actually addressed by Kierkegaard and referred to by him in the *Postscript* as subjective madness *(subjektive Galskab).*[28] It is important to note, however, that it is not possible to formalize the precise degree of passion which is sufficient to break down the aesthetic interpretation of existence so that the choice of another interpretation becomes possible, and yet not so great as to qualify the individual as pathological. It is precisely this resistance of passion, or of an understanding which is informed with passion, to such formalization that serves as a stumbling block to metaphysics. But this is simply our situation as human beings and part of the task of philosophy is to help us to achieve a more profound understanding of that situation.

IV

I have restricted my explication of the nature of the transition from one stage of existence to another to the transition from the aesthetic to the ethical stage. I have done this because this was the transition that MacIntyre examined and which he used in an effort to support his charge that Kierkegaard was an irrationalist. It should be clear now that Kierkegaard's own interpretation of the nature of this transition will not support MacIntyre's charge. Opponents of the view I am propounding might argue, however, that while it appears possible to consider the choice between any of the non-Christian interpretations as rational, the same thing cannot be said concerning the choice to adopt a Christian framework. It is tempting to interpret Kierkegaard such that it appears the transition to the Christian stage of existence is the result of a choice for which there can be no criterion.

We can see, however, from the quotation below, that there is a criterion for choosing the Christian interpretation; this criterion is precisely the phenomenon of the consciousness of sin. That is, Kierkegaard contends that "Christianity is only related to the consciousness of sin. Any other attempt to become a Christian for any other reason is quite literally lunacy; and that is how it should be."[29] Just as the ethical interpretation of existence provided a more adequate account of human suffering to the aesthete whose consciousness was informed with a sufficient degree of passion, so does the Christian interpretation provide a more adequate account of the subjective experience of the individual whose consciousness is informed with an even greater degree of passion.

Such passion arises, again, from an *interested* stance toward the question of which of the possible interpretations of existence is correct. The more extreme the interpretation presented to the individual, the more passionate—as opposed to dispassionate—must his or her self-examination be. That is, when an individual is presented with an interpretation of existence such as that offered by Christianity, an interpretation which makes his or her *eternal blessedness* or *eternal damnation* dependent upon its acceptance, then the proper response is not a casual concern as to the truth of this interpretation, but rather a deep and impassioned introspection in which the individual repeatedly asks himself: "Could this be the real nature of my existence?" "Does this interpretation of my existence make the most sense—i.e., more sense than any other interpretation—of my subjective experience?"[30]

V

With this we have a simple model of Kierkegaard's theory concerning the nature of human rationality. We must distinguish, however, what is essential to Kierkegaard's position as he understood it, and what is essential for the purposes of defending Kierkegaard against the charge of irrationalism as that charge was leveled against him by MacIntyre. It is important to appreciate that Kierkegaard's own understanding of the position described above involved a foundation of religious belief which is separable from the position itself. Kierkegaard would no more consider the persistence of an individual who has the good luck not to suffer in an aesthetic interpretation to be justified than we would consider the racism of an ignorant person to be justified. That is, just as we would consider that an ignorant person *should* know better than to be racist, Kierkegaard would consider that a fortunate person *should* know better than to persist in an aesthetic interpretation of existence.

Existence, for Kierkegaard, is characterized by sin and part of the way in which sin manifests itself is in the inability of the individual to sustain emotional equilibrium in the face of misfortune or adversity. It is this inability which accounts for the suffering in question. The difficulty is that this inability itself stems from an excessive attachment to worldly pleasure or comfort.[31] As long as the existence of an individual is characterized by such attachment, suffering is still present in it, *in potentia*. Hence, while suffering justifies the choice of an ethical over an aesthetic interpretation of existence, on Kierkegaard's view, the absence of suffering does not have the same significance. The absence of suffering does not justify the endorsement of an aesthetic view of existence because suffering is always present in the existence of an individual *in potentia,* so to speak, in the form of sin. Any individual who is sufficiently reflective to appreciate the tenuous nature of happiness on the aesthetic interpretation, would find his or her existence, no matter how "fortunate," characterized by an anxiety or fear of potential adversity which would itself constitute a kind of suffering. The only way to avoid such anxiety, on Kierkegaard's view, would be to avoid reflection.

We may argue that different levels of reflection are natural for different sorts of people and that it is even possible for certain individuals to live lives almost entirely devoid of reflection. Kierkegaard's religious convictions compel him to assume, however, that the activity of reflection is universally human and that whatever differences there may be in the degree of reflection which characterize various individuals, even the least reflective individual can only avoid recognizing the tenuous nature of happiness on the aesthetic view of existence by *willfully refusing* to reflect upon the significance of this view. And this willful refusal, on Kierkegaard's view, constitutes, in turn, a flight from the acknowledgment of oneself as sinful.

It is not necessary, however, that one share Kierkegaard's religious views in order to appreciate the force of his claim concerning the possibility of extra-framework criteria for choosing between competing interpretations of existence. If this were necessary, then the charge of irrationalism could still be leveled against him. That is, the support for his position would ultimately rest upon a foundation of dogma that could not itself be chosen for any reason, for it would only be relative to this foundation that reasons for such choices could exist.

One of the most important aspects of Kierkegaard's position is that experience is distinguished from the various interpretations which may be supplied to it. The medium of experience, according to Kierkegaard, is *actuality*, while the medium of such interpretations is *ideality*. That is, the interpretations represent clusters of concepts (hence the origin of the appellation "conceptual framework") and the medium of concepts is abstract, in contrast to the medium of experience, which is concrete.[32]

We can keep the view that subjective experience, insofar as it is actual, may be distinguished from a particular conceptual framework or ideal interpretation that is supplied to it and the claim that this experience can provide criteria for choosing between such frameworks, without having to accept the view that experience, properly defined, will always incline one toward a *particular* interpretation of existence. This is what one might refer to as the theoretical skeleton of Kierkegaard's view of rationality as it appears when stripped of the religious assumptions which gave the view its more specific definition in Kierkegaard's works.[33]

Taylor's contention that the transition from one interpretation of existence to another is effected through a move of error reduction is consistent with much of what Kierkegaard says concerning such transitions. On Kierkegaard's view, one rejects the aesthetic framework in favor of an ethical one precisely because a passionate interpretation of the persistence of one's suffering leads one to consider that there is an error in the aesthetic framework—the "error" in question being the view that suffering is of merely accidental significance or the result of misfortune. The difference between Taylor and Kierkegaard is that on Kierkegaard's account, the errors are not inconsistencies *within* a particular framework—for as we have seen, the persistence of suffering is not, objectively, inconsistent with the interpretation of existence which views such persistence as improbable—but are errors relative to the individual's subjective or impassioned *experience*.

One could express Kierkegaard's views in secular terms by substituting for "guilt consciousness" or "[t]he anguished conscience" what Taylor has identified as a "need for meaning."[34] Taylor contends that individuals are faced today with the problem of attempting to imbue their existence with some significance that goes beyond the expression and fulfillment—or lack thereof—of their daily needs.

Thus if one is more comfortable with the expression 'need for mean-
ing' than with Kierkegaard's overtly religious expression like 'guilt con-
sciousness,' an individual could be understood as adopting a particular
framework because he perceived that that framework promised to imbue
his existence with the meaning of which he felt a lack. In this way an ethi-
cal interpretation of existence could be seen as supplying meaning to the
suffering of an individual that the aesthetic interpretation was unable to
supply.[35]

Concluding Comments

It should now be clear that the charge of irrationalism leveled against
Kierkegaard by MacIntyre is based upon a misunderstanding of the rela-
tion between the aesthetic and the ethical interpretations of existence on
Kierkegaard's view. Not only is Kierkegaard's philosophy not irrationalist
in the way in which MacIntyre and others have claimed, his conception of
the nature of human rationality is one which can be of great help in rela-
tion to the contemporary debate on the nature of human rationality. The
view that "rational" decisions need not always be the result of purely objec-
tive or dispassionate speculation and that hence emotional or nonrational
phenomena may serve as criteria for such choices is clearly one which
would be of use to contemporary theorists.

Kierkegaard's interpretation of human rationality provides us with a
positive alternative to the traditional conception of reason as disinterested
and dispassionate. But it is not simply an alternative to this more traditional
conception. It is an alternative with an advantage. That is, it provides us
with a way to get beyond the impasse at which the contemporary debate
on this issue has arrived, by reminding us that there are some areas of
inquiry where "an objective indifference can . . . learn nothing at all,"[36] or
as Nagel expressed it in *The View From Nowhere,* where "the truth is not to
be found by traveling as far away from one's personal perspective as possi-
ble,"[37] and hence where being "rational" means taking a passionate or
interested stance in relation to the phenomena in question.

Kierkegaard's view of rationality possesses a further advantage over the
traditional view in that it provides us with a more descriptively adequate
account of our understanding of ourselves and of the phenomena of our
subjective experience. That is, it does not preclude the possibility that our
movement from one interpretation of existence to another may take place
as a natural or evolutionary development rather than as the result of a
choice, but it also allows us to make sense of the experience, that we at least
occasionally have, that we *choose* to adopt a particular interpretation of exis-
tence, that there are good *reasons* for adopting this interpretation and that

we choose to adopt it *for* those reasons and not simply as a matter of pure caprice.

What we have in Kierkegaard's picture of the role of passion in reason is a more "reasonable" picture of reason than the one that has been offered to us by the metaphysical tradition. It is a picture of reason that involves a positive incorporation of what we essentially are, subjects situated in and passionately engaged with the flux which constitutes our temporal existence. Finally, it is a picture that allows us to justify rationally the weight that we seem *compelled*, simply by virtue of the kind of creatures we are, to attribute to our subjective experience.

NOTES

1. Charles Taylor, "Inescapable Frameworks," in *Sources of the Self* (Cambridge: Harvard University Press, 1989), pp. 3–24.

2. Ibid.

3. Alasdair MacIntyre, *After Virtue* (Notre Dame, Ind.: University of Notre Dame Press, 1984), pp. 36–62.

4. This and all subsequent quotations of MacIntyre are taken from page 38 of *After Virtue* [Editor's note: this page is reprinted in the present collection].

5. There is some disagreement among Kierkegaard scholars as to the precise number of stages or interpretations of existence that are to be found in Kierkegaard's works. There is general agreement, however, that there are at least the four stages listed here, although there may be perhaps more than these four.

6. It is possible that the status of certain choices as rational will remain constant across frameworks. Candidates for such constancy, however, would most likely be very mundane or innocuous sorts of choices (e.g., the choice of an aspirin to alleviate headache pain).

7. *Concluding Unscientific Postscript,* tr. David F. Swenson and Walter Lowrie (Princeton: Princeton University Press, 1941), p. 388; *Søren Kierkegaards Samlede Vaerker,* ed. A. B. Drachman, J. L. Heiberg and H. O. Lang (Copenhagen: Glydendal, 1901–06), vol. VII, pp. 376–77.

8. *Postscript, p. 388; Samlede Varrker,* Vol. VII, p. 377.

9. See notes 7 and 8.

10. The failure of many philosophers to appreciate this point is very likely the result of what Thomas Nagel has pointed out is an "ambiguity in the idea of the rational." That is, Nagel observes that "'[r]ational' may mean either rationally required or rationally acceptable" *(The View From Nowhere* [New York: Oxford University Press, 1986], p. 200).

11. Michael Polanyi, *Personal Knowledge* (Chicago: University of Chicago Press, 1958), p. 24.

12. Heinrich M. Schmidinger, *Das Problem des Interesses and die Philosophie Søren Kierkegaards* (Freiberg/München: Verlag Karl Alber, 1983), p. 218.

13. Merold Westphal, *Kierkegaard's Critique of Religion and Society* (Macon, GA.: Mercer University Press, 1987), p. 46.

14. *Philosophical Fragments; Johannes Climacus,* ed.. and tr. Howard V. and Edna H. Hong (Princeton: Princeton University Press, 1985), p. 170; *Søren Kierkegaards Papirer,* ed. P. A. Heiberg, V. Kuhr, E. Torsting and N. Thulstrup (Copenhagen: Glydendal, 1968–78), vol. IV B 1, p. 149.

15. *Postscript,* p. 278; *Samlede Vaerker,* vol. VII, p. 296; *Søren Kierkegaard's Journals and Papers,* tr. Howard V. and Edna H. Hong (Bloomington: Indiana University Press, *1967–78*), vol. 5 5621; *Papirer,* vol. IV B 1, p. 149.

16. *Journals and Papers,* vol. 2 2283; *Papirer,* vol. IV C 99; *Journals and Papers,* vol. 1 891; *Papirer,* vol. IV B 13: 18.

17. See Schmidinger, op. cit., p. 254.

18. The purpose of Polanyi's claim that probability statements are objectively meaningless is to point out that such statements are essentially ambiguous. Probability statements relating to the behavior of electrons, for example, convey to the researcher that an electron *may* or *may not* be found in a particular spot at a particular time. Since this is something of which the scientist is undoubtedly already aware, even without the aid of the probability statement, Polanyi suggests that this ambiguity may lead one to conclude that probability statements do not *really* say anything. He argues, however, that there is "some meaning in assigning a numerical value to the probability of our finding an electron at a certain place on a particular occasion" (p. 21), but this meaning, he goes on to argue, is to be found in "our personal participation in the event to which the probability statement refers" (p. 21).

19. Ibid., p. 29. The "passionate" or "impassioned" quality of our judgements, statements or assertions is the theme of the section of *Personal Knowledge* entitled "The Nature of Assertions" (pp. 27–30).

20. Op. cit., p. 27.

21. Ibid., p. 24.

22. For a comprehensive treatment of the significance of the concept of interest in Kierkegaard's philosophy, see Schmidinger, op. cit.

23. One might argue that a completely arbitrary choice would still be possible. This is not Kierkegaard's position, however. Kierkegaard believes that we inherit an aesthetic interpretation of existence simply by being human and that we will never adopt any other perspective without a specific reason for doing so; and such a reason cannot arise, on his view, unless we take an interested stance toward the phenomena of our subjective experience.

24. *Postscript,* p. 19; *Samlede Vaerker,* vol. VII, p. 6.

25. This situation is perhaps best illustrated by referring to the example of little children. Young children have not yet learned to view their situations dispassionately (and, in general, the younger the children, the more this is true of them), hence their judgments are often informed with a very high degree of passion. Children thus often seize upon even the slightest improbability as grounds for rejecting either the event with which the improbability is associated, or the framework within which the event in question is viewed as improbable. Children playing a game, for example, often refuse to accept that the same person can win even twice in a row. When faced with such a phenomenon they will often attempt either to

show that the child in question has not actually won (i.e., that his evaluation of his situation was not correct) or that he cheated.

26. *Postscript,* pp. 169–244; *Samlede Vaerker,* vol. VII, pp. 157–211.

27. Ibid., p. 117; *Samlede Vaerker,* vol. VII, p. 106.

28. Ibid., p. 175; *Samlede Vaerker,* vol. VII, p. 163.

29. *Journals and Papers,* vol. 1 492; *Papirer,* vol. IX A 414. The translation above is from a book called *The Diary of Søren Kierkegaard,* ed. Peter P. Rhode (Secaucus, NJ: Citadel Press, 1960), p. 150, and not from the Hong and Hong translation of Kierkegaard's *Journals and Papers.* The Hong translation is not substantially different. I have chosen the former translation, however, because I believe it is a little more readable.

30. This is one of the reasons that Kierkegaard had so little patience with organized Christianity, or, more specifically, with the Lutheran church in Denmark. That is, the version of Christianity offered to Danes by the Danish church was so denatured that the impassioned consciousness would reject it and hence the possibility of the individual's coming to believe the truth of Christianity would be precluded. See *Postscript,* pp. 323–431; *Samlede Vaerker,* vol. VII, pp. 312–33.

31. The expression 'worldly' should not be equated with 'material.' 'Worldly' is a much broader determination which encompasses all human pleasures, including intellectual and emotional ones, conceived independently of any religious significance they might have.

32. It is important to acknowledge, however, that the conceptual framework to which an individual subscribes helps to define his experience. This point was clearly not lost on Kierkegaard, as is demonstrated by his observation that "the true conception of despair is indispensable for conscious despair" (*The Sickness Unto Death,* translated by Howard V and Edna H. Hong [Princeton: Princeton University Press, 1980), p. 47; *Samlede Værker,* vol. XI, p. 160). An individual's experience must still, according to Kierkegaard, be assumed to be substantially independent of the framework which helps to define it, or else it cannot have the role in transition from one framework to another that it is described by him as having. This putative independence is strengthened by Nagel's claim that "we don't ascribe such states [e.g., suffering] only to creatures who have mental concepts: we ascribe them to children and animals, and believe that we ourselves would have experiences even if we didn't have the language" (op. cit., p. 23).

33. This move should not be disturbing to anyone who shares Kierkegaard's religious convictions because *saying* that experience, properly defined, will not necessarily incline one toward a particular interpretation of existence does not make it *so.* If Kierkegaard is correct, then, of course, all roads will lead to Rome, so to speak (i.e., all experience, properly defined, *will* incline one toward a particular interpretation of existence). This is not, however, a matter for philosophers, but is rather between each individual and his or her own experience. That is, it is a matter for each individual as such, and this, according to Kierkegaard, is exactly as it should be.

34. See note 1 above. Such a substitution does not entail that a "need for meaning" is equivalent to "guilt consciousness," but merely that they are criteria of the same kind. That is, both expressions are qualifications of subjective experience, although their content may be quite different.

35. One could not conclude from this, however, that the ethical interpretation is *objectively* more meaningful than the aesthetic interpretation. A foundation of something on the order of Kierkegaard's religious convictions is necessary to sustain that sort of claim. It is enough, however, that one interpretation of existence is *subjectively* more meaningful than another in order for the choice of that interpretation to be viewed as a rational one for the individual in question.

36. *Postscript,* p. 51; *Samlede Vaerker,* vol. VII, p. 39.

37. Op. cit., p. 27.

4

The Meaning of Kierkegaard's Choice between the Aesthetic and the Ethical: A Response to MacIntyre

JOHN J. DAVENPORT

Summary

This paper challenges Alasdair MacIntyre's well-known argument in After Virtue *that the choice between the aesthetic and the ethical described in* Either/Or II *is an arbitrary or reasonless choice, but is nevertheless meant to ground the authority of moral principles. I argue on the contrary that for Kierkegaard, choosing in terms of the ethical means identifying (in Frankfurt's sense) with the motives guiding one's actions. By this step towards becoming a fully responsible mature agent, we give moral principles and ideals something to which their already-recognized authority can apply in our deep character. I also argue that Kierkegaard's conception of moral choice mediates between Kantian and Aristotelian poles, and that this in fact enables it to answer the familiar objection by Hegel and Bernard Williams that Kantian moral principles are too impersonal to have motivational authority. In connection with his theory of the primordial choice, Kierkegaard develops a subtle theory of inward or higher-order volitional character, which allows him to avoid the charge that radical choice will arbitrarily reversible and void of dispositional depth.*

I. Introduction: MacIntyre's Critique of Kierkegaard

In chapter four of his *After Virtue*, Alasdair MacIntyre argues that in Kierkegaard's *Either/Or* we witness the failure of the Enlightenment Project to provide a "rational justification of morality" to persons characterized by their transcendental freedom (AV 39).[1] This failure and its results, we are told, occur primarily because the Enlightenment was unable to demonstrate how moral "rules of conduct" can have "authority" or

"gerundive force" for concrete agents. MacIntyre argues that the failure of Kant's moral theory in particular is evident when Kierkegaard's pseudonym 'Judge William' suggests in *Either/Or II*[2] that a "radical and ultimate choice" is the only entrance into morality (AV 41).

MacIntyre notes that as the Judge presents it, "The choice between the ethical and the aesthetic is not the choice between good and evil, it is the choice whether or not to choose in terms of good and evil" (AV 40). But he argues that the Judge's portrayal of this choice as "ultimate" —i.e. as one in which "there are no rational grounds for choice between either position"—is *inconsistent* with the Judge's presentation of 'the ethical' as "that realm in which principles have authority over us independently of our attitudes, preferences, and feelings" (AV 41). If this is what the ethical attitude is, how can it be an option for radical choice? The result, MacIntyre thinks, is an incoherent combination of "the notion of radical choice with an unquestioning acceptance of *the* ethical" (AV 43). Kierkegaard's Judge regards traditional Kantian norms as having objective authority, yet "the doctrine of *Enten-Eller* [*Either/Or*] is plainly to the effect that the principles which depict the ethical way of life are to be adopted *for no reason*, but for a choice that lies beyond reasons, just because it is the choice of what is to count for us as a reason" (AV 42).

But Kierkegaard does not state any such "doctrine" in *Either/Or*, plainly or otherwise. Rather, the Judge presents the absolute choice as a free act in the inward world of personality, but he denies that it is an *arbitrary* choice (Lowrie, EO II, 178).[3] But MacIntyre's argument is that, in spite of Kierkegaard's intentions, the either/or between the aesthetic and ethical categories *must* be a choice in which the objective force of ethical norms cannot count as reasons. For if a hypothetical chooser is faced with the decision between the ethical and the aesthetic as ways of life, or modes of existence, then

> he can be offered no *reason* for preferring one to the other. For if a given reason offers support for the ethical way of life—to live in that way will serve the demands of duty *or* to live in that way will be to accept moral perfection as a goal and so to give a certain kind of meaning to one's actions—the person who has not yet embraced either the ethical or the aesthetic still has to choose whether or not to treat this reason as having any force. (AV 40)

If we grant this interpretation, then the incoherence in Kierkegaard's account would be inevitable. Since, as MacIntyre avers, principles for action only acquire objective authority when "good reasons" for them can be addressed to the person concerned, any authority ethical principles might have for us must be grounded in reasons rather than in radical choice (AV 42–43).

Despite the enormous influence of this critique, most Kierkegaard scholars reject MacIntyre's argument along with other reductive interpretations of *Either/Or*. For example, in his article on "Kierkegaard's Metatheology," Timothy Jackson characterizes the "picture that emerges" from critics such as Stout, Rosen, Fenger, and MacIntyre as follows: "[it is] one of S.K. as romantic egoist, totally unwilling or unable to argue for the choice of one way of life over another—a sort of 'dead-end Werther'."[4] Jackson notes that better informed commentators such as Wild, Malantschunk, and Elrod have adequately shown the errors of "those who would identity such phrases as 'subjectivity is truth' and 'the leap of faith' with moral relativism and religious fideism."[5] Nevertheless, I think MacIntyre's objection should not be dismissed too quickly, because it gives voice to several deeper misgivings about Kierkegaardian "subjective" choice that reveal the roots of widely held reservations about existentialism in general.

In this essay, I will argue that three closely related errors are woven together in MacIntyre's charge of incoherence in *Either/Or II*. First, MacIntyre's objection implies that Kierkegaard's conception of choice commits him to a form of 'metaethical *externalism*' inconsistent with his broadly Kantian notion of morality (which is closely related to the common misconception that Kierkegaard has a *fideist* conception of faith[6]). The second error is an interpretative one: MacIntyre misreads Kierkegaard's text as implying that what is at stake in the absolute either/or is *a choice to regard* the moral distinction between good and evil as having authority or normative force. I will argue that this is not what is at stake in the choice at all. When we analyze the crucial passages in the first thirty pages of the "Equilibrium Between the Aesthetical and the Ethical"[7] with Kierkegaard's quasi- Kantian conception of the conditions for moral responsibility in mind, we see that MacIntyre has simply gotten the wrong impression. Third, MacIntyre's objection assumes that since it involves negative liberty, Kierkegaardian choice must be *arbitrary* over time, and hence irreconcilable with motivation by any rational judgment of objective value. This 'arbitrariness' objection is the one usually raised against Sartre's conception of human freedom. For MacIntyre, it is clear that Kierkegaard is as much an "emotivist" as Sartre: there is no essential difference between the Judge's response to the aesthetic 'young man' of *Either/Or* volume I and Sartre's critique of the French bourgeoise "who cannot tolerate the recognition of their own choices as the sole source of moral judgment" (AV 22). Whether or not it is fair to compare Sartre with emotivists and utilitarians, I will show that the arbitrariness critique is misplaced when brought against Kierkegaard.

I take up each of these three problems in turn. By the end of the analysis, we will see how Kierkegaard not only avoids the traditional problems

thought to attend existentialist conceptions of freedom and moral responsibility, but also makes a positive contribution towards resolving these problems.

II. Kierkegaard's Internalism

In her essay on Kant's argument in *Groundwork* I, Christine Korsgaard notes that Kant followed eighteenth-century rationalists in objecting to the 'externalist' conceptions of moral reasons offered by their sentimentalist opponents.[8] Externalism, as she explains, is the view that the reason why an action is right (or required) need not be the subjective (or first-personal) motive for performing it. If we distinguish the objective "requiredness of an action" (its *binding* status) from our subjective feeling of being "under an obligation" to perform it, then we can think of externalists as separating these facets of duty.[9] Internalists, on the other hand, hold that "Moral reasons motivate because they are perceived as binding. A good person . . . does the right thing because it is the right thing, or acts from the motive of duty."[10] This 'internalist' principle can be understood as a *metaethical* restriction on substantive theories of normative legitimacy: whatever more specific properties are taken as sufficient to confer normative or binding status on a rule, action, or end must also be such that its resulting objective rightness can itself motivate the person. This metaethical principle leads internalists of every sort to reject any claim that the authority of moral principles can be grounded on bases that appear purely *positive* or decisionistic, such as divine commands or the choices of a Hobbesian sovereign: "Either we are obliged to obey the sovereign, [Samuel] Clarke argues, in which case obligation is prior to positive law, or there is no real obligation at all."[11] As Korsgaard goes on to show, Kant's task in the *Groundwork* is to respond to Hume's externalism by developing a conception of normative rightness which will meet the internalist requirements.

Despite Kierkegaard's indebtedness to Kant in *Either/Or*, MacIntyre's critique of the Judge's either/or implies that it leads to the aporia of externalism: if there is any *reason* for choosing the ethical as one's framework, then that reason cannot be the *motive* for doing so, since the choice is reasonless. This claim that Kierkegaard's theory necessarily implies externalism, however, still depends on MacIntyre's hypothesis that Kierkegaard intends an absolute choice to serve as a *substitute* for Kantian pure practical reason: "Kierkegaard and Kant agree in their conception of morality, but Kierkegaard inherits that conception together with an understanding that the project of giving a rational vindication of morality has failed. Kant's failure provided Kierkegaard with his starting point: the act of choice has to be called in to do the work that reason could not do" (AV

47). Thus Kierkegaard's *Either/Or* is supposed to be the last gasp of the Enlightenment Project: he is trying to make choice work as the basis for the binding force of moral norms, when Kantian practical reason has failed to do this. Crucial as it is to MacIntyre's entire project in *After Virtue*, this argument is very dubious. The Judge in *Either/Or* certainly never *says* that rational defenses of moral principles have failed; MacIntyre simply supposes that this was Kierkegaard's reason for focusing on the role of choice. And MacIntyre supposes this because he does not see that Kierkegaard has another independent reason for introducing the absolute choice between the ethical and the aesthetic.

But before I supply an alternative hypothesis, it is important to realize that, even if in his later religious works and *Edifying Discourses*, Kierkegaard does not accept Kant's formalist definition of normativity in terms of 'lawlike form' alone, he never deviates from the metaethical principle that the objective normativity of acting for certain ends ought itself to be our motive for so acting. Kierkegaard is in broad agreement with Kant that morality is "universal" and never justified by mere preferences or fiat, and that moral character depends entirely on motivation by one's recognition of good ends and right actions themselves. Ample passages in the *Concluding Unscientific Postscript* as well as other works confirm this. To take just one example, in the *Postscript*, the pseudonymous author 'Johannes Climacus' declares that "the true ethical enthusiasm consists in willing to the utmost limits of one's powers, but at the same time being so uplifted in divine jest as never to think about the accomplishment." Conversely, when the will measures its motives by outcomes, it becomes "greedy for reward, and even if it accomplishes something great, it does not do so ethically: the individual demands something else than the ethical itself."[12] Here Climacus affirms the core of metaethical internalism: acting ethically means acting for the sake of the ethical, which means being motivated primarily by the ethical rightness of the acts, or the goodness of their ends.[13] Similarly, in *Fear and Trembling,* Kierkegaard's pseudonym 'Johannes *de Silentio*' affirms that the highest stage of the ethical (which is directly prior to religious faith) is *absolute resignation*, in which one acts purely from the 'motive of duty' in Kant's sense—even without any practical hope of realizing the ends one is obliged to strive for.

The metaethical internalism Kierkegaard inherits from Kant also helps explain why he is not, contrary to widespread assumption, a fideist. In Kant's *Religion Within the Limits of Reason Alone*,[14] we not only find the model for Kierkegaard's "ethical choices" in Kant's idea of good and evil ultimate "dispositions" (highest-order maxims that are chosen by the transcendental self)[15]; we also find Kant's thesis that a moral revolution in ultimate character is possible. Without this possibility, the *eschatological* promise of a final balance between happiness and virtue could have no

genuinely *ethical* significance for us, but only serve as an 'external' incentive. Unless the promise of salvation requires a moral revolution in one's ultimate character, then motivation by this eschatological promise will amount only to divine favor-seeking of the sort Nietzsche suspected, rather than religious rectitude in accord with pure practical reason. In such religions, which are endeavors to win favor, ". . . man flatters himself by believing either that God can make him eternally happy (through remission of sins) without his having *to become a better man*, or else, if this seems impossible, that God can certainly *make him a better man* without his having to do anything more than to ask for it."[16] The thesis of moral revolution, then, is motivated by Kant's own opposition to the Lutheran doctrine of *sola fide*: unless we can bring about the revolution in our own ultimate maxim, or at least to take the initiative to accept grace, then *good works* are not even a necessary condition for salvation. Our ultimate character cannot be fixed from all time, because if it is, then good works and moral duty have no religious significance at all.[17]

It is well known that Kierkegaard was influenced by Kant's *Religion*.[18] But it is rarely emphasized that Kierkegaard shared Kant's view that an ethical component (such as 'good works') was necessarily included in salvation through faith. Not only is this clear in Kierkegaard's later religious writings;[19] it is also suggested in passages early in *Fear and Trembling* that are clearly intended as barbs against Danish adherents to *sola fide*. For example, Johannes *de Silentio* tells us that in the "world of spirit" where justice applies, it "holds true that only the one who *works* gets bread. . ." (FT 27).[20] The indispensability of good works is expressed for Kierkegaard by the fact that the religious stage is only accessible *through* the ethical stage, which implies that strong moral virtue remains a necessary condition within the stage 'beyond' it. *Fear and Trembling* also makes clear that faith which does not dialectically retain within it a commitment to ethical ends and good works, will be mere aesthetic childishness (FT 47). Moreover, the movement of faith is a volitional movement that identifies the self with its absolute relation to the Divine: it is not constituted by willing to believe something about the truth-value of propositions *sola fide*.[21] Thus, the sense in which the religious stage of faith is 'beyond reason' is the same as the sense in which it is 'beyond the ethical:' it contains reason dialectically within it, just as it contains the ethical. Kierkegaard's 'beyonds,' unlike Nietzsche's, are *cumulative*, and for this reason, Kierkegaard is not in any sense a fideist.

These reflections give us abundant antecedent reason to believe that Kierkegaard's pseudonymous works generally oppose an externalist analysis of ethical obligation in relation to the heroic will and to faith. This is all the more reason to suspect that if MacIntyre's interpretation leads to the opposite conclusion, something has gone wrong in that interpretation.

III. Authentic Identification and the Choice of the Ethical

As we saw, MacIntyre thinks that for Kierkegaard, the 'absolute' choice between the aesthetic and the ethical is supposed to be the basis of the authority that ethical principles have for the individual. Although he cites no particular passages to support this, the infamously difficult ones that might give this impression are found near the beginning of the "Equilibrium" letter, where, after explaining that "choice" in the "strict sense" always means an *ethical* choice of good or evil,[22] the Judge nevertheless adds:

> My either/or does not in the first instance denote the choice between good and evil; it denotes the choice whereby one chooses good *and* evil/or excludes them. Here the question is under what determinants one would contemplate the whole of existence and would himself live. . . . It is, therefore, not so much a question of choosing between willing the good *or* the evil, as of choosing to will, but by this in turn the good and evil are posited. (Lowrie, EO II, 173)

The 'primordial' choice described here ('choice$_p$' for short), is thus the choice whether or not to choose in the ethical sense (choose$_e$), i.e. to make choices the agent understands as involving a particular sort of *moral responsibility*. But by a choice$_e$ that is intelligible to the agent in terms of her moral responsibility for it, Kierkegaard means something more than what MacIntyre (following Aristotle) calls an intelligible "human action:"

> To identify an occurrence as an [intelligible] action is in paradigmatic instances to identify it under a type of description which enables us to see that occurrence as flowing intelligibly from a human agent's intentions, motives, passions, and purposes. It is therefore to understand an action as something for which one is accountable (AV 209).

For MacIntyre, it is intelligible human action—a performance that follows from 'internal' sources, such as preferences, desires, dispositions, cognitive apprehensions of value and reasoned deliberation—that involves human persons in moral responsibility and distinguishes them from animals.[23] In this account, MacIntyre is probably also following Hegel.[24]

Kierkegaard might not deny that when a person has performed a "human action" in MacIntyre's sense (i.e. performed something aimed at an end intelligible to herself and others in terms of cognitive and emotive states meaningful to the agent), normally she is legally liable for it. This

Aristotelian condition allows us to make the classical distinction between *wrongs* and mere *harms*: for example, if she acts in a way that knowingly causes unjustifiable pain to others, the agent does intentional harm, which satisfies traditional standards for criminal culpability. Kierkegaard's pseudonymous works never imply that the aesthete cannot recognize his legal liability for his actions in this sense, or be held to account for them like anyone else.

Nevertheless, by definition, the aesthete does not choose 'in terms of the ethical.' By choice$_e$ that is ethical in the *categorical* sense, Kierkegaard refers to a special subset of 'human actions.' What the aesthete lacks in his actions is a "choice between good and evil" that makes the *will* on which he acted good or evil (Lowrie, EO II, 170–71). However, the will to which these moral predicates principally apply—as Kant famously suggested at the beginning of the *Groundwork*—is something deeper than the action-maxim that makes an action "intelligible" or "deliberate." The will is a faculty of commitment that cannot be dissociated from the self, in the way that even deliberate actions (and the intentions that make them intelligible) sometimes can be dissociated.[25] As Kierkegaard's psuedonym writes in the *Postscript*: "The real action is not the external act, but an internal decision in which the individual puts an end to the mere possibility and *identifies himself* with the content of his thought in order to exist in it. This is the action."[26] It is only in the will in this sense that Kierkegaard recognizes a capacity for ethical choice and character that has moral worth. What the agent thereby acquires is not merely liability for actions that flowed from an intention 'internal' to her, but *strong* moral responsibility for her commitment to form that type of intention.

However, for Kierkegaard, "ethical" choice$_e$ that entails 'strong moral responsibility' will include not only (1) the *volitional conditions* which give one's actions the requisite personal significance required if the distinction between good and evil is to apply to the motive or ground of one's act, but also (2) cognitive awareness of the objective authority of moral principles.[27] My hypothesis is that the Judge's primordial choice is about what is required to satisfy the *former* condition: it has nothing to do with meeting the latter. What is "posited" by the choice$_p$ to become a chooser$_e$ (or to make choices involving strong moral responsibility) is not the *authority* of ethical principles but rather the volitional conditions under which the authority of such principles can become relevant to the moral worth of an individual's will. The aesthete's particular actions may be judged right or wrong by himself or by a third party, but without the choice$_p$ to choose$_e$ in terms of the ethical, they are not grounded in the kind of inward character that can be good or evil in the fullest sense, and hence such actions cannot be internally motivated by these ethical distinctions.

This distinction between (1) and (2) does not occur to MacIntyre, because he begins with the tacit assumption that there is no further 'volitional' condition for moral responsibility beyond performing a 'human action.' Hence for MacIntyre, there are no actions for which people are liable that still lack a basis in volitional commitment that can be morally worthy or unworthy. Yet this is precisely the state of the aesthete as Kierkegaard understands him. This is not to say that an aesthete lacks purposes, intentions, etc. in terms of which her action is intelligible or deliberate: rather, Kierkegaard recognizes that the presence of such 'inner' cognitive and emotive sources does not by itself establish the will to be a certain kind of *person*—the sort of volition that is required for strong moral responsibility. But since MacIntyre fails to see the difference between Kierkegaard's condition (1) and 'intelligible human action,' and since the aesthete clearly 'acts' in this latter Aristotelian sense, the aesthete and the ethical chooser would seem to differ only with respect to condition (2). As a result, MacIntyre must assume that the only difference made by the primordial choice between the aesthetic and ethical is a difference in recognition of the objective *authority* of the ethical principles.

This explains how MacIntyre arrived at the wrong conclusion. For Kierkegaard, both the aesthete and the ethical chooser (the Judge) satisfy condition (2), but only the latter satisfies condition (1). And he comes to satisfy (1) by choosing$_p$ to choose in terms of the ethical. Thus the role of the absolute existential choice$_p$ is to establish an inward dimension of undissociable volition, which is distinct from an internal desire or tendency to an end that is sufficient for 'acting' in Aristotle's and Hegel's sense.

In defense of this hypothesis, I will show that it is both historically plausible and yields a convincing interpretation of the most difficult passages in *Either/Or* II. Kierkegaard's more subtle conception of the volitional conditions for moral responsibility has its philosophical origin at the beginning of Kant's *Religion*, in what Henry Allison has aptly termed the "Incorporation Thesis:"[28] "freedom of the will [*willkür*] is of a wholly unique nature in that an incentive can determine the will [willkür] to an action *only so far as the individual has incorporated it into his maxim.*"[29] This "Incorporation Thesis" says that moral responsibility for *doing action A to realize end E* requires something more than that A flowed from some mental state such as a preference or impulse to realize E: willing that end, and acting on that action-maxim, requires a choice which "incorporates" the motives towards E into one's action-maxim. Although Kant's justification for the Incorporation Thesis is that it is entailed by negative liberty as a condition for moral responsibility,[30] its most immediate implication is that moral responsibility for an action requires that the individual has *identified herself* with the motive on which she acted.

In recent years, the crucial significance of 'identification' in this sense has been brought out most forcefully by Harry Frankfurt. Beginning with his 1971 essay on "The Freedom of the Will and the Concept of a Person," Frankfurt criticized Sir Peter Strawson for holding that certain cognitive capacities and "corporeal characteristics" taken together could be regarded as sufficient for personhood.[31] Frankfurt argues that it is not advanced capacities of reasoning and deliberation but "the structure of a person's will"[32] which accounts for her unique capacity for moral responsibility. A person not only has a first-order "will," which is defined as the "desire" (or preference, incentive) actually operative in her action,[33] but also *second-order volitions* to act (or not to act) on certain first-order desires.

Second-order volitions are important only because they explain how a person becomes morally responsible by *identifying* with or *alienating* their own first-order states of will. To illustrate this, Frankfurt considers three different addicts who "succumb inevitably to their periodic desires for the drug to which they are addicted."[34] The *unwilling addict* "hates his addiction" and wills$_2$ not to will$_1$ to take the drug (i.e. not to act on his addictive desire), but his second-order volition is in vain, and he is "helplessly violated by his own desires."[35] Thus he does not identify with the desire on which he acts (he does not 'incorporate' it in Kant's sense). Since this addictive desire is alienated by his higher-order will, Frankfurt argues that the unwilling addict is not morally responsible for his action, whereas the willing addict is (whether or not it was his higher-order will which *brought about* that he acted on his addictive desire). It is identification, not causation, that makes him responsible for his action, on this account.[36]

The third addict is "wanton," because he has no higher-order volition about the 'will' on which he acts. He neither identifies himself with his desire for the drugs, nor with an alternative desire to refrain from taking them: thus "he has no identity apart from his first-order desires."[37] As Frankfurt points out, a "wanton" in this sense may reason instrumentally, deliberating "concerning how to do what he wants to do;" but he does not *care* which of his inclinations happens to determine 'what he wants to do.'[38] Thus the wanton takes no *inward stand* towards the first-order character he exhibits in his action; he does not will to act on one publicly intelligible motive, desire, or impulse rather than another.

In sum, Frankfurt holds that it is intrasubjective identification (through second-order volitions) that makes persons morally responsibile for their actions. This conception of identification, which is anticipated in Kant's Incorporation Thesis,[39] explains how we establish a volitional identity through commitment to being one sort of social self or another. The *person* in Frankfurt's sense is this 'inward self,' which consists in the authentic

will to be a certain sort of 'outward self,' including the dispositions and projects the agent wishes to express in her actions.[40] A wanton lacks "personality" in this reflexive sense.

This brief summary of Frankfurt's analysis provides a basis for explaining the meaning of the Kierkegaardian 'choice' to make ethically significant choices. By *ethical* "choice" between good and evil, or "the act of choosing" that is "essentially a proper and stringent expression of the ethical" (Lowrie, EO II, 170), the Judge means a volition which satisfies the condition for strong moral responsibility implied by Kant's Incorporation Thesis. In other words, "choice$_e$" means *volitional identification* in Frankfurt's sense. To *choose* in this sense, one cannot just 'wantonly' act on whatever preference wins out in the "economy of one's desires."[41] Rather, one must actively associate oneself with some form of deliberate action; the higher-order acts of identification this involves will then constitute an authentic inward self. The primordial choice$_p$ between the aesthetic and the ethical generally, then, is the choice *either* to be wanton, *or* to become a 'person' in the full Frankfurtian sense.

If this interpretation can be sustained, then the choice to choose in terms of the ethical has nothing to do with choosing to regard ethical precepts as having normative authority: rather, it means a choice to engage in the kind of volitional identification that ethical principles of moral character can guide. The agent who chooses$_e$ in this sense can be guided by the intrinsic good or evil of the motives with which he identifies in forming his character.

Several themes in the Judge's discussion surrounding the primordial either/or provide convincing proof of this interpretation. First of all, by the *aesthetic*, Kierkegaard clearly means something similar to wantonness in Frankfurt's sense. The Judge begins the "Equilibrium" letter by contrasting the either/or which characterizes "the ethical" with the careless indifference of the aesthete's attitude towards alternatives: "'Do it/or don't do it— you will regret both' . . . 'I say *merely* either/or' (Lowrie, EO II, 163). The point is that the aesthete simply *lets* herself act on whatever motive happens to gain the upper hand. Thus "the aesthetical in a man is that by which he is immediately what he is" (Lowrie, EO II, 182). Here the 'immediate' means roughly the same as first-order preferences and dispositions in Frankfurt's sense. The Judge gives the following example: "The aesthetic choice is either entirely immediate and to that extent no choice, or it loses itself in the multifarious. Thus when a young girl follows the choice of her heart, this choice, however beautiful it may be, is in the strictest sense no choice, since it is entirely immediate" (Lowrie, EO II, 171).

'Following one's heart' in this sense is essentially *wanton*, lacking in the higher-order volitional movement of intrapersonal identification. No matter how much it is celebrated in romantic literature, this simulacrum of

choice—'impulse without incorporation'—does not involve one in full moral responsibility, or "mature one's personality" (Lowrie, EO II, 166).

The Judge also anticipates Frankfurt by noting that deliberation does not by itself supply the will which is missing in the wanton's lack of volitional identification with the impulse acted on. He says to the aesthetic young man, "Yea, if to deliberate were the proper task for a human life, you would be pretty close to perfection" (Lowrie, EO II, 169).[42] To become a self qualified as *good or evil*, "the crucial thing is not deliberation but baptism of the will which lifts up the choice into the ethical" (Lowrie, EO II, 173). Thus in the nearby passage (quoted above) in which the Judge distinguishes between "choosing to will" *per se* and the moral value of a particular volition, he is referring to this movement that first "lifts" us into the higher-order of volitional personality required for choice 'in the strict sense.' When one chooses to will in the ethically relevant sense, one chooses to identify, or to form volitional commitments. This same meaning is apparent when the Judge says of the person "who would define his life task ethically" (i.e. as good *or* evil),

> in making a choice it is not so much a question of choosing the right as of the energy, the earnestness, the pathos with which one chooses. Thereby the personality announces its inner infinity, and thereby, in turn, the personality is consolidated. Therefore, even if a man were to choose the wrong, he will nevertheless discover, precisely by reason of the energy with which he chose, that he has chosen the wrong. For the choice being made with the whole inwardness of his personality, his nature is purified. (Lowrie, EO II, 171)

In this context, it is clear that the "earnestness" and "pathos" characteristic of choice subjectively understood as *good or evil* do not signify mere intensity of emotion (which a first-order preference can also exhibit), but rather that the choice unequivocally commits the agent to the content chosen, and in the process forms an 'inner self' defined by this appropriation. Thus "personality" in this sense means what Frankfurt also calls the real 'person,' i.e. the inward self or 'I' who identifies with the sort of outward or social self it wills to be in its actions. If this is what is required for choice to yield responsibility of the deepest sort, it makes sense that in such choice, "the I chooses itself—or rather, receives itself" (Lowrie, EO II, 181), or acquires a definite inward identity. This "personality" cannot itself remain unaffected in morally responsible choice, because authentic identification *constitutes* this personality: "The choice itself is decisive for the content of personality, through the instant of choice the personality immerses itself in the thing chosen" (Lowrie, EO II, 167). Thus the Judge denies that the personality is a transcendental 'x' or pure subject of action, i.e. that "personality mean[s] nothing more than to be a kobold, which

takes part, indeed, in the movements, but nevertheless remains unchanged" (ibid). The wanton, who lacks "personality," *is* like the kobold: an unchanging monad moving through the chaotic alteration of his first-order impulses to act.

The sense of intrapersonal identification involved in the inward personality won through choice$_e$ is apparent in the Judge's implication that this personality *belongs* to the chooser in special sense, in which we cannot likewise say that the aesthete's own deliberate activities belong to him. Unlike a person's history, which is "not merely a product of his own free actions," the "inward work" of choice "belongs to him and must belong to him unto all eternity" (Lowrie, EO II, 179).[43] Through this inward movement, the contingent pieces of his external identity are 'incorporated' or appropriated as his own. By contrast, the Judge argues that the aesthetic hedonist "always posits a condition which either lies outside the individual or is in the individual in such a way that it is not posited by the individual himself" (Lowrie, EO II, 184). As before, "positing" here means incorporating: even when his preference or desire is "in him" in the sense that it would count as a psychological source of human action, he does not 'choose' or *identify* with this desire as the one he intends to be his first-order will: it is "his" only in the way that his external history is his, i.e. simply by being part of his contingent first-order psyche. Thus the condition for the aesthete's happiness is *external to his real self* in the same underlying sense, whether his goal is a physical one, such as beauty, or a psychological one, such as the development of a talent.[44]

Like Frankfurt, then, Kierkegaard's Judge holds that having a *self*, or being a person capable of moral responsibility, depends primarily on a special sort of *intrapersonal* volitional relation, which is *prior* to all interpersonal (Hegelian) dependencies.[45] The primordial choice between the aesthetic and the ethical is about the initiation of this intrapersonal relation:

> So the either/or I propose is in a sense absolute, for it is a question of choosing or not choosing. But since the choice is an absolute choice, so is the either/or absolute; in another sense, however, it is only by this choice [that] the either/or comes to evidence, for with that [the choice$_p$ between choosing$_e$ and not choosing$_e$] the choice between good and evil makes its appearance. (Lowrie, EO II, 182)[46]

It is apparent here that the objective authority of ethical principles does not originate with the absolute choice$_p$ but rather "comes to evidence" and "makes its appearance": these phrases refer to the newfound personal *significance* of the objective authority in ethical principles. Although the aesthete may already have been cognizant of their universally binding force,

they apply directly to identifying volitions, which the aesthete lacks. He is in the same position relative to these principles as someone who knows the rules of the road, but never drives. When that someone nervously decides to take the driver's seat for the first time, of course they do not think of this decision as creating whatever authority they recognize in the traffic laws. That authority is recognized antecedently to the choices that make it action-guiding for the individual. Similarly, the person who makes the primordial choice$_p$ to begin forming volitional identifications is not grounding the normative force of moral precepts or ideals governing agent-commitments; rather, she is giving these precepts *subjective* application within her own will, or giving them personal relevance.[47]

IV. Existential Choice: Kierkegaard's Route Between Aristotle and Kant

We have recognized the crucial importance of Kantian "incorporation" or identification in Kierkegaardian choice. We should not, however, assume that Kierkegaard conceives "the ethical" and choice in purely Kantian terms. Kierkegaard's theme of the practical significance of the eternal from an individual perspective derives from Socrates, while his conception of choice is indebted to the *Nicomachean Ethics*. Ironically for MacIntyre, Kierkegaard scholars writing both before and since *After Virtue* have emphasized the close connections between Kierkegaard's notion of choice and Aristotle's conception of *proairesis*.[48] In 1977, three years prior to *After Virtue*, George Stack published a lengthy treatment of "Existential Choice"[49] in which he argues that since Kierkegaard's conception is largely derived from Aristotle, it is neither arbitrary nor irrationalist.[50] The fundamental similarity is found in the fact that Kierkegaard emphasizes "the distinction between relatively insignificant 'choices' and existential choices . . . that have relevance for the development of the character of the individual."[51] Deliberation, as we have seen, is *aesthetic* if it never gets beyond what Stack calls intellectual possibilities, or detached speculation about logical possibilities. Deliberation becomes *ethical* (related to 'choice' in the true sense) for Kierkegaard—as for Aristotle—only when it is about what we might call *personal possibilities* of action: "For Kierkegaard, as for Aristotle, we deliberate not about the eternal, the necessary, or the impossible, but about that possible (*dunaton*) or that which we believe to be within our power to perform."[52] To be ethical, deliberation must be about practical possibilities of action rather than about 'disinterested' logical possibilities, but even then it is not by itself sufficient for action, and must terminate in a choice.[53] As we read in the *Postscript*, there is a "twilight zone" between mere thought or aesthetic deliberation, and action in

the fully incorporative sense: "Thus when I think that I will do this or that, this thought is not yet an action, and in all eternity it is qualitatively distinct from an action; nevertheless, it is a possibility in which the *interest* of action and of reality already reflects itself."[54]

Stack expresses this by saying that to make an ethical choice, "the individual must be passionately concerned with his own possibilities for choice, decision, and action."[55] On this basis, he argues that what Aristotle means by practical deliberation just is what Kierkegaard means by real ethical choice: "there is what might be called a concernful deliberation about one's own possibilities. Concernful deliberation (as opposed say, to the neutral or indifferent deliberations of the aesthete . . .) is tantamount to Aristotle's notion of deliberation (*bouleusis*)."[56]

Passages like the one just cited from the *Postscript* show that Stack is largely right that for Kierkegaard, ethical existence is choice in the sense of closure of practical deliberation on 'live' options with substantive ethical qualities (beyond merely justice or injustice). But for all this, Stack's analysis does not help to explain the primordial Kierkegaardian choice, the "first 'movement' of the self (or, more accurately, the potential self) . . . in choosing to realize the possibility of choice,"[57] which gives our possible actions their 'live' personal relevance in the first place. It is just at this point that Kierkegaard goes beyond the Aristotelian and Thomistic accounts of choice, through bringing in a Kantian insight: the personal relevance necessary for a choice involving strong responsibility does *not* arise simply from the fact that the choice is practical, i.e. about possible actions of the agent; rather, from it arises from the possibility of *identifying* with the intelligible intention involved in an action. It is this higher possibility that is added by the primordial choice to be a chooser$_e$.

For Aristotle, this question is masked because identification is just built into "choice" that expresses a virtuous or vicious character. Since virtues are dispositions *to choose* in a particular way, they are implicitly something more than merely acting on habitual urges. But because Aristotelians assume that it is reflection with an 'interest' in some end that differentiates choice from habit, on their account, identification is implicitly constituted by some relation of reason and desire, whereas Kierkegaard recognizes that identification is a further irreducibly volitional element. Thus I cannot completely agree with Stack that "The Aristotelian notion that *proairesis* is either reason served by desire . . . or desire served by reasoning . . . is one that underlies Kierkegaard's conception of choice despite his tendency to exaggerate the role of 'passion' in choice."[58] In ethically significant choice, Kierkegaard has in mind the *same phenomenon* as Aristotle does when he discusses the decision that is part of *phronesis* or practical deliberation. But Kierkegaard, following Kant, recognizes that the personal commitment of self involved in this phenomenon cannot be explained by any combination

of 'disinterested' reasoning and 'interested' desire alone: a further voli-
tional qualification, which comes directly from the individual, is required.
So Kierkegaard's conception of existential choice is neither purely
Aristotelian nor purely Kantian: it is a new synthesis.

For the same reason, I do not completely agree with Anthony Rudd,
who has also argued that Kierkegaard is a virtue theorist whose conception
of ethical choice is "Aristotelianism, without the Aristotelian conception of
the single specifiable *telos* of human nature as such."[59] Rudd insightfully
points out that for Kierkegaard's Judge, to have ethical *continuity* (a chief
theme of *Either/Or* II) one must have "ground projects" (in Bernard
Williams's sense) that "give one's life at least some aspect of secure narra-
tive structure": "But this means accepting that the project confers an iden-
tity on oneself, which means rejecting, or at least qualifying, the
disengaged idea of the pure autonomous self, distinct from all social roles,
relationships, and commitments."[60] It is true that Kierkegaard's later eth-
ical writings often concern the ethical agent as engaged in 'thick' phe-
nomena of interpersonal ethical life. Moreover, his ethical agent is
personally engaged—Kierkegaard has learned from Aristotle's Socratic
insight that ethics is about first-person motivation, and therefore concerns
the 'personal horizon' of possibilities for action with which character and
choice are bound up. But Kierkegaard sees a decisive internal differentia-
tion *within* this 'personal world' (as we might call it): although all its con-
tents have 'interest' for agency, since they are salient as 'relevant for
deliberate action,' some of them, such as social roles and communal prac-
tices, can be engaged in *without real inward commitment*, or first-personal
identification. And Kierkegaard finds the basis of this differentiation in
precisely the Kantian freedom that Rudd, MacIntyre, and Williams believe
can only "abstract" and "disengage" the agent. For Kierkegaard, precisely
the opposite is true: it is only the freedom of pure self-commitment that
makes it possible for the varied phenomena of social life to gain real first-
personal significance in the first place.[61]

These observations explain the seeming paradox that Kierkegaard typ-
ically focuses on rich ethical phenomena concretely significant to the
"existing individual"—and in this way he looks like Williams and even
Aristotle—while he also heaps scorn on mere aesthetic 'role-playing' and
holds that personal identity involves a power to 'choose oneself' that is
prior to outward social identity and not exhausted by any intersubjective
constitution, however rich—and in this way Kierkegaard looks more like
Kant, or even Sartre.

This new synthesis was not an accidental conglomeration, however.
Rather, it is likely that Kierkegaard developed his theory of the radical exis-
tential choice to become an ethical 'chooser' in order to resolve a crucial
Hegelian objection to Kant's ethics. As Robert Pippin explains, this

famous objection is that Kantian ethics is "rigoristic" and cannot take into account "the inevitably interested and individual character of our relation to any principle of action."[62] In the case of norms or objective reasons for acting, what Pippin refers to as "their possibly being mine (their motivating power)"[63] involves something particular to the agent: to have subjective force, the norms must acquire the concreteness of first-personal possession.[64] As a result, moral norms cannot adequately be understood in universalist terms.

Against this, Judge's primordial choice shows how the individual Kantian act of incorporation or volitional identification bridges this gap between the universal but abstract normativity of ethical principles and the creation of first-personal, subjective obligation in the life of real flesh-and-blood agents. This response to Hegel works equally well against similar contemporary criticisms of Kantian ethics, such as Bernard Williams's suggestion that "The Kantian emphasis on moral impartiality . . . provide[s] ultimately too slim a sense in which any projects are mine at all."[65] The proper Kierkegaardian response is that universality or impartiality is not the same thing as *impersonality*. Rather, *first-person universal* motivation is possible, and the primordial choice$_p$ to be a chooser$_e$ shows precisely how this is: through it, the objective authority of universal norms comes alive within the agent's irreducibly first-personal volitional perspective or personal world.

Of course it goes without saying that if Kierkegaard's Judge has an answer to Williams and Hegel, then the contemporary relevance of *Either/Or* is far greater than has been appreciated. Ironically, while MacIntyre alleges that Kierkegaard makes the objective authority of norms depend on radical choice, he also criticizes Kantian enlightenment rationalism for failing to show how to link objective normativity and subjective obligation for real existing individuals. But it turns out that the Judge's account of radical choice between the aesthetic and the ethical is actually an answer to the *latter* problem, and not about the question of whether the categorical imperative or some other rational basis can ground the authority of ethical principles. Not only does Kierkegaard's conception *not* fall into the *aporia* of externalism; it even resolves one of the main objections against the consistency of Kantian negative liberty with metaethical internalism.

In sum, the Kierkegaardian primordial either/or shows how metaethical internalism is vindicated in an individual life: with the choice$_p$ to make choices$_e$, objective ethical principles and ideals of virtue that govern agent-commitment become motivating in the wholly *first-personal* context. Of course, our libertarian freedom implies that the objectivity of ethical reasons is never *determining* even for the person who chooses under the conditions of strong responsibility: although ethical principles whose validity

she is aware of will have first-personal significance for her, she may nevertheless identify herself with dispositions that are evil, or with desires that violate her duties. Yet, it is the *very choice* to acquire an inward, higher-order personality that brings the normative force of ethical principles into an individual life in such a way that *personal evil* of character is possible in the first place.

Thus it is somewhat helpful to think of the choice$_p$ to enter "the ethical" as the generalized decision to identify with a *life plan* or stable pattern of first-order motivations that will give an intersubjectively intelligible meaning to one's whole life. But of course it is possible that from the outside, someone might interpret the activities of a wanton in terms of a life plan they appear to pursue. What concerns the Judge, however, is that individuals take a stand with their innermost being towards a life plan they *will* to adopt as their own—even if it is not initially a very admirable life plan: "That which is prominent in my either/or is the ethical. It is therefore not yet a question of the choice of something in particular, it is not a question of the reality of the thing chosen, but of the reality of the act of choice" (Lowrie, EO II, 180). In abstraction from the rightness or wrongness of particular higher-order acts of identification, the primordial choice emphasizes the subjective appropriation or first-personal *significance* of objective standards of goodness and duty, which become subjectively relevant in the process of forming identifications.[66] Yet it may be that this choice$_p$ is never actually made separately, or apart from the attempt to form self-shaping commitments. In this case, the Judge's distinction between choice$_p$ and choice$_e$ is an analytic one, for the former occurs only virtually in the latter.

V. 'Bad Faith' and the Primordial 'Duty' to Choose the Ethical

With this Frankfurtian analysis, we have seen that the Judge's ultimate either/or does not contemplate any subjective constitution of the authority of ethical principles. This does seem to leave one remaining doubt: if authentic identification is necessary for moral responsibility, then it looks as if one might not be responsible in the strong sense for choosing (or failing to choose) "the ethical" as one's mode of choice, i.e. for converting (or not converting) from being a 'wanton' to being a 'person' in Frankfurt's sense. But in fact, the Judge's account is designed to discourage this mistake.

In characterizing his challenge to the young man, the Judge says, "one either has to live aesthetically or one has to live ethically. In this alternative, as I have said, there is not yet in the strictest sense a choice" (Lowrie,

EO II, 172). Given my analysis, this might seem to imply that we are not responsible in the deep sense for whatever choice we make in the primordial either/or, since this is not a 'choice' in the 'strictest sense' or an act of identification. But in fact, according to the Judge, volitional identification and full responsibility is lacking only when the choice$_p$ is *tacit* and hidden for one who by default chooses$_p$ the aesthetic—i.e. one who 'by default' is continues to accept a life whose changes are made only 'by default.' The choice$_p$ to be an ethical chooser, however, cannot be merely tacit, for by definition it has a cognitive element: it requires us to *think* of ourselves as agents capable of strong moral responsibility. This is a position we do not just automatically grow into for Kierkegaard. As Stephen Dunning notes, the Judge argues later in the "Equilibrium" letter that we must *repent* of the aesthetic to move into the ethical: "Thus ethical self-choice is a conscious repudiation of the abstraction and autonomy of the aesthetic stage."[67]

This point is crucial, because the Judge is very clear that once the choice$_p$ has become *explicit*, either through despair of the aesthetic life or through the therapeutic of an existential critique (like the one he is personally addressing to the aesthetic young man), then a *primordial responsibility* to choose the ethical category is manifest even in the originary choice between the aesthetic and ethical. To make this choice 'explicitly' is to make it in the manner of a cognitively informed higher-order volition, an *identification*. Thus the Judge tells the young man that his purpose is to "bring you to the point where the choice between good and evil acquires significance for you," i.e. to the point where the unavoidability of the primordial choice is explicit (Lowrie, EO II, 172). If one openly *faces* this primordial either/or, then one will be brought to the point where "the necessity of [ethical] choice is manifest" (Lowrie, EO II, 182). In other words, because a primordial responsibility already exists when the primordial choice-situation is explicit, a person will recognize the moral necessity of choosing$_e$, i.e. of choosing to make ethically significant choices. To this account the Judge adds a *further* more controversial hypothesis: if he can get a person to recognize their primordial duty to become a person responsible for their own character by getting them to stand "at the crossways" where the primordial choice is explicit, then he believes the person will choose the ethical.[68]

To his credit, MacIntyre realizes that the Judge believes that "anyone who faces the choice between the aesthetic and the ethical will in fact choose the ethical" (AV 41). This idea, which may have Pascal's Wager as its inspiration, suggests that the primordial choice has a *pedagogical* rather than *justificatory* significance for Kierkegaard. Unfortunately, MacIntyre dismisses the Judge's conviction on the strength of the following alleged counterexample:

the aesthetic *can* be chosen seriously, although the burden of choosing it can be as passion-ridden as that of choosing the ethical. I think of those young men of my father's generation who watched their own earlier ethical principles die along with the death of their friends in the trenches in the mass murder of Ypres and the Somme, and who returned determined that nothing was ever going to matter to them again . . . (AV 41; my italics).

The honest urgency of this objection is clear, but we must note that MacIntyre is describing men who *gave up* the ethical after already living in it. The Judge has an answer to this concern: "he who after the ethical has manifested itself to him chooses the aesthetical is not living aesthetically, for he is sinning and is subject to ethical determinants . . ." (Lowrie, EO II, 172). Kierkegaard is wholly consistent on this point: once the personal significance of the authority of ethical principles is accepted, their author-ity can only be rejected in sinful despair that fails to undo their personal relevance.

This is true not only for persons who have already chosen$_p$ the ethical and confront the primordial choice again when trying to maintain ethical ideals becomes painful enough to require infinite resignation; it is also true for persons who confront this choice$_p$ for the first time. If the necessity of choosing the ethical is "evident" in the primordial choice-situation itself when that choice$_p$ has become explicit, then even if the Judge's further hypothesis proves false, and the young man facing this choice tries to hurl himself back into the aesthetic, this would be a *sinful* choice in the pres-ence of moral obligation, not an arbitary choice without reason. Because the primordial moral responsibility intervenes when choice$_p$ becomes explicit, trying to return to the aesthetic can only lead to a form of sin, not to one's original state: as Stack remarks, "Once an individual has made such an 'absolute' choice he has already made an ethical 'turn' even in his deliberate choice to exclude the notions of good and evil."[69]

Thus we have answered MacIntyre's remaining objection: for Kierkegaard's Judge, the choice of whether to become an ethical chooser to whom the categories of moral worth apply is *itself* a choice involving strong responsibility. When choice$_p$ is tacit (or the aesthetic/ethical divide is not salient as an either/or), one remains in naive aestheticism without sinning. But when these options become explicit, we can only choose the ethical under the appropriated requirement to choose it, or reject it in sin-ful 'defiance' under the same requirement. In other words, in facing the choice, we have already identified with this primordial responsibility.

However, one might still protest that if the primordial choice becomes explicit only by chance, then the origin of moral responsibility for the individual would be abandoned to moral luck. But Kierkegaard realizes that a complex pedagogical process lies behind the 'making explicit' of

this primordial choice—a process in which the resistance or willingness of the individual does play a role. Although one does not just will to keep oneself unconscious of the primordial either/or, or just decide to make it conscious, one can be more or less open to learning the lesson (in interaction with others and experience in society) that aesthetic pursuits can give no security in *eudaimonia* or continuity in one's being. For Kierkegaard, everyone is *able* to despair of the aesthetic when the normal course of life brings them to a point where the issue at stake in the primordial choice should present itself. In other words, the capacity for this choice to become subjectively explicit is innate or inevitable, but the individual has some control over how long this takes in their life.

But if the aesthete has a hand in determining whether the primordial choice comes to explicit consciousness at some particular juncture, then it turns out that the aesthete's lack of authentic inward personality cannot be pure Frankfurtian 'wantonness' after all, i.e. it cannot be *completely involuntary* wantonness. Rather, the aesthete has a hand in his wantonness because his innermost self or volitional identity consists in the *third*-order will not to have second-order volitions, a highest-order will to *remain wanton* at the second-order level. This fits with our previous analysis: since choice$_p$ is about whether or not to engage volitional identification that consists in second-order volition, the primordial choice refers to a third order of the will—or to an *absolute identification* even more 'inward' than specific acts of second-order identification and the volitional self they constitute.[70]

Within the individual, however, this highest-order core identification *begins as tacit*; as the most inward part of volitional identity, it exceeds reflective consciousness. But according to the Judge's model, no one can be neutral at this highest level. One's highest-order disposition is *always already* either to choose$_p$ aesthetic existence or the reverse. But since the choice$_p$ to engage in ethical choice$_e$ requires a conversion in which the highest order will comes explicitly into question, anyone for whom the primordial choice is still tacit is *eo ipso* still in the aesthetic. Therefore MacIntyre construed the choice$_p$ in false terms when he said, "Suppose that someone confronts the choice between [the aesthetic and ethical] *as yet having embraced neither*" (AV 40; my italics). We are here asked to suppose something that is not a possibility in the Kierkegaardian scheme: one may not have embraced either ultimate option *explicitly*, but then one is in the aesthetic starting-place. If instead one has faced the choice, then one is either in the sin of defiant lukewarmness or a 'full citizen' in the ethical (understanding one's character in terms of its good and evil).

This analysis brings out the intended *comprehensiveness* in Kierkegaard's theory of the stages of concrete human existence: there is no Archimedian point outside them. The aesthetic is the first existential 'stage' of human

existence, the default position, as it were. Thus we cannot think of the aesthete as 'wanton' in precisely Frankfurt's sense, since for Frankfurt, wantonness means being entirely without inward identification. Despite lacking substantive second-order volitions that would commit him to various related forms of motivation and activity, the aesthete does have a more or less tacit *highest*-order will:

> **Aesthetic Bad Faith:** The Aesthete *tacitly* wills$_3$ not to have any second-order volitions V_2 with respect to D_1 (the complex of first-order desires and preferences that presently motivate his actions). In other words, he tacitly intends not to take any authentic stance towards with any of the motives in D_1, in order to *seem* to be nothing more than his contingent first-order character.[71]

I call this a form of bad faith, since the tacit attempt to cultivate neutrality is at odds with itself. The Judge's recurring insistence that the aesthete cannot be *transparent* or revealed to himself because he does not choose$_e$ points us towards this problem: the aesthete's highest-order will *not to choose* in the ethical sense is an ultimate project that must strive to hide itself, or keep out of the light of clear choice. This clarity of an explicit either/or destroys the aesthete's ownmost purpose, because this purpose is to try to live wholly in the stream of first-order desires and dispositions by avoiding the recognition that he is an agent in the higher-order sense. This explains why the Judge opens his letter by eulogizing the experience of either/or as an almost-magical curative (Lowrie, EO II, 161).

It is therefore clear why the choice$_p$ which brings about the conversion to the ethical is *asymmetrical* with the aesthetic state of bad faith: the choice$_p$ to choose$_e$ *requires* an awareness of oneself not only as an agent (as we already said), but as one who has her *highest-order will* or ultimate stance to determine, since choice$_p$ is a choice at that level. When the primordial choice becomes explicit in this way, however, the objective primordial responsibility to choose$_p$ the ethical comes subjectively to bear on it. At this point, one cannot regain the initial aesthetic state. We can summarize Kierkegaard's scheme in terms of the following four steps from the aesthetic to the ethical (as shown on the following page).

As we have noted along the way, there are alternatives at each step in this progression. A person may try to stave off the despair or the appeal from others which may bring choice$_p$ to explicit consciousness; similarly, once they are aware of their power to choose whether or not to care about anything (or to incorporate authentic motivations), they may reject this 'call of primordial conscience' entirely and turn in sin to a defiant higher-order despair; finally, once they have accepted the strong moral responsibility of being an ethical chooser, they may identify with corrupt desires or with passions of hatred and contempt, knowing this is vice. But the

Volitional state	Consciousness	Moral sense
(1) Aesthetic highest-order will not to identify with any purpose for acting.	Tacit choice$_p$.	Both the objective duty to become an ethical chooser, and other ethical principles, lack subjective significance.
(2) Aesthetic highest-order will, but free to change.	Choice$_p$ has become explicit.	Objective duty to become an ethical chooser acquires subjective force; Ethical principles governing virtue/vice have objectivity but still no personal relevance or inward application.
(3) Ethical highest-order will, deciding with what values and purposes to identify.	Choice$_p$ made to choose$_c$; choice$_c$ still unsaturated.	Ethical principles governing goodness and evil of the will now have subjective application or significance.
(4) Ethical highest-order will; good second-order will, or authentic identification with an end or maxim because of its goodness.	Choice$_c$ to will good for its own sake.	The subjective relevance of ethical principles now applies directly to the inward character or real self for which the individual is responsible in the strong sense.

Judge's discussion suggests that if internalist motivation by moral norms and precepts is to be compatible with negative liberty of the will, then these stages must be distinguished, and the resulting distinction between the various perils is also an essential part of the point.

VI. The Issue of 'Arbitrariness' in Nagel, Frankfurt, and Kierkegaard

So far, we have seen why the highest-order choice between the aesthetic and the ethical is not arbitrary relative to the objective authority of ethical precepts. This makes possible the Judge's internalist conception of our motivation for choosing$_p$ to be ethical choosers: although this choice is "radical" (since it changes our highest-order volitional personality) and

underdetermined by the present state of that personality, it is *not irrational* or groundless.

But MacIntyre's objections also portray the Judge's ultimate either/or as arbitrary in another sense: namely, that it can easily be revoked and hence has no influence on future choices. He argues that if I choose a principle for no reason, "if I then chose to abandon the principle whenever it suited me, I would be entirely free to do so" (AV 42). Since he reads the ultimate either/or as a choice prior to any rational source of justification, the implication is that having chosen the ethical, for example, I could just as easily turn back to the aesthetic soon after. If the ethical was chosen 'for no reason,' then that choice is *reversible*, precisely because it was groundless. This kind of reversibility means that later choices are *arbitrary* with respect to earlier ones, since the agent 'starts anew' from nothing each time. This sort of arbitrariness in the *history of choice* is quite different from an arbitrary relation between will and normative reason, although critics of existentialism tend to run them together.[72] To keep them distinct, I will call the latter 'normative-motivational arbitrariness' (N-M) and the former 'volitional-historical arbitrariness' (V-H).

The charge of V-H arbitrariness is cause for concern, because it has been so extensively abused by opponents of libertarianism in general, and by critics of existentialism in particular. There are two broad *reductio* strategies that deploy the charge of V-H arbitrariness this way. The first is to argue that existentialism is subject to the same problems as utilitarianism: V-H arbitrariness infects utilitarian theories because they depend on emotivist conceptions of personal agency and motivation, and since existential choice allegedly implies such a conception of agency, it will also imply V-H arbitrariness. Second, critics of negative liberty in general may even argue that a constant availability of alternative logical possibilities for actions *entails* V-H arbitrariness with all its vices.

In his *The View From Nowhere*, Thomas Nagel adopts this second strategy. He argues that libertarianism leads to an incoherent result: the desire for autonomy includes the sense that

> in acting we ought to be able to determine not only our choices but the inner conditions of those choices Yet the logical goal of these ambitions is incoherent, for to be really free we would have to act from a standpoint completely outside ourselves, choosing everything about ourselves, including all our principles of choice—creating ourselves from nothing, so to speak.[73]

This serves as a kind of caricature for simplistic existentialist conceptions of transcendence, which Nagel critizes: such ultimate autonomy is "self-contradictory" because "in order to do anything, we must already be

something," and thus "we cannot assess and revise or confirm our entire system of thought and judgment from the outside."[74]

It is easy to see in this light why Kierkegaard's notion of an absolute choice suggests to some readers the impossible claim that the individual starts out as nothing, in limbo *between* the ethical and aesthetic frameworks or perspectives. But as we have seen, Kierkegaard actually holds that the individual always begins in the aesthetic, and thus is already in a non-neutral volitional position. *From this position,* he is nevertheless able to bring about a revolution in the being that is most inwardly 'his own.' Nagel assumes that being in any such initial position means having an inescapable substance definitive of their personal identity. Kierkegaard challenges this assumption: although the young man is an aesthete, limited possibilities of changing his highest-order will are contained in his aesthetic highest-order will itself. His freedom is conditioned but not determined. Yet, if no part of our motivational psyche is unchangeable, how can it constitute an order of personal existence at all? This is the question that still needs to be addressed.[75]

Despite the affinities between his work and Kierkegaard's, Harry Frankfurt himself tends to adopt the first type of strategy against Sartrian existentialism. In his essay, "Rationality and the Unthinkable," Frankfurt argues that utilitarianism requires "bare persons" for whom there are no limits to what is practically possible.[76] But when a person's freedom reaches this extreme, her identity (or capacity for volitional identification) evaporates:

> suppose that the field of alternatives from which a person may select is not merely extended; suppose that its boundaries are wiped out entirely. In other words, suppose now that every possible course of action is available and eligible for choice [i.e. *personally* possible], including those that would affect the person's preferences themselves. Since he can in that case even alter his own will, it seems that he has to confront the choices he must make without any specific volitional character that is definitively his A person like this is so vacant of identifiable tendencies and constraints that he will be unable to deliberate or to make conscientious decisions. He may possibly remain capable of some hollow semblance of choice. If he does, however, it will only be by virtue of a vestigial susceptibility to inchoate volitional spasms. And movements of his will of that sort are inherently so arbitrary as to be wholly devoid of authentically personal significance.[77]

MacIntyre portrayed the Kierkegaardian agent much the same way: i.e. as one who must decide if his preferences are to be informed by any principles that could limit his decisions and preferences. To avoid the V-H arbitrariness that infects such decisions made by bare persons, Frankfurt argues, the agent must have a character that guides and gives rational

continuity to the history of choices by acquiring and maintaining limitations on what the agent can choose or will—i.e. limitations that make some actions "unthinkable" for a person. Frankfurt understands these limitations which allow for "meaningful conceptions of personal integrity" not as "irresistible impulses" or desires for certain kinds of action, but rather as *volitional necessities* of the higher-order will itself.[78]

On this basis, Frankfurt maintains that such volitional necessities, rather than existential choice, must be the origin of authentic personality. He argues that for any person, "a decision to care no more entails caring than a decision to give up smoking entails giving it up" and thus "what he cares about is far more germane to the character of his will than the decisions or choices he makes."[79] He cites as an illustration Sartre's famous example of the young man who must decide whether to go to war or remain with his dependent mother: "even if we understand this choice to entail a decision on his part concerning what sort of person to be and not merely what to do," Frankfurt argues, his volitional dispositions (i.e. his *cares*) may not conform to his decision.

> The point is not that he might change his mind a moment after making his choice, or that he might immediately forget his decision. It is that he might be *unable* to carry out his intention. He might discover, when the chips are down, that he simply cannot bring himself to pursue the course of action upon which he has decided . . . Or . . . he might discover that he does not have and that he does not subsequently develop the feelings, attitudes, and interests constitutive of the sort of person which his decision has committed him to being.[80]

A decision contrary to what is volitionally necessary for the agent will thus be ineffective. The decision itself cannot be "wholehearted" because "he cannot make an *effective* decision to perform it. The difficulty for him is that he cannot organize himself volitionally in the necessary way."[81] Volitionally necessary cares cannot be reversed by simple choice; on the contrary, decisions are reversible except when they are in accord with our volitional necessities. "All a decision does is to create an intention; it does not guarantee that the intention will be carried out. This is not simply because the person can always change his mind. Apart from inconstancy of that sort, it may be that energies tending toward action inconsistent with the intention remain untamed and undispersed."[82] Reversibility, then, is a lesser sort of inconstancy than simple ineffectiveness in decision, but it is enough to undermine the significance of choice in the development of the self. Only a development understood in terms of the formation of volitional necessities will avoid the problem of V-H arbitrariness, in Frankfurt's view.

VII. Kierkegaardian Volitional Character: Why Existential Choice is not V-H Arbitrary

Any worthwhile existentialist approach to personhood and moral responsibility—especially one which traces the moral significance of volitional identification to choices made in libertarian freedom—must have an answer to these objections. In this section, I will briefly show not only that Kierkegaard anticipated these difficulties long before any contemporary critics of existentialism, but also that the absolute choice presented in *Either/Or* II is insulated from them by a highly interesting existential theory of character.

For Kierkegaard's Judge, not even the aesthete's 'choices' or actions can be V-H arbitrary, because the existing individual is a living being who always (by default or by choice) has a *character* that consists in certain dispositions to act, which make some options more salient for the individual than others. The free choice of an existing individual is embodied in this *existential structure*, which has a kind of inertia of its own. As the Judge remarks immediately after introducing the idea of acquiring an 'inward' self, although this involves a choice between *logically* possible alternatives, the alternatives are never *synthetically* symmetric in their availability for the individual:

> For an instant it is so, for an instant it may seem as if the things between which a choice is to be made lie outside the chooser, that he stands in no relationship to it, that he can preserve a state of indifference over against it. . . . [But in fact] That which has to be chosen stands in the deepest relationship to the chooser, and when it is a question of a choice involving a life problem the individual must naturally be living in the meantime, and hence, it comes about that the longer he postpones the choice the easier it is for him to alter its character. . . . One sees, then, that the inner drift of personality leaves no time for thought experiments, that it constantly hastens onward and in one way or another posits this alternative or that, making the choice more difficult the next instant because [to choose the other alternative] what has thus been posited must be revoked. (Lowrie, EO II, 167–8)

In this widely-overlooked passage, Kierkegaard's Judge makes clear that the "personality" of the individual always *already* takes us more towards some of the options in a given situation, and thus if we wish to act on another option, we must seize it decisively. Otherwise we will find that we have almost automatically 'chosen' —but without really choosing— the option towards which our dispositions tended. Thus someone who tries not to decide nevertheless acts as if they had made a choice.[83]

Our analysis of Kierkegaard's 'ethical' choice in terms of authentic identification in Frankfurt's sense can help us understand the idea at work here. The Judge's point is that we always already have a *first-order* will, or outward character consisting of motivations we tend to act on; like Frankfurt's wanton, we are thus led to act in one way rather than another in a new circumstance: "the personality is already interested in the choice before one chooses" (Lowrie, EO II, 168). Notice that 'wantonness' or failure to engage in authentic identification is not inconsistent with such dispositional continuity in first-order character: on the contrary, wildly shifting and chaotic changes in first-order will are rare indeed (except possibly among adolescents). However, through an authentic inward will to act on one sort of motive rather than another, the individual not only for the first time acquires an inward personality that is good or evil (and thus makes an 'ethical' choice): she attempts to *direct* the 'outward' character she acts on, in spite of its own 'drift,' by aligning herself with one kind of character over another. In this effort to take hold of oneself and actively shape one's outward character, *time* is connected to choice, because without such inward direction, the more one continues to act on one kind of motive, the disposition to it becomes further entrenched. Judge William illustrates this by figuring the individual and his "personality" as a "captain on his ship." The captain must remember that he is turning a thing with inertia of its own, and if he simply fails to turn it, it is "all the while making its usual headway" and will end up in one place rather than another (Ibid.).

Although Kierkegaard does not sufficiently clarify this point, we must distinguish such 'inertia' in first-order character from the character of the 'inward' personality that does the directing, for good or evil. The inward self that makes such choices$_e$ understood in their ethical significance is no more "a blank" that begins anew each time (Ibid.) than is the outward character it steers and forms; rather, the inward personality consists in dispositions *of identification* itself. Thus there are at least three distinct ways in which the free person is *not* an 'externally' neutral arbiter of her options: (1) her outward dispositions to act on given desires and incentives create differences in the salience or practical availability of her options; (2) when she acts, she either reinforces or tends to alter the shape and strength of these dispositions; (3) if she does authentically choose to act on certain incentives and desires rather than others (for the sake of some good or evil higher-order motive), then she also shapes the dispositions of her *inward* personality, which will incline future acts of identification or agent-commitment. Thus over time, the structure of one's personality as a whole, inward and outward, is affected by both authentic choice and failure to choose$_e$. The distinction between the 'levels' is important, because for Kierkegaard, real *virtues and vices* will be dispositions of the inward personality, or dispositions of *choosing$_e$* in the incorporative sense.[84]

This is important not only because it shows that there is a place for the notion of virtue *within* the existentialist conception of authenticity, but also because it distinguishes volitional character that makes virtue *and* vice possible from the mere aestheticism of first-order habit. As we have seen, the Kantian side of Kierkegaard's existentialism includes a critique of living by disposition in the immediate habitual sense, or letting 'outward' character take its course. But Kierkegaard does not thereby exclude all notions of character. The synthesis in *Either/Or* shows how to distinguish between authentic and inauthentic dispositions, and it turns out that authentic choice is actually impossible without the acquisitions of dispositions of the *higher* undissociable kind, which constitute the authentic character.

That volitional identification itself must have a dispositional structure becomes clear when the Judge emphasizes that the inward commitments of the ethical chooser *are not* arbitrarily reversible. Aesthetic deliberation and choice among a "multiplicity" of options remains in the category of 'immediacy' or outward character, "because the self-determining factor in the choice is not ethically accentuated, and because when one does not choose absolutely [i.e. choose$_e$] one chooses only for the moment, and therefore can choose something different the next moment" (Lowrie, EO II, 171). Choice that is 'ethically accentuated' involves volitional identification with certain motives, or commitment to certain ends, that establishes an inward character; this character would not even exist if it were 'bare' and immediately reversible. In fact, it is even *less* reversible than one's outward immediate dispositions. To make this contrast with the *inward character* acquired by "choosing absolutely," the Judge even rhetorically contradicts his earlier assertion that the outward or immediate personality has some consistency or inertia. Whereas the limitations on salience imposed by outward dispositions may still leave a multiplicity of options, the possession of inward dispositions to identify or choose$_e$, which bring strong responsibility and the subjective relevance of norms with them, more sharply limit the relevant options,[85] and ground choices that are *much less* reversible than outward dispositions to act. A Chillingworth or Napoleon who is intent on his malign purpose with the demonic steadiness of an inwardly evil will is far less easily swayed from his path than, say, a Schindler who is addicted to material and sexual pleasures. Thus although it is so often used as a critique against existential freedom, V-H arbitrariness is precisely what Kierkegaard's conception of personality and the primordial choice is designed to rule out.

In fact, an even stronger claim is implicit in the Judge's discussion: choice that has the consequence of strong responsibility, or potential moral culpability of the will, would not even be *possible* if the individual were not asymmetrically connected to his options through dispositions. Right after the passage (cited earlier) where he calls for the "baptism of the will" by choice that lifts it into full moral responsibility, the Judge declares that:

The longer the time that elapses, the more difficult it is to choose, for the soul is constantly attached to one side of the dilemma, and it becomes more and more difficult, therefore, to tear oneself loose. And yet this is necessary if one is to choose and is therefore of the utmost importance if a choice is to signify something. (Lowrie, EO II, 173)

In other words, if 'ethical' choices were arbitrarily reversible—if it were not at least more difficult (if not impossible) to become a bachelor once one has taken a wedding vow, for example[86] —then there would be no choice in Kierkegaard's strict sense at all, because choices would not establish the kinds of inward volitional characters, or dispositions of identification, that are the *only* things capable of being absolutely evil or good.[87] Hence if the absolute ethical either/or has any application, then choice must *both affect and be affected by* inward character in such a way that it alters the availability of options, and thus is not *arbitrarily* reversible. Thus an agent who has really chosen$_p$ the ethical is not in as good a position afterwards to choose the aesthetic (and the reverse).

This argument is the basis for all of Kierkegaard's own (non-pseudonymous) treatment of ethical character in his various "edifying" or "upbuilding" discourses. It is confirmed in a somewhat different context in the *Sickness Unto Death*, where Kierkegaard carefully distinguishes between the "own self" which the ethically responsible person chooses to "put on," and the purely abstract "infinite form, the negative self," which the demonic man in his most absolute despair wills to be.[88] In the self of *purely* negative freedom—the self of an individual who consciously *refuses* to authentically adopt any inward personality, and instead explicitly maintains the highest-order will to reject all authentic identification[89]—there can be "nothing steadfast" despite the grandeur of his plans, because every decision he makes lacks earnestness and commitment and so is reversible: "The negative form of the self exercises a loosening as well as a binding power; at any time it can quite arbitrarily start all over again."[90] V-H arbitrariness is a symptom of the demonic. By contrast, ethically significant choice, which Kierkegaard characterizes here in terms of "infinite resignation," cannot turn around and "arbitrarily dissolve the whole thing into nothing."[91] Ethical choices such as infinite resignation can never be withdrawn as easily as they are made, because by definition they involve an *investment* of the self in projects, roles, or attitudes.

VIII. Conclusion

We have now seen that in the "Equilibrium" letter of *Either/Or* II, what Kierkegaard means by authentic choice is closely bound up with a form of

inward character that rules out V-H arbitrariness as thoroughly as the primordial decision between lifeviews rules out N-M arbitrariness. Choice in the sense of volitional identification, which alone can establish strong moral responsibility, not only has nothing to do with establishing the objective authority of norms; it must also *exist* in a form of character that is inward but not *noumenal*, a character with a history that reciprocally affects and is shaped by the will to identify with moral and immoral motives of action. This characterological facticity ensures that, especially in the case of volitional identification or the formation of cares, no choice is arbitrarily reversible.

Once this is recognized, Frankfurt's and Nagel's objections against existentialist autonomy are answered. Kierkegaard adheres to the Kantian idea of spontaneity in choice, but where Kant contrasts the phenomenal actor in a net of psychological forces with a structureless and unschematizable noumenal will, Kierkegaard contrasts the inertia of immediate character with an inward volitional pattern, or process of identification, that *itself* has a history and a temporal structure involving synthetic constraints. Even spontaneous choice, then, is clothed in such a way that it is never utterly 'characterless' self-creation *ex nihilo*. Absolute choice as identification always brings a personality into existence by actualizing an option that is accessible or personally possible because of the outward or inward character *already* 'there.' As the Judge says, "For in case what I chose did not exist but absolutely came into existence with the choice, I would not be choosing, I would be creating; but I do not create myself, I choose myself" (Lowrie, EO II, 219–20).

In sum, this analysis shows that several traditional critiques of existentialism cannot apply to Kierkegaard, and are therefore only questionably applied to everyone Kierkegaard influenced. Those who would demythologize existentialism as a myth of atomistic individualism or decisionistic moral relativism themselves stand debunked. The implications of this conclusion go well beyond a mere corrective in our interpretations of Kierkegaard. For it shows that, far from revealing the failure of the Enlightenment Project, Kierkegaard has gone a long way towards showing how to make the Enlightenment combination of negative liberty and metaethical internalism succeed. The new possibilities *Either/Or* opens up have hardly yet been explored. They depend in large measure on Kierkegaard's unique way of synthesizing the medieval conception of substantive moral character with freedom as negative liberty, while retaining objective moral standards of right action and ethical norms applying to volitional character. MacIntyre is therefore wrong not only about the meaning and implications of Kierkegaard's primordial choice between the aesthetic and the ethical, but also about Kierkegaard's position in the history of ethics.

NOTES

1. Alasdair MacIntyre, *After Virtue,* 2nd ed. (University of Notre Dame Press, 1981, 1984).

2. Søren Kierkegaard, *Either/Or,* vol. II, tr. Walter Lowrie (Princeton University Press, 1944, 1972), 178–79. All parenthetical references to *Either/Or* will be to the Lowrie translation.

3. Note that the Judge also describes this solemn choice as an "inward work" of the sort that makes up "the genuine life of freedom;" but he distinguishes "genuine positive freedom" from "*liberum arbitrium*" (178). We should also recall that Kierkegaard wrote this part of *Either/Or* during the winter he spent in Berlin, during which he attended Schelling's lectures (see Lowrie's Introduction, xv), which would not have encouraged him to believe that spontaneity is *noumenal* in Kant's sense. As the Judge says, although "an either/or presents itself in the case of an individual who must act" (EO II, 179), he does not understand such practical choice in terms of "formal, abstract freedom" (EO II, 182).

4. Timothy Jackson, "Kierkegaard's Metatheology," *Faith in Philosophy* 4 no.1 (January 1987): 71–72.

5. Jackson, 72.

6. Thus after describing the absolute either/or between the aesthetic and the ethical, MacIntyre compares it to Kierkegaard's argument, in the *Philosophical Fragments,* that a "radical and ultimate choice" explains "how one becomes a Christian." This idea, he says, not only militates against Hegel, but "destroys the whole tradition of rational moral culture" (AV 41). Thus MacIntyre in so many words charges Kierkegaard's *Fragments* with a fideism that is directly contrary to Kant's rationally grounded moral faith.

7. This is the second of the Judge's three letters contained within *Either/Or* II, and it is near the beginning of this letter that the Judge introduces and expands on his idea of the choice between the aesthetic and the ethical.

8. Christine M. Korsgaard, "Kant's Analysis of Obligation: The Argument of *Foundations I,*" *Monist* 72, no. 3 (July 1989): 312.

9. Korsgaard, 311.

10. Ibid.

11. Korsgaard, 312. Korsgaard footnotes this to Clarke's "A Discourse Concerning the Unalterable Obligations of Natural Religion . . ." from *The Works of Samuel Clarke* (Garland Publishing, 1978), 609–10.

12. Søren Kierkegaard, *Concluding Unscientific Postscript,* tr. David F. Swenson and Walter Lowrie (Princeton University Press, 1941, 1971 printing), Part Two, ch. 1, "Becoming Subjective," 121.

13. I leave the notion of normativity open in this description, because as I have suggested, for Kierkegaard (unlike Kant) metaethical internalism need not imply *deontological, formalist* definitions of the right and the good. Medieval virtue theories also had internalist conceptions of virtuous motivation.

14. Immanuel Kant, *Religion Within the Limits of Reason Alone,* tr. Theodore Greene and Hoyt Hudson, with introductory essays by Theodore Greene and John Silber (Harper & Row, 1960).

15. Although the Judge rejects the *atemporal* abstractness of Kant's noumenal self, on the first page of the "Equilibrium" letter, he follows Kant in saying: "there is only one situation in which either/or has absolute significance, namely, when truth, righteousness and holiness are lined up on one side, and lust and base propensities are lined up on the other side" (Lowrie, EO II, 161).

16. Kant, *Religion*, 47.

17. It is a measure of the strength of Kant's *insistence* on good works and moral progress for eschatological salvation that John Silber even felt that Kant's theory is inimical to any adequate notion of divine forgiveness or mercy (Kant, *Religion*, cxxxi). I am not sure if this is a fair criticism of Kant, but it certainly indicates the strength of his emphasis on moral rectitude as an essential element of religious faith.

18. Although as Silber rightly points out, Kierkegaard opposed Kant's belief that strong 'demonic' evil is impossible for human beings (*Religion,* cxxix).

19. See *Attack Upon Christendom* (Princeton University Press, 1968), xvii. The title of *Works of Love* is also meant to emphasize this point.

20. Søren Kierkegaard, *Fear and Trembling,* tr. Howard V. Hong and Edna H. Hong (Princeton University Press, 1984); my italics.

21. This intepretation takes issue with more traditional readings of the meaning of "subjectivity" in Kierkegaard's philosophy. For example, in his *The Logic of Subjectivity* (University of Alabama Press, 1984), Louis Pojman thinks that Kierkegaard's account of subjectivity implies a "doctrine of volitionalism: the thesis that we can attain beliefs by willing them," which "has been accepted uncritically by every successive existentialist" and derives from the same tradition that includes Augustine, Pascal, and William James (pp. 103–4). I think this is a misreading: faith is an *inward movement* for Kierkegaard, like the choice of the ethical, and in both cases the movement consists in an *identification* of the self with an aim or end. This is what Kierkegaard means by truth in the sense of *personal appropriation*. Faith, like moral responsibility, is a *wholly practical* attitude for Kierkegaard, and it has nothing to do with voluntarism about the *theoretical truth of propositions*. To Kierkegaard, someone who believed some objective claim (i.e. proposition) by simply deciding to do so would be guilty of aesthetic arbitrariness, just as Sartre would suspect them of bad faith.

22. "Whenever in a stricter sense there is [a] question of an either/or, one can always be sure that the ethical is involved. The only absolute either/or is the choice between good and evil, but that is also absolutely ethical" (Lowrie, EO II, 170).

23. As MacIntyre says, "Human beings can be held to account for that of which they are the authors; other beings cannot" (AV 209). Yet MacIntyre would at least need to add that a human being is typically *aware* of the intelligibility of her action under terms referring to her *own* intentions at the time of enacting it. In other words, the action must be *intrapersonally* intelligible.

24. See Robert Pippin's account of Hegel's debts to Kant's analysis of agency, as described in his "Hegel's Ethical Rationalism," in *The Modern Subject: Conceptions of the Self in Classical German Philosophy*, ed. Karl Ameriks and Dieter Sturma (SUNY Press, 1995). As Pippin says, for both Kant and Hegel, "we know . . . that actions are those events that are explicable by reference to a subject's reasons for acting, that such reasons always presuppose certain norms for action, and

that such norms can be norms only as self-imposed, as conferring value upon a course of action for a subject, and so cannot be understood in what has come to be called some strictly 'externalist' sense" (155). Kant understands the self-imposition of norms differently than Hegel does, however. In particular acts, we *freely incorporate* the maxim we act on, as well as the norms or practical laws implicit in the ground or motive that led us to adopt that maxim.

25. For example, when the action is deliberate but done under "duress," or when done deliberately but without control of the act *or* the 'internal' source it flowed from (see the discussion of the insanity defense in *United States v. Freeman*, U.S. Court of Appeal, Second Circuit, February 1966, 357 F.2d 606). Our distinction between voluntary manslaughter and 'murder one' is based on the same intuition.

26. *Concluding Unscientific Postscript*, tr. Swenson and Lowrie, "The Subjective Thinker 2," 302; my italics.

27. And in fact, the *source* of this authority is not an issue the Judge anywhere directly addresses in the text, as important a question as it is. This problem is taken up by later pseudonyms in Kierkegaard's authorship.

28. See Henry A. Allison, "Spontaneity and Autonomy in Kant's Conception of the Self," in *The Modern Subject: Conceptions of the Self in Classical German Philosophy* (SUNY Press, 1995): 11–30.

29. Kant, *Religion*, Book One, "Observation," 19.

30. Ibid.: ". . . only thus can an incentive, whatever it may be, co-exist with the absolute spontaneity of the will [*willkür*] (i.e. freedom)."

31. Harry Frankfurt, "Freedom of the will and the concept of a person," *Journal of Philosophy* 68 No. 1 (January 14, 1971); reprinted in Frankfurt, *The importance of what we care about* (Cambridge University Press, 1988), 11.

32. Ibid., 12.

33. Ibid., 14. The person's first-order "will" in this sense is similar to the Kantian notion of an *action-maxim* which includes a description of the act to be done and the end or purpose for which it is done. Note that the distinction Frankfurt makes between orders of the will roughly matches the distinction that Korsgaard makes between Kantian "maxims" of different orders (Korsgaard, 324).

34. Ibid., 17.

35. Ibid.

36. This, of course, is the basis for Frankfurt's controversial claim that causal necessitation (lack of alternative possibilities for action) is not incompatible with moral responsibility for one's actions. One can *identify* in the relevant sense with the motives for an action, even when these impulses would have led to the performance whether or not one was *unwilling* to have such a first-order will.

37. Frankfurt, "Freedom of the Will," 18.

38. Ibid., 17.

39. Whether or not the "incorporation" which is necessary for moral responsibility requires absolute spontaneity in Kant's sense, it *at least* involves authentic identification in Frankfurt's sense, i.e. the individual's identification with the first-order will he acts on.

40. This way of putting the relation of identification helps clarify its relevance for understanding why Kierkegaard's Judge says authenticity involves becoming "transparent to oneself" (Lowrie, EO II, 164).

41. Frankfurt, "Freedom of the Will," 18.

42. From 169 to 170, he imagines the aesthete thinking through several options for a career and never making a decisive choice, thus remaining what he is by default.

43. Compare this to Frankfurt's argument that the unwilling addict, who "identifies himself . . . through the formation of a second-order volition, with one rather than with the other of his conflicting first-order desires," thus "makes one of them more truly his own and, in so doing, he withdraws himself from the other" ("Freedom of the Will," 18).

44. This is the argument of *Either/Or* II, 185–87. In technical terms, the point is that 'internality/externality to self' is not equivalent to Aristotle's contrast between deriving from an internal source in the psyche or being caused by an external force.

45. Thus the Judge chides the aesthete as follows: "your mask is the most enigmatical of all. In fact your are nothing; you are merely a relation to others, and what you are you are by virtue of this relation" (Lowrie, EO II, 163). However, as Stephen Dunning argues in his study, *Kierkegaard's Dialectic of Inwardness: A Structural Analysis of the Theory of Stages* (Princeton University Press, 1985), the "ethical resolution" of *Either/Or II* corresponds to the resolution "to be related to the other" as described in "Various Observations" in *Stages on Life's Way* (103). As Dunning notes, while *Either/Or* presents "primarily a dialectic of the inner and outer" (or the intrapersonal relations), Kierkegaard's "In Vino Veritas" and "Various Observations" cover the same stages of the ethical, but "are more concerned with the relation between self and other (100).

46. The bracketed explanatory words are Lowrie's, but I have added my own subscripts to assimilate Lowrie's point more clearly to my analysis.

47. Since publishing the 1995 version of this essay, I have realized that Peter Mehl also gestured towards this distinction in his criticism of Solomon (see Mehl, "Kierkegaard and the Relativist Challenge to Practical Philosophy," reprinted in this volume, p. 22). In his discussion of self-reception in ch.3 of *Selves in Discord and Resolve* (Routledge, 1996), Edward Mooney also suggests that the point of the Judge's discussion of self-choice is not to imply that we posit values or ways of life, but that we inwardly appropriate these through the commitments that make us "crystallized particulars" (22). I differ from Mooney's analysis there only in holding that the identification or commitment involved in subjective appropriation is a kind of "self-assertion." At the primordial stage, perhaps we should say that it is neither just actively assertive, nor passively receptive, but 'middle-voiced.'

48. In fact Anthony Rudd has argued that Kierkegaard's conception of the "ethical" parallels MacIntyre's own view that projects "significant enough to give one's life a purpose and meaning" will necessarily involve social interaction and be bound up with institutions and "practices:" see Anthony Rudd, *Kierkegaard and the Limits of the Ethical* (Oxford University/Clarendon Press, 1993), 94.

49. George J. Stack, *Kierkegaard's Existential Ethics* (University of Alabama Press, 1977): see chapter 3 in particular.

50. Stack, 92: "Insofar as Kierkegaard's conception of ethical existence appropriated at least some of Aristotle's views concerning the ethical becoming of man this may serve to indicate that two rather common interpretations of Kierkegaard's analysis of choice are basically false[:]. . . the assumption that Kierkegaard defends a conception of absolute freedom (à la Sartre) and that he propounds an irrationalist conception of choice."

51. Stack, 95.

52. Stack, 93.

53. As Stack points out, both Kierkegaard and Aristotle agree that "deliberation can only be brought to an end by a decision to choose or by the actualization of the possibility of choice. Deliberation is the condition for the possibility of choice, but it neither entails nor initiates choice" (93).

54. *Concluding Unscientific Postscript*, tr. Swenson and Lowrie, "Subjective Thinker 2," 302; my italics.

55. Stack, 94.

56. Ibid., 94–95.

57. Ibid., 96

58. Ibid., 101.

59. Rudd, 99. There is some truth in this claim, however. Note that it accurately encapsulates Duns Scotus's ethics, which is in some respects the beginning of a line that leads to Kierkegaard.

60. Ibid., 93.

61. Obviously my position and Rudd's have converged quite a bit since this essay was originally published in 1995. My new essay in this volume much more closely follows some of Rudd's formulations in *Kierkegaard and the Limits of the Ethical*.

62. Pippin, "Hegel's Ethical Rationalism," 156.

63. Ibid., 153.

64. As Pippin points out, this objection is deceptively similar to the Humean objection that "no consideration of what an impartial agent, motivated by no motives particular to him, would do could ever be on its own a motivating factor in action" (157). Interestingly, however, Pippin resists the idea that Hegel's view is a more subtle 'communitarian' version of Hume's in this respect (157–58).

65. Bernard Williams, "Persons, character and morality," reprinted in *Moral Luck: Philosophical Papers 1973–1980* (Cambridge University Press, 1981/1985), 12.

66. For this reason, the Judge says of the primordial either/or, "That in a sense it is not a question of the choice of a particular something, you will see from the fact that what appears as the alternative is the aesthetical, the indifferent" (Lowrie, EO II, 181).

67. Dunning, *Kierkegaard's Dialectic of Inwardness*, 78.

68. This further hypothesis also reflects the ethical optimism characteristic of this pseudonym, which is qualified by the more advanced perspectives of later pseudonyms, such as "Anti-Climacus" in the *Sickness Unto Death*. But as we shall see, the Judge's optimistic hypothesis is in principle dispensible for Kierkegaard.

69. Stack, 98.

70. Compare Heidegger's conception of the person's *ownmost meaning* (*Being and Time*, tr. Macquairre and Robinson, H178, H187–88, H250–1, H202–3).

71. This formulation of the Aesthetic in Kierkegaard's sense should remind one of Sartre's infamous waiter in the chapter on "Bad Faith" in *Being and Nothingness*.

72. For example, MacIntyre complains that the existentialist self is a 'ghost' without enduring character who thus lacks any rational basis for ethical choice. The conflation here occurs because MacIntyre understands V-H arbitrariness to be a *result* of N-M arbitrariness.

73. Thomas Nagel, *The View From Nowhere* (Oxford University Press, 1986), 118.

74. Ibid.

75. What I attribute to Kierkegaard in this and the following section is a *partial* resolution of this problem; the full existentialist answer to it will require a theory of *laws of volition* that is beyond the scope of this essay.

76. Harry Frankfurt, "Rationality and the Unthinkable," new in *The importance of what we care about* (Cambridge University Press, 1988); 179. Frankfurt borrows the phrase from Rawls, who criticizes utilitarianism for defining agents as 'bare persons' who lack any determinate conceptions of the good which commit them to substantive loyalties (see Rawls, "Social Unity and the Primary Goods").

77. Ibid., 178.

78. Ibid., 178, 182.

79. Frankfurt, "The importance of what we care about," reprinted in *The importance of what we care about*, p.84.

80. Ibid., 85.

81. Frankfurt, "Rationality and the Unthinkable," 181–82 (my italics). Frankfurt goes out of his way to make clear that this volitional capacity is to be distinguished from all other enabling conditions such as "opportunity and power" to act in the relevant way. Thus, "It may be that he would be able to perform the action easily, if only he had the will" (182). It is clear in retrospect that it is the possibility of this sort of purely volitional incapacity that Frankfurt has in mind when he objects to Sartre's famous example of existential decision. However, unlike Sartre, Frankfurt always thinks of "decision" not as volitional *resolve* but as essentially an act of rational "deliberation," and thus he calls it "making up our *minds*" (see 172–74, 181, 182).

82. Frankfurt, "Identification and Wholeheartedness," 174.

83. The meaning of this existentialist claim was altered by Sartre, however, who used it to mean that someone already always has a *highest-order* volition with which they are inwardly identified, or an "original project" as he called it. As we have seen, this idea is also implicit in Kierkegaard's critique of the aesthete.

84. I develop this idea much more fully in "Towards an Existential Virtue Ethics," new in this volume.

85. "He who would define his life task ethically has ordinarily not so considerable a selection to choose from; on the other hand, the act of choice has far more importance for him" (Lowrie, EO II, 171).

86. Kierkegaard's Judge selects marriage as his paradigm of decisive ethical choice in the first letter of *Either/Or* II. Clearly, marriage would be meaningless if

it entailed no change in oneself which made the option of being unmarried at least *less* available than it was when one was trying to decide whether to propose.

87. One will recognize here an echo of the first line of Kant's *Groundwork* Part I. That is appropriate, because this analysis of will in terms of volitional identification or 'incorporation' both makes clear the meaning Kant had intended in his claim that only the good will is absolutely good, and why Kierkegaard follows Kant in a view that leads to the same conclusion.

88. Søren Kierkegaard, *Sickness Unto Death*, tr. Howard V. Hong and Edna H. Hong (Princeton University Press, 1980), 'In Despair to Will to Be Oneself: Defiance,' 68.

89. Note that this 'defiant' person's will is fundamentally the same in structure as the aesthete's 'bad faith' (as I analyzed it), but with this crucial difference: the highest-order will *not to identify* or authentically care about anything is fully open in the demonic person (in Nietszchian 'amor fati' style), whereas it is only tacit in the aesthete's bad faith. This is important, because it shows not only why the demonic man sins while the ordinary aesthete does not, but also why every aesthete has the potential to become demonic if, when the moment of primordial choice comes, he or she rejects ethical existence.

90. *Sickness Unto Death*, 69. Of course, the demonic man is responsible for his defiance of the ethical: this is consistent, because his highest-order project is not *itself* V-H arbitary, even though it is the project of being thoroughly V-H arbitrary in second-order character.

91. *Sickness Unto Death*, 70.

5

The Place of Reason in Kierkegaard's Ethics

GORDON D. MARINO

Summary

What role, if any, does Kierkegaard assign to reason in ethics? Making constant reference to a book that challenges Kierkegaard's account of the ethical (Alasdair MacIntyre's After Virtue[1]*), the essay that follows is a reply to this question. Through some fault of his own, Kierkegaard has left MacIntyre and others with the impression that he did not believe the choice to live in ethical terms could be defended on rational grounds. Contra MacIntyre, I shall argue that Kierkegaard does in fact offer reasons for advancing from the first to the second stage on life's way. However, having defended Kierkegaard from one charge of irrationalism, I argue that when considered as a moral phenomenologist Kierkegaard did in fact underestimate the role of reason. Thus MacIntyre is right to complain that Kierkegaard paid insufficient attention to the problem of adjudicating between conflicting moral claims.*

1. A Synopsis of MacIntyre's Reading

MacIntyre hypothesizes that in the late seventeenth and early eighteenth centuries, morality emerged as a concept without a home, either in theology, law, or aesthetics (AV 39). Unhoused as he claims it was, the need for a justification of morality loomed up in the "enlightenment project." This project first failed, and with all hope being abandoned in the coming of a messianic justification, the more decisive cultural event took place—the project was perceived as a failure. It is in the protracted here and now of this dispiriting perception that MacIntyre situates the present dark age, an age which envisages moral debate in terms of a confrontation between incompatible and incommensurable moral premises and moral commitment as the

113

expression of a criterionless choice between such premises, a type of choice for which no rational justification can be given (AV 39).

Kierkegaard plays a protagonist's role in this, the first of MacIntyre's multi-volume philosophical drama, and with the purpose of illuminating both Kierkegaard's and MacIntyre's texts, I propose in what follows to examine a critical section of *After Virtue*. Please note, however, that in this section MacIntyre identifies Kierkegaard with one and only one text. For MacIntyre, Kierkegaard is *Either/Or* and *Either/Or* is Kierkegaard. Apart from one glancing reference, no other works are touched upon, let alone treated.

MacIntyre isolates three key features of *Either/Or*. For one, he notes that the book's mode of presentation and content are mirror images of one another (AV 39). As for the content, MacIntyre insists that through all the voices in *Either/Or* one message is bell-clear, there are no rational grounds for choosing between the ethical and the esthetic (AV 40f). There are no real arguments, only hurrahs and gestures of commendation. And so, MacIntyre glosses, we find in this work the perfect coincidence of form and content. Once more, the thesis is that there are nothing but commendations, and commendations are all the reader gets. 'A' commends the life of the esthete; 'B' (Judge Wilhelm) commends the life of duty; and the editor, Victor Eremita, arbitrarily arranges the recommendations of 'A' and 'B'.

Feature number two is this—for Kierkegaard, and not coincidentally, for Kant, "the ethical is presented as that realm in which principles have authority over us independently of our attitudes, preferences and feelings" (AV 41). But whence comes this absolute authority? For MacIntyre? For MacIntyre's Kierkegaard? And finally for Kierkegaard? To query number one MacIntyre replies: "To answer this question (whence comes the authority of ethical principles) consider what kind of authority any principle has which it is open to choose to regard as authoritative" (AV 42). Be it a principle of practical reasoning or the eleventh commandment, said principle or commandment has as much authority as I can give reasons for heeding it, so that "a principle for the choice of which no reasons could be given would be a principle devoid of authority" (AV 42). On MacIntyre's reading, Kierkegaard offers no reasons for choosing the ethical over the esthetic and so he presents Kierkegaard as blundering—the ethical has absolute authority, the ethical has no authority (AV 42).

Finally, MacIntyre calls attention to what he takes to be the fact that *Either/Or* is a highly conservative document, and he adds that the book's hidebound quality is at odds with the novel form of moral self-justification that Kierkegaard is depicted as peddling. True, it could be argued that the author of *Either/Or* was very soon to become, if he wasn't already, a spiritual insurgent of the first order, but just the same, MacIntyre persists in

claiming that the Kierkegaard of 1842 was trying to scribble in a "new practical underpinning for an older and inherited way of life" (AV 43). MacIntyre continues, "it is perhaps this combination of novelty and tradition which accounts for the incoherence at the heart of Kierkegaard's position" (AV 43).

2. Who is MacIntyre's Kierkegaard?

Anyone who has browsed through, much less written an introduction or two on Kierkegaard knows well enough that if you must equate Kierkegaard with the author of *Either/Or*, do so with all trepidation, for more than any of his many pseudonymous works, Kierkegaard held this, his bestseller, at a distinct arm's length. MacIntyre has been the full length of the corpus, and he has written a pair of critical summaries, but he still draws the equation with insufficient reluctance. To be sure, the reader is officially informed that one could argue what many scholars feel free to assume, namely, that if there is an ethical theory in *Either/Or*, Kierkegaard himself did not hold it. MacIntyre acknowledges that even if Kierkegaard did take the position *After Virtue* nails him to, it was not for long. Though he does not indicate how he thinks Kierkegaard's ethics have changed, the author is careful to whisper that by 1845 and with the publication of *Philosophical Fragments*, Kierkegaard's characterization of the ethical "has changed radically" (AV 41). But note well, this radical change "had become already abundantly clear even in 1843 in *Frygt og Bæven*" (AV 41);[2] that is, less than a year after completing *Either/Or*.[3] This much of a confession can be dragged out of *After Virtue*—if MacIntyre's Kierkegaard was Kierkegaard at all, it was only for a few of Kierkegaard's earliest semesters.

If, as the narrative insists, the Kierkegaard of *Either/Or* is laboring to lay a foundation for morals, then it would be absurd to identify him with any of his esthetic alter egos. But more than trying to ground morals, it is critical to this chapter of MacIntyre's history that Kierkegaard be considered a regular bastion of conservatism. Kierkegaard is supposed to be confused and incoherent, and the source of his muddled state is supposed to be the implacable need to combine immiscibles—radical choice and conservative values (AV 43). In point of fact, MacIntyre hints at what he is about to do, namely, to fuse the figure of Kierkegaard with that of the conservative and orotund Judge Wilhelm (or 'B'). Here are the fingerprints; while Kierkegaard is nowhere and everywhere in *Either/Or*, "perhaps we detect his presence most all in the belief that he puts into the mouth of 'B'. . ." (AV 41). Perhaps nothing. So far as MacIntyre is concerned, Kierkegaard's moral theory is the latent content behind the Judge's

manifest moralizing. For, if not the Judge, then who is the credulous curator of traditional values that MacIntyre has as his Kierkegaard of 1842? Note, however, that the Judge's style, his spoony Christianity, to say nothing of his self-contradictions are signs enough that this frequently touching, but often boorish pate is hardly a man after Kierkegaard's own heart.[4]

But are the ethics of Judge Wilhelm the ethics of the young Kierkegaard? Though I am by no means certain,[5] I move to accept MacIntyre's donee, for who, after all, can argue with someone as close to Kierkegaard as Kierkegaard's Johannes Climacus? And as Johannes tells it, the second part (of *Either/Or*) represents, "an ethical individuality existing on the basis of the ethical."[6] The equation drawn and accepted, let us examine MacIntyre's claim that in *Either/Or* Kierkegaard is not only representing the ethical but announcing the utter irrationality of it. According to this announcement, no one person can give another reason for understanding his or her life in ethical terms. No, as MacIntyre reads it, the choice of moral striving and guilt is a criterionless choice. But does MacIntyre's description fit?

3. The So-Called Criterionless Choice

Although he will disregard Kierkegaard's self-explanations a page later, MacIntyre is right to report that, "Kierkegaard's professed intention in designing the pseudonyms of *Enten/Eller* was to present the reader with an ultimate choice," *enten*—the ethical, *eller*—the esthetic mode of living and regarding life. Hypothesizing again, MacIntyre suggests, "suppose that someone confronts the choice between them, as yet having embraced neither" (AV 40). Well then, that someone is a self-deluded esthete. For Kierkegaard, there is no sitting on the fence between selves. If you have not chosen, you are an esthete, but if you are really facing the choice, you have already chosen to choose.

There simply is no earnestly facing the choice qua an individual who has yet to choose, for to acknowledge the choice is to affirm that you have a self, which marks the second, not the first, stage on life's way. And that in one breath is why Kierkegaard believed he only needed "to present the reader with an ultimate choice" (AV 40).

MacIntyre obliquely discloses the impossibility of the Kierkegaardian self on the fence. He comments that for Kierkegaard and certainly Judge Wilhelm, there is no choosing the esthetic (AV 40–41).[7] MacIntyre writes as though he believed the infallibility of the first genuine choice follows from the passion with which it is made—and that is that. It isn't. Of course, once the inwardness, which earmarks the ethical is present, the choice is made; and so, again, one cannot earnestly hover between life A

and life B. But even apart from this, there is no choosing the esthetic, simply because there is no one to choose it. As our public servant defines it, "the esthetical in a person is that by which he is spontaneously and immediately what he is" ("det æsthetiske i et Menneske er det, hvorved han umiddelbar er det, han er"[8]). Be he or she a sensualist, sincere social activist, or knight of faith, everyone has, or is, their esthetic side, and Kierkegaard repeatedly warns, we had better remember it. Once more, the earnest choice of oblivion that MacIntyre reproaches Kierkegaard for overlooking would amount to an earnest choice not to choose. But the choice not to choose would be the very kind of serious choice that the purely esthetic precludes. Rightly or wrongly, the Kierkegaard that MacIntyre's narrative takes to task has it that there is no leaping in and out of the *lethe* of immediacy. There is despair and defiance, but no dashing the brains out of self-consciousness.[9] The individual who is either gullible or serious enough to come to the uncoerced conclusion that he must choose between one self-perspective and another, is, by Kierkegaard's standards, a pretty serious fellow who has, in his very quandary, already acknowledged his ethical identity.

All unacceptable hypotheses aside, MacIntyre explains that the self, so situated between selves, could not be given reasons for the final imperative: I should choose the ethical, or for that matter, I should choose the esthetic (AV 40). Echoing *After Virtue's* analysis, the esthetic is no choice at all and, so for the purposes of the reconstructed argument we may proceed— any chain of moral reasons that might be stretched before an esthete presupposes his regarding those reasons as having force. Choose good and evil, the moralist imagines he is arguing, for by relating to yourself in those terms you will best "serve the demands of duty, or to live in that way will be to accept moral perfection as a good and so give a certain kind of meaning to one's actions" (AV 40). But what does a Sybarite care about duty, moral perfection, or meaning? Nothing, answers MacIntyre in his synopsis; for Kierkegaard it is only by radical choice, that is, a choice for which no reasons can be adduced that we come into the ethical, and it is only by radical choice that the ethical comes into its foundations.

Judging both from his encyclopedia entry[10] and *After Virtue*, MacIntyre has been pressing long and hard to inoculate every student against what he takes to be the dangerous charms of Kierkegaard's irrationalism. The already-mentioned scourge term is the so-called "criterionless choice" that MacIntyre's Kierkegaard enjoins us to make. And what renders the choice of the ethical a criterionless choice? Once again, the fact that it is supposed to be a choice of first principles renders it a criterionless choice. And if the proof is in the act of choice? It makes no difference. If a converted Don Juan cannot provide the next Don Juan with compelling reasons to follow his lead, his conversion is without a basis in reason. And

what is to count as a compelling reason? As I understand MacIntyre, so long as the esthete has a choice that reason cannot mindlessly make, say the choice whether or not to give force to appeals to a meaningful life, he has no reason. But, to cover the same ground again, we always have a choice, which is not to say that we always have a coin to toss. There is, as the sequel to *After Virtue* concedes,[11] something in between chance and demonstration; or more to my point, from the fact that one life view cannot be strictly deduced from a crumbling or absent other, it does not follow that the choice of the one, from within the context of the other, is necessarily arbitrary.[12] Besides, the Judge explains that and why it is in an individual's enlightened self-interest to choose the ethical.

Make no mistake about it, A and B are not from different planets. Whether or not it is to his ultimate discredit, if the Judge could step out of his pages, he would be quick to remind MacIntyre that there is more continuity (equilibrium) between the ethical and the esthetic than MacIntyre encourages us to imagine. Even assuming that the Judge has made the turn he is prodding A to make, he has not left the esthetic behind.[13] He need not march back and forth to the Royal Library and lucubrate for months on end in order to reconstruct the world as seen through the categories of hedonic interests. The Judge argues that A has every good reason, every rational motive, for choosing to live seriously as opposed to indifferently. There is only space and call for a sample of these briefs,[14] but each comes to this—an ethical existence is superior to and/or a cure for the ills endemic to estheticism.

No more an ethical theorist than an ethical rigorist, the Judge charges that there is no unity in a life that cannot sit still.[15] Since there is no unity in his life, A cannot provide a coherent account of himself.[16] And in the event A couldn't care less about giving a coherent account of his life, B admonishes, "he who cannot reveal himself cannot love, and he who cannot love is the most unhappy man of all."[17] Everyone wants to be happy, therefore one should choose the ethical, for it is only by that act of choice that a person can create the ballast that makes unity and happiness possible. In 1839 Kierkegaard remarked, "longing is the umbilical cord of the higher life." The Judge more than agrees;[18] he fills in the content of what he takes these ubiquitous longings to be. There are, he assumes, universal desires for *inter alia* a life view, meaning, serenity, and as mentioned, happiness. In short, the allegedly debunking question of the esthete's "giving force" to the terms of the Judge's appeals does not arise. True, every desire will appear differently according to the categories through which it is conceived, but both the Judge and Kierkegaard suppose that there is enough continuity to reason the esthete out of one conception and toward another. And so B writes as though to grant "think of these ends as you may, there is more meaning, peace of mind, and happiness in a life devoted

to duty than in one devoted to fleeing boredom." And if beauty be your lodestar then take heed, there is more beauty to be garnered with an eye fixed upon the Good than with one trained for the interesting.[19]

Finally both character and creator assume that despair is everyone's negative Prime Mover. On solid evidence, if not confession, the Judge diagnoses his friend as a case of intense (and so for Kierkegaard, promising) despair. Though only possessing a balm, B offers the remedy that Kierkegaard's anthropology has A groping for. What is twice as important, he argues, and with Kierkegaard's blessings, that where the esthete has a goal—e.g., happiness, success—the conditions for satisfaction are always beyond the ken of his control.[20] This, having one's axis outside of oneself, emerges as the primary definiens for despair and from it B draws out the conclusion that a fleeting, unduty-bound existence is necessarily a despairing one.[21] Despite the curtain of problems that Johannes *de Silentio* is poised to let drop, the Judge assures his distraught companion that nothing can come between an individual and his duty. So again, if only by reason of its being a cure, A should choose the ethical and by implication, he should choose to regard himself as the culprit responsible for his despair.[22]

Even Aristotle throws up his hands here and there, and not just at the individual who will not listen to the law of non-contradiction. There is, for instance, no reasoning with the underground man who refuses to accept happiness as his final good. If the choice that Kierkegaard worked into his every work were an unloaded one between box A and box B, MacIntyre would have his point—but it isn't.[23] Explaining their inevitable failure to make compelling moral sense, MacIntyre remarks that Diderot, Smith, and alas, Kierkegaard, "all reject any teleological view of human nature, and of man as having an essence which defines his true end." And this is "why their project of finding a basis for morality had to fail" (AV 54). I cannot vouch for the other defendants, but the author behind the editor of *Either/Or* has his *telos*, and it is relative to it that choice finds its rational grounds. Whether or not Kierkegaard has the right *telos* remains another gaping question, but the *telos* is assumed to be there, pushing from behind (despair) and pulling from above (longing). All children of miraculous faith aside, every natural person is naturally in despair, some much more intensely than others. Some much more intensely than others, every natural person naturally yearns to be free of the despair which Kierkegaard contends every natural person is himself spinning. Aristotle's *Ethics* presupposes his psychology, and likewise Kierkegaard's concept of choice presupposes a universal but not universally recognized need to be whole. Despair is sin, sin the universal sickness, and faith alone the cure, which can only begin to be secured by a choice that A has yet to make and other choices that B (the Judge) may need his C and D to awaken him to.

4. A Critical Note

Understandably, Kierkegaard scholars complain that Kierkegaard was simply not trying to do the kinds of things that MacIntyre chides him for failing to do. As *After Virtue* tells it, Kierkegaard perceived Kant's failure to provide a basis for morals, panicked, and took up the search for the next Holy Grail. Now, there are entries aplenty on Kant in the *Papirer*, and it is true that Kierkegaard recognized that Kant had not exactly proven the esthetic life to be one of self-contradiction.[24] Nevertheless, there are no textual signs that this recognition ever prodded Kierkegaard into taking up the foundational project that MacIntyre charges him with bungling. Kierkegaard wrote and wrote about his writing and there is no hint of his aspiring to produce a basis for morals, and of this MacIntyre is well aware. Why then the decision to ignore Kierkegaard's hyperconscious intentions? Does MacIntyre believe that while Kierkegaard thought he was writing about choice in fundamental connection with the formation of the self and the purification of the will, he was actually struggling to solve a problem that he was unaware of being driven by? Is there a latent appeal to the unconscious behind MacIntyre's manifest historicizing? There has to be.

Do not get me wrong; I have no innate aversion to the idea that neither Kierkegaard nor MacIntyre necessarily knows what he is really up to; just the same, I see no reason for automatically dismissing an author's long-held and continuously-stated intentions. MacIntyre has a lot of territory to cover and naturally travels in seven league boots, oblivious to the nitpickers. But is it nitpicking to complain that MacIntyre has not shown Kierkegaard's self-explanations to be inadequate? He has not justified his appeal to oblique purposes by showing us why he takes Kierkegaard to be in the dark about his projects. If I am any judge of the present age, someone is bound to reply that the story is the demonstration, but that is a rather unconvincing story. As some of Freud's early case studies will attest, the richness of a narrative is no proof of the details of that narrative. Far from it, historical narratives, personal and otherwise, that roll smoothly and comprehensively along usually do so because they plow everything under. And for all his epiphanies, it must be said that MacIntyre has done his share of plowing. But now for one of the epiphanies.

5. The Place of Reason in the Moral Life

Though we may not have access to the justifications, Kierkegaard certainly held that there are universal moral truths. There is, however, another critical message in the bottle of *After Virtue*, and I shall argue that this message sticks. As I read him, MacIntyre charges that Kierkegaard fails to

acknowledge the role of reason in the moral life, and in a related blindspot, he fails to appreciate, let alone help us come to grips with, a fact that unsettles many a conscience and nearly every ethical theorist—the fact of moral diversity.

Kierkegaard's greatest service may well have been to paint the ideal or at least one constellation of ideals from the inside out. A psychological realist in his own right, Kierkegaard teaches us to see with discernment just what the world looks like through ideals otherwise quite easily bandied about. I am no expert keeper of records on such topics, but on my judgment Kierkegaard ought to be reckoned either the first or the best moral phenomenologist, and yet for all of the arresting detail of his portraits of perfectly fallen creatures striving to live in their thoughts of the right and the good, there is something missing. As MacIntyre observes, Kierkegaard pictures the earnest life as though there were nothing to it but what we moderns and postmoderns might call commitment. In his words and silences, Kierkegaard affirms that behind every piece of moral confusion there is a will flapping in the breeze of whims. If you don't rightly know what to do, then you don't really will to do what is right.

That moral worth has as little to do with moral reasoning as it does with knowledge, is indirectly revealed in Kierkegaard's jottings on the method of indirect communication. In his outlined but never delivered lectures on the ethico-religious dialectic of communication, Kierkegaard teaches that in the realm of the truly important there is much for a moral teacher to do, but nothing to teach; there is no object of communication, no knowledge to be conveyed. Kierkegaard's thinking is clear and Kantian enough. Moral duties are universal. If, however, I was wanting in knowledge, then I wouldn't be possessed of the duties that my sense of guilt assures me obtain. And Kierkegaard avows that if there is one thing I can trust it is my sense of guilt. Thus, while I may require a moral teacher to prevent me from eclipsing the knowledge to which my duty and guilt witness, I don't need anyone to put me in the know.

As every student of Kierkegaard comes quickly to understand, Kierkegaard believed the age to be suffering from an excess of mental activity; but in the excess of his struggles against such excesses, Kierkegaard could easily lead one to believe that every act of deliberation is an ethical evasion, that is, the will using reason to confuse and so excuse itself from what it now knows and is now trying to forget is its unconditional duty.[25] A grand master of suspicion, Kierkegaard was right to observe that reason often functions in the service of the pleasure/complacency principle, but is the abuse of reason a good reason to sow blanket suspicions about reason? My reason says, "no."

As I have complained, MacIntyre is mistaken to think that Kierkegaard does not offer reasons for choosing the ethical, but the justification of

particular ethical precepts is altogether another matter. To reiterate, MacIntyre argues that a principle has as much authority as we have reasons for abiding by that principle. As MacIntyre notes, Kierkegaard could not disagree more. An enemy of every form of meliorism, Kierkegaard is unambiguous, the ethical no less than the religious is "the unconditionally unconditional." Just as unambiguously, Kierkegaard warns that while the unconditional has its reasons, the provision of those reasons relativizes it and thus subtracts rather than increases authority.[26] MacIntyre reports that Kierkegaard was the first to sever the connection between reason and authority (AV 42). Again, Kierkegaard couldn't disagree more. According to his chronology of emerging ideas, it was only in the age of pure reason that people began to require explanations of their imperatives. Either way MacIntyre is on the mark, for Kierkegaard the force of our oughts in no way rests upon the answers to our whys. More than that, Kierkegaard would have judged the whole project of pressing for such reasons unethical. This is not hyperbole; listen to the terms in which Vigilius Haufniensis upbraids the individual who would dare to accuse good conscience of being unreasonable in its expectations: "The more ideal ethics is the better. It must not permit itself to be distracted by the babble that it is useless to require the impossible. For even to listen to such talk is unethical . . ."[27]—whether that talk be about being unable or about being unsure.

Kierkegaard all but takes it as a given that we ought to do what our father, worldly and other-worldly, commands us to do, and that is pretty much that. The ideal is obedience, and for all its other merits, obedience is not an ideal that is likely to prod consciousness-raising about either the interests of others or the consequences of our actions. But why should it? These are precisely the kinds of conditions that devotion to the unconditional has to be careful to blinker itself to. Though this is not to advise that one should ruminate until the moment to act has passed, it is irresponsible to cut the process of reflection short with the reflection that a choice must eventually be made, and besides, so long as you can imagine that you possess the best intentions, you cannot go morally wrong. But what is more important, doing the right thing or having the right intention? For Kierkegaard, as much as for Schopenhauer,[28] it is the intention, the relative purity of heart[29] that determines the moral worth of an action. The rest is external, which for Kierkegaard is to say, not of the utmost importance, i.e., "accidental." Take this page from the Journal, a page which happens to find its way into the papers of Victor Eremita:

> The main point is still that one should not be diverted by the external. When, in order to subvert the position that there is an absolute in morality, an appeal is made to variations in custom and use and such shocking examples as savages

putting their parents to death, attention is centered merely upon the external. That is to say, if it could be proved that savages maintain that a person ought to hate his parents, it would be quite another matter; but this is not their thought; they believe that one should love them, and the error is only in the way of expressing it. For it is clear that the savages do not intend to harm their parents but to do good to them.[30]

Note the initial intimation—such questions are not raised in good faith, but rather in an attempt to subvert and so to excuse oneself from the unconditionality of absolutes. Slit your parent's throats or sacrifice your life taking care of them, it is all essentially the same, so long as your intentions are good. For the one who finally gave us the esthetic of morals that Kant lacked the Muse to write, the main thing is not to allow externals—i.e., the perceived consequences of our actions—to make us flinch. As though perceived consequences had nothing whatsoever to do with our intentions!

The inordinate emphasis that Kierkegaard lays on the how of our actions and our beliefs has its natural shadow in a delusory de-emphasis on the question of what precisely is to be done. This imbalance is nowhere more apparent than in the lack of urgency Kierkegaard shows with respect to questions of social justice. And yet, it hardly needs to be written that our virtuoso of inwardness did not decry all forms of reflection. While Kierkegaard did not trouble himself unduly about the moral worth of this action as opposed to that, his conscience was downright yeasty when it came to trying to decide whether or not it was God's will that he do X or Y. Make no bones about it, he was quite concrete on this score, or as Kant would have judged him—he was quite fantastic. For Kierkegaard, believing in a personal God entails the belief that God may at any time be personally involved in the events of this world. Thus, the true believer utters his intercessory and petitionary prayers; and thus, Kierkegaard rather quietly insists that the knight of faith is ever searching the palimpsestal text of daily events for directive "hints from God."[31]

Kierkegaard was not much concerned with trying to hammer out the right secular "oughts," and in MacIntyre's terms, MacIntyre is essentially correct—for Kierkegaard "there were no great problems of interpretation," or at least not beyond deciding whether or not he was an exception to duties otherwise accepted. But when it came to hammering out what it meant to believe in God, Kierkegaard's reflections render it easy to see how Kierkegaard came to associate reflection with dizziness. For this essay's final illustration, in a much abused teaching, Jesus tells us that the poor will always be with us.[32] He also commands us to be merciful. Yet how can a peasant with neither money nor power be merciful? Kierkegaard understood well that the impecunious have plenty to wrestle with, but he was in his own way generous enough to add this characteristically Kierkegaardian

scruple. The poor ought to be merciful enough not to make the filthy rich feel filthy about their riches:

> So the discourse turns to you, you wretched one, who can do nothing at all; do not forget to be merciful! Be merciful. This consolation, that you can be merciful, let alone that you are that, is far greater than if I could assure you that the most powerful person will show mercy to you. Be merciful to us more fortunate ones! Your care-filled life is like a dangerous criticism of loving providence; you have it therefore in your power to make us anxious; therefore be merciful! In truth, how much mercifulness is shown toward the powerful and the fortunate by such an unfortunate! Which, indeed, is more merciful— powerfully to alleviate another's need or by suffering quietly and patiently to take care mercifully lest one disturb the joy and happiness of others?[33]

The answer worked out with both rigor and consistency is that the one fortunate in his misfortune is the more merciful, but I present this only as an instance of the kinds of interpretive problems that Kierkegaard recognized and of the kind of reflection he would seem to recommend. For all the paragraphs he may have turned over in his mind and into his diaries, there are precious few of the form: Is it right, for example, to do as Kierkegaard seems to have done, to lend money at interest?[34] There are double, triple, and quadruple reflections upon his duties to God, but very little scrupling about his duties to his fellow human beings.

Unfortunately, MacIntyre pays no heed to Kierkegaard's rather congenial critique of the tradition MacIntyre is trying to resuscitate, but as one distinctively Lutheran line of that critique repeats, the opposite of sin is not virtue, but faith.[35] Whether it be for the reasons Kierkegaard himself adduced, or for those woven into *After Virtue*, Kierkegaard had no faith that reason could compel us to compel ourselves to make the sacrifices that Kierkegaard understood to be the signature of the ethical. The conquest of self-love, to say nothing of the demon Kant could not discern, defiance, requires a much stricter taskmaster than we can bring to bear upon ourselves. For all his affinities with Kant, Kierkegaard marks this important difference:

> Kant held that man was his own law (autonomy), i.e., bound himself under the law which he gave himself. In a deeper sense that means to say: lawlessness or experimentation. It is no harder than the thwacks which Sancho Panza applied to his own bottom. I can no more be really stricter in A than I am or than I wish myself to be in B. There must be some compulsion if it is to be a serious matter. If I am not bound by anything higher than myself, and if I am to bind myself, where am I to acquire the severity as A by which, as B, I am to be bound, so long as A and B are the same.[36]

One of Kierkegaard's most astute interpreters, Louis Mackie, aptly puts the meaning of this journal entry in Kierkegaard's own apothogem— "no man is stronger than himself."[37] To put it in words that some claim have seen their day and their twilight, it is only by the love/fear of God that we are able to slip out of the snare of self-love and willfulness, and that— getting outside of oneself—is what distinguishes the ethico-religious from the esthetic. On this decisive point, MacIntyre's reading of Kierkegaard is true to the author that I know; for Kierkegaard early, middle, and late, moral reasoning and ethical theorizing have as little to do with being moral as they do with the quest which Kierkegaard marks as singularly important—the quest for a pure will.

NOTES

1. Alastair MacIntyre, *After Virtue* (Notre Dame, Ind.: University of Notre Dame Press, 1981) Hereafter referred to in the text as "AV."

2. It is clear that MacIntyre must recognize *Fear and Trembling* for the counterexample to his reading that it is. As MacIntyre's history repeats, Kierkegaard discovered the concept of radical choice and put it to the task of forming a basis for morals (AV 33). But if anyone ever made a radical choice it was Abraham, and he was anything but ethically justified. Just the opposite, as Johannes de Silentio puts it, no matter what the religious expression might be, "The ethical expression for what Abraham did is that he would murder Isaac." (*Fear and Trembling*, trans. Howard and Edna Hong [Princeton: Princeton University Press, 1983], p. 30).

3. By the latest reckoning we are actually talking about a period of approximately six months. See, "The Period of Composition of Kierkegaard's Published Works," by Alastair McKinnon and Niels Jørgen Cappelørn, *Kierkegaardiana* 9 (1974): 132–46.

4. For an excellent likeness of the Judge see Stephen Dunning's, *Kierkegaard's Dialectic of Inwardness* (Princeton: Princeton University Press, 1985), pp. 75ff.

5. In his *Kierkegaard* (London: Routledge, 1982) Alastair Hannay meticulously shows that one need not go beyond the covers of *Either/Or* to find a critique of the Judge's 'both/and' view that one has only to will the conventional (*'Det Almene'*) and all will be reconciled—inner and outer, spirit and flesh, ethical and aesthetic. See pp. 58–63.

6. Kierkegaard, *Concluding Unscientific Postscript*, trans. Howard and Edna Hong (Princeton: Princeton University Press, 1992), p. 253.

7. I follow George Stack here. See his "Kierkegaard's Analysis of Choice: The Aristotelian Model," *The Personalist* 52 (1971): 643–61.

8. Kierkegaard, *Either/Or*, vol II, trans. Howard and Edna Hong (Princeton: Princeton University Press, 1987), p. 178.

9. This is certainly one of the central claims of Kierkegaard's *Sickness Unto Death*, trans. Howard and Edna Hong (Princeton: Princeton University Press, 1980).

10. *The Encyclopedia of Philosophy*, ed. Paul Edwards, 4 vols. (New York: MacMillan Press, 1967), 4:336–40; see also MacIntyre's *A Short History of Ethics* (New York: MacMillan Press, 1966), pp. 215–18.

11. Alasdair MacIntyre, *Whose Justice? Which Rationality?* (Notre Dame: University of Notre Dame Press, 1988).

12. And so I would argue that the author of *After Virtue* is working with a somewhat hyperbolic notion of what is to count for a moral justification. For authors who have come to a conclusion similar to my own, see C. Stephen Evans in his essay, "Where there is a will there's a way: Kierkegaard's theory of action" (in *Writing the Politics of Difference*, ed. H.J. Silverman [SUNY Press: Albany, 1991], pp. 73–88) and Anthony Rudd, *Kierkegaard and the Limits of the Ethical* (Oxford University Press, 1993).

13. *Either/Or*, II:177–78.

14. For more exhaustive presentations of the Judge's defense of the ethical, see Harold Ofstad, "Morality, Choice, and Inwardness: Judge Wilhelm's Distinction between the Esthetic and the Ethical Way of Life," *Inquiry* 8 (1965): 33–73.

15. *Either/Or*, II:248, 262ff.

16. Ibid, II:202, 254, 322.

17. Ibid, II:159.

18. Ibid, II:242.

19. Ibid, II:271ff.

20. Ibid, II:179–80.

21. Ibid, II:192.

22. Ibid, II:208f.

23. Ibid, II:163–64.

24. MacIntyre is, however, right to emphasize what all too many Kierkegaard scholars, myself included, have failed to stress—namely Kierkegaard's debt to and dialogue with Kant. For an example of a scholar without this blindspot, I refer the reader to Ronald M. Green's *Kierkegaard and Kant: The Hidden Debt* (Albany: SUNY Press, 1992).

25. For a truly genial page in the hermeneutic of this kind of suspicion consider the *Sickness Unto Death*, p. 48.

26. See *Journals*, vol. 4 entry no. 4895–4896; also, vol. 3, entry no. 3091; 4900.

27. Kierkegaard, *Concept of Anxiety*, trans. Reidar Thomte (Princeton: Princeton University Press, 1980), p. 17.

28. See, for example, Schopenhauer's *The World as Will and Representation*, trans E. J. Payne (New York: Dover, 1969) , vol. I, Bk. iv, §66, p. 367f.

29. Kierkegaard, *Works of Love*, trans. Howard and Edna Hong (New York: Harper and Row, 1962), p. 150.

30. *Journals*, entry 889, p. 393, vol. I and *Either/Or*, II:69.

31. *Sickness Unto Death*, p. 82.

32. Matthew 26:11.

33. *Works of Love*, p. 301.

34. See Frithiof Brandt, *Søren Kierkegaard og Pengene*, 1935.

35. *Sickness Unto Death*, p. 82.

36. Kierkegaard, *The Journals of Søren Kierkegaard*, trans. and ed. Alexander Dru, London (Oxford: Oxford University Press, 1938), no. 1041, pp. 364–65.

37. Louis Mackie, *Points of View: Readings of Kierkegaard* (Tallahassee: University Presses of Florida, 1986), pp. 31–32.

I would like to thank the American-Scandinavian Foundation for their generous fiancial support and Poul Lübcke, Vanessa Rumble, Philip Rieff, and an anonymous editor of *Kierkegaardiana* for their helpful comments.

PART II

MacIntyre and Kierkegaard Today

6

Reason in Ethics:
MacIntyre and Kierkegaard

ANTHONY RUDD

Summary

This paper attempts to elucidate Kierkegaard's understanding of moral reasoning, comparing and contrasting it with that given by Alasdair MacIntyre. I argue that Kierkegaard's existential, first-personal approach to ethics does not lead to subjectivism or to the irrationalism of which MacIntyre and others have accused him. Rather, it enables him to offer a subtle account of the possibility of rational choice between apparently incommensurable alternatives—and one which avoids certain problems from which MacIntrye's account of ethical reasoning still suffers.

In this paper, I want to consider the striking and pessimistic account of ethical thinking in the modern world that Alasdair MacIntyre has presented in *After Virtue* and subsequent works. I shall argue that one can, while sympathising with much of what he says, still hold that greater moral resources are available to the modern self than he seems willing to allow for. I shall do this by considering the work of a writer whom MacIntyre dismisses in *After Virtue* as one of those who have helped to lead us into the modern morass—Kierkegaard. Kierkegaard's dialectic of the stages of life suggests firstly, how a rational appeal might be made to the disengaged or ironic modern self—one who stands outside of all traditions—to reengage with tradition, with those social roles that confer moral identities and carry standards of assessment with them. I shall concentrate on this theme and on criticising MacIntyre's own dismissal of Kierkegaard as an irrationalist. But I shall also argue, secondly, that Kierkegaard's work suggests ways in which the self may be able to find moral resources in a non-arbitrary way which do not depend, as MacIntyre supposes that they must depend, on tradition

and social values. Kierkegaard therefore shows us how modernity can be understood as an ambiguous, but ultimately positive phenomenon, even by someone who shares much of MacIntyre's account of the nature of morality, personal identity, and the formation of character.

<div style="text-align:center">

I

</div>

Central to MacIntyre's account of modernity is the rise of the idea of the self as disengaged, independent, self-defining. This is apparent both in social practice, and in theory. Within social life, we have experienced the decline of traditional communities of the sort that provided their members with a sense of identity, and the concomitant rise of the autonomous individual, whose social relationships are regarded as contingent, and alterable without affecting his identity. This development has not necessarily increased individual freedom; instead of the constraints imposed by the internal relations which bind a person to those relationships and roles which are constitutive of his or her identity, we suffer now from the constraints imposed by a purely external relationship to powerful bureaucracies, whether of the State or of private corporations. This radical individualism is also reflected in moral and political philosophy, political science and sociology, which, perhaps particularly in the English-speaking world, have been dominated by an abstract individualism, often taken for granted rather than explicitly articulated or stated.[1]

Of course, there is nothing original in these reflections; something like this diagnosis of modernity in terms of the rise of the autonomous individual and its increasing disengagement from tradition and community is accepted by proponents as well as opponents of modernity. However one might quibble about the details, it seems undeniable that something like this has taken place in the Western world over the last few centuries. What is more original in MacIntrye's narrative, is his estimate of the effect of this individualism on moral thinking. For him, the coherent moral thinking that flourished in premodern times, and which is still maintained by those communities which have stubbornly resisted the corrosive impact of modernity, has certain features which are incompatible with the presuppositions of modernity. These are: firstly, the notion that ethics is concerned with the direction of human life towards a *telos,* a goal, which is supposed to constitute the good for a human life; secondly, the idea that this *telos* can only be pursued socially, and that life in a properly ordered society is itself a crucial aspect of that *telos*; thirdly, that the identification of what the *telos* is, and the ways in which it can be pursued, involves a process of collaboration not only among people at any one time, but across generations (moral thinking is thinking which takes place within a tradition); fourthly,

that a central part of moral theory is the identification of those traits of character which enable one to pursue the good (the virtues) and those which hinder one in this pursuit (the vices). Similarly, moral practice, on this view, centrally involves the cultivation of the virtues and the suppression of the vices; this is itself a social activity which draws on the resources of tradition—both on the tradition of explicit, articulated thinking about ethics as pursued by moral philosophers and theologians, and the socially embodied traditions, the ways of doing things, which constitute the life of the community.

All these notions have been called radically into question by the rise of the modernist disengaged self. This modern self does not feel itself to be essentially constituted by its relations to community or tradition. Modern, post-Cartesian philosophy characteristically starts with the predicament of the individual asking, "What can I know?" and finding answers not in the tradition which he has inherited but in his own immediate clear and distinct ideas, or sense data. (Of course, few philosophers these days would put it as simply as this, but, despite the influence of such (very different) thinkers as Hegel, Wittgenstein, and Gadamer, this radically individualist account of knowledge—and so of moral knowledge—has continued to have a decisive influence on contemporary philosophy.) The notions that human beings have an essence, which can only be fully realised in the relation to a single *telos*; that there is an absolute Good for us, that there is a determinate set of virtues and vices which moral education can teach us to cultivate and shun; that tradition can be authoritative for us and so forth, have become immensely problematic, if not simply incomprehensible, to the modern self. What is left over from the older understanding of morality, is the idea that there are rules which regulate our social existence, prescribing or forbidding certain types of behaviour either absolutely, or in certain situations. And moral philosophy turns into the task of trying to explain why these rules should be binding upon us. According to MacIntyre, this "Enlightenment Project" of justifying morality failed, as it was bound to, for it was attempting to justify fragments of a once coherent conceptual scheme, taken out of the context which had given them sense.

MacIntyre's analysis of modernity seems to be wholly pessimistic. However, there is an irony in this, for that analysis itself is one that relies on a characteristically modernistic self-consciousness about history and conceptual change. MacIntyre forcefully argues that we cannot understand "morality" as though it were a timeless essence, to be uncovered by conceptual analysis; to understand moral concepts we have to understand their history and their social setting, how they have evolved. MacIntyre is a member of that very modernistic species, the historical philosopher—his whole methodology and understanding of philosophy is characteristically post-Hegelian (or post-Viconian), and is therefore decidedly un-Aristotelian.

MacIntrye's thinking subsequent to *After Virtue* has in fact moved in an increasingly Thomistic direction, but his perspective remains historicist.[2] He argues that rationality is tradition-bound; that claims can only be rationally assessed within the bounds of a tradition. Nevertheless, one tradition can still demonstrate its superiority over others, by displaying an ability to understand their weaknesses in its own terms, while continuing to resolve the internal difficulties which arise within it. Thomism itself came into being as a synthesis of rival traditions—Aristotelian and Augustinian—and this synthesis stands for MacIntyre as the paradigm of a fruitful encounter between rival traditions. But this distinctively historicist, quasi-Hegelian account of Thomism does not seem to be identical with St.Thomas's own standpoint, which appeals, not to the historically developing standards of assessment internal to a tradition, but to timeless, universal principles of rationality. (As well, of course, as revelation.)[3] MacIntyre criticises Rosmini for allowing his Thomism to become diluted by elements of the Kantianism which he was criticising;[4] but it seems that MacIntyre's Hegelian background has influenced his own version of Thomism. And it is hard to see how things could have been otherwise. For MacIntyre's own thinking did not develop within the sort of traditional community which he praises, but within the modern, liberal University which he condemns. Since, according to MacIntyre himself, most of us no longer stand in any real relation to a living tradition, how can our relation to the great thinkers of the past avoid being personal and selective? How can we, in reappropriating a thinker like Aquinas, avoid interpreting him in the light of our post-Kantian and post-Hegelian problems and assumptions? And given the fragmentation of the modern world, the lack of any consensus (which MacIntyre insists on, and deplores) how can we avoid having as many Thomisms, for instance, as there are Thomists, each, with his or her own background, problems and concerns, each looking at Aquinas through the lenses that they provide?

MacIntyre's work since *After Virtue* has focused on the question of how different traditions can understand one another; on how we can avoid relativism while recognising that rationality is itself constituted within traditions and cannot be appealed to as an external authority. But the considerations I have raised suggest that a more fundamental problem is that of how we, as modern or postmodern selves, can enter into a tradition in the first place. There is indeed some ambiguity in MacIntyre's use of the concept of a tradition. On the one hand he wishes to use the concept in a normative sense, according to which a tradition is the setting in which moral education and debate can proceed, because it carries within itself the standards of assessment, criteria of relevance, and so on, by appeal to which disputes between divergent views may be reconciled or decided. But he also sometimes uses the concept in a broader, descriptive sense, and in this sense

is prepared to call liberalism a tradition.[5] And, although he does not use that word of them, he plainly regards the particular mode of liberal moral enquiry that he calls "Encyclopedia," and the "Genealogical" project initiated by Nietzsche and carried forward by thinkers such as Foucault and Deleuze,[6] as traditions, in a sense.[7] This is the sense that they have their own defining paradigms and classic texts, and appeal to standards and argumentative techniques which are taken as fixed points of reference by their own members, but which would be rejected by outsiders. Nevertheless, they lack the normative adequacy of "traditions" in the former sense, since they are based on the denial of the rational authority of tradition.

Thinkers such as Rawls and Rorty have, in their different ways suggested that we should understand liberalism as merely the characteristic discourse of the Western democracies, rather than as the voice of autonomous, universal rationality. But it remains in an incoherent state as a tradition that is based on the rejection of the authority of tradition. Similarly, Genealogy, while it repudiates any notion of universal rationality, still has its own universalistic aspirations, in that it aims to subvert or undermine all tradition; and this is difficult to reconcile with its own status as one more tradition among others. For MacIntyre, liberalism and Genealogy are traditions *malgré lui;* they are traditions in that they lack the universality which they implicitly or explicitly claim, but they are not traditions in the sense of being vehicles within which genuine, constructive moral thinking can proceed, for their own foundational commitments to the ideal of the autonomous self prevent them from attaining that status.

The picture that seems to emerge is this. As modern selves, we can be participants in traditions in one sense; that we recognise that the intellectual and moral doctrines that have influenced us and to which we continue to appeal, cannot be justified in universal terms, but only in a circular fashion, by reference to the sensibility which they have themselves created or moulded. In that sense, we recognise that our beliefs and values are merely part of one tradition amongst others. But we have lost the ability to participate in traditions in the richer sense to which MacIntyre wishes to lead us back; we can no longer recognise a set of socially embodied moral principles and the tradition of their discussion and refinement, as unproblematicaly authoritative for us. The "traditions" to which we do belong are such as to inhibit rather than enable the sort of coherent moral development with which MacIntyre is concerned.

II

I first started reading Kierkegaard seriously after having been greatly impressed by my first reading of *After Virtue*. And it seemed to me that

much of what Kierkegaard had to say was extremely close to MacIntyre. (Or to be fair, that MacIntyre was very close to Kierkegaard.) Like MacIntyre, Kierkegaard's concern was not with a system of moral rules considered in the abstract—his concern was with the moral development of the person, his whole approach being agent- rather than act-centred. He was concerned with the long term development of character traits—virtues and vices. He too saw social roles as providing the essential setting for the development and exercise of the virtues. Why, then, is MacIntyre's account of Kierkegaard in *After Virtue* (he has hardly mentioned him in his subsequent work) so negative?

The answer seems to be that MacIntyre thinks of Kierkegaard as an irrationalist. This is still a common enough view of Kierkegaard, though one that seems to me quite untenable in the light of recent Kierkegaard scholarship[8]—or, indeed, simply in the light of an unprejudiced and careful reading of Kierkegaard. However, the image of Kierkegaard as an enemy of rationality and an apostle of arbitrary, criterionless choice has become well-entrenched. In what follows I shall try to show that Kierkegaard is opposed not to rationality, but to a certain metaphysical mythologisation of reason. The effect of his critique is to return us to a clearer understanding of what rationality is and of how it can function in the context of ethical and religious choice. In other words, Kierkegaard provides us with an understanding of ethical rationality which can allow us to confront in a constructive fashion, some of the problems which MacIntyre has raised.

I have said that Kierkegaard is often charged with irrationalism, but the charge is obviously a vague one. What is "irrationalism"? Many different things might be meant, but in this context, we should look at what MacIntyre himself is charging Kierkegaard with. He concentrates on Kierkegaard's *Either/Or*, which offers us a choice between an aesthetic/hedonistic and an ethical approach to life. Both points of view are expressed by pseudonymous spokesmen, whose papers are edited by yet another pseudonym. None of them is identifiable as Kierkegaard himself. The ethical and the aesthetic are presented in this book as incommensurable attitudes to life. What counts as a good reason for an aesthete (in Kierkegaard's sense) to do something will not be recognised as a good reason by the ethicist, and vice versa. According to MacIntyre, "Each of the two ways of life is informed by different concepts, incompatible attitudes, rival premises."[9] Accordingly, if "someone confronts the choice between them, having as yet embraced neither [then he] can be offered no *reason* for preferring one to the other." For him to choose the ethical or the aesthetic is to choose what sorts of reasons will carry weight with him, and therefore there can be no question of having reasons for what will count as a good reason.

This is MacIntyre's first objection to Kierkegaard; that his account makes rational choice in ethics impossible. The second is to charge that there is an incoherence within his conception of the ethical. In the ethical sphere, one is bound by principles and admits their authority irrespective of one's feelings or inclinations. But, so MacIntyre says, Kierkegaard tells us that the authority of those principles derives from our ultimately ungrounded choice. "[T]he ethical is to have authority over us. But how can that which we adopt for no reason have any authority over us? The contradiction in Kierkegaard's doctrine is plain."[10] MacIntyre traces this incoherence back to the fact that Kierkegaard has simply taken over a thoroughly traditional conception of morality, but given it a radically new sort of foundation, in arbitrary choice. However, this fails to explain not only why we should choose any ethical principles at all, but also why we should choose these particular principles (work, conventional bourgeois marriage, and so on) rather than another set. The traditional morality which Kierkegaard wants to support cannot, according to MacIntyre, be supported on the slender foundations of arbitrary choice which are all that he allows for.

MacIntyre's characterisation of *Either/Or* is strangely at odds with the book itself. Clearly, the idea that one could adopt the ethical by making a choice which one recognised to be arbitrary is absurd; the notion of arbitrary choice is itself an aesthetic one, and is therefore incommensurable with a serious ethical stance. Camus once remarked, "If all experiences are indifferent, that of duty is as legitimate as any other. One can be virtuous through a whim."[11] But this is wrong—it is a logical or conceptual error, a misunderstanding of the concept of the ethical. Of course, one can, on a whim, choose to *act* in a way that conforms to ethical rules. But to *be* ethical is to have internalised those rules, to have developed virtuous dispositions. In which case the actions which are prompted by those dispositions will not be whimsical or arbitrary. Could one choose to adopt such dispositions themselves on a whim? To do so would involve committing oneself to continue to work at the development of such dispositions over time. (If it did not, then it could not count as a choice to develop dispositions.) But a genuinely arbitrary choice is one which, by its nature, can always be reversed by another arbitrary choice;[12] it cannot, therefore, involve making a long-term commitment. The decision to continue working at the development of the virtues would have to be continually renewed by new arbitrary choices, and that would be flatly incompatible with the genuine development of virtues—that is, long-term dispositions.

Kierkegaard, however, is not guilty of this error (and neither is Judge William, his pseudonymous ethical spokesman in *Either/Or*). Judge William *argues* for ethical commitment. He does not tell his aesthetic interlocutor (identified simply as "A") to adopt the ethical stance because it is

his duty to (which would be begging the question) nor does he tell him to just choose it for no reason at all. (Volume 2 of *Either/Or* would have been a great deal shorter if that had been what he was doing.) Nor is he simply painting an idyllic picture of the charms of the ethical life, in the hope of making it look appealing. (He does try to do that but this does not take us to the core of his project. Obviously, persuading someone to adopt an ethical life by presenting it in aesthetically alluring terms would be missing the point.) What he does do is to argue that a purely aesthetic life is one that which makes impossible the development of a coherent sense of personal identity, and therefore one that makes personal fulfilment impossible. The aesthetic life is—and, Kierkegaard argues, is seen by its more insightful practitioners themselves to be—one of despair. What makes the ethical a rational choice for the aesthete is precisely that it contains within itself the resources which could enable him to overcome the limitations which become apparent within the aesthetic itself.

The aesthete's life is one of despair because it lacks continuity. What is essential to it, as Kierkegaard describes it, is the avoidance of commitments which would tie the self down, provide it with a stable identity. The aesthete will enter into relationships with others, will fill social positions and roles, but he will not see them as conferring any identity on him, will not regard those relations and roles as defining him. Kierkegaard's aesthetic pseudonym "A" describes himself as attempting to "insure against sticking fast in some relationship of life," in order to "make possible the realization of a complete freedom."[13] Hence, although he participates in social life and relationships, he does not commit himself to them, and always retains the option that he can "sheer off at will" from them. If this option is lost, "then you have lost your freedom; you cannot send for your travelling boots whenever you wish, you cannot move aimlessly about in the world."[14] Moreover, such commitments bring one "into fatal connection with custom and tradition . . ."[15] Kierkegaard's "A," then, is the prototype of the rootless, individualistic modern self, for whom all relationships, traditions and roles are contingent—Sartre's existentialist self; or the role-playing self of sociological theory.[16] (MacIntyre is, of course, well aware of this.[17])

Why does this constitute despair? It is because such a life has no principle of unity. To put it in MacIntyre's terms, it is a life which lacks a narrative structure. For the ethicist, life has meaning because it is directed towards the achievement of goals, which themselves lead on in intelligible ways to further projects at which she may succeed or fail. To understand any action is to situate it in a context which renders it intelligible, and that context is itself rendered intelligible by the wider narrative of the agent's life to which it contributes. Our lives make sense to us as long as we can tell ourselves an intelligible story about who we are and what we are doing.

To lack such a narrative structure in one's life is to lack any stable sense of personal identity, any sense of oneself as enduring through time as the same person, as one who can be the bearer of obligations and entitlements. (Which is why the aesthete is an amoralist.) The aesthete's life reduces to a series of moments, pleasurable or unpleasurable, but with no principle of unity discernable in them. Furthermore, the ethicist recognises that the projects and commitments which define her identity are themselves socially defined, and require engagement with—though not uncritical acceptance of—the traditions which give that society its sense of identity and coherence, which define what is characteristic about its way of life.

The preceding paragraph could equally well stand as a summary of the argument of chapter 15 of *After Virtue,* and as a summary of Judge William's argument for the ethical in *Either/Or.* This would seem to present MacIntyre with an uncomfortable dilemma—if he is using what are essentially the same arguments as Kierkegaard, then either Kierkegaard is not the irrationalist he took him for; or else, if he is, then so, too, is MacIntyre. But the summary I have given of Judge William's argument makes no reference to arbitrary choice. Rather, he admonishes the aesthete (and more generally, the modern disengaged self) that a stable personal identity can only be achieved through commitment to social roles and relationships which carry with them objective standards of assessment. One must become a participant in communities and the traditions which define them, and must develop the virtues necessary for such participation. The failure to do this will render one's life quite literally pointless. Without any unifying *telos,* one's life collapses into a series of disconnected moments, and to live in this way, when one has stripped off all illusions and is really aware of what one is doing, is to live in despair.

III

The character of the argument, it is true, is hypothetical. If one wishes to lead a meaningful life, then ethical commitments and the cultivation of the virtues will be necessary. But Kierkegaard postulates that we do all have, at least implicitly, such a desire for coherence and meaning in our lives. In *The Sickness Unto Death,* he argues that the self is a synthesis of elements or aspects which are in an (ideally creative) tension with one another—"the infinite and the finite . . . the temporal and the eternal . . . freedom and necessity."[18] But selfhood defined as such a synthesis is a task, not a given. To fail to resolve these elements into a synthesis is to be in despair—even if a despair of which we are often unconscious because we repress the awareness of it. And this is because, by failing to establish the synthesis, we are failing to develop stable selves. Kierkegaard's justification for this claim

is provided by his descriptions of the various stages and states of despair. If his descriptions are telling, if we can recognise ourselves in them, then the formidable-sounding theoretical framework which he assembles at the beginning of the work,[19] has justified itself by being put to work to produce perspicuous representations of aspects of human life.

In *Either/Or* this account is not worked out so formally, but the basic idea is already present. We have a desire for a coherent, meaningful life; this desire may not be consciously formulated in those terms, but it is present within us, and makes itself manifest in our feelings of boredom and despair when it goes unfulfilled. As MacIntyre notes, we are naturally story-telling animals; we do spontaneously seek, not only to understand our lives retrospectively in narrative terms but to live them in those terms. Where we are unable to find any coherent narrative which would make sense of other people's lives, we feel baffled and disturbed. And when we can find no coherent narrative structure in our own lives, we feel lost—despairing, even.[20] So if Kierkegaard and MacIntyre are right that we do have an unavoidable need for a meaningful narrative structure in our lives, and if they can show us that there is a connection between living one's life as a meaningful narrative, and making ethical commitments and developing the virtues, then they will have shown that the ethical life is (rationally) to be preferred to an amoral aesthetic existence.

This argument attempts to get round the problem of the incommensurability of the ethical and the aesthetic. MacIntrye had supposed that Kierkegaard was telling us that the ethical could not be chosen for a reason, "but for a choice that lies beyond reason, just because it is the choice of what is to count as a reason for us."[21] The thought is that there is no basis of agreement which the ethicist and the aesthete can start from, and therefore no possibility of rational argument between them. But this Kierkegaard denies. For him, we share a desire for our lives to be coherent narratives, and it is the failure of the aesthetic to meet that desire which makes it rational to prefer the ethical to it. One might object at this point that the aesthete is precisely someone who does not share that desire, who does not want to make her life a coherent unity, and who therefore has no reason to respond to the Kierkegaardian argument. But if MacIntyre were to take this line in defending his claim that Kierkegaard is after all an irrationalist, then he would have to explain why the same reasoning does not show that he is as well. For if some of us do not have the desire or need for a narrative structure in our lives, then we will have no reason to respond to MacIntyre's call to return to an Aristotelian form of ethics. His appeal to us to choose between Aristotle and Nietzsche[22] will become a call to make a choice as arbitrary as he thinks the Kierkegaardian choice between the aesthetic and the ethical is.

MacIntyre is acutely aware of the difficulty of showing how there can be rational argument between people who lack a basis of shared presuppositions. He admits that in *After Virtue* itself he has not given any adequate treatment of the issue;[23] it becomes, however, the major theme of his next two books. There it takes the form of the question how, if rationality is relative to traditions, can there be rational debate between traditions? ("Traditions" construed in the broad sense, whereby liberalism and Nietzschean Genealogy would count as traditions.) His answer is in some ways similar to the suggestion made in the philosophy of science by Imre Lakatos, addressing the post-Kuhnian question of how there can be a rational choice between rival scientific research programmes.[24] Lakatos rejects the simple Popperian idea that a theory can be conclusively falsified, but argues that some research programmes can be seen to be flourishing, overcoming their problems, developing fruitful new approaches and so forth, while others are degenerating, getting bogged down in difficulties that are not being solved, producing increasingly complex and clumsy auxiliary assumptions in order to defend their original theses. MacIntyre suggests similarly (though he himself does not make much of the parallel) that some traditions of moral enquiry clearly fail to meet their internal problems, or to adjust to changed circumstances, while others enjoy a greater success. Moreover, some traditions are able to give a convincing account in their own terms of why their rivals are failing. It is by these sorts of criteria that we are able to make rational choices between traditions.

MacIntyre's account is subtle and complex, and I shall not attempt to explore it further here. But two points are worth noting. Firstly, even if he is right, the sort of procedure he recommends would only entitle one to make a very tentative and provisional choice between rival traditions. One may show an unexpected power to cope with what had seemed to be a crisis, while another which had seemed to be flourishing may suddenly run into an acute and unforseen difficulty. And, as Feyerabend liked to point out in respect of Lakatos's analogous proposal,[25] in fact, research programmes may fade away, not because of their rational deficiencies, but because of all sorts of external pressures. The *zeitgeist* may be against them, clever propagandists may make them look ridiculous, funding may get cut off. As a result, talented people may be discouraged from becoming involved with that tradition, and its problems go unsolved as a result of the lack of capable researchers considering them. Thus a research programme may degenerate for reasons that have little to do with its inherent merits or demerits. In other words, the sort of rational preference that might emerge from the comparative procedure MacIntyre recommends, would not be enough to base a commitment to a way of life on.

This brings us to a second point. MacIntyre concentrates on the question of how we are to choose between rival traditions (or "modes" or

"versions") of moral enquiry. His concern is with the conditions for a rational choice between theories; hence, the plausible parallel with the philosophy of science. But this does little to address the question which Kierkegaard takes as primary; "How shall I live?" For all his serious and indeed passionate concern, MacIntyre takes as his main question, "How are we to establish or re-establish an adequate tradition of *theorising* about morality?" Kierkegaard's concern is not with the choice between different moral theories, but with the issue of why someone should make any moral commitments. His either/or does not call on us to choose between traditions of enquiry, but between ways of life.

From this, there follows the crucial point about Kierkegaard's methodology. It is essentially first-personal. Not in the Cartesian/empiricist sense of appealing to an abstract disengaged self, but, on the contrary, in appealing to real people in all the concrete circumstances of their lives. This is why *Either/Or* is written not as a formal treatise, but as a (rather strange) sort of novel. Judge William's letters in volume 2 of *Either/Or* are closely argued, but they are also frankly emotive and personal—as is appropriate, for they are supposedly not an academic book on ethics, but letters of advice written to a friend, whom the Judge has observed to his distress to be frittering away his life, and wasting his talents. Hence passages such as this celebrated one:

> Do you not know that there comes a midnight hour when everyone has to throw off his mask? Do you believe that life will always let itself be mocked? Do you think you can slip away a little before midnight in order to avoid this? Or are you not terrified by it? . . . Or can you think of anything more frightful than that it might end with your nature being resolved into a multiplicity, that you really might become many, become like those unhappy demoniacs, a legion, and you thus would have lost the inmost and holiest thing of all in a man, the unifying power of personality?[26]

For Kierkegaard, rationality in ethics is not something that can be impersonal, abstract, or objective. But it is nonetheless rational for that. The point is that ethical (and religious) questions only become intelligible if asked from the first-personal perspective. Their central concern is with how I shall live, what I should make of my life. If I fail to understand that the question is addressed to me in this way, then I have failed to understand what ethics is. Accordingly, what is demanded by rationality in ethics is not abstraction or detachment from my emotions, my passions, my particular circumstances, but a reflection on them that is itself passionate yet sober and rigorous. Since before Plato the metaphysical tradition has been opposing reason and passion as irreconcilable opposites, whether it has supposed that the task of reason is to subdue the passions, or with Hume,

that it is reason which should be the slave of the passions. What Kierkegaard argues for is a conception of passionate, interested rationality. But this so goes against the grain of dualistic assumptions in the central traditions of Western thought, that it has generally been misunderstood; Kierkegaard is thus regarded as an enemy of reason, an advocate of anti-rational emotionalism, or of arbitrary choice.

What he is really suggesting, though, is something quite different. According to Kierkegaard it is *rational* for me to choose an ethical over a purely aesthetic life (and a religious over a purely ethical life; but that is another, though related story). It is rational because aestheticism undermines the coherence of my life, destroys its narrative structure, and thus leaves me a prey to boredom and despair. To choose to live aesthetically in full awareness of that—and in awareness that there is an alternative way of life which promises to overcome such defects—would surely be grossly irrational. However, the only way in which the premise can be established, is by each individual applying it to his or her own life; engaging in the most honest and searching self-scrutiny. This involves my coming to an understanding of what matters most to me; what I really fear, desire, gain satisfaction from. Do I, on reflection, find my life to be meaningful, find that it embodies a coherent narrative? If not, do other possible attitudes towards life, which I can explore imaginatively through, for instance, the reading of literature such as Kierkegaard's, suggest the possibility of overcoming the sense of emptiness that I now feel? If so, then it is rational for me to abandon my present attitude to life and adopt the other one.

This process is analogous to the process whereby a scientist or indeed, one of MacIntyre's moral enquirers, decides to adopt one theoretical framework over another; not because of any knock-down proof, but because of the accumulation of problems with one approach and the comparative fruitfulness of its rival. Even in those cases, there is no algorithm to spell out exactly when it is the right time to abandon an apparently degenerating programme for a more promising one; a decision is required, based on an unformalisable "feel" for the situation. However, it is still possible to approach such decisions in a relatively "objective" spirit. The difference with the sort of case that Kierkegaard is considering is that the data on which the decision must be based are inescapably personal. If you do not have a passionate concern about how you are living and how you might live better, the questions which concern him will not even be intelligible to you.

Does this understanding of Kierkegaard's position enable us to overcome the line of criticism which I mentioned earlier? I noted that Kierkegaard appeals to the desire for a meaningful existence as something that we all have in common, and which provides a fixed point of reference against which different ways of life can be rationally judged. But surely to

acknowledge this desire, to accept the need for a coherent narrative structure in one's life, already involves adopting an ethical outlook. This criticism parallels the argument in the philosophy of science that observations cannot decide between different theories because they will be differently interpreted by those different theories. Nevertheless, it would be absurd to exaggerate this point in the way that some forms of structuralism seem to, and make theories into self-enclosed systems, sealed off against experience, or able to distort it into whatever shape they please. When a Ptolemaic and a Copernican astronomer are looking at the stars, or when an Aristotelian and a Gallilean are looking at the movement of a pendulum, there is a clear sense in which they are both seeing the same thing. Maybe they can both give an account of what they see that is formally consistent with their theoretical principles, but one of these accounts may be very strained, over-complex, and depend on a mass of ad hoc auxiliary hypotheses, while the other is simple, straightforward, and fits easily with the rest of the theory. In which case, other things being equal, it will be rational to prefer the latter theory, and then describe what the former theorist thought he saw, in terms drawn from the later, which we now take as giving the true (or at least the better) account of what it really was.

Similarly with the ethical case. The aesthete, if Kierkegaard is right, has a sense of emptiness and dissatisfaction, which he cannot articulate adequately in his own terms. "A" in *Either/Or* describes his own life as meaningless, unhappy, despairing.[27] Yet at the same time he does not quite take his despair seriously; he keeps it at arm's length by writing about it, by making it one more pose that he can adopt. Accordingly, Judge William's advice to him is that he should despair in earnest, really face up to the inner emptiness of his life,[28] for in this way alone can he gain the momentum that will impel him from the aesthetic sphere to the ethical. (Analogously, a contradiction or insoluble problem may exist within a scientific theory, known about but not really troubling the adherents of the theory. Only when some practical circumstance suddenly makes it important does the reality of that problem lead to an epistemological crisis, and motivate the researchers to explore other paradigms.) The aesthete and the ethicist will give different descriptions of the mental state which the self-conscious aesthete finds himself in. But they may still be recognisably describing the same phenomenon, and it may become clear to the aesthete himself, if he really attends seriously to his own state of mind, that the ethicist's description is more adequate, and is so in part because it suggests a way out from his despair.

Either/Or as a whole challenges us to compare the self-portrait of the aesthete in Volume 1, with the description of him that emerges from Judge William's letters in Volume 2, and consider whether the Judge's account enables us to gain a better understanding of "A" as he had

appeared to us in his own writings. Within the work itself, the Judge challenges "A" to consider whether the ethical perspective will enable him to articulate more adequately what he already feels about his own life. Of course, the aesthete may not be convinced. The ethicist would then regard him as a victim of false consciousness, someone who will not acknowledge his own nature because he is frightened by the demands that this might impose upon him. But the ethicist will not suppose that his inability to convert the aesthete shows that his own views are wrong—he finds his way of life justified by the way in which it satisfies the need he feels for narrative structure in his life.[29] The fact that one may not be able to argue an aesthete out of his aestheticism, does not make aestheticism a rational option. After all, one may also fail to argue a stubborn and consistent flat-Earther, or a fundamentalist who believes in the literal truth of the *Genesis* Creation story out of their beliefs; but that doesn't make *them* rational. As MacIntyre says, "The idea of *proof* is a relatively barren one in philosophy."[30] (Especially, we may add, in the sort of existential philosophy that Kierkegaard practices.[31])

I have attempted to explain the sort of moral reasoning Kierkegaard employs, in order to show that he is not the irrationalist that MacIntyre takes him to be, and to point out the striking similarities between his ethical thinking and MacIntyre's own. I have concentrated on *Either/Or*, and have so far taken it that Kierkegaard's own standpoint is to be identified with that of the ethicist in that work. But, of course, it is not as simple as that. Kierkegaard certainly regards the ethical as an advance on the aesthetic, but he did not at all regard it as the final truth, and went on to develop an account of the religious as transcending the ethical. In a sense, therefore, Kierkegaard is not simply siding with the ethicist against the aesthete; one always has the feeling that he is in fact personally closer to the aesthete he portrays (indeed, that what he gives us is very largely a self-portrait of his younger self) rather than to Judge William. We are thus left with the feeling that someone with the disconcerting brilliance, radicalism, and individuality of "A" will not be able to find fulfilment in the enlightened but still rather blandly conventional morality preached by the Judge. For him, if there is to be a real alternative to the aesthetic, one that will truly be able to satisfy his need for meaning in his life, it will have to be found in the harsher, more demanding challenge of the religious.

I shall not attempt to examine Kierkegaard's religious thought here. I shall, however, conclude by noting a number of problems for the purely ethical sphere which are raised by Kierkegaard's later works. It is interesting to note that these coincide rather closely with some of the main challenges that have been made to MacIntyre. Given the closeness of his stance to the sort of ethics defended by Judge William, this should not be so surprising. Firstly, there is the argument that the sort of ethical commitments

that Judge William (and MacIntyre) recommend are simply not available to us today. They depend on the existence of a stable community with relatively well-defined social roles, and agreement on basic principles, within which an education in the virtues can proceed. Clearly, this is not the situation in which we now live. MacIntyre, in *After Virtue,* seemed frankly despairing about the prospect for ethics in the modern world while also sounding both vague and utopian in his hope for "the construction of local forms of community within which civility and the intellectual and moral life can be sustained through the new dark ages which are already upon us."[32] But neither mournful nostalgia, nor Utopian fantasy offers much to someone who is concerned with how to lead a fulfilled and moral life in the conditions in which we do live now.

The second problem is that even if the moral commitments with which MacIntyre is concerned were still available to us, they would not be adequate to do the job that they are required to do—namely, to provide us with the coherent narrative structure in our lives for which we were seeking. This is in part because the argument in *After Virtue* and *Either/Or* gives us no criteria for deciding between different and incompatible *ethical* commitments. If there are a variety of different commitments deriving from work, citizenship, family life, friendships—how am I to combine and order them? (A particularly acute problem in modern society). MacIntyre recognises the need for a conception of one overriding *telos* for a whole human life[33] but in fact says little about how we can achieve this. In *After Virtue,* his positive prescription about the Good, "the good life for man is the life spent in seeking for the good life for man,"[34] seems, ironicaly enough, to have a decidedly modernistic, agnostic ring to it, as well as sounding disappointingly empty.

A third problem is that MacIntyre's views at first sight appear both conservative and authoritarian. Does his account of socially based morality allow for the free flourishing of the individual? Does it not risk turning into an apologia for the suppression of dissident or "deviant" minorities (or even majorities)? MacIntyre's essentially nostalgic picture on the coherence of traditional communities does not explicitly deny that those communities have often been stiffling or oppressive to their members, or to particular sets of their members, but it certainly doesn't stress this aspect. A more realistic view of the past and of what was wrong with the traditional communities which MacIntyre celebrates, might perhaps encourage us to think that there may be something to be said for the individualistic ideals of liberalism after all. Now MacIntyre clearly does not want to be an authoritarian; his own proposals for a better moral community are exceedingly vague, but they do seem to involve good liberal principles of dialogue and inclusion. One of the ways in which his historicist, post-liberal neo-Thomism differs from Aquinas's own position is that MacIntyre requires

his views to meet in rational, unconstrained debate, alternatives whose proponents would have burned at the stake in the time of St. Thomas.

What one wonders is whether MacIntyre is entitled to draw on such principles of toleration and openness without incurring a debt to the very liberalism which he has set out to oppose. And we also have to face the question; can a unity of beliefs and values be created without the use of force to suppress or exclude dissenters—as always happened in the past where unified communities have flourished? The alternative, which MacIntyre often seems to favour, would be to allow society to fall apart into a mass of small groups, each internally coherent, but sharing no common moral language. But in that case, we would still have to ask whether these groups would be entitled to constrain their members, if their own principles permitted them to do so; or would individuals be able to move freely between different groups? In the former case, we seem to have a sort of pluralistic authoritarianism; in the latter, we seem to have returned to liberalism. In any case, unless the communities could be physicaly isolated from one another, we would still seem to need a common set of principles to ensure peaceful co-existence between the groups. And for this, we would surely need to draw on the resources of modern liberalism. And here we might reflect that liberalism actually started this way, when adherents of different religious points of view realised that they could not impose their beliefs on their opponents, and therefore started to work out a practical *modus vivendi*, which gradually developed into the basic social morality of the tolerant State.

Kierkegaard addresses these issues in developing his conception of the religious; in essence he is arguing that the need for a strong sense of narrative unity in ones' life cannot come simply from the occupancy of social roles. He agrees with MacIntyre on the need for an overriding *telos*—"Purity of Heart is to Will One Thing," but argues that the "One Thing" cannot be any social good, but only "the Eternal".[35] (Which is really the problem of "A" in *Either/Or*, one that goes deeper than anything that Judge William is able to address—he knows that only "the Eternal" can give his life meaning, but he cannot find within him the possibility of belief. Which is also why Nietzsche thought that the "Death of God" would unravel the Ethical.) In *The Present Age*, Kierkegaard argues that the disintegration of traditional organic society is forcing the individual to stand on his own, and, by squeezing out the middle course of the socially established Ethical life, is forcing a choice between the aesthetic and the religious. And, although he has a certain nostalgia for the old order himself, and can hardly be enlisted as a social rebel or radical, he ultimately sees this as a valid and even liberating development. The process of "levelling" forces each individual to stand alone before God, without the support of a social morality, which inevitably harbours within it corruptions and complacencies.[36]

However, I cannot develop these themes further now. What I have attempted to show is that Kierkegaard is not the irrationalist that MacIntyre claims him to be; that he does advance positive views that are very similar to MacIntyre's in important ways; that he stresses a crucial factor in moral reasoning—its first-personal character—which MacIntyre somewhat neglects, though it is needed to make sense of his own account; and that this enables him to suggest a way of understanding how we can avoid moral relativism or arbitrary choice. And finally I have suggested, though briefly, that there are resources in Kierkegaard's thought for dealing with problems that dog MacIntyre's approach, and which enable us to give a more positive estimate of modernity and liberalism than MacIntyre is able to find.

NOTES

1. This may be less true of Continental countries where Marxism has had greater influence. It is, I think, important for understanding MacIntyre to remember that he was for a long time quite strongly sympathetic to Marxism, though never uncritical of it. However, in *After Virtue* he concludes that Marxism is itself caught up in the confusions of modernity which it had sought to diagnose—one more disease masquerading as the cure.

2. See the tentatively Thomistic *Whose Justice? Which Rationality?* (London: Duckworth, 1988) and the subsequent, firmly Thomist, *Three Rival Versions of Moral Enquiry* (London: Duckworth, 1990).

3. See J. Coleman, 'MacIntyre and Aquinas' and J. Haldane, 'MacIntyre's Thomist Revival: What Next?' both in *After MacIntyre*, ed. J. Horton and S. Mendus (Cambridge: Polity Press, 1994) for more detailed versions of this line of criticism; also MacIntyre's brief replies in the same volume.

4. *Three Rival Versions of Moral Enquiry*, 70–71.

5. *Whose Justice? Which Rationality?*, ch. 17.

6. *Three Rival Versions of Moral Enquiry*, chs. 1 and 2 and passim.

7. Although, to confuse things further, he tends to use "Tradition" in *Three Rival Versions of Moral Enquiry*, in an especially narrow sense, to refer specifically to the Thomist tradition.

8. See, for instance, amongst recent English-language scholarship on Kierkegaard, C. S. Evans, *Kierkegaard's Fragments and Postscript* (Atlantic Highlands, NJ: Humanities Press,1983) and *Passionate Reason* (Bloomington, IN: Indiana University Press, 1992); M. J. Ferreira, *Transforming Vision* (Oxford: Clarendon Press, 1991); M. G. Piety, 'Kierkegaard on Rationality', (*Faith and Philosophy* 1993) [reprinted in this volume]. I give a fuller account of the role of rationality in Kierkegaard's ethical thought, in my book, *Kierkegaard and the Limits of the Ethical* (Oxford: Clarendon Press, 1993).

9. *After Virtue*, 39.

10. Ibid., 41.

11. *The Myth of Sisyphus*, trans J. O'Brian (Harmondsworth: Penguin, 1975), 65.

12. At least in principle. Someone's arbitrary choice may, of course, have placed him in a situation where external factors limit the range of possibilities open to him if he does change his mind.

13. *Either/Or* I, trans. D. F. and L. M. Swenson (Princeton: Princeton University Press, 1959), 291.

14. Ibid., 293.

15. Ibid.

16. See *After Virtue*, 30–31.

17. Ibid., 24, 70.

18. *The Sickness Unto Death*, trans. H. V. and E. H. Hong (Princeton: Princeton University Press, 1980), 13.

19. For instance: "The self is a relation that relates itself to itself, or is the relation's relating itself to itself in the relation; the self is not the relation but is the relation's relating itself to itself" (Ibid., 13).

20. See *After Virtue*, 196–203.

21. *After Virtue*, 41.

22. *After Virtue*, chs. 9 and 18.

23. *After Virtue*, 241–42.

24. See I. Lakatos, 'Falsification and the Methodology of Scientific Research Programmes' in I. Lakatos and A. Musgrave, eds., *Criticism and the Growth of Knowledge* (Cambridge: Cambridge University Press, 1970) .

25. P. K. Feyerabend, *Against Method* (London: Verso, 1978), ch. 16.

26. *Either/Or* II, trans. W. Lowrie (Princeton: Princeton University Press, 1959), 164.

27. See in particular the first section of *Either/Or* I, The 'Diapsalmata.'

28. *Either/Or*, vol 2, 212 ff.

29. Of course, both MacIntyre and Kierkegaard assume that we do share a basic need for coherence and meaning in our lives. I think there is no doubt that this is a widespread human need. But is it universal? And might it not admit of degrees? If so, then an ethical life might be the rational choice for some people, and an aesthetic one for others. This might be one (un-Kierkegaardian) way in which one could take his Either/Or. But it should be noted that this would not make the choice of the ethical (or the aesthetic) an arbitrary one. As far as the ethicist is concerned, he does have this need for inner unity, and would be miserable and discontented without it. If some people really do not have that need (rather than simply repressing or avoiding it) then the ethical would not be a rational choice for them; but it remains just as much a rational choice for those who do find that they have this fundamental need.

30. *After Virtue*, 241.

31. Meaning, a philosophy that stays close to life and to the realities of human experience, not one which theorises abstractly about notions of existence.

32. *After Virtue*, 245.

33. *After Virtue*, 187–89.

34. *After Virtue*, 204.

35. See his long discourse, "Purity of Heart is to Will One Thing," in his *Edifying Discourses in Various Spirits*. MacIntyre, incidently, alludes with approval to the maxim which Kierkegaard takes as his title in *Whose Justice? Which Rationality?*, 65, and *Three Rival Versions of Moral Enquiry*, 143.

36. Bruce Kirmmse has noted how, as Kierkegaard's version of Christianity becomes more polemically other-worldly, so his sympathy with political liberalism increases. See his *Kierkegaard in Golden Age Denmark* (Bloomington: Indiana University Press, 1990).

7

Neither Aristotle nor Nietzsche

RICHARD JOHNSON

Summary

This paper emphasizes some substantial differences between Kierkegaard and MacIntyre, and shows how a Kierkegaardian critique of objectively oriented ethics and religion applies to MacIntyre's brand of Thomistic virtue ethics and natural theology (which Kierkegaard would categorize as a version of religiousness A). It argues that MacIntyre's own critique of modern universal reason should lead us to doubt that divine law, as interpreted by Christian theology or any other historical faith, simply adds to Greek doctrines on human nature without essential alteration.

MacIntyre's philosophy is another version of the secular paradigm, in Milbank's sense. For precisely this reason, he is not as well-positioned as Kierkegaard to meet Nietzsche's challenge. [Eds.]

In recent years, criticism of modern philosophy has grown to such proportions that, were it not for its role as the acceptable face of 'globalization', one might begin to suspect that the liberal paradigm had outlived its ideological usefulness. In no small part this is due to the efforts of Alasdair MacIntyre, who for the last twenty years has been trying to warn us that, given the failure of 'the Enlightenment project' to establish a rational foundation for morality, the only thing that can save us from the horrors of post-Nietzschean nihilism is a revival of the classical teleology which was rejected at the outset of the modern era. By the time that the Aristotelian standpoint of *After Virtue* has evolved into the full-blown neo-Thomism of *Three Rival Versions of Moral Enquiry*, MacIntyre's thesis has developed into a powerful apologetic for the kind of philosophical theism or 'onto-theology' which has long been the primary target of postmodern

polemics. Unfortunately, as he admits himself,[1] it is futile trying to engage in dialectical argument with an opponent who repudiates the logic of identity and contradiction, not least because, up to a point, he shares that opponent's rejection of the liberal assumption that every discourse can be translated into the terms of one's own. As Kierkegaard remarked in the context of his dispute with Hegel, "[i]f there is to be any mediation in this case (and let us not forget that mediation is a speculative category), it will mean that speculative thought judges between itself and its own opposite, and therefore plays the double role of litigant and judge."[2] What is needed is someone who is able to converse with both protagonists in their own terms, a native speaker of two first languages, and this is where Kierkegaard comes in.

As this implies, my argument is based on MacIntyre's own formula for overcoming the conflicts between rival traditions of enquiry, thereby rescuing at least one of them from an impending epistemological crisis. In short, I suggest that Kierkegaard's analysis of the structures of human existence contains the resources to identify and account for the limitations and defects of both positions, 'tradition' *and* 'genealogy'. According to Kierkegaard the process of spiritual development or becoming a self consists of three stages: the aesthetic, the ethical, and the religious. In the philosophical idiom of the *Postscript*, the sphere of religion is divided into religiousness A, which covers every kind of religion that is not distinctively Christian, and religiousness B, or Christianity proper, which is set apart by the 'absolute paradox' of the God-man and the entry of the eternal into time. Now, if the fundamental dimensions of existence once thought to participate in the Names or attributes of God (Goodness, Beauty, Truth, etc.) have become restricted to autonomous, incommensurable fields of discourse, MacIntyre wants to reclaim morality for reason but can only do so at the expense of poetry and rhetoric, while Nietzsche's elevation of art over truth paves the way for a wholesale aestheticization of morality and cognition. In other words, "[i]f thought speaks deprecatingly of the imagination, imagination in its turn speaks deprecatingly of thought; and likewise with feeling" (CUP 311). Philosophy, both classical and modern, has always tried to organize these factors within its own knowledge of them, thus subordinating art, morality, and religion to epistemology and ontology. But neither of these disciplines constitutes an essential part of the task of life.

> The metaphysical is abstraction, and there is no human being who exists metaphysically. The metaphysical, the ontological, is [*er*], but it does not exist [*er ikke til*], for when it exists it does so in the esthetic, in the ethical, in the religious, and when it is, it is the abstraction from or a *prius* [something prior] to the esthetic, the ethical, the religious.[3]

Kierkegaard accuses the practice of philosophical speculation of ascribing an absolute value to something relative, i.e., the power of the human intellect. As such, no less than the pursuit of sensual gratification, it is an expression of an aesthetic mode of existence, in this case the 'aesthetic-metaphysical'. In life, however, where one never encounters the abstract structures of ontology, "[t]he true is not higher than the good and the beautiful, but the true and the good and the beautiful belong essentially to every human existence, and are unified for an existing individual not in thought but in existence" (CUP 311). Accordingly, "[t]he task is not to exalt the one at the expense of the other, but to give them an equal status, to unify them in simultaneity; the medium in which they are unified is *existence*" (CUP 311). The significance of the aesthetic, for instance, is not confined to the existence sphere it governs, but is taken up into the sphere of religion as the 'second immediacy' of faith (the point being that faith is not, as Hegel taught, an aesthetic immediacy superseded by reason). Nevertheless, until the task of life is completed, "the different spheres must be kept clearly distinct, and the qualitative dialectic, with its decisive mutation that changes everything so that what was highest in one sphere is rendered in another sphere absolutely inadmissible, must be respected" (CUP 311). In this light, the difference between MacIntyre and Nietzsche can be explained by pointing out that Nietzsche's values are exclusively shaped by aesthetic considerations, while MacIntyre's natural theology is, at best, an expression of religiousness A. At worst, it might be read as an aesthetic-metaphysical production, which is how Kierkegaard construes all attempts to translate the teachings of Christianity into the idiom of Greek philosophy.

Anticipating the tactics of deconstruction, Kierkegaard illustrates the difference between religiousness A and the aesthetic-metaphysical by showing how the character of Socrates calls into question the metaphysical presuppositions of the text that he inhabits. Having solved the problem of the *Meno*[4] by positing the thesis that all knowledge is but recollection (*anamnesis*), Socrates is said to be "always departing from it, in order to exist. . . . the Platonic tendency, on the other hand, is to pursue the lure of recollection and immanence." "This proposition is not for Socrates a cue to the speculative enterprise, and hence he does not follow it up; essentially it becomes a Platonic principle. Here the way swings off; Socrates concentrates essentially upon accentuating existence, while Plato forgets this and loses himself in speculation" (CUP 184). While Plato goes on to initiate the whole project of Western philosophy, Socratic ignorance (which should not, of course, be confused with the ignorance that he equates with sin) becomes an analogue of faith, reflecting the objective uncertainty of all systematic and historical knowledge for anyone but God, and the insight that truth must therefore be sought in one's subjective relation to the unknown. Since thought is only one aspect, albeit an essential one, of

existence, no philosophy, not even the post-metaphysical variety which Kierkegaard did so much to make possible, can lend significance to one's life as a whole. Only God can do that, and God cannot be an object of enquiry "because God is a subject, and therefore only exists for subjectivity in inwardness" (CUP 178).

In order to highlight the difference between Christianity and the philosophy that presumes to make it intelligible, the author of the *Postscript* sets himself the task of rendering Christianity more difficult, though not more difficult than it actually is, which is the same for everyone in that it does not vary according to one's intellectual capacity. Since the object of faith is the absolute paradox, the Christian must believe against the understanding. But this is definitely not a prescription for irrationalism, for "the believing Christian not only possesses but uses his understanding, respects the universal-human, does not put it down to lack of understanding if somebody is not a Christian; but in relation to Christianity he believes against the understanding and in this case also uses understanding . . . to make sure that he believes against the understanding."

> Nonsense therefore he cannot believe against the understanding, for precisely the understanding will discern that it is nonsense and will prevent him from believing it; but he makes so much use of the understanding that he becomes aware of the incomprehensible, and then he holds to this, believing against the understanding. (CUP 504)

The function of the understanding is to distinguish the paradox from nonsense, or, in MacIntyre's terminology, incommensurability from logical incompatibility. Since belief requires the renunciation of reason's claim to comprehend the paradox, and doubt can only be brought to an end by an act of will, the philosophical foundation of faith is scepticism. The problem with the practice of moral philosophy, even when it takes its bearings from Augustine and Aquinas, is the high degree of intelligence it requires, which establishes an essential difference between the philosopher and the ordinary person. But "God is affronted by getting a group of hangers-on, an intermediary staff of clever brains; and humanity is affronted because the relationship to God is not identical for all men" (CUP 204). Before God, the difference between the readership addressed by Kierkegaard and those relatively lacking in education and leisure "consists in the insignificant trifle that the wise man knows that he knows, or knows that he does not know, what the plain man knows" (CUP 204). This accounts for what MacIntyre regards as Kierkegaard's 'moral conservatism', for the ethical is not a question of making a selection from a range of ethical alternatives, each requiring an investigation into their foundations, but of a choice between the ethical and the aesthetic.

The ethical is quite consistently always very easy to understand, presumably in order that no time may be wasted, but a beginning made at once. On the other hand it is quite difficult to realize—equally difficult for the wise and for the simple, since the difficulty does not lie in understanding it. If it were a matter of understanding, the clever would have a great advantage. (CUP 350)

According to MacIntyre, it is the combination of an inherited morality with a radically new way of founding it that accounts for the incoherence at the heart of Kierkegaard's position.[5] But even if the ethical were a matter of understanding, as he is well aware, the goal of moral enquiry is an ever-receding horizon, and since the best answers to have emerged so far are always liable to be overturned by some as yet unforeseen argument, there can be no way of ruling out "the possibility that what has so far been accepted may have to be modified or even rejected."[6] MacIntyre frequently makes the point that the rational excellence of a philosophical system is proportional to its vulnerability to dialectical refutation. However, "the absence of a conclusion has the retroactive power to make the beginning doubtful and hypothetical, which is to say: unsystematic. So at least from the standpoint of dialectical fearlessness" (CUP 17). Given that the problem he sets out to address is the intractability of philosophical disagreements, MacIntyre presumably hopes to secure an objective basis for agreement, but the open-ended character of dialectical enquiry ensures that the process continues indefinitely; "and while the grass grows under his feet the inquirer dies, his mind at rest, for he was objective" (CUP 33). It is not that Kierkegaard denies the validity of objective knowledge. "There are indeed, in the objective sense, results everywhere, a superfluity of results. But there is no decisive result anywhere. This is quite as it should be, since decisiveness inheres in subjectivity alone, essentially in its passion, and maximally in the personal passion which is infinitely interested in an eternal happiness." (CUP 34–35) A sufficient reason to choose the ethical could only be supplied if ethics were a regional discipline within ontology, and moral activity the automatic outcome of an intellectual exercise. A morality that requires intellectual justification will always be hypothetical, dependent on arguments that may be overturned, subject to the question that undermines metaphysics as a whole: 'Why the why?' If metaphysics is defined as the enquiry into universal grounds ('Why being rather than nothing?'), then, as Jean-Luc Marion suggests, "it cannot but collapse, when the obvious necessity of there being a grounding of being turns out to be thrown into question."[7]

The difference between Plato and Socrates, and by extension MacIntyre and Kierkegaard, can be seen most clearly in the latter's distinction between the ontological 'what' and the ethical 'how'. To start with the enquiry into ontological grounds is to put the cart before the

horse, for "Ethics does not have the medium of *being*, but the medium of *becoming*, and consequently rejects every explanation of becoming which deceptively explains becoming within being, whereby the absolute decision that is rooted in becoming is essentially revoked, and all talk about it rendered essentially nothing but a false alarm" (CUP 377). For Kierkegaard, no less than for Nietzsche, truth is subjectivity, so that, objectively speaking, truth is perspectival. "When subjectivity, inwardness, is the truth, the truth becomes objectively a paradox; and the fact that the truth is objectively a paradox shows in its turn that subjectivity is the truth" (CUP 183). Rather than attempting to reduce this paradox to a contradiction, as in MacIntyre's treatment of perspectivism and relativism, Kierkegaard accentuates it: "*The objective accent falls on WHAT is said, the subjective accent on HOW it is said.* This distinction holds even in the aesthetic realm, and receives definite expression in the principle that what is in itself true may in the mouth of such and such a person become untrue" (CUP 181).

When the person who is speaking happens to be God we arrive at the formula for religiousness B, in which the how and the what are identical, for *the teaching is the teacher himself.* "The presence of the god in human form—indeed, in the lowly form of a servant—is precisely the teaching, and the god himself must provide the condition; otherwise the learner is unable to understand anything."[8]

> The object of faith is not a doctrine, for then the relationship would be intellectual, and it would be of importance not to botch it, but to realize the maximum intellectual relationship. . . . The object of faith is the reality of the teacher, that the teacher really exists. The answer of faith is therefore unconditionally yes or no. For it does not concern a doctrine, as to whether the doctrine is true or not; it is the answer to a question concerning a fact: "Do you or do you not suppose that he has really existed?" (CUP 290)

If the teaching is the teacher himself, the disciple is not required to comprehend it but invited to follow the way of the cross. As Cornelio Fabro pithily remarks: "Christ wants imitators not speculators."[9] The decisive Christian category is not intelligence but obedience, for the truth of Christianity is rooted not in reasons but in the authority of the Word. Steven Emmanuel argues that Kierkegaard's insistence on presenting Christianity as an 'existential communication' anticipates the theology of George Lindbeck, who argues that the purpose of an objective body of doctrines is not to provide propositions about reality but to shape and regulate the follower's subjectivity. "From this perspective, a religious statement acquires the status of an ontological truth only in so far as it is a performance that creates a correspondence between self and God."[10] Even

the author of *The Antichrist* agrees on this point. In a polemic directed at the Protestant doctrine of *sola fides*, Nietzsche writes:

> the only thing that is Christian is the Christian mode of existence, a life such as he led who died on the Cross. . . . To this day a life of this kind is possible; for certain men, it is even necessary: genuine, primitive Christianity will be possible in all ages. . . . To reduce the fact of being a Christian, or of Christianity, to a holding of something for true, to a mere phenomenon of consciousness, is tantamount to denying Christianity.[11]

The affinities between Kierkegaard and Nietzsche are not confined, as is usually thought, to their respective diagnoses of modernity, for, insofar as Nietzsche's philosophy is as purely parasitic as MacIntyre claims it is, one has only to reverse its axiological coding in order to convert it into a repetition of what it repudiates. Not only does genealogy function as an "inverted mirror image" of the Enlightenment (WJ 353); more importantly, it shows us the underside of the faulty Platonic metaphysics behind the Enlightenment. If, as Derrida claims, "[t]here has not yet been an authentically Christian politics because there remains this residue of the Platonic polis,"[12] then as we shall see, unless there is something in the self that transcends its historical and social context and raises the individual above the public and the universal, Nietzsche is right to add: "*In fact there have never been any Christians.*"[13]

The transition from Platonism to Christianity involves a conversion with regard to one's relationship to death. Whereas the doctrine of recollection became for the Greeks a demonstration for the pre-existence of the soul, secure in its possession of eternity (this is the basis of every model of learning which presupposes an immanent capacity for acquiring genuine knowledge), for the Christian eternal life is a gift which can only be received by relating to the eternal in time, a gift made possible by the resurrection which inaugurates the 'new' category of repetition. Since existence is a process of becoming, the precarious synthesis of the temporal and the eternal, achieved at the moment when the paradox becomes a reality for faith, requires continual repetition. This is the function of the Eucharist, which would not be possible if the Incarnation were merely a historical event. In that case the contemporary witness would have an inestimable advantage over the follower at second-hand, but then the event could not be absolute, for the historical is always relative. If the teaching and the condition for receiving it can only be received from the god himself, and not from anyone else (for then that person would become the god), then every generation must be equally contemporaneous with Christ. Faith, whose object is eternal, no more depends on being close to the event than it does on the legacy, however rich, of tradition.[14]

As John Caputo has argued, MacIntyre's account of the history of philosophy as a narrative of decline bears comparison with Heidegger's.[15] Both are engaged in trying to rewind the Ariadne's thread of that history back to some prelapsarian origin; they only disagree about the date of the fall. Such projects are symptomatic of what Kierkegaard portrays as the Greek mentality, in which "the significance of the Platonic 'recollection' is obvious. For the Greeks, the eternal lies behind as the past that can only be entered backwards."[16] Such is the importance, for MacIntyre, of the rupture between classical and modern philosophy, that one can get to the heart of his quarrel with Kierkegaard by asking whether the consequences of the Enlightenment outweigh the significance of the 'foolishness' described by St. Paul as the stumbling-block between Christianity and the wisdom of the Greeks. For Kierkegaard, there can be no question of measuring a discontinuity in the history of philosophy on the same scale as the distance between human reason and divine revelation. For MacIntyre, the question does not arise because, like Nietzsche, he completely overlooks the possibility of any essential difference between Christianity and Platonism.[17] Indeed, his critique of Kierkegaard is explicitly based on the assumption that the categorical imperative of divine law merely reinforces the hypothetical imperative of Greek philosophy, which "is complicated and added to, but not essentially altered, when it is placed within a framework of theistic beliefs, whether Christian, as with Aquinas, or Jewish with Maimonides, or Islamic with Ibn Roschd" (AV 53). The fact that MacIntyre is able to include all these traditions within a single category is sufficient to show that he is working in the medium of religiousness A, the religious consciousness which is possible within paganism. (Here it is worth noticing that the geographical setting of the *akedah*—the story which reveals the incommensurability between divine and human morality—is the Dome of the Rock, a site which, as Derrida points out in his commentary on *Fear and Trembling*, is disputed by all three of the religions which claim this story as their patrimony. "These three monotheisms fight over it, it is useless to deny this in terms of some wide-eyed ecumenism; they make war with fire and blood, have always done so and all the more fiercely today, each claiming its particular perspective on this place and claiming an original historical and political interpretation of Messianism and of the sacrifice of Isaac."[18]) MacIntyre does not follow through his insight that standards of rational accountability are immanent to traditions of enquiry. What incommensurability signifies in this context is that philosophy cannot accommodate Christianity without being transformed into theology. The alternative is to reduce theology to philosophy, a reprise of the project of universal translation which is the focus of MacIntyre's critique of modernity, and whose crowning achievement is Hegel's demythologization of Christianity.

Just as all philosophy is based on the assumption of the essential good-will of thought, the hypothetical imperative is predicated on the view that one can realize one's essential nature by means of ethical activity. It is encapsulated in the structure of Aristotle's practical syllogism, in which the major premise specifies the goal of some activity, the minor premise identifies the means thereto in the present circumstances, and the outcome is the activity itself. This is the framework of MacIntyre's classical teleology, in which the virtues are those qualities prescribed in the middle term of the syllogism. The essential defect in the practical reasoning of liberal modernity consists in the insertion of an indefinite gap between calculation and action, which allows the resulting openness to a range of alternative preferences to be seen as a characteristic of practical reasoning as such (WJ 340–41). The great advantage of the Aristotelian model is that it leaves no room for hesitation between the conclusion of a practical syllogism and its execution; the action *is* the conclusion (AV 161). But this is precisely the feature of pagan philosophy that provides the opening for Kierkegaard's critique of the hypothetical imperative.

> In pure ideality, where the actual individual person is not involved . . . there is no difficulty at all connected with the transition from understanding to doing. This is the Greek mind (but not the Socratic, for Socrates was too much of an ethicist for that). . . . In the world of actuality, however, where the individual person is involved, there is this tiny little transition from having understood to doing; it is not always . . . *geshwind wie der Wind* [fast as the wind]. Quite the opposite, this is the beginning of a very long-winded story.[19]

Without the interval between thinking and doing there would be no foothold for sin, which is not the result of a mistaken calculation but arises from the corruption of the will. "In this transition Christianity begins; by taking this path it shows that sin is rooted in willing and arrives at the concept of defiance, and then, to fasten the end very firmly, it adds the doctrine of hereditary sin" (SUD 93). The slightest delay between knowing and doing gives willing the opportunity to extend the interval indefinitely until, in the end, knowing comes over to the side of willing and admits it was right all along. The Greek mind was too naive, too playfully aesthetic to believe that anyone could knowingly do wrong. "This appears clearly in its definition of virtue and in what Aristotle frequently, also in *Ethica Nicomachea*, states with amiable Greek naiveté, namely, that virtue alone does not make a man happy and content, but he must have health, friends and earthly goods and be happy in his family" (SUD 17). This is not to say that no practices display the automatic quality ascribed to the practical syllogism.

> That there are cases, particularly in connection with evil actions, where the transition from thought to action is scarcely noticeable, is not denied . . . They show what happens when the individual is in the power of a habit, that through often having made the transition from thought to action he has lost the power to keep this transition under the control of will. (CUP 304)

Habit, whether virtuous or vicious, is repetition drained of originality, which "marks precisely the eternal in earnestness, for which reason earnestness can never become a habit . . . The earnest person is earnest precisely through the originality with which he returns in repetition" (CA 149). For Aristotle, repetition (*anapalin*) signified the means by which one acquires virtuous habits, which, like anything else that must be learned, can only be acquired by means of repeated exercise (*Nicomachean Ethics*, II, i). For Kierkegaard, however, the full significance of repetition only comes into view in the region beyond ethical self-sufficiency, where natural reason is suspended, for so rigorous is the infinite requirement of the ethical that "[e]ither all of existence comes to an end in the demand of ethics, or the condition [faith] is provided and the whole of life and existence begins anew, not through an immanent continuity with the former existence, but through a transcendence" (CA 17).

At first sight, the sequence of Kierkegaard's stages of existence seems closer to MacIntyre's account of moral apprenticeship than to Nietzsche's venture beyond good and evil, for it is an essential requirement that the route to the religious should pass through the ethical. As in the Hegelian dialectic, the lower spheres are not discarded but incorporated into the ones above, where each receives its rightful due (for instance, the aesthetic dichotomy of duty and pleasure is resolved in the ethical paradigm of marriage). Thus it is not denied that the religious pathos of religiousness A is a component of Christianity; in fact it is a precondition. However, there is no room in MacIntyre's scheme for anything like the 'teleological suspension of the ethical', exemplified by the religious trial which earned Abraham the title of the father of faith. For Kierkegaard, the ethical is only a transition sphere, coextensive with the stoical illusion of self-sufficiency and the unconscious hubris of pagan philosophy, a hubris for which there is no longer any excuse after the reception of Christianity. Its highest expression is repentance, which cannot occur until the ethical has been shipwrecked on the discovery of sin. At this point it becomes evident that the route has to double back, for the desired ideality of ethics can only be approached by way of "the religious ideality that precisely is the ideality of actuality, and therefore just as desirable as that of esthetics and not as impossible as the ideality of ethics" (CA 17).

> Then faith's paradox is this, that the single individual is higher than the universal, that the single individual (to recall a theological distinction less in vogue

these days) determines his relation to the universal through his relation to the absolute, not his relation to the absolute through his relation to the universal.[20]

For Kierkegaard, as for Aquinas, classical ethics comes to grief on the revelation of sin, which is where Christianity begins. MacIntyre acknowledges this but refuses to allow that it puts the whole question of morality on a different footing, so that, as John Milbank puts it, "Christian morality is a thing so strange, that it must be declared immoral or amoral according to all other human norms and codes of morality."[21]

A crucial component in the classical account of practical reason is the faculty of *phronesis* or *prudentia*, whose function is to identify a particular circumstance as a case in which one or more of the virtues is universally applicable. This is why MacIntyre cannot accept the Kantian notion that a person can be both good and stupid (AV 155). Kierkegaard, by contrast, regards prudential reasoning as a hindrance to the exercise of genuine responsibility. Its scope is limited to the realm of probabilities where its sediment is deposited in the form of proverbs, "which are nothing more than the rules of prudence" (SUD 34). A repository of worldly commonsense, proverbs are usually preoccupied with avoiding the risk of loss. "For example: we say that one regrets ten times for having spoken to once for having kept silent" (SUD 34), for self-disclosure can involve one in difficulties. But to keep silent is more dangerous still, for in seeking to evade the consequences of speaking we forfeit the possibility of correction. The ethical makes an unconditional demand for disclosure; it tolerates "no justified hiddenness, no justified incommensurability" (SUD 34). But where does this leave Abraham, who cannot justify his action even to himself? He cannot speak out, for in ethical terms he is about to commit infanticide. Admittedly, Abraham is the exception; his ordeal is a religious trial in which the ethical itself has become the temptation. But the point is that, before God, everyone is the exception, for unless we are to be judged *en masse* like cattle or a shoal of fish, sin must always be the sin of a single individual and never of humanity in general. The exception is inevitably cancelled by the generality of speech and ethics. "Just as no one can die in my place, no one can make a decision, what we call a 'decision', in my place. But as soon as one speaks, as soon as one enters the medium of language, one loses that very singularity. One therefore loses the possibility of deciding or the right to decide" (GD 59–60).

> The paradox of faith has lost the intermediate term, i.e. the universal. On the one hand it contains the expression of extreme egoism (doing this dreadful deed for his own sake) and on the other the expression of the most absolute devotion (doing it for God's sake). Faith itself cannot be mediated into the universal, for in that case it would be cancelled. Faith is this paradox, and the single individual is quite unable to make himself intelligible to anyone. (FT 99)

This unavoidable secrecy is the mark of an interiority that is incommensurable with the exteriority of language and explanations, an absolute responsibility which "declines the autobiography that is always auto-justification, egodicy," and where "the violence that consists of asking for accounts and justifications" becomes an incitement "to dissolve my singularity in the medium of the concept" (GD 62). Even if there is something higher in *phronesis* than mere calculative shrewdness or the union of policy and duty, the science of making the appropriate connection between particular and universal cannot help Abraham, whose action must remain a permanent scandal to any philosophy of immanence.

The example of Abraham is unique, yet its very unicity demonstrates the element of incommunicable singularity at the core of every decision. "Such, in fact, is the paradoxical condition of every decision: it cannot be deduced from a form of knowledge of which it would simply be the effect, conclusion, or explication" (GD 77). So why does Kierkegaard assign this essentially unpredictable operation to the category of repetition? He cannot be referring to the repeatability of universal moral laws in particular circumstances for it is crucial to his position that there should be a re-emergence of individuality beyond the ethical-universal. Abraham's behaviour only makes sense if there is a court of appeal higher than that of human ethics, which can only be the case if the ethical life has its *telos* outside itself. "Unless this is how it is, faith has no place in existence; and faith is then a temptation, and Abraham is done for, since he gave in to it" (FT 98). If, on the other hand, there is nothing in the individual that is incommensurable with the universal, "one needs no other categories than those of the Greek philosophers, or whatever can be deduced from them" (FT 84).

It is not hard to see that the prospect of appealing to a teleological suspension of the ethical opens up all sorts of disturbing possibilities. This is unavoidable, for what the category of the religious trial has in common with the state of sin is that they are both outside the universal, and in order to be saved the sinner must, like Abraham, resort to the paradox of faith. The paradoxical logic of sacrificial responsibility belongs to the same order as the 'duty of hate' enjoined in Luke 14: 26. "If any one comes to me and does not hate his own mother and father and brothers and sisters, yes and even his own life, he cannot be my disciple." Abraham can only sacrifice his son by renouncing ethics, yet if it is to be a genuine sacrifice, "the ethical must retain all its value; the love for his son must remain intact, and the order of human duty must continue to insist on its rights" (GD 66). Because he overlooks the distinction between the hypothetical imperative of classical ethics and the categorical imperative of divine commandment, this dimension of responsibility remains invisible to MacIntyre, whose philosophy restricts him to the economy of reciprocity exemplified by his Aristotelian ethic of proportional desert.

> In part this is a pagan view, which is satisfied with a merely human criterion and simply does not know what sin is, that all sin is before God. No, *the opposite of sin is faith*, as it says in Romans 14: 23: "whatever does not proceed from faith is sin." This is one of the most decisive definitions for all Christianity—that the opposite of sin is not virtue but faith. (SUD 82)

In the religious trial, as in the leap of faith, everything turns on the distinction between the absolute and the universal, the God of Abraham and the *arche-telos* of the hypothetical imperative. "For when through his own guilt the individual has come out of the universal, he can only return to it on the strength of having come, as the particular, into an absolute relation to the absolute" (FT 124). Just as Isaac was returned to Abraham, repetition in the eminent sense refers to the restoration of the ethical as a task made possible by grace.

What separates repetition from recollection, both in the life of the individual and the history of the race, is the event of the Incarnation, which redeems the past and opens the future to eternity.

> The pivotal concept in Christianity, that which made all things new, is the fullness of time, but the fullness of time is the moment as the eternal, and yet this eternal is also the future and the past. If attention is not paid to this, not a single concept can be saved from a heretical and treasonable admixture that annihilates the concept. One does not get the past by itself but in a simple continuity with the future (with this the concepts of conversion, atonement and redemption are lost in the world-historical significance and lost in the individual historical development). The future is not by itself but in a simple continuity with the present (thereby the concepts of resurrection and judgement are destroyed). (CA 90)

In a sense, the Christian life is essentially futural, for although life can only be understood retrospectively, it has to be lived forwards. Either way, it is a matter of relating the temporal to the eternal, but whilst "[t]he speculative principle is that I arrive at the eternal retrogressively through recollection . . . an existing individual can have a relationship to the eternal only as something prospective, as something in the future" (CUP 380); hence the need to relate to the eternal through the repetition of the encounter with the eternal-in-time rather than through time itself, in philosophical or historical investigation. The transition from religiousness A to religiousness B requires something more than the "shock of recognition" induced by MacIntyre's contemporary restatement of the classical account of practical reason (WJ 394). The situation is more like the predicament of "the kind of post-Enlightenment person who responds to the failure of the Enlightenment to provide neutral, impersonal tradition-independent

standards of rational judgement by concluding that no set of beliefs pro-
posed for acceptance is therefore justifiable" (WJ 395). The only hope for
such a person, we are told, is "a change amounting to a conversion" (WJ
396).

Such was the energy and passion of Nietzsche's struggle with the
nihilism which he saw as the legacy of Christianity and Platonism that it is
tempting to read his career as a striking illustration of "the paradoxical pas-
sion of the understanding" that wills its own downfall (PF 37), continually
colliding with its own limits in the attempt to think what cannot be
thought. Like Kierkegaard, he tried to break free from the Platonic way of
recollection, but he sought repetition in the doctrine of eternal recurrence
rather than in the moment of conversion, thus reopening one of the
Kantian antinomies which reason cannot decide. So deep was his offense
at the paradox that it held him spellbound, as if transfixed; hence the inten-
sity of his rhetoric.

> And could spiritual subtlety imagine any *more dangerous* bait than this?
> Anything to equal the enticing, intoxicating, overwhelming, and undermining
> power of that symbol of the 'holy cross', that ghastly paradox of a 'God on the
> cross', that mystery of an unimaginable ultimate cruelty and self-crucifixion of
> God *for the salvation of man?*[22]

The vehemence of Nietzsche's reaction suggests an alternative inter-
pretation of his own typology of active and reactive forces. In the
Fragments, Kierkegaard identifies two degrees of offense, which anticipate
the categories of active and passive despair discussed in *The Sickness unto
Death*.

> We can . . . very well distinguish between suffering offense and active offense,
> yet without forgetting that suffering offense is always active to the extent that
> it cannot altogether allow itself to be annihilated (for offense is always an act,
> not an event), and active offense is always weak enough to be incapable of tear-
> ing itself loose from the cross to which it is nailed or to pull out the arrow with
> which it is wounded. (PF 50)

The risk of offense is an inevitable consequence of God's descent to
humanity in the guise of a suffering servant, in order to awaken love as a
freely-given response. "But the more passion and imagination a person
has—consequently, the closer he is in a certain sense (in possibility) to
being able to believe, N.B., to humbling himself in adoration under the
extraordinary—the more passionate is his offense, which finally cannot be
satisfied with anything less than getting this rooted out, annihilated, tram-
pled into the dirt" (SUD 86). The offense can be described as the effect

of an 'acoustical illusion' wherein "[t]he more deeply the expression of offense is couched in passion (acting or suffering), the more manifest is the extent to which the offense is indebted to the paradox. So the offense is not the origination of the understanding—far from it, for then the understanding must also have been able to originate the paradox" (PF 51). It might even be characterized as a manifestation of *ressentiment,* a term which Kierkegaard employs in much the same way as Nietzsche.[23] "Offense is unhappy admiration. Thus it is related to envy, but it is an envy that turns against the person himself . . . The uncharitableness of the natural man cannot allow him the extraordinary that God has intended for him; so he is offended." For measured by the standard of the Aristotelian mean between excess and deficit (*Nicomachean Ethics,* II, vi–ix), Christianity is infinitely more transgressive than Nietzsche's titanism.

> The *summa summarum* [sum total] of all human wisdom is this "golden" (perhaps it is more correct to say "plated") mean: *ne quid nimis* [nothing too much]. Too little and too much spoil everything. . . . Now and then there is a genius who goes a little way beyond this, and he is called crazy—by sensible people. But Christianity makes an enormous giant stride beyond this *ne quid nimis* into the absurd, that is where Christianity begins—and offense. (SUD 86–87)

In terms of Kierkegaard's phenomenology of anxiety, the 'bad conscience' that Nietzsche attributes to Christianity belongs in the category of anxiety about evil, while his own position is an expression of anxiety about the good, or 'the demonic'. In terms of the degrees of despair, this is the mentality of the self-legislating sovereign individual that wants to create itself in its own image.

> Like Prometheus stealing fire from the gods, this is stealing from God the thought—which is earnestness—that God pays attention to one; instead, the self in despair is satisfied with paying attention to itself, which is supposed to bestow infinite interest and significance upon his enterprises, but it is precisely this that makes them imaginary constructions. (SUD 68–69)

The distance between man and God is measured in sin, which is "*before God, or with the conception of God, in despair not to will to be oneself, or in despair to will to be oneself*" (SUD 77). With the doctrine of the eternal return, Nietzsche envisages the possibility of endowing his creative choices and his tragic affirmation of existence with infinite significance. This is the kind of infinitizing hypothesis made possible by "the despairing misuse of the eternal within the self to will in despair to be oneself. But just because it is despair through the aid of the eternal, in a certain sense it is very close

to the truth, and just because it lies very close to the truth, it is infinitely
far away" (SUD 67). To the extent that Kierkegaard's stages of despair can
be mapped over the course of history, the emergence of the modern indi-
vidual bears comparison with the moment at which the self first becomes
conscious of having an eternal dimension—"this naked abstract self,
which, compared to immediacy's fully dressed self, is the first form of the
infinite self and the advancing impetus in the whole process by which a self
infinitely becomes responsible for its actual self with all its difficulties and
advantages" (SUD 55). One can trace in this process the whole develop-
ment from Kant to Nietzsche.

> In order in despair to will to be oneself, there must be consciousness of an infi-
> nite self. This infinite self, however, is really only the most abstract form, the
> most abstract possibility of the self. And this is the self that a person in despair
> wills to be, severing the self from any relation to a power that has established
> it, or severing it from the idea that there is such a power. With the help of this
> infinite form, the self in despair wants to be master of itself or to create itself,
> to make his self into the self he wants to be, to determine what he will have or
> not have in his concrete self. (SUD 68)

Despair at its minimum is ignorance of even being despair, or of hav-
ing anything eternal in the self. At its maximum it is personified by the
devil, "for the devil is sheer spirit and hence unqualified consciousness and
transparency; there is no obscurity in the devil that could serve as a miti-
gating excuse. Therefore his despair is the most absolute defiance" (SUD
42). But the relation between God and the self is so dialectical that, in a
sense, the more intensive the despair, the closer a person is to salvation. At
least the passionate atheist acknowledges that the question posed by the
Incarnation cannot simply be ignored. There is a categorical imperative to
choose. "That Christianity is proclaimed to you means that you shall have
an opinion about Christ; He is, or the fact that He exists and that He has
existed is the decision about all existence" (SUD 129). This is where the
essentially disinterested practice of philosophical enquiry comes to grief,
for "[i]n making a choice, it is not so much a question of choosing the
right as of the energy, the earnestness, the pathos with which one chooses
[the 'how', not the 'what']. . . . Therefore even if a man were to choose
the wrong, he will nevertheless discover precisely by reason of the energy
with which he chose, that he has chosen the wrong."[24] It is precisely at this
contention that MacIntyre levels his sharpest criticism. While most of his
objections to Kierkegaard are aimed at what he takes to be the concept of
fundamental freedom or arbitrary choice, now it is MacIntyre's turn to
point out that there is nothing automatic about choosing the good, and
Kierkegaard who is accused of claiming that the process of becoming eth-

ical is *necessary*, that "the energy, the passion, of serious choice will, so to speak, carry the person who chooses into the ethical" (AV 41).

At first sight, Kierkegaard's account of the passionate energy of serious choice not only undermines his emphasis on freedom, it also runs counter to his view that the requirement of ethics infinitely exceeds our powers to fulfill it. Whereas the ordeal of Abraham involved a teleological suspension of the ethical, the normal condition of fallen humanity is one of suspension *from* the ethical. This should not be understood in terms of falling short of an ideal.

> The suspension in question consists in the individual's finding himself in a state precisely the opposite of what the ethical requires, so that far from being able to begin, each moment he remains in this state he is more and more prevented from beginning. . . . in a desperate ironical manner he is as if set free . . . and the more profoundly its requirement is made known to him, the clearer becomes his fearful freedom. The terrible emancipation from the requirement of realizing the ethical, the heterogeneity of the individual with the ethical, this suspension from the ethical, is *Sin*. (CUP 238–39)

Thus the kind of freedom cited by MacIntyre as an objection to Kierkegaard's account of the passion of serious choice is nothing more than bondage to sin, the forfeited condition (PF 16–17), the loss of freedom incurred, both collectively and individually, by the Fall. The harder one tries to break out of this self-imposed bondage the more one becomes aware of the need for divine assistance. In this perspective, "the aesthetic triviality of the nineteen-twenties" (AV 41) is a foretaste of the ludic climate of postmodern capitalism, where consumer choice is elevated to the status of an absolute value. As MacIntyre points out himself, "freedom of choice of values would from the standpoint of a tradition ultimately rooted in heroic societies appear more like the freedom of ghosts—of those whose human substance approached vanishing point—than of men" (AV 127).

For Kierkegaard, the difference between the consciousness of classical antiquity and that of modernity is reflected in the difference between ancient and modern drama. In the classical world, "[e]ven if the individual moved freely, he nevertheless rested in substantial determinants, in the state, the family, in fate."

> This substantial determinant is the essential fateful factor in Greek tragedy and is its essential characteristic. The hero's downfall, therefore, is not a result solely of his action but is also a suffering, whereas in modern tragedy the hero's downfall is not really suffering but is a deed. . . . The tragic hero is subjectively reflected in himself, and this reflection has not only reflected him out of every immediate relation to state, kindred, and fate but has even reflected him out of his own past life.[25]

In terms of the stages of despair, this is the point at which "[t]he self becomes an abstract possibility; it flounders in possibility until exhausted but neither moves from the place where it is nor arrives anywhere, for necessity is literally that place; to become oneself is literally a movement in that place" (SUD 36). If the object of anxiety in classical times was fate, in relation to which necessity's despair is to lack possibility, the despair of modernity is to lack necessity, to lose oneself in reflection as an abstract member of an amorphous 'public.' The difference between the modern world and antiquity is:

> that totality is not concrete and is therefore unable to support the individual, or to educate him as the concrete should (though without developing him absolutely), but is an abstraction which by its abstract equality repels him and thus helps him to be educated absolutely—unless he succumbs in the process. The *taedium vitae* so constant in antiquity was due to the fact that the outstanding individual was what others *could not be*; the inspiration of modern times will be that any man who finds himself, religiously speaking, has only achieved what *every one can achieve*.[26]

But if the ethical proves to be an 'impossible ideality,' in which to be a bit moral is precisely to be immoral, and the freedom of the aesthetic is the demonic will of unfreedom and exclusion from the good, what part can freedom possibly play in the process of moral and spiritual development? This raises the question of the relation between grace and nature, the will of God and human autonomy. How can belief be the outcome of an act of will when even the desire for faith is a gift of God I must pray for? And even then "to pray aright must again be given to me so that I may rightly pray for faith etc. There are many, many [envelopings]—but there must still be one point or another where there is a halt at subjectivity . . . unless we want to have fatalism."[27] What, then, is this subjectivity? Ultimately it is defined in terms of the relation of a creature to its creator.

> The human self is such a derived, established relation, a relation that relates itself to itself and in relating itself to itself relates itself to another. This is why there can be two forms of despair . . . If a human self had itself established itself, then there could only be one form: not to will to be oneself, to will to do away with oneself, but there could not be the form: in despair to will to be oneself. This second formulation is specifically the expression for the complete dependence of the relation (of the self), the expression for the inability of the self to arrive at or be in equilibrium and rest by itself, but only, in relating itself to itself, by relating to that which has established the entire relation. (SUD 13–14)

If this can be credited, then the kind of despair I have attributed to Nietzsche is as good a 'proof' as any of the truth of Christianity. The "sin of dismissing Christianity *modo ponendo* [positively], of declaring it to be untruth," is defined as "sin against the Holy Spirit" (SUD 125). Yet it also bears witness to the dependence of the self in despair on the very thing it denies, to the point of denouncing it as the embodiment of decadence and the historical motor of nihilism. "This offense is the highest intensity of sin, something which is usually overlooked because the opposites are not construed Christianly as being sin/faith" (SUD 131).

Kierkegaard is not suggesting that we should turn to Christianity as a means of avoiding despair. That would be to relapse into the reactive dread of the ethics of scarcity, which presupposes an ontology of conflict and chaos. Instead, as Alastair Hannay points out, Kierkegaard's account is based on "a preconstituted *assumption* of a 'highest good' or unity, to which despair only gradually becomes an accompaniment as, with consciousness's increasing transparency, this assumption's implications and difficulties become increasingly apparent."[28] Despair is not a given but is always in some sense freely chosen, even if only by default, and in the transparency of the 'first form of the infinite self', the emergent self has to take responsibility for its own constitution by deciding how it will relate to itself. The task can be postponed or evaded by not willing to be oneself, but it cannot be eliminated any more than one can get rid of oneself, "which, after all, is one and the same thing, for the self is the relation to oneself" (SUD 17). The alternatives are clear. "Such a relation that relates itself to itself, a self, must either have established itself or have been established by another" (SUD 13). Nietzsche takes the first option, Kierkegaard the second; and there are no independent, objective criteria by which to decide between them. In terms of Nietzsche's own analysis, however, a self that denies its dependence on the power that established it has become reactive, which is how the history of nihilism begins. Like the history of philosophy of which it is the product, this heroic self relates to itself by way of increasingly grandiose constructions and self-images, but the process is always subject to a dialectic of sudden reversal, because "no matter how long one idea is pursued, the entire action is within a hypothesis" (SUD 69). In order to realize its absolute significance, the self must renounce the conditionality of hypothetical imperatives and accept the unconditional obligation which is the essence of subjectivity. "The formula that describes the state of the self when despair is completely rooted out is this: in relating itself to itself and in willing to be itself, the self rests transparently in the power that established it" (SUD 14).

The rampant individualism of modern consumerism is thus the antithesis of the individuality championed by Kierkegaard, which always contains an ineliminable reference to God as the principle of subjectivity. If the self

is constituted by its God-relatedness, the most fundamental expression of selfhood must be the prayer of thanksgiving in which that relation is acknowledged; hence the overwhelming sense of gratitude which prompted Kierkegaard to offer his entire authorship back to God "with more diffidence than a child when it gives as a present to the parents an object which the parents had presented to the child."[29] The genius of Nietzsche found expression in an unequalled outburst of defiance, a demonic ingratitude which yet bears an illusive resemblance to the suspension of the ethical in the religious trial. MacIntyre describes himself a Catholic philosopher, but he is more comfortable with his meritocracy of proportional desert than with the more rigorous economy of sacrifice and gift. For those of his readers who have cut themselves off from the path of recollection he has nothing to offer beyond the assertion that only a conversion can save them. But this is the whole point, for the matter at issue is subjectivity. "This must constantly be borne in mind, namely, that the subjective problem is not something about an objective issue, but is the subjectivity itself" (CUP 115).

NOTES

1. MacIntyre attributes Nietzsche's aversion for dialectic to his desire to avoid any prior commitment to the traditional conception of the interdependence of rational and moral excellence: "For he perceived correctly that only by breaking with the dialectic at the outset could one hope to escape from arriving at Platonic and Aristotelian conclusions." *Three Rival Versions of Moral Enquiry: Encyclopaedia, Genealogy, Tradition*, London: Duckworth, 1990, p. 60.

2. Søren Kierkegaard, *Concluding Unscientific Postscript to the Philosophical Fragments*, trans. David F. Swenson and Walter Lowrie, London: Oxford University Press, 1941, p. 336. All subsequent references to this work will be given parenthetically in the text after the abbreviation CUP.

3. Kierkegaard, *Stages on Life's Way*, trans. and ed. Howard V. Hong and Edna H. Hong, Princeton: Princeton University Press, 1988, p. 476.

4. "Do you realize that what you are bringing up is the trick argument that a man cannot try to discover either what he knows or what he does not know? He would not seek what he knows, for since he knows it there is no need of the enquiry, nor what he does not know, for in that case he does not even know what he is to look for" *Meno*, 80 e; *Platonis opera*, IX, pp. 222–23.

5. MacIntyre, *After Virtue, A Study in Moral Theory* (subsequently referred to as AV), London: Duckworth, 1981, p. 43.

6. MacIntyre, *Whose Justice? Which Morality?* (subsequently referred to as WJ) London: Duckworth, 1988, p. 172.

7. Jean-Luc Marion, "Metaphysics and Phenomenology: A Summary for Theologians," in *The Postmodern God*, ed. Graham Ward, Oxford: Blackwell, 1997, p. 283.

8. Kierkegaard, *Philosophical Fragments* (subsequently referred to as PF), ed. and trans. Howard V. Hong and Edna H. Hong, Princeton: Princeton University Press, 1985, p. 56.

9. Cornelio Fabro, "Faith and Reason in Kierkegaard's Dialectic," in *A Kierkegaard Critique* ed. Howard A. Johnson and Niels Thulstrup, Chicago: Henry Regnery, 1962, p. 168. Kierkegaard's emphasis on 'works' leads Fabro (rightly in my view) to claim him for Catholicism. He attributes Karl Barth's eventual repudiation of Kierkegaard to a 'crude Calvinism' which would not permit him to regard the natural religiosity of religiousness A as a prerequisite for the reception of revelation. *Ibid.*, p. 90.

10. Steven Emmanuel, *Kierkegaard and the Concept of Revelation*, Albany: State University of New York Press, 1996, p. 99.

11. Friedrich Nietzsche, *The Antichrist*, trans Anthony M. Ludovici, in The Complete Works of Friedrich Nietzsche, Vol. 16, ed. Dr Oscar Levy, London: George Allen & Unwin, 1927, pp. 178–79.

12. Jacques Derrida, *The Gift of Death* (subsequently referred to as GD), trans. David Wills, Chicago: Chicago University Press, 1995, p. 28.

13. Nietzsche, *The Antichrist*, p. 179.

14. Commenting on Kierkegaard's epilogue to *Fear and Trembling*, Derrida writes: "[e]ach generation must begin again to involve itself in it without counting on the generation before It thus describes the non-history of absolute beginnings which are repeated, and the very historicity that presupposes a tradition to be reinvented each step of the way, in this incessant repetition of the absolute beginning." (GD 80).

15. See John D Caputo, *Radical Hermeneutics: Repetition, Deconstruction and the Hermeneutic Project*, Bloomington: Indiana University Press, 1987, pp. 241–54.

16. Kierkegaard, *The Concept of Anxiety: A Simple Psychologically Orienting Deliberation on the Dogmatic Issue of Hereditary Sin* (subsequently referred to as CA), trans. and ed. Reidar Thomte and Albert B. Anderson, Princeton: Princeton University Press, 1980, pp. 89–90.

17. See for instance Nietzsche's comments on Plato in *The Twilight of the Idols or How to Philophise with the Hammer*, trans. Anthony M. Ludovici, in The Complete Works of Friedrich Nietzsche, Vol. 16, ed. Dr Oscar Levy, p. 114: "Plato is boring. . . . In the great fatality of Christianity, Plato is that double-faced fascination called the 'ideal', which made it possible for the more noble natures of antiquity to misunderstand themselves and to tread the bridge which led to the 'cross'. And what an amount of Plato is still to be found in the concept 'church', and in the construction, the system and the practice of the church!"

18. Derrida, *The Gift of Death*, p. 70.

19. Kierkegaard, *The Sickness Unto Death: A Christian Psychological Exposition for Upbuilding and Awakening* (subsequently referred to as SD), trans. and ed. Howard V. Hong and Edna H. Hong, Princeton: Princeton University Press, 1980, pp. 93–4.

20. Kierkegaard, *Fear and Trembling: Dialectical Lyric* (subsequently referred to as FT), trans. Alastair Hannay, London: Penguin Books, 1983, p. 97.

21. John Milbank, *The Word Made Strange*, Oxford: Blackwell, 1997, p. 219.

22. Nietzsche, *On the Genealogy of Morals*, trans. Walter Kaufmann and R. J. Hollingdale, New York: Random House, 1989, p. 35.

23. As Nietzsche might have put it himself: "*ressentiment* becomes the constituent principle of want of character, which . . can never understand that eminent distinction really is distinction. Neither does it understand itself by recognizing distinction negatively (as in the case of ostracism) but wants to drag it down, wants to belittle it, so that it really ceases to be distinguished. And *ressentiment* not only defends itself against all *existing* forms of distinction but against that which is still *to come*." Kierkegaard, *The Present Age*, trans. Alexander Dru and Walter Lowrie, London: Oxford University Press, 1940, pp. 26–7.

24. Kierkegaard, *Either/Or*, Vol. II, trans. Walter Lowrie, Princeton: Princeton University Press, 1944, p. 114.

25. Kierkegaard, *Either/Or*, Vol. I, trans. David F. Swenson and Lolian M. Swenson, Princeton: Princeton University Press, 1944, p. 143.

26. Kierkegaard, *The Present Age*, p. 41.

27. Quoted from *Journals and Papers*, vol. 4, p. 352 (X2 A 301) by Emmanuel, *Kierkegaard and the Concept of Revelation*, p. 80.

28. Alastair Hannay, *Kierkegaard*, London: Routledge & Kegan Paul, 1982, p. 192.

29. Kierkegaard, *The Point of View For My Work as an Author*, trans. Walter Lowrie, New York: Harper & Row, 1962, p. 88.

8

After Paganism: Kierkegaard, Socrates and the Christian Tradition

KAREN L. CARR

Summary

This paper places Kierkegaard in a different intellectual context than does MacIntyre, who sees him as one of the first representatives of modern emotivism. I believe that Kierkegaard is more profitably read against the background of Christian thinkers (dating back to the first century) who are suspicious of philosophy and natural theology because of the tendency of each to dilute or remove the absoluteness of Christian revelation. Not all Christian thinkers share this suspicion, of course, (Aquinas being the most obvious representative of the other camp), but Kierkegaard stands in a very long tradition within Christianity. (Socrates figures into this discussion because, despite Kierkegaard's admiration, even love, for Socrates, Kierkegaard uses him as a foil to demarcate what is distinctively Christian in contrast to Socratic "paganism.") This suggests one of two things: 1) that MacIntyre's reading of Kierkegaard as a proponent of emotivism is problematic (since, within the Christian paradigm, the reality of sin means that subjectivity is not truth, but untruth), and Kierkegaard really should not figure into MacIntyre's narrative at all or 2) that if Kierkegaard is nonetheless still justifiably described as participant in emotivist culture (since he does admittedly sever the connection between reason and authority, which MacIntyre regards as one of its hallmarks), this culture has a much longer history (and a different origin) than MacIntyre's account would have us believe.

Kierkegaard's important place in post-Enlightenment intellectual history is undisputed. His psychological model of the self, his emphasis on the "single" individual and his or her radical freedom, his adoption of multiple masks and the ever-shifting ground of his authorship combine to make this

father of existentialism and forerunner of postmodernism an apparently irretrievably modern thinker. Thus when Alasdair MacIntyre locates Kierkegaard at a pivotal point in the transition from classical rationalism to modern emotivism, there seems little basis for criticism on that point alone. While one might object to some of the specifics of his reading of Kierkegaard (a reading based, in *After Virtue*, solely on *Either/Or*) or with his extremely negative take on the nature and consequences of the emotivist framework, probably few would contest his placement of Kierkegaard as one of the initiators of something fundamentally new and fundamentally modern.

In this paper, however, I will argue that reading Kierkegaard as a distinctively and peculiarly modern thinker is a mistake, that it obscures fundamental features of his thought and ultimately leads to a distortion and misreading of his overall position. While Kierkegaard does, as MacIntyre states, presuppose the failure of the Enlightenment project, the articulation and meaning of his position is not dependent upon that presupposition. And while much of the vocabulary he introduces (and to some extent, the approach he employs) is new and innovative, the underlying view of the human self and its relationship to its surroundings (in particular, its relationship to philosophical reasoning and to God, or the absolute) is not and has in fact a long history within the Christian tradition. MacIntyre is correct that, in Kierkegaard's thought, the connection between reason and authority is severed, but for many Christian thinkers, dating back to the very beginnings of Christianity, their differentiation is a fundamental prerequisite of genuine faith; even those thinkers who value the use of reason clearly regard it as subordinate to the revelation of God in Christ. In other words, a significant portion of what MacIntyre regards reprovingly as modernity's mistake (the severance of reason and authority) has in fact a much longer presence in western thought, a presence intimately connected to Christianity's historical emphasis on the absolute authority of revelation. Indeed, from the standpoint of Kierkegaard and the tradition he follows, modernity's problem is that it has abandoned the traditional focus on revealed theology in favor of naturalized, rationalized, domesticated religion.

In what follows I will examine Kierkegaard's rejection of reason not in terms of the Enlightenment's failure to provide rational foundations for morality and religion, but in terms of his conviction that the very intention to provide such foundations is fundamentally flawed, given the reality of human sin and the necessary absoluteness of revelation for a Christian. In Kierkegaard's eyes, Christianity introduces a strikingly new epistemological model, which he develops by contrasting it with what he terms the Socratic or "pagan" approach to truth. I will show further that this understanding of Christianity is not idiosyncratic within the tradition (although

it is, in places, somewhat extreme) but is in fact relatively orthodox. If I am correct, then what MacIntyre identifies as a distinctively modern problem has been a "problem" for almost two thousand years, and offers quite a different basis for diagnosing modernity's ailments.

<div align="center">

I

</div>

To reject or restrict the use of reason in the pursuit of truth seems a questionable strategy, on the face of it. While not all rational, well-grounded beliefs are true, more of them are more likely to be true than beliefs randomly or arbitrarily adopted. (Part of the standard objection to modern emotivism stems precisely from this fact.) So why might a religious thinker, particularly a Christian thinker, regard reason with suspicion? To answer this question, we need briefly to review the origins of Christianity and the early development of its theology, Christology, and soteriological vision.

Christianity emerges in the first century as a minor Jewish sect; the followers of Jesus were attracted to his message of love, devotion, obedience, and forgiveness. Some regarded him as a prophet, others saw him as the Jewish Messiah, who would deliver and redeem the Jewish people. After a very short ministry, he was executed in a not uncommon but particularly humiliating and base fashion. His death apparently took his disciples by surprise (despite accounts in the Gospels of Jesus foretelling his death) and their immediate reaction was one of sorrow, confusion, and disbelief. One might have expected the community surrounding Jesus to dissipate after his messy death, but surprisingly, it did not; as accounts of Jesus's resurrection circulated, the community fairly quickly increased dramatically in numbers, non-Jews as well as Jews entering its ranks.

The most important challenge the fledgling community faced was to try to make sense of Jesus's death. Paul, arguably the first Christian theologian, develops a soteriological model in which the death of Jesus (and its flip side, the resurrection) is the central event in history. Christ, identified as the Son of God, took on the sin of the world with his obedient sacrifice and died so that others could be made free of the bondage of sin. Christ's death slays sin; his resurrection promises eternal life. Through faith in the saving efficacy of this event, individuals could be reborn into a new life, a life in the spirit, and ultimately realize their own eternal salvation.[1]

Two things, in particular, are important to note about Paul's theology: first, the Christ event is the absolutely central tenet of this newly emerging religion. As Paul writes, "if Christ has not been raised, then our proclamation has been in vain and your faith has been in vain. . . . If Christ has not been raised, your faith is futile and you are still in your sins" (I Cor 15:14–17).[2] The Christian's faith is in a historical event that, at the same

time, has an absolute and transcendental meaning, as it is the single entry point for all time for salvation. While in history, this event is simultaneously outside of history. Second, Paul repeatedly acknowledges the difficulty, even the absurdity of this message, even as he insists he is "not ashamed" of it. "Jews demand signs and Greeks desire wisdom, but we proclaim Christ crucified, a stumbling block to Jews and foolishness to Gentiles, but to those who are the called, both Jew and Greek, Christ [is] the power of God and the wisdom of God. For God's foolishness is wiser than human wisdom, and God's weakness is stronger than human strength" (I Cor 1: 22–25). Paul, in other words, juxtaposes the saving knowledge that comes from God (and humanly speaking, is a folly and stumbling block) with the lesser, non-saving knowledge of the human realm. He suggests further that the two realms are not merely distinct, but in direct competition. Together these two things mean that belief in the uniqueness of the Christ event (his death and resurrection) and its revelatory and saving power are the central components of early Christian faith, even though, to the eyes of the world, this event is "foolishness."[3]

The desire absolutely to privilege the death and resurrection of Jesus led many Christian thinkers to be ambivalent about natural theology. Natural theology is the knowledge about God that can be gained through the use of reason and experience or through intuition and introspection, i.e., through the operations of the unaided human mind. If it is possible to gain full saving knowledge through the proper exercise of one's own mental faculties, then not only is the absoluteness of the Christ event destroyed, but there seems to be no need for it whatsoever. For the Christ event to maintain its uniqueness, in other words, it must give us something we cannot acquire or possess through our own actions. On the other hand, if no natural knowledge of God is possible, then it seems difficult, if not impossible, to hold individuals accountable for having breached God's laws; in this case, a God who holds humans accountable for their failures and subsequently punishes them becomes unjust. Natural theology also raises questions about the authority of the apostles and the church they founded after Jesus's death; if humans, left to their own guidance, are unable to discern the truth, the institutional church (and the doctrines and dogmas it formulates) is of crucial importance for an individual's salvation. If, on the other hand, each individual is capable of understanding the highest religious truths on his or her own, the church becomes unnecessary as an intermediary between the individual and God, and individuals should be free to follow the paths dictated by their own consciences.[4] The net effect of this is to make the question of the status and legitimacy of natural theology (and, by extension, the status and legitimacy of reason and philosophical reflection) a central, if problematic, question for Christian theologians to address.

Most, if not all, early Christian thinkers accepted, minimally, that all humans possess an innate awareness of God's existence and a general sense of what is right and wrong. Paul, for example, states that "Ever since the creation of the world [God's] eternal power and divine nature, invisible though they are, have been understood and seen through the things he has made" (Rom 1:20). Similarly, most, if not all, also believed that this natural knowledge was insufficient for human salvation, that it needed to be perfected (in some cases, corrected) by God's revelation in Christ, since Christ is "the way, and the truth, and the life. No one comes to the Father except through [him]" (John 14:6). The early Christian fathers disagreed, however, on how much rational reflection (particularly, on how much Greek philosophy) figured into the Christian world-view. At one end of the spectrum are those who regard philosophy as something almost akin to the anti-Christ, luring Christians away from the true path into heresy or unbelief. Paul worries about those who "may deceive you with plausible arguments" and admonishes, "[s]ee to it that no one takes you captive through philosophy and empty deceit, according to the human tradition, according to the elemental spirits of the universe, and not according to Christ. For in him the whole fullness of deity dwells bodily" (Col 2:4, 8–9). Tertullian, writing in the second century, emphasizes the absolute authority of revelation, as transmitted to the apostles by Christ, to which all Christians must submit, and warns that "worldly wisdom culminates in philosophy with its rash interpretations of God's nature and purpose. It is philosophy that supplies the heresies with their equipment. . . . A plague on Aristotle, who taught them dialectic, the art which destroys as much as it builds, which changes its opinions like a coat, forces its conjectures, is stubborn in argument, works hard at being contentious and is a burden even to itself." "What has Jerusalem to do with Athens," he asks, "the Church with the Academy, the Christian with the heretic. . . . After Christ we have no need of speculation, after the Gospel no need of research. When we come to believe, we have no desire to believe anything else; for we begin by believing that there is nothing else which we have to believe."[5]

Less hostile, more welcoming stances toward philosophical reflection also existed, particularly among those thinkers sensitive to the need to reach a Greek audience in their apologies for the faith. Clement of Alexandria, also second century, argues that "before the advent of the Lord, philosophy was necessary for the Greeks for righteousness. And now it becomes conducive to piety; being a kind of preparatory training to those who attain to faith through demonstration."[6] Justin Martyr goes even further, stating that "Christ is the First-begotten of God and . . . he is the reason of which every man partakes. Those who lived in accordance with Reason are Christians, even though they were called godless, such as, among the Greeks, Socrates and Heraclitus and others like them . . .

[T]hose who lived by Reason, and those who so live now, are Christians, fearless and unperturbed."[7] Justin Martyr sought in a sense a fusion of Christianity and hellenism, arguing that Plato had, in his philosophy, anticipated many of the key elements of the Christian faith, now brought to perfection through Christ's appearance on earth.

Yet even those thinkers who embraced Platonic and neo–Platonic writings with great fervor insisted that Platonic philosophy alone was not sufficient for salvation: human reasoning, "worldly wisdom" can at best only take people so far. One needs in addition the saving experience of Christ, an experience that is the ultimate authority in one's religious life. Augustine of Hippo, who charts his conversion to Christianity in his *Confessions*, sees much that is valuable in Platonism (it enables him, for example, to solve, or rather, dissolve the problem of evil, something which had long vexed him, as well as providing him with an intellectual apprehension of God's immutability), but at the same time states that "all the truth I had read in the Platonists was stated . . . [in Christian scripture] *together with the commendation of [God's] grace.*" This is no trivial addendum, given Augustine's (and early Christianity's) picture of the self: Platonism lacks any teaching about the perversity of will that so troubled Augustine, and consequently offers no solution to it. Even worse, his study of Platonism left him "puffed up with knowledge," lacking the "foundation of humility which is Christ Jesus," something nowhere to be found in the Platonist books. Augustine writes that Platonism does "not contain the face of this devotion [displayed by Jesus in his obedient submission to God's will to the point of death], tears of confession, [God's] sacrifice, a troubled spirit, a contrite and humble spirit, the salvation of your people . . . the guarantee of your holy spirit, the cup of our redemption."[8] Only when Augustine realizes the full depth of his own perversity and wretchedness and throws himself at the feet of Christ, is his divided self healed and his properly Christian self realized

What's important to note here is that even within the varying views of the role of philosophy/natural theology/innate intuition in pursuit of Christian life, all of the thinkers stress that, ultimately, there is an authority and a truth higher than that provided by rational reflection or natural intuition. Even those thinkers who embrace reason as a useful tool for Christian apologetics or for clarifying aspects of Christian teaching, regard the revelation of God in Christ as the ultimate authority, by which all human teaching is to be measured. For those thinkers who endorse what could be called "Platonic Christianity," it is not the Platonism that confirms the truth of Christianity, but Christianity that confirms the truth of Platonism.[9]

The pinnacle of rational approaches to Christianity occurs, of course, in the late medieval period when, propelled by the establishment of

modern universities and the rediscovery of Aristotle (whose works had largely been lost to the west after the fall of Rome), scholasticism reached its greatest heights. Thomas Aquinas, as much or more than any other Christian thinker, sought the rational articulation of Christianity. Yet even for Aquinas, ultimately the revealed word of God was absolute, and the criterion and measure by which all rational truths are to be judged. "Holy teaching should be declared to be wisdom highest above all human wisdom, not indeed in some special department but unconditionally." While theology is a rational enterprise (a "science," in Aquinas's terms), it begins and ends with revelation. Revelation tells us what the truths are to be examined and what the ultimate conclusions regarding them are to be. Rational reflection then is applied to these truths to deepen our understanding of them. Aquinas explains, "Christian theology . . . uses human reasoning, not indeed to prove the faith, for that would take away the merit of believing, but to make manifest some implications of its message. Since grace does not scrap nature but brings it to perfection, so also natural reason should assist faith as the natural loving bent of the will ministers to charity." Reason, however, has its limits, and "should not pry into things too high for human knowledge, nevertheless when they are revealed by God they should be welcomed by faith."[10] The point here is that even the so-called "rational faith" of the scholastics recognizes the ultimately superior authority of divine revelation.[11]

The Protestant Reformers were perhaps the most vehement rejecters of reason and philosophical approaches to Christianity, refusing to abandon their interpretations of Scripture even in the face of apparently logical inconsistencies. In his debate with Erasmus over free will, Luther responded to Erasmus's claim that God would be unjust in punishing us if our will were not free (as sin is not sin when it isn't voluntarily committed) with the unequivocal statement, "God is God, for whose will no cause or reason may be laid down as its rule and measure. For nothing is on a level with it, not to speak higher. It is itself the measure of all things. If any rule or measure or cause or reason existed for it, it could no longer be the will of God. What God wills is not right because He ought to or was bound to so will. On the contrary, what takes place must be right, because He wills it."[12] For Luther, reason was a "whore," seducing us away from the purity of God's revelation in Scripture.[13]

Not until the seventeenth century and the beginnings of deism do we find Christian thinkers placing reason on a par with (and, in the case of the later deists, higher than) revelation. Fueled, in part, by the fact of religious pluralism (a pluralism that had resulted in decades of often bloody conflict throughout Europe and England), in part by the emerging Enlightenment mentality, the priority of revelation over reason began to erode. John Tillotson, for example, argued that religious beliefs have no

special immunity from rational inquiry and must be tested and verified like any other beliefs. One can deduce from nature, he said, that there is a God and that man should act virtuously, but these tenets of natural religions are insufficient. They must be supplemented by Christian revelation, which provides a firmer motivation for virtuous behavior and clarifies and expands the notion of duty that reason provides us. At the same time, however, revelation is liable to certain constraints: it cannot contradict reason and the alleged revelation must itself be established as genuine before being accepted. According to Tillotson, the truth of the revelation in Christ is confirmed by the miracles he performed and his fulfillment of past prophecies concerning the coming of the Messiah. Thus, while Tillotson does regard revelation as crucial to a full and genuine Christian existence, revelation is not authoritative within itself, but is verified by a higher court of appeal—it must be rationally certified.

John Locke similarly argued that one needs both natural religion and revealed religion for religious fulfillment, but, like Tillotson, he emphasized the need to test or verify revealed truth claims. Revelation might provide us with truths that are above reason (like the resurrection of the dead), but never that are contrary to reason (for Locke, the existence of more than one God). Like Tillotson, prophecy fulfillment and the presence of miracles were sufficient grounds for regarding a revelation as reliable (i.e., as coming, ultimately, from God.)

Later deists took a stronger, and arguably, more consistent stance, and eliminated the need for any special revelation whatsoever. John Toland's *Christianity Not Mysterious: A Treatise showing there is nothing in the Gospel Contrary to Reason, not Above It* argues that the essence of Christianity is identical with natural religion; while Toland allows, in a sense, for the presence of revelation, he stresses that the truth of any revealed claim has to be rationally justified independently of the simply fact that it is revealed. The step initiated by Toland is completed by Matthew Tindal; in his *Christianity as Old as the Creation*, revelation is entirely eliminated from the picture. Natural religion is utterly perfect and complete—the very notion that God would send a special revelation to a particular group at a particular time suggests that God is partial and unfair, and this is obviously incompatible with his total goodness (a tenet "proved" by natural religion).[14]

The point here is that it is not until the seventeenth century that Christian thinkers began to regard reason as an authority on a par with, much less higher than, revelation. While the position on the role and use of reason prior to the seventeenth century was by no means uniform among Christian thinkers, a significant number wanted its scope severely limited, arguing that it too easily led the devout from the path of true faith. And no non-heretical Christian thinker regarded reason as the

highest authority. Kierkegaard may well sever reason and authority in his writings, but it is a severance that has a long and well-established presence in Christian theology.

II

One might expect that the best way to understand Kierkegaard's position on natural theology and, more generally, on the use of reason in the pursuit of religious truth, is to examine his attitude toward Hegel and speculative philosophy. After all, the Hegelian system is, in a sense, the most grandiose work of natural theology ever developed. Yet Kierkegaard's attitude toward Socrates actually proves more instructive on this point, for two reasons. First, Kierkegaard uses Socrates as a positive counter-example of the subjective thinker (one who wrestles with concrete ethical and religious questions with the full force of his individual, passionate will) to the Hegelian abstract, objective thinker, thus clarifying Kierkegaard's position on the defects of the Hegelian model. At the same time, second, Kierkegaard uses Socrates as a foil for articulating what he understands the distinctively Christian point of view towards religious truth to be. Thus Socrates functions both positively and negatively within Kierkegaard's thought. His ambivalence towards Socrates nicely mirrors the classical Christian tradition's ambivalence towards natural theology. As a result, examining Kierkegaard's view of Socrates not only throws into sharp relief what distinctively Christian religiosity is, but also clarifies why, for Kierkegaard, reason can never function as an authority in the Christian epistemological model.

Socrates, clearly, fascinates Kierkegaard, and he appears in some form in many, if not most, of his writings. In many of these, Kierkegaard seems to manifest a special bond with Socrates. What accounts for this fascination?[15] Three things, in particular, stand out. First is what could be termed his existential integrity. Rather than flitting about with various theories and ideas, he concentrates his mind on a single idea, and seeks to live it fully; in Kierkegaard's view, this idea was belief in the immortality of the soul. Second, Socrates has a correspondingly lucid self-perception; his wisdom consists in the fact that he acknowledges his own ignorance, yet despite that ignorance, is willing to commit himself fully to his idea of God. Finally, third, Socrates is a superlative ethical teacher, functioning as a gadfly to foster spiritual and intellectual awakening in those with whom he speaks. He does not set himself up as a genius, with truths to dispense, but uses questions and irony to force the individual back upon himself. These three things together combine to make Socrates a person who is, in Kierkegaard's eyes, unquestionably worthy of emulation.[16]

Kierkegaard's admiration for Socrates is sufficiently great that he uses him in *Postscript* to concretize his understanding of the subjective thinker. He writes, "The thesis that subjectivity, inwardness, is truth contains the Socratic wisdom, the undying merit of which is to have paid attention to the essential meaning of existing, of the knower's being an existing person. That is why, in his ignorance, Socrates was in truth in the highest sense within paganism" (CUP, 204). As he explains in a journal entry, "how true and how Socratic was this Socratic principle: to understand, truly to understand, is to be. For us more ordinary men this divides and becomes twofold: it is one thing to understand and another to be. Socrates is so elevated that he does away with this distinction" (JP, 4:4301). Socrates functions, in other words, as Kierkegaard's existential hero in the *Postscript*, the person who recognizes the full meaning of the claim that truth is subjectivity, and expresses it constantly in his own life.

Socrates figures positively in the *Postscript* in another way—Socrates is an "analogue" to the genuinely faithful Christian. While Kierkegaard is careful never to say that Socrates was, effectively, a Christian "in drag," one in everything but name (the position that Justin Martyr endorsed, as discussed earlier), he does see embracing the Socratic approach to life as a fundamental precondition to becoming a genuine Christian. (Or, as Merold Westphal puts it, "the point of the Socrates analogy is to present in concrete form the generic subjectivity that is the condition of the possibility for the specifically Christian mode of subjectivity."[17]) Socrates's willingness to commit to an objectively uncertain idea mirrors the Christian's willingness to commit to the absolute paradox. Kierkegaard writes,

> Socrates could not prove the immortality of the soul. He simply said: This matter occupies me so much that I will order my life as if there were an immortality—should there not be any, all right, I still will not regret my choice, for this subject is the only thing that really occupies me.
>
> How much Christendom would already have been helped if there were someone who said and did the following: I do not know if Christianity is true, but I want to order my whole life as if Christianity were the truth, risk my life on it—if it is not truth, all right, I still will not regret my choice, for it is the only thing that occupies me. (JP, 4:4280)

Socrates, then, is in a similar position as the Kierkegaardian Christian who is famously swimming over those 70,000 fathoms, without foundation and alone, and yet committed in his or her faith.

Kierkegaard's clear preference for Socratic "ignorance" and inwardness over speculative systems of thought (be they philosophy or theology) might seem itself sufficient to point to his aversion to natural theology. Yet

Kierkegaard's admiration for Socrates is not unalloyed; as Westphal notes, Socrates "the hero" in the *Postscript* is accompanied by Socrates "the villain," in *Philosophical Fragments* and *Sickness Unto Death*.[18] While Kierkegaard uses Socrates positively, in the *Postscript*, to deepen his presentation of the subjective thinker in contrast to philosophical objectivity, he uses him negatively, in these other two works, to articulate a distinctively Christian epistemological framework, one predicated by the reality of sin and the deep-rooted nature of human disobedience to divine authority.

Kierkegaard's negative discussion of Socrates focuses on two related questions: Can the truth be learned? (in *Philosophical Fragments*); how do we explain someone turning away from the good? (in *Sickness Unto Death*). Socrates's answers, as presented by Kierkegaard, are, first, yes, the truth can be learned, because the truth is already within us; and second, humans choose evil out of ignorance, because they fail to recognize the truth that is already within them. Christianity's answers, according to Kierkegaard, are in contrast: first, no, the truth cannot be learned, as we must be transformed by a savior and given the condition to see the truth; and second, humans choose evil because of their sinfulness, which willingly obscures the call to be obedient to God and chooses self-aggrandizement instead. In both of these answers, we see Kierkegaard's suspicion, even rejection, of reason and introspection as valid routes to the true and the good, and his emphasis on the need for divine revelation and correction for human flourishing.

The "thought project" of *Philosophical Fragments* is an attempt to determine whether an alternative epistemological model to the Socratic is possible, and if so, what it would look like. According to Climacus, "Socrates thinks. . . . that all learning and seeking are but recollecting. Thus the ignorant person merely needs to be reminded in order, by himself, to call to mind what he knows. The truth is not introduced into him but was in him" (PF, 9). This means that the person who aids the ignorant one in his discovery of the truth is merely a "Teacher," incidental in the process in the sense that someone else could have served the same function; the Teacher is merely an "occasion" in the individual's discovery of truth, and the moment of discovery itself is "accidental," because at the moment of discovery, the individual realizes that he or she had already been in possession of the truth.

What, asks Climacus, must be the case for an alternative model to exist? He reasons that the moment of discovery must not be accidental, but "must have such decisive significance that for no moment will I be able to forget it, neither in time nor in eternity, because the eternal [the truth], previously non-existent, came into existence in that moment" (PF, 13). For the moment to be truly momentous, in this sense, the seeker after the truth must previously "not have possessed the truth, not even in the form

of ignorance. . . . he has to be defined as being outside the truth. . . . or as untruth" (PF, 13). What does this imply about the Teacher? The Teacher must not only bring the learner the truth, but "along with it, he must provide him with the condition for understanding it," for if he could, without assistance, understand the truth, Climacus reasons, "then he merely needs to recollect" (PF, 14). Consequently the Teacher, in this alternative model, before he can teach, must "transform" the learner, and thus is no ordinary teacher, but a Savior.

Where does the ignorance of the learner, his inability to understand the truth, come from? It cannot come from the Savior, ("for this is a contradiction,") nor can it merely be an accident ("for it is a contradiction that something inferior [an accident] would be able to vanquish something superior [the condition for understanding the truth]"); rather, it must come from the individual himself—the individual must be willing his condition of untruth. "The untruth . . . is not merely outside the truth but is polemical against the truth, which is expressed by saying that he himself has forfeited and is forfeiting the condition" (PF, 15). Nor can the learner change this condition himself, for then, once again, the truth would be within his possession, and the moment would lose its decisiveness. In an obviously disingenuous move, Climacus suggests we call this state of untruth that we have placed ourselves in and cannot ourselves get out of, "sin." The moment of confrontation with the Savior, in which we are, literally, reborn, and acquire something we previously lacked (namely, the condition for apprehending the truth) is now of decisive significance.

Climacus proceeds in the *Fragments* to detail why the Savior, in order to effect the necessary transformation of the learner, needs to be a God who takes on human form, but what is of interest to us here is the introduction of this category, "sin." Sin, for Kierkegaard, is not merely an existential category, one that describes our fundamental condition lived apart from God; it is also an epistemological category, one that plays havoc with any and all attempts to reach God through purely human devices. It is because of the reality and pervasiveness of sin that Kierkegaard believes the Socratic model ultimately fails as an accurate description of human nature and knowing. Further, sin is what makes the construction of any sort of natural theology impossible. Finally, the reality of sin is what dictates the need for an alternative authority in the religious life to reason, since sin leads to the corruption of our reasoning faculties and points to the futility of Socratic introspection.

The insidious influence of sin is most fully addressed in the second part of *Sickness Unto Death*. After detailing a model of the authentic self which is predicated upon self-conscious willing to be a self in relation to God, and analyzing the various ways in which this process breaks down (all labeled forms of despair), Anti-Climacus proceeds by labeling all forms of

despair sin. Once again, to clarify the Christian definition of sin Kierkegaard employs the Socratic model in order "to bring out [Christianity] in its radicality" (SUD, 88). For Socrates, sin is simply ignorance—those who do evil do so under the mistaken impression that it is really good; no one willingly chooses evil, in the Socratic model. According to Anti-Climacus, "the defect in the Socratic definition is in its ambiguity at to how the ignorance itself is to be more definitely understood, its origin, etc." (SUD, 88). Sin is indeed ignorance, Anti-Climacus agrees; however, it is not "an original ignorance" but "a later ignorance," which lodges "in a person's efforts to obscure his knowing" (SUD, 88). Anti-Climacus argues that if sin is really only simple ignorance, than genuine sin does not exist: sin, literally understood, is willing to do what one knows is wrong. What Socrates understands as sin is not sin, but simply error, a misunderstanding. Here is the point at which Christianity decisively parts from all forms of paganism, according to Anti-Climacus: "It is specifically the concept of sin, the teaching about sin, that most decisively differentiates Christianity qualitatively from paganism, and this is also why Christianity very consistently assumes that neither paganism nor the natural man knows what sin is: in fact, it assumes that there has to be a revelation from God to show what sin is" (SUD, 89). Just as in *Philosophical Fragments*, where the learner needs a savior not only to be healed of his untruth but even to become aware that it exists, so too in *Sickness Unto Death*, Anti-Climacus affirms that "no man of himself and by himself can declare what sin is, precisely because he is in sin. . . . That is why Christianity begins in another way: man has to learn what sin is by a revelation from God; sin is not a matter of a person's not having understood what is right but of his being unwilling to understand it, of his not willing what is right" (SUD, 95).

Anti-Climacus acknowledges that this doctrine is "nothing but offensiveness toward man, charge upon charge," (SUD, 95) for at every juncture the individual is found to be guilty, and he asks, "Can any human being comprehend this Christian teaching?" His answer: "By no means, for it is indeed Christianity and therefore involves offense. It must be believed. To comprehend is the range of man's relation to the human, but to believe is man's relation to the divine. How then does Christianity explain this incomprehensibility? Very consistently, in a way just as incomprehensible: by revealing it" (SUD, 95). The reality of human sin, in other words, points to the impotence of any natural religion or theology in apprehending the full truth, and mandates revelation alone as the sole possible source of genuine religious truth. The Socratic, while admirable in its awareness of the subjectivity of truth (that a truth understood is a truth lived), fails to recognize the pervasive power of humanly willed error, and thus ignores the fundamental untruth of subjectivity; because of sin's insidious influence, no truth understood by humans will ultimately be able to save them.[19]

III

Kierkegaard's emphasis on sin and the priority of revelation over reasoned reflection seems to place him squarely in the emotivist camp, since the acceptance of revelation is not, in Kierkegaard's model, something for which reasons can be given and therefore appears groundless to an outsider. But there is something strange, even forced, about placing Kierkegaard in the lineage of modern emotivism, as conceived by MacIntyre, when one considers the fundamentally Christian framework in which Kierkegaard operates. According to MacIntyre, "what emotivism asserts is in central part that there are and can be *no* valid rational justification for any claims that objective and impersonal moral standards exist and hence that there are no such standards" (AV, 19). Replace "moral" with "moral and religious" and it might seem that we have an accurate characterization of Kierkegaard's position. Yet in point of fact, while Kierkegaard would agree with the first part of the statement, he does not agree with the second; in other words, Kierkegaard does reject the possibility of rational justification for ultimate beliefs (be they moral or religious), but his view clearly does presume that there is an absolute standard by which humans are judged: God's standard. This standard is inaccessible to the human mind save through revelation, in part because of the "infinitive qualitative difference between time and eternity," in part because of the corrupting influence of sin. But the very use of the notion of sin implies a normative vision of what humans should be and are failing to live up to. Kierkegaard's thought, in other words, possesses precisely the kind of teleological orientation that MacIntyre finds lacking in modernity, even as Kierkegaard denies that humans can, through reason or introspection, apprehend the ultimate goal.[20]

One might object that even if Kierkegaard does apply a normative standard he regards as absolute, he still should be labeled an emotivist, because a standard that cannot be rationally justified is one that can only be arbitrarily chosen. There is some truth to this, but at the same time, there is something jarringly wrong about employing the language of preference (the currency of emotivism) within a Kierkegaardian context. To say that Abraham "prefers" to believe that God commanded him to slay his son or that Paul "prefers" the "folly" and "stumbling block" of Christ crucified to the wisdom of philosophers doesn't capture the anxiety and effort involved in countermanding what common sense tells one is (or is not) the case. The very notion that faith requires "the crucifixion of the understanding" entails that one's commitment overturns what one naturally would prefer to regard as true. Kierkegaard does not see commitment to the Christian path in terms of a simple choice, reaffirmed over time (as one can choose to be married, or choose to honor one's parents). While

revelation does present the would-be Christian with a choice, it is not "Choose, or say, 'No, thank you, I'd prefer something else'"; it is "believe, or be offended." And for Kierkegaard (as for Luther, as for Paul), the offense is precisely the affront to our common-sense notions of what is true or false, notions regarded by all three as tainted by sin.

This suggests that the dichotomy that MacIntyre poses between "classical rationalism" and "modern emotivism" is far too simple, that it is possible both to reject the authority of reason and to hold humans accountable to a higher standard than simply the uncoerced exercise of their own arbitrary wills. Indeed, much of the Christian tradition historically has done precisely that; although the extent of the rejection of reason varies from theologian to theologian, the emphasis on the necessity and priority of revelation is a largely uncontested truth until the seventeenth century. Even those who attempt to marry faith and reason do not regard it as a marriage of equals. There are times when reason, like Paul's ideal woman in church, must be silent.

Reading Kierkegaard as a fundamentally modern thinker thus obscures the very traditional Christian orientation that his thought both presupposes and develops. It also obscures the on-going critique of modern intellectual trends that runs throughout Kierkegaard's writings. Kierkegaard is probably best known for his rejection of Hegel, but he was as critical of contemporary religious trends, which he believed were anathemas to genuine religious expression. He rejects, for example, the relevance of historical criticism of the New Testament, arguing that it offers no results of significance to the committed believer.[21] Less overtly, but no less vehemently, he attacks the accommodation strategies of modern liberalism, which sought to reduce Christianity to, essentially, a set of ethical precepts and an inner relationship to God. And above all else he attacked cultural Christianity (labeled by him Christendom), in which an individual is a Christian solely by virtue of being born into a "Christian" society. All of these strategies transform Christianity back into a form of paganism. All make God directly recognizable; all regard Christianity as essentially an ad hoc set of beliefs that one can possess. But the very point of his contrasting the Christian and the Socratic in *Philosophical Fragments* and *Sickness Unto Death* is to underscore the infinite gulf that separates Christianity from any and all kinds of naturalized religion. In his eyes, Christianity requires *faith*, belief *against* the understanding, not with or above it.

This does not mean that Kierkegaard rejects the power of reason; far from it, for the believing Christian is continually pushing against it as that which tempts him away from his faith. But reason functions negatively within his model, as that which must be sacrificed in order to win God. Climacus explains, in the *Postscript*, that "the believing Christian both has and uses his understanding, respects the universally human, does not

explain someone's not becoming a Christian as a lack of understanding, but believes against the understanding, and here uses the understanding—in order to see to it that he believes against the understanding" (CUP, 568).

One might be tempted to regard this sacrifice as itself a peculiar product of the modern period—that is, that living in an age of scientific progress and enlightened rationalism (albeit one on its way to the dregs of emotivism, if MacIntyre is correct) is the reason why reason must be so fully rejected; since reason casts doubts on the credibility of Christianity, Kierkegaard has launched a last-ditch effort to make it viable, by turning its "absurdity" into a virtue. Yet Kierkegaard would respond that he is simply trying to put the would-be believer in the same place as those contemporaries of Christ found themselves. It was, Kierkegaard insisted, no easier for people in the first century to embrace Christ; being there gave one no advantage. In a manner eerily reminiscent of MacIntyre's own nostalgic bent, Kierkegaard seeks to recapture what he calls "contemporaneity with Christ," in which the individual imaginatively confronts Christ and the demand he places on individuals to believe or be offended, just as first-generation believers (and skeptics) did.[22]

Thus Kierkegaard shares with MacIntyre a conviction that something fundamentally has gone awry in modern western culture. Unlike MacIntyre, however, he sees the problem not being the loss of reason's authority, but the crowning of reason as the supreme authority. While he, like MacIntyre, regards the failure of the Enlightenment as inevitable, his reasons for so thinking are quite different. Not only does the attempt rationally to ground ethics and religion falsify the fundamental fact that humans, as humans, can only think subjectively about life's essential questions, but it also is both the manifestation of sin and its perpetuation, for it is attempt to think from a God's-eye perspective. The Christian message, in Kierkegaard's eyes, calls for us above else to be humble before God; and nowhere is the need for this humility more poignantly and pointedly expressed than in the claim that a lowly human being, Jesus, was at one and the same time, God, a claim that forces us to set aside our reason if we are to believe. Kierkegaard the Christian thinker really has no place in MacIntyre's reading of the history (and downfall) of Western moral philosophy, for his sights are firmly fixed on a past event, the moment when the eternal entered time; and in his view, the only redemption possible for human beings is to confront this moment in full awareness and to respond with faith, for it is a moment before which reason can only be offended. This offense, however, is not to be seen as something new in the intellectual history of the west; rather, it is as old as Christ himself and yet remains eternally present to the would-be Christian.

NOTES

1. For an excellent discussion of early Christian attitudes toward Jesus, see Paula Fredriksen's *From Jesus to Christ: The Origins of the New Testament Images of Jesus* (New Haven: Yale University Press, 1988).

2. All references are to the New Revised Standard Version.

3. That many Romans did indeed regard Christianity as a foolish superstition is amply attested to by the polemics written against Christianity, for example, that by Celsus, in the middle of the second century. Celsus argued that it makes absolutely no sense that God would wish to "save" the world, as he surely would have created it the way he wanted it to be, and that if, for some reason, he nonetheless decided to send a redeemer, it would not be an ignorant bastard from a backwater province. For a discussion of Celsus's views, see W.H.C. Frend's *The Rise of Christianity* (Philadelphia: Fortress Press, 1984).

4. It is worth noting that natural theology also raises questions about the authority of the Bible as well, by the same logic; if humans already possess the means and ability to know God fully, then there is nothing particularly sacred about biblical texts.

5. From Karen Jolly, ed. *Tradition and Diversity: Christianity in a World Context to 1500* (Armonk: M.E. Sharpe, 1997), pp. 35–36.

6. Jolly, p. 37.

7. From Cyril Richardson, ed. and trans. *Early Christian Fathers* (New York, Macmillan, 1979), p. 272.

8. Henry Chadwick, trans. *Confessions* (New York: Oxford University Press, 1992), pp. 130–31, my emphasis.

9. Christian missionaries did attempt to "prove" that Jesus was the Jewish messiah by pointing, on the one hand, to prophecies (found in the Hebrew Bible) about the Messiah that they claimed Jesus fulfilled, and on the other by pointing to the various miracles Jesus was believed to have performed during his mission. Yet neither of these supports the key feature of Christian soteriology, that Jesus's death and resurrection make us whole. This claim was foreign to the Jewish messianic expectation, and thus could not be rationally supported by any appeal to it.

10. Thomas Gilby, ed. *Summa Theologiae*, vol 1. (Garden City: Image Books, 1969), p. 50, 55, 43.

11. Ecclesiastical authorities did not unanimously welcome the use of Aristotle Early bans against lecturing on Aristotelian philosophy divided church officials on the relationship between philosophy and theology. Critics "saw in Thomism only a pernicious rationalism" of heretical tendencies. The point here is that even during the heyday of rational theology, strong opposition to it simultaneously existed. See Thomas Bokenkotter, *A Concise History of the Catholic Church* (New York: Doubleday, 1990), p. 147.

12. Erasmus/Luther, *Discourse on Free Will,* trans and ed. by Ernst F. Winter (New York: Ungar, 1987), p. 130.

13. MacIntyre acknowledges the extreme views taken by Luther and other reformers, saying that they "embody a new conception of reason," for they believe that "reason can supply . . .*no* genuine comprehension of man's true end; the

power of reason was destroyed by the fall of man" (AV, 53). My claim, as discussed above, is that MacIntyre overstates the prior tradition's reliance on reason and ignores the many instances where reason is clearly seen not only as subordinate to revelation, but as a rival to it. For many Christian thinkers, the true end of human beings can only be supplied by revelation and received in faith.

14. For selections from Toland, Tindal, and other deists, see *Deism and Natural Religion: A Source Book*, ed. E. Graham Waring (New York: Ungar, 1967).

15. In my discussion of Socrates, I am focusing only on how Kierkegaard regards Socrates, not as Socrates was or may have been in and of himself

16. Kierkegaard himself mimics Socrates: consider how the protestations of Johannes Climacus in the *Concluding Unscientific Postscript* and *Philosophical Fragments* echo Socratic ignorance—Johannes Climacus is only asking how he can become a Christian and does not claim any special knowledge; in *Philosophical Fragments* he repeatedly acknowledges to his impatient critic that he is saying nothing new. Indeed, the entire pseudonymous authorship can be seen as an elaborate instance of Socratic indirection.

17. Merold Westphal, *Becoming a Self* (West Lafayette, IN: Purdue University Press, 1996), p. 127.

18. Calling Socrates a "villain" is arguably a bit extreme, since in Kierkegaard's eyes, Socrates went as far as one could go in a pagan framework: "Socrates did not have the true ideal, neither the conception of sin nor that the salvation of man requires a crucified god The watchword of his life therefore could never be: The world has been crucified to me, and I to the world. Therefore he maintained irony, which expresses only his elevation over the world's shabbiness. But for a Christian irony is insufficient; it can never come up to the dreadful fact that salvation means God crucified, although for a time irony can be used in Christendom for awakening" (JP 4:4279).

19. There is a Socratic version of "subjectivity is untruth," but that is simply the failure to recognize that subjectivity is truth and wanting instead to be objective See CUP, 207.

20. MacIntyre claims, rather surprisingly, that Kierkegaard "reject[s] any teleological view of human nature, and view of man as having an essence which defines his true end" (AV, 54). Such a reading of Kierkegaard is only possible by ignoring his many Christian writings.

21. In addition to fostering the wrong sort of attitude—a disinterested, "objective" stance—biblical criticism fails to recognize that Christ, as the literally the God-man cannot be rationally apprehended. In *Practice in Christianity*, Anti-Climacus baldly asserts that "one cannot *know* anything at all about *Christ*; he is the paradox, the object of faith, exists only for faith. But all historical communication is the communication of *knowledge*; consequently one can come to know nothing about Christ from history" (PC, 25).

22. See, in particular, PC, pp. 62–66.

9

Kierkegaard and MacIntyre: Possibilities for Dialogue

BRUCE H. KIRMMSE

Summary

The specific critique of Kierkegaard contained in After Virtue *(which in my view rests upon a misunderstanding) is not essential to the larger argument of that work, and in any case preoccupation with MacIntyre's treatment of Kierkegaard's* Either/Or II *has obscured some of the underlying points of contact between Kierkegaard's and MacIntyre's views of modern society. These points of contact are worth investigating, and the present essay attempts to move the discussion in this direction. The historical Kierkegaard was a more radical critic of modernity than MacIntyre, and thus his views challenge MacIntyre's own diagnosis of modernity's ills. But it may be that MacIntyre's account also helps us see in what respects Kierkegaard's critique was perhaps too radical.*

Introduction

Alasdair MacIntyre's epoch-defining programmatic declaration *After Virtue* is so important a work and is conceived on so grand a scale that I will refrain from technical criticism or any extended correction of inaccuracies in its depiction of Kierkegaard's *Either/Or*.[1] In the first place, MacIntyre's treatment of Kierkegaard is not really central to his larger argument, which only accords Kierkegaard a relatively minor walk-on part, primarily by using Kierkegaard's aesthete "A" as an example of the pernicious character (and a pernicious "character") of much modern culture, and by using "A's" counterpart, Judge William, as an example of the arbitrariness of ethical commitment supposedly espoused by Kierkegaard. In brief, I believe that there has been a misunderstanding in the case of Judge

191

William, who is in any case a straw man and cannot be said to represent Kierkegaard's final views on ethics. And with respect to the aesthetic character, *After Virtue* would be the same book if instead of "A" MacIntyre had used Baudelaire (who in my view would be an even better example).

Instead of investigating MacIntyre's particular treatment of Kierkegaard, I will first attempt to sketch what sort of overall response Kierkegaard might have made to the general thesis and standpoint of *After Virtue*, and then try to assess how Kierkegaard fares in the light of the book. In attempting to formulate Kierkegaard's response to MacIntyre, I must of course take considerable liberties with Kierkegaard and his pseudonyms, and I will attempt to take the position I believe to be that of the historical person Søren Kierkegaard, who is responsible for the myriad of names and layers which he placed between himself and his readers. Similarly, statements of Kierkegaard's position will often be based, in shorthand fashion, on the general argument put forth in an entire work or works (e.g., *The Concept of Irony*, *The Concept of Anxiety*). Except for a number of crucial instances where it is especially helpful to see Kierkegaard's own words, his position will be set forth in this general way rather than in specific "proof text" passages. Finally, it should be pointed out that I am an historian rather than a philosopher, and am attempting to let Kierkegaard appear as an historical person in a specific historical context rather than as a disembodied theoretical position. This approach seems doubly appropriate both because MacIntyre historicizes the argument in *After Virtue* and also because Kierkegaard as well took an historical view of truth and of the task of philosophy.

Though assuming a fundamentally "Aristotelian" position in *After Virtue*, MacIntyre concedes that Aristotle himself did not think historically and was weak on narrative.[2] In this Aristotle differs not only from the biblical approach to understanding the human condition but also from MacIntyre and from Kierkegaard, who are writers in the Christian tradition and follow the lead of the Bible in attempting to construct a narrative history of our predicament, not merely out of intellectual curiosity in searching for a diagnosis, but also in hope of a cure. Indeed, it is precisely the historical-genealogical nature of MacIntyre's project that lends it its power and persuasiveness as a diagnosis and explanation of the present sorry state of our culture. Only a few years after the initial appearance of *After Virtue* came the sudden implosion of the so-called socialist bloc and with it the disintegration of much of the support Marxism had formerly enjoyed. Although *After Virtue* had neither foreseen nor had had any pretensions of foreseeing this world-shaking event, the situation as it has begun to sort itself out in the decade following the end of the Cold War is much as a reader of MacIntyre might have expected: despite the collapse of communist tyranny, our political and intellectual culture is if

anything even more banal and two-dimensional than previously (cf. AV 261).

Kierkegaard would have agreed with much of MacIntyre's criticism of what is wrong with our culture, but he would have insisted that MacIntyre is wrong in making any imputation that he (Kierkegaard) had been coopted by modernity or had helped foist it upon the world. Rather, Kierkegaard would have insisted that he was an even more radical critic of modernity than MacIntyre—and, as this essay will subsequently argue, Kierkegaard was in fact *too* radical in his critique. We will investigate each half of the above statement in turn.

I. Christianity vs. Classical Culture:
Kierkegaard's Radicalism

First of all, Kierkegaard would have criticized MacIntyre for being insufficiently cognizant of the radical difference between Christianity and classical culture. Kierkegaard's own chronological and intellectual placement made him a witness to the unravelling of neoclassical and Romantic philhellenism and the notion of Greek harmony,[3] so that unlike Judge William, Kierkegaard was unable to feel much nostalgia for the organic-harmonic picture MacIntyre paints of "the forms of social life to which the theorists of the classical tradition give expression . . . [in which] to be a man is to fill a set of roles, each of which has its own point and purpose: member of a family, citizen, soldier, philosopher, servant of God" (AV 58–59).

Instead of focusing on this presumably happy state of harmony and communal wholeness, Kierkegaard continually pointed to the terrible and omnipresent anxiety that haunted Greece and classical civilization generally in the form of *fate*. Greek social embeddedness went hand in hand with an increasingly burdensome (if sometimes unacknowledged) sense of sadness that was connected with a fatalism or resignation (cf. *The Concept of Anxiety*). The gods ultimately determine the fate of everything and everyone, and each of us—like Achilles or Hector or Semele—is but the plaything of those gods. Thus Kierkegaard points to the late-Hellenic breakdown of the classical synthesis, focusing on Socrates, who committed treason against the old culture and adopted the negative standpoint of *irony*, which was the appropriate response to the disharmony represented by the coexistence of the failed, corrupted, disenchanted polis (in the sphere of the state) and a brooding, "zero-sum" fatalism (in the sphere of the spirit) (cf. *The Concept of Irony*).

In Kierkegaard's historical view, classical culture was neither reconstructed by Socrates' ironic heroism nor was its impasse subsequently

transcended in the centuries from Socrates' time until the arrival of Christianity. This intervening period was characterized by various zero-sum forms of pessimism and withdrawal, most notably Stoicism—of which, as MacIntyre helpfully reminds us, Kantianism and analytic philosophy are each in their own way modern descendants. This ancient zero-sum view can be seen in the wisdom of Silenus ("It was far the best thing for man not to be born at all, but the next best was to die as soon as possible" [Cicero, *Tusculan Disputations*, vol. I, xlviii. 114 (Loeb trans.); cf. also Plutarch, *Moralia*, 115 E and Sophocles, *Oedipus at Colonus*, 1225]) and of Solon ("Count no man happy until he is dead" [Herodotus, vol. I, 32]). But nowhere is the bleakness of the zero-sum approach more trenchantly expressed than by Socrates, who was revered by Kierkegaard as representing the highest *human* knowledge: at the end of the *Phaedo*, the dying Socrates asks Crito to sacrifice a cock to Asclepius, the god of healing, thereby firing off his parting shot: namely, his witheringly ironic insistence that life itself is an illness, while death is deliverance, healing. Yet Socrates was the greatest of the ancients, indeed, the greatest of men, Kierkegaard insisted. If one looks beyond Socrates and his followers to such schools as the Stoics, the Cynics, or the Epicureans, one repeatedly finds variations on the zero-sum theme. The ancients could come no further. Nor, as has been noted, could Kant, the greatest of modern men, come further. The gods were dead, and classical culture, paralyzed by fate and anxiety, was ready for a God who could grant freedom, ready to embrace the full meaning of God's omnipotence.

Thus for Kierkegaard the crisis of classical fatalism is only resolved by the arrival of Christianity, which teaches that existence is more than a zero-sum game. Specifically, according to Kierkegaard, Christianity's crucial difference from antiquity lies in its insistence upon the availability of something extra *from without*, a quite unmerited gift, i.e., *grace* instead of *nemesis*, and thus, Pauline *new being* instead of Greek *self-knowledge*, Christian *rebirth* instead of Socratic *maieutics*, *agape* instead of *irony*, and, most important in this context, the *new*, which cannot be recollected, that is, *freedom* instead of *fate* (cf. *Philosophical Fragments*). Thus, just as MacIntyre draws his great divide between the classical-medieval and modern periods, Kierkegaard draws *his* great divide between classical and Christian.

Kierkegaard takes seriously the implications of the existence of an omnipotent, omniscient, and benevolent Deity, and as a result he takes seriously the problem of human freedom. Only freedom—a freedom the Greeks never knew despite all their apparently harmonious embeddedness in "the forms of social life"—can make life bearable. And, Kierkegaard insists, only God can grant freedom. How can this be so? It sounds like a contradiction, and indeed, Kierkegaard believed that for the Greeks the very power of the gods meant that human freedom was excluded. But

Kierkegaard insists that on the postclassical, Christian side of *his* great divide, the omnipotent God Who grants freedom is not a contradiction:

> The greatest thing that can be done for a being, greater than anything one could make it *into*, is to make it *free*. And it is precisely here that Omnipotence is required. This seems strange because of course Omnipotence has the capacity to make dependent. But if one thinks about Omnipotence, one will see that Omnipotence must of course possess the capacity to withdraw into itself again, in an expression of Omnipotence, precisely in order to render independent that which Omnipotence has created. Therefore one human being cannot make another entirely free, because the person who possesses power is himself entrapped by that possession and thus continually comes into the wrong relation to the person he wishes to set free. Furthermore, every finite form of power (talent, etc.) contains a finite self-love. Only Omnipotence can withdraw into itself while it gives away, and this relation is precisely the independence of the recipient. God's Omnipotence is therefore His goodness. Because goodness is to give away entirely, but in such a way that by omnipotently retreating into oneself again one makes the recipient independent.[4]

MacIntyre rightly points out the problematic role that "the ethical" plays in Kierkegaard's works. Much of what MacIntyre says rings fundamentally true, inasmuch as the ethical realm seems to be a continually receding horizon for Kierkegaard. The ethical is certainly hard-pressed and indeed ultimately appears to collapse between the monoliths of the aesthetic and the religious, which flank it on either side. As Kierkegaard's thought developed, his initial trialism (aesthetic-ethical-religious) is compressed into a dualism (Christianity vs. everything else).[5] In any case, however, Kierkegaard does *not* say that we "adopt" the ethical for "no reason" or for something that "lies beyond reasons" and then try to give it ethical authority over us (AV 42). This is precisely the view that Kierkegaard rejects in pointing out the absurdity of the situation of the person who whacks himself on his own bottom like Sancho Panza as equivalent to the absurdity of the situation of "binding" oneself to a moral law à la Kant: in both cases there is "little real seriousness" (*Pap.* X 2 A 396, p. 280). Kierkegaard both appreciates Kant's greatness and emphasizes his ultimate failure.

MacIntyre is thus perceptive in putting us on the track of Kierkegaard's relative neglect of ethics, a result of his lack of fundamental interest in the problem of reason and ethics as he had inherited it from the Enlightenment, i.e., the project of constructing a rule-based rational morality as a product of human self-legislation. In Kierkegaard's view, this project reached its high-water mark with Kant, and again MacIntyre is right to note Kierkegaard's deep indebtedness to Kant, whose moral philosophy stands in judgment over modern philosophy and modern man.

But Kant, even if he is permitted to stand as a best-case scenario, serves only to help us appreciate the grandeur of an edifice humanity can erect but not inhabit. The egalitarian "measure-for-measure" (*Lige for Lige*) of Kierkegaard's ethical sphere functions as a heuristic device: even a merely human legalistic ethics is *beyond* us and humbles us, preparing us to receive grace (*Works of Love*).

But such an ethical project is not only beyond us, it is also *beneath* us: in Kierkegaard's view, a strictly equal measure-for-measure is the best that such a project can do, but as such it is only another articulation of the zero-sum syndrome which characterized classical civilization. The project of a merely human rational morality remains paralyzed in an equilibrium of impoverishment.

For Kierkegaard, the only alternative to the melancholy and fatalistic *nothingness* of classical civilization cannot be yet another attempt to resuscitate that failed project, but rather, as already mentioned, the *something* of Christianity, the something which comes from outside the paralyzed equation of human reciprocity, namely grace, and its concomitant, freedom. For Kierkegaard the categories are thus not predestined *hamartia* and unavoidable nemesis, not fate-obsessed melancholia and the grim Socratic irony of the gallows, but the categories of Christianity: freedom, faith, sin, and repentance—categories which were not available to classical antiquity.

Thus on Kierkegaard's reading, Christianity does not put forth a "theistic version of classical morality" (AV 53), but something wholly new. *Virtue* is the key category for MacIntyre, who writes that medieval "theistic" thinkers (Jewish, Christian, Muslim) "amended" "the table of virtues and vices," so that "a concept of sin [was] added to the Aristotelian category of error" (AV 53). MacIntyre concedes that "in Aristotelian terms [it is very difficult] to distinguish between *failure to be good* on the one hand and *positive evil* on the other," and he concedes, further, that the Aristotelian scheme does not supply an understanding of how "the will can delight in evil," something that is very important to Christianity (AV 175). In Kierkegaard's view it is precisely here that Christianity's fundamental difference from classical thought is to be found. Thus Kierkegaard would insist that MacIntyre's notion of "man-as-he-happens-to-be" is an inadequate descriptor: we don't just "happen to be" the way we are—we have *chosen* to be something (something which, as will be pointed out shortly, involves *sin*). And, as though he were directly replying to MacIntyre's language, Kierkegaard insists that this predicament is not just "something which *happens* to a person."[6]

Kierkegaard explicitly assigned the "error/virtue" dichotomy to the pre-Christian world view, pointedly noting that just as the Greek insistence on rooting evil actions in "error," or ignorance of the good, is pushed

aside in the Christian category of sin, so the opposite of sin is not the Greek category of virtue, but the new Christian category of *faith* (*The Sickness Unto Death, SV1* XI 194). In this sense, Kierkegaard's way of thinking does indeed come "after virtue," but only because he insists that everything after the arrival of Christianity is after virtue, and that faith is what Christianity puts forth instead of virtue.

MacIntyre holds that we have lost our compass. If this position sounds familiar to the reader of Kierkegaard, it is because this is, of course, also Kierkegaard's contention. Or rather, Kierkegaard contends that this is *Christianity's* contention. But there is a crucial difference. *After Virtue* articulates an understanding of our predicament which is historical in the commonly accepted sense of the term, locating the origins of our present situation in developments which have taken place over the past 500 or so years. Kierkegaard's understanding of the situation is a biblical-historical view, locating the source of our troubles at the very beginning of history, indeed on the very first pages of Genesis, where humanity lost its compass in the Fall, an archetypal act of perdition which each of us replicates over and over again. And of course, Kierkegaard asserts, we find it impossible not only to grope our way back but even to accept the fact that we have actually lost anything at all. Indeed, we reject the notion, pushed on us by external revelation, that we are lost and need to be found again. We cannot recognize that we have lost our compass because we have changed, precisely as a result of having lost it. Thus the way out is not to find our compass again, because the person who would have to find that compass is quite different in crucial respects from the one who lost it and would not even recognize it as something he had lost (*Philosophical Fragments*). MacIntyre, on the other hand, (for reasons either theological or philosophical or both) is a less radical lapsarian than Kierkegaard and believes that we can at least catch a glimpse of our previous state, reflected in the political shards and odd linguistic survivals which confront us in modern society, and he seems to hint that from these bits some sort of reconstruction project might be possible.

Similarly, despite significant areas of agreement, the differences between Kierkegaard and MacIntyre seem to become marked when one asks the two authors to assess responsibility for the act of losing our compass. MacIntyre appears to point in the direction of a number of unfortunate historical developments and semi-blunders; he is silent on the matter of *will.* Thus, for MacIntyre our lapse seems to have been a series of *errors*, partly theoretical, partly institutional and social. Kierkegaard on the other hand insists that the loss was an intentional act, an act of will, a sin, and "sin is not a negation, but a position" (*The Sickness Unto Death, SV1* XI 207). And it is precisely here, of course, that Kierkegaard fastens his critique of the Greek standpoint:

The concept by which Christianity most decisively and qualitatively differentiates itself from paganism is precisely sin, the doctrine of sin. . . . What sort of a concept is it, then, that Socrates lacks in his definition of sin? It is the will, defiance. Greek intellectualism was too happy, too naive, too aesthetic, too ironic, too witty—too sinful—to be able to get it into its head that a person, with full knowledge, could refrain from doing the good, or that a person, with full knowledge, knowing what is right, could do wrong. The Greeks posited an intellectual categorical imperative. (*The Sickness Unto Death, SV1* XI 200–1)

As with the Christian/Greek juxtaposition of sin/error, so with the parallel juxtaposition of faith/virtue. On MacIntyre's account of the classical view, the virtues are what a good man is capable of under the right circumstances. Kierkegaard maintains that faith is what every person is capable of under all circumstances. MacIntyre does allow that although in the Greek world external circumstances such as ugliness, poverty, and childlessness can render it impossible for a human being to attain the good, "in the medieval perspective . . . no human being is excluded from the good by such characteristics [and] no evil whatsoever that can happen to us need exclude us either, if we do not become its accomplice" (AV 176). This is fully consistent with the Christian view as set forth by Kierkegaard, but because MacIntyre does not show clearly how this view is consistent with an "Aristotelian" or "classical" notion of virtue, the search for common ground for the two philosophers is made more difficult.

It is only faith which makes possible behaving in the manner of those "characters" praised in Christianity's beatitudes, who are in a number of ways the antitheses of the characters who exemplify the classical virtues: the poor in spirit, those who mourn, the meek, the pure of heart, the peacemakers, etc. Here MacIntyre himself emphasizes the difference between classical and Christian "virtues," pointing out that humility, for example, "could appear in no Greek list of virtues" (AV 136). In light of this and in light of the fact that MacIntyre also points out that "the most striking contrast with Aristotle's catalogue [of virtues] is to be found neither in Homer's nor in our own, but in the New Testament's" (AV 182), one wonders indeed whether it is useful to speak of Christian "virtues" at all. It should also be noted that in setting forth his view, MacIntyre restricts his focus to one (admittedly important) strand of "the medieval world . . . in which . . . the scheme of virtues [is] enlarged beyond an Aristotelian perspective" (AV 178). Kierkegaard, it is certain, would have looked with disdain or bemusement upon this attempt to cobble together a compromise table of virtues comprising both classical and Christian entries.

Finally, in its description of the embeddedness of the Greek in his culture of the virtues, *After Virtue* is quite clearly nostalgic for a world we

have lost (to use Laslett's term). But was that world a Christian world? MacIntyre would say 'yes,' and would argue that it was indeed a Christian world, or view of the world, or at the very least a particular Catholic one:

[I]n much of the ancient and medieval worlds, as in many other premodern societies, the individual is identified and constituted in and through certain of his or her roles. . . . I confront the world as a member of this family, this household, this clan, this tribe, this city, this nation, this kingdom. There is no 'I' apart from these. . . .[W]hat about my immortal soul? Surely in the eyes of God I am an individual prior to and apart from my roles? This rejoinder embodies a misconception which arises from a confusion between the Platonic notion of the soul and that of Catholic Christianity. (AV 172)

Kierkegaard would say 'no,' the world we have lost is not necessarily a Christian one. He would argue that there are other and perhaps older understandings of Christianity than MacIntyre's medieval "Catholic" understanding, and that if MacIntyre's terminology is to be accepted, then a great deal of Christianity appears to be steeped in "Platonic" notions. In any case, citing the Gospels, Kierkegaard would insist that according to Christianity it is the Samaritan—a foreigner not a tribesman—who is our "neighbor," and that our "brethren" are not necessarily our kinsmen. In consequence of this, Kierkegaard would point out, in opposition to MacIntyre, that the attitudes and actions which Christianity requires of a person do *not* appear to be "socially local" and do indeed seem to aspire to "a universality freed from all particularity" (AV 126–27). Christianity may not have gone so far as to "invent" "the individual" (AV 61), but it is radically subversive of the notions of kin and community revered by the ancients:

[Jesus Christ replied] Who is my mother? and who are my brethren? And he stretched forth his hand toward his disciples, and said, Behold my mother and my brethren! For whosoever shall do the will of my Father which is in heaven, the same is my brother, and sister, and mother. (Matt. 12:47–50)

 Suppose ye that I am come to give peace on earth? I tell you, Nay; but rather division: For from henceforth there shall be five in one house divided, three against two, and two against three. The father shall be divided against the son, and the son against the father; the mother against the daughter, and the daughter against the mother; the mother-in-law against her daughter-in-law, and the daughter-in-law against her mother-in-law. (Luke 12:51–53)[7]

Nonetheless it may be possible to find common ground here between MacIntyre's view and Kierkegaard's version of Christianity. MacIntyre seems willing to concede that despite his earlier insistence that all morality is "socially local," things may be different with Christianity, where the

character of the *hermit* first enters the scene not as the unfortunate fate of the wronged hero Philoctetes but as a praiseworthy ideal, signifying the presence of "a great historical divide" between Christianity and classical culture (AV 135). Similarly, MacIntyre admits that "charity is not of course, from the biblical point of view, just one more virtue to be added to the list. Its inclusion alters the conception of the good for man in a radical way" (AV 174). Perhaps agreement between Kierkegaard and MacIntyre can be found here, inasmuch as they both insist that Christianity has changed things "in a radical way" and inasmuch as MacIntyre notes in the second edition of *After Virtue* that he must reexamine points of his argument in the light of "the religion of the Bible and its theology" (AV 278).

II. Kierkegaard Went Too Far

Like MacIntyre, Kierkegaard believed it was impossible to treat "theory" (philosophical and religious self-understanding) apart from the "practice" of social and political institutions. Again, though different from MacIntyre in many ways, Kierkegaard shares with him a fundamentally historical view of the human condition (in contrast, say, to Aristotle). And finally, like MacIntyre, Kierkegaard's view of history involved a lengthy period of decline.

True, according to Kierkegaard, history did develop in what might be called an "upward" direction, in the sense of raising the stakes or increasing the level of tension, prior to Christ's coming, readying the human race for the paradoxical presence of "God in time." But human history since Christ's ascension has fundamentally been one long "parenthesis," a waiting for the second coming, judgment day, and Paradise (*Pap.* XI 2 A 201, pp. 217–18; cf. *Pap.* III C 15). Our hope is for the recovery of that which was originally present, which we have lost, and which lives on in us only in its symptomatic disguises. But we must not pretend we can become whole again within our historical, worldly existence. Our temporal life is an existence in which truth remains incognito, a time of trials and suffering and misunderstanding, of the *unfailing* perversion and inversion of the good, not its triumph and recognition (*Practice in Christianity*).[8] This position Kierkegaard calls "the Christianity of the New Testament." Thus although he is an optimist in the sense in which every Christian who, like Dante, accepts the soteriological drama or *Heilsgeschichte* of a gracious God is ultimately an optimist, Kierkegaard is a pessimist with respect to *human* history.

After Virtue, on the other hand, despite the fact that it deplores the wrong turn taken by Western culture during the last 500 or so years, is fundamentally optimistic with respect to human history. MacIntyre is an

open-ended progressive (in the nontrivial meaning of the term) who believes that the main stem of human history (or at least Western history) has been a series of choices regarding *"the best answer so far"* (AV 277). And if we have made a number of foolish choices in the past few centuries, this still does not foreclose the possibility of some sort of reconstruction, of finding our way to better answers. Thus MacIntyre is an indeterminist in the sense that we are always confronted with the possibility of framing a better "moral scheme" "by identify[ing] and transcend[ing] the limitations of its rival or rivals," thereby moving on, never *to* "a perfect theory" (AV 270) but always *from* less satisfactory solutions, *to* "the best theory to emerge so far in the history of this class of theories" (Ibid.). This is a task which "can never be brought to completion"; it involves "a kind of historicism which excludes all claims to absolute knowledge" (Ibid.). There is no ultimate *"to,"* no independently existent "edge of objectivity," and thus we are not moving in vulgar positivist fashion *toward* some independently existing state of perfect knowledge. Rather, MacIntyre tells us, we are moving *away* from relatively inadequate answers to more adequate ones, and in the course of our development we move toward "excellences our conception of which changes over time as our goals are transformed" (AV 274). This open-ended set of possibilities for development and improvement, and not some already existing goal, is our *telos.*

Kierkegaard's historical view is very different. Although he viewed the end of classical civilization as a major turning point in human history, he also viewed the revolutions of 1848, with the concomitant triumph of mass society and the majoritarian state, as a "time of dissolution" (*The Point of View for My Work as an Author*, SVI XIII 605) and as a "world-historical catastrophe" that was "greater than the dissolution of ancient civilization" (Ibid., p. 555).[9] Dreadful as Kierkegaard believed modern culture to be, he felt that there was no use pretending that we had not got the civilization we deserve. It would do more harm than good to pretend that the moral desert with which we are surrounded is some kind of misunderstanding and not indeed the result of our history thus far.

In Kierkegaard's view, pretending that the Christianity offered by modern Christendom—a marriage of the newly launched democratic state and the ominously renamed "People's Church"—was "the Christianity of the New Testament," was not only an absurd fiction, it was a terribly dangerous one. It was dangerous because the apparent legitimacy conferred by popular sovereignty upon the doddering old State Church of the now-defunct absolute monarchy could tempt many to believe that this new purveyor of "Christianity" actually was the *People's* Church, that *vox populi* had finally really become *vox dei.*

Assuming as he did the indivisibility of theory and practice, Kierkegaard was preoccupied with the triumph, in the *practical* sphere, during the

1840s and 1850s of the modern *vox populi-vox dei* mobocracy (cf. *The Point of View for My Work as an Author*, *SV1* XIII 609). He sums up this development in *Practice in Christianity*—"The deification of the established order makes everything worldly" (*SV1* XII 86)—and he explains it as the result of the parallel *theoretical* triumph of Hegelian pantheism during the 1820s and 1830s:

> The qualitative difference between God and humanity has been pantheistically abolished, first aristocratically, speculatively, then by the mob in the streets and alleys. . . . [Although] of course a good number of philosophers who participated in spreading this doctrine . . . have turned away in disgust, now that it is the mob who is to be the God-Man. (*The Sickness Unto Death*, *SV1* XI 227–27)[10]

Kierkegaard's respect for Hegel's power was coupled with contempt for his pretensions, but he had no doubt that Hegel was a sign of the end, certainly of so-called mainstream Continental philosophy, but perhaps also of much more. Kierkegaard was not deceived by appearances. He saw the continuity between the Right and Left Hegelians of the nineteenth century as unerringly as MacIntyre sees the connection between the Right and Left Nietzscheans of the twentieth. He saw an historical thread running from the breakdown of German idealism in Hegel, thence to the radical Left Hegelians Strauss and Feuerbach (to whose lineage we might legitimately add Marx), and finally to the deification of the mob in the street.

Kierkegaard was literally surrounded by Hegelians. Strauss and Feuerbach, major influences on Kierkegaard's intellectual milieu, were the most significant figures from abroad, but locally there were also such personal associates as the aesthetician Johan Ludvig Heiberg; Adolph Peter Adler (later the subject of Kierkegaard's unpublished "Book on Adler"); Kierkegaard's distant cousin and close friend Hans Brøchner, an unabashed Left Hegelian; and quite a number of others. Kierkegaard regarded these second-generation Hegelians as the sound of the other shoe dropping. According to Hans Brøchner, Kierkegaard "often referred to Feuerbach in his conversations" and "appreciated the clarity and penetration with which Feuerbach had understood Christianity."[11] Indeed, in the *Concluding Unscientific Postscript* Kierkegaard himself notes his respect for Feuerbach, who "attacks Christianity and at the same time expounds it so creditably that it is a pleasure to read him, and a person who has difficulties in presenting Christianity properly and definitely is almost compelled to resort to him" (*Concluding Unscientific Postscript*, *SV1* VII 535). Thus Hegel on the one side and Feuerbach and Strauss on the other can be said to have flanked Kierkegaard's career and to have defined his sense of his task: namely, to articulate an understanding of Christianity

which avoided what Kierkegaard regarded as Hegel's unserious intellectualism while not falling prey to the materialist anthropology of the brilliant "unmasker" Feuerbach, whom Kierkegaard respected as an honest and powerful intellect. Kierkegaard's respect for Feuerbach was of precisely the same, limited sort as MacIntyre's respect for Nietzsche, and could be summarized as follows: If the account of man and God given by philosophy up to and including Hegel is correct, then Feuerbach is correct, too. His honesty and consistency must be respected.

But again, Kierkegaard, like MacIntyre, felt that Western culture had taken a wrong turn and that therefore Feuerbach was certainly *not* the answer. As we have already seen, Kierkegaard's big difference from MacIntyre lies in *where* he felt Christian culture had taken its fatal misstep, and this is where Kierkegaard is open to criticism not only by MacIntyre, but by many others.

For Kierkegaard was far more radical than MacIntyre. Disgusted with the laxity and banality of his own society, Kierkegaard went backward on an historical-genealogical quest, searching for the point where the wrong turn was taken.[12] The problem did not begin in 1849 with the dangerous nonsense of the "People's Church." Nor could the source be found in the *ancien régime*, in Bishop Mynster and the old absolutist State Church, with its Biedermeier smugness, though this was certainly bad enough. Nor even was the root of the problem to be found in the Reformation with its dangerous message of "inwardness" or in the medieval Church with its papal corruption, ritual externality, and monastic fetishism. Was the source of the problem to be found in the prostitution implicit in the Constantinian settlement of the fourth century and the subsequent domestication of Christianity as the state religion, then? Well, that was certainly a major step on the road to perdition, but Kierkegaard relentlessly and radically pursues his quarry even further back in time. It wasn't the Roman Empire and the fourth-century Church which betrayed "the Christianity of the New Testament," according to Kierkegaard. No, Kierkegaard writes in a journal entry he entitles "An Alarming Note," it began with St. Peter and the other apostles at the first Pentecost:

> Those 3000 who were added to the congregation en masse on Pentecost—isn't there fraud here, right at the very beginning? Ought not the apostles have been uneasy about whether it really was right to have people become Christians by the thousands, all at once? [Didn't the Apostles forget] that if the genuine imitation [of Christ] is to be Christianity, then these enormous conquests of 3000 at once just won't do? . . .
>
> With Christ, Christianity is the individual, here the single individual. With the Apostles it immediately becomes the congregation. [*added here in the margin:* And yet it is a question as to whether the principle of having to hate

oneself—which is of course the principle of Christianity—of whether that principle is not so unsocial that it cannot constitute a congregation. In any case, from this point of view one gets the proper view of what sort of nonsense State Churches and People's Churches and Christian countries are.] But here Christianity has been transposed into another conceptual sphere. And it is this concept [i.e., the concept of the congregation] that has become the ruination of Christianity. It is to this concept [i.e., the concept of congregation] that we owe the confusion about states, nations, peoples, empires, which are Christian. (*Pap.* XI 1 A 189)

So, it was that first Pentecost and the very idea of congregation itself that began the watering-down of Christianity to a mass-produced consumer good rather than an unending "ransacking of the soul." Thus, according to Kierkegaard: (1) "Christianity" is too unsocial for any "concept of congregation"; and (2) this concept of congregation has been "the ruination of Christianity."

But in saying this doesn't Kierkegaard abandon a crucial part of Christianity, namely, the doctrine of the Holy Spirit, which is God's person intervening in human history? Here Kierkegaard goes much further than MacIntyre and perhaps much further than is compatible with his own Christian standpoint. In railing against mobocracy he finally turns against the value of community for any other than pragmatic, material purposes, rejecting any positive connection between matter and spirit,[13] between pragmatic association and any higher communal purpose.

In order to save "the Christianity of the New Testament" from the clutches of liberal modernity and the People's Church, Kierkegaard insisted that the only option was "honesty" [*Redelighed*] ("What do I Want?," *SV1* XIV 52), whereby we cut our losses and admit that the world is the theatre of "worldliness"—at best the setting for various associations for mutual advantage of the practical, temporal, finite, material sort.[14] Thus Kierkegaard would agree with MacIntyre's statement that "from an Aristotelian point of view a modern liberal political society can only appear as a collection of citizens of nowhere who have banded together for common protection" (AV 156). The burden of Kierkegaard's notorious "attack on the Church" is his insistence in the name of "honesty" that we admit that this is in fact the sort of society we have, and he asserted further that it is dangerous to pretend that we have a moral whole when we don't. This is not the gleefully self-serving honesty of Nietzsche, though it has been confused with it. There is no *Schadenfreude*, no self-assertion here.

So much for the "world," the public realm, according to Kierkegaard. The sphere of "the spirit," where one deals with matters of infinite and eternal import, is reserved for the invisible Kingdom of Heaven, which requires and tests the faith of each person individually here on earth, while

as we have seen, any form of "congregation" or the Church as such is ruled out as an historical possibility. In fact, as early as his *Practice in Christianity* (written in 1848, published in 1850) Kierkegaard puts us on notice that "congregation" is reserved for the life to come: the "concept of 'congregation,' . . . when applied to this life, is really an impatient anticipation of eternity" (*Practice in Christianity*, SV XII 204). It would certainly appear that Kierkegaard has here fallen into the "Christian stoicism" which MacIntyre attributes to Dr. Johnson, in which "hope is necessarily deferred to another world" (AV 234). As Kierkegaard puts it in this same work, "the day Christianity and the world become friends, Christianity is abolished" (Ibid., p. 205).

In sum, Kierkegaard unmasks "Christendom," the marriage of Christianity and "the world," so thoroughly that "the concept of congregation" itself is lost, and it is difficult to see that there is any role left for the Holy Spirit as the bearer of God's community on earth. *This* is the historical actor Kierkegaard's radical response to his contemporary context. *This* is his reply to the unparalleled "catastrophe" he perceived in 1848. After millennia of consulting and being supported by Heaven, the human community is cut off from intercourse with the divine. After millennia of intercourse with the human community, the gods (or God) are silent except in the interior of the individual human heart.

Here Kierkegaard has gone too far. If MacIntyre in his polemic against the banal individualism of modern liberalism does not acknowledge the radicality of the difference between classical civilization and Christianity, between the biblical beatitudes and the classical virtues, for his part, Kierkegaard does not see that his assault on modern democratic Christendom leaves what is left of the human community squabbling over finitude, consigning the individual to the darkness of his or her own interior (and whatever perhaps fanciful notion of the divine the individual perceives or thinks she or he perceives). It is an invitation to "do your own thing" and to the absurd and embarrassing carnival midway of "spirituality," of auras, angels, and miracles, of "New Age" religiosity in which we are awash. (Though perhaps it should be noted that this cafeteria of do-it-yourself spirituality is itself only a sideshow in the riot of consumption that now seems to be the only common activity in what was formerly called "the Free World.")

In the light of the changes taking place in the times during which he was writing, Kierkegaard's reaction is understandable, even if some of its unforeseen implications and consequences are lamentable. No less than MacIntyre—and indeed even more—Kierkegaard was a critic of modernity. As we have seen, he would have criticized MacIntyre severely for not giving sufficient emphasis to the divide between classical culture and Christianity. But in his individualistic Christianity, Kierkegaard himself stands open to

the charge that he was more of a child of his bourgeois-individualistic times than he himself realized, and thus he certainly seems open to much of the criticism levelled at modern individualism by *After Virtue*.

Nonetheless, there may still be a possibility of bringing Kierkegaard and MacIntyre into a fruitful dialogue rather than simple mutual rejection. In mentioning "one type of Christian teaching, influential to varying degrees throughout the middle ages," i.e., the bibliocentric tradition inherited by Luther and others, MacIntyre seems at first blush to dismiss this tradition out of hand, noting that it leaves "the shape of the Christian life in the twelfth-century world, or in any other specific social world, insoluble" (AV 167).

And, of course, Kierkegaard's flat rejection, cited above, of "the day Christianity and the world become friends" would seem to merit MacIntyre's rejection of *him*. In similar fashion, the Shakespearean quip with which Kierkegaard opens *Philosophical Fragments*, "Many a good hanging has prevented a bad marriage," can only be interpreted as "Better hanged in opposition to the world than poorly married to it." But are these the only alternatives? *Must* one either be well-hanged or ill-wed? *Must* Christianity and the world *either* be (false) friends *or* be (true) enemies? Perhaps Kierkegaard has left the door for discussion open a crack, because these are in fact not absolutely disjunctive statements. As a critical but not utterly dismissive response to Kierkegaard, it might be noted that the possibility of coexistence, of parallel lives, of being "in the world but not of it," has always been recognized within Christianity. It is not necessarily the case that *all* times are appropriate times for martyrdom. Why are not *some* times appropriate for critical engagement? These and similar issues are the ones which must be discussed with Kierkegaard.

And from the other side we must ask MacIntyre if it must *always* be the case that a Christian (perhaps by means of accepting some composite classical-Christian table of virtues) must enter into a compromise with the world, no matter what sort of world it is? This time it is MacIntyre who has left the door for dialogue open a crack, for he writes that

> there are of course times when what the contemporary secular world offers merits only complete rejection, the kind of rejection with which Jewish and Christian communities under the Roman Empire had to confront the demand that they worship the Emperor. These are the moments of martyrdom. But for long periods of Christian history this total either/or is not a choice with which the world confronts the church. (Ibid.)

Here it should be pointed out (for the sake of future argument) that although it has been, is, and always will be true that *communities* are indeed confronted with the choice of absolute opposition, it is only as

individuals that people actually make such choices, and that as a matter of empirical historical fact such choices have always fractured communities and have been roundly condemned by many, often the majority of the community in question. This was the case with the early Christian community during the Roman Empire and it was also the case, for example, with abolitionists in the nineteenth-century United States and with the Christian resistance to the Nazi regime in Germany. All talk of "community" should be given careful scrutiny, especially where acts of heroism or martyrdom are concerned. Usually it is only after the fact, often long after, that the community can take credit for the actions of individuals who during their lifetimes were very unpopular.

Interestingly, it is in this context that *After Virtue* goes on to discuss Abelard, only to reject him. MacIntyre does grant that Abelard's view looks back both to "certain New Testament texts" and to Stoicism, but then he proceeds to discuss—and reject—Stoicism without daring to take on the New Testament (AV 168–69). Perhaps Kierkegaard, Abelard, and Dr. Johnson all deserve to be brought into serious dialogue with MacIntyre who both in what he has said (i.e., that in fact there are indeed times and places for a Christian to refuse cooperation with the social order) and in what he has left unsaid (by not confronting the radicalism of the Gospels head on) has left open such a possibility.[15]

But, of course, it is not my intention to let Kierkegaard off the hook. Kierkegaard's Christianity is historically based because he needs the historicity of God for his Paradox. But it is not fully historical. As we have seen, the congregation—and by extension any form of society except the instrumental, which by Kierkegaard's admission is merely secondary—is reserved for the hereafter, for Eternity, not for history. If this case against Kierkegaard can be made to stick, does this not mean that Kierkegaard, in failing to allow for the Holy Spirit, fails to leave himself—and by extension human history—open to the *new*? This is where Kierkegaard's failure could stand correction by some version of MacIntyre's optimistic-progressive notion of development *from* less-satisfactory-solutions *to* the-best-answer-so-far. As we have seen, according to MacIntyre's account of our historical development, it is precisely that which we can develop *to* that remains open, vindicating the possibility of freedom, something which is of vital importance to both MacIntyre and Kierkegaard. This is the *good* sense in which philosophical discussion remains interminable.

NOTES

1. I am thankful for the support I have received from Connecticut College's R. Francis Johnson Fund for Faculty Development and from the Institute for Systematic Theology of the Theological Faculty of the University of Copenhagen.

2. In this connection see Alasdair MacIntyre, *After Virtue*, 2nd ed. (Notre Dame, IN: University of Notre Dame Press, 1984), for example pp. 147 and 159. All subsequent references to *After Virtue* will be included in the main text as page numbers in parentheses following the abbreviation AV.

3. Among Kierkegaard's teachers at the University of Copenhagen in the 1830s were world-renowned classicists, including the Hellenist P. O. Brøndsted and the Latinist J. N. Madvig, both of whom sat in judgment on Kierkegaard's dissertation, *On the Concept of Irony, with Constant Reference to Socrates*. See Bruce H. Kirmmse, *Encounters with Kierkegaard* (Princeton, New Jersey: Princeton University Press, 1996): 29–32.

4. *Søren Kierkegaards Papirer* [Søren Kierkegaard's Papers], I–XVI, ed. P. A. Heiberg, V. Kuhr, and E. Torsting; 2nd augmented ed., ed. Niels Thulstrup; index by N. J. Cappelørn (Copenhagen: Gyldendal, 1968-78), vol. VII 1 A 181. Subsequent references to Kierkegaard's *Papirer* will be included in the main text in parentheses, in the following format: "*Pap.*" followed by the volume number, the tome number (if applicable), then the letter "A," "B," or "C" (denoting, respectively, journal entries, drafts, and reading notes), the serial number, and the page number (if the entry extends over several pages).

5. Indeed, as I point out in my article "Kierkegaard, Jews, and Judaism," *Kierkegaardiana* 17 (Copenhagen: C.A. Reitzel, 1994): 83–97, Kierkegaard tended to equate "ethics" with "the Law" and "Judaism," and he saw the Jews as a tribal society in which relations with the divine were no less communal than relations with one's fellows. Kierkegaard felt that this was a stage to be left behind, and he eventually placed the Jews (who had originally represented the ethical) together with the pagans (who had originally represented the aesthetic) to form the negative pole in his final dualistic scheme: "the Christianity of the New Testament" vs. everything else. In the light of *After Virtue* and the present essay, however, it could be argued that our culture would benefit from being a bit more "Jewish" in Kierkegaard's sense.

6. *The Sickness Unto Death* in *Søren Kierkegaards Samlede Værker* [The Collected Works of Søren Kierkegaard], I–XIV, 1st ed., ed. A.B. Drachmann, J.L. Heiberg, and H.O. Lange (Copenhagen: Gyldendal, 1901-1906), vol. XI, p. 212. Subsequent references to Kierkegaard's collected works will be in the main text in parentheses in the following format: the title of the work in English, then *SV1* (for *Samlede Værker*, 1st ed.), then volume number, then page number; e.g., (*The Sickness Unto Death*, *SV1* XI 212).

7. There is of course plenty more of this sort of social and familial subversion present in the Gospels, for example:

> He that loveth father or mother more than me is not worthy of me: and he that loveth son or daughter more than me is not worthy of me. And he that taketh not his cross, and followeth after me, is not worthy of me. He that findeth his life shall lose it: and he that loseth his life for my sake shall find it. (Matt. 10:37–39)

See also, e.g., Luke 14: 26–27, Matt. 19:29, Mark 10: 29–31.

8. On the necessary reversedness of God's truth in the world see, for example, *Practice in Christianity*, *SV1* XII 183.

9. In this connection and in connection with the views attributed to Kierkegaard in this paragraph and those which follow, see my articles: "Apocalypse Then: Kierkegaard's *A Literary Review*" in *Kierkegaard Yearbook 1999* (Berlin and New York: Walter de Gruyter, 1999): 182–203; "On Authority and Revolution: Kierkegaard's Road to Politics" in *Kierkegaard Revisited* (Berlin and New York: Walter de Gruyter, 1997): 254–73; "'Out With It!': Kierkegaard's Modern Breakthrough for Himself and for Denmark" in *Cambridge Companion to Kierkegaard*, Alastair Hannay and Gordon Marino, eds. (Cambridge, UK and New York: Cambridge University Press, 1998): 15–47; "Kierkegaard and 1848" in *History of European Ideas* 20, nos. 1–3 (1995): 167–75; "Call Me Ishmael, Call Everybody Ishmael: Kierkegaard on the Coming-of-Age Crisis of Modern Times" in *Kierkegaard's Vision of Community*, G. Connell and C. S. Evans, eds. (Atlantic Highlands, NJ: Humanities Press, 1992): 161–182. See also Bruce H. Kirmmse, *Kierkegaard in Golden Age Denmark* (Bloomington, IN: Indiana University Press, 1990).

10. See also *The Point of View for My Work as an Author, SV1* XIII 608.

11. Kirmmse, *Encounters with Kierkegaard*, pp. 233–34.

12. In addition to many passages in his journals, the principal texts in Kierkegaard's retrospective history of Christendom are *Practice in Christianity, Judge for Yourself!* (especially the discourse entitled "Becoming Sober"), and the various writings constituting the attack on the Church. In brief, Kierkegaard's view is that if history from ancient times up to the arrival of Christ had been one of increasing tension, anxiety, and fatalism, history since His departure has been one of steady decline, laxity, and comfortable corruption. The explicit expression of Kierkegaard's direst historical views comes fairly late in his journals and the significance of these views has neither been widely known nor adequately discussed, but it is clear that they underlay his attack on Christendom. See my pieces "The Thunderstorm: Kierkegaard's Ecclesiology," in *Faith and Philosophy* 17, no. 1 (January 2000): 87–102, and "'I am not a Christian' — A 'Sublime Lie'? or 'Without Authority,' Playing Desdemona to Christendom's Othello" in *Anthropology and Authority: Essays on Søren Kierkegaard*, Poul Houe, Gordon Marino, and Sven Rossel, eds. (Amsterdam and Atlanta: Rodopi Press, 2000): 129–36.

13. The one sort of communal connection between matter and spirit that Kierkegaard appears willing to grant is a sort of *negative* one, in that deceptive and demonic social-political arrangements seem to conduce to lead people away from the quest for spiritual truth, but there do not seem to be any corresponding *positive* social-political arrangements conducive to encouraging such a quest.

14. On society as pragmatic association and on the acceptability of majority rule for—and only for—pragmatic, finite, material purposes see, e.g., *The Point of View for My Work as an Author, SV1* XIII 592n and 595–96, and *A Literary Review, SV1* VIII 99. For the same point made in the context of the attack on the Church, see "The Comfortable—And Concern for Eternal Salvation," in *The Moment* No.2, *SV1* XIV 121–22.

15. More recently, in addition to the implied commitment in the second edition of *After Virtue* (AV 278) (already pointed out in the present essay) where

MacIntyre acknowledges the need to provide a treatment of "the relationship of the Aristotelian tradition of the virtues to the religion of the Bible and to its theology," MacIntyre has also indicated that an account of "the whole Prussian tradition in which public law and Lutheran theology were blended" is an area in which "once again more needs to be done" (*Whose Justice? Which Rationality?*, p. 11). When MacIntyre turns his attention to these areas, his dialogue with Kierkegaard will be enriched and deepened, and further discussion will be facilitated.

Even in his discussion of Greek philosophy, MacIntyre seems deliberately to leave important issues open to further discussion. In discussing Plato, MacIntyre notes that despite the fact that he was a political philosopher, Plato kept philosophy and politics separate, inasmuch as he held that no actual political entity could meet the demands of philosophy: "what is satisfying is attainable only by philosophy and not by politics" (AV 140–41). Plato's separation of politics from philosophy is not without importance for those whom he taught, and these, of course, include both Kierkegaard and Aristotle. In his subsequent discussion of Aristotle, MacIntyre adverts to a related point, reminding us of Aristotle's notion of the human *telos* as "metaphysical contemplation," after which MacIntyre goes on to point out "a certain tension between Aristotle's view of man as essentially political and his view of man as essentially metaphysical" (AV 158). This is not a minor matter over which to have "tension," and it may leave the door open for significant dialogue between Kierkegaard, who is certainly more a Platonist than an Aristotelian but is equally certainly in sympathy with the contemplative side of Aristotle's tension, and MacIntyre, who seems to tilt markedly toward the political side of Aristotle's tension.

Another opening or opportunity for dialogue presents itself with MacIntyre's discussion of Aristotle's views on slavery. MacIntyre quite reasonably rejects Aristotle's acceptance of slavery as a part of the natural order of things (AV 159). But is it quite so simple to reject just this part of Aristotle's world view? True, removing slavery from Aristotle's understanding of the world might very well be accomplished without doing serious damage to his entire structure, which could perhaps have been envisioned in a society without slaves. But that is not the main point. The real question is: What assumptions in *our own* worldview make it so important for us to attend to the problem of slavery right off? What is the source of the urgency of our own preoccupation with the dignity, and yes, the *rights*, of every individual human being, that makes Aristotle's view of slavery so glaringly unacceptable to us? Isn't *that*, whatever it is, the view of the human person (yes, a universal view) which is ultimately rooted in the biblical rule- or law-based understanding of human life—the very sort of view which MacIntyre finds incompatible with the localized and virtue-based classical understanding? If this is the case, then Aristotle's distasteful views on slavery (and other matters) cannot be so neatly excised from any use *we* might want to make of the rest of his systematic understanding of human life and society. Despite his expressed distaste for universal and law-based moral theories, MacIntyre has not closed off access to biblical morality, and he has also expressed distaste for Aristotle's views on slavery and similar issues. So there is clearly some room for dialogue here.

10

Thinking with Kierkegaard and MacIntyre about Virtue, the Aesthetic, and Narrative

NORMAN LILLEGARD

Summary

In Two Ages *and elsewhere Kierkegaard sometimes attributes virtues to aesthetic characters. Aesthetic virtues are separated from ethical virtues by two related features: (1) aesthetic virtues are not, as the ethical are, internally connected to a passion or set of passions of a kind more or less adequate for filling out or making rationally intelligible a whole life, dimensionally and chronologically; (2) aesthetic virtues are not generated by or contributory to any rational self-concept or life view* (livs anskuelse), *which can be expressed in classical terms by saying that they are not a function of* prohairesis, *with all that Aristotleian concept implies for the notions of rationality, self-knowledge, and agency. Reflection on these points supports the claims that Kierkegaard's ethical thinking is not irrationalist in the way MacIntyre argued in* After Virtue, *but instead shares many significant features with the classical tradition which MacIntyre extols.*

There is, MacIntyre avers, an "inescapable question, in that an answer to it is given *in practice* in each human life," namely, the question "what sort of person am I to become?" (1981, 112). That way of framing the questions of ethics is alien, he claims, to "characteristically modern moralities." It is not, however, alien to Kierkegaard, and to that extent his ethical thinking belongs to "the classical tradition" rather than to modern, act-centered (and/or rule centered) theories which take agreement in answers to that question to require some agreement on an account of human nature which is purportedly no longer possible. Such a classical account will allot a central place to the virtues and the notion of character, and both figure crucially in Kierkegaard's thinking, in a way that they do not in Mill or Kant.

211

Also, it will be an account which stresses moral psychology, and few writers are more interested in moral psychology than Kierkegaard.[1] But if Kierkegaard has such an account, what is it, and where in his writings is it?

It would be natural to start looking in *Either/Or*, the second volume of which is the work of an avowed "ethical" persona. But Kierkegaard's thinking about the religious/ethical is disseminated throughout the huge literature which he produced in the few years of his authorial career.[2] Not everything he says on the ethical fits neatly together. Here I intend to pay particular attention to *En Literaire Anmeldelse* (TA), a work published under his own name three years after *Either/Or* and just before *Concluding Unscientific Postscript*.[3] As I look back and forth between the *Anmeldelse*, *Either/Or*, the *Postscript*, and various other works (particularly *The Sickness Unto Death*) the following connected questions and puzzles arise: (1) Can there be "aesthetic" virtues, and if so what are they like, and how do they differ from ethical virtues? (2) What is the role of "passion" in the formation of virtues, and what is the role of reason? (3) Must there be some narrative form for the expression of character? (4) What are the relations between the virtues and particular historical/cultural forms of life? My attempt to answer these questions, the first two in particular, is intended to show that Kierkegaard does in fact have an account of human nature, and what sort of account it is, and that it enables a reasonable answer to the classical question, "what sort of person am I to become?" The questions naturally bring to mind and have been prompted in part by MacIntyre's thoughts about virtues, narrative, and historical change.

I. Aesthetic Virtues and Reason

The first question is prompted by the way in which some of the characters in Fru Gyllembourg's novels which Kierkegaard discusses in his *Anmeldelse* are presented as possessing virtues, even though he explicitly denies that those characters instance "the ethical." For example, Claudine in *To Tisaldre* (Gyllembourg, 1845, passim) exhibits patience, constancy, or faithfulness, even a kind of fortitude. But Kierkegaard describes her as primarily motivated by an "immediate" passion, which is sufficient to make her count as an "aesthetic" individual. Yet *this* variety of aestheticism is, he claims, able to bring one to the border of the religious, just as the ethical does. The aesthete of *Either/Or* on the other hand *necessarily* has no virtues, and can only progress to either the ethical or the religious by despairing of his attempt to live in aesthetic categories. It appears then that in some versions of the aesthetic life, aestheticism is incompatible with the possession of virtues, and in others not. But if the virtues in question are really virtues, what rules out their belonging to "the ethical?"

Judge William tells us that the aesthetic is that by which a person is what they are immediately (EO II 225).[4] I take that to mean that the governing content in an aesthete's life is what he finds himself possessed by: certain tendencies, passions, physical traits, capacities (sic!) and historical circumstances. Thus what the aesthete is, is not *chosen*. But choice, the Judge tells us, is the most fundamental expression for the ethical (EO II 166). Those who do not choose are mere functions of circumstances. They live within the categories "fortune, misfortune, good luck, bad luck, fate." But there are many kinds of aesthetes. William himself presents a spectrum of types (cf. EO II 180–92). Some are mere couch potatoes, passive and semi-conscious. A, the representative of aesthetic existence in *Either/Or* is near the more active and reflective end of the spectrum, and Johannes the Seducer is perhaps at the very end. A recognizes that a mere victim of fortune and impulse cannot maximize enjoyment, and so he seeks ever more refined ways of controlling his experience. He seeks a certain kind of self-mastery. A is not *akratic*. Nor is he vicious. Nor is he moved by any Aristotelian species of *orexis*, since if he were he could be subject to distraction from what is really good by some desire. But that is clearly not his difficulty. Yet his particular effort at self mastery is not aimed at the formation of a *self*, on the judge's view. Otherwise put there is no motivational self-concept behind his furious struggles. It is evident that he is in the process of disintegration as he vainly attempts the practically contradictory task of freely and reflectively *being* his own immediacy. Thus his abiding contempt for "either/or." You can get a sense of the madness of his project from a famous Yogiism: "when you come to a fork in the road, take it."

However, that lack of a motivational self-concept is not sufficient for aestheticism in the sense in which aestheticism is tied to self disintegration, as it plainly is in the case of A. For Claudine, the heroine of the first part of Gyllembourg's *To Tisaldre*, also lacks such a self-concept. She is moved by an "immediate passion," namely a romantic attachment to the French officer Lusard, who goes off to war and leaves her with child. That attachment persists in such a way as to give her life a certain consistency, continuity, unity. Her immersion in the immediate does *not* generate self-disintegration. Claudine is faithful. Why is that not an ethical virtue, on Kierkegaard's view? Answering this question requires saying something about kinds of choice and about passion.

First, Claudine does not in an obvious sense "choose" this passion. It simply acts on her, immediately. But does anyone choose their passions? I will offer a qualified 'yes' to that below in the course of explicating 'passion.' But even if we grant that Claudine's initial passion is not in any sense chosen, choices come to play an important role in her life, and some of those choices do involve assigning relative weights to various sometimes

conflicting passions, emotions, and desires in such a way as to bring about a kind of coherence and narrative unity in her life. So even if Claudine is not ethical but aesthetic, it is not because choosing is not important in her life, and the choices she makes are not just the trivial aesthetic selection from the smorgasbord of life, nor are they choices motivated by a refined attempt to avoid boredom and other difficulties blocking the pursuit of enjoyment, such as feature in A's disintegration. Some of her choices are directly life integrating choices. In fact her decision not to marry a Baron who is devoted to her is a good example of a life integrating choice. But Kierkegaard will still not count her as an ethical figure.

What Claudine lacks is, I believe, the effort whereby she takes what she is by nature and history (and that will include what *moves* her, passions) and consciously tries to integrate it into a *rational* self-concept by reference to which a more or less unified life might be achieved. I believe that that is in fact the nub of the notion of choice in William's thought, and also in that of other pseudonyms, such as Climacus, who quotes with approval Plutarch's "splendid definition of virtue: 'Ethical virtue has the passions for its material, reason for its form'" (CUP 161-62). I will try to say in what sense Claudine's virtues, and aesthetic virtues generally, do not have reason for their form (and thus are not ethical), and in what sense those with ethical virtues do exercise reason. Doing that requires saying something about the relations between passion, emotion, reason, and the place of all of these in a whole unified life (sec. A). And it requires explicating the notions of freedom and agency as exhibited in something like Aristotelian *prohairesis* (sec. B).

A. Passions, Emotions, and Rational Life Unity

Kierkegaard is passionately interested in passion. Character without passion is on his view impossible. For in one use of 'passion' (*lidenskab*) a passion is simply an enduring interest which gives shape to my life.[5] Kierkegaard's principal complaint against his own age (the second of Gyllembourg's "two ages") is that it lacks passion and *for that reason* lacks character. And character is necessary for having a "self." 'Passion' can also refer to an emotion, i.e. a relatively transitory occurrent state. By his usage Kierkegaard indicates that emotions (*lidenskaber*) are often the product of or provoked by passions (*lidenskaber*). There is a similar usage of 'passion' in English. For instance, if I "have a passion for" classic automobiles I will most likely "get in a passion" (experience strong emotions of anger, despair, and the like) when the teen next door sideswipes my '55 chevy.

Now passion in both senses is possibly qualified by thought in at least two ways. First, I can to some extent control what emotions I have by

thinking certain thoughts. Claudine turns her mind to Lusard when tempted by the Baron's offer, and thus deflects certain emotions (for example, a feeling of relief after years of seclusion, loneliness, and suffering) to which she might have given way. In this way thoughts could actually block or disarm certain emotions, and thus keep certain passions afloat, and thus play a role in what passions I have.[6] In that sense someone might "choose" his or her passions. Hume remarks upon the power of "reason" to direct a passion.[7] It appears from the context that what he has in mind is the sort of case in which reason clears away obstacles to the fulfillment of a desire, by showing that desire how to unfold towards fulfillment in particular circumstances through the skillful deployment of means. But he does not consider the kind of case in which a passion employs devices of thought to get rid of competing desires. I am imagining a case in which a competing desire threatens to cancel the original motivators for the course of an action, but is brushed aside by a sort of technique of "talking to oneself." On Hume's account of the mechanics of the mind, that sort of thing should not be able to happen. The strongest desire should always win out, other things being equal, and presumably the criterion for which desire is strongest is not simply that it does win out. I do not think that in the sort of case instanced by Claudine we have what amounts to the employment of "reason," but thought is involved. If her emotions are qualified by thought, to that extent they are removed from pure immediacy.[8] Thought in this sense is integral to her acquisition of character, it works in the service of constancy, so that the persistence of her passion is not necessarily simply a function of its original "immediate" strength.

But there is a second way in which emotion may be qualified by thought which does not apply to Claudine. Her character is limited to whatever shape she can be given by a romantic passion, assisted by thought but not thoughtfully adopted. That is to say, Claudine lacks a life view (*livs anskuelse*),[9] and within a life view emotions are qualified by thought in another sense. A life view is more than the "immediate" output of a single dominating passion, or just a congery of passions, but has a grammar or logic to it by which *various* domains of acting and feeling (also action/feeling dispositions, i.e. passions) get some unity or coherence, such as that which resides in consistent rank-ordering for the sake of an end, and other operations of *agency* (further discussed in sec. B). Life views are full of conscious teleology, thus, full of thought in the service of wholeness or unity. A obviously lacks a life view in this sense, but so does Claudine.

It does not follow however that there cannot be aesthetic views on how to live (I will not call them "life views"). Someone could consciously choose to live for pleasure or success or to unfold and develop a talent. MacIntyre was thus right when he claimed that someone could *choose* an

aesthetic life (though I believe the example he gives would be counted by William not as an aesthetic life but as "sin." Cf. AV 39, 40 and EO II 168). And they could follow through on this choice by thoughtfully rank-ordering various motivational factors, and in the process even achieve a certain kind of wholeness or unity in their lives. There must then be further ways of distinguishing aesthetic from ethical virtues. It cannot be that the definitive feature of aesthetic virtues is that they are immediate in the sense of being unqualified by thought in either of the senses explicated above, or that they are dissociated from any *kind* of life unity or life view.

We can begin to see what further constraints there must be on the notion of an ethical virtue by considering further what it is that makes us so inclined to attribute ethical virtues to Claudine in the first place. She is motivated by a romantic passion (attachment to Lusard). Such a passion can confer something that looks more like ethical character than would the shape given to a life by, say, a passion for ping pong. Why is that so?

A romantic passion can by its very nature take up or penetrate much of a life. On the other hand, a passion for ping pong is not likely to give any particular shape over a significant period of time to my relations with my wife, friends, or parents, my work, my characteristic hopes or fears for my whole life, my attitudes towards the passage of time, or my relations to the larger social order from which my life has emerged. But a romantic passion might impart a particular shape to any or all of those, as is clear in the case of Claudine. A passion for ping pong on the other hand could shape my entertainment hours, and very little beyond that (though it will occasionally show up in non–ping pong daily life in various ways, by, for example, my noticing announcements in the paper about ping pong matches). If a passion for ping pong became consuming in someone's life, and moreover paid their way, we would be entitled to question the wholeness or unity of that life in the following ways: how could such a passion bear upon the great variety of relations to other persons so as to shape them one way rather than any other?; how would it bear on their thoughts and concerns for community, which surely must be thoughts for more than just the community of ping pong players?; how would it bear on thoughts and feelings about "birth, copulation, and death"? If someone were to take as the meaning of death simply "oh dear, no more ping pong" we would rightly, I think, believe that they had missed something essential, that they had trivialized themselves (but I think it would be difficult for most of us to "find our feet" with such a person, assuming that such a person is a real possibility).[10] I think we would not be likely to count whatever virtues such a person might have as ethical largely because of the impossibility of unifying a life around such a passion. It follows that the *kind* of wholeness or unity conferred by ethical virtues is not the kind that comes from devotion to the increasing articulation of some immediate capacity or interest.

Consistent and even successful striving to achieve supremacy in ping pong, or in violin playing, however disciplined and full of choices and rank ordering it might be, and however much it would thus in a way unify a life, would not confer the unity in question.

This notion of the adequacy of a passion or set of passions to a "whole life" is in fact a key to Kierkegaard's thinking both about the relations between the aesthetic and the ethical and to his thought about the religious. Consider how William touts the superiority of active despair over doubt as the avenue to the ethical because active despair (another expression for which is "choice," he tells us) takes in more of the personality than does doubt (EO II 212). Or consider how the notion of "purity of heart" which consists in willing *one* thing (*not* to be confused with monomania) is constantly invoked in the discourses and elsewhere. Purity of heart is a matter of a consistent ordering of all the dimensions of life through time around a single (though highly ramified) passion. Kierkegaard's thought is surely close to that of Aristotle, and MacIntyre, when they insist that the *telos* of actions which can genuinely be said to be chosen (*prohairetike*) and thus as exhibiting ethical virtues, must be something that qualifies a whole life, rather than just a summer's day, or some limited feature of one's life (say, one's work life, or one's life *qua* possessor of this or that talent). The extent to which a life view can in some sense unify a life is thus intuitively relevant to the ethical character (or lack thereof) of the virtues associated with it, and the unifying power of Claudine's passion is, I believe, what inclines us to think her virtues ethical.

But what senses of 'unify' or 'whole life' are relevant? I have already argued that the comprehensiveness of the unity in question is relevant. A life view which can support and be supported by ethical virtues must be one which somehow is able to articulate in a very comprehensive way the bearings of my various passions and concerns upon one another and upon the various dimensions of my life (I will call this "dimensional wholeness"). It must also be a view which can articulate a way of ordering those passions over time (I will call this "chronological wholeness"). It must be able to do these two things in a way that somehow beats all competing life views. The reflections found in *The Sickness Unto Death* prove helpful in seeking more clarity on this matter.

Anti-Climacus (the pseudonymous author of *The Sickness Unto Death*) supposes that it is a permanent feature of human beings that they are constantly in pursuit of ideals. My actual self, the finite being which I am necessarily at any given moment (necessarily since only the future contains possibility), my given or immediate self, is constantly being related to some ideal (the possible, the infinite, since there are no finite number of them) by spirit; or, 'spirit' is the name for that feature of humans by which they constantly seek a "positive" unity between themselves *qua* actual, given,

necessary, and an ideal self. I take the notion of an ideal self to include, but not be equivalent to, what I have called a motivational self-concept. The least "spirited" of humans hardly strive at all. The low grade aesthete, the couch potato, may have no more of an ideal than that of a self with and titillated by "pretty guls" (thus "General" Sash in Flannery O'Connor's "A Late Encounter with the Enemy" (O'Connor, 1971, 134–44)), and even that "ideal" is not consciously chosen as providing the terms within which to live (so, as I'm using the terms, it does not amount to a motivational self-concept). There is little more than sullen immersion in the most primitive immediacies in such a life, which nonetheless is threatened by anxieties of various kinds and even by significant awakening to the fact of one's own despair (such as Sash experiences at the last moments of his life).[11] The more spirited individual is more troubled not only by failures, which plague everyone, to live up to his or her ideals, but by the short-comings of various ideals themselves. It is this last feature which is partic-ularly relevant to my theme.

Suppose that a few hard knocks from life (perhaps from the behavior of others) have caused a person to move beyond "pure immediacies." "He now acquires a little understanding of life, he learns to copy others, how they manage their lives. . ." (SUD 52). This amounts to progress. The new ideals, though borrowed ("the reflective immediacy of the crowd") have behind them some experience, some knowledge of what actuality can do to a person. The new ideals ramify further in my life, take in, for example, the vagaries of the behavior of others in a way that more immediate ideals did not. As reflectiveness grows, "reflection helps him to understand that there is much he can lose without losing the self. He makes concessions; he is able to do so—and why? Because to a certain degree he has separated his self from externalities, because he has a dim idea that there may even be something eternal in the self" (SUD 54–55). This progress is marked by an increase in intensity of passion. Every ideal that is adopted and then abandoned ups the ante, places higher demands on the next ideal, requires that it be capable of withstanding the pounding that our surroundings and our own inadequacies give to our ideals, and thus requires that it be less bounded by such contingencies, thus, more "infinite" (unbounded).

Suppose that, amid the difficulties of life, a person in a sort of desper-ation concentrates his or her whole self, invests everything, in one passion. That might be the case with Claudine. It is either Lusard or the whole world is lost. "When the self in imagination despairs with infinite passion over something of this world, it's infinite passion changes this particular thing, this something, into the world *in toto*. . . " (SUD 60). Now such passion is not commendable in many ways, but not because the passion is infinite. Such passions at least show courage or at any rate spirit, as opposed to philistine prudence. But the object is wrong. Infinite passions

require an infinite object, which Lusard is not. They require an object capable of consuming all of one's interest, but Lusard (or any other human) does not meet that condition either. As long as her passion remains untested internally (as opposed to the test of external trials, remaining unmarried, living apart), it may seem otherwise, but it is difficult to imagine all of Claudine's interest being in Lusard were they married. In fact, this romantic ideal, as Judge William shows in some detail, can only be fulfilled ethically. Thus, the "immediate eternity" of romantic love will disappear sooner or later, even where it is purest and strongest, under the pressure of everyday life with a real person. Other interests are almost certain to arise, for example the interest of children, which would require modification of the original ideal. The original ideal would be seen to possess less dimensional wholeness than at first seemed to be the case. So Claudine's ideal could not be pursued with absolute earnestness. Experience would require its modification, or abandonment. The latter shows that the passion was not so strong after all, the former shows how deep passion infinitizes, not in the imagination, but in daily struggle in which ideals become modified in the direction of the religio/ethical. The original more immediate passion recedes as experience shows that one cannot have much of a self in the terms it provides after all.

The conditions which a more adequate "ideal self" must meet are discovered through *reasoning*. It may be of various kinds. Some of the reasoning involved is like Aristotelian *epagoge*, in that experience of particulars (experience of the conflicts and unpredicted and unpredictable contingencies that fill life) leads one to induce that an ideal or *arche* must be modified. Or some of the reasoning involved could consist in simply thinking through, analyzing, the nature of a given ideal. That is what Anti-Climacus does with the Stoic ideal. The Stoic has an abstract ideal of the self as total master of itself, but the ideal is empty, since the one that rules the self is internal and "it is easy to see that this absolute ruler is a king without a country actually ruling over nothing; his position, his sovereignty, is subordinate to the dialectic that rebellion is legitimate at any moment" (SUD 69). If I am the only one in charge of me, then I can certainly kick myself out at any time in the name of my own authority. That is, the Stoic is play-acting. It follows that a more adequate ideal must posit something objective, a power outside the self which will provide real rigor in the conduct of life. This thought is developed further when Anti-Climacus points out that "A cattleman who (if this were possible) is a self directly before his cattle is a very low self, and, similarly, a master who is a self directly before his slaves is actually no self—for in both cases a criterion is lacking" (SUD 79). The master before his slaves is something like the Stoic self before himself (he can order himself around any way he likes, he can even order rebellion, so there is no criterion for success at "being a master"). Consider the ideal

of "self-as-cattleman." The criterion for the achievement of that ideal would be, presumably, the condition of the cattle. Thus he has succeeded in being a self by a very part time standard. He might even hire someone else to ensure the cattle's condition, in which case the criterion would be, as Patrick Goold puts it, "the paradigm of minimal selfhood" (Goold 1987, 314). Goold sums up the situation neatly: "To the extent that the ideal self makes a lesser demand the spiritual self is diminished, because the synthesis of actual and ideal selves that is the spiritual self becomes an intermittent thing. The ideal so construed is an inadequate object for an absolute earnestness because it is something it is possible to escape" (ibid). The ideal so construed lacks dimensional and chronological wholeness or unity.

The two kinds of reasoning I have just described bear on conduct in a non-Humean way. The reasoning in question does not simply serve desire by finding causal connections or adjusting the pursuit of interests in the light of experience. Rather than showing that a given desire cannot be fulfilled under certain conditions, reason shows it as unworthy of fulfillment because of a kind of sentimentality inherent in it, which shows up in the way it dissipates in the face of obdurate facts. It then loses its capacity to unify life. In this way reason might change the interests or desires themselves. Further, reason can eliminate the motive force of desires and more complex motivational structures by displaying a kind of fraudulence or self-deception at their heart. Thus reflection on myself, the many dimensions of my life, and the importance of my own agency to them shows how paltry the ideal of a "self-as-cattleman" must be, and may show that it actually functions as an escape from a more comprehensive ideal, or as a self-deceptive way of "losing oneself in one's work."

There is a further way in which non-Humean reason operates in the ethical life as construed by Kierkegaard. Consider how William regards much of the ethical life as a more adequate articulation or specification of aesthetic passions. I believe we can generalize on this point in the following way: maturation, development of a self, is in important part a matter of sharpening vague and amorphous desires and life-projects. Even at the level of some seemingly specific desire (the desire for a nice evening out) the problem that faces me is not necessarily or even typically one of finding a means to satisfying the desire but rather one of finding the best specification of it. How much more so is this the case with something as general as "wanting a good life"! Wiggins puts the point this way: "the problem is not to see what will be causally efficacious in bringing this [some desire or project] about but to see what *qualifies* an adequate and practically realizable specification of what would satisfy this want. Deliberation is still *zetesis*, a search, but it is not primarily a search for means. It is a search for the *best specification*. Till the specification is available there is no room for means" (quoted in Jacobs 1989, 13).

Kierkegaard views life-fulfillment as requiring an ideal self which exists before an objective being capable of consuming all of one's interest, filling one's whole life, and providing an external criterion for living. That sounds like a being closely related to, perhaps identical to, God. In fact that is the direction that Anti-Climacus thinks enhanced consciousness and reasoning of the kind just described must lead. His argument is a kind of argument for the necessity of faith. But it also gives us some general notions of how to rank ideals. And it should be evident that aesthetic ideals will rank low by virtue of their nonrational (in the senses just proposed) character. Claudine does not reason in any of the senses mentioned. If she should begin to, she would no longer be an aesthete, but would be in movement over the border into the religious or the ethical. Ethical and religious ideals will be ranked by how much reasoning of the kind proposed they can survive. The kinds of reasoning involved are, again, non-Humean.

B. *Rational Life Views, Agency and Prohairesis*

I mentioned above the possibility of choosing an aesthetic life. Nonetheless "choice is the most stringent expression for the ethical" (EO II, 166). It is necessary then to further explore the conception of choice relevant to the ethical.

The notion that virtue has the passions for its material, reason for its form, calls to mind Aristotle's definition of choice as deliberative desire. Aristotle's account contains interesting points of contact with William's. In what follows I adopt, without argument, MacIntyre's construal of practical syllogisms and practical reason generally (WJ 124–33).

The reason required for the deliberation in "deliberative desire" is practical reason, and its operation requires being able to descend from some *arche* to a particular statement about what is to be done in such and such a situation, which together with the statement saying that this is such a situation, issues in an action as a "conclusion." That is, deliberation has the form of a sort of syllogism. The employment of syllogisms is itself an exercise of reason. This deliberation also requires being able to ascend from particulars to the *arche* (the kind of *epagoge* mentioned above) and also *zetesis*. The possibility of such deliberation depends upon the existence of virtues (otherwise contrary passions, impulses, other contingencies, would interfere) and the ensuing action is also virtue-building. Choice in the required sense is life-forming. Obviously not all choices are. A choice is rational if it is correctly deliberated, which requires among other things soundly drawing particular conclusions from the beginning points, noninterference from aberrant desires, and accurate perception of particulars, but also, an *arche* which is itself reasonable.

This last requirement, which is absolutely central, marks the point where most modern philosophers have felt compelled to break completely with Aristotle. Modernity has generally rejected the idea that there is some good for humans as such since human desires and ideas of fulfillment are so heterogenous and can be ordered in so many incommensurate ways. This objection to Aristotle does I think most often depend upon the supposition that an individual's confrontation with various life conceptions is from a standpoint external to all such conceptions. MacIntyre sums up the situation of the individual in modernity thus:

> Such an individual has as yet *ex hypothesi* no commitments, and the multifarious and conflicting desires which individuals develop provide in themselves no grounds for choosing which of such desires to develop and be guided by and which to inhibit and frustrate. From Aristotle's point of view such an individual has been deprived of the possibility of rational evaluation and rational choice. And it is precisely because it is the *ergon*, the peculiar task of humans beings to evaluate, to choose, and to act *qua* rational beings that human beings cannot be understood in detachment from their necessary social context, that setting within which alone rationality can be exercised. (1988, 133)

Now William explicitly rejects the notion that human beings might be understood in detachment from their necessary social context or that they might adopt a life view from a position external to the life conceptions supplied by those contexts. He constantly reiterates that human life is inescapably situated within the family and other communities (civic, religious) and that ethical life requires an "owning" of that fact. He stresses the way in which my involvement in them from birth through death gives me the materials for a self even as I seek to shape them in turn. William's descriptions of the ways in which I take over the materials of a potential self and shape them by my own activity are richly detailed and sometimes very redolent of the "classical tradition:"

> The person who has ethically chosen and found himself possesses himself defined in his entire concretion. He then possesses himself as an individual who has these capacities, these passions, these inclinations, these habits, who is subject to these external influences, who is influenced in one direction thus and in another thus. Here he then possesses himself as a task in such a way that it is chiefly to order, shape, temper, inflame, control—in short, to produce an evenness in the soul, a harmony, which is the fruit of the personal virtues. (EO II, 262)

Here I will briefly examine two ways in which an *arche* that William could count as the source of *ethical* action might also be considered

"rational" even while belonging to a particular tradition of thought and life. Consider, first, the significance of repentance, which figures centrally in William's account of the ethical and has an obvious source in religious traditions.

Repentance is a way of owning my personal and communal past. Consider the latter. If I can only choose myself when I recognize my place in the historical communities to which I belong, and if it is a fact that those communities will always include evil as well as good (which William seems to regard as obvious) then my relation to the past must be one in which I "repent myself back into it." I take this to be not very different from a point made by MacIntyre which he illustrates by showing the importance, to being an American, of recognizing the place of slavery in the history of that civic community (AV 205). Now there are various ways in which doing this might be thought "rational." One way to characterize what is rational (done or thought with reason or good reason) would be to contrast it with what is arbitrary. There seems to be something arbitrary in thinking about myself, who I am, in terms which leave out ingredients which anyone can, on reflection, see to be relevant (I suppose this comment has a vaguely Kantian ring). This idea is at least part of what is behind William's association of the ethical with the universal. The universal is, minimally, what can be understood by all, that which contains no arbitrary exclusions or inclusions which would depend upon various kinds of partiality or accidental features. Thus construed the universal lends *transparency* (another favorite term of William's for describing the ethical person) to myself. Repentance is a way of taking up the past, taking responsibility for it. When I am responsible for what I am or become then my self is not viewable as simply the output of forces beyond my control, and to that extent who I am "makes sense" both to myself and others. The aetiology of my actions, virtues, and defects, comes to be seen as lying in myself, which conduces both to self-knowledge and transparency to others. I gradually, through a protracted struggle, can strip away puzzlement about "why I did that" or "why I am like that."

I am trying to indicate here a connection between rationality and free agency which at least has Aristotelian overtones. Practical rationality requires free agency, and its output is "*prohairesis*" which requires that the various motivational forces in my life (not just occurrent desires, but passions, feelings, historical influences) have been taken up, owned, and shaped in such a way as to constitute a guiding self-concept or *arche*, which enables me to account for or explain myself to any reasonable person. I connect that *arche* to the particular thing to be done via something like a practical syllogism (though other forms of practical reasoning are surely possible). *Prohairesis* requires *rational* agency which among other things requires "repenting myself into the past." Otherwise the content of my self-concept

would be arbitrarily cut off from "actuality," as William would put it, that is, cut off from the only features available to anyone for a life, namely, particular inheritances, this civic history, these capacities, and so on.

A second related way to see the rationality of the ethical *arche* is afforded by William's reflections on work. The aesthete seeks occupation on the basis of talent, that which differentiates him. But this too involves something arbitrary. How do I justify my daily activity as the exercise and development of a talent without drawing some line between myself and others, or between each person and every other, which is "more or less quantitative" (EO II 292). This is not to deny that the difference between myself and a great concert pianist might not be so great as to seem qualitative, but there is some professional musician out there, living off his talent, so to speak, who differs from myself only quantitatively. But where should I draw the line which allows me to say "this scholarly life was the one for me, not the musician's life?" But that very arbitrariness makes my (work) life deeply inexplicable to me and to anyone else who would care to think about it. For aesthetes, the Judge tells us, "the nerve in their view of life lies precisely in this arbitrariness" (ibid.).

The ethical view on the other hand treats work as vocation. So if I ask some ethical person why they are occupied as they are they will answer, "because it is my job, my vocation" and that answer is or can be intelligible to anyone since anyone's work can be so conceived and understood. Not many people can understand why anyone would want to teach philosophy. Everyone can understand that people generally need to labor. That is universal. So the ethical view is "in harmony with actuality, explains something universal in it, whereas the aesthetic view puts forward something accidental and explains nothing" (II 288). In that sense aesthetic views of life, and aesthetic life itself, are irrational.

But could not someone say with perfect *reason* "work is the curse of the laboring class, an unfortunate necessity, which gets in the way of real self-development" (cf. Marx on the significance of work and the basically aesthetic development of the *"total entwickelte Individuum"* which will only be possible where work as constituted within the capitalist regime, namely as drudgery, is practically eliminated)? William's response consists in calling work a "vocation" and elaborating that notion; which is to say that his way of thinking about the ethical life grows out of reformation and particularly Lutheran traditions (William suggests more than once that he has nothing to offer not contained in Balle's catechism). In those traditions work, marriage, and other roles are vocations, the ways God orders the world, and the ethical individual is "responsible to the order of things in which he lives, responsible to God" (EO II, 260). That order is "rational." "The ethical thesis that every human being has a calling expresses, then, that there is a rational order of things, in which every human being,

if he so wills, fills his place in such a way that he simultaneously expresses the universally human and the individual. . . . He has also found a more significant expression for the relation of his work to other people; inasmuch as his work is his calling, he is thereby placed essentially on the same level as all other human beings" (292–93). We see in this quote also how work as vocation has a civic significance which work as expression of talent does not. The ethical view of work as vocation takes in or "meets" more of the circumstances of human life, and thus meets one of the criteria for a rationally adequate life view (dimensional wholeness).

Here, too, we have an opportunity to apply the previously made point about the thought-qualified nature of passion and emotion. To have a passion for one's work *as a vocation* would then be to think certain kinds of thoughts (about the place of "accomplishment" for instance [EO II 294–6]) and have related appropriate feelings (for instance, to not be downcast by what some might consider lack of accomplishment). By unfolding the content of these passions, William is able to show how the ethical life view is able to overcome the deficiencies which plague the aesthetic life. It provides a picture of selfhood that can be deeply articulated, compared to alternatives, defended by numerous strategies. But it is also a view rooted at least partially in a particular tradition or set of related traditions—theistic, biblical, even Lutheran. Kierkegaard does not explicitly attempt to find some neutral standpoint from which to evaluate its purported rationality. He does give reasons, some of which I have discussed, for the claim that the ethical view can appropriately be thought of as rational in a way that the aesthetic life cannot. But for the full specification of the nature of such virtues as patience, contentment, faithfulness, industriousness, and courage, one needs to be able to refer them to an *arche* formed in part by a specific tradition.[12] Only then can we fully see *what* it is to choose in accord with it, and also to see how one must possess those virtues in some degree in order to so choose.

To summarize: I have been proposing and explicating the claim that aesthetic virtues, although not forms of mere immediacy in the sense of being more or less unqualified by thought, and although genuinely virtues, are separated from ethical virtues by two related features: aesthetic virtues are not, as the ethical are, internally connected to a passion or set of passions of a kind more or less adequate for filling out a whole life, dimensionally and chronologically; aesthetic virtues are not generated by or contributory to any rational self-concept or life view, which can be expressed in classical terms by saying that they are not internally connected to *prohairesis*, with all that implies for the notions of rationality, self-knowledge, and agency. [13]

These constraints on what counts as an ethical virtue will apply even where someone exhibits what we would normally consider to be an ethical

virtue par excellence. Oskar Schindler had or developed a passion for saving Jews. He was, that is, passionately committed to preventing the shedding of innocent blood. A strong disposition to act in accordance with the principle "innocent blood must not be shed" certainly seems to be an "ethical virtue." Over a certain portion of his life this passion shaped much of his life, and various other virtues were necessary for his actions, such as courage and quick-wittedness, which suggests even some limited unity to his virtues. But he was also unfaithful to his wife, overly fond of fine foods and drink, and fast cars, and apparently enjoyed the exercise of his own capacity to trick others. Moreoever he seemed to enjoy risk itself, which might call into question the motivational structure of his remarkable actions. Once the war ended, Schindler's life continued much as it had before the war, that is, not in a way that would attract attention for its ethical qualities.[14]

What are we to think of someone like Schindler? Lawrence Blum characterizes him as a "responder" who simply reacted immediately (in Kierkegaard's terms) to a perceived need, rather than operating from some "principle."[15] There is certainly some connection between this notion of a responder and my account of an aesthetic virtue. A responder reacts "immediately." Nonetheless Blum's way of characterizing Schindler does not explain much. It implies a contrast between an ethics of principles and some other kind(s) of ethics. But it is not obvious why Schindler should not be thought of as operating from some such principle as the one just mentioned, even if he never formulated it. The contrast needed is, I believe, that between someone whose choices issue from and are formed by a rational motivational self-concept (which might include in its structure various "principles" and rules or might not) and someone who does not so choose. Schindler did not so choose, it seems. We might have unbounded admiration for a person with the kind of passion that propelled Schindler into his heroic actions, and we might admire his cleverness and related capacities too, but still want to deny that his life is one of *ethical* virtue. At any rate as I read Kierkegaard, he would deny it for the same reasons that he denies that Claudine is "ethical." Whether we accept the usage matters less than that we see what distinction Kierkegaard wishes to mark, and, as I have argued, also see its Aristotelian character.[16]

II. Ethical Life, Narrative, and the Present Age

The notions of the wholeness and unity of a human life have figured prominently in part I. One achieves wholeness in what might be called a dimensional sense proportionate to the extent to which one's guiding passion or passions ramify through the various dimensions of life, personal,

familial, vocational, civic, religious, and so forth. But the notion of a passion also implies unity or continuity through time, consistency, or reliability from day to day. More needs to be said about *kinds* of dimensional and chronological wholeness. William describes A as capable of great exertions, extended over as much time as a few years, in which his whole life is devoted to exploring every angle to a certain vocational possibility, say, being a pastor, rather than an actor. It sounds as though A is capable of being gripped by passions in a way that unifies his life by subordinating every waking moment to the unfolding of a single theme. Yet A is also the absolutely discontinuous. His passions are 'put on;' he is merely experimenting with himself. And his own history contributes only accidentally to his projects.

Claudine, on the other hand, has an unaffected passion strong enough to carry her through many years and call forth various virtues which confer continuity. But she does not consciously choose her way of life, nor does she see or understand how her life arises out of her personal and cultural past, a past which must be owned in order for her to acquire transparency and real self-knowledge. Yet Claudine is portrayed so as to enable the reader to understand her in a way she herself does not. The capacity of the author to provide us with such understanding is highly praised by Kierkegaard. The novelist has produced a narrative in which the psychology and actions of the characters are shown in their relations to familial histories, cultural movements, great political events, the intertwining of all of these and their "reflection" in everyday life. In order to produce such a worthy object the novelist must, on Kierkegaard's view, be someone who is in possession of a *livs anskuelse*, a rational life view, who personally understands what it is for passions and feelings to be gathered up in a thoughtful deliberate way, who understands the obstacles to the development of those virtues which are required for such a life view, who grasps the great variety of ways lives can more or less succeed or fail, and can exhibit or "render" (Henry James) that understanding in a narrative. Novels are narratives.

Now MacIntyre has argued, convincingly to me, that the very form of human action is narrative, that the intelligibility of any action requires its embeddedness in various narratives, and he infers that the telling of stories is thus significant, perhaps essential, to the formation of character, in order that people not become "unscripted stutterers in words and actions" (AV 201). In conferring such high praise on the novelist and crediting her with a social importance that has nothing to do with any propensity to reflect current ideologies, and in stressing the importance of constancy in life (the main virtue of Gyllembourg's heroines) Kierkegaard upholds, I believe, a similar view of life as a narrative unfolding. Moreover, William's insistence on the importance of winning a self in and through time obviously

comports well with the ideas expressed in the *Anmeldelse*. The time in question for William is a lifetime, not just a summer's day (chronological wholeness). Likewise the novels Kierkegaard discusses take us through not just whole lifetimes but through interlocked generations. It is true that William is suspicious of "the poet" (though I think primarily lyricists), but his suspicion is focused upon any literature which pictures human life and history in terms of "externalities," such as lack of money for a marriage, a difficulty which might then, in dime novel fashion, be overcome by the sudden appearance of a rich uncle. But *To Tisaldre* would not, on William's view, count as a dime novel, any more than would those novels of Jane Austen upon which MacIntyre comments in illustrating the notion of constancy. It testifies through its two main characters to the way in which externalities can be met by subjective power, molded by character, and taken in particular formed ways, rather than serving simply as factors in an "external" causal explanation of action.

There is a further feature of Kierkegaard's *Anmeldelse* which brings to mind a well known thesis of MacIntyre's. Kierkegaard affirms that different ages by virtue of varying customs, standards, views of life, will turn individuals with similar psychological motivations towards different courses of action and life.[17] Nonetheless Kierkegaard assumes (at least in *The Sickness Unto Death*) that there are some structural dynamics within persons which are more or less invariant from age to age. Behind every "morality" or ethics, behind the *sittlichkeit* of different ages, there seem to be on Kierkegaard's view a limited number of psychological/spiritual conditions.[18] But Kierkegaard claims that there is something unique about "the present age." It has norms and customs respecting marriage, work, and, of course, lying, stealing, and murder. But it "drains the meaning" out of ethical concepts through passionless indolence (TA, 77), i.e., simply does not see the point in moral distinctions and decisions (the point is in part that these are things to be *done*, chosen, or avoided: practical syllogisms end in *action*, not more and more reflection). The concepts (of right and wrong, proper and improper) are still used, but are drained of all meaning by virtue of their detachment from a life view which is passion-generated and thus produces consistent *action* (TA 73). The present age, Kierkegaard complains, is passionless and sentimental, incapable of anything but "crowd actions" which are not true actions at all. Is Kierkegaard describing something like an "emotivist" age in which moral definiteness is displaced by the play of public sentimentality? MacIntyre's account of *our* "present age" details a decline into emotivism and the splitting up of such "actions" as occur into outputs of role assignments, with no "life view" behind them. MacIntyre's interest seems to me to be more historical, Kierkegaard's more psychological, but their diagnoses of their respective ages converge in the ways suggested, and that fact also fits with

MacIntyre's claim that the extreme emotivist decline of *our* age is in fact the result of a process already well under way in Kierkegaard's day. But, of course, the further claim made by MacIntyre, that Kierkegaard himself was a key figure in that process of decline, is quite mistaken if the account I have given here of some features of Kierkegaard's thought is on target.[19]

REFERENCES

For abbreviations for MacIntyre's and Kierkegaard's works, see the General Sigla at the beginning of this volume.

de Sousa, Ronald. 1987. *The Rationality of Emotion*. Cambridge, MA: MIT Press.

French, Uehling and Wettstein, eds. 1988. Midwest Studies in Philosophy, vol. XIII. *Ethical Theory: Character and Virtue*. Notre Dame, IN: University of Notre Dame Press.

Goold, Patrick. 1987. "Kierkegaard's Christian Imperative." *Faith and Philosophy* 4, no. 3.

Gyllembourg, Thomasine. 1845. *To Tisaldre*. Copenhagen: C. A. Reitzel (published pseudonymously "by the author of 'A Story of Everyday Life'").

Hannay, Alistair, and Marino, Gordon, eds. 1998. *The Cambridge Companion to Kierkegaard*. Cambridge: Cambridge University Press.

Hume, David. 1888. *A Treatise of Human Nature*. Edited by Selby-Bigge. Oxford: Clarendon Press.

Jacobs, Jonathan. 1989. *Virtue and Self-Knowledge*. Englewood Cliffs, NJ: Prentice Hall.

MacIntyre, Alasdair. 1981. *After Virtue*. Notre Dame, IN: University of Notre Dame Press.

———. 1988. *Whose Justice? Which Rationality?* Notre Dame, IN: University of Notre Dame Press.

Nussbaum, Martha. 1986. *The Fragility of Goodness*. Cambridge: Cambridge University Press.

O'Connor, Flannery. 1971. *The Complete Short Stories*. New York: Farrar, Strauss and Giroux.

Sommer and Sommers. 1993. *Vice and Virtue in Everyday Life*. Fort Worth, TX: Harcourt, Brace and Jovanovich.

NOTES

1. See Robert Roberts, "Existence, Emotion and Virtue: Classical Themes in Kierkegaard" in Hannay and Marino, 1998, 177–206.

2. I do not wish in any way to minimize Judge William's contribution, which has been mistakenly written off as bourgeois Hegelianism and misconstrued in other ways. Kierkegaard's jibes against those who are eager to "go beyond"

(Socrates, faith) should I think be taken to heart by William's critics, who pass him too quickly and miss some rich rewards, philosophical and existential. His thinking fits in important respects with the other works I mention here, and also with the discourses, which are full of acute *aperçus* respecting the passions, emotion, thought, and the virtues.

3. Kierkegaard's review involves him in speaking directly about literary matters. It was, as he says, produced "qua critic, not qua author" (PV 10). The other works I cite here are pseudonymous. I take the position that Kierkegaard's uses of pseudonyms do not amount to the rejection of "authorial presence" or "signature" as some postmodern readings would have it. *En Literaire Anmeldelse* can be invoked in support of my position, but I do not try to make a case for that claim here.

4. The notion of "immediacy" which Kierkegaard employs is obviously a borrowing from the contemporary philosophical argot, Hegelian especially, and the concept's murkiness is a constant affliction when reading and discussing Kierkegaard (not to mention Hegel). For example, are the developed linguistic capacities of a three-year-old "immediate?" They are not chosen. They simply appear in the child's history more or less willy nilly, or so it seems. But they are obviously on a very different level from, or a different *sort* of thing from the "immediate" enjoyment of hot fudge, and both in turn are very different from the religious beliefs which young people absorb without *certain kinds* of reflection (though not entirely unreflectively). Of course, Hegel was not unaware of these difficulties. It is worth mentioning that Judge William, in his review of various stages of aesthetic existence, mentions the Epicurean whose enjoyment is "reflective" and thus *not* immediate, but who nonetheless qualifies as an "aesthete" (EO II 191).

5. "Character" is thus used not in the sense in which everyone has a character, a "way they are" of some sort or other (even if the way they are shows a "total lack of character"), nor in a "normative" sense in which it refers to being generally good or bad. Rather it denotes simply continuity or consistency in some behavior domain.

6. It is also probably correct to think of Claudine's attachment to Lusard as attachment to a nonfungible object. Such attachments are arguably deeply connected to rationality in ways which I cannot take space to explore here. See de Sousa, 1987, passim, for discussions of the place of such emotions in the highest levels of intentionality and the senses of "rationality" pertinent to them.

7. ". . . reason and Judgement may indeed be the mediate cause of any action, by prompting, or by directing a passion" (Hume, 1888, 462). (I take Hume to mean by 'passion' something more like an occurrent state, but his thought here seems to be consistent with a dispositional account too).

8. It is worth noting that many emotions, though not all, are thought-dependent. If I am angry at Bill for drinking my beer, that anger will disappear when I learn that Bill did not drink my beer (and thus cease to have that thought). Pure immediacy would have to be devoid of all but perhaps the most primitive emotions (stimulations of the limbic?). But the "thought" I attribute to Claudine here is not merely reactive but exists on a higher level; it is thought employed in the interest of a passion governed *life*.

9. The expression is sometimes used in a quasi-technical way in Kierkegaard's works. A has a "view" of how to live, but he does not have a "life view" (EO II , 202. On 180, 184 etc. it is used nontechnically. The technical use is prominent in the introduction to Kierkegaard's *Anmeldelse* [TA 7–31]). Life views are formed by thought, *including* the thought "this is the way to unify my life." A's project consists in trying to avoid any such thought.

10. Molière is reported to have said, as death approached, "Lower the curtain, the farce is over." The bitterness and self-reflective character of this remark place Molière leagues away from our imaginary ping pong player, even if in a sense Molière also trivialized his own life. The remark aptly illustrates Kierkegaard's beliefs about the powers, and limits, of irony and humor. See Andrew Cross, "Neither either nor or: The perils of reflexive irony" in Hannay and Marino, 1998, 125–53.

11. The end of O'Connor's story in which General Sash momentarily feels forced, right at the point of death, to witness the "procession" of his own life perfectly illustrates the following remark respecting unconscious despair: "eternity nevertheless will make it manifest that his condition was despair, and will *nail himself to himself* so that his torment will be that he cannot rid himself of his self. . ." (SUD 21, my emphasis).

12. See Robert Roberts, "Will-Power and the Virtues" in Sommers and Sommers, 1993, p. 286 nt. 21.

13. Two warnings are in order: the quasi-Aristotelian conceptions expounded here do not necessarily involve the notion of a single moral metric, or show a failure to appreciate tragic dilemmas and other incommensurabilities. The ethical life does not have to be "seamless" in *that* way. Martha Nussbaum's account of this feature of Aristotle is I believe on target (cf. Nussbaum, 1986, 378–94). Secondly, Kierkegaard does not ultimately disown the ethical, in the sense I am expounding here, in favor of the religious, since the religious also must be understood in terms of passions and virtues, but he certainly does require its transformation in the religious, in a way somewhat analogous to the transformation of the aesthetic in the ethical. (The first of these warnings is prompted by Phillip Quinn's sensitive comments on this paper during the Kierkegaard Society meeting at the December 1999 Eastern APA meeting, a revised version of which appear in this volume).

14. These features of Schindler are discussed by Lawrence Blum in "Moral Exemplars: Reflections on Schindler, the Trocmes, and Others," in French, Uehling and Wettstein, 1988, 199–203.

15. Ibid., 208–12.

16. That this is not just a verbal matter is, however, suggested by such considerations as these: can we imagine someone like Schindler looking back on the failures of agency, the capitulation to impulse that marked much of his life, and not feeling regret or remorse? Should we not imagine him as saying to himself "I have failed to live as well as I might have had I been faithful, temperate. . ."? In the film *Schindler's List* he is represented as experiencing, at the end, intense remorse over the fact that even at his best he had not done all that he might have done. Surely remorse in such a person could also arise as testimony to his own realization that at his worst he had not lived well! And that would amount to the realization that he had failed to achieve the kind of narrative coherence possible only for those who

operate out of a rational motivational self-concept. Of course, these considerations also beg for discussion of the limits of the ethical, and may remind the reader of the sermon at the end of *Either/Or* II. But that opens onto a related but different topic which cannot be treated here, namely the sense of "ethical" in which the ethical *is* superseded in the religious life (cf. endnote #13).

17. Cf. TA 31, 32. Similar ideas are briefly explored by Gyllembourg herself, in her preface to *To Tisaldre* (Gyllembourg, 1845, p. v–viii).

18. Kierkegaard occasionally proclaims that the concept of sin has distinctive Christian content, and that the absence of that concept implies certain limits on the passional/ethical life of, say, pre-Christian Greeks. Even A explores related ideas perceptively. See "The Tragic in Ancient Drama" in EO I 139–64. I do not believe such a claim entails historical relativism. Nonetheless an exploration of the tension between the historical particularity of various virtues (see note #11 above) and the "dialectical algebra" of the *Sickness Unto Death* would be useful, I think, in addressing these issues in more detail. Such an exploration might even figure into answers to questions that have arisen about "tradition relativism" in MacIntyre.

19. Much of the work that went into this paper, and attendance at the APA meeting where it was first discussed, were enabled by generous support from the Seminars in Christian Scholarship program at Calvin College, funded by The Pew Charitable Trusts.

11

The Perils of Polarity:
Kierkegaard and MacIntyre in Search
of Moral Truth

EDWARD F. MOONEY

Summary

This essay begins by noting ways in which MacIntyre and Kierkegaard share methods and concerns. It then suggests that more "cross-sphere dialogue" occurs in Kierkegaard's texts than MacIntyre allows in After Virtue. *Kierkegaard sets up balanced oppositions between life views not to portray them as incommensurable, but rather to expose and challenge the reader's own tendency towards detached neutrality. Kierkegaard aims not just to alter a reader's beliefs but, more radically, to temper and humble a reader's will. This raises the question whether such an aim can be any part of the search for moral truth as MacIntyre conceives it. Kierkegaard's style of urgent but indirect address challenges the completeness of MacIntyre's three-part taxonomy of rival versions of moral inquiry.*

I

Nearly twenty years ago in *After Virtue*, Alasdair MacIntyre introduced Kierkegaard as a central actor in the narrative of Western moral philosophy, thus according him a prominence that had been withheld in twentieth-century English-speaking philosophy.[1] At mid-century, the reigning story was that if Kierkegaard had a part to play in Western Philosophy, it was through association with Hegel. But in Anglo-American philosophical circles at the time, Hegel was hardly a figure to take seriously; so in this respect, Kierkegaard's position held little interest. Furthermore, it was assumed that his distaste for Hegel was the other side of an embarrassingly ardent embrace of Christianity—an avowedly subjective, even "irrationalist" embrace. Thus there was little to commend a provincial Danish writer whose unimportance, or worse, outright danger to clear and worthy thinking, was

233

further confirmed by his presumed affinity to Heidegger, Sartre, and other "continental" or existential thinkers. The state of Kierkegaard avoidance— one could hardly say "reception"—at the time of *After Virtue* (1981) reminds us of a simple debt. Whatever hesitation we may have about the detail of MacIntyre's account of Kierkegaard, we should be grateful that he brought Kierkegaard to center-stage in a narrative of moral theory writ- ten well within the mainstream of English-speaking philosophy—a place where Kierkegaard till then was conspicuously absent.

In this essay I try to bring Kierkegaard into more sustained contact with the MacIntyre of *After Virtue* than actually occurs in that text. My interest is partly to display common concerns that might otherwise escape notice, partly to correct the picture MacIntyre draws of Kierkegaard, and partly to develop contrasts between MacIntyre's conception of a moral philosopher's search for truth and Kierkegaard's concern for truth.

I will allude in passing to developments that have occurred in MacIntyre's thinking subsequent to *After Virtue*. His view of the limits of reasoning across moral traditions takes a new tack in *Whose Justice? Which Rationality?*, and *Three Rival Versions of Moral Enquiry*.[2] Nevertheless, *After Virtue*'s account of the downfall of Enlightenment reason, and its account of Kierkegaard's role in that event, remain my primary focus. I should also mention, before launching this exploration, that often I will speak of moral concern and moral truth in the broadest, classical sense as a concern for the best way of life and the truths that direct it. This may seem to blur the specifically Kierkegaardian contrasts between ethical, aes- thetic, or religious interests. But I need to characterize the broad concern for satisfactory lives, however measured, that makes these Kierkegaardian contrasts matter. Also, I will speak of "Kierkegaard" and "Kierkegaard's intentions" often as a convenient shorthand not meant in any way to jeop- ardize the differences among his varied pseudonyms.

1. Polarity and Equipollence

The opening passages of *After Virtue* attest to MacIntyre's sense of immi- nent if not actual moral and cultural collapse, an event continuous with and no less ominous than the crisis depicted and forewarned in Kierkegaard's *Two Ages* and *Attack on Christendom*.[3] Granted that Kierkegaard distin- guishes levels of ethical and religious corruption, both writers evince a per- vasive moral urgency, tempered frequently in Kierkegaard's case by humor and satire. Each writer shows considerable flair for concise, analytical cri- tique. Delineating the contours of moral space and its collapse becomes for both MacIntyre and Kierkegaard a project informed by hope that dimin- ished moral resources will be renewed.

Both Kierkegaard and MacIntyre employ a technique for the diagnosis and deflation of the "self-images of the age" that we can call "polarity," a technique that proceeds by laying out oppositions. Kierkegaard constructs pseudonyms to counter other, opposite pseudonyms, one life view facing another, challenging its viability. In an analogous vein, MacIntyre opposes Nietzsche and Aristotle, emotivist anarchy and Enlightenment order. We are asked to choose, as it were, between these polarized alternatives.

An effect of this method is to raise the specter of a general skepticism and deflation of moral will. If each position is poised to cancel its opposite, and no clear superiority of one over the other is apparent (and no third option appears), then we have the ingredients for moral collapse. If the polarity has been effectively staged, the choice between options is likely to seem momentous and urgent, but also insecure, perhaps impossible to believe in—as a *choice*. Radical extremes can paralyze the will they confront. But vivid contrasts are nevertheless helpful in mapping the lay of the land. Like Dostoevsky's construction of three brothers in well-matched ideological contest, the use of polarity keeps alive a sense that the path we follow is of ultimate concern, that our particular commitments are at risk, and that we are free to risk a choice despite the fact that morale in general, as well as our commitments, are at risk.

It is no accident that MacIntyre chooses the contest between Judge Wilhelm and an aesthete (known only as A) to open his account of Enlightenment reason's defeat in moral skepticism (or emotivism). Both Kierkegaard and MacIntyre, we could say, compose in existential space. Their prose is meant to captivate not only intellect but passion and the will.

Forcing existential oppositions resembles Hegel's more spectatorial and developmental dialectical approach in which we observe from a safe distance a new historical or philosophical perspective develop through conflict with its precedents. But it also resembles a technique that Michael Forster calls "equipollence," the strategy of ancient skepticism.[4] The method works not by discovering internal flaws in a position or its conflict with "the facts" but by challenging a nonskeptic to present any position at all—whereupon the skeptic will produce a counter-position of equal strength. Kant employs this strategy in the *Critique of Pure Reason* in order to display the limits of theoretical reason.[5] A thesis about the beginning of the universe or about human freedom is countered by an equally persuasive argument for its opposite. Since each alternative undermines its opposite, both thesis and antithesis become all but vacuous.

The fear that an opposed position can be constructed by a skilled speaker to effectively counter any position entering the arena of debate throws doubt not only on targeted positions, but on counter-positions, as well. They either cancel each other out explicitly, as in Kant's case of dialectical oppositions, or we anticipate an interminable cycle of contestant's

moves and counter-moves, an endless philosophical debate that shows the ineffectuality of reason to settle a case decisively. If our moral-cultural options are as extreme as MacIntyre or Kierkegaard have it, we *may* feel forced to choose. But we may also feel moved to vacate the arena of discussion altogether on the grounds that we've been shown the plausibility of a *general* moral skepticism.

For ancient skeptics, the aim of equipollence was precisely to spread general skepticism as a means to escape the thralldom of abstraction and overwrought conviction. Safe ground, for them, was *apatheia*—a suspension of all passion and belief. MacIntyre and Kierkegaard see suspension of all passion and belief as a contemporary *malaise*—a weakness, not a goal. They hope to pave a way *past apatheia*.[6] They hope to transcend complacency, and to dispose of a bandying of fashionable but empty religious and moral opinion. This means inducing skepticism about contemporary practices and standpoints; but it is a skepticism that ultimately must be contained and transcended. For both Kierkegaard and MacIntyre, it must preserve or leave space for a "higher" truth.

In the *Postscript*, Kierkegaard's Climacus counters Hegel, and in *Either/Or* the Judge disarms "A." Climacus, the Jutland Priest, Abraham, and Socrates undermine Judge Wilhelm's apparently solid position, while Anti-Climacus seems to counter Climacus in *The Sickness Unto Death*.[7] How much room remains on the cultural-conceptual map for a true Christian is unclear. Notoriously, Kierkegaard is out to make things difficult for would-be Christians. And toward the end of his career, Kierkegaard confronts not only all of Christendom in an accusatory vein, but also all his pseudonyms, which raises awkward questions about the import of his pseudonymous work.[8] A pervasive irony adds to this destabilizing effect.[9] Of course, there is much more in Kierkegaard's tool bag than the technique of equipollence: one could argue that humor, irony, and sharp critical analysis are his preferred instruments of critique. But I think the idea of equipollence captures an important feature of his procedure as he first displays and then finds wanting successive life views. Clearly his aim is not to induce terminal skepticism but to induce skepticism about the shallow Christendom of his time—as a step toward appreciation of Christianity's true depth.

But Kierkegaard does not immediately deliver, at least in his dialectical and pseudonymous works, the viable and lasting alternative he endorses.[10] In some texts, considered singly, and certainly given the oppositions that crop up *among* his several texts, Kierkegaard's skepticism can *seem* pervasive. Given his obsession with the emptiness of the options Christendom presents and (outside the context of his directly Christian discourses) his reticence to mark out acceptable alternatives to the positions he overtakes, it could occur to an impatient and frustrated reader that Kierkegaard's

parade of initially attractive but ultimately doomed life-options might represent a project whose upshot was largely "aesthetic," a morally frivolous project—a brilliant display that is, in the last analysis, only a theatrical display.

Turning to MacIntyre, *After Virtue* opens with a "disquieting" portrait of a society in moral ruin. MacIntyre deploys what we could call prophetic admonition to challenge easy confidence in our condition. If the center does not hold, the need for rescue is made immediate and intense. Prophetic condemnations of indifference or corruption, coupled with a challenge to reverse these conditions, work like Kierkegaard's ironic and earnest ventures in life-sphere portraiture. They work to bring us to the brink of skepticism, all the while resisting a defeatist retreat into emotivist, relativist, or nihilist positions. This is a difficult balance to maintain.

MacIntyre presents a surprising number of polar oppositions in describing the moral landscape which we inhabit and from which we must plot an escape. The polarity "Nietzsche or Aristotle" marks a central pivot of *After Virtue*. One writer refers to MacIntyre's "mesmeric dichotomies."[11] In a kind of parody of polarity, *After Virtue*'s final chapter is subtitled "Trotsky *and* St. Benedict." Perhaps the solution to our contemporary moral crisis is for MacIntyre both necessary and unlikely—precisely as a "Christian" solution is for Kierkegaard.

2. Reason and Will

As MacIntyre has it in *After Virtue*, the opposition in *Either/Or* between A and Judge Wilhelm defies any resolution based on reason. Criteria for choice within the world of the Judge by definition have no counterparts within the world of the aesthete—as MacIntyre reads the matter. There is no master-position or universal principle for assessing the moral desirability of either position vis-à-vis its opposite. Since neither skepticism nor indecision is a sustainable option, we are forced to choose without criteria—choose the criteria of choice, as it were. MacIntyre thus finds Kierkegaard to be the inventor of Sartre's anxious, existential, "radical choice."

Now we can ask if this sketch is true to the Kierkegaard texts, to *Either/Or* and to other sources; and apart from this textual question, we can ask if this account is true to the crisis of moral reason that seems to permeate our culture. The sketch can ring true to aspects of our cultural condition—I suspect it does—quite apart from any scruples we may have about its strength as Kierkegaard-interpretation. I defer to the next section the textual issue, one that has been thoroughly discussed in recent years.[12] For the moment, I would like to explore what I suspect is a background

assumption in MacIntyre's sketch—an apparently smooth but in fact questionable transition from a critique of moral reason to a presumably inevitable outcome for the moral will.

In MacIntyre's account, radical voluntarism seems to rise inevitably in the wake of epistemological skepticism. It grows in scope as the coherence of tradition dissolves. Kierkegaard highlights the crumbling of tradition (as MacIntyre has it) by avowing, or eliciting our recognition, that no criteria for moral choice between "aesthetic" and "ethical" life views exist; and Kierkegaard then "discovers" the outcome of this impasse: a doctrine of radical choice. This doctrine, in MacIntyre's view, defines Kierkegaard's signal contribution to post-Enlightenment moral theory. Now this transition from an epistemological impasse to a doctrine of choice or will may seem natural to Sartre, or to inhabitants of a liberal consumerist culture that places unbounded confidence in free choice.[13] But the transition is neither inevitable nor necessary.

It might be true that in a fragmented, emotivist culture we have no criteria for deciding between competing moral life views or practices and yet it could be false that we are thereby forced to accept radical choice. We might fall into unreflective conventionalism; or, like ancient skeptics, we might cultivate moral agnosticism and *apatheia*. We could follow frankly nonrational action-guides, unconcerned by the consequences; or drift in a sea of despair, despair of will, despair of knowledge. We could find ourselves in any of these positions by a default of passion, will, or freedom—rather than by an exercise of radical choice. Or finding ourselves at an impasse, we might reconsider our understanding of the will thus momentarily disabled. Rather than assuming that the "natural" shape volition takes in post-Enlightenment culture is radical choice, we might reconceptualize or reconfigure our sense of volition. What shape best fits the nature of our condition?

We fail to take full notice of the narrowness of the Enlightenment conception of autonomous will. Following one strand of Kant, the purely epistemic strand, we pursue multi-tiered critiques of reason and set aside questions of will, imagination, and passion—as if this territory were too dark for clear analysis and best left for Romantics to wrestle with.[14] In the guise of an unqualified autonomy, radical choice spreads to fill any gap left undecided by reason. Such freedom, prudently linked to personal responsibility, becomes an irresistible master value.[15] In various ways Hegel and Schopenhauer had questioned what becomes the liberal assumption of a transparent individual will; and the Augustinian tradition frankly denies full transparency and autonomy to the will. Kierkegaard's taxonomy of despair, laid out in Anti-Climacus's *Sickness Unto Death*, calls into question several Enlightenment assumptions: that the will operates in its own interest; that it is a reliable executive of the needs and desires of the self; that it

is transparent to reason; and that the only obstacles to its effectuality are external ones placed in the environment or in social or political structures. Most importantly, it calls into question the assumption that when the mind sees the good, the will obediently follows.

Cognitive critique for Kierkegaard is not just preliminary to an exercise of will. A critique of reason is in the service of deflating hubristic will. Kierkegaard links post-Kantian cognitive humility to premodern volitional humility. The dialectical pseudonyms are major players in the task of bringing the will back from its more grandiose projects. The pseudonymous authors of *Fear and Trembling*, *Postscript*, *Fragments*, and *Sickness Unto Death* focus on cutting back the expansionist aims of a rationalist or idealist or romantic philosophical-intellectual culture. Wilhelm is meant to humble the exaggerated conceits of the aesthete in *Either/Or*. Abraham is humbled before God, and his ordeal in turn is meant to humble an over-confident Judge Wilhelm. The *Postscript* notions of the absurd and the paradox confound both our intellectual aspirations and our sense of self-sufficient will. *Sickness unto Death* identifies sin as the culprit blocking our capacity to will the good. A proper volitional humility acknowledges sin, and places us religiously " before God"—a concept George Pattison has recently construed as akin to a Kantian regulative idea, a measure, or standard, that brings down self-aggrandizing aspirations and perceptions.[16]

Of course, there is much more to Kierkegaard's critique of current assumptions than the shorthand phrase "humbling the will" can begin to suggest. But it begins to focus his departure from common Enlightenment pictures of volition, and also begins to identify the motive for his deflation, in particular, of a Judge Wilhelm, and more broadly, of theologians, philosophers, and intellectuals of his day (and ours). Humbling our cognitive aspirations makes room for existential engagement, where knowledge of our condition and its possibilities is not the heroic outcome of scholarship or science, or not only that, but more akin to learning to cope domestically, authentically, in the everyday. Likewise, deflating boundless confidence in an unencumbered Faustian will—a will in pursuit of exclusively natural human ends—clears a space for acknowledging an essential need of the will: its dependence on and need of support and assistance, natural and otherwise. Our wills are not self-grounding or self-positing.

For the Greek skeptic, partially disabling the will ushers in a state of *apatheia*. For a pious Christian, the proper stance of human will is a deferential stance before God. For Kierkegaard, humbling the will means living with a will that is less heroically assertive, self-centered, or declamatory. It is letting the will be quieted before God even as its interest in the good—an "infinite interest," in Kierkegaard's account—remains undiminished.

3. *Cross-Sphere Dialogue*

Even if quieting the will is of a piece with cognitive critique, nevertheless, the capacity of reason to function modestly in our affairs remains intact. This means that MacIntyre's depiction, in *After Virtue*, of Kierkegaard's radical break with rationality, encased, as he sees it, in the narrative of *Either/Or,* must be critically reviewed.

Kierkegaard's picture of stage-shift cannot be the simple two-step, nonrational process it is typically taken to be. It cannot be that a person first is thrown into a life-crisis (constituted in part by pervasive moral ignorance about the way out) and then reacts by mustering the will to choose despite complete lack of moral guidance—thus enacting, as it were, an irrational blind choice, a leap in faith and desperation. *Sickness Unto Death* shows the will to be anything but a simple mechanism we can call on in crisis for explosive stage-leaps. And there is ample textual evidence against the idea that Judge Wilhelm (or Kierkegaard) pictures the will in a stance of radical, Sartrean choice. Choosing the ethical, as the Judge puts it, is not "identical with creating myself." The ethical individual, as he sees it, does not "have absolute power to make himself into what it [merely] *please[s]* him to be" and "does not become someone other than he was before, but becomes himself."[17] And so far as rationality or reason is concerned, *Either/Or*—and other texts—show that it has far more scope than MacIntyre allows. As I will try to show, moral dialogue and the giving of reasons can play a substantial part in moral development, for example, in the shift from an aesthetic to an ethical way of life.

As we have noted, MacIntyre's view of the power (and impotence) of reason has evolved, so it may seem unfair to give only secondary attention to the two important books that appear subsequent to *After Virtue*— *Whose Justice? Which Rationality?* and *Three Rival Versions of Moral Inquiry.* This subsequent writing is not so pessimistic about reason's effectiveness in moral dialogue, and gives us a better grip on *Either/Or* than *After Virtue* provides. But MacIntyre himself has not revised his early sketch of *Either/Or* in the light of these developments.[18] So the better course will be to stick with the MacIntyre of *After Virtue*. This lets us focus on the view of Kierkegaard dominant among non-Kierkegaard specialists, a view that needs correcting. It also lets us focus on a counter-Enlightenment, strangely fascinating yet rather empty, view of reason that is vaguely tied to relativist, emotivist, and "postmodern" presumptions, and whose core is laid out in *After Virtue*. Finally, staying initially with *After Virtue*'s account of reason's collapse makes MacIntyre's later views all the more appealing.

The MacIntyre of *After Virtue* writes as if each life-sphere were hermetically sealed from every other, with no effective moral communication

or evaluation possible across spheres. Because a judgment is always made from within the individual sphere of a person's existence, so MacIntyre argues, it can have no grip on a life lived within another sphere of existence. And he asks readers to picture *themselves* as without footholds in either aesthetic or ethical commitments. MacIntyre believes (mistakenly) that Kierkegaard wants us to position ourselves "hovering in mid-air," as it were, without rooted intuitions about the two "spheres" Kierkegaard presents. And I also think that MacIntyre believes that to choose from such an "unencumbered," "detached" position is paradigmatic for the Enlightenment view of practical reasoning.

But how can the gears of moral reasoning engage if we adopt the position of complete outsiders alienated from the appeal of either the ethical or the aesthetic perspective? This proposed disengagement leaves us staring in blank moral ignorance at the opposition between these ways of life. Then *of course* we'll find nothing to tilt our assessment this way or that: *of course* we'll look in vain for some basis from which to choose one way of life over the other. It is as if the price for admission to the chambers of deliberation is the requirement that we leave at the door everything that is essential to deliberation. We may rightly suspect, then, that the perceived collapse of reason's ability to guide us flows from a misleading picture of what rational deliberation requires. In any case, on MacIntyre's construal of the lesson of *Either/Or*, it is clear that just when we most need reason's guidance, say, as we confront the possibility of choosing a radically different way of life, then reason fails us. We can have no idea if the proposed life-change is morally for the better or for the worse—or neither: perhaps it is morally inconsequential.

MacIntyre's account of why the Judge's reasons fail to penetrate the world of A rests on general considerations regarding how reasoning takes place. It is thought to require, roughly speaking, a disinterested appeal to universal principles legitimated without reference to our local commitments or particular passions. In a response to Charles Taylor's view of moral advance, MacIntyre suggests that without a general principle to resolve disputes between conflicting positions, the commitments of each disputant are demoted to the rank of "preferences," perhaps "mere preferences," which sounds dangerously close to "mere tastes."[19] But why do we collude in assuming that we need access to such independent principles, or that lacking such access, our commitments are demoted in importance? Furthermore, why should the fact that I encounter an opponent whom I cannot convince proceed to convince me that *my* convictions are no longer full-fledged moral concerns but merely the expression of personal taste? Closer to the present case, why assume that moral conversation (which would include conversation about why the aesthete *should* adopt a moral point of view) is automatically blocked between the Judge and A either

because their life-spheres seem to have no overlap (an implausible view), or because they seem not to share a common commitment to an overarching general principle?

The plausible alternative to this disheartening view of moral reasoning begins to be developed by MacIntyre in *Whose Justice?* and *Three Rival Versions*. It turns out to be a roughly Aristotelian picture of practical reasoning. Without presuming to speak for MacIntyre, I think his present standpoint gives us a framework to describe the moral discussion that could take place between A and the Judge. Let me imagine such a discussion now, bringing out the plausibility of a neo-Aristotelian reading.

We might easily assume that terms common to both the aesthetic and the ethical sphere, for instance, "pleasure," "happiness," or "despair," are intelligible both to the Judge and to A. If, in addition, we assume, for reasons I will provide, that these terms are sufficiently intelligible to each to permit a functional conversation, then their intelligibility ought to open toward allowing dialogue and moral growth. Granting these assumptions is compatible with allowing that the salience or interpretation of these terms will shift between the Judge's world and A's.

Can A sense the different slant the Judge has placed on such terms of moral evaluation? If so, he can sense features of the angle on the world that the Judge assumes, as in fact the Judge, presumably, can sense features of the angle on the world that the aesthete assumes. We would expect, then, that the weight of the Judge's viewpoint could gradually dawn on the aesthete. Whether or not he finally adopted the Judge's stance, he would have the capacity to do so. He would have the capacity for moral learning, the capacity to become familiar and at home with something that is initially unfamiliar. He would have the capacity to acquire an expanded vocabulary, say, and a new appreciation of the saliences of the old vocabulary, and a related set of new ways of seeing and acting. But why should we adopt this somewhat Aristotelian set of assumptions about the possibilities of evaluation across traditions or life views? Are we merely begging the question?

I think there are several reasons to shift away from MacIntyre's original characterization of moral impasse and toward a more Aristotelian account. For one thing, MacIntyre's pessimistic view of the possibility of moral exchange between the Judge and A runs counter to some straightforward features of the books before us. The second volume of *Either/Or* is first and foremost philosophy written out as the letters of a municipal Judge to a poet-essayist, an author whose work we have read in volume one. The framing intention of the Judge's letters is to persuade—morally persuade—the young aesthete, his friend, of the inadequacy of his poetic, bachelor life. Kierkegaard is not writing an impersonal moral tract for just any interested (or idle) reader. What we have is a personal communication,

a confidential set of pleas and warnings and extended reflections from one friend to another. Similarly, the figure of Abraham, in *Fear and Trembling*, is presented by the poet-dialectician Johannes *de Silentio* in a personal, at times confessional, set of reflections that clearly bear adversely on the conventionalism of Judge Wilhelm.[20] The text, we could say, is critically addressed to the Judge.

Either/Or and at least some of the texts related to it create a context of moral dialogue, a space where specific moral-religious-aesthetic encounter takes place. This is emphatically not the solitary even solipsistic world of an Underground Man from Dostoevsky.[21] We might utterly disregard these immediate features of the texts. But if we credit their apparent display of moral dialogue between figures and stage-exemplars, and grant that Kierkegaard's aim is to show this dialogue taking place, then cross-sphere intelligibility and cross-sphere evaluation are constitutive parts of this morally modulated conversational field.[22] It is not outlandish to discern a field of moral communication in *Either/Or*. To accept MacIntyre's *After Virtue* argument, we would have to believe that the Judge's letters are not really to be read as letters addressed to A. Or perhaps we would have to believe that A cannot grasp the general shape of the Judge's appeal, and on *a priori* grounds, can never learn anything from the Judge. If their worlds are utterly incommensurate when it comes to a broad moral sensibility, then perhaps we would have to grant that our aesthete cannot comprehend a single bit of what the Judge offers to him to ponder.

Alternatively, we could credit the evidence. The Judge admonishes A. As the Judge sees it, the aesthete pursues only fleeting pleasures. In addition, at some level, A is probably aware of this unhappy fact, and aware that he needs a more enduring basis for his happiness. Perhaps A feels exactly the despair the Judge detects in his view of himself and the world. And as the Judge avers, there is a way out of this despair. Wilhelm presents a portrait of married life and its stability as an answer to the aesthete's (perhaps disowned) discomfort with an anchorless life of drift.

Let us assume that A finds the Judge's admonitions and his sketch of married life intelligible; so far, the Judge will have provided a nest of cross-sphere reasons. A can ponder these considerations according to his own lights. And as readers we can ponder their bearing on A and also on our own lives. If there is no impartial position from which to assess these reasons offered to A, this just means that assessment will be comparative. Rather than an absolute assessment, totalistic, and once-for-all, it would be weighing a series of separable contrasts, pair by pair, each pair extracted from the contested life views. All along, we would be seeking an intuitive grasp of relative total weight, bearing this way or that, overall. This would be a matter of discovering a contextual "better or worse" rather than a timeless, perspectiveless "right or wrong."

It is as if the Judge, avoiding a crudely absolute assessment removed from the particulars, were to say to the aesthete: "Here's the best case I can make for your adopting a *radical* change in your life. I've tried to address *your* cares and needs with sensitivity and respect, and to consider how my different sort of life might have answers that could be of benefit to you. Of course you may see things quite differently. But these words are coming from a friend who has your best interests at heart. And if not today, perhaps at a later time you may remember what I've said."[23]

If A is unmoved by the Judge, that does not mean he doesn't see himself as a participant in moral dialogue, or that we should conclude that the Judge and A are *doomed* to talk past each other. Moral evaluation has been initiated by the Judge, and A could be evaluating *that* evaluation, or be ready to initiate a counter-argument. There could be considerable overlap in their terms of appraisal. For example, A might agree with the Judge that he was afflicted by despair—but A might lack the courage or desire to alter that fact. Or A might agree that he pursues only fleeting pleasures, but be unconvinced that the Judge has produced a believable case for non-ephemeral pleasure. Nothing in the text rules out the plausible assumption that moral evaluation is underway within a world shared by the Judge, A, and third-party readers.

If this sketch of moral dialogue persuades, then we have an alternative to the position that MacIntyre finds epitomized in *Either/Or*. We can list five features of this alternative view.

First, robust moral dialogue or argument does not require that in cases where resolution is not immediately available (as in the case of the conflict between the Judge and the aesthete) then in order to negotiate and adjudicate differences, there must be recourse to an "independent rational third party" or an "independently grounded rational principle" or a moral "super-framework." Second, the failure of either party in such a dispute to convince the other is not enough to justify the conclusion that no legitimate moral communication has taken place—that we have witnessed only an animated exchange of preferences or tastes. Third, conflict and agreement can vary in degree. The Judge and A can share a space of moral discussion—which presupposes some agreement—and yet have that space provide ample leeway for conflict between their views. Fourth, A and the Judge (not to mention third-party readers or observers) will enter the arena of deliberation with some moral opinions, reasons, and standards already in place. Why should this fact disqualify our entry—unless we hold to an extravagant (and barely intelligible) hope for adjudication free of relevant commitments and passions? Fifth, moral learning can take place. We can sustain a hope that A can gather insight from the Judge's admonitions. And we can expect that the Judge might learn something from A.

Overall, then, this alternative view of moral reasoning both appears inherently more plausible than MacIntyre's early *After Virtue* view, and also manages to stay closer to the spirit and the text of *Either/Or*.

As I see it, there is a complex relationship between MacIntyre's presuppositions as he approaches *Either/Or*, the outcome of his reading, and his later less abstract and stringent approach to moral reasoning. In *After Virtue*, ironically, MacIntyre lets himself be caught in the sort of desperate either-or that he describes as disturbingly present—and as finally leading to incoherence—in *Either/Or*. He finds himself facing a number of disturbing "mesmeric dichotomies." Later, he finds a way to soften the stark and demoralizing either-or he found earlier between an Enlightenment reason and a shallow, irrationalist emotivism. The "either-or" softens as MacIntyre comes to embrace a roughly Aristotelian position which tolerates moral conflict between divergent positions, supports rational debate between them, and avoids the purported Enlightenment wish for an ahistorical spot hovering safely above the battle from which to deploy universal and impartial standards.[24] But insofar as MacIntyre finds a viable path that avoids the false rigors of such an Enlightenment reason, just to that extent, he relieves pressure on his unfortunate reading of Kierkegaard's *Either/Or* as well. For as I've tried to show, his early reading flows far more from his preconceptions of what reason should demand than from the detail of Kierkegaard's narratives.

II

I turn now to a divergence between MacIntyre and Kierkegaard that goes beyond a review of MacIntyre's reading of *Either/Or*. It concerns their differences in understanding the aims of moral writing or moral inquiry. Kierkegaard aims to alter his reader in a way that goes well beyond the aims of inquiry alone. Kierkegaard and MacIntyre share an aim of inquiry, the discovery and transmission of moral truth. But when all is said and done, although his commitment to moral truth remains, Kierkegaard leaves inquiry aside. Let's start with Kierkegaard's conception of his audience, his reader.

4. Reader's Will and Reason

We have challenged the abstract argument MacIntyre presents for the impossibility of cross-sphere reasons, but the idea that no arguments can pass between the Judge and A is strangely seductive apart from its implausibility as a strict interpretation of the text. Why should this be? When it is a seductive reading we're looking at, we can count on a reader's half-willing

participation in its seductiveness. Perhaps some common thoughts about moral argument work behind the scenes to keep the picture of an intractable standoff attractively alive.

There is nothing unfamiliar about moral standoffs where neither party listens to the other: why should the present case be an exception? Second, there is an analogy between the case of moral conflict and the Kuhnian idea of incommensurability between contrasting conceptual spheres. In Kuhn's well-known view, reasons cannot mediate the gap between radically contrasting scientific views. We are left powerless to show that later views—say those in place after a revolution in physics—are an improvement on earlier, now discarded views. Third, the widespread idea that moral judgments are subjective, personal, and cannot be "imposed" on others may work to make an ultimate moral standoff in this case seem plausible. Then there is a behavioral consideration: Kierkegaard fails to give us A's reaction to the Judge, so we assume that Wilhelm's pleas don't get through. We get inclined to the view that neither A nor the Judge can breach the other's persuasion-resistant shield. But perhaps the aesthete doesn't discard the Judge's reasoning utterly, but is insufficiently moved to alter his views or change his life. Then he *does* feel the weight of the Judge's reasons: they are just not weighty enough. A fifth factor might be the all-or-nothing view that if a reason does not defeat its competitors outright, then it has no weight at all.

These thoughts might slant our perceptions toward the conclusion that the impasse between Judge Wilhelm and A cannot be broken by dialogue or moral learning. If Kierkegaard is co-conspirator in this outcome, what motivates him? Why would he seduce us toward the impression of an impasse? One answer is his interest in interpretive freedom. Shielding us from A's response to the Judge's letters lets Kierkegaard push a reader to make her own reading of the contest. Kierkegaard does not rush to resolve it for us. This augments our free participation in a comparative evaluation of the Judge and A's positions and lets Kierkegaard escape the charge that he's rigged the encounter to come out as a one-sided victory—a victory, say, for the Judge.

By their relative interpretive engagement or detachment, and their scholarly or personal inclinations—things partly subject to the will—readers can play a role in the construction of the impasse between A and the Judge, or in brokering a resolution. The text of *Either/Or* leaves a wide area open to interpretation, ample space to apply the "slant" that is needed to keep the standoff resolute, say, instead of malleable. The lesson I would draw is not that Kierkegaard's text can be exploited to say just anything at all. Nor would I conclude that the author has no preferred way of reading *Either/Or*. I would see a more complex lesson here, one that concerns the attraction and danger of interpretive freedom. Let me elaborate.

Although Kierkegaard knows our readiness to enter this interpretive arena, and creates his fascinating labyrinth knowing we will be drawn in, nevertheless he thinks we are also courting danger and must be *warned*. Against appearances, this arena is not merely, or only, a captivating playground. The apparent standoff is both apparent and a warning. But a warning against what?

Kierkegaard sees us resting all too comfortably in a decision-adverse, passionless culture. If that is the place we inhabit, we would seek to avoid a choice between two lives as contrasting and (in certain lights) as appealing as the aesthete's and Wilhelm's.[25] We would be comfortable in maintaining equipollence. Keeping a roughly equal balance between the rational appeal of these two figures would satisfy a shadowy desire to remain neutral, undecided.[26] And the tensions between these polar opposites would stay seductive, fascinating, "very interesting." If Kierkegaard exploits our desire to remain neutral, merely "interested" observers, it is probably for a moral end. And that end—in proper Kantian fashion—counters our "natural inclinations."

Beyond arousing our amusement or tweaking our interest in a scholarly conundrum, Kierkegaard would entice us with this fascinating (apparent) standoff in order to let us savor freedom. But just as important, he would have us swallow the bad moral taste, the reek that attaches to a voyeur's merely "interested" position. An onlooker's life of spectacle and spectating is not a fully human life. The freedom to have distance from engagement and a safe cover for interpretation, is morally valuable. But it is also morally valuable to break free from endless personal irresolution. In the portrait of the aesthete, and in having the apparent standoff force *us* into the position of aesthetes, we are given an immediate taste of the moral (and mortal) danger of such iterated, pleasurable irresolution.

Kierkegaard aims to change our will in the direction of commitment. A *Postscript* passage on *Either/Or* bears out this interpretation: "That there is no conclusion and no final decision is an indirect expression for truth as inwardness and in this way [is] perhaps a polemic against truth as [detached] knowledge. . . . Only the truth that builds [or commits] is truth for you."[27] Of course, Kierkegaard's failing to provide a conclusion or final decision does not mean that for *him* there is no better or worse between these two lives. It does not mean that he does not want *us* to distinguish the better from the worse, or does not want us to take that distinction to heart. It just means that Kierkegaard will not hand the decision to us on a platter—which would be to *take* the decision from us.

There are personal risks in making judgments that expose our own commitments (or lack thereof). Objective scholarly pursuits provide cover from such risks. As detached scholars we can enjoy aesthetic indecision. On the other hand, we might resist the aesthetic allure of indecision.

Operating from a more engaged stance would flatten the dramatic appeal of an irresolvable either-or. Being existentially action-oriented would undo the neutrality-tilt in our construals. Our half-knowing, half-willing role in constructing equipollence would be exposed. Equipollence would begin to look like an irresponsible ruse devised to get us off the moral hook.

Once comparative evaluation is approached from closer range, as if it had immediate, existential bearing, it is hard to imagine that reason would fail to bear, one way or the other, in our assessment of the case. Adopting a moral stance, the odds are most *unlikely* that we would arrive at the same answer on each test of the competing positions, or arrive at the unlikely result that the weight of A's reasons *exactly* match the Judge's. And apart from our upwardly revised sense of the power of reason in general, we would then have a new sense of our moral stance as readers. *Either/Or* would become more than a "provocative," "interesting" text. In the last analysis, we would see that we face a text that, in eliciting our response, reveals our own position within the oppositions it describes. We all—including Kierkegaard—have a stake in how this crux resolves.

Kierkegaard is unabashed about his resolve to test the moral standing of his readers. We are tried (and found wanting) insofar as we avow moral interests yet find that our desire to remain aesthetically poised and morally neutral gets the better of us, and now is getting full exposure. And from a quite different angle, we are tried insofar as the apparent intractability of an either-or reminds us that despite our taking existential engagement seriously—if we do—nevertheless the moral will can be defeated, stymied. It is not omni-competent. A choice is intractable when my will cannot even begin to achieve what it properly wants to achieve without immediate and devastating loss. In the present case, the will cannot even begin to achieve what it wants: the stability and security of the ethical *and* the excitement, novelty, and risk of the aesthetic. One or the other must be painfully sacrificed. If Kierkegaard succeeds in administering these tests, our overconfident wills are taken down a notch.

How far MacIntyre intends *his* texts to test our moral standing is not easily determined. His depiction of deep moral crisis would misfire if his intent were merely to "interest" us in historical phenomena. Clearly he would like more than scholarly curiosity about his narrative. But how much more? Is his concern for his reader's soul as urgent, persistent, and perhaps invasive, as Kierkegaard's is?

5. *Three Modes of Inquiry*

So far, I have been giving an informal running exposition of the sort of moral truths Kierkegaard is after—truths, say, that would help us see the

relative advantage for one's soul that a Judge's life might have over an aesthete's life. The outcome of a moral dialogue between the two perspectives displayed in *Either/Or* should be a move in inquiry that takes us closer to the truth we seek. So far, we have been staying close to the way *Kierkegaard* (or his pseudonyms) would describe the conflict and its possible resolution. But we could try to locate Kierkegaard's interests in the pursuit of moral truth by starting with a more general map of inquiry, of ways to track and assimilate truth. In fact, MacIntyre provides such a useful map in *Three Rival Versions of Moral Enquiry.*

The rival versions that MacIntyre explores are the Encyclopedic, the Genealogical, and what he calls simply "Tradition." The Encyclopedic version sees inquiry as scholarly or scientific devotion to the accumulation of timeless objective truths. One assumes a position of detached impartiality above the fray of conflicting cultures, societies, or interest groups. The Genealogical style rejects any presumption to objectivity or detachment and sees inquiry as always compromised by struggles for power and advantage. The winners get to call their victory "truth." Inquiry becomes the Nietzschean project of unmasking what passes for "inquiry," "objectivity," "rationality," or "truth." Along the way, these ideals are reduced to artful rhetorical ploys.

The Thomist, Augustinian, or Aristotelian approach to inquiry, the version that MacIntyre calls "Tradition," sees truth-acquisition as craft-related, as part of an historically embedded practice that includes the initiation of apprentices into the skills, attitudes, and sensitivities that a specific tradition identifies as the excellence of the master of the craft. Here the *telos* of inquiry is not merely to arrive at knowledge but to become an exemplary person of a certain sort, an exemplary inquirer. Where the Encyclopedist, as a child of the Enlightenment, would see a failure in inquiry as a failure in rationality—a failure to grasp timeless truths of method or canons of justification—the Traditionalist would locate failure in inquiry as a failure to incorporate in one's life-practice the virtues of one's tradition. The practitioner of Tradition puts at the heart of inquiry virtue and the emulation of those recognized as embodying it.

Elaborating this third model of inquiry, we might say that for a Thomist or Aristotelian, the master of a craft has character and stands for the best in a certain way of life. From this angle, the life of inquiry and the life of moral excellence fall under a single general model of worthy activity. Virtues of objective theoretical inquiry are not in principle sundered from virtues of moral practice.

In this scheme of things, there is no great chasm between apprenticing oneself to the life of inquiry and apprenticing oneself to the life of moral or religious virtue. This is because the life of science and the moral or religious life have a similar structure: the structure of virtue-pursuit. More

specifically, these two callings, sometimes violently opposed in the Enlightenment tradition, hold an array of particular virtues in common. They share respect for truth and candor, respect for the community of one's fellow practitioners, respect for relevant traditions and practices and a commitment to carry them forward in the light of new challenges, acknowledgment of luminous exemplars and the desire to incorporate and carry on their example. This consensus in aspiration gives reason to hope that the virtues of a moral or religious life and those of a life of inquiry can converge in an ongoing life whose fabric is single. The morally valuable and virtuous, in the university or outside it, would not be divorced from the "objective," the scholarly, and the scientific. Thus the idea of the philosopher as a moral sage or of the scientist as a moral exemplar would not seem aberrant, confused, or incoherent.[28]

Kierkegaard's interest in moral truth is at odds with both the Enlightenment/Encyclopedic version of moral inquiry and with the Genealogical style. Against the Genealogical style, he holds that there is moral truth to discover. Inquiry is not confined to unmasking *illusions* of moral truth. And against the Encyclopedic version, he does not believe that moral or religious truth has been accumulating in the library of objective knowledge, acquired by impersonal science or scholarship. Does he fit, then, within MacIntyre's Tradition version of inquiry?

Kierkegaard cannot be *simply* a Traditionalist. He could endorse the moral realism characteristic of Tradition: we confront nonillusory ideals and virtues. He could embrace the inescapability of apprenticeship: moral learning is not primarily abstract rational inquiry. It is more like learning to follow in the footsteps of a St. Francis, a Socrates, or Christ. He could endorse the Traditionalist view that researchers or scholars (and for the most part, teachers) should be engaged in changing the hearts and lives of students and others who come in contact with their work—a view of moral engagement that does not square happily with the "value free" assumptions of a modern research university. However, in the long run Kierkegaard's perspective on truth and inquiry cannot be aligned with inquiry-as-Tradition. There is no ready label for the rogue position that he occupies.

That Kierkegaard falls outside MacIntyre's three-part division of the world of inquiry becomes apparent when we consider his use of pseudonyms and indirection. By these devices, he intentionally blurs the difference between what he *seems* to mean and what he *really* means. Kierkegaard's practices of indirection are incompatible both with inquiry and with master-apprentice relationships. Furthermore, there are respects in which his perspective fits only some accounts of virtue. For one thing, the sort of virtue a Traditionalist might advance would typically set a goal we can achieve with effort and training. Yet some aims Kierkegaard will

stress in his religious voice are aims we *cannot* achieve with effort and training. Attainment of these can only be welcomed as a gift from sources we cannot control. They are not gained through hard work or straightforward imitation of an exemplar.

6. Truth and Inquiry

MacIntyre has faith in reason's power to deflate false goals—a faith in reason's critical powers that Kierkegaard shares. But Kierkegaard denies that apart from its deflationary role, reason is a major engine for moral progress. If we fail to capture moral truth, the fitting follow-up (for Kierkegaard) is neither an embrace of radical choice nor a new campaign to corner truth. It is living under the shelter of a pious will, resigning unchecked assertive freedom, renouncing the claims of an imperial, endlessly colonizing self. Yet a humbled will cannot be one that's flattened or destroyed. Receptive willingness remains.[29] And on Kierkegaard's account, a patient, quieted will must be nevertheless sufficiently energized and active to support "an infinite interest" (no less) in ethico-religious truths—truths grasped in "infinite passion."[30] Kierkegaard takes such interest or passion to be essential to a fully human identity. What is appropriately crushed or humbled is an infinitely self-assertive drive toward self-sufficiency. This drive can be suppressed without tamping down passion or producing a flat or supine self.

MacIntyre too may wish to challenge some of the more grandiose utopian presumptions of Enlightenment will. His return to a neo-Aristotelian or Thomist stance and his recent exploration of rational dependence suggest as much.[31] Epistemic failure is often a proper incentive to further pursuit of truth. But failure might also become an incentive to reconsider the place of inquiry within the wider pursuit of human virtue. It might lead us to see limits to the search for knowledge. But a more radical Kierkegaardian, Christian response to failure, taken as an incentive to embrace a more explicitly religious patience or humility, is at best a marginal possibility on the cultural horizon, and hardly a prominent feature of MacIntyre's present agenda.

However constrained or limited it may be in the face of competing life-necessities, passionate regard for truth is hardly dispensable, either for Kierkegaard or for MacIntyre. It is what keeps conflict between contending moral positions within the domain of discussion and inquiry and not just part of post-modern culture wars. Of course, the conflict-riven history of social thought, of moral traditions, or of science suggests that a better regard for truth is not on its own enough to smooth things out in human affairs. Nevertheless, to deny regard for truth is to deny the progress

marked by Darwin over his predecessors, or by abolitionist arguments over arguments for slavery, or by the increasing recognition since premodern times of the value of free speech. The fact of progress in any sphere of activity, including religious practices, presupposes something like a Kantian regulative ideal of truth.

Kierkegaard can—and does—endorse this broadly anti-skeptical position. Although he intends his work to have a critical impact, his final aim cannot be thoroughgoing skepticism. His evolving string of counterpositions produce a set of existential contrasts that *strengthen* his preferred position. Testing preliminary positions is essential to grasping the appeal of subsequent, "higher" positions. Knowing the paths we *might* have taken can solidify confidence that it is the *right* path we have taken. On this view, "religiousness B" becomes comprehensible through its contrasts with positions that "precede" it. Kierkegaard has no bone to pick with objective truths delivered by inquiry, or truths related to discriminating moral-spiritual advance along life's way, so long as the pursuit of objective truth does not distract us from pursuits of "subjectivity," the demands of a full human identity or character.[32] Worthy inquiry about a worthy life should culminate in living and fashioning a worthy life.[33]

For MacIntyre, moral inquiry is the search for methods and principles adequate to ground evaluation of moral lives and practices. This project has two targets: first, the clarification of standards of assessment and their grounds; and second, the discovery, or production, of a rich stock of exemplary moral lives and practices against which we can test our intuitions about these standards and their grounds. Generating (or discovering) pertinent stories requires fine-tuning our ears for narrative, for story-embedded rationality, for the fit of story to principles. But it also requires fine-focusing our eyes for exemplary responsibility or generosity, patience or piety, courage or justice. Good comparative evaluations—weighing the life-perspectives of the Judge and "A," for example—will rest on having good principles and a good "feel" for the operative perspectives. And it will also require sensitivity to the structure of varied, complex moral virtues.

Kierkegaard would accept much of this contemporary project that MacIntyre advances. But in the long run, Kierkegaard seeks much more than truths of inquiry. He seeks a truth for which he could live and die.[34] A good life, a life exemplifying a truth for which he could properly stake his life, requires commitment to virtues or ways of being. It means following the path of a Socrates, say, and also, perhaps, heeding the limits of striving and knowledge. The sort of truth that can be potentiated in a life, giving it moral-religious substance, we could call "inclusive," "essential," or "saving truth." There is moral truth to access from the position of a moral agent's life, and there is also the moral truth that truth is to be

incorporated *within* an agent's life. So to seek truth, on this view, is to seek the contours of a virtue or way of being and also to be answerable to the truth, responsive to its demand that it be incorporated in one's life. The truth we try to live is truth we labor to incorporate. And what moral truth we gain will depend, at least partially, on what moral truth we try to live.[35]

As we have seen, a stock of persuasive stories of exemplars serves an aim of inquiry; but it also bears directly on the will by bolstering confidence in our ability to make concrete changes toward a life of virtue. As a moral exemplar and exhortator, Judge Wilhelm has a part to play here. But getting moral truth to lodge in life, thus actualizing its full potential, calls on capacities and powers apart from those of reasonable inquiry. For one thing, it requires not just the capacity to grasp a virtue and what it abstractly demands. It also requires the capacity personally to answer or respond in action to the demands of virtue in the concrete situations in which we find ourselves. We must know how to mobilize our will in the modes of incorporating and answering.

One way to mobilize our will in response to virtue perceived and a sense of its demand is to *get* something to happen. That is a proper model of *working* to be virtuous. But in other cases, the capacity to answer or respond to a demand, or the capacity to incorporate a virtue, may require that we know how to let some aspect of the will become slack or incapacitated. Kierkegaard has a place for both tracks along which the will can be mobilized. But his emphasis on the latter sort of case, the strategy of releasing will from striving (though not from passion), prevents us from placing him unequivocally within those versions of virtue ethics that place exclusive stress on the dynamic *pursuit* of virtue.

Say the will responsive to virtue is required to shift to the mode of *letting* something happen, perhaps letting an offensive fact sink in. Consider the demand that we acknowledge Socratic ignorance. One is asked by Socrates (or Kierkegaard) to let the virtue of the will-to-know ultimately become rebuffed in the name of a contrary virtue. We are asked to let go of or relinquish the project that knowledge demands of us. But is it a positive capacity of will thus to let itself be turned back? And in any case, how can relinquishing the will-to-know be essential to *inquiry?* To let the will be stopped, incapacitated, seems at most a negative capacity.

Acknowledging Socratic ignorance is like letting a pursuit of virtue get disengaged. We may *be* virtuous in acknowledging ignorance, but we don't *pursue* this ignorance (though we might abide it). We live with something that at first we find offensive, namely, that at the limit we will be stymied in our pursuits. Without reluctance or reserve, we're asked to accept this limit to our will.[36] This is to answer a demand of virtue by letting something happen. It is not the steadfast *exercise* of virtue—though it may *instantiate* a virtue.

The upshot of these reflections on virtue is this. To be virtuous, for Kierkegaard, cannot mean to be always engaged in capturing, containing, and incorporating a virtue. To be virtuous is not simply to join the pursuit of virtue. Thus in addition to Kierkegaard's penchant for disguise, there is another feature of his perspective that makes him fit poorly both within the compass of MacIntyre's Tradition version of inquiry and within some versions of "virtue ethics."[37] Where a Socratic teaching (or encounter with Socrates, or encounter with Christ) by its brute offense, effectively turns back the human will, precisely *there* we find that the will cannot be an engine of virtue-pursuit.

Finally, we can now refocus a wider point about the sort of truth Kierkegaard is captured by and wishes us to know. To seek essential, saving truth takes us beyond straightforward inquiry, where all truths are legitimized by reason, to a sphere where truth is realized as it becomes enacted in the fabric of a life responsive to it. Our place becomes a sphere for truthful answering and incorporation.

As *Postscript*'s Johannes Climacus would have it, advance toward truth means "living in the truth." The narrative and critique that Climacus supplies can advance inquiry, persuading us (for example) that a Socratic life is better than the Judge's more conventional life, because it is truer to the real exigencies of a human life, truer to all a person can and ought to be, truer to our sense of what is human in its complex mix of passion, responsibility, and intellect. And beyond this outward-looking task of virtue-appreciation, there is an inward-looking task, also truth-related, of authentic incorporation. We are persuaded by narratives that the truth both Socrates and the Judge pursue is one to be incorporated in their lives—and that we, too, have our own tasks of responsive, answering incorporation to perform.

Kierkegaard's imaginative, artistic skills work to convince us of the importance in others' lives of the truths *they* actualize; and his artistry moves us to actualize relevant truths within our *own* lives. Vivid description of alternative virtues and ways of life is also the familiar terrain of MacIntyre's work. But Kierkegaard's aims seem to outstrip the aims of strictly philosophical work. He boldly assumes readers receptive to queries or warnings about the moral quality of their lives. [38] Perhaps all a current philosophic work can do is ask its readers to see the truth, not to exemplify it in their lives. Yet the desire to have moral insight fulfill itself in moral character is strong. We hope, in fact, that a philosopher who can delineate the contours of the virtues and the good life will also be a person who leads a life answerable to such admirable, worthy insight. We hope, as Robert C. Roberts puts it, that "a philosopher can be a person with especially deep moral understanding and insight and with unusual powers of imaginative expression [We hope that] the philosopher may be a moral sage."[39]

Whether MacIntyre's work speaks quietly to those concerned to find essential, inclusive truth—to find the truth that would change *their* lives—I leave an open question. The matter for Kierkegaard is not ambiguous. With Socrates, he embraces the aims of midwifery, of ministering birth or change—an aim we might with trepidation yet embrace, but that no method of inquiry alone is set to deliver.[40]

As I mentioned above, the place where Kierkegaard most clearly diverges from standard modes of inquiry—from *any* mode of inquiry—is in his embrace of disguise and concealment as communicative and communication-blocking devices. MacIntyre would not encourage researchers to disguise the intentions of their texts. Yet Kierkegaard revels in disguise, and more importantly, finds disguise essential to his project of changing hearts and lives. There is no place in standard inquiry for sustained use of rhetorical devices meant to humble a reader's will, especially when a broadly spiritual goal is at stake. Bringing one closer to becoming an exemplar of a specific religion, by academic lights, would amount to preaching or proselytizing, not inquiry. There is no place in standard inquiry for the frank admission that indirect communication, in the matter at hand, is essential, or that the truth that one wishes to impart must in some sense remain hidden, out of easy public view. Yet Kierkegaard embraces indirect communication as essential to bringing readers closer to the existential truths of Christianity, truths that are not easily communicated or directly open to public inspection. Apart from motives of political expediency, a standard philosopher, even one as provocative and innovative as MacIntyre, could have no interest in disguising truth.

7. Beyond MacIntyre and Inquiry: Masking Truth

If we need access to truths that matter to our moral-religious identities, then we might seek a logic of discovery. But Kierkegaard would fault the search for such a logic. The search would require a stance that necessarily blocks access to the truths one seeks. The activity of looking for a method that would capture love, wonder, or even the appeal of moral ideals, at least partially positions a seeker's will against the possibility of being captured *by* wonder, love, or moral ideals. Discovering truths that answer to one's deepest needs cannot be the outcome of looking for and applying a method for their discovery. The mistake would be something like a clumsy novitiate trying to maneuver God in order to capture God's power to rescue or to save. For a religious person, such maneuvering to force God's hand is both impossible and irreverent. But not having a logic of discovery does not entail that there is nothing to discover by way of answer to our needs. It is just that we cannot *control* discovery. And

admitting defeat in this case may be a precondition of being ready for the truth one needs.

My will must be properly open to the truth I seek or publicly avow. It must be properly aligned if I'm to gain access to a *saving* truth. The properly receptive will is one that's run through available strategic options for capturing the truth, and has despaired of the project of finding a method one can wield to capture truth. It is a will not dominated by habit. It refuses to hold even otherwise commendable beliefs only "by rote." It is not a will suffused with self-importance, holding otherwise commendable beliefs in a self-satisfied way, proudly, fanatically, or dogmatically. Divested of the conceits that we already possess the truth, or that we already hold it in the right way, or that we have the means to capture it, we would be ready for the advent of a saving truth, even as the truth bestowed might be recognized as having content that matched beliefs held earlier—perhaps previously held indifferently, dogmatically, or fanatically.

The Judge or A or Socrates may hold any number of true beliefs. Nevertheless, these are idle and lack "existential" or "inclusive" truth if they reside in a will that's misaligned. Thus Kierkegaard's recurrent ironic skepticism about given sets of beliefs or positions is fully compatible with his holding that some of the same beliefs or positions that he roundly lampoons nevertheless embody potentially saving truths. His irony can target the manner of our holding them—say thoughtlessly, or with inappropriately humbled mind and will. Our attachments can be mistaken in the features of our grip, in the manner, the *how*, of our connection—not only mistaken in *what* is gripped.

A careful reader can identify a good number of beliefs and convictions that Kierkegaard holds to be saving truths: for example, that truth is subjectivity, and that equally, in other contexts, or from a different angle, that truth is objectivity. He holds that God speaks to persons one by one and not in crowds; and that hubristic will can block one from the truth; that saving truths cannot be had at second hand. Nevertheless, Kierkegaard has good reason to avoid unequivocally *announcing* these truths as saving truths.[41] Thus he has reason for maintaining an ironic mask of intermittent yet insistent disavowal, extending perhaps even through his signed works.[42]

For the sake of his *own* moral-spiritual health, Kierkegaard must avoid the overbearing pride of assuming that his salvation is *secure* by virtue of his holding such potentially saving truths. He cannot believe he is himself secure, secure, perhaps, because such truths are surely in his possession, or because they have been acquired on his own, unaided. Perhaps by slippage he would come to conceive these truths as fully within the mastering powers of his will to keep well-caged and tame, no doubt serving occasionally as objects of his spectatorial enjoyment and regard.

For the sake of his *readers'* moral-spiritual health, he must avoid distorting the will of his audience by his presence. This means that we should not believe something just because he believed in it, or because he said it was true; that we not believe in what he says by rote, and that we not "run with the truth" fanatically or dogmatically, or with self-satisfied assurance. To discover the truth that matters cannot be simply to discover what matters to Kierkegaard. He preserves a reader's independent will even as he counters its drive toward self-aggrandizement. He does this by breaking both the crutch and pride of a reader's claim to have at last unraveled Kierkegaard's meaning, and thus to have acquired a saving truth.

With regard to addressing his audience, there are two tasks Kierkegaard must artfully distinguish and balance. He must down-size the pretensions of a boundlessly assertive will, say, by knocking down the crutch and pride of a reader's exaggerated claim to know. But equally, and simultaneously, he must protect and encourage an "infinite passion" for the truth. This latter task ensures that a humbled will is still a *person's* will—not something anonymous, drained of vital personality, and so made listless and vulnerable to exploitation by individuals or institutions out to mold or master others. But how can pretension be drained while preserving passion?

For Kierkegaard, an "infinite passion" for ethical-religious truth is at the root of vital personality. This passion is our deepest value to protect. But it must be kept distinct from a planned pursuit of virtue, or other self-conceits. Our "infinite passion" for truth includes deep and passionate gratitude for truths already bestowed; it includes infinite, passionate respect for and devotion to the overarching sources of truth-bestowal; and it includes a vital, heart-felt sense of the need for a moral-spiritual identity answered and sustained by a world, a creation, replete with such bestowals. Humbling residual Promethean aspirations does not deplete but opens us to such an "infinite passion" for saving truth. Kierkegaardian passion can fully animate a humbled will, and *only* such a humbled will can be the site and sponsor of this necessary passion.

Kierkegaard cannot deliver guidelines for the capture of the truth that he anticipates will rescue him; nor can he transmit after the fact a saving encounter or truth that might have rescued him.[43] Say the saving truth for him is the truth that his will must be humbled. Access to this truth excludes him from proclaiming it. One cannot assertively impress on others that one's will is less assertive without denying the point in the making of it. Paradoxically, however, if he has a wish to engage with his listeners on these matters, there are communicative strategies available. What cannot be announced assertively can be presented tentatively under the guise of a pseudonym. What cannot be stated as a capturable truth can be alluded to, and then disavowed—enacting in the mode of its delivery-and-

revocation its elusiveness to capture. If he learns that truth lies in a humbled will, he can convey that thought obliquely by disowning his creations, by not exercising a possessiveness toward them, and by not basking in their beauty, wisdom, or truth before the adoring eyes of others.

In summary, then, deploying communicative strategies that keep truth partially hidden is an appropriate, even necessary response in light of Kierkegaard's desire to be true to his faith and calling. He must, in all humility and passion, honor the truths he's received by not pretending to a security he cannot possess, by not shouting foolishly from rooftops. Second, with regard to his audience, indirection and concealment are rooted in his desire to defeat a puzzle-solving, merely aesthetic "interested" stance in pursuit of packaged truth. Third, he sees the need to prevent his persuasive artistry from flooding his reader's will, thus drowning individuality, and making moot the necessity for a reader to exercise her *own* passionate "infinitely interested" will—however humbled it may be. And fourth, Kierkegaard wants to disclaim ecclesiastical or special moral-religious authority for his views. He disarms the potential of his writing to deceive in these respects by pleading a kind of ironic Socratic ignorance and by taking his own name from the pseudonymous works. He thus honors the truth he has received and preserves for his reader a sanctuary of volition for self-fashioning before an absolutely Other.

8. A Final Thought

There is a nearly irresistible impulse to seek out from among the multiple deliverances of Kierkegaard's texts, pseudonymous or signed, what precisely Kierkegaard *himself* might hold, in his midnight hour, in the privacy of his chamber, in all candor. But yielding to this impulse, devoting hours of detective work to the task, is ultimately bound to fail and remain a project misconceived. It is what Kierkegaard would call a humorous endeavor.[44] This is partly because he himself may be unsure what he "in truth" holds—holds with properly humbled will and mind; and this is also a humorous endeavor partly because if we fall for the temptation to take his writing solely as a puzzle to be solved, we'll have missed two crucial points of his writing—namely, that we should avoid an aesthetic problem-solving approach to saving truths, and that we should avoid making his "private belief" relevant to our lives merely because it is *his*. So it is not as if a sifting process occurs in which Kierkegaard gradually lets more and more of the truth out of the bag. The decisive event is not a sifting out of propositional truths but a reduction of will and increase in passion—caused, or aimed at, by Kierkegaard's progressively sophisticated deployment of counterpositions.

This sifting from within the authorship for a collage revealing Kierkegaard's settled views is, from Kierkegaard's predominantly *existential* position, largely idle work. Charming explorations are allowed to overtake the urgencies of incorporation, commitment, and engaged response. Yet this sifting for the settled views may have an *indirect* role to play. Perhaps it can only dawn on us that sifting is idle existentially after we have begun to sift, or have sifted fruitlessly, for some painful time. More specifically, perhaps we can only absorb the humbling impact of his repeated refusals to provide a special packaged truth after we have engaged for some painful time in our familiar pursuit of (appropriately disguised) specially packaged truth. He knows his audience.

It is hard for us to know how much the answers that we seek lie in clues strewn through the lines of an ever-fascinating text—and how much the answers lie in a readiness for our wills to be altered radically.

NOTES

1. If one counts his entry in *The Encyclopedia of Philosophy*, ed. Paul Edwards (The Free Press, 1967), then MacIntyre's first account of Kierkegaard is pushed back another decade. But here he made no attempt to define Kierkegaard as a pivotal figure in Western moral philosophy.

2. MacIntyre, *Whose Justice? Which Rationality?* (University of Notre Dame Press, 1988), and *Three Rival Versions of Moral Enquiry* (University of Notre Dame Press, 1990).

3. Likewise, see MacIntyre, *Secularization and Moral Change* (Oxford University Press, 1967), and *Against the Self-Images of the Age* (Schocken Books, 1971). Among MacIntyre's other early writings dealing indirectly with Kierkegaardian themes, see "The Logical Status of Religious Beliefs" in *Metaphysical Beliefs*, ed. Stephen Toulmin, Ronald E. Hepburn, and Alasdair MacIntyre (St. Martins Press, 1957); "Notes from the Moral Wilderness," *New Reasoner*, 1958–9; and "Breaking the Chains of Reason," in *Out of Apathy*, introduced by E. P. Thompson (London: Stevens and Sons).

4. Michael Forster, *Hegel's Idea of a Phenomenology of Spirit* (University of Chicago Press, 1998).

5. See Kant, *Critique of Pure Reason*, The Antinomy of Pure Reason [A:405–459] [B: 430–487].

6. The *apatheia* ancient skeptics wished to induce is not the apathy or complacency Kierkegaard and MacIntyre wish to dislodge. Skeptics wished to remedy an *excess* of (one kind of) passion, while Kierkegaard and MacIntyre wish to *increase* (a kind of) passion.

7. In his journals, Kierkegaard sees Anti-Climacus less as an adversary than as a continuation of Climacus. Yet his naming a continuator by adding the prefix "anti-" suggests his relish for opposition. See JP (VI) 6349, 6433, and 6501.

8. Whose voice are we hearing under the cover of a pseudonym? The immediate effect of a pseudonymity is to raise the question. Keeping that question alive can be crucial even if, in the long run, it is Kierkegaard's own voice speaking through a cover-identity. The voice of a pseudonym is not necessarily a voice Kierkegaard intends to fully disavow. I thank Alastair Hannay for reminding me of the possibility of continuity of "voice," as well as difference, throughout the complex authorship.

9. The technique of irony differs from that of polarity or equipollence. With regard to the latter, no explicit counter position is developed—only a skeptical relation to any and every given position. Irony, in contrast, leaves open the possibility of serving and aiming to bring out a non-ironic truth, available for our whole-hearted embrace. Irony, unlike equipollence, need not be geared to undermine every positive belief or position whatsoever (though in some contemporary writing it appears to assume this form). On a related issue, it is unclear whether Kierkegaard remains ironic (or unironic) in his apparently candid self-descriptions, say in "The Point of View for My Work as an Author." In any case, he is ultimately unironic in his embrace of (some form of) Christianity. For illuminating discussion, see Michael Strawser, *Both/And: Reading Kierkegaard from Irony to Edification* (Fordham University Press, 1997).

10. For a sustained account of the continuity between Kierkegaard's *Christian Discourses* and his more philosophical and pseudonymous works, see George Pattison's forthcoming book (working title, *The Socratic Witness to Love: An Interpretation of Kierkegaard's Upbuilding Discourses*). Marcia C. Robinson also defends such a continuity in "*Ars Divina*: Kierkegaard's Positive Conception of the Aesthetic in the Christian Sphere of Existence" (Ph.D. diss., Emory University, 2000).

11. See Phillip Pettit's article on MacIntyre, "Liberal or Communitarian: MacIntyre's Mesmeric Dichotomy" in *After After Virtue*, ed. John Horton and Susan Mendes, University of Notre Dame Press, 1994. The haunting opposition of Trotsky and John Maynard Keynes appears in an essay from the collection aptly titled *Out of Apathy*.

12. Other critiques of MacIntyre on EO II are found in *International Kierkegaard Commentary: Either/Or II*, ed. Robert L. Perkins (Mercer University Press, 1995).

13. See "Self-Choice and Self-Reception: Judge Wilhelm's Admonition," chapter 2 in *Selves in Discord and Resolve: Kierkegaard's Moral-Religious Psychology from Either/Or to Sickness Unto Death* (Routledge, 1996).

14. See Kant's discussion of radical evil in *Religion within the Bounds of Reason* Iris Murdoch faces the complexities of will, imagination, and passion in *Metaphysics as a Guide to Morals* (Allen Lane, 1992 / Penguin USA, 1994), and *Existentialists and Mystics* (Allan Lane, 1998 / Penguin USA, 1999).

15. Murdoch detects this link between down-sized reason and up-scaled will in both existentialist and liberal theories of the self. See *The Sovereignty of Good* (Schocken Books, 1970 / Routledge, 1985 reprint). This link also appears in post-modern views that accord readers unlimited interpretative freedom.

16. See George Pattison, "'Before God' as a Regulative Concept," *Kierkegaard Studies Yearbook*, ed. Niels Cappelørn and Hermann Deuser (Walter

de Gruyter, 1998), and his forthcoming book on the discourses as an entry to the authorship (note 10, above).

17. EO II p. 217, p. 260 (my emphasis), and p. 177. I discuss Judge Wilhelm vacillating between picturing the will as option-selective and as non-choosing-but-receptive in chapter 2, *Selves in Discord*, first published as chapter 1 of the *International Kierkegaard Commentary: Either/Or II*.

18. He does, of course, address his Kierkegaardian critics in the closing essay in the present book

19. See MacIntyre's response to Taylor in *Philosophy and Phenomenological Research* (March 1994): 188–89. MacIntyre *doesn't* hold this view in *Whose Justice?* or in *Three Rival Versions*. Taylor takes MacIntyre to require that a principle must be administered "from above the fray:" pp. 204–6.

20. See my *Knights of Faith and Resignation: Reading Kierkegaard's Fear and Trembling* (State University of New York Press, 1991).

21. Martin Buber, Sartre, and Adorno launch the distorted picture of Kierkegaardian figures as essentially asocial and self-enclosed, a view which neglects the massive fact of dialogue among the figures, as well as the fact that many of Kierkegaard's figures have rich social lives.

22. The view of practical reason implicit in Kierkegaard is described by Stephen Mulhall as follows:

> [W]hen one party to a moral debate presents her reasons for advocating a certain transition [from one standpoint to another], she should do so in a manner which acknowledges the personal experiential and intuitional roots of her argument. If she were to present them as impersonally decisive, the form of her discourse would imply a belief that pure logic dictates a certain perspective on the issue at hand, when the reality of the matter is that the adoption or rejection of any ethical stance is a personal decision, an existential act, the responsibility for which one cannot avoid by sloughing it off onto logic (Mulhall, "The Sources of the Self's sense of Itself," in *Can Religion be Explained?*, ed. D. Z. Phillips [London: Methuen, 1997]).

I would add a caveat about Mulhall's use of the phrase "personal decision." As a characterization of what occurs in adopting or rejecting an ethical stance, "personal decision" cannot be quite the proper phrase if it encourages the idea that the relevant decision is "merely personal," hence, falling beneath a threshold of significance appropriate for public recognition or acknowledgment. "Existential act" might do more than "personal decision" does to reflect the idea of an occasion of some moment, rich with significance, a natural candidate for recognition and acknowledgment by others. And "existential event" might be even more accurate: this phrase would qualify some of the implications of Mulhall's "decision." If an ethical stance results from seeing something new in one's situation, its "adoption" can have an inevitability about it that makes it seem *less* like an option chosen than like a response dictated by the milieu itself—an emerging *event*. The agent is surely involved in transitions. But a new stance does not flow simply from a selective choice.

23. This attempt by the Judge to offer an "internal critique" of the aesthete's position illustrates MacIntyre's claim, in *Three Rival Versions*, that inquiry can

advance when one contesting party offers a critique of its competitor in terms that the competitor, from her own angle, can recognize as her own. This permits (but does not guarantee) that a critique can be decisive, unreservedly successful.

24. Amartya Sen reminds us that Hume and Adam Smith were enlightenment critics of "Enlightenment Reason" See his "East and West: The Reach of Reason," *The New York Review of Books*, July 20, 2000. Wholesale attacks on Enlightenment Reason unhappily simplify the target.

25. Some aspects of A's "moral character" may be unappealing to the Judge, but apparently A's conversational skills, tact, imagination, loyalty, and decency are appealing enough to the Judge to sustain friendship between them, and to keep him welcome at the Judge's home.

26. I can imagine a scholarly and cultural context where we would be soothed into complacency by a text that presented frank one-sidedness in its polemic, rather than simulated equipollence In this hypothetical context, we might imagine the Judge portrayed as far-and-away ("one-sidedly") superior to the aesthete. This would allow these differently-placed readers to revel comfortably in his victory. But for Kierkegaard's broadly educated, "tolerant," and "interested" audience, one-sidedness is *not* the dominant form of complacency: neutrality strikes closer to the mark. So Kierkegaard makes his entrance playing to this neutrality-slant. The fact that this apparent "standoff" is less a defense of neutrality than a provocation to us to test our commitments only slowly dawns on us. Kierkegaard exposes his own one-sided passion only at a considerably later date. For the moment, he gives his audience what it enjoys. We are first lured into his net, our complacency soothed— then shattered.

27. CUP, p. 252. The bracketed insertions are my own.

28. It is reported that in British philosophy circles in the 1950s it was not uncommon for undergraduates to be warned that "philosophy is absolutely useless." Like "art for art's sake," it had—on this view—a kind of inviolable and detached purity that made "wisdom" or "engaged philosophy" seem quite out of place.

29. I develop the contrast between willing receptivity and assertive and selective will in chapter 2 of *Selves in Discord*.

30. I thank John Davenport for reminding me that "the humbled will" must still be imbued with "infinite passion" and for his other helpful comments on an early version of this essay.

31. See Alasdair MacIntyre, *Dependent Rational Animals: Why Human Beings Need the Virtues* (Chicago: Open Court, 1999).

32. On Kierkegaard's views on subjectivity, inwardness, and passion as continuous with the classical view of character, see Robert C. Roberts's ground-breaking article "Existence, Emotion, and Virtue: Classical Themes in Kierkegaard," *Cambridge Companion to Kierkegaard*, ed. Alastair Hannay and Gordon Marino (Cambridge University Press, 1998): 177–206.

33. See Robert C. Roberts, "The Philosopher as Sage," *Journal of Religious Ethics* 22 (Fall 1994).

34. See the Gilleje testament, JP (V) 5100. Mid-way through his student life Kierkegaard avows, in this testament, his need not of more and more scholarly knowledge but of a truth on which he can stake his life, a truth to unify and give coherence to his life. This would be a truth for (and of) subjectivity, meaningful

moral agency. Only agents who are engaged in real moral-religious projects are properly positioned for access to a truth they can live (and die) for. Both MacIntyre and Kierkegaard, although committed to the importance of "subjectivity" in *this* sense, stand opposed to the non-sequitur that since subjects must endorse the truth that will matter to them, therefore truth for an individual is nothing but what he or she may be committed to. This is acknowledged in Johannes Climacus's surprising claim, which follows a vigorous defense of truth as subjectivity, that "subjectivity is untruth" (or truth is objectivity). CUP, p. 207. I discuss this interplay between subjective and objective aspects of Kierkegaardian truth in *Selves in Discord*, chapter 6.

35. This sentence owes much to John Davenport.

36. "Letting something happen" in answer to a demand is related to what Kierkegaard calls "repetition" See my "*Repetition*: Getting the World Back," *Cambridge Companion to Kierkegaard*: 282–307. A willingness to "let something happen" also figures as a prescription for the cure of sin or defiance, a refusal of the will to accept the good it confronts. See *Sickness Unto Death*.

37. I thank Marcia Robinson for reminding me of the considerations that place Kierkegaard outside some versions of "virtue ethics," and for many other helpful comments. See also the important discussions of these issues in Roberts, notes 32 and 33, above.

38. See Alastair Hannay's important discussion of personality as a persistent Kierkegaardian theme in "Kierkegaard and what we mean by 'Philosophy'," *International Journal of Philosophical Studies* 8, no. 1 (2000): 1–22. This essay has provoked my writing here in several ways.

39. Roberts, "The Philosopher as Sage," p. 430.

40. We cannot control the deliverances of repetition, or, in theological terms, of grace These deliverances necessary to life lie outside the purview of inquiry. In secular terms, for moral insight to lodge as part of personal advance, we may need among other things a supportive community and not-too-oppressive political surroundings, parents who have given good enough love, friends, mentors, and any number of other "aids." Inquiry alone cannot line up these factors (over which we may have little or no control) in the service of moral growth.

41. See my "Exemplars, Inwardness, and Belief: Kierkegaard on Indirect Communication," in *International Kierkegaard Commentary: Concluding Unscientific Postscript*, ed. Robert L Perkins (Mercer University Press, 1997). Pursuing the task of humbling our minds and wills might mark humility on his part—Kierkegaard does not presume to give us a final truth, only to prepare us for it. Then again, he presumes our wills or minds need humbling.

42. For an argument that irony permeates even Kierkegaard's signed, "veronymous" works, see Michael Strawser, *Both/And* Thus the preface to the early discourse reads: "This little book . . . wishes to be only what it is, a superfluity, and desires only to remain in hiding" (EUD, p. 5). Not only pseudonyms realize that a religious author must remain ironically "hidden"—in the interest of indirect communication.

43. See my "*Repetition*: Getting the World Back," in the *Cambridge Companion to Kierkegaard*: 282–307.

44. See Hannay, "Kierkegaard and What We Mean by 'Philosophy'."

12

Towards an Existential Virtue Ethics: Kierkegaard and MacIntyre

JOHN J. DAVENPORT

Summary

This paper argues that Kierkegaard's interpretation of the relation between freedom, dispositional character, and earnestness provides the basis for an existential version of virtue ethics that both benefits from and solves remaining problems within MacIntyre's social account of the virtues. In place of the classical notion of eudaimonia as the human telos, existential virtue ethics puts authenticity, *understood as practical coherence among earnestly willed projects that can give narrative shape and enduring meaning to a human life. While authenticity in this sense requires ethical consciousness as an ultimate basis for our cares and ground projects, and thus also requires certain protovirtues, it does not require moral goodness, nor does it provide a complete foundation for ethics. Unlike its eudaimonist predecessor, this minimal teleology of human selfhood is thus compatible with the full range of human freedom, including the possibility of radical evil.*

I. Preliminary Reflections: Common Ground in the Twentieth Century

Historical Introduction

French and German existentialism became popular among Anglo-American writers and intellectuals during the middle of the twentieth century, at the same time as what is now commonly called "virtue ethics" (or sometimes more specifically "Neo-Aristotelian" ethics) began its revival in Anglo-American philosophy. While college students in the 1960s were

265

taught books like Kierkegaard's *Fear and Trembling* and *Concept of Anxiety*, Sartre's *Being and Nothingness*, and Robert Solomon's *The Passions*, quite independently writers such as Philippa Foot, Elizabeth Anscombe, G. H. von Wright, and Stanley Hauerwas were returning to the idea that virtues of character are the central concept in ethics, which cannot be adequately understood simply as dispositions to adhere to moral precepts derived from deontic standards of justice or from some conception of the natural law. While interest in existentialism has waned in continental philosophy, giving way to versions of postmodernism that tend to reject the notion of persons as subjects of consciousness responsible for their individual destiny, interest in virtue ethics has deepened as dissatisfaction with formalist or Kantian approaches to duty and justice has increased. It is not surprising in this context that MacIntyre, as the first writer in the virtue ethics revival to address the new genre of existentialism, should have construed Kierkegaard as one more neo-Kantian, and interpreted his notion of a radical choice between "aesthetic" and "ethical" modes of existence as an attempt to supply what the rationalist tradition had failed to provide for ethics: namely, some basis other than divine command or a built-in motivational orientation towards a natural *telos* of the human species.[1]

Ever since existentialism and virtue ethics first encountered each other in *After Virtue,* it has been taken for granted that these two genres are fundamentally opposed in their interpretations of human personhood and morality. The most simplistic gloss is that virtue ethics views moral character as a matter of habit or disposition, without any concern for freedom, while existentialism puts all the emphasis on a freedom so absolute that stable character becomes inconceivable—a freedom so arbitrary that it must select its guiding values themselves for no reason in an absurd and groundless choice.[2] Moreover, while virtue ethics seems to subordinate all interior individuality or self-relation to social relations that ultimately determine our self-interpretations, existentialism allegedly abstracts the individual from all the interpersonal connections that could give his or her life any meaning. While virtue ethics regards each person's life as simply one part of a social whole, existentialism supposedly makes them into a self-generating intrapersonal consciousness, an atom in a social void whose external ties and group memberships are a matter of self-interested contract at best, or self-deception at worst.[3] What two dogmas could then be farther apart, or define more opposite extremes in the spectrum of philosophical anthropology and ethics? The idea of an 'existential virtue ethics' must then be an oxymoron.

Certainly the combination I hope to explore will remain unintelligible if we insist on these caricatures of virtue ethics and existentialism in their most facile form. To be fair, this reductive gloss is not so close to the richly

detailed story Alasdair MacIntyre told in *After Virtue*. Yet the widespread acceptance of this caricature (or something like it) may still be attributable in part to MacIntyre's dramatic contrast between Nietzsche/Sartre and Aristotle/Aquinas. Although MacIntyre's full account was more subtle, one of the polemical effects of *After Virtue* was to fix an image of existentialism that associates it profoundly with the Hobbesian individualism that Nietzsche admired and in many ways extended. However this may be, the recent history of existentialism and virtue ethics reveals shared concerns that should immediately give us *prima facie* reasons to doubt any story that places these genres in absolute opposition. At least in the twentieth century, existentialism and virtue ethics played parallel parts in a shared story that has both a theoretical and a social dimension.

By mid-century existentialism had become a social phenomenon in American and European high culture: from the seminars of philosophers in the phenomenological school, it spread to politics, literature, psychology, and other fields. Today virtue ethics is approaching a similar prominence, and its influence is clearly visible in some genres of contemporary sociology, psychology, and political theory. In both cases, the popularity of the philosophical paradigm was partly a result of the convergence of several factors in modern industrial society. Existentialism became a 'movement' because of the widely felt need in the West to privilege individual freedom in response to totalitarian political ideologies. It also responded to the subtler threats posed by behaviorism in psychology, technocratic theories of management and organization, and alienation produced by a mass consumer culture molded by distant, inaccessible, and bureaucratic corporations and state institutions. For example, existentialist themes were blended with the early Marx in Frankfurt-school critical theory because they seemed to promise emancipation from the dominance of instrumental reason, or from life as a mass man, an anonymous unit in a profit-maximizing machine. Its ideal of authenticity, or being true to one's own original potential,[4] seemed to offer an inspiring alternative to the reduction of all value either to utilitarian sums or to charismatic/persuasive expressions of private brute preferences. And it is significant that the return at mid-century of analytic ethical theory to virtues of character was propelled largely by the same set of interconnected social and theoretical concerns.

This was the intellectual environment in which MacIntyre began work on *After Virtue*, and without its influence the questions he asked in particular about the value of Sartrean ideas could not have been posed and would not have seemed so relevant to readers in the 1980s. Indeed, such has been the power of his critique that to new readers of *After Virtue* today, it may seem odd that he should have been so concerned about existentialism. But just as existentialism was born in the late nineteenth century out

of romantic dissatisfaction with Hegelian rationalism, contemporary virtue ethics was born of twentieth-century doubts about analytic rationalism and relativism in ethics. The main rationalist and noncognitivist alternatives in ethical theory no longer appeared viable as bases for social criticism and political reform. Following the linguistic turn, positivism had reduced the main discussion in ethics to a metaethical debate about the semantics of moral language, in which the chief question was whether or not ethical propositions could even have a cognitive meaning aside from their alleged noncognitive function of charismatic influence on blind emotions and brute preferences. But outside this tedious and fruitless level of argument, the main alternatives in normative ethics had become existentially suspect as a basis for life, even if (as Rawls surely showed) they were not theoretically bankrupt. Kant's ethics of rational duty had not saved Europe's ordinary citizens from the mass corruption of culture that led to the Holocaust. Likewise, although consequentialist ethical theories began from beneficent motives, by the middle of the twentieth century, utilitarianism had become little more than a convenient rationalization for the unlimited free-market capitalist ideology of neo-classical economic theory.[5]

The twentieth-century revival of virtue ethics cannot be adequately understood without reference to this historical situation. Like Kierkegaard and Sartre, MacIntyre responded (and still responds) to the human circumstances of his time. In *After Virtue*, he unmasked the cast of characters dominating post-war industrial Western democracies: "the aesthete, the therapist and the manager, the bureaucratic expert" (AV 73). The perceived emptiness of these characters' lives is similar to the hollowness Kierkegaard finds in the nominally Christian bourgeoisie of Renaissance Copenhagen and Berlin, or that Sartre finds in the ritualized numbness of Parisian social roles. While the existentialists thought the cure lay in personal authenticity, MacIntyre responds with a neo-Aristotelian ethics. Despite the apparent irreconcilability of these philosophical therapies, twentieth-century existentialism and virtue ethics understood themselves as practical responses to similar diseases of the soul and society, and as theoretical responses to similar conceptual aporias.[6]

Even at the political level, existentialists and virtue ethicists shared more common ground in the twentieth century than is commonly imagined. MacIntyre wrote that "the politics of modern societies oscillate between a freedom which is nothing but a lack of regulation of individual behavior and forms of collectivist control designed only to limit the anarchy of self-interest," and he praises Solzhenitsyn for rejecting both as intolerable (AV 35). Existentialists likewise opposed both these tendencies. Although libertarians like Ayn Rand sometimes vainly hoped to make an ally of Sartrean existentialism, the existentialists' common focus on the

facticity of human life—its situated temporality—made clear from the beginning that the independence to be valued as part of mature selfhood was something quite different from mere Lockean freedom from interference in doing whatever we want with our property. This is not to deny that twentieth-century writers in the genres of existentialism and virtue ethics have had different and conflicting interpretations of the importance of liberties in contemporary society, but they have both rejected the libertarian ideology of prepolitical natural rights and its illusion of atomic, unencumbered, or nonsituated selves.[7]

The Structure of the Analysis

These preliminary reflections are sufficient, I think, to cast doubt on the prevailing myth that existentialism and virtue ethics are wholly opposed or incommensurable paradigms, and thus to motivate a more substantive comparison of them. But this alone is not enough to establish the possibility of an existential virtue ethics, or to clarify what this would involve. To move towards this goal, we need to concentrate on one particular sort of existentialism, and then on one version of virtue ethics, which show promising connections. Such connections emerge if we consider the relation between the thought of Søren Kierkegaard and the tradition of virtue ethics, focusing in particular on MacIntyre's continuing effort to devise a new basis for a Thomistic version of virtue ethics.

There are several ways one might develop this comparison, but I will focus on Kierkegaard's unique contributions to the psychology of moral virtue, and why his insights should lead us to modify the traditional Aristotelian model in the direction of an existential conception of the role virtues play in a meaningful life. In section II, after arguing generally (in sympathy with Mehl, Turner, Rudd, and others) that Kierkegaardian ethics and moral psychology shares much more than virtue ethicists have recognized with their tradition(s), I introduce two initial distinctions between Kierkegaard's approach and Aquinas's. The development of these differences reveals what is distinctive about an existential virtue ethics.

In section III, I will outline Kierkegaard's general conception of virtue in relation to his understanding of freedom. Although this analysis reveals some immediate similarities to MacIntyre's narrative conception of human agency, it also locates one important difference between MacIntyre's and Kierkegaard's conception of persons. Nevertheless, MacIntyre finds himself closer to Kierkegaard than to rival theories of virtue ethics on a number of questions regarding virtues, and I will argue that this convergence becomes even more apparent in MacIntyre's Carus Lectures, where he moves closer to Kierkegaard's conception of agape as the chief substantive virtue.

After canvassing these connections between Kierkegaardian and MacIntyrean virtue ethics, section IV argues that Kierkegaard and MacIntyre have each focused on only part of the task of defending a complete virtue ethics, and that the parts they have developed stand in a largely complementary relation. Kierkegaard and MacIntyre each need key insights provided by the other thinker to resolve certain pressing problems with their accounts as they stand. Some of the apparently deep differences between them thus result from each thinker's 'onesidedness,' and can take their place on different sides of the synthesis characteristic of an existential virtue ethics. Nevertheless, I will argue that this combination requires replacing the eudaimonist conception of the human *telos* with a more promising existential conception of a meaningful life.

Finally, section V focuses on the remaining differences between MacIntyre and Kierkegaard involved in this division between eudaimonistic and existential teleology. These differences result from the existentialist's rejection of the Platonic/Aristotelian theory that all human motivation ultimately traces to the apprehension of ends as "good" in some way for the agent. The possibility of a positive will to evil becomes intelligible once we recognize that the human will is not simply rational control of appetites and desires that aims at a *unified eudaimonia*. On the alternative existentialist model, the *kinds* of teleology and freedom essential to human personhood are different than those implied by eudaimonist moral psychologies, but they are not empty or arbitrary. Thus the existentialist model derivable from Kierkegaard remains compatible with a conception of *phronesis* as moral sensitivity and virtues as dispositions of free willing. This shows why virtue ethics does not depend essentially on a neo-Aristotelian moral psychology of the sort MacIntyre has defended. A fruitful exchange between MacIntyrian and Kierkegaardian ideas leads to a better way of framing and conceiving virtue ethics in distinctively existentialist terms.

II. Kierkegaard: A Kind of Virtue Ethicist

Kierkegaard's treatment of "the ethical" as a category of lived human experience—and his understanding of its content and metaphysical status—is in deep accord with some central features of the tradition(s) of virtue ethics stemming from Aristotle and Augustine, and in discord with at least some alternatives within those tradition(s). Kierkegaard is *a kind* of virtue ethicist, and although he is not exactly the same kind as MacIntyre,[8] they are closer to each other than to rival views on some controversial questions in contemporary virtue ethics. I begin by outlining five general areas of broad agreement between MacIntyre and Kierkegaard.

Then I explain my approach to Kierkegaard's concept of "the ethical" as a prereligious stage of selfhood.

First, like Aristotle, Plato, and Socrates (who so profoundly influenced his thought, as well as his conception of his role in Danish society), Kierkegaard also takes motivational character and the direction of one's whole life, rather than particular types of action, to be the primary *subjects* of ethics.[9] For him, ethics concerns the entire range of traditional virtues and duties, but Kierkegaard focuses in particular on what I will call 'proto-virtues,' which function as the *conditio sine qua non* for the attainment of the more substantive moral virtues. For example Kierkegaard writes (in his own name) that "cowardliness keeps a person from acknowledging what is the good, the truly great and noble, which ought to be the goal of his striving and his diligence early and late."[10] Kierkegaard interprets courage in a way that gives it a central role in attaining moral maturity, for it is the courage to make resolutions—to make a beginning in striving for any challenging goal the pursuit of which demands commitment over some extended course of time, in the face of likely adversity—that first brings specifically *aretaic* ethical contrasts of 'noble' versus 'base' into sharp focus for us.[11] The salience of these contrasts is crucial for the cares and commitments that determine a significant part of our character.

Second, to be in the ethical life-stage or existential "sphere" for Kierkegaard is to be *disposed* to interpret one's actions, motives, and interests in terms of an ethical language of "strong contrasts," in Charles Taylor's sense.[12] The ethically existing agent for Kierkegaard has not necessarily become virtuous, but is at least prone to see wrong actions in terms of concepts like "untruthful, unchaste, [or] unjust."[13] For Kierkegaard, as for Taylor, this sort of "strong evaluation" must also be "anchored in feelings, emotions, aspirations," and so involve a kind of "affective awareness" of our act or motive as worthy or base in some particular way.[14] In other words, to be an ethically existing agent is already to have a certain kind of *character* that makes rich ethical contrasts salient for the agent—even if this character may not yet be virtuous. As James Collins says, Kierkegaard thought of existential stages as basic forms of life defined by "the most fundamental commitments and organizing ideals available to men."[15] The fundamental commitment of the ethical agent is to interpret his or her actions, cares, and overall life-direction under the discipline not simply of some ethical criterion or other, but under what ethicists today call *agent-centered restrictions*.[16] For only restrictions of this kind make possible the sorts of cares and commitments around which an agent can form a life that will have narrative unity and continuity for him.

Third, this tendency to evaluate options for choice in terms of strong evaluations also means that the ethical attitude for Kierkegaard is wholly opposed to *consequentialism* in Anscombe's sense, i.e., evaluation solely

and simply in terms of the likely aggregate external effects of various possible actions, motives, character-traits, policies, and so on. In fact, since other kinds of strong evaluation are involved even in the higher forms of aesthetic existence for Kierkegaard, even aesthetic heroism is incompatible with utilitarianism in his analysis.[17] What distinguishes *ethical* agent-restrictions and the strong contrasts they involve from aesthetic strong evaluation is in part the universality and necessity of the former for all moral agents. It is important to note, however, that ethical values can be "categorical" in this agent-focused sense, as obligating all responsible persons, without being impersonal in *content*, or (in Jorge Garcia's words) "being independent of anyone's interests, needs, flourishing, or happiness."[18] For Kierkegaard, what virtue requires of us will vary according to our particular historical circumstance, role-relationships, and inner resources. In "Against Cowardliness," he writes,

> But the good, the truly great and noble, is, of course, not just something general and as such the general object of knowledge; it is also something particular in relation to the individual's particular talent, so that one person is capable of more than another, so that one person is capable of it in one way, another in another. The talent itself is not the good, as if exceptional capability were the good and limited capability the bad (what a bane for the fortunate, what despair for the unfortunate!)—no, talent is the indifferent that nevertheless has importance. (EUD 358)

But although his ethics is aretaic and perfectionist,[19] Kierkegaard does often present it in terms that allude to deontic concepts of duty, obligation, and obedience. Need this place his conception outside the scope of "virtue ethics" properly understood? Under the influence of Elizabeth Anscombe's 1958 paper,[20] some authors in the twentieth-century revival of virtue ethics have argued that the notion of obligation or moral necessity is either dispensable or even deceptive. Thus an introduction to one new reader says that for virtue ethicists, "aretaic notions like virtue, admirability, and excellence are more basic than—or even replace—deontic notions like moral obligation and rightness."[21] Similarly, Garcia writes that in serious or "radical" virtue ethics, "what is morally required" is conceptually less basic than "what is morally virtuous."[22]

If one *must* demote the concept of obligation or moral necessity to the status of a completely derivative concept to count as a virtue ethicist, then Kierkegaard would probably have to be excluded, since he constantly emphasizes the absoluteness of ethical requirements and ideals. But his pseudonym Judge William warns against understanding the ethical solely as abstract law, or a list of particular duties external to the self: instead he urges that the person who lives ethically understands duty as "the expression of

his innermost being" (EO II 254) and thus "expresses the universal" in his individual life (EO II 256). This conception of the intimate self-knowledge of the ethical agent who sees himself in light of ethical contrasts is clearly modeled on Socrates rather than Kant. And in his later religious writings, Kierkegaard's own 'categorical imperative' is to love one's neighbor, or to follow the ideal of universal agape.[23] Thus for Kierkegaard it seems that aretaic and deontic concepts are equiprimordial and interdependent. Similarly, MacIntyre has always resisted the anti-nomological extremism of some contemporary virtue ethicists. Despite being "deeply indebted" to Anscombe, MacIntyre has argued that medieval virtue ethicists in the Aristotelian tradition had a coherent understanding of moral principles simultaneously as "teleological injunctions" describing qualities necessary to realize our true nature and as "divinely ordained law" (AV 53). This connection between the aretaic and the nomological remains for MacIntyre when virtue ethics is disconnected from divine commands. He is explicit that his social account of the virtues cannot dispense with the idea that "a morality of virtues requires as its counterpart a conception of moral law" (AV 200). For MacIntyre, then, deontic and virtue concepts are two sides of the same coin, just as they are for Kierkegaard.[24]

Fourth, Kierkegaard follows the tradition(s) of virtue ethics in affirming "the reality of certain types of character-traits"[25] constitutively involved in virtues, and holding that these traits begin with habits, evaluative attitudes, and sentiments whose initial shapes are formed in childhood. For example, Robert C. Roberts notes this theme in *The Book on Adler*, where Kierkegaard argues that a reverence for Christianity learned in childhood provides a surer basis than theological study for choices that reflectively affirm that reverence against incompatible inclinations.[26] The same general idea is found in many of his works. For this reason, Kierkegaard shares MacIntyre's view that ethics can be understood only as part of a broader inquiry into moral psychology, philosophical anthropology, and metaphysics.[27]

Fifth, as scholars have often emphasized, Kierkegaard's shares with Augustine and Aquinas the notion that virtues are qualities of character connected to the attainment of beatitude as the final end and highest good of human life. As Alastair Hannay remarks, Climacus's notion of an "eternal happiness" in the *Postscript* seems very close to Aquinas's conception of the human *telos* as "a special kind of contentment bestowed by God, a happiness or heavenly bliss, in the form of a maximally satisfying human participation in the divine."[28] But although he regards this infinite happiness as the true *telos* of human life (so failure to move towards it constitutes deficiency and pathology), the relation between virtue and this teleological conception of the self as ordered to God is not as clear for Kierkegaard as it is for Aquinas. As MacIntyre argues, Aquinas follows the basic

Aristotelian view which defines the virtues as those qualities which make possible the attainment of our true end. Among the Jewish, Islamic, and Christian Aristotelian theologians of the early medieval period, "The true end of man can no longer be completely achieved in this world," but otherwise the Aristotelian schema remains unchanged (AV 53). This implies a *metaphysical foundation* in the form of humanity for the normative authority of virtue-ideals and the associated precepts of natural law. MacIntyre emphasizes this point: for Aquinas as for Aristotle, "virtue is a secondary concept" defined by some prior concept of "the good life for man" or what it is to flourish as human (AV 184–85). And virtually all its contemporary advocates seem to assume that virtue ethics is impossible without such a foundation in roles, functions, divine design plans, or natural *teloi*— i.e., that virtue-values must be grounded in facts that are not in themselves ethical but have a different and prior metaphysical status.[29]

In this sense, contemporary virtue ethics is *eudaimonistic*. For present purposes, I define eudaimonistic theories as those which (1) propose a metaphysical foundation for virtue ethics, defining virtues as qualities of character that promote the attainment of the human *telos* and vices as qualities of character that impede its attainment, and (2) conceive the human *telos* as happiness in a holistic sense embracing all that is desirable in human life. As I understand it, Kierkegaard's virtue ethics follows neither of these patterns. For Kierkegaard, we have a *telos* in the sense of an end whose practical necessity is set for us by our nature, but it is not an Aristotelian chief good, and it does not function as a complete metaphysical foundation for ethics.[30]

This is complicated by the fact that for Kierkegaard, our *telos* has both a provisional abstract form and a final wholly concrete form (corresponding to the two main transitions between life-views or spheres of existence): our *telos* first appears in the abstract form of *authenticity of the will,* and only later as salvation in God. Once we have moved from the wantonness of aesthetic existence into ethical earnestness, we can eventually discover that the kind of self-relation intended in the ideal of authenticity can only be attained through "an absolute relation" to the Absolute as the personal God who saves from sin. Unlike other authors in this volume, I will focus almost exclusively on the provisional form of the human *telos* as authenticity, since my present aim is to reconstruct and extend those aspects of Kierkegaard's thought that have critical relevance even for secular virtue ethics. But this approach may have an added heuristic advantage: I believe its findings will also shed some light on how we should understand Kierkegaard's notion of our *telos* in its concrete religious form. Although he refers to it as an infinite happiness, properly understood I do not believe this is simply a version of eudaimonia as the 'chief good,' as beatitude apparently is for Aquinas.

Moreover, while the authority of ethics and the attainment of authenticity are closely tied together for Kierkegaard, our teleological impetus towards authenticity does not in his view suffice to ground the authority of ethics (see sections IV and V below). This remains true at the religious stage: our *telos* understood as the happiness of salvation does not *ground* the virtues of moral life or faith for Kierkegaard, but is instead their final complement or true reward. As Alastair Hannay argues, for Kierkegaard "the notion of a transcendent God as the source and guarantor of personal value" gives an absoluteness to ethical requirements which transcends the social basis of "civically defined virtue" and implies that there is "no determinable limit to what a person might be required to do in pursuance of the good."[31] Hannay calls this absoluteness "the autonomy of ethics:"

> In Kierkegaard's context the autonomy of ethics has two sides corresponding, one might say, to an upper and lower limit. On the one hand, ethical principles and concepts are not mere expressions of a surpassable stage in spiritual development; they contain specifications of irreducible, and in that sense ultimate or absolute, *desiderata*. In this sense, to say that ethics is autonomous is to say that one *cannot* go beyond ethics, for ethics forms an upper limit. . . . But ethics is, on the other hand, also autonomous in the sense that it envelops, rather than arises out of, the conditions of human existence; neither ethical principles and concepts themselves nor the individual's understanding of them are a natural, logical, or 'dialectical' product of elements already found in a pre-ethical stage. Ethics in this respect lies beyond the self and its world, that is, beyond time. . . . In this respect one can say that although the ethical forms an unsurpassable upper limit from the moral agent's or moral describer's point of view, its own lower limit nevertheless lies beyond nature, time, and history.[32]

In other words, for Kierkegaard ethics has no pre-ethical metaphysical foundation in any teleological essence, or even in Kantian implicit commitments of reason. The "autonomy of ethics" in this sense is roughly equivalent to what Emmanuel Levinas later called the *priority* of ethics to metaphysics, or the radical originality of our experience of responsibility.[33] As Hannay says, within this freestanding or absolute perspective, we can still speak of a desire for transcendent fulfillment which points towards the true *telos* of human nature, but only because this 'nature' is understood from the beginning in terms of the irreducibly ethical categories of "selfhood and individuality,"[34] rather than as a kind-essence or substantial form. In this respect, Kierkegaard's existential virtue ethics is a postmodern rather than a eudaimonistic ethics. Yet it remains (most clearly in its religious form) a kind of virtue ethics, rather than a merely "adverbial" ethics of attentiveness and solicitude of the sort we get from Heidegger, for example.[35] This is possible precisely because not all virtue ethics has a

eudaimonist form. To understand the alternative, we need to consider Kierkegaard's existential psychology.

III. Existential Virtues as Dispositions of Freedom

Earnestness/Care as the Form of Virtue

Kierkegaard understands the sort of psychological states that can constitute virtues in a particular way that sets him apart from several other virtue ethicists. His insights on this question show that Kierkegaard is important as a virtue ethicist in large part because he makes some unique contributions to the Anscombian project of clarifying the basic psychological concepts involved in notions of agency and character without which an ethics of virtue cannot be articulated.[36]

Some authors think of virtues primarily as dispositions *to behave* in certain characteristic ways, that is, as one set of the various "personality traits" measured by psychological inventories asking us how we tend to behave in reaction to different situations and problems. A more complex view stems from Aristotle's notion that *aretê* is "a state concerned with choice, lying in a mean relative to us, this being determined by reason and in the way in which the man of practical wisdom would determine it."[37] Virtues in this sense cannot be unthinking habits of action of the sort that could be produced by mindlessly drilling children in certain patterns of behavior. To say they are concerned with "choice" (*prohairesis*) means they involve not a tendency to some noncognitive urge or brute impulse but rather a stable disposition to act in the relevant way when appropriate because one thinks and feels in the right way about the situation. In other words, the virtuous disposition is not mechanistic in form: it is not an inarticulate pattern of behavior of the sort that might be produced by brainwashing, posthypnotic suggestion, or the creation of tropistic mechanisms in the brain,[38] but rather the sort of "deliberative desire" that links up with decision.[39] Lear characterizes it as moderate desire for whatever is judged noble or best by a kind of prudence whose sensitivity to circumstances is itself dependent on already having the right sort of "character."[40] As Roberts has emphasized, this character itself partially consists in tendencies to pleasure and pain in various experiences and prospects, and to related emotions, that are linked to particular ways of interpreting one's choice-circumstances. Thus for Aristotle, "direct dispositions to right appetite and emotion, which do not require moral strength [or self-control] for their exemplification, can be virtues."[41] This view is recast by writers such as von Wright, Williams, Nussbaum, McDowell, and MacIntyre, who all think virtues involve dispositions to desire certain kinds of goods as ends in

themselves, as well as to feel and think appropriately in reaction to the circumstances. They do not, however, connect virtue with *will* in any sense distinct from some combination of desire, emotion, or practical reasoning. Existential virtue ethics will differ significantly here in seeing virtues as *volitional* states of resolve that involve the exercise of libertarian freedom.[42] How can this be?

Kierkegaard gives us some clues in his account of "earnestness" as the basic proto-virtue of the will (the lack of which underlies the proto-vices of aestheticism). In the *Concept of Anxiety*, Kierkegaard's pseudonym Haufniensis says that earnestness cannot be reduced to a conceptual definition without disconnecting it from the first-personal function that makes it earnestness, namely, the function of engaging the self wholeheartedly in some cause or purpose. He uses love as an analogy for this aspect of earnestness: "Whoever loves can hardly find joy and satisfaction, not to mention growth, in preoccupation with a definition of what love properly is" (CA 147), since to love is to be focused actively on the good of what one loves.[43] Just as virtue involves *phronesis* for Aristotle, earnestness is related to an understanding of truth, but it consists in *taking to heart* the relevant truth, or being "certain" of it in the practical sense of being willing to *act* on it. In earnestness,

> truth is for the particular individual only as he himself produces it in action. If the truth is for the individual in any other way, or if he prevents the truth from being for him in that way, we have a phenomenon of the demonic [or avoidance of earnestness]. Truth has always had many loud proclaimers, but the question is whether a person will in the deepest sense acknowledge the truth, will allow it to permeate his whole being. . . . (CA 138)

We might compare this to Frankfurt's Augustinian point that what seemed to be a decision about our commitments, if it produces no tendency to action, may not really be a wholehearted decision[44]—or in Kierkegaardian terms, it may not represent an earnest appropriation of the subjective reason for that decision. Earnestness in this respect is similar to the kind of volitional attitude that Frankfurt calls *caring* about something, which involves being personally "invested" in it and self-consciously "guiding oneself along a distinctive course" of agency that such devotion requires.[45] Caring in this sense is a reflexive attitude, as is earnestness.

Haufniensis distinguishes earnestness from "disposition," which he defines following Rosenkranz's *Psychology* as a tendency involving "the unity of feeling and self-consciousness" (CA 148). A "disposition" in this sense is distinct from a blind conatus or drive: "If the clarity of cognition is lacking, [or] knowledge of the feeling, there exists only the urge of the spirit of nature, the turgidity of immediacy" (CA 148). We should understand this to mean that a disposition is a tendency to some sort of *intelli-*

gible action, that is, to an action that is intelligible to its agent in terms of the intention that constitutes it as an action (rather than mere behavior). This will include a tendency to the desires, emotions, and judgments that underlie the formation of such an intention. A "disposition" in this sense could be understood in MacIntyre's terms as the recurrence of a significant motif in the interpersonally accessible narrative in terms of which the agent understands his or her agency.[46] The agent need not reflectively recognize the significance of such a motif for it to count as a disposition of her character, but it must be so recognizable. MacIntyre clearly thinks that virtues are kinds of disposition in this sense,[47] but Kierkegaard holds that earnest states of motivation involve something *more* than dispositions so defined. For Haufniensus writes,

> Earnestness and disposition correspond to one another in such a way that earnestness is a higher as well as the deepest expression for what disposition is. Disposition is a determinant of immediacy, while earnestness, on the other hand, is the acquired originality of disposition, its originality preserved in the responsibility of freedom and its originality affirmed in the enjoyment of blessedness. In its historical development, the originality of disposition marks precisely the eternal in earnestness, for which reason earnestness can never become habit. . . . [H]abit arises as soon as the eternal disappears from repetition. When the originality in earnestness is acquired and preserved, then there is succession and repetition, but as soon as originality is lacking in repetition, there is habit. The earnest person is earnest precisely through the originality with which he returns in repetition. (CA 148–9)

It will help in interpreting the distinctions in this difficult passage to connect them with some more recent themes in moral psychology. States of earnestness and dispositions are distinguished here because dispositions to think, feel, intend, and act in certain ways can—for all their regularity and pervasiveness in one's 'personality' (as interpreted by external observers and interlocutors)—still remain just tenacious psychological recurrences that are not more deeply integrated into the person's self, or that play no essential role in what we might call the *inward narrative core* of one's agency. This deeper level involves states of the "higher-order will" in Frankfurt's sense, i.e., states of identification with certain motives or reasons for acting, which are then in Kierkegaard's sense subjectively appropriated, rather than held in speculative detachment. The difference is that Kierkegaard has a *narrative* understanding of this inward core (as opposed to Frankfurt's initial time-slice understanding of such higher-order volitions[48]). In other words, for Kierkegaard, earnestness is realized in "dispositions" of the higher-order will. This is why he can say that earnestness is constituted by a *kind* of "disposition," that "earnestness is a higher as well as the deepest expression for what disposition is" (CA 149).

Earnest states of will are not *mere* dispositions in the familiar sense (i.e., patterns of attitude and intentional action), but rather dispositions of agent-commitment which are deeply integrated in (and thus partially constitutive of) the whole self. That there are dispositions at this deeper narrative level means that we can speak of an inner volitional *character*. This is not a set of character-traits the self *has* as accidental properties; rather this character *is* the self. Thus in existential virtue ethics we distinguish two levels of character: the outer and the inner. This is the distinction Alastair Hannay finds in the *Sickness Unto Death* between the self as a particular set of psychosomatic traits and aptitudes and "the self that one can possess only by taking an 'inward direction'" or position towards features of one's outer self.[49]

This again suggests a comparison of earnest states with what Frankfurt calls *cares*, which are higher-order volitions sustained over time, so that the person's reflexive stand towards her own desires, emotions, and patterns of intentional action become integral parts of the lasting commitments that define her enduring self.[50] States of earnestness involve the same kind of reflexivity as caring. There is a sense in which the proper object of earnestness is always the agent himself, and without this an earnest concern for any more particular cause or purpose can become comical (CA 150). What Kierkegaard means by this is not that we must care primarily *about* ourselves, but rather that earnest caring about anything or anyone else will also involve a reflexive effort to control and organize our own character in accordance with our concern, if it is truly earnest. This reflexivity distinguishes cares from "habits" of the outward psyche in Kierkegaard's sense. For as Frankfurt also says, we cannot assume

> that whenever a person's life displays over a period of time some more or less stable attitudinal or behavioral disposition, this reflects what the person cares about during that time. After all, patterns of interest or of response may be manifestations only on habits or of involuntary regularities of some other kind; and it is also possible for them to develop merely by chance.[51]

Cares are dispositional, but they are states of a deeper kind than "dispositions" or "habits" in the more familiar outward sense. Moreover, cares and the volitional identifications they involve are not among the initial 'raw materials' of the human psyche: rather, they are self-generated responses to our given tendencies and our situation. Kierkegaard explains his distinction in a similar fashion: "one may be born with dispositions, but no one is born with earnestness" (CA 150). This also helps to explain why, as Frankfurt says, what a person cares about is "more germane to the character of his will" on which we judge a person's worth than all the more particular "decisions or choices he makes."[52] Kierkegaard says much the same thing:

"the essential worth of an individuality" can best be judged by ascertaining "what has made him earnest in life" (CA 150) or (in effect) what he *cares about*.

Dispositions and habits as 'personality traits' in the common sense—as tendencies to certain first-order psychic states of desire, emotion, thought, intention, and action—are not as central to the estimation of moral worth because they may not be expressions of the whole or deep self, however significant their effects on the person's life. Habits in this sense, such as tendencies to be grumpy or cheerful, outgoing or shy, nervous or confident, impulsive or planned in action, extroverted or introverted, and so on are patterns of first-order states, which may be due more to contingencies of the individual's early environment, genetic endowments, social influences and accidental patterns of response, than to the agent's self-guiding will. Whatever responsibility we have for such features of our personality (and they are hardly irrelevant), virtues and vices cannot consist merely in habits of this sort. The "character-traits" we are looking for are instead those that constitute *volitional character*. To have definite traits at this level of character is to be in earnest about something. Being earnest or having volitional character in this sense is the opposite of the irresolution of immediacy, as Kierkegaard calls the default form of aesthetic existence. Yet such irresolution is still compatible with exemplifying habits and dispositions in the ordinary sense, or having first-order character. Many higher mammals can also be said to have habits and dispositions of this sort, and the first-order character-traits they constitute. But only persons are capable of volitional character constituted by patterns of earnest caring, and only persons can have moral virtues and vices of character.

Earnest dispositions and outward habits are also differently related to freedom. In earnest dispositions, the intelligible pattern consists in *repetition* in the existential sense, rather than simple *reiteration* of the same actions, desires, and emotions. In reiteration, the pattern becomes a 'second nature' to the individual. This does not mean it consists only of mindless routine or a blind tendency to a given kind of action, since the habit can involve patterns of thought, affect, and intention as well. But the entire complex becomes 'second nature' in the sense that it operates for the most part without the need for continued guidance, reaffirmation, and renewed resolve by the will in its libertarian freedom. Not so with caring, as Kierkegaard understands it. The dispositions of the higher-order will are distinct, in his analysis, because they involve a repetition of volition that is free in the libertarian sense, a continuity of *recommitment*. The kind of "volition" involved here is not a "choice" in the sense of simple *selection* between discrete alternatives laid out beforehand; rather, it is a movement of the self that has the potential to move in different ways, crystallizing its alternatives in the process.[53] So the "repeated" pattern is not simply made

up like a collage out of a sequence of isolated choices; rather, Kierkegaard thinks of each new moment of original rededication as conditioned, inclined, and shaped by the volitional character already acquired up to that point in the process. If the pattern were simply a mereological sum of radical choices, then each such choice would be all originality, without any conditioning by the past. On the other hand, if the pattern involved no libertarian freedom to deviate in the present from the volitional momentum already underway, it would be nothing but an entirely rote reiteration of the past, or at best the playing out of a program pre-established in a Leibnizian monad. "Repetition" instead names the kind of temporal pattern in which the factical hold of already-established tendencies and the transcendence of freedom are *combined*: the past is reinscribed, but in a moment of novelty. Thus particular volitional moments in such a pattern can be individuated only by abstraction, and they involve libertarian freedom in the sense that they are not totally *determined* by their preconditions, but still involve varying degrees of openness to different alternative ways of being. This is what makes these dispositions open-ended *processes* of freedom or 'narrative wholes' in which pattern and choice are reciprocally interconnected in relations that are continually rewoven in the process. 'Dispositions of freedom' in this sense are self-guiding patterns, and, hence, qualitatively distinct from a pattern of mechanical repetition.

This picture of free self-determination as having an essentially narrative form as a holistic process fits well with Ed Mooney's argument that the event of "self-choice" is not so much an active selection among alternatives as a receptive embrace of the values, roles, and concrete potentialities that require our response.[54] The self as a self-forming narrative[55] requires the idea of existential dispositions of freedom. This picture of freedom is also arguably necessary to explain how it can be that "the narratives which we live out have both an unpredictable and a partially teleological character," as MacIntyre holds (AV 216). If so, then MacIntyre's analysis of virtues in terms of their role in unifying one's life actually requires something like Kierkegaard's novel conception of freedom, which is not to be found in Aristotle or Aquinas.[56] Still, MacIntyre (like Frankfurt as well) apparently remains opposed to the idea that the process by which our fundamental "commitments" are determined can involve freedom. In *After Virtue* he argued not only that (1) the self cannot be detached from "its social and historical roles and statuses" (with this much Kierkegaard agrees), but also that (2) I *am* the character defined by a set of "longest-term intentions" attributed to me by the community in whose narrative my character is inscribed (AV 217). More recently, MacIntyre has again insisted that our "mode of involvement in reality" (in Heidegger's terminology) is beyond the reach of libertarian freedom: "Our fundamental commitments are at a level quite other than that at which we make our choices."[57]

I distinguish these two positions as (1) the thesis of the facticity of human selfhood, and (2) the thesis of 'narrative essentialism.' Existentialists accept (1) but reject (2), for reasons that become clear once we grasp how Kierkegaard's unique understanding of the relation between disposition, character, and freedom allows us to rethink this problem of "ownmost" or "highest-order" cares. For Kierkegaard's idea—one of his most subtle—is that there can be dispositions of libertarian freedom itself, or (equivalently) that libertarian freedom is actually *schematized* (in Kant's sense) in a temporally extended process of a peculiarly complex kind, in which the deep character already acquired through past attitudes of care both conditions and is partially reshaped through each new exercise of freedom in this process, in which we at the same time voluntarily shape our deep character. This idea, which is the inspiration for Heidegger's later notion of factical freedom or "thrown possibility," is the foundation of Kierkegaard's conception of virtue. Let us call volitional tendencies evinced by patterns arising in this sort of process *existential dispositions*. Earnestness is then the defining quality of such existential dispositions. And since any virtue-state must be a state of earnest will for Kierkegaard, all genuine virtues are existential dispositions (though not the reverse, since some existential dispositions are vices).[58] Other sorts of traits may be involved in evaluations of personality, e.g., why we like or do not like a person, or why we value or do not value them for various purposes, or why we can or cannot cooperate with them in various ways. But though such traits can be involved in various kinds of evaluation of the person, according to existential virtue ethics, they are not as central to moral evaluation of the person herself, which must instead focus primarily on her self-defining existential dispositions.

In this light, we can see why (1) and (2) are distinct, even though neo-Aristotelians tend to run them together. The facticity of selfhood (1) does not entail the distinctive idea of narrative essentialism (2), namely, that the free choices in which I write some aspects of my personal life-narrative or partially shape how this story unfolds must ultimately be referred (in order to be intelligible as *my* choices) to a set of longest-term intentions that are the deepest motifs running from the beginning to the end of my story, which I cannot myself have freely determined in any libertarian sense (on pain of infinite regress). The ingenuity of Kierkegaard's concept of freedom is that, without reducing this process to one of arbitrary choices, it gives freedom a place even in the deepest or ultimate core-narrative out of which the person-as-narrative-character partially writes itself (in negotiation with the factical limitations of nature and the intersecting narratives of its multiple social contexts). Thus this core-narrative is not random, but it is not a fixed 'essence' either. Even at the ultimate level of personal

identity, we do not simply play out a predefined role. Our individuality is not reducible to our simply *instantiating* a certain "story" about ultimate commitments or highest-order volitions, or a certain process of longest-term intentions, or any other ersatz construct of this kind. We do not have an 'individual nature' in any such sense. Thus, it is distinctive of existentialism not only to reject metaphysical essentialisms, or theories that identify the individual with a metaphysical essence of some sort (a monad, a noumenal substance, or a Molinist set of subjunctive conditionals), but also to reject narrative essentialisms of the sort proposed by MacIntyre, Scheler, and others in the phenomenological tradition.[59] Personal 'existence' does indeed precede 'essence' in these multiple senses, but without turning the person into a bare "pinpoint of will."[60]

Medieval Virtues and Neighbor-Love

Kierkegaard's ethical thought can be situated within the traditions of virtue ethics and compared to MacIntyre's own contribution to these traditions in one further way. Although he lacks MacIntyre's more developed conception of human communities, Kierkegaard clearly takes engagement in practices and personal commitment to social roles to be essential to ethical life, and to require recognition of the authoritative moral norms and ideals of character needed for sustaining noninstrumental personal relationships, such as marriage (his paradigm case).[61] But beyond the particular virtues required for devotion to any profession or style of life with shared standards of excellence defined in the history of the practice itself, Kierkegaard finally interprets moral virtue in terms of agape or neighbor-love.[62] Among the many facets of neighbor-love he examines, Kierkegaard emphasizes "[h]ow deeply the need for love is grounded in the nature of man" as beings dependent on community,[63] and he repeatedly urges us to care unconditionally for the actual individuals we find before us, whoever they are and whatever they are like: "when it is a duty in loving to love the men we see, there is no limit to love. If the duty is to be fulfilled, love must be limitless. It is unchanged, no matter how the object becomes changed."[64] In calling love a duty, Kierkegaard implies that it is something categorically owed to the other person *qua* person; thus agape even "gives in such a way that the gift appears as if it were the receiver's possession."[65] But he also distinguishes agape clearly from the Aristotelian virtue of justice that "gives to each his own."[66] As the highest virtue, agape instead seems to combine aspects of justice and beneficence. Even though each person has this duty, my owing generous and attentive care to a universal range of others is not dependent in principle on anyone else *actually* loving me in the same way (though they ought to).

In his most recent book, *Dependent Rational Animals*, MacIntyre has clearly moved towards this Kierkegaardian position. He argues that to understand the "virtues of acknowledged dependence," we must see that "the central virtue exhibited in relationships of receiving and giving" is one that the conventional list of virtues does not name, which "has aspects of both generosity and justice" (DRA 120).[67] Although he distinguishes this virtue from *caritas*, which requires divine grace on Aquinas's account (as on Kierkegaard's), this virtue of "just generosity" is closely related to *misericordia* (or sympathy for suffering), which Aquinas treated "as one of the effects of charity" (DRA 124). "Just generosity" involves recognizing that I owe to all particular others a kind of "uncalculating giving" that responds to the basic reality of human dependence on "the attentive and affectionate regard of others" (DRA 121–22). While it is distinct from "blandly generalized benevolence," which only directs us towards "a generalized Other" (DRA 119), just generosity helps make possible a communal life of particular others pursuing common goods precisely by reaching beyond the contingent boundary of communal membership and recognizing the urgent needs of strangers as claims on us with no determinate limits, which may override "even claims based upon the closest of familial ties" (DRA 123–25).

Of course, MacIntyre does not construe his new emphasis on pity and generosity as Kierkegaardian: he regards it as a development of ideas introduced in his earlier discussions of medieval virtue ethics. In several works, MacIntyre has rightly emphasized that the tradition(s) of virtue ethics in ancient and medieval philosophy are far from monolithic. Unlike Aristotle, Stoics such as Cicero "provided classical authority for treating benevolence as a central virtue."[68] Similarly, Jewish, Christian, and Islamic scriptures emphasized "humility, patience, peacemaking, and charity, virtues either unknown or less important to the classical world."[69] The forgiveness and charity even towards corrupt persons that medieval virtue ethicists emphasized was obviously foreign to Aristotle's thought and to Greek virtue ethics in general: "There is no word in the Greek of Aristotle's age correctly translated 'sin,' 'repentance' or 'charity'" (AV 174). Thus in his synthesis, Aquinas also emphasizes the importance of humility, and medieval narratives about virtue valued qualities such as "patience and purity" which made individuals resilient against the conflicts, instabilities, and sufferings of medieval life (AV 176–77).

Whatever his debts to Kant, Kierkegaard's conception of ethical personality clearly fits within this Christian subtradition of virtue ethics. Kierkegaard regards patience not only as a central social virtue but also as a religious virtue essential to developing one's relation with God. It is patience which in Kierkegaard's view makes possible the "unswerving" pursuit of good purposes, as opposed both to empty wishing and to

despair. And the patient will can earnestly pursue its purposes without desperation because it rests secure in "faith's covenant with the eternal, in hope's covenant with the future" (EUD 192).[70] Patience for Kierkegaard is a confidence of will that does not try to base its strength on its own fervor or enthusiasm. The impatient radical lacks this maturity of spirit: "He cannot and will not understand the slowness of the good, that in its compassion it is long-suffering, that in its love for the free it will not use its power, that in its wise understanding of the weak it shuns every deception . . ." (PH 62). At root, Kierkegaard thinks such impatience, which prevents authentic singleminded devotion to the good, is rooted in the agent's self-willful desire for personal glory, or "the good in its victory. . . through him" (PH 63).

Kierkegaardian existentialism, unlike its Nietzschian counterpart, does not conceive individuality as a distinction achieved mainly by the will to triumphal ascendence, but rather as requiring humility before a God who is encountered fully and personally only in a recognition of sinfulness. Our moral inadequacy is not constituted merely by our "guilt" for particular acts or omissions as violations of moral precepts, but rather by deep flaws of character, including a fundamental disposition to put oneself before others. These are flaws that can only be redressed through the acquisition of virtues—partly through our own will to self-reform, but also (as becomes apparent at the stage of faith) partly through grace.[71] Thus Kierkegaard departs from Aristotle and follows the medieval tradition in holding that:

(a) a corrupt person remains capable in principle (however difficult it becomes) of promoting the improvement of their own moral character over time;

(b) some of the most important virtues are precisely those that facilitate, promote, and make possible such moral self-correction; and

(c) nevertheless, given Augustine's recognition of the will's original capacity to "delight in evil" (AV 175), human character can never fully achieve its proper moral perfection without God's aid and mercy.[72]

In other words, the virtues are volitional qualities of self-forming but still metaphysically dependent beings. As Robert C. Roberts put it, Kierkegaard ultimately rejects "a conception of virtue as unaided human accomplishment, perhaps something like Aristotle's picture of the magnanimous man who takes great pleasure in thinking himself glorious because of his courage, his generosity, his temperance, etc."[73] Kierkegaard also has plenty to say about how virtue can be manifested in human suffering even more profoundly sometimes than it is in active striving for the good (PH 99–120).

On these points, in following Aquinas, MacIntyre now finds himself in deep accord with Kierkegaard. While recognizing that Aristotle (like Aquinas and Merleau-Ponty) regarded the temporally-lived animal body as essential to the human self, MacIntyre now takes Aristotle sharply to task for his portrait of the magnanimous man as a "paragon of the virtues," since this fosters the illusion of the virtuous agent as "self-sufficiently superior," and makes Aristotle "unable to give due recognition to affliction and dependence" in his analysis of virtue (DRA 5–7). By contrast, MacIntyre notes Aquinas's rejection of "the attitudes of Aristotle's *megalopsychos*," and now emphasizes the "resources that [Aquinas] provides for an account of the virtues that reckoned not only with our animal condition, but also with the need to acknowledge our consequent vulnerability and dependence" (DRA xi). Although he still conceives dependence in broadly naturalistic terms, and does not include the final sort of existential dependence on God which Kierkegaard emphasizes, Kierkegaardians will regard MacIntyre's new dialectic of independence and dependence as a move in the right direction, since it gives greater centrality to such qualities as humility, gracious acceptance of help and being in others' debt, patience with others and with oneself, and purity of heart—the noble qualities that Kierkegaard believed are united in neighbor-love.

IV. Kierkegaard and MacIntyre: Complementary Existential Philosophies

In *After Virtue*, Alasdair MacIntyre portrayed Kierkegaard's notion of authentic self-choice as an attempt to find within the fragments of the failed Enlightenment tradition some residual basis for ethical norms. In "The Meaning of Kierkegaard's Choice" (reprinted in this volume) I argued that this was not Kierkegaard's intention in the discussion of 'self-choice' in *Either/Or* II: rather than trying to *ground* duties in a choice to acknowledge moral norms, his aim was to decipher how moral norms and ideals whose authority is already cognitively apprehended by the agent (at least in a partial and abstract way) can gain 'live' motivational significance for that agent, or concrete relevance in her life.[74]

Given that *Either/Or* is not about trying to give ethics the kind of Sartrean basis that MacIntyre (rightly) rejects, what *can* it (and the other pseudonymous works) tell us about the authority of ethics? The answer depends on understanding Kierkegaard's relation to the history of ethics in a different way than MacIntyre construed it in *After Virtue*. Rather than trying to rescue the failing Enlightenment project (or Encyclopedia

tradition), as I have suggested, Kierkegaard is really picking up the frag-
ments of the *Eudaimonist* tradition in the wake of the Reformation. The
goal of his new synthesis is to reconstruct on a new basis what was valuable
in eudaimonism, while recognizing that any acceptable understanding of
free will must render untenable a fundamental claim of the primary
Aristotelian version of that tradition. Thus, Kierkegaard's aim is to show
how the *fact of freedom* can be reconciled with some crucial elements of the
older teleological approach(es) to ethics, leading to what I have called an
'existential virtue ethics.' Ultimately, for Kierkegaard this ethics can be
completed only within a religious context of faith, but (just as for the
eudaimonists) the articulation of the "ethical sphere" in personal existence
does not *start* from a basis in revealed religion or personal commitment to
God.

If this hypothesis is right, then Kierkegaard's and MacIntyre's ethics
should stand in a partially complementary rather than wholly hostile rela-
tionship. This is what we have already found, and further working out this
complementary relationship will help clarify how Kierkegaard's reforma-
tion of eudaimonism works, and why it is motivated by problems internal
to eudaimonism itself.

I will argue that MacIntyre's positive proposals for a virtue ethics in
After Virtue work only if supplemented with something like Kierkegaard's
conception of authenticity in *Either/Or*. While authenticity in this sense is
not itself a formula for a virtuous life, but rather only a precondition of
both genuine virtue and vice, Kierkegaard believes that it necessarily
involves full recognition of the objective authority of ethical standards.
On this view, an authentic agent who fails to live up to the relevant ethi-
cal norms cannot (without willing self-deception) avoid interpreting him-
self *as* morally blameworthy or as having negative moral worth. But this
view faces the serious objection that it might be possible to live an authen-
tic life guided and evaluated by standards or ideals that have no resem-
blance to traditional virtue-concepts, requirements of impartiality, or
beneficence. Here I think MacIntyre can help Kierkegaard. Specifically,
MacIntyre's argument concerning practices and the art of living a unified
life as the final or embracing human practice provide the right model for
developing Kierkegaard's own answer to the problem of 'authentic aes-
theticism.' In developing this answer along MacIntyrian lines, we'll see
that Kierkegaard's departures from the eudaimonist tradition(s) are mod-
ifications made from *within* that general approach. The modifications are
required by problems with the classical formulation of eudaimonia as the
chief good—problems structurally related to the inadequate role of free-
dom in these formulations. The resulting 'existential virtue ethics'
involves a teleology which is sufficient to show that a nonemotivist ethics
is an unavoidable part of a life with *human meaning*, even though this

imperative is more minimal and true to experience than that supplied by a fixed and ultimate desire for fulfillment or happiness in Aristotle's holistic sense.

Why MacIntyre needs Kierkegaard:
The Existential Significance of Practices

In *After Virtue*, MacIntyre hoped primarily to show that "the Aristotelian tradition can be restated in a way that restores intelligibility and rationality to our moral and social attitudes and commitments" (AV 259). Building on Aristotle's functionalist approach to the human good, he argues (compellingly) that we can recognize a range of complex human activities or "practices" in which participants pursue various "goods internal to the practice" for their own sake (AV 187–88).[75] To count as a participant in a given practice *is* to value intrinsically the goods that can only be achieved through this kind of practice, whose pursuit requires following objective criteria of excellence developed in the history of the practice—and therefore "[t]o enter into a practice is to enter into a relationship not only with its contemporary practitioners, but also with those who have preceded us in the practice, particularly those whose achievements extended the reach of the practice to its present point" (AV 194). In other words, practices, even when apparently pursued in solitary devotion, are essentially *cooperative* activities as opposed to strategic games aimed at acquiring various "external goods" whose sum total is limited. On this basis, MacIntyre can argue that various *virtues*—such as courage, honesty, and personal justice—can be provisionally defined as qualities of character that are necessary preconditions for sustaining the kind of human relationships essential to genuine participation in practices of all sorts (AV 191–93). MacIntyre completes this analysis in the next chapter by connecting it with a "narrative concept of selfhood" according to which "I am the *subject* of a history that is my own and no one else's, that has its own peculiar meaning" (AV 217). On this account, it becomes clear that "[t]he unity of a human life is the unity of a narrative quest." The virtues are necessary to sustain a life with a point, a life felt to be moving towards some worthwhile end—even if part of this goal is precisely better to articulate what goals we seek, and what ends are worth pursuing. Virtues are those qualities which every life-quest requires to excel as a life-quest: thus they define "*the* good for man," or the supreme good that every human life requires in pursuing and defining its own more peculiar goods, ends or goals (AV 219).

This argument is appealing in many ways, but suffers from two related and fundamental weaknesses. First, what can be said about someone who

wishes to avoid the commitments implicit in engaging in practices or intimate human relationships (whose cultivation, as MacIntyre urges, is also a type of practice)? They are not pragmatically committed to the authority of the virtues as preconditions for such practices, since they do not belong to any.[76] MacIntyre has not provided an argument that a life lived virtually without any prolonged engagement in practices would not be worth living. This might almost seem self-evident, since such a life would be one in which every paid job is merely a means to external goods and every unpaid activity is simply for "leisure" (amusement, entertainment, or distraction); yet many people surely do lead lives at least approximating to this description. But unless we can say why human persons as such need to engage in practices and commit themselves to developing the noninstrumental goods of human relationships, the pragmatic necessity of virtues will lack universal force for all human persons.

Second, likewise, what are we to say about someone who does not *want* to see her life in terms of a unified quest for some good, perhaps precisely because pursuit of any demanding or challenging goals of the kind that could give unity to a whole life requires virtues that enable one "to overcome the harms, dangers, temptations, and distractions" which beings like us inevitably encounter as obstacles to staying on course, maintaining our priorities, or keeping loyal to our commitments? (AV 219). These problems are made more acute by the fact that there is likely to be an overlap between those who avoid practicing any demanding art, pursuing any challenging ends whose attainment requires excellence, or cultivating any complex interpersonal relationship for the sake of its internal goods, and those who don't care about living a unified life (either in terms of its narrative intelligibility to themselves and others,[77] or in terms of formulating a more explicitly rational "life-plan" in Rawls's sense[78]). As I have previously argued, this is precisely the initial and most common form of aestheticism, according to Kierkegaard's analysis.[79] So the possibility of aestheticism is a problem for MacIntyre's account. He can argue that such a person could not understand herself in terms of an intelligible life-narrative; but if the aesthete's existing short-term preferences and desires happen largely to be satisfied, perhaps she can be quite happy (though in a sense of happiness different from that achieved by Aristotle's virtuous man). So why are the virtues binding on her as moral ideals for human life?

It is important to see that this is not primarily a question about moral education, for MacIntyre was careful *not* to claim that his analysis should convince anyone (including aesthetes) to recognize that they should engage in practices, or try to live a volitionally unified life, and thus cultivate the social virtues as part and parcel of these general aims.[80] And the virtue-existentialist can agree that analytic philosophical argument is often unsuited to changing people's motivational and cognitive dispositions in

the ways needed to move them towards such a fully engaged life.[81] The problem is instead a *theoretical* one about the adequacy of the concepts deployed in *After Virtue* to explain the authority of the virtues. MacIntyre is committed to the claim that the role virtues play in making possible cooperation in the practices and pursuit of subjective life-unity explain a major part of the authority of virtue-ideals. But this argument has a gap: it does not explain why aesthetes should be obligated to exhibit the social virtues.

In *Dependent Rational Animals,* MacIntyre may be trying to close this gap by focusing on the conditions of human interdependency, which provide further grounds for the social virtues. But our need for care, as dependent animals, does not by itself seem enough to explain why participation in practices and an effort to organize one's life as a coherent whole are both feasible for and required of persons. It seems that persons can alternate between being care-receivers and care-providers at different times of life without ever engaging in practices aimed at providing care, and without grasping this basic alteration or rhythm of human life as part of the unified narrative of their individual story. Of course they should, but we need to know more to see why this is so.

Kierkegaard's account of authenticity in *Either/Or*, and subsequent development of its themes in the other pseudonymous works, seems to address exactly these problems that prevent MacIntyre's analysis from reaching its goal. For the Judge argues in *Either/Or* II that "Every human being . . . has a natural need to formulate a life-view, a conception of the meaning of life and of its purpose" (EO II 179),[82] and that we cannot have a meaningful and fulfilling life without authentically engaging ourselves in practices, or becoming authentically devoted to something worth caring about. Without involving our entire self in this way, we suffer from a dispersion of identity that leads not only to self-defeating incoherence but also to despair. Kierkegaard's aim is to show that the natural tendency or "teleology" of human selfhood (or maturation of the "spirit") *is* towards choices that involve commitments to substantive social roles (with functional definitions), engagement in practices (or vocations and callings), and the cultivation of human relationships. It is only in terms of such commitments, in the Judge's view, that the chooser can establish an intelligible self with a meaning that endures over time and thereby fulfills the existential *telos* of personal narrative unity. This 'minimal teleology' is towards a meaningful exercise of the human capacity to define oneself in terms of what Harry Frankfurt has called *cares*,[83] or what Bernard Williams has called *ground projects*.[84] We become authentic selves in Kierkegaard's sense only when we define ourselves in terms of such cares or projects.[85]

Such self-definition, however, does not itself proceed from nothing, or from choices unguided by any prior criteria and constraints: it grows from a combination of particular experiences in time and an initial orientation

towards a meaningful life that is built into and already observable in the aesthetic initial position of human nature.[86] Authenticity is the 'proto-virtue' the attainment of which means moving in the right way from the aesthetic initial position towards a life of devotion to specific cares and ground projects, a life we can recognize as standing for something (in Cheshire Calhoun's phrase).[87] Thus, authenticity in this sense is the pre-requisite for what MacIntyre calls "the place of integrity and constancy in life."[88] Ironically, then, Kierkegaard's *Either/Or* provides what is missing in MacIntyre's analysis: namely, an argument that grounds the necessity of engaging in practices and a committing oneself to the unification of life-goals in an account of the human *telos*. Kierkegaard shows the existential indispensability of precisely the sort of personal commitments that MacIntyre succeeds in linking to the virtues. However, in the process, the conception of our *telos* has changed in a subtle yet crucial way: what is basic is no longer eudaimonia or happiness in the holistic sense, but rather the existential meaningfulness of her life to the agent. Meaningfulness in this sense is a more minimal *telos* than eudaimonia, since eudaimonia entails meaningfulness but not the reverse.

But I have not yet shown that Aristotelian moral psychologists should accept this existential revision. To show that, I need to show not only that Kierkegaard's account has the resources to close the gap we found in MacIntyre's *After Virtue* account, but also to explain why the Aristotelian tradition lacks the resources to solve this problem. Aristotle's belief that *eudaimonia* defines a single ultimate *telos* for human life depends on the thesis that there is some way of unifying or harmoniously ordering all the intrinsically valuable ends we can pursue, or (equivalently) that there is a well-defined highest good that is not itself just one more item in the list of intrinsically valuable activities or products, but is rather what *embraces them all*. As Terence Irwin writes, "The most complete end is the one that includes the other ends; we are not to pursue an unordered collection of ends, but the complete single end that is the whole formed by them."[89] Jonathan Lear suggests that this inclusive ideal expresses Aristotle's hope "that it is at least possible for a man's motivational structure to form a har-monious whole."[90] This inclusive concept of the chief good also depends on the notion that desire for the one embracing good *underlies* desire for all other intrinsic goods—not that other intrinsic goods are a *means* to this embracing good, but because it is constituted by their right relation, the desire for the highest good flows through and is present in (ordinate and inordinate) desires for all the particular intrinsic goods. This transcendent desire is then the well-spring of the more particular desires not in the instrumental sense, but rather in the constitutive sense that we desire hap-piness itself *only by desiring* all these particular things in the right way. In Heideggerian terms, the desire for eudaimonia is the "jointure" of all

desires. On this view, the particular desires are expressions of the general underlying desire, radiating from it. Depending on the form they take, they will be more or less perverted or perfected expressions of the one true implicit desire.[91]

This idea of the chief good is certainly beautiful, but it was never plausible. Bernard Williams has challenged this notion of desire for an all-embracing good, arguing that the goods of practical reason and theoretical reason (which include creative genius) need not go together, and may even be incompatible in some cases.[92] In particular, the virtues that contribute to the flourishing of social cooperation and family life may conflict with "the unimpeded development of human creative and intellectual aspirations."[93] This and similar tensions render it unclear why we should believe that there is any single embracing good such as eudaimonia that can play the role of Aristotle's inclusive 'chief good.' Happiness may instead be achieved in different ways of living, each of which aims at some set of goods that is internally consistent, but which conflicts with (some) other such sets of goods and their associated ways of living. Then although there may be various coherent ways to find fulfillment, since some of these are mutually unharmonizable, none of them will separately constitute happiness in the holistic sense of an all-embracing or chief good of all human desire. Neither can all these goods and all these ways of living be combined to form such a chief good.

Now the eudaimonist might respond that, if there is any way to compare the goods central to these conflicting ways of life, there must be some *maximally good* possible combination of them, although we cannot have them all. But aside from problems of comparison among incommensurable goods, the idea of a complete good was *not* the idea of a maximal good or best possible combination of the most weighty or important intrinsic goods; rather, it was the idea of a good that leaves out no desirable proportion of any intrinsic good that is valuable for human life. In other words, it was a threshold concept, not a maximizing concept. The thesis that there is a chief good is not merely formal, but involves a substantive claim about the sort of goods that make human life fulfilling and their practical relationship to one another. As Williams has argued, this substantive claim is simply false: no possible combination of human goods reaches this threshold.

But although Williams does not notice this, his objection need not imply that a unification of our ends and ways of living for them is impossible. Paramount among a person's ground projects can be precisely a practical unification of her (other) ground projects. Frankfurt has argued that all persons automatically have this as their deepest ground project: since no one can be satisfied with volitional ambivalence and conflict in their cares, "It is a necessary truth about us, then, that we wholeheartedly desire to be wholehearted."[94] I think Frankfurt is on the right track here,

but his thesis as formulated is too strong: as Kierkegaard held, people sometimes work to remain ambivalent, although they never wholeheartedly will to reject the ideal of wholeheartedness.[95] But a weaker claim is true: for those of us who do unequivocally pursue wholeheartedness, this typically involves some readjustment of our different priorities, and sometimes the rejection of projects and ends incompatible with other commitments we find more important, until we have reinterpreted or refashioned our ground projects so that they are mutually reinforcing in spirit (rather than pulling in opposite directions), and so that they can all be pursued together (each in its proper respect) in one harmonious life. Let us call this the goal of *existential coherence*. All mature human agents wholeheartedly will this sort of practical coherence in their life.

What Williams's objection to Aristotle really shows, then, is *not* that such a practical or existential coherence is impossible, nor that pursuing it is unimportant, but rather that it cannot be all-embracing, and so its function and motive cannot be holistic eudaimonia as the chief good. For the conflict-between-intrinsic-goods objection shows that no good functions as Aristotle thought the chief good would function (there is no such complete good, at least in the span of mortal life). The goal of existential coherence or the practical unity of a life-narrative must therefore have some other basis than an ultimate desire for Aristotle's chief good: for the idea of such a chief good, which is supposed to consist in the natural harmony and embracing unity of all significant human goods, cannot be the motive for an effort of self-integration that aims at *bringing about* a unity that does not integrate all human goods, but only some set that can coherently fit together.[96]

Kierkegaard's account remedies this error by reinterpreting the human *telos* as *authenticity* rather than holistic eudaimonia.[97] The realization of this *telos* requires the sort of self-integration and existential unity of life-narrative which in turn (as MacIntyre has argued) explains part of the practical necessity of the social virtues. Against this model of authenticity as the will to existential coherence, Williams's objection has no force: the fact that the different worthwhile ends we can find fulfillment in pursuing through the use of different natural capacities may sometimes conflict shows that they cannot all together constitute a unitary good called eudaimonia, but it does *not* show that the true human *telos* can be attained without an effort to identify and integrate some reconcilable subset of worthwhile ends to pursue in harmonious fashion.[98] To accept this alternative existential model is, however, to accept that the human *telos* (as authenticity) is not a chief good in Aristotle's sense. It is not the underlying object of all desires, but rather the end at which the will must aim if it is to aim at anything else in earnestness.

Since "earnestness" in Kierkegaard is the form of all the virtues (as I argued in section III), it operates in his thought much as the virtue of con-

stancy operates for Jane Austen, according to MacIntyre: "without constancy all the other virtues to some degree lose their point" (AV 242). Moreover, the same connection MacIntyre sees between the virtues of constancy, patience, and courage in Austen are apparent in Kierkegaard, since (as we have seen) he links courage and patience to earnestness. And MacIntyre sees the connection here: for Kierkegaard,

> in the ethical life the commitments and responsibilities to the future springing from past episodes in which obligations were conceived and debts assumed unite the present to the past and to the future in such a way as to make of a human life a unity. The unity to which Kierkegaard refers is that narrative unity whose central place in the life of the virtues I identified in the preceding chapter. (AV 242)

This description of the continuity provided in Kierkegaard's view by an eternal ethical basis for the commitments and cares that give narrative unity to one's life may not do full justice to the notion of higher-order will it implicitly involves, as I have argued, but this passage is a clear enough recognition that Kierkegaard's existential proto-virtues (as I've called the dispositions of freedom involved in authenticity),[99] are indeed preconditions for all the other substantive virtues. As MacIntyre says earlier, "In some ways constancy plays a role in Jane Austen analogous to that of *phronesis* in Aristotle: it is a virtue the possession of which is a prerequisite for the possession of other virtues" (AV 183). The only difference is that MacIntyre (in line with his quasi-Marxist historical hermeneutics of values and institutions) suggests that the need for constancy or earnestness as a precondition of virtue is a peculiarly modern problem, one created only by the anonymity of industrial society and mass culture. Kierkegaard agrees that the circumstances of "the present age" have made the quasi-virtues of mature ethical agency more difficult to attain and maintain, but he nevertheless sees that the indispensable teleological role of these proto-virtues has a *ontological* basis in the initial default form of human selfhood. This default of 'chrysalis' stage is naive aestheticism, a virtually non-'spiritual' form of life without recognition of freedom and responsibility for one's character. The aesthetic individualism of modern life is thus only a symptom, not the whole cause, of the problem for Kierkegaard.

Why Kierkegaard Needs MacIntyre: The Challenge of 'Authentic Aestheticism'

If this argument is right, then an account of virtues grounded in the necessary conditions of participation in practices and the unity of a life will be

complemented by Kierkegaard's account of the need to become a chooser in the ethical sense, or to become an agent whose choices find continuity in earnest commitments. But at this point, Williams could raise another sort of objection, one analogous to his well-known objection that our ground projects may conflict with the norms of both utilitarianism and Kantian morality: "somewhere . . . one reaches the necessity that such things as deep attachments to other persons will express themselves in the world in ways which cannot at the same time embody an impartial view."[100] The analogous objection to Kierkegaard is that we need not even *see* our ground projects in the light of thicker ethical distinctions (such as vices and virtues), or be disposed to evaluate them in these terms, because we may not care about being moral. Frankfurt apparently agrees with this view: he has argued not only (a) that our cares may not involve peculiarly moral concerns,[101] and (b) that the "volitional necessity" of certain cares may conflict with ethical requirements for us,[102] but also (c) that there is nothing about the nature of caring *per se* which suggests that it should be important to us to care about ethical distinctions.[103] For Frankfurt, then, it seems possible to build a unified life that is integrated solely around *aesthetic* projects in Kierkegaard's sense (perhaps Gauguin would be an example), without this requiring any special interest in or sensitivity to ethical distinctions. MacIntyre makes a similar point in his initial critique of Kierkegaard: the Judge in *Either/Or* incautiously assumes that "the energy, the passion, of serious choice will, so to speak, carry the person who chooses into the ethical;" but on the contrary, "the aesthetic *can* be chosen seriously" (AV 41).

There is a real problem for Kierkegaard here. The problem is easier to explain if we distinguish between two aspects of "aestheticism." On the one hand, Kierkegaard portrays the "aesthete" as one without authentic commitments, or as a "wanton" without higher-order volitions in Frankfurt's sense. Let us call this aestheticism$_1$. On the other hand, he thinks of aestheticism as the phase of life before the objective authority of ethical requirements and ideals has taken on any 'live' practical significance for the individual, beyond mere speculative contemplation. Let us call this 'innocence' of ethics aestheticism$_2$. In parallel, we will have two senses of authenticity that are the opposites of aestheticism$_1$ and aestheticism$_2$. We can now phrase the problem as follows: Williams and Frankfurt think it is possible to be authentic$_1$ (or nonaesthetic$_1$) in the first sense, while remaining aesthetic$_2$ (or inauthentic$_2$) in the second sense. In other words, they think it is possible to form a unified or integrated volitional character around a set of projects and earnestly to cultivate constancy in one's devotion to these aims, without taking much account of moral distinctions, or at least without giving them central or overriding significance relative to other persisting devotions, interests, or concerns. This frequent thesis in

late twentieth-century critiques of Kantian ethics in particular can thus be cast in Kierkegaardian terms as the problem of 'authentic$_1$ aestheticism$_2$.'

Note that this is not the other familiar problem of the 'authentic terrorist' or the 'authentic Nazi.' This objection has no force against Kierkegaard's account, since (unlike at least some of Heidegger's and Sartre's formulations) he is especially careful *not* to argue that all the substantive conditions of a good will are implicit in the requirements for authenticity.[104] This is part of the point of distinguishing the move from aesthetic indifference to ethical willing from the formation of a *good* will. Thus, in Kierkegaard's sense of authenticity, it is possible in principle to be an authentic torturer, as long as one is attuned to and can take seriously the wrongness of one's action. This sounds difficult, but there are examples of it (in fiction, perhaps Chillingworth in *The Scarlet Letter*, or Saliari in *Mozart*). For the proto-virtues of authenticity and earnestness—including courage, patience, and purity or constancy—are not by themselves *moral* virtue in the full sense.[105] In this sense it is possible to pursue evil ground projects authentically, in the full recognition of their evil. MacIntyre had to make a similar concession regarding the social virtues necessary to sustain practices: even evil practices may require and be sustained by these virtues (and thus virtues defined at *this* level do not supply the criteria for distinguishing good and evil practices) (AV 200).

According to Kierkegaard's moral psychology, it is also possible to pursue challenging and worthwhile but nonmoral goals seriously for the sake of the internal goods realized in their pursuit, and to cultivate various excellences in the process, while remaining *aesthetic* in one's deep character. But he always suggests that such a pursuit, however passionate it may seem, remains in some sense on the surface of personality. The serious aesthetic agent's entire attention is directed outward, and he lacks reflexive earnest concern about maintaining and ordering his commitments to form a stable identity over time. Such an agent therefore remains in "immediacy," and the conditions for his interests, concerns, and commitments remain outside himself, not under his control. In that sense, these ends cannot really constitute cares or commitments of the higher-order will if they are aesthetically pursued.

But Kierkegaard also held the stronger thesis that 'authentic$_1$ aestheticism$_2$' is not a mode of life we can maintain, because he thought that aestheticism$_2$ implies aestheticism$_1$ (or inauthenticity$_1$). Why should he have thought this? Why should he have believed that we cannot live a life united by ground projects with which we identify, or that we are deliberatively engaged in forming and maintaining, *without* at least taking seriously the content of ethics (including norms of action and virtues as ideals of character), even if we violate them?[106] In other words, why think (as Judge William implies) that the conscious formation of ground projects, the

investment of oneself in meaningful relationships and social roles, and engagement in practices *also necessarily involves* personally appropriating the binding force of moral norms, or becoming 'in earnest' about morality—even to the extent of recognizing that moral ideals should have overriding force for us (whether we actually follow their guidance or not)? As Peter Mehl puts it, "Judge William's conviction seems to be . . . that if an individual strives for autonomy he or she will come to appreciate the importance and role of social virtues;" but why think this involves any commitment to morality as opposed to mere convention?[107]

Here MacIntyre's analysis helps us see precisely how this challenge is to be answered. His account of virtues internal to practices seems to provide most of what Judge William needs. For if MacIntyre is right, then when we move to an understanding of ourselves in terms of the commitments involved in caring about goods internal to practices and relationships in which we engage, then the objective authority of certain virtues, such as honesty, courage, justice, and integrity, must become important to us (even when we violate them). These moral ideals and the norms and precepts related to them must become, in Bernard Williams's terms, part of our subjective "motivational set" (our *S*). If we do not at this point take such norms seriously, or give them the status of reasons internal to our *S*, we will be guilty of a kind of pragmatic contradiction. This is the upshot of MacIntyre's analysis.

This argument complements and helps fill out Kierkegaard's own answer to the 'authentic aestheticism' objection. The Judge writes, "There comes a moment in a person's life when immediacy [or aesthetic sensitivity] is ripe, so to speak, and when the spirit requires a higher form, when it wants to lay hold of itself as spirit. As immediate spirit, a person is bound up with all earthly life, and now spirit wants to gather itself together out of this dispersion, so to speak, and to transfigure itself in itself; the personality wants to become conscious in its eternal validity" (EO II 188–89). But the human spirit can fully gather together its inclinations and desires for various earthly ends, its various worldly interests and pursuits, only by evaluating and ordering its motives themselves according to ethical criteria. No self-integration can be complete unless it is ultimately guided by values that have the distinctive universality and necessity of moral norms. Thus, as Alastair Hannay argues (in a Hegelian analysis of the implicit commitments of an agent seeking authenticity$_1$), "a will bent even single-mindedly upon worldly achievement lacks unity, [and . . .] it is an illusion to suppose that it does not."[108] For the eternality/universality of ethical norms and ideals provides the necessary *Anstoß* (in Fichte's sense[109]) for authentic$_1$ self-integration. To call it an *Anstoß* is to say that in ethical necessity we find something radically *alterior*, something exterior to subjective perspectives of the mind, something that acts as a barrier to the dreaming conscious-

ness of aestheticism, something that is an unmistakable "reality-check."[110] The eternal and universal significance of ethical necessity provides the only secure foothold upon which spirit can raise itself up in the ascent towards full selfhood. The ethical provides the stable basis on which the spirit can recognize itself as more than a mereological sum of different psychic states, as something that *endures* through time and can reidentify itself later in terms of the same eternal framework of interpretive significance.[111] Only in such a narrative framework of strong contrasts between good and evil, virtue and vice, do we find something in-itself immutable and firm (even if our consciousness of it is not) against which the value of different traits and tendencies of the character we are becoming stands out in clear relief. Against the background of this *final or widest evaluative horizon* of meaning, which transcends all the more conventional evaluative schemes we find nested within it, we can make strong evaluations not only of our outward options for actions, but of the different psychic tendencies latent, potentially present, or already active within us (e.g., various patterns of desire, emotion, interest, and concern). Only in this light can selfhood, in the form of an intrapersonal effort to organize these elements of our motivational character, really begin in earnest. For without such an objective basis, we lack a stable ground for this 'work upon ourselves;' our efforts to guide and shape these raw ingredients into some greater whole will itself be guided by considerations too dependent on the shifting contingencies of time. Without ethics, we would have no absolutely firm point outside the stream of our own immediate first-order psychic states through which we could reflect back practically on them and thus arouse the higher-order volitional capacity to control these states that is characteristic of selfhood and determines all fully human virtue and vice. As Peter Mehl puts it, in the ethical I find "the point from which I can transcend the vicissitudes of time and context, and that is myself as a responsible agent, as spirit. Without this absolute foothold, the individual, the Judge suggests, would lack the philosophical basis from which to legitimately take up one posture rather than another."[112]

Pace Williams, then, Kierkegaard insists that personal commitments which entirely lack any basis in sensitivity to ethical contrasts (i.e., commitments that are "aesthetic" in Kierkegaard's wide sense of the term, which includes but goes beyond "aesthetic" projects in the narrower artistic sense), must therefore lack the kind of rationality needed if putative commitments are to have the sort of enduring stability in turn required for them to attain the resilience of wholehearted commitments, through which full narrative unity is attained in human life. The aesthete's goals, as Hannay says, by themselves lack the kind of significance needed to give meaning to a human life *as a whole*, and thus "the aesthetic life is in a crucial sense an empty one."[113]

This may initially appear to be a counterintuitive thesis, but it contains a deep insight. Kierkegaard allows that aesthetic life-views can sometimes have "a certain unity, a certain coherence" (EO 183); we can also have "infinite passions" for nonethical goals (or ends not pursued by the agent for the sake of their perceived ethical value). But he holds that such passions cannot *by themselves* constitute wholehearted cares and commitments.[114] To attain that status, they must function as parts of larger projects that do have a moral basis for the agent. Thus the whole range of aesthetic significance is open to the ethical agent, but for her, aesthetic values are finally nested in the absolute narrative of moral values. However strongly an aesthetic passion is felt, its immediacy renders it too changeable for it to be the sole basis of a life in which the agent can find lasting and secure meaning. The well-known fickleness even of 'infinite' aesthetic passions is a symptom of this deep problem: when in their grip, we think they are real commitments, but they are instead like fevers, bound to break after they have carried us to their culminating point, beyond which they inevitably lose their meaning for us. This fickleness does not mean that aesthetic motives cannot be genuine passions *while they last*, involving loyalty to corresponding aesthetic principles and even a form of purity that ignores other side-effects or consequences unrelated to the goal. It only means that this loyalty and purity cannot but be temporary, and must eventually fail the challenge of time. Like Ovid's demons, they are ultimately compelled to a sudden change of form, across which there can be no narrative continuity of volition. This point is developed in Kierkegaard's forceful critique of "will[ing] the great, no matter whether it is good or evil" (PH 30).

The reason for this inherent vulnerability of aesthetic passions is not only, as Judge William argued, that aesthetic ground projects or life-goals lead to despair when the external conditions of their success disappear, showing the aesthetic agents "that they had built their lives on something that was transient" (EO II 192). It is also that this liability to frustration leads too easily to the abandonment of the passion itself, because this passion is only an immediate desire for some goal external to the self. There is no basis here for a higher-order passion to preserve the passionate pursuit of this goal, whether or not its goal appears attainable. But ethical evaluation always forces us to this higher level: if it is right to pursue a given end in a particular way, then it is usually noble to preserve the passion itself, without discounting for the probabilities of success.

As the Judge argues, the final and most subtle aesthetic life-view (the one exemplified by his interlocutor A, the young man of *Either/Or* I) is the one that accepts this inevitable transience of passion, and even cultivates it. This "final esthetic life-view" recognizes the "vanity" of any more particular aesthetic passion as a basis for life, "for up to a point it has absorbed the nothingness of such a life-view" (EO II 194). Thus A avoids devotion to

any activity whose meaning would require continuity; he acts "with as little teleology as possible" (EO II 195). This negative pursuit of diachronic volitional disunity becomes for A the only commitment continuing through lived time. But this *maximally thin* form of volitional unity is the analogue in the volitional realm of absolute skepticism in the epistemological realm. It is a kind of suicide in which the will tries to destroy the very power that defines it: the power to form substantive commitments that can bind together personal agency across time. Far from attaining authenticity$_1$, it actively avoids it. Thus, again it appears that refusing ethical authenticity$_2$ entails a failure to attain narrative authenticity$_1$. The two sides of authenticity go together: this is why earnestness is the form of virtues, and why "the sin of not willing deeply and inwardly . . . is the mother of all sins" (EO II 189).

Precisely because no commitment can ultimately be maintained without foundation in a wholehearted will for the good, trying to maintain aesthetic commitments can be instructional: "an honest erotic love is also an upbringing to the good" (PH 35). Even though the relevant commitment here is not to the good, the agent will find that she can maintain it only by nesting it within ethical commitment (or by performing what the Judge calls the ethical transformation of aesthetic values). Thus the Judge's view that earnest willing leads human agents towards the good is reaffirmed in Kierkegaard's discourse on "Purity of Heart:" "all roads lead to the good if the person in truth wills only one thing; and if there is indeed any truth in his willing one thing, this also assists him to the good" (PH 35). The formation of commitments functions in effect as practicing for the ethical (which is why A studiously avoids it): it leads us naturally towards the only adequate basis for such commitments, as long as we don't "swing off to the great instead of being led to the good" (Ibid.).

A full defense of the thesis that aesthetic passions lack existential resilience without an ethical foundation would require a rich enough phenomenology of caring to show that apparent counterexamples—lives apparently united around enduring aesthetic passions—were not really unified as they seemed, or were not united only or primarily by the relevant aesthetic concerns. Since third-party interpretation of lives is always a risky business fraught with uncertainties, such an argument for Kierkegaard's position could never be more than a plausibility-defense. But it is vital to realize that the same goes for the interpretation of lives Williams needs to support his counter-position. Any adequate existentialist answer to Williams's challenge must involve these difficulties, and cannot be decisive. But Williams can do no better: he cannot prove with demonstrative certainty that authentic aestheticism is possible. In response, the task of existential virtue ethics includes the development of a moral phenomenology that will make ever more plausible the Kierkegaardian thesis that narrative authenticity$_1$ without ethical authen-

ticity$_2$ is impossible. As I've suggested, MacIntyre has already contributed much of what this phenomenology will require.

V. Existential Teleology and Existential *Phronesis*

Minimal Teleology

Robert C. Roberts says, "An Aristotelian assumption operates throughout Kierkegaard's authorship, to the effect that human nature has fixed parameters that can be developmentally violated, all right, but to do so means, to one degree or another, failure as a person, and more or less obvious dysfunction."[115] This is right in my view, except that this idea need not be specifically *Aristotelian*. The kind of teleology Kierkegaard finds in the normal course of development from latent "spirit" to full selfhood[116] is not an Aristotelian teleology, because the true nature we must realize on pain of dysfunction is first specified only in terms of the selfhood of authentic commitments that may be either good *or* evil, and then at the next stage further specified in terms of the selfhood of recognized moral inadequacy and infinite resignation that can proceed either to faith or to demonic despair. This is what we might call a branching teleology:

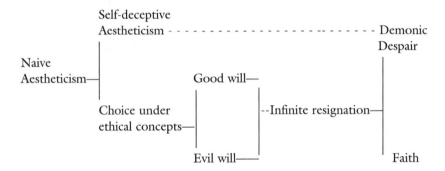

The tendency latent in the nature of human spirit is to realize our freedom by moving from left to right through these stages. So the impetus to such movement is teleological: it is a movement towards the full expression of the personal form of being. The development of the human self thus has a definite direction from immature to mature. But the teleological distinction between regression and progression in spirit underdetermines our basic choice at each stage: the teleological requirements of fulfilling our potential for authenticity do not determine us to good will, and likewise, the requirements of fulfilling our highest potential for infinite resignation (the most we can achieve on our own) do not by themselves determine us

to faith as opposed to despair over the good and rebellion against creation. On the other hand, as we've seen, their underdetermination does not make the movement one way or another at these 'branches' simply arbitrary either.

Thus MacIntyre was partly right and partly wrong in claiming that Kierkegaard, like Diderot and Smith, rejects "*any* teleological view of human nature, any view of man as having an essence that defines his true end" (AV 54). He is right that Kierkegaard rejects *Aristotelian* teleology, but wrong to infer that he is therefore opposed to any account of human nature that counts as teleological. The rival existential version of human teleology is more minimal than the Aristotelian, since it conceives personhood as a process of freedom including certain forced choices, rather than as a substantial form involving a single encompassing definition of flourishing for beings with that natural kind. And thus on the existential version, the true teleology does only *half* the work of grounding the ethics of virtue that is proper for human life. Our existential teleology grounds the existential proto-virtues, and in addition shows why a meaningful life necessarily involves the sort of participation in practices and narrative unity of self that in turn requires other substantive social virtues. But this teleology does not ground the whole of morality: in particular, it does not explain the necessity of all natural duties, or of agape as the ultimate determinant of the good will. And what it does ground, it justifies by reference to the requirements of a meaningful life, rather than a life of eudaimonia as the chief good. Thus the human *telos* provides only a partial basis for ethics.

Hence my analysis in section IV remains compatible with the "autonomy" of the ethical discussed in the end of section II. The maturing self finds itself under moral obligation to form and pursue good rather than evil projects, and finally under religious obligation to choose faith over despair, but the *sui generis* status of natural duties and of agape as the highest virtue shows that the requirements ethics makes on our freedom are at least *partially* independent of the teleological requirements of becoming a self. In other words, Kierkegaard is committed to a kind of realism about ethical values, but without their full reduction to teleological facts.

Evil as a Positive Alternative

This deep difference results in part from Kierkegaard's absolute rejection of Plato's doctrine of motivation by the apparent good. This doctrine had at least two essential aspects:

(1) If I desire or am moved to attain some end E, then I regard E as good or as contributing to well-being in some relevant sense (some

sense that could be referenced in an intelligible explanation of an
action directed at E).
(2) If I regard some possible end of action E as good or as contribut-
ing to well-being in some sense, then I will have some desire for E
or be moved in some way (however limited it may be) to attain E.

Aristotle, notably, rejected the further Platonic claim that
(3) that if I act to attain some end E, this can only be because my rea-
son recognized the value of E as the best I can achieve in the
circumstances.

Aristotle allowed for the possibility that we could act against the judgment
of practical reason out of anger or other strong appetites. It is more ques-
tionable whether his account of *akrasia* rejects (2) and allows for the pos-
sibility of recognizing the value of some possible object of action without
any commensurate motivation towards this object at all. But he does not
reject (1), since he holds with Plato that we always act for the sake of *some*
apparent good, even if not the best we know. Aquinas follows him in this.

By contrast, Kierkegaard denies not only (3) and (2) but even (1). Just
as in the *Fragments* he rejects the Socratic doctrine that all knowledge
depends on immanent sources universally latent in human nature, in the
Sickness Unto Death he rejects the Socratic doctrine that evil derives from
ignorance, that the wrongdoer must not have "understood what is right"
(SUD 94). He says: "This means the Greek mind does not have the
courage to declare that a person knowingly does what is wrong." But the
capacity for wrongdoing Kierkegaard has in mind here is not simply *akra-
sia* in Aristotle's sense, which gives us only one way in which people may
do what they know is worse. Rather, Kierkegaard has in mind a more rad-
ical capacity for rebellion, which is clarified only in the revealed doctrine of
sin: "sin is not a matter of a person's not having understood what is right
but of his being unwilling to understand it, of his not willing what is right"
(SUD 95). There is an apparent paradox here: Kierkegaard seems to con-
nect passionate pursuit of what we clearly recognize that morality forbids
and an effort *not* to clearly recognize the content of morality. Unlike
Socrates, who does not distinguish inability and unwillingness to see the
good, when someone does not act in accordance with the moral under-
standing we may expect of them,

> Christianity goes a little further back and says that it is because he is unwilling
> to understand it, and this again because he does not will what is right. And in
> the next place it teaches that a person does what is wrong (essentially defiance)
> even though he understands what is right, or he refrains from doing what is
> right even though he understands it. . . .

Therefore, interpreted Christianly, sin has its roots in willing, not in knowing, and this corruption of willing affects the individual's consciousness. (SUD 95)

The Reciprocal Relation between Choice and Moral Sensitivity

To make sense of this, we have to understand it in terms of a complex reciprocal linkage between two analytically distinguishable psychological processes. Think of our present cognitive grasp of shared ethical values and norms as forming a *background* against which we make particular decisions in the course of ordinary life. Behind this background, and thus often invisible to the consciousness in which we consider our options, is an acquired volitional character—including commitments formed by past choices—that conditions both how we understand our various options and to what extent they are volitionally possible for us, though it does not *determine* our present decision. Different parts of the background are brighter or dimmer, according to what we might call (in Kierkegaard's terms) their *subjective relevance* to our lives as lived so far, or in what ways we have appropriated them into our character. The brightness of some parts of the background thus indicates both the motivational hold of these values on our character, *and* how circumspect and clear our understanding of these values is. In this model, then, there is an intimate connection between the volitional significance that ethical values have for us and the phronetic depth of our awareness of them. Against this background of ethical understanding, it is difficult, but not impossible, to choose commitments and particular actions we know with great clarity and force to be despicable, dishonorable, dishonest or deceitful, cruel, callous, uncaring, and so on. Yet if we do will against our conscience or present sense of how to apply such evaluations (either through some great crime or, more likely, via the accretion of many smaller 'venial sins') then the entire background of moral understanding—or at least relevant parts of it—shifts away from us, dimming both in conceptual clarity and gerundive force or hold on our will. In short, the reciprocal relation between moral cognition and moral motivation in the temporal flow of human existence means that conscience fades with persistence in evil. In particular, the distinctness and motivational force of moral knowledge can fade by attrition, not only by more dramatic movements of radical evil:

In the life of spirit there is no standing still (really no state either; everything is actuation); therefore, if a person does not do what is right at the very second he knows it—then, first of all, knowing simmers down. Next comes the question of how willing appraises what is known. Willing is dialectical and has under

it the entire lower nature of man. If willing does not agree with what is known, then it does not necessarily follow that willing goes ahead and does the opposite of what knowing understood (presumably, such strong opposites are rare); rather, willing allows some time to elapse, an interim called "We shall look at it tomorrow." During all this, knowing becomes more and more obscure, and the lower nature gains the upper hand more and more . . . (SUD 94)

This danger of losing one's conscience by sheer attrition and irresolution is the reason why courage becomes a key existential virtue for Kierkegaard, since it forces us to face and care about aretaic demands, even if we cannot immediately (or ever fully) live up to them. On the other side, consonant with the tradition, Kierkegaard's model implies that as long as we are still living selves, we never completely lose our volitional/cognitive connection to moral norms and ideals:

the good, the truly great and noble, has the quality of not allowing the observer to be indifferent. It elicits a pledge, as it were, from the person who has once caught a vision of it. However deep that person sinks, he never actually forgets it completely; even in his reprobate state, this recollection is certainly a torment to him, but also at times a deliverance. But just as it lifts a person up, so also it humbles him, because it requires of him all his power, yet retains the authority to call him an unworthy servant even when he has done his utmost. (EUD 359)

This is why cowardice and pride do not simply encourage our violation of recognized ethical demands, but also to numb us to such demands, suppressing our awareness of and sensitivity to ethical considerations understood as such.

Kierkegaard's sharp rejection of the Socratic/Platonic model of moral motivation and knowledge thus implies that we have many ways of knowingly feeling, willing, and doing wrong. This means that we have to reject any teleological account of human nature built on the notion that human motivation strictly follows the mind's judgment of the apparent good. We cannot expect to realize our *telos*, or fulfill the human destiny that it will be the function of human virtues to help us attain, simply by enlightenment of the mind, as Plato hoped. But nor can we acquire the qualities needed to realize our nature or fulfill our essence simply by being lucky enough to get the right kinds of training and habituation in our youth. Only through earnest willing in the face of alternative possibilities, which involves a process of cultivating our own entrenched dispositions of freedom, can we become thoroughly devoted to the goods we are meant and required by moral ideals to pursue. This is the position of *existential* virtue ethics. But it does not mean that we become full selves devoted to the good purely by

our own bootstraps: the development of an earnest will may have a myriad of social conditions that are necessary though not sufficient for it.

I have argued that the elements of such a position can be found in Kierkegaard's *Sickness Unto Death, Concept of Anxiety,* and the *Works of Love* in particular. But despite the distinctiveness of his overall position, the phenomenology of moral values Kierkegaard gives us in his analysis of the relation between will and knowledge is in other ways in deep accord with virtue ethicists such as Aristotle, Aquinas, McDowell, and MacIntyre. In his phenomenology, ethical values have a dual status in our consciousness: they are never simply believed or judged to be true, nor simply followed by the will as pure imperatives. Rather, as intentional objects, ethical values always appear to us in some superposition of both these intentional dimensions. As their motive force fades towards nothing, they tend to become mere speculative beliefs in which we are largely uninterested, but for this reason the beliefs themselves also tend to become more schematic and abstract, rather than finely articulated with a view towards a horizon of live potential applications in our future. Oppositely, the more we tend to feel ethical values as imperatives with personal relevance for our practical questions, the more likely our interested attention is to discriminate nuances in their content that become clearer in the process of trying to live according to such values.

Thus, if the virtuous person is, as Aristotle thought, the one who is *sensitive* to the right considerations in judging how to act in a variety of concrete circumstances calling for the exhibition of different virtues, then the required "sensitivity" will involve precisely the combination of subjective appropriation of—and phronetic aptness with—moral values that we find in Kierkegaard's psychology of the ethical and religious stages. His contribution to this central theme in the tradition(s) of virtue ethics is to emphasize how vital the development of authentic will is to the attainment of such sensitivity and responsiveness to moral concerns. The intrapersonal attitude of concern about the desires on which one acts and concern for one's individual character, which is the beginning of authenticity, does not by itself constitute the moral sensitivity of virtuous agency; but it is nevertheless essential for forging the key bond of relevance between our initially vague and abstract understanding of ethical norms or ideals and the task of evaluating our own actions, character, and life-narrative as lived so far, with a view towards continuing or changing features of this narrative in the future. Only when this vital connection is made can both the cognitive and motivational sides of moral sensitivity grow together in the process of living lives centered around particular cares and projects under the increasingly firm guidance of moral precepts and paradigms.

But, coming back finally to *Either/Or* II, although this vital connection originates in what Judge William calls the decisive step from the aesthetic

to the ethical mode of existence, we should not be deceived by his emphasis on the instant of transition. For at the level of our deep self or core narrative, this instant can only be an imaginary abstraction. If the "choice" of ethical over merely[117] aesthetic existence *is* the forging of the bond between the cognitive and motivational sides of moral sensitivity, then this "choice" is not a sudden leap between life-spheres but rather a continual process in which these two aspects of moral sensitivity—which are at the start only weakly linked by a thin strand of volition (or latent "spirit")—grow steadily stronger together, and become ever more fully interwoven in their symbiotic relationship.

Properly understood, then, the "choice" of whether to deepen one's commitment to ethical mode(s) over aesthetic mode(s) of life, which is initially made ever so tentatively (or almost unconsciously), lies *virtually* behind every more particular choice between good and evil, or virtue and vice, since these particular choices determine whether the cognitive and motivational significance of these very distinctions weaken or strengthen for us. The increasing salience of this moral background—this practical horizon for our action in the external world and our work on ourselves as individuals—is the development away from the aesthetic towards the ethical and religious modes of life. To differentiate between this vertical dimension of cognitive/motivational development and the horizontal oppositions in the ethical value of the options between which we choose in any present circumstance, Kierkegaard distinguished the aesthetic/ethical contrast in life-stages from the good/evil contrast of moral evaluation. But he never meant to say that these two pairs of phenomena are dynamically unrelated in human life, or that their existential relation is simply that second pair (moral vs immoral) is just *posited* in consciousness by electing the ethical over the aesthetic in the first pair. On the contrary, these two poles of opposition are organically related dimensions of one single developmental complex (the human spirit or free will). The more we choose good over evil, or the more firmly we commit ourselves to virtuous motives and dispositions (which are united in agape) in forming our projects, the keener our moral sensitivity grows, and the stronger becomes the bond between our cognitive receptivity to moral considerations and our volitional disposition to be guided by such moral understanding. And the strengthening of this bond, as both sides of moral sensitivity develop together, *is* perseverance in the "choice" of ethical over merely aesthetic sensibility.

Hence, the choice between the aesthetic and the ethical is not what it first seems. It has its start in moments of existential courage, when we open ourselves in some way to a maturing of spirit, and some new increment of initiation into moral sensitivity. The possibility of such an opening is built into the human spirit: we have an innate capacity to discover the limitations

of aesthetic sensibility, and to feel the absence of higher kinds of sensitivity as voids of meaning in our lives. This is ultimately what explains how our movement from the aesthetic to the ethical frame of reference can be rational, as Marilyn Piety has argued. I have altered her explanation only by emphasizing that our teleological orientation is towards the maximally meaningful frame of reference (rather than simply to infinite happiness or beatitude, which is a goal that becomes intelligible only within that frame of reference). In these terms, we can within our initial frame of reference discover or become sensitive to the possibility of richer and higher frames of reference into which we could enter.[118] But this latent capacity within us does not begin to unfold without something akin to willing participation on our behalf. It must be carefully nurtured and cultivated, first by significant others in our milieu, but then also by we ourselves, on the basis of whatever limited resources in moral understanding we have so far been able to acquire. Yet once it has started to have a significant role in our lives, moral sensitivity grows as we attend to it, or atrophies as we suppress or ignore it when convenient. The courage to let such sensitivity develop and gain a hold on us itself grows in a self-reinforcing circle the longer and more profoundly we continue to follow it, especially if we hold to it through dark periods in life. This is difficult for more than one reason. For the outcome of this process is a moral sensitivity articulate enough to make our imperfections stand out in stark relief, and powerful enough to move us in the end to a kind of ethical despair about the world, and over ourselves.[119]

Then finally we have reached the threshold of that type of consciousness which includes not only aesthetic and ethical sensitivity but also a sensitivity to the divine which (paradoxically) unites them through hope and faith in eschatological possibilities—the consciousness which Kierkegaard calls religious. That is a further story, which we would have to trace to get Kierkegaard's complete conception of existential virtue fully in view. But since that story of the religious cannot be understood without first having an adequate interpretation of the ethical stage, I have concentrated in this paper on outlining the more general form of existential virtue ethics that need not involve faith.

Conclusion

As I have described it, the project of existential virtue ethics is to reinterpret the social virtues and their teleological basis in a manner consistent with the freedom that defines personhood. Given this constitutive freedom, personhood is not a kind-essence, and so the specifically Aristotelian ambition to provide a complete rational foundation for virtue ethics solely on the basis of a teleological analysis of human nature *alone* is manifestly

unrealistic: if it avoids fatal non-sequiturs, this project will either yield an insufficiently substantial set of moral demands on character, or it will distort our understanding of human personhood in ways that deny or understate the essential place of libertarian freedom in order to generate the result that evil commitments are less "natural" for us than good commitments. It is because the eudaimonistic project is bound to fail in this way that Kierkegaard revises it, developing a new philosophical anthropology in which the essential place libertarian freedom can at last be fully recognized *without* giving up the notion that the self has an inherent teleology that is organically linked to the role of ethical norms and virtue-ideals in human life—a teleology that still provides *part* of the basis or the authority of those norms and ideals. This project of existential virtue ethics is more honest about the nature of personhood and about the ways in which virtue-ideals can be grounded on it, but without simply disconnecting the virtues from their basis in human moral psychology and the factical conditions of temporal, finite, mortal existence. And unlike both the enlightenment and eudaimonist projects, we have not found any reason to think this project has to fail on its own terms.

NOTES

1. See MacIntyre, *After Virtue*, 2nd ed. (University of Notre Dame Press, 1984), ch. 3. All further references to this text are given parenthetically with the abbreviation AV.

2. For example, Ronald de Sousa, *The Rationality of Emotion* (MIT Press, 1987), takes over this conception of existentialism from Solomon. After arguing for his neo-Freudian view that "the canons of normality according to which we must assess the rationality of emotions are ultimately *individual*," he adds: "This doctrine must not be interpreted in the existentialist manner, as placing the origins of value wholly in authentic individual choice" (p. 303).

3. Compare this sketch to Michael Walzer's brilliant summary of a typical communitarian caricature of modern western liberalism (written largely in response to MacIntyre) in "The Communitarian Critique of Liberalism," *Political Theory* 18, no. 1 (February 1990): 6–23, pp. 7–8.

4. On the liberating value of this theme, and its difference from autonomy conceived as "self-determining freedom," see Charles Taylor, *The Ethics of Authenticity* (Harvard University Press, 1991), pp. 28–29. Compare Kierkegaard's view that each individual has a unique mission or calling: "Every man is endowed by guidance with distinctiveness. The meaning of life, then, should be to carry through this distinctiveness. . . . Every distinctive character (as indeed everyone originally is) successfully prosecuted is a real enrichment, a plus which enters the world . . ." (JP 51 XI A177). See *Søren Kierkegaard's Papers and Journals: A Selection* (Penguin Books, 1996), p. 630.

5. Via the notion that it is the most extensive set of property rights that creates the most unregulated market economy in which unchecked market forces create the greatest GNP, and hence the highest average utility. This is the myth of "the old rights-utility synthesis via the market," as my teacher Ian Shapiro used to say.

6. Thus it is no accident that from the beginning of the twentieth century, neo-Thomist and existentialist themes were frequently combined, especially in theological works. We can see this especially clearly in the genre of *personalism*, represented by such authors as Emmanuel Mounier, Jacques Maritain, John MacMurray, and the early Paul Ricoeur. The contemporary assumption that there is a diametrical opposition between existentialism and virtue ethics would have been unthinkable to these authors (and indeed Ricoeur has resisted this assumption even in recent works like *Oneself as Another*).

7. See MacIntyre, *After Virtue* (p. 67 and pp. 248–50). MacIntyre's phrasing is more radical here, since he rejected the notion of "human right" *tout court* (although his view may have changed since *After Virtue*). But this seems to be precisely because he insisted that rights can only be political norms, while he took all talk of human rights to be about prepolitical abstractions. Since Gewirth and Nozick, however, Jürgen Habermas has given us a new non-libertarian account of how political rights derive from moral norms and these in turn from the implicit commitments of language-using human agents who seek cooperatively to validate practical claims. MacIntyre's critique of Gewirth and Nozick thus does not hold against this new and much more sophisticated account, which seems to demonstrate that a system of social organization based on the rule of law must recognize certain basic human rights or fall into pragmatic contradiction. This is an argument that in my view both existentialists and virtue ethicists can and should now accept without abandoning the rest of their projects.

8. Of course, this point of contact coexists with other profound differences: Kierkegaard is *a kind of poet* (in Louis Mackie's phrase), and also a devotional writer, neither of which apply to MacIntyre; on the other hand, MacIntyre is *a kind of historian*, and also a kind of radical critic of contemporary politics, neither of which were Kierkegaard's particular strengths. Although their conceptions of authorship itself are quite different, MacIntyre and Kierkegaard are nevertheless closer to each other than they are to most other twentieth-century philosophers in aspiring to have an unsettling impact on the self-satisfied presumptions of their society.

9. At one point, MacIntyre implies that Kierkegaard's conception of the ethical is entirely Kantian: "Promise keeping, truth-telling and benevolence embodied in universalizable moral principles are understood in a very simple way" (AV 43). But despite his enormous debts to Kant, Kierkegaard clearly did not think that rational autonomy alone sufficed for moral virtue. Although Judge William in *Either/Or* says that he will not treat the content of the choice between good and evil ("the choice posited in and with the first choice"), he says bluntly, "I am no ethical rigorist, enthusiastic about formal, abstract freedom" (EO II 178). Instead, throughout *Either/Or* II, the transformation of erotic into conjugal love provides the basic paradigm for ethical maturity. The unification of personality is the prerequisite to ethical life because without it, authentic love is impossible: "the person who cannot open himself cannot love, and the person who cannot love is the

unhappiest of all" (EO II 160). Many other connections to the tradition of Christian virtue ethics are apparent in the text. For example, in criticizing A (the aesthetic hero of *Either/Or* I) for sharing fundamentally the same "life-view" as the lowest egoistic pleasure-seekers, the Judge argues that all aesthetes base their happiness entirely upon things that depend on externally given conditions, which are not within their control in the same way as virtues of character: e.g., physical health, beauty, wealth, honor, romance, the development of some talent, or (worst of all) the pursuit of whatever multiplicity of desires we find in our psyche (EO II 180–85). This is simply one more version of the most time-honored argument in the eudaimonist tradition, as found in Socrates's *Apology*, Plato's *Republic*, the *Nicomachean Ethics*, and Aquinas's *Summas*, and many lesser works: secure happiness cannot be based on things as insecure as power, fortune, fame, honor, or even mortal life itself.

10. Kierkegaard, "Against Cowardliness," in *Eighteen Upbuilding Discourses*, tr. Howard V. Hong and Edna H. Hong (Princeton University Press, 1990): 347–76, p. 357. Further references to discourses in this book are given parenthetically with the abbreviation EUD.

11. In light of Kierkegaard's interpretation of courage as an existential virtue in this crucial edifying discourse, we can now see that he understands the transition from the aesthetic to the ethical as a movement guided by the felt need for courage, or as *the* courageous choice that makes possible all more specific forms of courage in loyalty to particular persons or causes, or in heroic allegiance specific role-responsibilities in spite of difficulties encountered in doing 'what nobility requires.'

12. See Charles Taylor, "What is Human Agency?," in *Human Agency and Language: Philosophical Papers* I (Cambridge University Press, 1985): 15–44. Taylor notes that the richer language of essential contrasts involved in "strong evaluation" is necessary for the articulation of virtues such as courage, which require an agent to be moved by a desire or disposition seen as *qualitatively higher* than "mere impulse" (p. 25, note 8).

13. This is the sort of language Elizabeth (G.E.M) Anscombe asks for in her famous essay, "Modern Moral Philosophy," *Philosophy* 33 (1958). Obviously we could add other virtue terms to the list.

14. See Charles Taylor, "Self-Interpreting Animals," *Human Agency and Language: Philosophical Papers I*: 45–76, p. 67.

15. James Collins, *The Mind of Kierkegaard* (Princeton University Press, 1983 paperback reprint), p. 43.

16. For an exploration of this concept, see Samuel Scheffler, *The Rejection of Consequentialism*, Rev. ed. (Oxford University Press, 1994). Also see my discussion in "The Ethical and Religious Significance of Taciturnus's Letter in Kierkegaard's *Stages on Life's Way*," in the *International Kierkegaard Commentary: Stages on Life's Way*, ed. Robert Perkins (Macon, GA: Mercer University Press, 2000).

17. See my paper, "The Ethical and Religious Significance of Taciturnus's Letter in Kierkegaard's *Stages on Life's Way*."

18. See J.L.A. Garcia, "Lies and the Vices of Deception," *Faith and Philosophy* 15, no. 4 (October 1998): 514–537, p. 523. In this passage, he means to define what he calls a "categorical imperative," as opposed to a "patient-focused" ethics that determines the virtue or vice of the agent's "personal attitudes (and,

derivatively, the actions to which they give rise)" according to how these help, benefit, or respond appropriately to the patients on whom the agent is acting in various role-relationships. But Garcia here falls into the Williams-fallacy of conflating the universally required with the impersonal. For Kierkegaard, the duty of agape is both categorical in the (true) Kantian sense of being universally necessary for all responsible agents, and incidentally impartial in the sense of being a duty *to* all persons as such, *and* "patient-focused" in Garcia's sense.

19. Although this is clear enough from various passages scattered throughout his works, such as the one quoted above on cowardice, in attributing a broadly aretaic conception of the ethical to Kierkegaard, I do not mean to imply that he attempts anywhere in the pseudonymous works which focus on the existential stages to give us very much of the content of such a normative ethics. Instead, in these works we get only fragments or isolated parts of a moral catalogue of virtues, such as the virtue of the father in loving his children (in *Fear and Trembling*). There are more hints and suggestions about the content of ethics in some of Kierkegaard's various "edifying" or "upbuilding" discourses, but these works are not parts of a systematic normative ethics: rather their normative themes are usually introduced in the course of developing other psychological and religious themes. *Works of Love* is Kierkegaard's only book specifically on normative ethics, but I think we can understand how the ideals of this work fit with and develop ethical themes earlier in his authorship by reconstructing the implications of the fragmentary clues gives in the pseudonymous works and edifying discourses.

20. Elizabeth (G.E.M) Anscombe, "Modern Moral Philosophy," *Philosophy* Vol.33 (1958).

21. Roger Crisp and Michael Slote, eds., *Virtue Ethics* (Oxford University Press, 1997): Introduction, p. 4.

22. Garcia, "Lies and the Vices of Deception," p. 522.

23. See the discussion of "the Christian imperative" in Kierkegaard's *Works of Love,* section II.A, p. 40. Note that for Kierkegaard what love requires cannot be captured in terms of moral laws, or codified in a finite list of precepts: see the discussion of love as the fulfillment of the law in *Works of Love*, section III.A, p. 110.

24. Likewise, I think both Kierkegaard and MacIntyre favor what Michael Slote calls an "agent-focused" rather than an "agent-based" version of virtue ethics: see Slote, "Agent-Based Virtue Ethics," in *Virtue Ethics*, ed. Crisp and Slote: 239–62. For agent-based views "treat the moral or ethical status of actions as *entirely* derivative from *independent* and fundamental ethical/aretaic facts (or claims) about the motives, dispositions, or inner life of the individuals who perform them" (p. 240, my emphases). But while St. Thomas and Kierkegaard may conceive the rightness or wrongness of an act as dependent in various ways on the motive behind it, they both seem clear that the ethical value of one's character is also partially a function of the ethical value of its fruits, i.e., the actions it actually prompts and guides.

25. Ibid. p. xii.

26. Robert C. Roberts, "Kierkegaard, Wittgenstein, and a Method of 'Virtue Ethics'," pp. 150–51. Roberts cites the older edition of this work, which was titled *On Authority and Revelation*, tr. Walter Lowrie (Princeton University Press, 1955).

27. In his article on "Virtue Ethics" in the *Encyclopedia of Ethics,* MacIntyre emphasizes that "Aristotelian and Thomistic theses about the virtues are integral parts of complex, unified bodies of political, psychological and metaphysical theory" (p. 1281, col. 2). Although Kierkegaard rejects the notion of a philosophical "system" in Hegel's sense as a theory that claims complete gnostic comprehension of the 'laws' governing changing and particular forms of inward consciousness and outward life in temporal existence, he does clearly base his notion of ethical personality on a complex moral psychology and closely connected metaphysical distinctions between the particular and universal, the temporal and eternal, lived experience and speculative concept or essence, actuality and possibility, and so on.

28. Alastair Hannay, *Kierkegaard* (Routledge, 1982), p. 210. He goes on to emphasize Kierkegaard's agreement with Kant that this religious conception of the highest good "cannot provide an incentive to moral practice," but must rather be the upshot of moral practice followed for its own sake (pp. 212–13). MacIntyre says the same of Aquinas: virtues are a means to our supernatural end only in the "internal" sense (AV 184). It would be clearer, I think, to say that this is not a means-end relationship at all.

29. They are not empirical naturalistic facts in the sense of Humean realisms, but neither are they abstract facts, universals, or conceptual truths of reason. They seem rather to form a distinct subclass of the synthetic/*a priori.*

30. In this usage "*telos*" does not mean all that it did in the classical usage. In particular, it does not mean the good (or embracing set of first-order goods) that gives life meaning. In my present, more minimal sense, it denotes an end that it is built into our nature to seek, or the terminus of *a process* that it is built into our nature to go through in the normal development distinctive of or essential to our kind of being. I think this shows that Quinn and MacIntyre's dissatisfaction with my description of authenticity as a kind of *telos* turns mainly on a verbal or terminological point. For I do not mean to claim that authenticity as the formal condition for narrative meaningfulness of human lives is our *telos* in the full classical sense, i.e., that it is the worthwhile end the seeking of which makes life truly fulfilling. MacIntyre is quite right that authenticity or narrative meaning itself cannot be the first-order goal the seeking of which makes life *meaningful*, let alone happy. Authenticity is instead the formal second-order condition on the volitional pursuit of first-order goals and projects, the commitment to which can satisfy our need for meaning. The process of becoming authentic is therefore our *telos* in my weaker sense of that concept. (I apologize here for any confusion my somewhat novel usage has caused, and I would be willing to use another word for "*telos*" in my more minimal sense if I could think of an appropriate one).

31. Hannay, *Kierkegaard,* p. 64. Although (like me, and unlike Philip Quinn), Hannay does not read *Fear and Trembling* or the *Works of Love* as endorsing divine command ethics—at least in the Ockhamist or voluntarist sense)—he adds that for Kierkegaard the absoluteness of ethics "involves the idea, totally alien to [Judge] William's standpoint, of the individual's inability merely as a human being to satisfy the requirements of human fulfillment" (p. 64). I agree that Judge William is intentionally portrayed as lacking the category of sin introduced in the *Fragments, Stages,* and the *Postscript.* But although in this respect the Judge's conception of life in the ethical stage is humanistic and incomplete in Kierkegaard's view, I

disagree with Bruce Kirmmse's suggestion (in the present volume) that Judge William's portrayal of ethical requirements and ideals itself is erroneous in Kierkegaard's view and represents for him merely a transitional illusion prior the religious understanding of ethics. On the contrary, it seems to me that *most* of what Judge William says about the universality and eternality of ethical ideals and about love as a primary form of expressing ethical universality in concrete relations actually anticipates and is further developed in the *Works of Love*. But I think I'm in the minority in this view.

32. Ibid., pp. 158–59.

33. Levinas takes this idea mainly from Buber's notion that the I-Thou relation does not supervene on I-It relations. For Buber this theme comes both from Franz Rosensweig (himself influenced by Kierkegaard) and from a radical reading of Kant's notion of the priority of practical reason. Kierkegaard may also have been inspired in this respect by Kant's notion of moral necessity as an irreducible 'fact' transcending the grasp of theoretical reason.

34. Hannay, *Kierkegaard*, p. 159.

35. See Merold Westphal's discussion of the "adverbial formalism" of Kierkegaard's "originary ethics" of authenticity in his paper, "Climacus: A Kind of Postmodernist," *International Kierkegaard Commentary: Concluding Unscientific Postscript to the "Philosophical Fragments,"* ed. Robert L. Perkins (Macon, GA: Mercer University Press, 1997): 53–71, esp. 61–63.

36. I will touch on some of these contributions in the last section of the essay as well.

37. Aristotle, *Nicomachean Ethics* 1107a. I am using the translation by W. D. Ross in *The Complete Works of Aristotle: The Revised Oxford Translation*, vol. I, Bollingen Series LXXI no. 2, ed. Jonathan Barnes (Princeton University Press/Bollingen Foundation, 1984), p. 1748.

38. See Daniel Dennett, "Mechanism and Responsibility," in *Free Will*, ed. Gary Watson (Oxford University Press, 1982): 150–73, pp. 162–63.

39. See Jonathan Lear, *Aristotle: The Desire to Understand* (Cambridge University Press, 1988), p. 165.

40. Ibid. p. 171.

41. See Robert C. Roberts, "Character Ethics and Moral Wisdom," *Faith and Philosophy* 15, no. 4 (October 1998): 478–99.

42. This type of virtue ethics thus has its beginning and medieval precedents in the tradition beginning with Duns Scotus. See Bonnie Kent, *Virtues of the Will* (Catholic University of America Press, 1995). MacIntyre says little about Scotus in *After Virtue*, but in chapter VII of *Three Rival Versions of Moral Enquiry* (University of Notre Dame Press, 1990), he does criticize Scotus on a number of points, even making him the beginning of the new "distinctive 'ought' of moral obligation" (p. 155). But though he raises some good questions about Scotus's epistemology, I think MacIntyre goes fundamentally wrong in his assessment of Scotus. As I understand him, in assigning "primacy" to the will, Scotus is neither implying that intellect is "inert" in relation to will nor that the will can be good only by obedience to revealed divine command, as MacIntyre claims (pp. 154–55). He is rather opening up the possibility that a virtuous will may not be best construed as a will towards the agent's *eudaimonia*—as seems particularly evident in

the virtue of agape. With this goes the notion that what makes a will vicious is not simply its misapprehension of or deviation from its own true good. We cannot assume that if *eudaimonia* as a natural *telos* is not the sole criterion, then only revealed divine command can take its place. There are alternatives, and for Scotus the *natural* duty of love for others illustrates this.

43. Compare this to Bernard Williams's famous "one thought too many" objection in "Persons, character, and morality," *Moral Luck*, p. 18.

44. See Harry Frankfurt, "Identification and Wholeheartedness," in *Responsibility, Character, and the Emotions: New Essays in Moral Psychology*, ed. Ferdinand David Schoeman (New York: Cambridge University Press, 1987); reprinted in Frankfurt, *The importance of what we care about* (Cambridge University Press, 1988): 159–76, p. 174.

45. See Frankfurt, "The importance of what we care about," *Synthese* 53, no. 2 (1982); reprinted in *The importance of what we care about*: 80–94, p. 83.

46. See the discussion of a narrative whole of intelligible actions in *After Virtue*, ch.15, pp. 204–17.

47. Despite the vagueness of the phrase "an acquired human quality" in MacIntyre's first provisional formulation of a definition of virtues in relation to practices at *After Virtue*, p. 191.

48. In the account presented in Frankfurt's paper, "Freedom of the Will and the Concept of a Person," *Journal of Philosophy* 68, no. 1 (January, 1971); reprinted in *The importance of what we care about*: 11–25.

49. See Alastair Hannay, "Kierkegaard and the Variety of Despair," *Cambridge Companion to Kierkegaard*: 329–348, p. 336.

50. This is an interpretation in my own words of what Frankfurt says about caring in "The importance of what we care about," reprinted in *The importance of what we care about*, pp. 83–85.

51. Ibid. pp. 82–83.

52. Ibid. p. 84.

53. Compare this to Robert Nozick's notion (only vaguely described) of "reflexive self-subsuming acts" in *Philosophical Explanations* (Harvard University Press, 1981): pp. 299–307.

54. See Mooney, *Selves in Discord and Resolve: Kierkegaard's Moral-Religious Psychology from Either/Or to Sickness Unto Death* (Routledge, 1996), pp. 16–22.

55. See Mooney's description of our self as a reflexive narrative whose meaning develops by reframing itself: *Selves in Discord*, pp. 28–30.

56. The same is even more evidently the case for Charles Taylor's notion of radical self-evaluation (see "What is Human Agency" in *Human Agency and Action*, pp. 41–43, and "Responsibility for Self" in *Free Will*, ed. Gary Watson [Oxford University Press, 1982], pp. 123–26).

57. See MacIntyre's interesting Foreword to *Wilderness and the Heart: Henry Bugbee's Philosophy of Place, Presence, and Memory*, ed. Edward F. Mooney (Georgia University Press, 1999): xiii–xx, p. xvii. MacIntyre's remarks in this piece are as overtly grounded in the hermeneutic tradition in continental philosophy as anything he has ever written.

58. Whether any existential dispositions can be ethically neutral is a difficult and important question for Kierkegaard, which I abstain from treating here.

59. I would include Husserl's conception of persons in *Ideas II*, but the argument that Scheler and Husserl are also narrative essentialists must await another forum.

60. Mooney, *Selves in Discord*, p. 19 (citing Iris Murdoch).

61. This is the main thesis in Anthony Rudd's book, *Kierkegaard and the Limits of the Ethical* (Oxford: Clarendon Press, 1993).

62. See Kierkegaard's *Works of Love*, tr. Howard and Edna Hong (Harper and Row, 1962); reprinted in revised form by Princeton University Press, 1997. Since I cite the Harper Torchbook edition, rather than the newer Princeton edition, my references to this work are given by footnote rather than standard sigla abbreviations.

63. Kierkegaard, *Works of Love*, p. 153.

64. Ibid., p. 164 (italics omitted).

65. Ibid., p. 255.

66. Ibid., p. 248.

67. Alasdair MacIntyre, *Dependent Rational Animals: Why Human Beings Need the Virtues*, 1997 Paul Carus Lectures (Open Court, 1999). All further references to this text will be given parenthetically using the abbreviation DRA.

68. MacIntyre, "Virtue Ethics," *The Encyclopedia of Ethics* (Garland Publishing, 1992), p. 1278 col.1.

69. Ibid.

70. See Kierkegaard, "To Preserve One's Soul in Patience," *Eighteen Upbuilding Discourses*: 181–203. Note here that a patient will's confidence is not human naivete but rather a belief that the cause of right is ultimately inexorable. It is this faith which enables one to be "lovingly in peace and unity with God and with human beings" in one's heart, whatever disappointments life brings (EUD 192). Kierkegaard thinks that losing patience in this sense means losing one's soul, because it leads to despair and malice.

71. On the relation of freedom and grace in Kierkegaard, see Timothy P. Jackson, "Armenian edification: Kierkegaard on grace and free will," *The Cambridge Companion to Kierkegaard*: 235–256.

72. This balanced view, which is presented in the *Concept of Anxiety*, the *Postscript,* and later works, obviously also owes much to Kant's notion (presented in *Religion within the Limits of Reason Alone*) of radical evil as a basic disposition of the will. See Philip Quinn's useful treatment of this connection between Kant and Kierkegaard in his essay, "Original Sin, Radical Evil, and Moral Identity," *Faith and Philosophy* 1, no. 2 (April 1994): 188–202.

73. Robert C. Roberts, "Kierkegaard, Wittgenstein, and a Method of 'Virtue Ethics'," in *Kierkegaard in Post/Modernity*, ed. Martin J. Matuštík and Merold Westphal (Indiana University Press, 1995): 142–66, p. 151.

74. Also see my paper "Piety, MacIntyre, and Kierkegaardian Choice: A Reply to Professor Ballard," *Faith and Philosophy* 15, no. 3 (July 1998): 487–501, in which I argue (i) that my earlier analysis agrees with Marilyn Piety's in "Kierkegaard on Rationality" (reprinted in this volume) and (ii) defend our joint approach against Bruce Ballard's criticisms, which defend MacIntyre's original critique of Kierkegaard.

75. MacIntyre first defines a practice as "any coherent and complex form of socially established cooperative human activity through which goods internal to that form of activity are realized in the course of trying to achieve those standards of excellence which are appropriate to, and partially definitive of, that form of activity, with the result that human powers to achieve excellence, and human conceptions of the ends and goods involved, are systematically extended" (AV 187). He later adds that "Practices never have a goal or goals fixed for all time—painting has no such goal, nor has physics—but the goals themselves are transmuted by the history of the practice" (AV 194).

76. At least, they do their best to avoid such 'encumberments.' Whether it is psychologically feasible to live without participating (however imperfectly) in *some* practices—even if it is only a collector's hobby, or an enthusiasm for some sport, or just a connoiseurship of some pleasure, usual or unusual—is an interesting question, but one that need not detain us here.

77. And Philip Quinn's objections to the demand for narrative unity only seem to me to make this problem more pressing. See Quinn's new essay in this volume.

78. Kierkegaard's Judge will help us see why these two failings are existentially connected. Without commitments to goals outside ourselves, we cannot see ourselves as having a unified volitional identity over time, and hence we cannot become existentially "revealed to ourselves."

79. See my argument in "The Meaning of Kierkegaard's Choice between the Aesthetic and the Ethical" (reprinted in the present volume, chapter 4) that aestheticism can be understood as a tacit highest-order commitment not to form concrete or substantive higher-volitions. This can be rephrased in Williams and MacIntyre's terms: aestheticism is an attitude that avoids the question of articulating ground projects and engaging in practices. However, note that 'A' in *Either/Or* is a special case of more advanced aestheticism: he makes an intentional studied art of avoiding commitment, practices, and the social roles these involve. But even if there were a cult of romantics perversely devoted to noninvolvement in this sense, they would hardly count as praciticioners cooperating in the same practice (as *would* an order of Zen Buddhist monks, by contrast).

80. I am indebted to MacIntyre for making this point at the Kierkegaard Society session during the American Philosophical Association conference in Boston (December 1999), where an earlier draft of section IV of this paper was discussed.

81. Yet the Judge *does* argue, in a certain sense, with A. His effort fits into the genre which Martha Nussbaum has called "therapeutic argument:" see *The Therapy of Desire* (Princeton University Press, 1994), ch. 1. So Kierkegaard is committed to the view common to the Hellenistic philosophical schools that certain kinds of argument *can* have a curative effect on ills of the soul, or that practical reason is not utterly ineffective at persuading agents to come to terms with vices and overcome them. Much of what is valuable in psychoanalysis would seem to proceed on the same premise. In this respect, the virtue-existentialist may have somewhat more faith than the neo-Aristotelian typically has in the possible efficacy of rational persuasion as a means for bringing about motivational changes in persons—or at least in competent, mature adults.

82. And Kierkegaard clearly struggled to define the meaning of his own life (or to determine the unique role God intended for him). See JP I A 75 53 (August 1, 1835), reprinted in the Supplement to *Either/Or* II (EO II 361).

83. And in his comments on Frankfurt's essay, "The importance of what we care about," MacIntyre acknowledges the fundamental importance of this volitional phenomenon.

84. See Williams, "Persons, Character, and Morality," in *Moral Luck* (Cambridge University Press, 1981): 1–19, pp. 12–13.

85. Frankfurt's work has helped to show that there are at least two substages to this process, which Kierkegaard notably tends to run together. (1) Formulating *cares*, or at least discovering what one already considers important and making it the focus of active caring, is still compatible with conflicts among cares (and the same holds for Williams's ground projects). (2) But we are capable (and Frankfurt thinks we must) of willing that our cares be "wholehearted," which requires that they be mutually consistent and reinforcing, and thus undiminished by ambiguity arising from conflicting commitments. Kierkegaardian authenticity or purity of heart involves both these achievements.

86. How this default volitional orientation differs from the classical orientation towards eudaimonia, how it provides a basis for further development of cares and commitments as experiences accrue, and in what ways these further developments involve libertarian freedom, are the most difficult questions for formulating a Kierkegaardian virtue ethics. I postpone them here, in order to return to them in the last sections of the essay.

87. This "right way" is differently explained in different accounts of authenticity. In addition to explaining the general *concept* of this proto-virtue and its role in the development of selfhood, Kierkegaard's Judge also gives pieces of a particular *conception* or interpretation of what the right way to develop cares and commitments is. This particular account reflects some of the biases of his limited perspective as a pseudonym, and is revised by the accounts in the later pseudonymous works. It is important to make this distinction, since doubts about eccentricities in the Judge's portrait of life-goal articulation need not imply doubts about the importance for virtue ethics in general of having some viable account of authenticity. The same point holds for Williams, Frankfurt, and Taylor: they too give a few hints as to how cares and ground projects should or could be developed and interpreted by human agents, but the persuasiveness of their suggestions is largely independent of the force of their more general point that meaningful human life *requires* such commitments.

88. MacIntyre, *After Virtue*, p. 219.

89. See Aristotle, *Nicomachean Ethics*, Second Ed., trans. Terence Irwin (Hackett Publishing, 1999): Notes to Book I, chapter 7, section 3 (p. 181).

90. Lear, *Aristotle: The Desire to Understand* (Cambridge University Press, 1988), p. 160.

91. It is interesting to consider whether this thesis of a unified embracing *telos* acting as the underlying motive for all action (in the constitutive sense just explained) could be maintained *without* believing that the *telos* playing this chief role is "eudaimonia." This will depend on whether we think that happiness in the relevant holistic sense is just functionally *defined as* 'whatever plays this role of

embracing or chief good,' so that to believe eudaimonia is our highest good just is to believe that there is *some* unified embracing *telos* underlying all motivation, and no more. If instead we think that eudaimonia has a more specific psychological sense, so that the thesis 'eudaimonia is the chief good' is synthetic rather than analytic, it *will* be at least logically possible for the chief good of human life not to be eudaimonia.

But however we interpret its thesis that 'the highest good embracing all human motivation is eudaimonia,' eudaimonism involves the related claim that our motivational attitude towards the highest good can properly be understood as a *desire* (i.e., as having the appetitive form of an attraction towards something that satisfies some want or lack in us), and hence that our motivation to pursue more specific ends regarded as intrinsically good must also be types of desire in this psychological sense, since they are expressions or extensions of the one ultimate desire. Calling the highest good "eudaimonia" or happiness, and thus referring us to the flourishing of individuals (and the communities of which they are members) as that which is to be desired when it is lacking, implies that all human motivation is desiderative, driven by a sense of lack or imperfection towards completeness. This is a substantive psychological claim beyond the merely formal claim that motives must by definition be aimed at (or have as their intentional objects) some content qualified as "good" or "valuable" in *some* sense or other.

This desiderative thesis has implications which can be used to challenge eudaimonism. Thus if it were found that our motivation towards some of the ends we pursue for their own sake did *not* have the psychological form of appetitive motivation, this would undermine the eudaimonist thesis that these motives must be expressions of the deepest *desire* for the underlying highest good. Such an argument is developed in chapter 2 of my Ph.D. dissertation, *Self and Will* (University of Notre Dame, 1998). And although Kierkegaard often uses the language of "desire" for infinite personal happiness, I believe that his understanding of will also rejects the eudaimonistic assumption that all human motivation has the desiderative structure of lack-seeking-equilibrium. If so, this will be another point of difference between eudaimonistic and existential virtue ethics.

92. See Bernard Williams, *Morality: An Introduction to Ethics* (Harper and Row, 1972), ch. 7: "Moral Standards and the Distinguishing Mark of Man."

93. Ibid, p. 63.

94. Frankfurt, "The Faintest Passion," Presidential Address of the Eastern Division of the APA, *Proceedings and Addresses of the APA,* vol. 66 (1992): 5–16, p. 14. This essay is reprinted in Frankfurt's new collection, *Necessity, Volition, and Love* (Cambridge University Press, 1999): 95–107.

95. I have explored this thesis at length in "Kierkegaard, Anxiety, and the Will," forthcoming in the next *Kierkegaard Studies Yearbook,* ed. Niels Jørgen Cappelørn and Hermann Deuser (Walter de Gruyter, 2001).

96. This is a difficult but crucial point. The practical coherence at which we aim in existential self-integration is analogous in *form* to the harmony of ends involved in the ideal of holistic eudaimonia, but existential coherence is at least partly a *made product* of will, unlike the coherence Aristotle thought was waiting to be *found* in (using Heidegger's term) the 'jointure' of all human goods. Existential coherence is achieved only through adjustments and changes in goals

governed by an ideal of volitional unity, sacrificing in the process Aristotle's ideal of the embracing jointure of all human goods. This sacrifice would not have to be made if different human goods were not incompatible in ways which show that there is no sort of eudaimonia that is all-embracing or stands in the jointure of human goods, as Aristotle's chief good was supposed to. Since these conflicts show that the eudaimonistic or holistic notion of a chief good is illusory, the motive for overcoming such conflict must therefore derive from some other ideal. The existentialist ideal of practical coherence as a volitional unity of meaningful projects supplies the answer here.

97. As I noted in section II, Kierkegaard does of course also emphasize (in the *Postscript* and other works) our desire for an "infinite happiness." This plays a role especially in bringing us to the religious stage, but I do not think Kierkegaard understands the infinite happiness that can be gained only through salvation as our *telos* in the way Aquinas did. He seems to think of it in a fashion analogous to Kant's notion of the Highest Good. Desire for this ultimate happiness plays a role in our dissatisfaction with ethical authenticity alone, but it can only play this role when (a) sin-consciousness brings us to recognize our ethical deficiency and (b) faith introduces the absurd possibility of a miraculous reprieve. That more is involved in this process than the unfolding of an immanent teleology is one of Kierkegaard's basic objections to Hegel's philosophy of spirit.

98. In his response (in this volume) Philip Quinn seems to be arguing that this second-order unification project is not essential to leading a life that is subjectively meaningful for the agent. I think he is right that appreciation of a diversity of values may be one significant component of the overall meaningfulness of a life (and Leonardo de Vinci certainly comes to mind as an exemplar). But given the facticity of human life, the diversity of the practices and pursuits in which we are authentically engaged is usually inversely proportional to the depth of our involvement in them. For some people, the meaningfulness of life may gain more from involvement in some committed relationship or pursuit that can engage otherwise unrelated talents and interests at once, or even come to pervade virtually every aspect of their lives. But the kind of unity that is *required* in my view (and I think MacIntyre's) for a meaningful life need not involve this singleminded devotion to one theme that structures virtually every aspect of my subjective universe of 'matterings' (or my "being-in-the-world"): it can instead be the unity of a narrative with a wide range of diverse themes and subplots involving values that are incomparable or not ranked on any single objective scale. The hard problem is to interpret correctly the difference between *right and wrong* kinds of diversity in a life of multiple devotions, vocations, or cares. In Kierkegaard's view, there can even be conflicts between the subplots of our life, due to contingencies of external circumstance. In Kierkegaard's sense, then, my life-narrative can even be *tragic* and yet exhibit existential unity (I discuss this further in "The Ethical and Religious Significance of Taciturnus's Letter in *Stages on Life's Way*" in the *IKC* volume on *Stages*). But if the cares or ground projects that delineate the subplots of my life are in *essential conflict,* in the sense that some directly embrace principles and goals that others directly exclude or remove from my entire scale of value-rankings, then my commitment to these ground projects is halfhearted or ambiguous in Frankfurt's sense, or doubleminded in Kierkegaard's sense, and hence necessarily

less meaningful to me. Such a conflict is not tragic, since I would be in the same boat if all external circumstances were as fortuitously arranged as possible. Rather it is an ambivalence of the will, a weakness of spirit, and a loss of self. I have to ask in such a circumstance which of my commitments really does matter to me, or which ought to matter. (It is not a question of which matters *more*: the question arises in that form when the problem is only that I cannot realize both due to external circumstances). Hence, while contrary to Frankfurt I think that such *akrasia* of the highest-order will is volitionally possible for human persons, I hold that such a person fails to lead a life that is fully meaningful for her. This is also Kierkegaard's view: aestheticism is a kind of *akrasia* or wantonness of the highest-order will (as I argued in "The Meaning of Kierkegaard's Choice Between the Aesthetic and the Ethical," reprinted in the present volume). The position taken in existential virtue ethics thus falls somewhere in between Quinn's and Frankfurt's.

99. To clarify my use of this term, the proto-virtues are formal virtues of character whose presence adds to the person's moral worth. They exclude certain possible forms of volitional character (namely those that manifest the vices of aesthetic inauthenticity). But they have priority in the order of virtues because attaining these qualities in their basic form is the constitutive condition for having any of the higher virtues *or vices* of volitional character. This is not to say that the proto-virtues must be developed first in the temporal sense, after which higher virtues of vices may develop 'on top of' these formative conditions. On the contrary, the proto-virtues are formal in the sense that they may never exist in a person *by themselves*, without the higher virtues or vices. This is equivalent to the claim that a person whose volitional character meets the constitutive condition for being evaluated in terms of the strong contrasts between the higher virtues and vices is never in a *neutral* position on that scale. Thus the priority of the proto-virtues consists in their being necessarily involved in any of the higher virtues *or vices* of volitional character, not in their being a separable and temporally prior state of the will.

100. Williams, "Persons, Character, and Morality," *Moral Luck*, p. 18.

101. See Frankfurt, "The importance of what we care about," in *The importance of what we care about*, pp. 81–82.

102. See Frankfurt, "Identification and wholeheartedness," in *The importance of what we care about*: 159–176.

103. See Frankfurt, "Autonomy, Necessity, and Love," in *Vernuftbegriffe in der Moderne: Stuttgarter Hegel-Kongre 1993*, ed. Hans-Friedrich Fulda and Rolf-Peter Horstmann (Klett-Cotta Sonderdruck, 1994): 433–447; reprinted in *Autonomy, Necessity, and Love* (Cambridge University Press, 1998).

104. This again is what Merold Westphal means by the "adverbial formalism" of the requirements of authenticity in his paper, "Climacus: A Kind of Postmodernist" (op. cit.). I hope to have shown, however, that this "adverbial" proto-ethics is not entirely without content, since the proto-virtues involved in authenticity are the conditions for a person's inner character having moral worth of any substantive sort.

105. Otherwise put, there is no full 'unity' of the proto-virtues and the substantive virtues: the latter require the former, but not the former the latter.

106. A problem similar to this is considered by Alastair Hannay in his discussion of *The Purity of Heart* (see *Kierkegaard*, pp. 231–33).

107. See Peter Mehl, "Moral Virtue, Mental Health, and Happiness: The Moral Psychology of Kierkegaard's Judge William," in the *International Kierkegaard Commentary: Either/Or Part II,* ed. Robert Perkins (Macon, GA: Mercer University Press, 1995): 155–82, p. 165.

108. Hannay, *Kierkegaard,* p. 235.

109. See Daniel Breazeale, "Check or Checkmate: On the Finitude of the Fichtean Self," in *The Modern Subject,* ed. Ameriks and Sturma (SUNY Press, 1995): 87–114.

110. There are numerous arguments in the German Idealist tradition that the human self must have some unmediated access to the Real in order for the self-relations that constitute its individuality (including even unitary self-awareness over time) to be possible. Kant gave such an argument in his "Refutation of Idealism," and Husserl and Heidegger followed him in arguing that our access to Being cannot only be through the mediation of appearances, images, signs, or mental representations. For these writers, there are points of direct contact with the Real without which self-consciousness itself would be impossible (e.g., perhaps in the awareness of real motion as an index of time-passage, or in internal time-consciousness). In a parallel sense, for Kierkegaard, moral imperatives provide the *Anstoß* that first makes possible the sort of reflexive volitional relation to our own first-order psychic states that constitutes *practical* selfhood. Ultimately, however, the reflexive relations of selfhood find their final basis only in a divine *Anstoß* for Kierkegaard. Thus *Sickness Unto Death* begins with the claim that full or developed selfhood is a reflexive relation resting on a divine third term.

111. Thus as Hannay says, the aesthete has a "growing sense of the inability of temporal categories to provide criteria of personal identity and humanly fulfilling achievement. This is the birth of anxiety . . ." (*Kierkegaard,* p. 164).

112. Mehl, "Moral Virtue, Mental Health, and Happiness," pp. 167–68.

113. Hannay, "Kierkegaard and the Variety of Despair," *Cambridge Companion to Kierkegaard,* p. 337.

114. I pursue this point more fully in "The Ethical and Religious Significance of Taciturnus's Letter in Kierkegaard's *Stages on Life's Way*" (op. cit.).

115 Robert C. Roberts, "Kierkegaard, Wittgenstein, and a Method of 'Virtue Ethics,'" p. 149.

116. Kierkegaard's formula for full selfhood combines the individuality achieved through an ethically qualified intrapersonal relation to oneself, or care for one's own character, and dependence on and relation to the external through recognizing one's creaturely finitude and temporal facticity. The pseudonym Anti-Climacus expresses this in quasi-Hegelian terms as a relation or synthesis of the temporal and eternal that recognizes itself as created by God and rests in faith on this divine *Anstoß:* see *Sickness Unto Death,* p. 13.

117. The "merely" is important here, because the ethical mode also includes or involves aesthetic sensitivity, but now as nested within and transformed by a deeper horizon of moral sensibility.

118. This Kierkegaardian idea that (a) the basic life-views defining the existential stages operate as frames of reference or salience, and yet (b) these frames are not incommensurable but connected (each opening at the limiting horizon of its immediate inferior) is similar in spirit and point to Hans-Georg Gadamer's

conception of the unity of horizons of intelligibility. Since MacIntyre's own notion of rationality within competing traditions owes so much to Gadamer's hermeneutics, we naturally find here another set of overlaps with Kierkegaard (as Anthony Rudd's essay in the present volume emphasizes).

119. I would cite Schindler (at least as portrayed in *Schindler's List*) as a prime example of this development. For what the hero in *Schindler's List* undergoes seems to be precisely a Kierkegaardian movement from an aesthetic to an ethical existence, culminating in a recognition of unanswerable or categorical guilt before the infinite ethical demand to save "one more" than he has. On this topic, see my paper, "*Schindler's List*: A Personal Kierkegaardian Reflection on the Nature of the Ethical," in *Religious Humanism* (forthcoming 2001). My view contrasts with Lillegard's discussion of Schindler near the end of his essay in this volume. But Lillegard is of course referring to the actual Oskar Schindler, rather than to Steven Spielberg's quasi-fictional character.

PART III

Responses

13

Unity and Disunity, Harmony and Discord: A Response to Lillegard and Davenport

PHILIP L. QUINN

In philosophy, Kierkegaardians, as I shall call them, are committed to the view that Kierkegaard's writings have something valuable to contribute to contemporary philosophical debates. They hope to show that Kierkegaard is not merely a cultural icon of Golden Age Denmark or an eccentric but witty sectarian religious apologist. The papers by Lillegard and Davenport to which I am responding are unified, in the first place, by the fact that they are the work of Kierkegaardians.[1] Second, they express the conviction that Kierkegaard has something important to say on the subject of virtue ethics, and, third, they agree that this can be brought out by creating a comparative context in which Kierkegaard and Alasdair MacIntyre intellectually engage one another across a gap of a century and a half.

I am no fan of virtue ethics. I do, however, count myself as a Kierkegaardian of sorts. For example, I greatly admire and have elsewhere tried to defend the divine command ethics in *Works of Love*.[2] But I also think Kierkegaard is an author whose seductive voice should put us on our guard. It seems to me that he has a proclivity for pushing things to extremes from which we would do well to recoil. This may have begun as a rhetorical strategy, connected with the adoption of pseudonyms, that was chiefly meant to provoke the reading public of Copenhagen. It ended, in my opinion, sadly out of control, with Kierkegaard thinking that he had a providential mission to overturn the Established Church.[3] The loss of control is not prominent in the writings on which Lillegard and Davenport focus, but the extremism is there. So my response to what they take to be Kierkegaard's enduring contributions will be, to a large extent, skeptical and critical.

I shall not enter into complicated and vexing exegetical issues. My aim is not to ask whether Lillegard and Davenport have got Kierkegaard or, for that matter, MacIntyre right. My question instead will be what we should

make of the views they attribute to Kierkegaard and MacIntyre and seem to endorse. To what extent should we endeavor to appropriate these views? I begin with reflections on Lillegard and then move on to thoughts about Davenport. In each case, I highlight and probe critically what I take to be a central concern of the paper, seeking to expose what I consider a dangerously one-sided perspective. I conclude with some brief thoughts about how to rectify this one-sidedness.

I. Lillegard on Life Views: In Praise of Disunity

Norman Lillegard's essay (chapter 10 of the present volume) addresses us from the border area between Kierkegaard's aesthetic and ethical stages or spheres of life. The question that provides the best way into his complex and subtle discussion is this: What is the difference between aesthetic and ethical virtues? Claudine, a character in Thomasine Gyllembourg's *Two Ages*, has, according to Lillegard, aesthetic virtues: they include "patience, constancy or faithfulness, even a kind of fortitude" (p. 212). She is moved by passion to a romantic attachment that gives her life a certain consistency, continuity, and unity. She makes choices that bring a kind of coherence and narrative unity to her life; some of them "are directly life-integrating choices" (p. 214). She is not sunk in sheer immediacy like a couch potato, and she does not just go with the flow like the legendary California surfer. So why are her virtues not ethical? What does she lack?

As Lillegard sees it, Claudine has not taken the material of her life, including her romantic passion, and consciously tried "to integrate it into a *rational* self concept by reference to which a more or less unified life might be achieved" (p. 214). What is involved in achieving such integration? At one point, Lillegard connects it with acquiring purity of heart, which, as Kierkegaard famously says, is to will one thing or, as Lillegard adds by way of a gloss, "is a matter of a consistent ordering of all the dimensions of life through time around a single (though highly ramified) passion" (p. 217). More often, however, he mobilizes Kierkegaard's conception of a life view (*livs anskuelse*) to forge the link with ethical virtue he wishes to emphasize. He says: "A life view which can support and be supported by ethical virtues must be one which somehow is able to articulate in a very comprehensive way the bearings of my various passions and concerns upon one another and upon the various dimensions of my life (I will call this 'dimensional wholeness'). It must also be a view which can articulate a way of ordering those passions over time (I will call this 'chronological wholeness')" (p. 217). And in a particularly lucid summary of his position, he claims that ethical virtues are "internally connected to a passion or set of passions of a kind more or less adequate for filling out a

whole life, dimensionally and chronologically" while, by contrast, mere aesthetic virtues "are not generated by or contributory to any rational self-concept or life view" (p. 225). So Claudine's virtues are not ethical because they are not generated or supported by a rational life view that furnishes her life with dimensional and chronological wholeness. A life of ethical virtue must be informed by reason in a way that provides strong synchronic psychic integration and tight diachronic narrative unity.

The specter haunting this ideal of narrative unity is, of course, the fear that the unity we attribute to our lives will turn out to be almost entirely a retrospective illusion. Perhaps the worry is unavoidable because, as Kierkegaard reminds us, though we must live life forward, we can only understand it backward, and where there is room for understanding, there is also space for self-interested misunderstanding, rationalization, and mythologization. This fear cuts deeper than the ordinary fear of Freud. After all, a Freudian hermeneutic of suspicion merely leads to the substitution of an unflattering unified narrative for one that feeds our self-esteem. Unlike Freud, we fear that our lives really lack narrative unity all the way down and are, to that extent, without meaning. How should we react to this fear of absurdity?

I am inclined to try to mitigate it with a deflationary response to the yearning for unity, integration, and wholeness in our lives. I think it is easy to overestimate the importance such values should have in our lives and to judge too harshly people whose lives fail to exemplify them in a sufficiently lofty manner. In my view, something of this sort infects Lillegard's treatment of Oskar Schindler. While acknowledging that we might admire Schindler's passion for saving Jews, Lillegard notes that he was also a philanderer, a gourmand, a trickster, and a person who seemed to enjoy risk-taking. He observes that Schindler's life before and after the war was not lived "in a way that would attract attention for its ethical qualities" (p. 226). He therefore takes Schindler to task for not choosing out of a rational motivational self-concept and urges that we might "want to deny that his life is one of *ethical* virtue" (p. 226). I want to resist the suggestion that such a denial might be an appropriate response to Schindler. I think we should celebrate Schindler for displaying the ethical virtue of courage to a heroic degree during the war. That he was then also intemperate and even incontinent seems to me only to make him a counterexample to the thesis of the unity of the ethical virtues. That his life was at other times unheroic or even mediocre seems to me only to show that life's demands on his ethical virtues were variable. Though surely not a man for all seasons, Schindler had what it took to rise to the ethical occasion when it really counted in his life. I think Lillegard's one-sided emphasis on synchronic integration and diachronic unity renders him partially blind to the way in which Schindler's life was one of real but limited ethical virtue.

What is more, I suspect that the yearning for unity and wholeness can be a danger to ethics if it is not balanced by other factors. Maybe it represents an appropriate aspiration in a limited range of social contexts; it could be that this is a lesson to be learned from the example of life in a traditional fishing village that MacIntyre is fond of citing. But suppose I have a vocation to philosophize. Must I, if I am to be ethical, imitate Kierkegaard's renunciation of Regine and forego marriage and children just because I foresee that they may well introduce disunity, conflict, or even tragic dilemmas into my life? Must I order my passions so that I make no open-ended commitments to friends or political causes about which I care deeply? I think not. I consider relinquishing a certain amount of rational control over one's life in order to allow space in it for some disunity, either psychic or narrative, to be a price worth paying to purchase opportunities to pursue plural but potentially conflicting goods if they are great enough. Of course, Lillegard does not believe that ethical life must be made invulnerable to all internal tensions. In a note, he makes it clear that his conceptions "do not necessarily involve the notion of a single moral metric, or show a failure to appreciate tragic dilemmas and other incommensurabilities" (p. 231, note 13). Ethical life, he acknowledges, does not have to be seamless in that way. However, as its relegation to a note indicates, this consideration is in the background rather than the foreground of his picture of the ethical life. As a result, he does not display a keen awareness of the pressure to simplify by exclusion that the yearning for unity and wholeness puts on ethical life. In Sophocles's play, as I read it, both Antigone and Creon are flawed because each of them unifies life around a single value, a very great religious and familial value in her case and a very great political value in his. Both of them oversimplify the value landscape to which they should be sensitive and responsive. In my opinion, Lillegaard's one-sided emphasis on unity and wholeness blocks his paper from commanding a clear view of the need to balance the risks of allowing conflict against the risks of imposing oversimplification within our ethical lives.

Perhaps an infinite good that transcends the created world could be the total and exclusive focus of our aspirations. But even to broach this possibility is, in Kierkegaard's terms, to suggest motion from the ethical sphere into the realm of religion. And in the Christian depiction of that realm, it too contains the potential for conflict. We are instructed to love both God and the neighbor, and the danger is that the pressure for unity will drive us to simplify by loving one to the exclusion of the other. Here a way must be found between total devotion to God that precludes due care for created goods and an idolatrous concern exclusively for finite goods. I think a narrow preoccupation with unity and wholeness in our religious lives will not serve us well in the quest to strike a balance that is suitably responsive to claims both finite and infinite goods make on us.

II. Davenport on Authenticity:
In Praise of Discord

John Davenport's essay (chapter 12 in the present volume) speaks to us from the boundary between territories staked out by Kierkegaard and MacIntyre. It depicts their ethical views as complementary existential philosophies, each needing to incorporate something from the other in order to achieve completion. So it proceeds in accord with a transgressive strategy that is no respecter of boundaries and borrows freely and eclectically from both Kierkegaard and MacIntyre.

From MacIntyre, Davenport takes the idea of the virtues as preconditions for genuine participation in practices and the thought that the self is unified by a narrative quest. But then he raises two important questions. First, "what can be said about someone who wishes to avoid the commitments implicit in engaging in practices or intimate human relationships (whose cultivation, as MacIntyre urges, is also a type of practice)" (pp. 288–89)? Will the virtues be merely excess baggage for such a person? Second, "what are we to say about someone who does not *want* to see her life in terms of a unified quest for some good" (p. 289)? Is such a person bound to have a pathologically fragmented life or dispersed self? Perhaps Davenport's first question should be addressed to someone like the desert hermit Simeon Stylites, whose vocation was sitting atop a pillar for forty years. Without doubt, as my remarks on Lillegard's paper indicate, his second question is appropriately directed to me. It is particularly urgent for Davenport, too, because, following Bernard Williams, he rejects the Aristotelian view that there is a single, all-embracing *telos* for human life. There is, according to Davenport, no comprehensive good such as eudaimonia at which every human life is aimed by nature or toward which every human quest should strive, and so no such *telos* can be invoked to provide narrative unity to human selves through time.

Davenport's response to his questions appeals to a Kierkegaardian notion of authenticity. It does not abandon teleology. Instead it retreats to a minimal and very abstract teleology according to which the human goal is self-definition in terms of what Harry Frankfurt describes as cares or what Bernard Williams characterizes as ground projects. As Davenport puts it, "we become authentic selves in Kierkegaard's sense only when we define ourselves in terms of such cares or projects" (p. 290). Our lives will be meaningful only if we become authentic selves, and the project of doing so furnishes us with "the existential *telos* of personal narrative unity" (p. 290). On this view, therefore, we are to avoid the Aristotelian error "by reinterpreting the human *telos* as *authenticity* rather than holistic eudaimonia" (p. 293). According to Davenport, "the realization of this *telos* requires the sort of self-integration and existential unity of life-narrative

which in turn (as MacIntyre has argued) explains part of the practical necessity of the social virtues" (p. 293). But if self-definition is to yield such integration and unity, it must operate under a constraint. Davenport insists that this *telos* cannot be attained "without an effort to identify and integrate some reconcilable subset of worthwhile ends to pursue in harmonious fashion" (p. 293). Unlike the Aristotelian *telos*, it permits different individuals to pursue different proper subsets of the set of all worthwhile ends, subsets that may conflict with one another. But it does enforce internal harmony. We have not succeeded in becoming authentic selves "until we have reinterpreted or refashioned our ground projects so that they are mutually reinforcing in spirit, rather than pulling in opposite directions, and so that they can all be pursued together (each in its proper respect) in one harmonious life" (p. 293). In short, Davenport requires an authentic self to be an internally harmonious self.

Does authenticity thus construed yield satisfactory answers to Davenport's two questions? I think not. In the first place, it gives us nothing to say to our pillar-hermit. The narrative of Simeon's life is, after all, about as tightly unified as one can imagine a story being. It is also apt to strike us as boring precisely because of its unity, though perhaps this judgment should be regarded as of doubtful relevance to the present inquiry on the grounds that it is aesthetic rather than ethical. However, Simeon's life is surely authentic because its ground project, devotion to God, is supremely worthwhile, and it is internally harmonious because it rigorously excludes competing ground projects. Yet it lacks richness and balance. It is responsive to so little of the full range of values that we cannot seriously view it, ethically speaking, as a good life. Nor can we, I think, regard it as showing us the practical necessity of a large array of social virtues. Simeon seems to need only a sort of ruthless perseverance that borders on the fanatical in order to pursue his quest successfully. Though he has become an authentic and internally harmonious self, he is not an ethical paradigm for us to imitate. Perhaps, for religious reasons, we ought to admire him. If so, our attitude should, according to tradition, be this: *admirandum sed non imitandum*. The upshot is that internally harmonious authenticity cannot, by itself, be the human *telos*; achieving it can be, at most, a necessary but not sufficient condition of reaching any genuine *telos* there may be for us.

Confirmation for this conclusion can be derived from another source in Davenport's paper. He admits that "it is possible to pursue evil ground projects authentically, in the full recognition of their evil" (p. 296). It is easy to see why this is so. Authenticity is a formal feature of human selves, and so it is possible, as Davenport concedes, to be an authentic torturer. And adding a requirement of internal harmony does not alter the situation because it too is a formal feature, a kind of coherence constraint. It is thus

possible to be an internally harmonious authentic torturer. Like R. M. Hare's formalist prescriptivism, which has nothing to say against the Nazi fanatic, Davenport's account of authenticity has nothing to say against the Nazi camp guard who tortures the inmates if he is lucid and single-minded enough. What this shows, Davenport rightly notes, is that authenticity, which he describes as a proto-virtue, is not by itself moral virtue in the full sense. What he does not observe is that it also shows that authenticity, or even authenticity augmented with internal harmony, cannot by itself be the human *telos*. It can, at most, be a necessary condition or, perhaps, a proper part of any real human *telos* there may be.

However, my deeper disagreement with Davenport concerns the answer he returns to his second question. He requires the authentic life to be internally harmonious. I admire the calm Classicism built into this picture of life—its Apollonian note, so to speak. But I also think it obscures a great deal of what is most valuable in human life. What needs to be restored to our view, if we are to achieve a balanced portrait of authenticity, is a Dionysian perspective. More precisely, it is our legacy from Romanticism. In a way, my appeal to the romantics at this stage of the argument should come as no surprise. After all, authenticity, or at least sincerity, its close cousin, is a romantic virtue par excellence.

Consider some aesthetic analogies. There are values in the orderly beauty of a formal garden, in the harmonies of a Haydn symphony and in the cool colors of a Poussin painting. They are the classical values of harmony. But there are also values in the wild sublimity of a storm at sea, in the discords of Berlioz, and in the tensions of a Delacroix canvas. These are the romantic values of discord. And as with the arts, so too with authentic lives. Isaiah Berlin sums up part of what we inherit from the romantics as follows: "The notion that there are many values, and that they are incompatible; the whole notion of plurality, of inexhaustibility, of the imperfection of all human answers and arrangements; the notion that no single answer which claims to be perfect and true, whether in art or in life, can in principle be perfect or true—all this we owe to the romantics."[4] I share with the romantics the sense that human values are irreducibly plural, inexhaustible, sometimes incommensurable, and often conflicting. I think an authentic response to this situation is to welcome plural values into our lives, risking the possibility of tragic conflict among them, and to manage the inevitable tensions as creatively and skillfully as we can. To be sure, this is not the only possible authentic response; I do not deny that purity of heart can, in some circumstances, be to will one thing. Yet a less narrow and exclusive form of authenticity seems to me better in most instances precisely because it is better attuned to the actual contours of value modernity has enabled us to realize. Of course, there are bound to be limits to how much conflicting value any of us can incorporate into our lives. If we

go beyond them, our selves will disintegrate, and we will descend into madness. Berlin states the issue vividly: "Some among the Great Goods cannot live together. That is a conceptual truth. We are doomed to choose, and every choice may entail an irreparable loss."[5] But the loss is always to be acknowledged and calls for regret or, in some cases, mourning. I submit that Davenport's account of authenticity is one-sided because of its demand for internal harmony within an authentic self. It emphasizes a classical ideal that stands in need of a romantic counterweight or corrective. Absent this countervailing ideal, we are likely to be too eager to exclude genuine values from our lives and to be blind to the loss and desirability of regret involved in the exclusions that must be made for the sake of sanity.

I do not want to suggest that the romantics themselves were free of a hankering for unity and wholeness. In a nostalgic form that projects these ideals into the past, the yearning is expressed in Schiller's poem "Die Götter Griechenlands." In a form that projects them into the future as infinite tasks, the longing is revealed in Kleist's short narrative "Über das Marionettentheater." And the dialectical resolution of conflict in Hegel's philosophy addresses, if only at the level of thought, what Edward Craig describes as "the one great metaphysical theme with which the minds of this time were obsessed: unity, its loss and its recovery."[6] But we, like Kierkegaard, do not find the Hegelian resolution persuasive. And I think we should not purchase resolution at the price of demanding of the authentic self that it harmonize its cares or ground projects in a way that excludes manageable conflict among genuine values. So my opinion is that we should not go along with Davenport's insistence that we have not become authentic selves until we have shaped our ground projects so as to make them mutually reinforcing rather than being, to some extent, in tension with one another. A balanced view of authenticity will put less stress on harmony than his account does as well as allowing more room than it does for creative conflict management within authentic selves.

III. Conclusions

I think we owe a debt of gratitude to the papers by Lillegard and Davenport for raising and trying to answer very important questions. Should we buy into a conception of life views that stresses, to the extent Lillegard's does, a single-minded focus on such values as unity and wholeness? And should we adopt the hybrid conception Davenport offers us of the romantic master virtue of authenticity with the classical values of harmony and reconciliation? My answer to both questions is negative. As I see it, a positive answer to either of them would commit us to a one-sided and unbalanced attitude toward the actual shape of the ethical landscape in which we live

our lives. If we are to be properly sensitive to that landscape, we must be appropriately responsive to values that are plural, often conflicting, sometimes incommensurable and perhaps even occasionally incomparable.[7] But then I will be asked how we might do better than Lillegard and Davenport have done in carrying out the project of framing balanced conceptions for use in reflecting on our ethical lives. It would be churlish on my part simply to duck this question. So with considerable diffidence, I advance a suggestion about how we might take a step or two forward.

It seems to me that we should begin by enriching our conception of the human self, for the self must be at the heart of any Kierkegaardian ethical deliberation. For this purpose, I find a conception of the self proposed by Wayne Booth helpful. According to Booth, we should think of each human self as in its essence a society of selves. He offers a choice of metaphors. Each of us is, not the atomic individual scorned by critics of modern liberalism, but "a kind of *society*, a *field* of forces, a *colony*, a *chorus* of not necessarily harmonious voices; a manifold *project*, a *polyglossia* that is as much in us as in the world outside us."[8] It is important to Booth that these pluralistic selves can craft lives that display narrative coherence, but he sees this process as constituted by "encounters best described as a kind of *taking in of new selves* (along with the effort, more difficult, to slough off old ones)."[9] In other words, our selves are constituted *e pluribus unum*. As a result, "our lives—are narratable as *plot lines*, but the plots are plotted not just outside us but within us: my father and my mother are in me, encountering one another there; they meet there with my playmates from infancy, my schoolmates, my teachers, my various friends and enemies, my favorite literary characters and their authors, all of whom enter and some of whom remain forever."[10] And all these characters who contribute to the internal plot line of the self "form a society that is in flux: accepting, rejecting, wrestling with conflicts, some of which will never be resolved."[11] Booth contends that this picture of the self is truer to our selves as we actually experience them than any theory of the self that portrays it as an integrated and harmonious unit.

Some of the advantages of Booth's conception for present purposes are worth mentioning briefly. It encourages the thought that life-narratives can and should have the unity, not of a monological autobiography, but of a multiple dialogical drama. It also concentrates attention on the task of striking a balance in the process of self-definition among excluding voices from the internal choir, introducing new voices and being responsive to voices that are not in perfect harmony. And, more generally, it allows plural and conflicting ethical values to be mirrored structurally within the soul, as it were, and thereby counteracts the temptation to think that self-definition must always be a reductive and simplifying operation. It thus shows significant promise.

Of course, the model of the self as a society of selves will not help metaphysicians answer the question of whether personal identity through time is to be understood as endurance or perdurance. Yet if we bear in mind that Kierkegaard thinks of the passage from one stage of life to another, not as a sharp break or complete rupture, but as a transition in which values from the earlier stage are taken up, in transfigured form, into the later stage, we may find Booth's conception of an internally plural self helpful in grappling with the problem of the relations between the structure and contents of the self at different stages on life's way. If we do, I may, by having commended that conception, turn out to be in another respect a sort of Kierkegaardian, though I must leave it for others to say whether in this respect mine is an unorthodox sort. In any event, regardless of the fate of my particular suggestion, I am persuaded that we need to wrestle with perplexing issues in moral psychology if we wish to advance the discussion of the deepest questions raised by Lillegard and Davenport in their stimulating papers.

NOTES

1. An earlier version of this response consisted of comments delivered at a session of the Søren Kierkegaard Society at the 1999 APA Eastern Division Meeting in Boston (Dec. 27). At that session, I was commenting on talks by Lillegard, Davenport, and Robert Perkins. In revising my comments, I have deleted my remarks on Perkins and made other changes in order to respond to revisions by Lillegard and Davenport and to take into account points raised in the discussion in Boston. [Perkins's interesting paper, which had less relation to MacIntyre, unfortunately could not be included in the present volume because of the volume's length—Eds.]

2. See Philip L. Quinn, "The Divine Command Ethics in Kierkegaard's *Works of Love*," *Faith, Freedom, and Rationality*, ed. Jeff Jordan and Daniel Howard-Snyder (Lanham, MD: Rowman and Littlefield, 1996), pp. 29–44. For a nicely complementary study of *Works of Love*, see M. Jamie Ferreira, "Equality, Impartiality, and Moral Blindness in Kierkegaard's *Works of Love*," *Journal of Religious Ethics* 25, no. 1 (1997): 65–85.

3. See Bruce H. Kirmmse, "The Thunderstorm: Kierkegaard's Ecclesiology," *Faith and Philosophy* 17, no. 1 (2000): 87–102.

4. Isaiah Berlin, *The Roots of Romanticism* (Princeton, NJ: Princeton University Press, 1999), p. 146.

5. Isaiah Berlin, "The Pursuit of the Ideal," *The Crooked Timber of Humanity* (New York: Knopf, 1991), p. 13. It is worth noting that John Rawls, who holds that there are several reasonable but conflicting comprehensive doctrines, recognizes that not all of them can flourish in a single society. Citing the passage quoted in the body of my text and referring also to Berlin's essay "Two Concepts of

Liberty," Rawls endorses the view that there is no social world without loss. See John Rawls, *Political Liberalism* (New York: Columbia University Press, 1993), pp. 197–99.

6. Edward Craig, *The Mind of God and the Works of Man* (Oxford: Clarendon Press, 1987), p. 136.

7. On this topic, see Michael Stocker, *Plural and Conflicting Values* (Oxford: Clarendon Press, 1990), especially the four chapters in Part I, which focuses on conflict, and the two chapters in Part III, which is devoted to plurality and conflict.

8. Wayne C. Booth, "Individualism and the Mystery of the Social Self; or Does Amnesty Have a Leg to Stand On?," *Freedom and Interpretation: The Oxford Amnesty Lectures 1992*, ed. Barbara Johnson (New York: Basic Books, 1993), p. 89. As one might expect in an Amnesty Lecture, Booth argues that his conception of the self gives us a cogent response to the torturers of this world. I argue that it does not in Philip L. Quinn, "Relativism about Torture: Religious and Secular Responses," *Religion and Morality*, ed. D. Z. Phillips (New York: St. Martin's Press, 1996), pp. 151–70.

9. Ibid., p. 90.

10. Idem.

11. Ibid., pp. 90–91.

14

Once More on Kierkegaard

ALASDAIR MACINTYRE

I

Kierkegaard and MacIntyre? What kind of a juxtaposition is *that*? Certainly one that pays me an undeserved compliment, but perhaps one that is something of a joke, just because of the evidently disproportionate importance of Kierkegaard's writings to mine. Yet the essays in this volume have a philosophical interest that is to some large degree independent of their engagement with my work. For the issues that have made me deeply critical of Kierkegaard and the concerns that I share with Kierkegaard and Kierkegaardians are issues and concerns that would be just as important, if I had never written about them. My presence in these essays therefore has a certain accidental quality and one consequence is that I do not have to dwell upon what I take to be misunderstandings of my own views, except where it is relevant to defining some disagreement with Kierkegaard or with my Kierkegaardian critics.

Let me begin by acknowledging three just criticisms of my strictures on Kierkegaard, addressing them in the form in which they have been expressed elsewhere by Edward Mooney. Mooney has pointed out that in my remarks about Kierkegaard's account of the transition from the aesthetic stage to the ethical, I have written as though, on Kierkegaard's view, all shifts from stage to stage have the same general form. "But Kierkegaardian stage-shifts do not share a single structure" (*Selves in Discord and Resolve*, New York: Routledge, 1996, p. 96). And here Mooney is clearly right. His examples of different types of stage-shift include both those between "several substages within the esthetic sphere" and that of the change from the ethical to the religious, or rather to Christian faith. More needs to be said and will be said about this latter, but the force of Mooney's criticism is undeniable. And the same holds of his

339

charges that I have ignored the complexity of the relationships between the choice of the ethical, the self that makes that choice, and the self that is constituted by that choice, and that in so doing I have unjustly assimilated Kierkegaard's position to that of Sartre.

Mooney's third criticism is as telling as the first two. In my account of the relationship between the aesthetic and the ethical as distinct and opposed spheres I failed, so he asserts, to recognize the nature of the argumentative conversational exchanges that take place between their protagonists. For Kierkegaard in *Either/Or* presents us with characters whose conversations only have the point that they have, because "cross-sphere intelligibility and cross-sphere evaluation are constitutive parts" of those conversations ("The Perils of Polarity," this volume, p. 243). And once again Mooney is clearly in the right.

So the question arises: were I to take adequate account of those features of Kierkegaard's subtle and nuanced positions which were ignored and obscured by my earlier oversimplified expositions, what would be the effect on my overall criticism of Kierkegaard? In answering I need, of course, to attend separately, as I had previously failed to do, to the significantly different issues posed on the one hand by Kierkegaard's characterization of the relationship of the aesthetic to the ethical and on the other by his characterization of the relationship of the ethical to Christian faith. So let me begin with the former, focusing initially on Mooney's third criticism.

That Judge Wilhelm has much to say to A that is relevant to A's self-evaluation and that the Judge has no problem in making what he says to A intelligible to A is not at issue between us. I should indeed have said more than I did, but I always took it for granted that, whatever occurs between the Judge and A, it is not a failure in communication. What matters, however, is whether the Judge does provide or could have provided reasons that might be judged sufficiently good reasons by A in the light of A's standards for a verdict in favor of the ethical over the aesthetic. A has his aesthetic standards of practical reasoning, just as the Judge has his very different ethical standards. What for the Judge are taken to be overriding considerations are for A considerations of a kind that can be and often are overridden. And indeed, apparently ethical considerations that might seem to carry weight with someone whose attitudes were those of the aesthetic, as Kierkegaard characterizes it, could scarcely be genuinely ethical. It is not difficult to imagine an aesthete enjoying, for a time at least, the play-acting involved in presenting himself as a-man-of-duty, mimicking with some artistry what he takes to be the tedious scrupulosity of the moral life. But for that aesthete to be moved by genuinely ethical considerations, he would have already to have discarded his aesthetic attitudes and have become another sort of person—as Kierkegaard of course recognizes.

Therefore I do not find in Mooney's third criticism any ground for abandoning the view that what Kierkegaard intended to convey to us was that the only way in which the transition can be made from the aesthetic to the ethical is by way of a criterionless choice. Consider two features of Kierkegaard's characterization of that choice.

The first is his denial that there can be mediation between the aesthetic and the ethical. For "if we concede mediation, then there is no absolute choice, and if there is nothing of that sort, then there is no absolute either-or. This is the difficulty, yet I believe that it is due partly to the fact that two spheres are confronted with one another, that of thought and that of freedom" (*Either/Or*, vol. II, trans. W. Lowrie, New York: Doubleday, 1959, p. 177). The exclusion of mediation between the aesthetic and the ethical is an exclusion of thought and therefore of reasoning and *a fortiori* an exclusion of philosophy, since "The spheres with which philosophy properly deals, which properly are spheres for thought, are logic, nature and history" (Ibid., p. 178). If one could indeed think one's way out of the aesthetic into the ethical, then one would be able to move from aesthetic premises to ethical conclusions. But this is not a transition that can be made by thinking.

Suppose someone were to respond to this by pointing out that the aesthetic way of life leads to despair and that despair at least affords reasons for skepticism about the claims and premises of the aesthetic. So that reasoning might after all play some part in the transition to the ethical. There is perhaps a certain plausibility about this, but it is not Kierkegaard's view. For to despair is already to have chosen. Despair is not a state of intellectual skepticism, of doubt. "So then choose despair, for despair itself is a choice; for one can doubt without choosing to, but one cannot despair without choosing. And when a man despairs he chooses again—and what is it he chooses? He chooses himself, not in his immediacy, not as this fortuitous individual, but he chooses himself in his eternal validity" (Ibid., p. 215). That is, he chooses himself as the subject of the ethical; he becomes by his choice, not by any argument, someone who has acknowledged the claims of the ethical. And in saying this I am after all doing no more than repeating what has been said by others who have immersed themselves in Kierkegaard's texts. So Alastair Hannay wrote that "neither ethical principles and concepts themselves nor the individual's understanding of them are a natural, logical, or 'dialectical' product of elements already found in a pre-ethical stage" (*Kierkegaard*, London: Routledge, 1982, p. 158).

Mooney is of course right to emphasize that the choice of the ethical, while it does not make me someone other than I was before, constitutes me, so that I cannot from now on regard myself in an aesthetic light. I am in a new way at one with myself and also with others (*Selves in Discord and Resolve*, pp. 16–17). But it is just those features of the either-or choice that

make it so radical a break with the aesthetic. Say, if you like, that it is not a criterionless choice, because in making the choice of the ethical the authority of the standards of the ethical is *already* acknowledged. Yet, insofar as that choice expresses a choice of those standards and a rejection of the standards of the aesthetic, it remains criterionless. What makes Sartre's conception of choice in *L'Existentialisme est un humanisme* so very different is not that Kierkegaardian choice is guided by criteria, while Sartrian choice is not so guided, but both that Sartre lacks any conception of stages and that his conception of the ethical is so attenuated and even incoherent.

What then of the transition from the ethical to Christian faith? About this it seems rather more compelling to say that what I wrote in *After Virtue* needs to be retracted, for I asserted there that in *Philosophical Fragments* "Kierkegaard invokes this crucial new idea of radical and ultimate choice to explain how one becomes a Christian" (AV 41). What this ignores is twofold: first, that, on Kierkegaard's as on any Christian view, faith is a gift by God and could only be a gift, for although "Human thought knows the way to much in the world . . . the way to the good, to the secret place of the good, it does not know" (*Edifying Discourses*, vol. I, trs. D. F. & L. M. Swenson, Minneapolis: Augsburg, 1962), and, secondly, that the human being is not free to acquire the truth, but is in bondage until released by a divine act (*Philosophical Fragments*, tr. D. F. Swenson & Howard V. Hong, Princeton, NJ: Princeton University Press, 1967, pp. 19–21). Yet my hesitation in acknowledging a need for an unqualified retraction arises from the fact that, if I misconstrued *Philosophical Fragments*, I followed Kierkegaard himself in so doing. For in the *Concluding Unscientific Postscript* to the *Philosophical Fragments*, in order to characterize "the transition by which something historical and the relationship to it becomes decisive for an eternal happiness," Kierkegaard borrows from Lessing the concept of "a leap" and asserts that "the leap is the category of decision" and that "the leap is itself the decision" (*Concluding Unscientific Postscript*, tr. D. F. Swenson & W. Lowrie, Princeton, NJ: Princeton University Press, 1961, pp. 90-94).

How then are we to reconcile what is said in *Philosophical Fragments* with what is said in the *Postscript*? The answer is surely that the transition from the ethical to Christian faith, in this respect like that from the aesthetic to the ethical, is understood very differently from the standpoint of those who have yet to make the transition than it is from the standpoint of those who have already made it. What can only be understood as a gift and a liberation from bondage retrospectively appears prospectively as matter for decision and for a decision that takes one beyond anything that dialectic can afford. "For dialectic is in truth a benevolent helper which discovers and assists in finding where the absolute object of faith and worship is—there, namely, . . . where the resistance of an objective uncertainty

tortures forth the passionate certainty of faith . . ." (Ibid., p. 438). What from the standpoint of faith is gift and liberation is from the standpoint of objective uncertainty a criterionless choice. So far at least the acknowledgment of what was omitted or one-sided in the account that I gave of Kierkegaard in *After Virtue* does nothing, so far as I can tell, to undermine the substance of that account. But am I then entitled to claim that my critics were simply, at least on these central points, mistaken? The answer that will finally emerge is 'No.' But in order to arrive at the reasons for this argument, I must first consider some further disagreements.

II

How should I respond to the arguments advanced by Peter J. Mehl, by John Davenport and by Anthony Rudd, each of whose essays has a philosophical interest that is quite independent of their disagreements with me? Each of them understands Kierkegaard to have constructed a view of human nature, a philosophical anthropology, such that human beings in virtue of their nature move or fail to move towards a *telos*. And each of them also ascribes to Kierkegaard the view that human beings have good reasons to move towards that *telos* and that, if they fail to do so, they fail as rational agents. So Mehl writes that "To Kierkegaard's mind, it is the destiny of every individual to become spirit, spirit being rational and responsible self-determination" ("Kierkegaard and the Relativist Challenge to Practical Philosophy," p. 254; this volume, p. 10), and he quotes Kierkegaard: "Personality manifests itself as the absolute which has its teleology within itself" (*Either/Or* II, p. 267). That teleology requires us to "will the infinite." And the account of human nature that underpins it was arrived at, on Mehl's view, by a philosophical method that he characterizes as an existential empiricism.

John Davenport draws upon the interpretive resources provided by Mehl, but gives a rather different view of Kierkegaard's teleology. It is, on Davenport's view, a teleology that "conceives personhood as a process of freedom including certain forced choices" ("Towards an Existential Virtue Ethics: Kierkegaard and MacIntyre," p. 302), whose *telos* is the "goal of existential coherence or the practical unity of a life-narrative" (p. 293), which in turn is equated with "authenticity" (p. 293), and which requires what Davenport calls the "existential proto-virtues" (p. 294). And Kierkegaard, so Davenport claims, provides "an argument that grounds the necessity of engaging in practices and of committing oneself to the unification of life-goals in an account of the human *telos*" (p. 291).

Anthony Rudd in similar fashion ascribes to Kierkegaard the postulate that "we do all have, at least implicitly" a "desire for coherence and

meaning in our lives" ("Reason in Ethics: MacIntyre and Kierkegaard," p. 139). This desire "makes itself manifest in our feelings of boredom and despair when it goes unfulfilled" (p. 140). And it is "when we can find no coherent narrative structure" in our lives that "we feel lost—despairing even" (p. 140). So if it can be shown that "there is a connection between living one's life as a meaningful narrative, and making ethical commitments and developing the virtues," then it will also have been shown "that the ethical life is (rationally) to be preferred to an amoral aesthetic existence" (p. 140). Rudd not only takes Kierkegaard to have advanced just such an argument, but he interprets parts of *After Virtue* as giving expression to an argument of the same type (p. 141). So it seems that I am not only mistaken about Kierkegaard, but also that I cannot consistently reject Kierkegaard's argument and reaffirm my own.

My response to Mehl is somewhat different from my response to Davenport and Rudd. For I have no difficulty in agreeing with the substance of his account of Kierkegaard's view of human nature and more especially with his characterization of the teleology that is central to Kierkegaard's view (Karen L. Carr justly chides me in "After Paganism: Kierkegaard, Socrates, and the Christian Tradition," footnote 20, for having denied that Kierkegaard has a teleological view of human nature, an error perpetrated in one of the clumsiest and most misleading sentences of *After Virtue*). And it does indeed follow from that view that there are good reasons for individuals to move from the aesthetic to the ethical and not merely good-reasons-from-the-standpoint-of-the-ethical. Those reasons are in general the ones advanced by Judge Wilhelm. But this is not in the least inconsistent with the thesis that the transition from the aesthetic to the ethical is and can be made only by a criterionless choice. For to be in the aesthetic stage is to have attitudes and beliefs that disable one from evaluating and appreciating those reasons. One has to have already chosen oneself as an ethical subject in order to do so. So I reiterate the claim that, on Kierkegaard's view, what can retrospectively be understood as rationally justifiable cannot be thus understood prospectively.

My disagreements with Davenport and Rudd extend a little further. For they both ascribe to Kierkegaard a kind of teleological view that I cannot find in his writings: that it is a central goal of human existence to find meaning and coherence in our lives. Kierkegaard did of course recognize that human beings find a lack of coherence and meaning in their lives disquieting and Judge Wilhelm in some of his arguments relies on that fact. But it is not meaning *as such* nor coherence *as such* that we have to achieve, if we are to become what we are capable of becoming as ethical subjects, but that very specific type of meaning and coherence which belongs to the lives of those to whom it is given to stand before God and to acknowledge that they are in the wrong. And Davenport's account of

Kierkegaard's concern for authenticity as such is in some danger of assimilating Kierkegaard's preoccupations to those of twentieth-century German and French existentialists.

Rudd's not dissimilar view of Kierkegaard is closely related to his misunderstanding of what I wrote about narrative in chapter 15 of *After Virtue*. I did suggest there that "When someone complains—as do some of those who attempt or commit suicide—that her or his life is meaningless, he or she is often and perhaps characteristically complaining that the narrative of their life has become unintelligible to them, that it lacks any point, any movement towards a climax or a *telos*" (AV 217). But to say that a life that does not embody movement towards a *telos* may be found meaningless is not to say that the goal of living a meaningful life ever is or could be the *telos* of a human life. An activity, a set of activities, or a life all get their point and purpose from having some worthwhile goal. But someone who finds point and purpose absent from her or his activities or from her or his life as a whole, but who very much wants her or his life to have point and purpose—and I do not disagree with Rudd in his insightful emphasis on the importance of this desire in an agent's movement towards the discovery of an adequate *telos* for her or his life—is not someone who has thereby already found a worthwhile goal, but someone who is acknowledging their lack of any such goal.

About this Kierkegaard was not mistaken, nor am I. But what I take to be my agreement with Kierkegaard on this limited issue may not be all that important. For my disagreements on the interpretation of Kierkegaard, not only with Davenport and Rudd, but also with Mehl, depend upon a distinction to which I am committed, but which some or all of them may well repudiate. I have argued that, although Kierkegaard does indeed understand human lives as having a *telos*, and although Kierkegaard does indeed believe that subsequently individuals may come to recognize that there were good reasons for them to move towards that *telos* out of the aesthetic and into the ethical, at the time that they did so move theirs was not a progress directed or even guided by reason, but rather a set of psychological developments. Their story, as I have interpreted it, is a story of the passions rather than of reasons. But just this distinction between the kind of story that concerns the passions and the kind of narrative that would recount a rational progress is put in question by Marilyn Gaye Piety in "Kierkegaard on Rationality," as it is also by Gordon D. Marino in "The Place of Reason in Kierkegaard's Ethics."

Piety begins from Kierkegaard's contrast of passion with reflection. Reflection is disinterested, dispassionate thought and we cannot move from the aesthetic to the ethical by means of reflection. But, if we conclude, as I have done, that we cannot move from the aesthetic to the ethical by reasoning, this will be the result of "a failure to appreciate that the

intellectual dimension of human experience is not reducible, for Kierkegaard, to reflection" (p. 63). The reasoning that enables an individual to move from the aesthetic to the ethical is passion-informed. It is passion that "breaks down the apparent coherence or descriptive adequacy of a particular interpretation of existence" (p. 66). Piety says too little about how an individual's response to that breakdown comes to be reason-informed. But I take it that she might endorse Marino's admirably lucid statement of what is involved. Marino's account runs as follows.

As in Piety's account, passion provides reason with its incentive. Both Judge Wilhelm and Kierkegaard "assume that despair is everyone's negative Prime Mover" (p. 119). The impact of despair is upon individuals for whom coherence in their lives is a condition without which they will be unable to love and for whom being able to love is a condition without which they will be unable to be happy. Desires for coherence, for love and for happiness are universal and it is only through the choice of the ethical that those desires can be satisfied. "True, every desire will appear differently according to the categories through which it is conceived, but both the Judge and Kierkegaard suppose that there is enough continuity to reason the esthete out of one conception and toward another" (p. 118). Marino has put us all in his debt by this excellent statement of the case against my view. He supplements and reinforces points made by Mehl, Davenport, and Rudd, as well as by Piety. And his account is unquestionably right about Judge Wilhelm. But is he right in identifying Kierkegaard's views with the Judge's?

The difficulty that I have in identifying them can be most easily expressed by attempting to imagine what it would be for A to consider and to be convinced by the Judge's arguments. A would have to ask systematically and with real seriousness such questions as: "What, if anything, might rescue me from my despair?" "In what does genuine happiness consist?" "What are the conditions that could secure my own happiness?" and "What kind of person must I be to love and be loved?" But for A to ask even the first of these questions with due seriousness, A would have to have already left the aesthetic stage behind. In choosing to pose such questions systematically and to answer them by sound arguments, he would already have chosen himself as an ethical subject. His questioning would not at all be the kind of questioning of which an aesthete is capable (*Either/Or* II, p. 163). It would not be such that it could be represented as "the necessary unfolding of the immediate" (Ibid., p. 233). So A's either-or choice between the ethical and the aesthetic would precede and not follow upon A's reasoning, although it would remain true, as Piety and Marino are right to insist, that passion would have provided reason with its incentive.

Should we then conclude that Kierkegaard's view of the relationship between the ethical and the aesthetic is not the same as the Judge's? Matters are perhaps not as straightforward as that. The possibility that I want to entertain—and I am aware that in entertaining it I am going counter to the established tradition of Kierkegaard exegesis—is that Kierkegaard's presentation of that relationship masks an underlying unresolved tension in his own thought and that some, although only some of the differences between myself and my critics, may perhaps be explained by that tension.

III

Kierkegaard put moral philosophy permanently in his debt in a number of ways, among them by his account of the aesthetic. And it is a sign of the cultural impoverishment of most Anglo-Saxon moral philosophy that it has not been able to learn from Kierkegaard, that it has devoted so little attention to the aesthetic. For I take it that the attitudes and way of life that Kierkegaard characterized as the aesthetic stage have a reality outside Kierkegaard's writings and that we can ask whether and how far Kierkegaard's descriptions of the aesthetic capture that reality in its full complexity. This was what I was asking when I asserted in *After Virtue* (AV 41) that Judge Wilhelm—and perhaps Kierkegaard—was mistaken in supposing that the aesthetic could not be seriously and deliberately chosen.

Norman Lillegard ("Thinking with Kierkegaard and MacIntyre about Virtue, the Aesthetic and Narrative," pp. 215–16) has replied that I am right in thinking that the aesthetic can be deliberately chosen, but mistaken in supposing that this is incompatible with Kierkegaard's view of the aesthetic, remarking also that the example that I gave of a deliberate abandonment of the ethical and choice of the aesthetic would be counted by the Judge "not as an aesthetic life, but as 'sin.'" And Lillegard's account of what Kierkegaard intended by his presentation of the aesthetic in *En Literaire Anmeldelse* of 1846, by juxtaposing it with what had been said three years earlier in *Either/Or*, makes Kierkegaard's point of view clearer in at least two ways.

First, he makes us more aware of the varieties of the aesthetic. Kierkegaard's discussion of Claudine, the heroine of the first part of Thomasine Gyllembourg's novel *Two Ages*, provides a sharp contrast with the portrait of A in *Either/Or*. And Lillegard emphasizes that although Claudine's virtues do not take her beyond the aesthetic, her life does exhibit virtues. In Claudine's life as in A's, passion is the incentive to virtue, but it is a very different type of passion, one that inspires

constancy of purpose. Nonetheless Claudine does not evaluate her passion, as reason would require her to do, and so she remains excluded from the ethical.

Yet in thinking about Claudine in the light of Lillegard's analysis we might reach a conclusion which, a little more surprisingly, we ought perhaps also to reach about A. It is that Claudine is not merely excluded from the ethical; she is to some significant degree self-excluded. For there are possibilities that she could consider, but fails to consider, while, for example, she makes up her mind about the Baron's proposal of marriage—considerations that would have raised questions concerning the shape of her life as a whole. If we say of Claudine that she chooses not to entertain such considerations, we are of course still speaking of the kind of choice within the aesthetic that Lillegard characterizes so well. But it is a kind of choice that could have been a prologue to ethical choice and was not, and only because Claudine did not allow it to be. Now consider or reconsider the case of A.

Judge Wilhelm says of and to A that "Every man who lives merely aesthetically has for this reason a secret terror at the thought of despair, for he knows very well that what is brought forth by despair is the universal" (*Either/Or*, p. 233) and he fears understanding his own difference in universal terms. But this secret fear must open up the possibility of thinking about himself in universal, that is, in ethical terms and to resist that possibility by not admitting to this fear is once again to have excluded oneself from the ethical.

Why does this matter? Both I who have understood the transition from the aesthetic to the ethical as one of criterionless choice and my critics who have argued that this transition is or can be made by reasoning have agreed in supposing that the aesthetic and the ethical are two distinct conditions, such that to be in the aesthetic is not yet to be in the ethical. But suppose instead that the aesthetic personality is viewed as one that is engaged in covert and unacknowledged resistance to the ethical, so that the aesthetic life requires a silent, but determined refusal of the ethical. Implicit in that refusal is a recognition that only from the standpoint of the ethical are there answers to a set of questions which the aesthete needs to ask, but insistently evades asking. The aesthete, that is to say, is a divided self, on the surface—and for that in him which *is* aesthetic the surface is everything—unable to move beyond immediacy, but in his unacknowledged secret depths already engaged with the ethical.

If that were so, then there would be that in the aesthete to which arguments from the standpoint of the ethical could appeal. The premises of those arguments would be dismissed by one part of the self, but might be compelling to the other. And the response of the individual would depend on the particular relationship between the two parts of the

divided aesthetic self within that particular individual, a relationship which might be very different in different types of case, so that A's response might not be at all the same as Claudine's, and there might be types of the aesthetic personality which differed relevantly from both A and Claudine. Yet is this what Kierkegaard held? Perhaps and perhaps not. What I am suggesting is that there are two different strands to the account of the relationship of the aesthetic to the ethical in *Either/Or* which co-exist uneasily: the dominant strand is one in which the radical discontinuity between the aesthetic and the ethical is emphasized, but in the subtext continuities are identified. And one source of the disagreements between interpreters of *Either/Or*, including the disagreements between my critics and myself, is perhaps the attention that they have given to one or the other of these two strands.

Jeffrey S. Turner's insights in "To Tell a Good Tale: Kierkegaardian Reflections on Moral Narrative and Moral Truth," are relevant to these issues of continuity and discontinuity. For they suggest that within the ethical something of the aesthetic is preserved. And this is surely right. Turner argues that Judge Wilhelm, in artfully arguing against the aesthetic, betrays by his artistry the fact that he has to some degree aestheticized the ethical and that he has not in fact escaped from the aesthetic. And Turner then argues that I, too, may have fallen victim to my "own inventive literary construction," so that I project on to others an aestheticism that I fail to recognize in myself (p. 55). I am complimented by this comparison with Judge Wilhelm, even if it is in respect of our alleged shared vices, although I believe that Turner's accusations are exaggerated in both our cases. But Turner makes exactly the right point when he says that what matters about all of us is the relationship between the stories that we tell about our lives and the reality of those lives. That relationship depends on the fact that, as I argued in *After Virtue*, our lives are themselves stories, enacted narratives. And what matters is that the stories that we tell about our lives should be true. Turner speaks of "moral truth" and I do not know what he means by that. It is in fact truth in the plainest and most ordinary sense that is at stake. Yet to be truthful, to tell the truth in one's story-telling, is not at all incompatible with exhibiting artistry in that telling. So the question about Judge Wilhelm, and much less importantly about me, is whether the artistry is such that truth has been sacrificed to it or instead that the artistry has been made to serve the purposes of truth. Insofar as it is the latter—and in the case of Judge Wilhelm I believe that it *is* the latter—the conclusion to be drawn is that, just as intimations of the ethical were present in the aesthetic, so what was genuinely valuable in the aesthetic reappears in new guises in the ethical. And Kierkegaard himself is of course the prime example of an artist in the service of the ethical.

IV

Let me now put on one side for the moment questions of Kierkegaard interpretation, even though more certainly needs to be said. For I owe it to Karen L. Carr, Richard Johnson, and Bruce H. Kirmmse, whose impressive essays all focus on central issues that divide me from Kierkegaard, to say something about those issues. They arise not from any thesis or argument that is peculiarly mine, but from large differences between any Thomistic position and some of Kierkegaard's theological affirmations. All that I can hope to do here is to restate some of those differences. Carr provides my discussion with its appropriate setting in her historical survey of the very different views of the relationship between Christian revelation and philosophical enquiry that have been taken in the course of the history of the church. And at the close of her survey she quotes the declaration by Anti-Climacus in *Sickness Unto Death* that, on a Christian view, the relationship of the human to the divine is incomprehensible, but nonetheless to be believed. Carr then adds that "The reality of human sin, in other words, points to the impotence of any natural religion or theology in apprehending the full truth . . ." (p. 185). But Carr's "other words" do not say quite what Anti-Climacus said. That natural theology cannot apprehend the *full* truth—or indeed anything like the full truth—about the relationship of God to human beings does not entail that there is not an important part of the truth which it does apprehend. What is at issue here between Kierkegaard and Kierkegaardians on the one hand and Thomists on the other can be brought out by beginning from the passage from *Stages on Life's Way* (tr. Hong and Hong, Princeton: Princeton University Press 1988, p. 476) which Richard Johnson quotes (p. 152), where Kierkegaard asserts that "there is no human being who exists metaphysically," since the metaphysical is either an abstraction from or a prologue to the aesthetic, the ethical, or the religious.

What Kierkegaard failed to recognize, here as elsewhere, is that human beings are by their essential nature metaphysical enquirers and that one central task of philosophers, identified by the present Pope in a recent encyclical, is to articulate coherently and systematically the same questions that plain persons pose about their lives: "Who am I? Where have I come from and where am I going? Why is there evil? What is there after this life?" (John Paul II, *Fides et Ratio*, 1) and, inseparable from all of these, "What is my good and how is the achievement of that good related to the achievement of the good by others?"

These are questions whose answers bear on concrete questions of how to live our lives. And any attempt to answer them involves some degree of metaphysical abstraction, abstraction without which we cannot adequately understand such questions, let alone attempt to answer them construc-

tively. Metaphysical abstraction is thus partly constitutive of and therefore neither a flight from nor a mere prologue to the particularities of human existence. Of course, indulgence in metaphysical speculation—like indulgence in other types of human activity—can become a vice, but to regard metaphysical enquiry itself as a vice is to make both a metaphysical and a moral mistake about human beings. And Christian revelation addresses the human being as one who enquires and reasons, as well as one who eats, drinks, loves, hates, prays, and sins.

Kierkegaard, himself an exemplar of an enquiring and reasoning human being, misconstrued the relationship between reasoning and revelation. For he failed to recognize that God in revealing Himself to us appeals to our recognition of standards independent of Christian revelation, statements which we cannot, as rational agents, set aside even in our dealings with Him. This is part of the significance of what Paul wrote about the Gentiles in *Romans* 2 v. 15: "They show that the demands of the law are written in their hearts." The precepts of that law instruct us as to how we must act, if we are to achieve our common and individual goods and exhibit the virtue of justice in our relationships with others. And the knowledge of those precepts provides a partial answer to our metaphysical and moral questioning. Hence, when God reveals Himself to us as good and just, although His goodness and justice transcend our prior conceptions of them, it is with those prior conceptions that we have to begin. For it is only insofar as we are able, by the best standards that we already possess, to judge that God is indeed good and just, that we are right to worship Him and to entrust ourselves to Him, so that we may learn from Him more about goodness and justice than we could ever learn from the resources of natural reason alone. If we were not able so to judge, then the only divine attribute that our worship could acknowledge would be power and power divorced from goodness is not an adequate object of worship (for a fuller treatment of these issues see my essay, "Which God Ought we to Obey and Why?," *Faith and Philosophy* 3 no. 4, October 1986).

It is only because, prior to and independently of revelation and of the gift of faith, we do have a conception of the human good adequate to provide direction for our actions and a knowledge of the corresponding precepts of the natural law that we can be held accountable by God for not directing ourselves towards our good and for disobeying those precepts. And this is one of the respects in which, as Aquinas puts it in a passage quoted by Carr (*Summa Theologiae* Ia, 1, art. 8, ad 2; Carr p. 10), "Grace does not destroy nature, but perfects it." What we learn from the revelation of God's commands, both on Sinai and in the Sermon on the Mount, extends and reinforces but never abrogates the precepts that God promulgates as the natural law. So there is no possible place for anything that could be characterized as a teleological suspension of the ethical. And

Aquinas characterizes the events narrated in *Genesis* XXII so that Abraham is innocent of any intention to commit murder. Johnson is therefore quite right in asserting that "there is no room in MacIntyre's scheme for anything like the 'teleological suspension of the ethical'" (p. 160), but here it is not just *my* scheme, but the central tradition of Catholic Christianity that he is indicting.

It is, of course, true that Christianity in crucially important ways both corrects and enriches any secular morality. In so doing it transforms our understanding of what is required of us. But what is required is always more, never less, than secular morality at its best requires. For whatever understanding of the human good that we possess, including that afforded by philosophical enquiry, is also God-given. We therefore need, as Augustine taught us, to pass through and beyond Platonism or any other philosophy, recognizing nonetheless, as Augustine did, what we have learned and perhaps had to learn from philosophical enquiry. And Aquinas embodies this recognition in his theology. Johnson says that "classical ethics comes to grief on the revelation of sin" (p. 161) and imputes this view to Aquinas as well as to Kierkegaard. But the sense in which this is so and the implications of its being so are very different in the two cases.

A Thomistic Christian is therefore bound to take a view of secular cultures in general and of ancient Greek culture in particular which is incompatible with that taken by Kierkegaard. For in each such culture we need to distinguish that which expresses a culturally specific, but genuine apprehension of human goods, and of the good, from the local perversions of that apprehension that are the consequences of sin. And so a Thomist account of both the discontinuities and the continuities between classical Greek culture and Christianity would be very different from Kierkegaard's view, as summarized by Kirmmse. Classical culture, on such an account, would be neither the story of a "failed, corrupted, disenchanted polis . . . and a brooding 'zero-sum' fatalism" (p. 193) nor that of what Kirmmse calls "the organic-harmonic picture MacIntyre paints" (p. 193; since I speak of ancient Athens as a place of "rivalries and inconsistencies" [AV 138], one where we find "a recognition of a diversity of values, of conflicts between goods" [AV 157], and since I have repeatedly argued that we should follow John Anderson in understanding social orders in terms of the conflicts internal to them, I find this ascription of an 'organic-harmonic' view very odd indeed). It would instead be an account of the tensions and conflicts between a range of visions of the human condition in which generally partial and one-sided, but sometimes striking apprehensions of the truth about that condition are distorted and obscured by human sinfulness. And just because classical Greek thought and practice supplied so much of the background belief of the culture within which the early church developed the new forms of the Christian life, it became a

source of those questions to which Tertullian and Kierkegaard on the one hand and the Greek fathers, Augustine, and Aquinas on the other gave such different and incompatible answers.

What both sides agree upon is that the grace that issues in faith, hope, and love is unqualifiedly a gift. "Grace is not acquired by our acts, but by a gift of God" (*Summa Theologiae* Ia-IIae 76, 2). But grace, on Aquinas's view, presupposes and builds upon nature and so, from the standpoint afforded by revelation, we can come to understand how natural theology points us towards truths which we would have been incapable of apprehending but for grace. There is therefore, for Aquinas, a kind of relationship between the moral and intellectual virtues, which we are capable of acquiring by nature, and the theological virtues, which are infused in us only by grace, for which there can be, it seems, no place in Kierkegaard's thought. And Kierkegaard in such denials and rejections is, as Carr and others make clear, the exponent of a much older way of understanding Christianity, albeit an original and creative exponent.

Kirmmse has put us all in his debt by his perceptive identification of the points at which further dialogue is most needed between the standpoint that I have tried to express and that of those who follow Kierkegaard. And the next step would therefore be to consider more fully each of the particular issues that he has identified. But our hopes for a constructive outcome to such conversations should be modest. For what my arguments in this essay seem to have shown is that any realistic statement of particular issues reveals two not only different, but irreconcilable perspectives, systematically at odds both philosophically and theologically. The gap between an Aristotelian or Thomist ethics of the virtues and a Kierkegaardian ethics is just too great.

V

How great it is becomes clear when we recognize the difficulty that Kierkegaardians have had in interpreting Aquinas. An example is provided by Davenport's assimilation of Aquinas's view of evil to Plato's ("Towards an Existential Virtue Ethics: Kierkegaard and MacIntyre," pp. 302–3). Davenport ascribes to Plato, Aristotle and Aquinas the thesis that, when someone is moved to act, it is always by the prospect of some apparent good, something that the agent takes to be good. Davenport agrees with Kierkegaard that "the Greek mind does not have the courage to declare that a person knowingly does what is wrong" (*Sickness Unto Death* 94). And he goes on to describe the conditions in which "it is difficult but not impossible to choose commitments and particular actions we know with great clarity and force to be despicable, dishonorable, dishonest or deceitful, cruel, callous, uncaring, and so on" (p. 304). It is the plain implication

of Davenport's statements that Aquinas, like his Greek predecessors, cannot find any place for such choices. Yet this of course is a mistake.

Interestingly, Aquinas's discussion of this question, which terminates with the conclusion that someone can indeed knowingly do what is evil, begins with an objection to that conclusion, one of whose premises is that every bad human being is ignorant. But this objection does not prevail against the argument that "when an inordinate will loves some temporal good, for example wealth or pleasure, more than the order of reason or of divine law, or more than the love of God or something of this kind, it follows that it wills to suffer the loss of some spiritual good, so as to obtain some temporal good. But evil is nothing other than the perversion of some good and accordingly such a one knowingly wills some spiritual evil, something which is unqualifiedly evil" (*Summa Theologiae*, Ia-IIae 78, 1). And Aquinas concludes that such a human being is said to sin from a certain malice or purposefully, as one who knowingly chooses evil.

The perverse will, as portrayed by Aquinas, is in one way more strikingly perverse than the will portrayed by Kierkegaard in *Sickness Unto Death* and by Davenport in his essay. For, although Kierkegaard leaves open the rare possibility of the will acting directly contrary to what it knows to be good, the case that he and Davenport consider in more detail is that in which the will contrives that "knowing becomes more and more obscure," so that, when the will finally acts wrongly, it does not after all at the time of acting fly in the face of some judgment about what is good and best. But this is just what the will, as portrayed by Aquinas, is able and even apt to do.

What Aquinas argued—I believe, successfully—is that there is no incompatibility involved in holding both that, when someone is moved to act, it is always by the prospect of some apparent good and that someone may on occasion knowingly choose to will what is evil. Kierkegaard's moral psychology prevents the recognition of this possibility, and it does so because of a conception of the sovereignty of the will and corresponding conceptions of the passions and of reason. It is this conception, or rather the overall psychology in which it is embedded, that puts Kierkegaard and those who follow him clearly at irreconcilable odds with a wide range of different rival views, including those of Aquinas. From Kierkegaard's standpoint, the differences between those rival views are often obscured, since they are apt to be characterized by what they share, namely a rejection of his psychology.

Consider in this light the concept of choice. Kierkegaard's understanding of choice presupposes a very different set of relationships among the will, reason, and the passions from those described by either Aristotle or Aquinas. In an early set of notes (quoted by Gregor Malantschuk in *Kierkegaard's Thought*, Princeton: Princeton University Press, 1971, pp.

80–81) Kierkegaard takes it that not reason, but the will prohibits our being influenced by the arguments of the philosophical sceptic. Doubt is halted "by the categorical imperative of the will" (p. 80). And later on Kierkegaard wrote that the more will someone has, the more self that individual has, and that "A man who has no will at all is no self" (*The Sickness Unto Death*, tr. W. Lowrie, Princeton: Princeton University Press, 1954, p. 162). If, beginning from these passages, we were to spell out in full Kierkegaard's doctrine of the will, we would find that it leaves open no possibility of those relationships between desire, reason, and will which for Aristotle and Aquinas constitute rational choice. There is no place for *prohairesis* or *electio* in Kierkegaard. Yet it is through the exercise of choice understood as *prohairesis* or *electio* that, on a Thomistic or Aristotelian view, those habits which are the virtues and vices determine the character of our actions. And without such an understanding of choice the virtues and vices would have to be understood very differently.

Davenport is therefore in the right when he focuses our attention upon the radical disagreements between Kierkegaard and Aquinas in this area. But once we have taken account of the systematic character of these disagreements and their ramifications, then we are unlikely to be other than skeptical about Davenport's ambitious project of an existential virtue ethics.

VI

Yet philosophical projects that fail often turn out to be as philosophically instructive as projects that are successful and they sometimes contribute even more to the ongoing philosophical conversation. Moreover, insofar as any philosophical project enlarges the possibilities for conversation between different and rival philosophical standpoints, it serves that ongoing conversation. Hence, although my own criticisms of and disagreements with Kierkegaard may have appeared to Kierkegaardians as in large measure mistaken and obtuse, they may nonetheless, by stimulating and in the end clarifying what it is that divides Kierkegaard from rival standpoints, and not only from those rival standpoints that engaged his own attention, have had a constructive philosophical effect. May the conversation continue!

Index

Since references to Kierkegaard and MacIntyre occur throughout the book, only a few major themes have been listed under their names. Similarly, only the more significant or extended discussions of specific writings by them have been indexed.

DATE DUE

AUG 1 9 2002		
AUG 2 5 2002		
OhioLINK		
OCT 1 8 2002		
AUG 1 6 2003		
JUL 0 9 REC'D		DISCARDED
JUL 0 9 REC'D OhioLINK		
OhioLINK		
FEB 0 4 REC'D		
AUG 2 0 2007		
DEC 2 1 2007		
DEC 1 9 REC'D		
GAYLORD		PRINTED IN U.S.A.

B 4378 .E8 K54 2001

Kierkegaard after MacIntyre